S E S S I O N S !

I am especially grateful to publishers Robert and Lorie Goodman, who had the courage to accept the daunting task of this book, and for making it a personal passion and an uncompromising act of excellence. My thanks to wordsmith and editor Paul Berry, for the many hours of looking, layer by layer, so that I could feel securely seated in what I wanted to say. To director of production Tony Lau, fantastic! Thanks also go to production assistant Richard Osaki. To Shawn Randall (and our friend Torah), who helped uncover the essence of the text and give it form. To Shirley Laub, for her insights, and to Lesley Taplin, for the many in-depth discussions and her work on the text. To designer Dave Bhang, for the focus and thought, refinement, and acuteness of his creative eye. To John Van Hamersveld, who has constantly broken boundaries and created new vision for me. To Keith Williamson, who brought to the printing of the images his discerning eye. To Jeff Markus, for masterful prints and Marion Markus, for your help. To Robert Cavalli, for prints. To Cinematographers, Michael Murphy, John Sharaf, and Neil Reichline, who brought a brilliance and a vision of their own to the filming of the sessions, and thanks to Cinematographers Pat Darrin, Baird Bryan, Ric Robertson and Paul Ryan. To principal sound mixer John Vincent, so calmly and astutely present, and to Ken King, for sound. To Filmmakers John Joseph, Joe Kwong, Bob Estrin, and Kit Kalionzes, who contributed in many different capacities. To photographic assistant Cameron Wong, who set a remarkable standard. To photographers Darius Anthony, Alan Levenson, Jay Buchsbaum, Mike Chiabaudo, Janet Baker, Masaharu Homma, and to Gary Heery and Jerry Czember, for the years of fruitful association. To the photographic purity of Al Van Den Berg, and to Georgina Karvallas, my first photographic inspiration in South Africa. For make-up to Natasha Ciura, Fumiko, and Lewis Rabkin. To Art Directors and Designers, for the creative collaboration over the years: Bob Cato, John Berg, Vartan Kurjian, Glenn Christensen, Robert Lockhart, Rod Dyer, Mac James, Kathy Boss, and Tony Hudson. And to so many who supported me in so many different capacities. To Taryn Power, a special thanks for her partnership and enthusiastic contribution. To Alice Passman, Louise Scott, and Cathy Elliot, who brought a life and spontaneity to the session. To Tony Powers, a one man session of his own. To Ginny Winn, a dedicated and loving friend. To Johanna Van Zantwyk, for your strength, sense of principle, and love. To Sumana Harrison, for planning and steering the ship so beautifully. To Michael Lasesne and George Garvin, who contributed so much. To Alex Ducane and Joan Sauers, who gave of their tremendous talent. To advisor and insightful friend Robert Schuster, who has been so key to the development of this book. To David Schnaid, my financial shrink. And to all those who contributed in unique ways: Glenn Owen, Tony Culpepper, Jason Johnson, Suzanne Doudy, Samantha Glazer, Susan Helinck, Jerri Dazell, Kirk Williamson. To Rick Garson and Bill Freston for your innovative ideas. Special thanks to Photographer Bob Witkowski, Buddy Berke at Stat House, Bill White at Studio 46, Drew Andresen at Andresen Typographics, Bob Dingle, for the excellence of his contribution, and all the crew at Glendale Blueprint, and at the Phillip Nardulli Lab. To Jack Schwartzman, for his early and unprecedented support, and to Henry Gellis, for your help on the project. To Herb Wise, for my first book opportunity. To Kent Bateman, for your belief and efforts. To Wally Coover, for your support and my Americanization. To my Japanese friends and team on our Japanese trip, Masa Mikage, Tan Ohe, and Yokoo Tadanori. And on a more personal level, to Jach Pursel, whose friendship and impactful guidance I cherish. To Peny North and Michaell North, who were there to initiate me into a new level of commitment to looking at the truth. To my friends so dedicated to the making of new maps, and through whose authenticity of spirit I can see my own way more clearly: Barne, Debra, Barnett, Sandy, Samantha, Griff, Veronica, Mimi, and Melanie. To Virginia Team for the seminal creative relationship we have had over the years. To Nancy Workman, for our unbounded friendship and fulfilling creative partnership. To my daughter Tai and my son Shayne who continuously reflect back to me that the essence of who we are, and what we truly want, is found in Love and Intimacy. To my late father, Dr. Harry Seeff, an artist, filmmaker, and one of the last of a breed of medical doctors so loved by all those he cared for. And to my vibrant and courageous mother, Hanny Seeff, still an inspiration to be with. I love you.

Book design and text by
NORMAN SEEFF

Text section design in collaboration with
DAVE BHANG

Cover typography with
JOHN VAN HAMERSVELD

Text editor
PAUL BERRY

Original silver prints
KEITH WILLIAMSON

Publishers
ROBERT & LORIE GOODMAN

First Trade Hard Cover Edition
October, 1994

Second Printing
November, 1994

Published by
THE WHALESONG COLLECTION
13333 Bell Red Road,
Suite 230
Bellevue, WA 98005.
(808) 595-3118

Copyright © 1994 Norman Seeff
Library of Congress Catalogue Card Number 94 - 060773
ISBN 0 - 9627095-5-7

Printed in Korea by Dong-A Printing Co. Ltd.,
in Association with
P. Chan & Edward, Inc. Anaheim, Ca.

Gallery representation by
FAHEY/KLEIN Gallery, Los Angeles.

Session Documentation Photo Credits

KEITH WILLIAMSON
page 2-3, Rufus session
page 6-7, Joni Mitchell,
Peter Frampton, Devo sessions
page 8-9, Isaac Hayes

BOB KLEWITZ
page 4-5, Al Jarreau session
page 10-11, Norman Seeff portraits

CAMERON WONG
page 26-27, Martin Scorsese,
John Huston sessions

JOE ADAMS
page 16-17, Ray Charles

To my wife and partner Sue, *whose inner beauty shines through her passionate desire to see those she works with fulfill their creative potentials, and through her gift for giving others a sense of visibility and value.*

To Bob Klewitz, *who came to me fifteen years ago with a dream and a vision. Through his loyalty, courage of commitment, and belief in possibilities, he has helped me realize that vision.*

To the prodigiously creative Bob Cato, *a true artist in the depth of his soul, who opened the doors, and mentored me into my new world, assuring me that I could do it.*

To the multidimensional Lynne Wenner, *who came into my life so magically. Without her I have difficulty imagining how this project could have been done.*

And to Lazaris, *who has allowed me to discover that Love can be trusted, who shows me the door and gives me the key so that the power of choice is eternally in my hands.*

I also dedicate this book in gratitude to all of those immensely creative individuals I have photographed over the years, so willing to give of themselves and from whom I have learned and received so much.

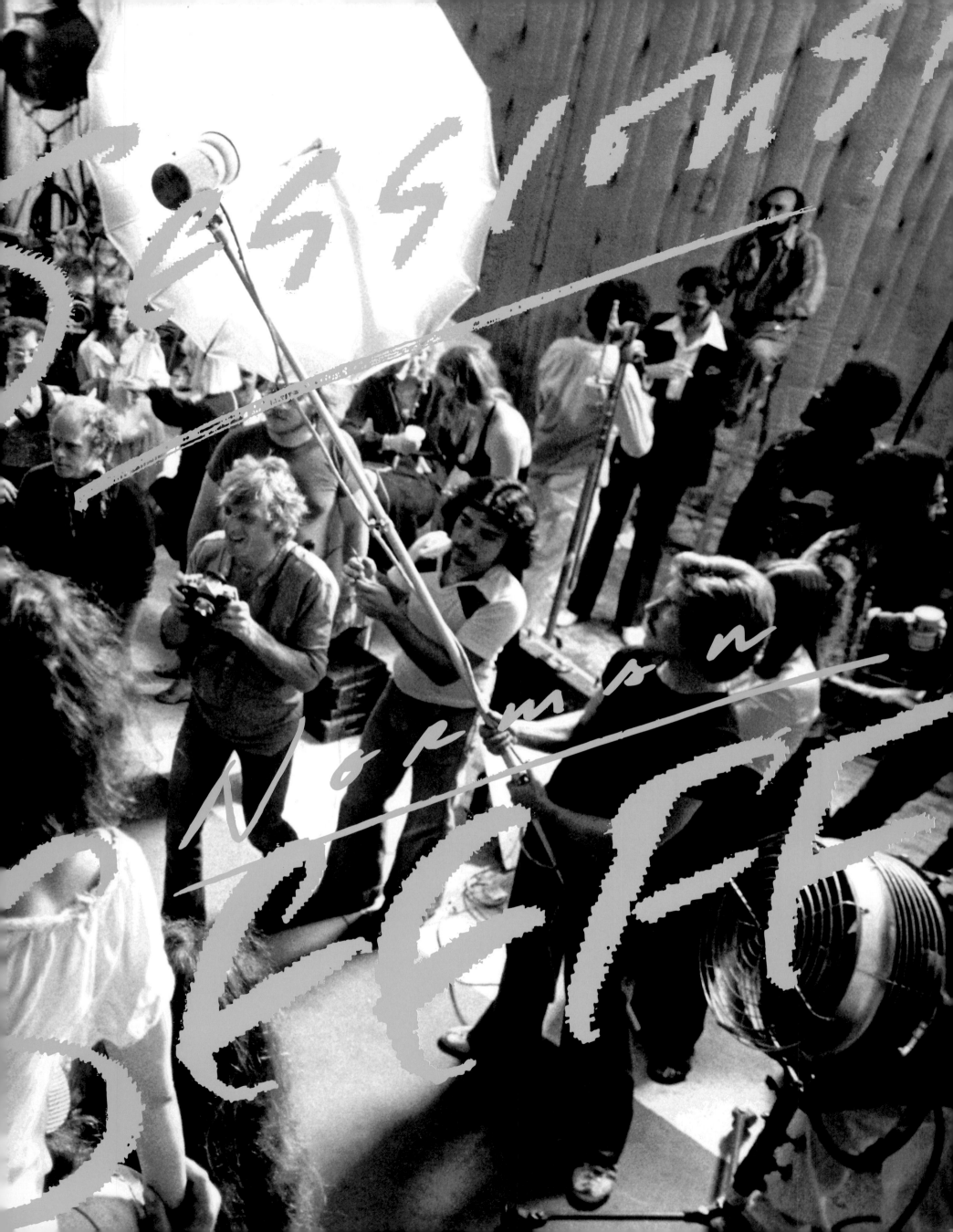

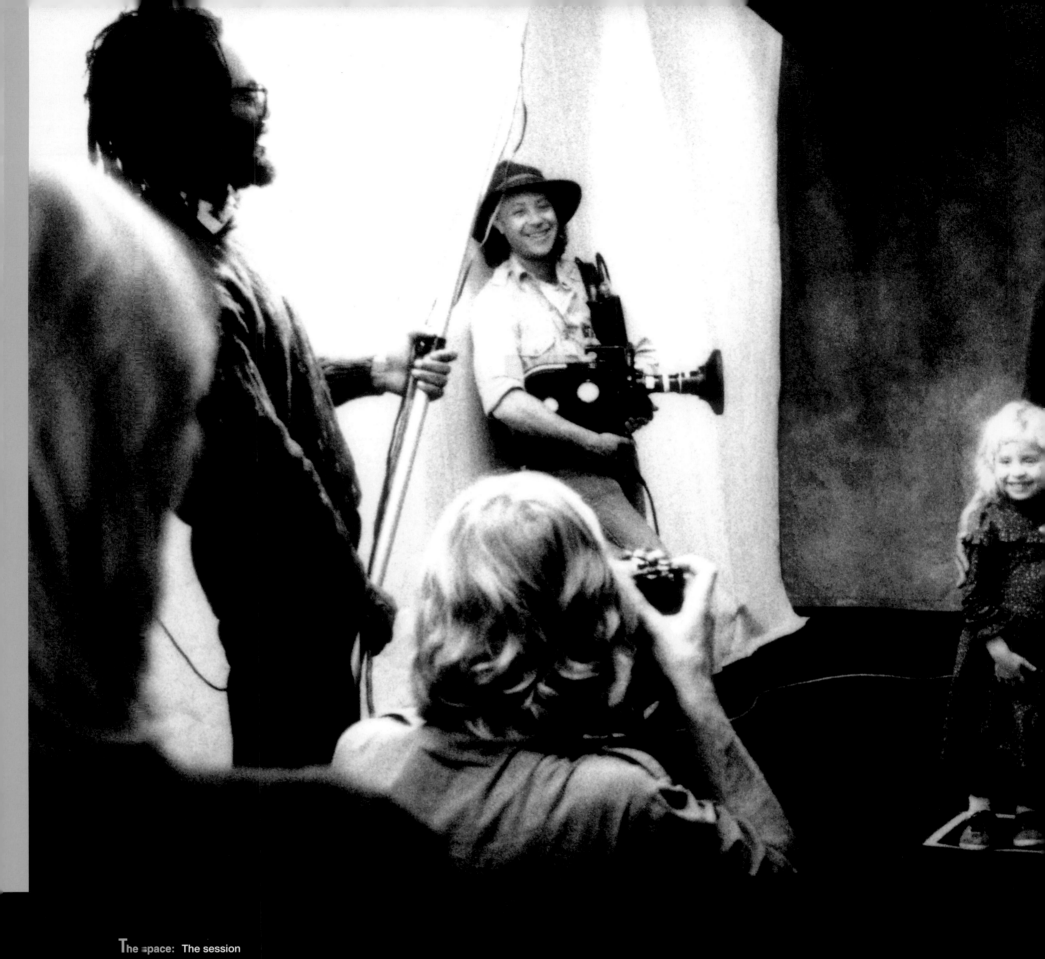

The space: The session began with creating the space in which it was safe to be oneself, to explore, to make mistakes (and have it be okay) and to change. It required a balance between nurturing and challenge, releasing our fears and limitations, and engaging our strengths and talents. It was a subtle dance of directing and allowing, giving and receiving, and out of this could come a dynamic creative partnership. ◾

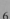

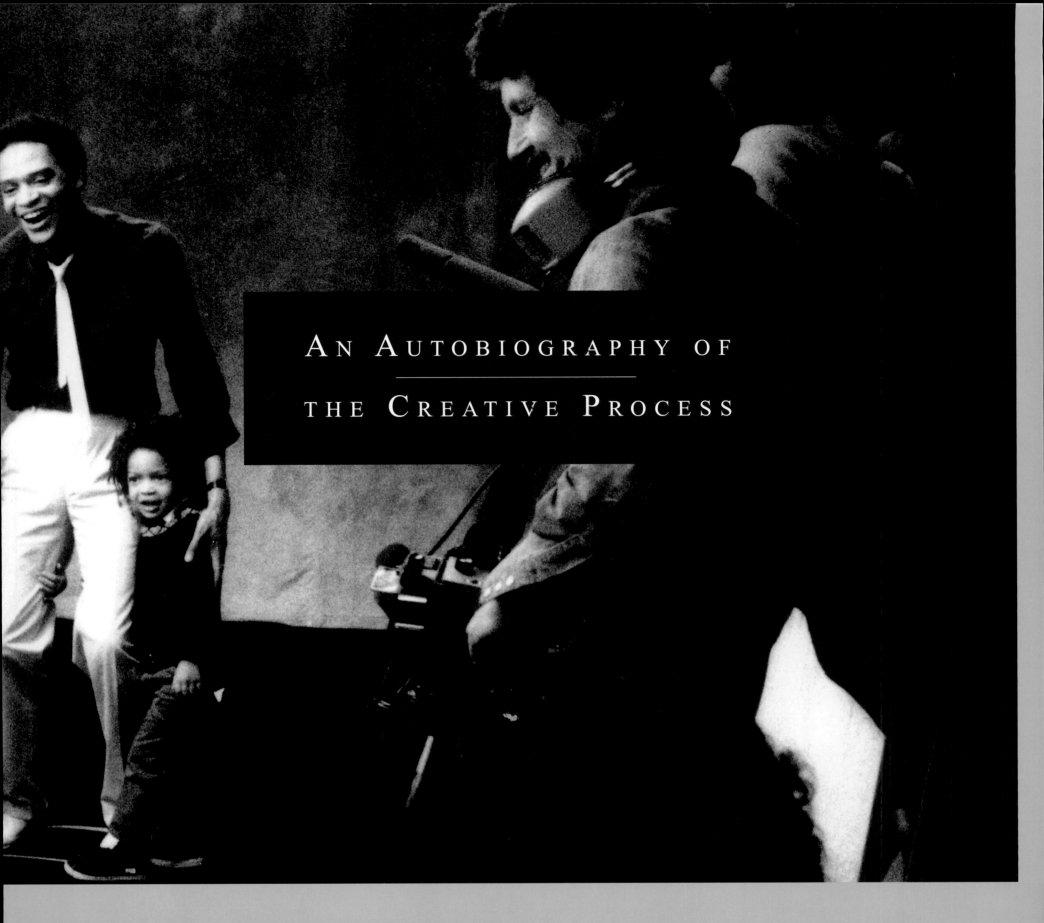

AN AUTOBIOGRAPHY OF
THE CREATIVE PROCESS

AT THE AGE OF SEVEN, while other kids were drawing stick figures, I was drawing anatomically well formed figures in three dimensional rooms. It was just something I was able to do, and I was somewhat mystified why others could not do the same. I spent many hours drawing, and although my parents and friends acknowledged my ability, there was an unstated but nevertheless clear message that being an artist was not something that one should consider as a career.

My father was a doctor, and as a very young child, I would go on his rounds into the poor areas of Johannesburg. As we drove through the narrow shantytown streets, people would come out of their houses to point and chant his name. I was proud of my father and the importance of his role in society, and it seemed self-evident that I would become a doctor like him.

Although I excelled in sports at a rigidly academic and authoritarian "Boys Only" school, the peer status that athletic ability carried did not compensate for my sense of alienation, and in the subjugation of the system, I felt

as if my spirit had died. My passion and joy in my artistic talent were better reserved for my private moments. Unaware of any alternatives, I played the game, suppressing my emotional side, and going for competition and control as my strategy for survival.

Years later, as an intern in the emergency room of Baragwanath hospital in the segregated black township of Soweto, I saw people dying, not only in physical pain, but in a deeper pain of separation and hopelessness. Despite my horror at the brutality and the bloody stench of traumatic medicine, I ended up becoming adept in the management of shock, watching all too often in despair as patients covered in vomit, feces, and blood slipped across a curtain that we could never see beyond.

At night, wearing a still bloody hospital coat, I would ride my motorcycle the thirty miles back to my penthouse apartment in the 'white' city of Johannesburg and become the Artist. Against this backdrop of starvation, social injustice, and physical brutality, the drug and surgery paradigm of

Photosession with Al Jarreau for album cover, 1982. (Left to Right) Darius Anthony, John Sharaf (cinematographer), Normar Seeff, Tai Seeff (daughter), Al Jarreau, Amanjah Anthony (Darius's son), John Vincent (soundman).

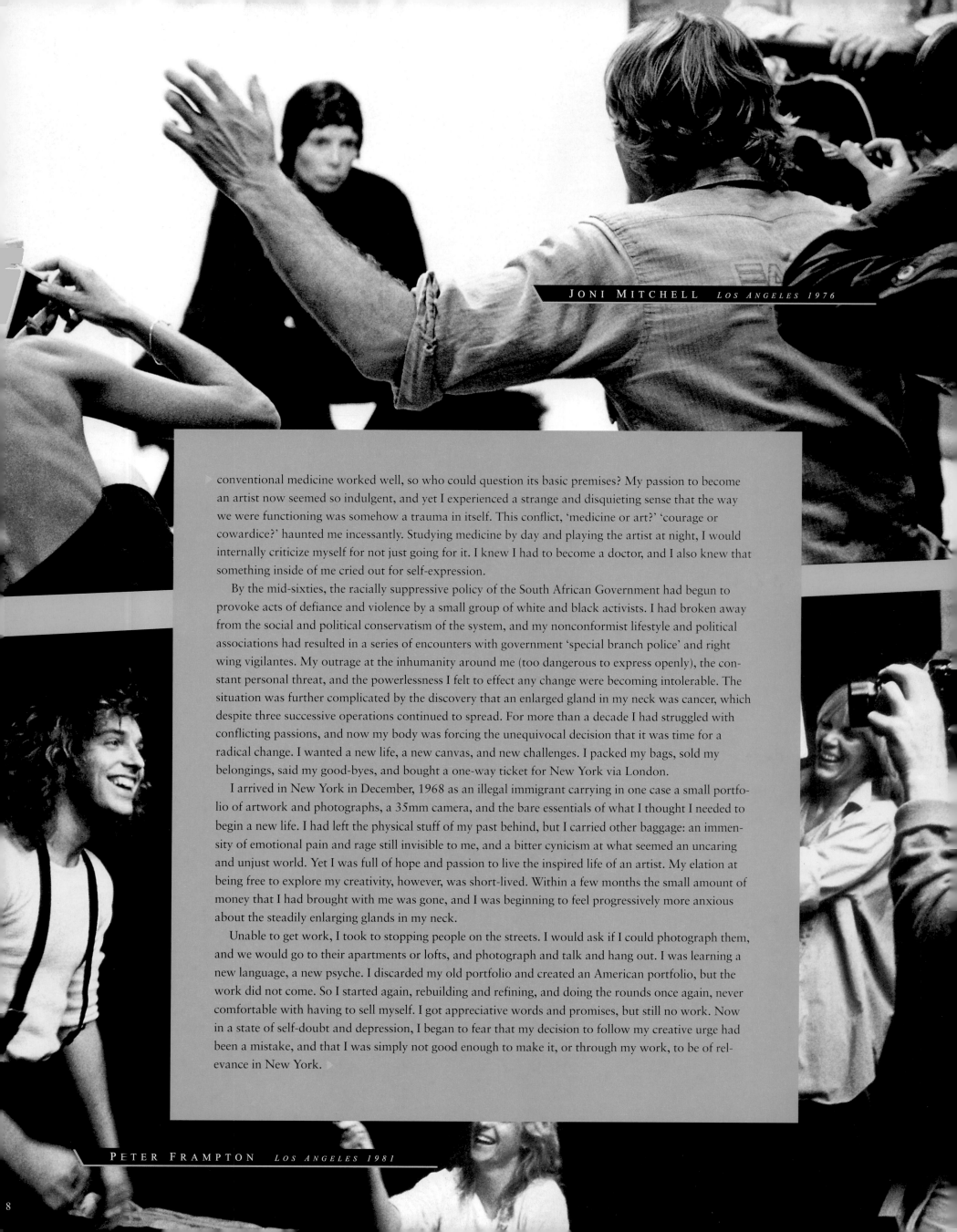

conventional medicine worked well, so who could question its basic premises? My passion to become an artist now seemed so indulgent, and yet I experienced a strange and disquieting sense that the way we were functioning was somehow a trauma in itself. This conflict, 'medicine or art?' 'courage or cowardice?' haunted me incessantly. Studying medicine by day and playing the artist at night, I would internally criticize myself for not just going for it. I knew I had to become a doctor, and I also knew that something inside of me cried out for self-expression.

By the mid-sixties, the racially suppressive policy of the South African Government had begun to provoke acts of defiance and violence by a small group of white and black activists. I had broken away from the social and political conservatism of the system, and my nonconformist lifestyle and political associations had resulted in a series of encounters with government 'special branch police' and right wing vigilantes. My outrage at the inhumanity around me (too dangerous to express openly), the constant personal threat, and the powerlessness I felt to effect any change were becoming intolerable. The situation was further complicated by the discovery that an enlarged gland in my neck was cancer, which despite three successive operations continued to spread. For more than a decade I had struggled with conflicting passions, and now my body was forcing the unequivocal decision that it was time for a radical change. I wanted a new life, a new canvas, and new challenges. I packed my bags, sold my belongings, said my good-byes, and bought a one-way ticket for New York via London.

I arrived in New York in December, 1968 as an illegal immigrant carrying in one case a small portfolio of artwork and photographs, a 35mm camera, and the bare essentials of what I thought I needed to begin a new life. I had left the physical stuff of my past behind, but I carried other baggage: an immensity of emotional pain and rage still invisible to me, and a bitter cynicism at what seemed an uncaring and unjust world. Yet I was full of hope and passion to live the inspired life of an artist. My elation at being free to explore my creativity, however, was short-lived. Within a few months the small amount of money that I had brought with me was gone, and I was beginning to feel progressively more anxious about the steadily enlarging glands in my neck.

Unable to get work, I took to stopping people on the streets. I would ask if I could photograph them, and we would go to their apartments or lofts, and photograph and talk and hang out. I was learning a new language, a new psyche. I discarded my old portfolio and created an American portfolio, but the work did not come. So I started again, rebuilding and refining, and doing the rounds once again, never comfortable with having to sell myself. I got appreciative words and promises, but still no work. Now in a state of self-doubt and depression, I began to fear that my decision to follow my creative urge had been a mistake, and that I was simply not good enough to make it, or through my work, to be of relevance in New York.

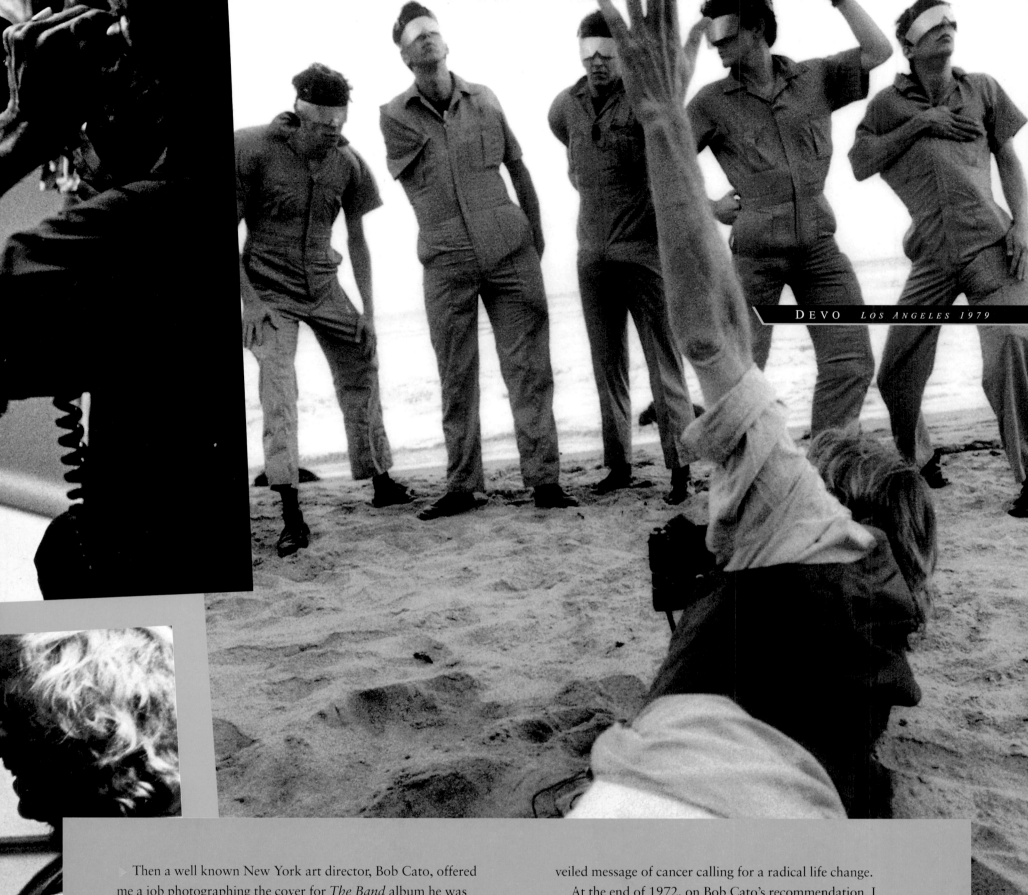

Then a well known New York art director, Bob Cato, offered me a job photographing the cover for *The Band* album he was designing. The image stimulated tremendous public response, and my situation altered drastically for the better. Doors that had previously been closed now began to open, and I began to get freelance photographic assignments on a more regular basis. I also began designing album covers for record companies, and simultaneously started teaching photography on a part-time basis at Bennington College in Vermont. A short time later, after drinking two doses of radioactive iodine at a research center in Boston, I watched the enlarged glands in my neck begin to dissolve, and ultimately they disappeared over a period of a few months. I had paid allegiance to my belief in conventional medicine, but in the depth of my soul I knew I had responded to the

veiled message of cancer calling for a radical life change.

At the end of 1972, on Bob Cato's recommendation, I flew to Los Angeles to become Art Director of United Artists Records. I had been in the country for only three years, and I now headed up the design department of a major record company. I threw myself into my new role of designing and photographing album covers, living the Rock 'n Roll life, working late into the night, and then hanging out in music scene bars and clubs into the early hours of the morning. Life was defined very clearly. Rock music was the New Religion, and I was creating Devotional Icons.

Two years later, having decided to go out on my own as a photographer, I found a small A frame house on Sunset Boulevard. By 1975 I was photographing musicians, actors, writers, directors,

Photosessions (top left) Joni Mitchell for "Hejira" album cover, (top right) Devo on Santa Monica Beach for Life Magazine, (bottom left) Peter Frampton for album cover.

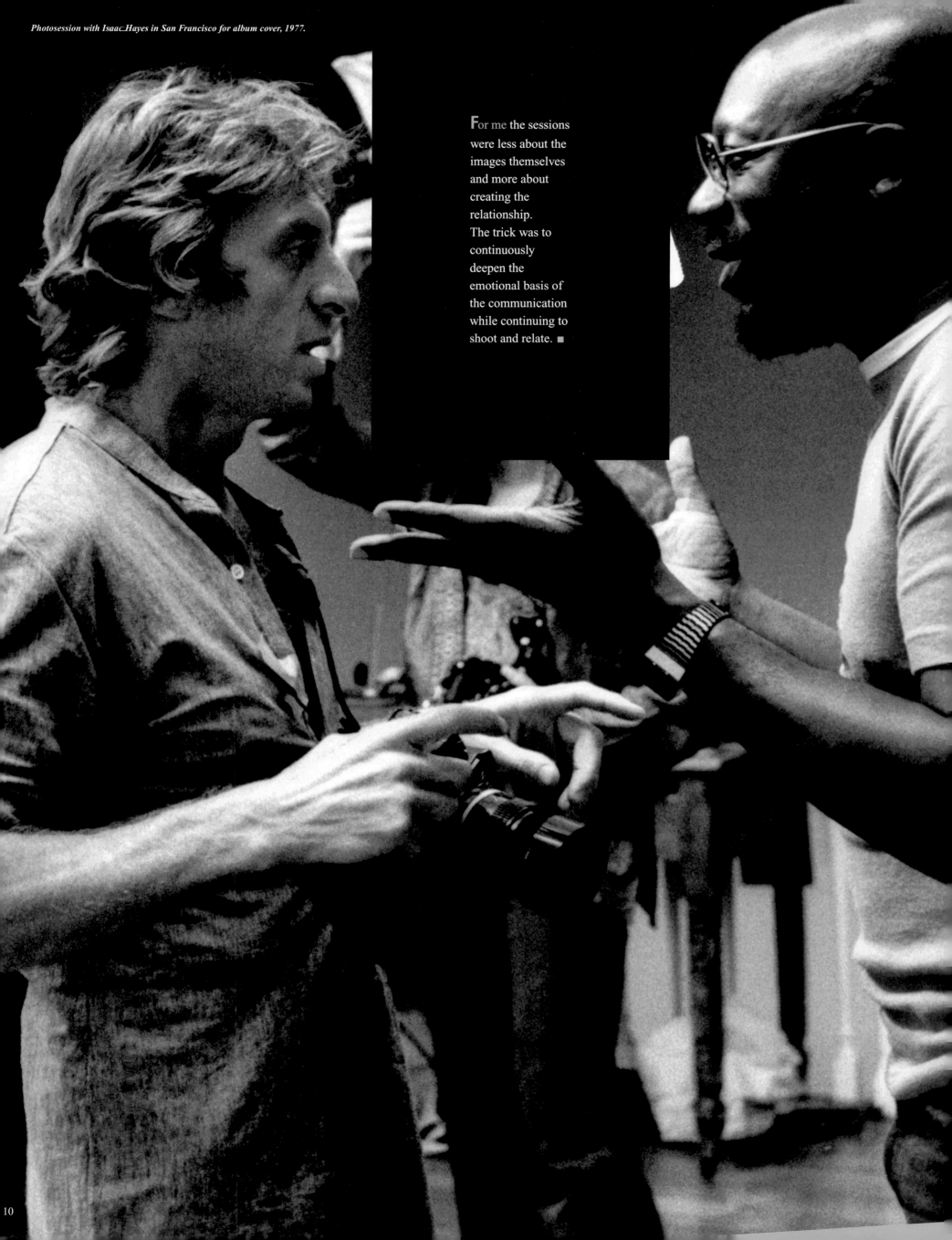

Photosession with Isaac Hayes in San Francisco for album cover, 1977.

For me the sessions were less about the images themselves and more about creating the relationship. The trick was to continuously deepen the emotional basis of the communication while continuing to shoot and relate. ∎

10

and other public figures in the diminutive studio only 12 feet across. I had been shooting on a regular basis for about five years, and now I was beginning to discover and formulate a personal vision. It was becoming clear to me that I did not want simply to photograph the outer surface of the physical body. I was looking to capture something deeper, an inner essence, a soul behind the eyes, a living, breathing sense of the 'beingness' of the person.

I knew where I wanted to go, but did not know how to get there with any sense of certainty. In time I came to recognize that for me *the session was not so much about taking photographs as it was about creating a relationship with the person I was photographing.* As simple as this realization was, it had monumental impact on the way I worked. I would tell people, "I care more about the relationship and less about the end result," not meaning that I didn't care about the images, but that the process of getting them was the key.

At this time I came to another fundamental realization, *that the emotions and more specifically, emotional intensity, were the absolute basis for the creative process.* It was evident that if I was not honest about how I was feeling, then my communication with the person I was photographing was not going to work. The problem was, as I intensified the emotional basis of communication, I began to run into resistance from many of the people I was photographing. Initially as this came up, I thought it was some flaw in my ability to relate effectively. Later I was able to recognize that this resistance was a consistent and clearly identifiable stage that almost everybody went through as we began to go beyond surface emotion.

I step into the ring with a world heavyweight boxing champion to do a session. I have watched, appalled at the intensity of physical violence as he batters his training partner into submission. "Are you scared of anything?" I ask. He looks at me with derision, almost a sneer on his face. "Of what?" he replies. I raise my camera, and then I see it, almost imperceptible, a flash, but a clear give

away, a subtle quiver to the eyes. Johnny Mathis stands in front of the camera. "Sing" I prompt him. He shakes his head. Something holds him back. We play "Misty" in the background. "Will you dance with me?" a young woman asks. They dance together, and he begins to sing to her, and she joins him in a spontaneous duet. The energy changes. It is pure magic, and it strikes me how, paradoxically, vulnerability and the power to impact go together. Phoebe Snow picks up her guitar. This is going so smooth, I think, no problems. And then she falters, "Three thousand people going Yea!! That's OK, but one guy with a camera!" She shakes her head in disbelief at her own sense of inhibition. Bob Fosse tells me with a touch of humor that before he shoots, his fear is so intense that he vomits. "And if I don't, I get scared that I am becoming arrogant." "What is the fear?" I ask him. "That they will find out that I am a phony." "Then what happens?" I ask. "Then I admit it and I say, Yes."

I was surprised to discover that many public personalities hated being photographed. I came to the strange perception that many people related to the camera almost as a weapon, and that I was the one 'holding.' Sometimes I could pick up a hostility and sense the projection onto me as the bad guy, and it was this presumption of threat that gave the session the dynamics of antagonist, protagonist, and dramatic plot. In time I was able to see that breaking through people's fears of the camera was the key to the session, and I began to develop a strategy in the form of a loose 'script' to deal with the resistances in ways that were not too heavy or confronting.

At a personal level, as I entered into the session at a more emotionally intense level, invariably I would break out into a cold sweat, hitting that wall of dread and fear. Rationalizing that alcohol and drug consumption was a natural part of being creative, I would impulsively reach for the double scotch, then another and another until I felt I had crossed a barrier of self-control and inhibition. Eventually, however, I had to own the truth of what

I did not want to just passively record what was happening, but to be a participant in creating the emotional states. More, I wanted to record those emotions that represented the highest states of creative inspiration and spirit we could achieve together. If the moment was real and alive, then the image was real and alive. I was searching for an inner essence, a soul behind the eyes, an authenticity in them as well as in myself. ∎

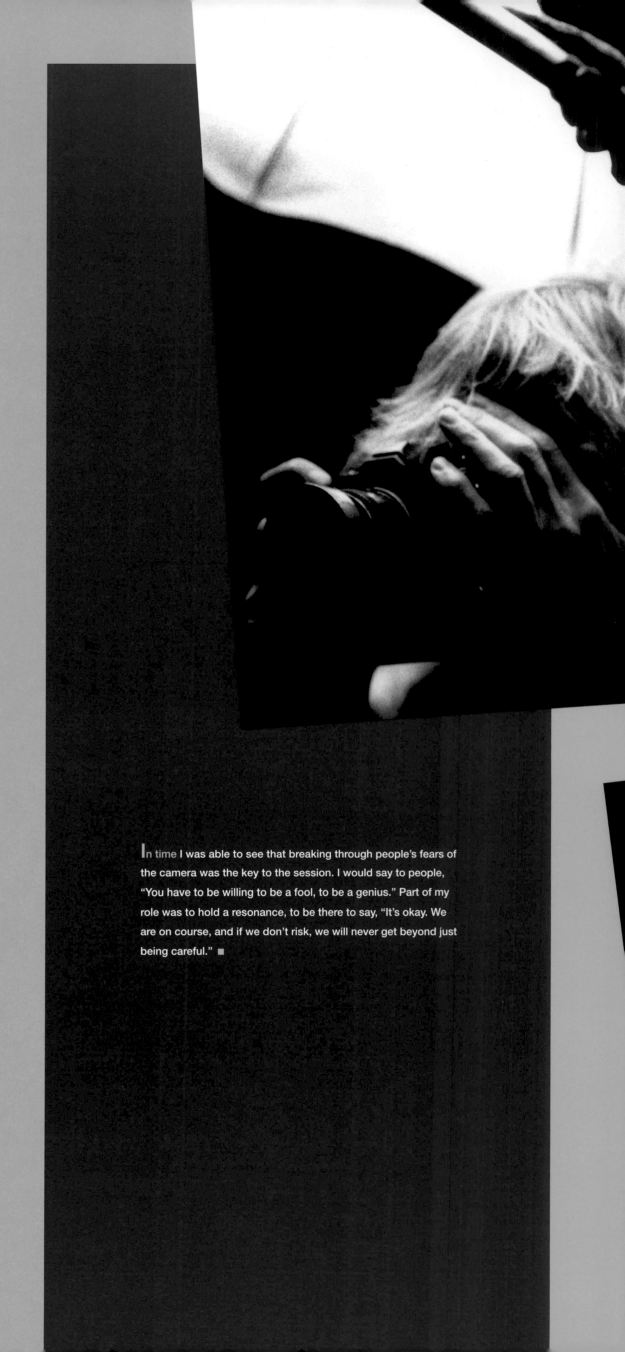

was going on. I was becoming dependent on alcohol, believing I could not handle the session without it. In time, as I was willing to be more honest with myself, I was able to see the hypocrisy of my actions as I pushed *them* to let go and denied my own fear. Subsequently over a difficult period of two to three years I was gradually able to end my dependency, and handle the session clean and face the fear that I had previously attempted to overcome synthetically.

In order to get the type of image I was looking for, I needed to create a context *the space* in which it was safe to be vulnerable and authentically who we were. I wanted to record the continuous and rapidly changing nuances of emotion I saw played across people's faces, but more, I wanted to be a participant in creating the emotional states we were experiencing. Also, more specifically, I wanted to record the emotions as artists achieved inspired and heightened states of creativity. *The session, for me, had become an art form itself.*

To achieve the intensity and the sense of aliveness I was looking for in a three to four hour session, I needed to move into emotional intimacy as quickly as possible. However, if I pushed too fast, and challenged them too soon, up would come the resistance. I was urging people to trust what was happening, to let go of habitual ways of functioning, and to explore new forms of expression. I wanted people to open up, not only to their vulnerability but also to their strengths.

So I would begin in as informal and conversational a way as possible, and I would tell people, "I like to hang out and have fun, and I shoot in a way that is very free form, very loose. Also, I am going to be as honest with you as I can. I know that many people are uncomfortable being photographed (I am), and know that I am totally here for you." Often while I was doing that, one of my assistants would hand me a camera, and I'd start to shoot as I was talking, so the session was often happening without them even realizing it. It was also necessary in many cases for me to open up first. I would say, "I am feeling kind of nervous now, and I don't quite know where I want to go, but let's go anyway." Often the other person would say, "I'm so glad you said that. I hate being photographed, and I am terrified."

As a first practical step to creating a sense of safety, I would mark a rectangle on the floor and tell people, "That's your space." They would ask, "What do I do in my space?" My answer would be, "Anything you want. Just don't attack the photographer." Often I could get a pretty good idea of what the session was going to be like from their reaction to the symbolism of this space. Essentially it came down to a basic dialectic. Emotional honesty and vulnerability produced a sense of trust, and people would then feel safe enough to open up and let go.

Another surprising discovery was that those artists who were willing to be vulnerable and to show their fears would at some point function as if they were not scared at all, and act in spite of their fears. Those who were defensive never got past their fear and were incapable of acting decisively. When someone was vulnerable with me, I would feel a real sense of respect for their courage, and it inspired me to risk going deeper myself.

Also, it was essential for the success of the session that I build a creative partnership with the person I was working with. My own tendency to try to control reflected back at me when issues of competition would come up. I would communicate to the artists that I wanted to be there for them, and that I wanted to work *with* them in getting the greatest shots we could. Invariably with the recognition of what was going on, we could drop the ➤

In time I was able to see that breaking through people's fears of the camera was the key to the session. I would say to people, "You have to be willing to be a fool, to be a genius." Part of my role was to hold a resonance, to be there to say, "It's okay. We are on course, and if we don't risk, we will never get beyond just being careful." ■

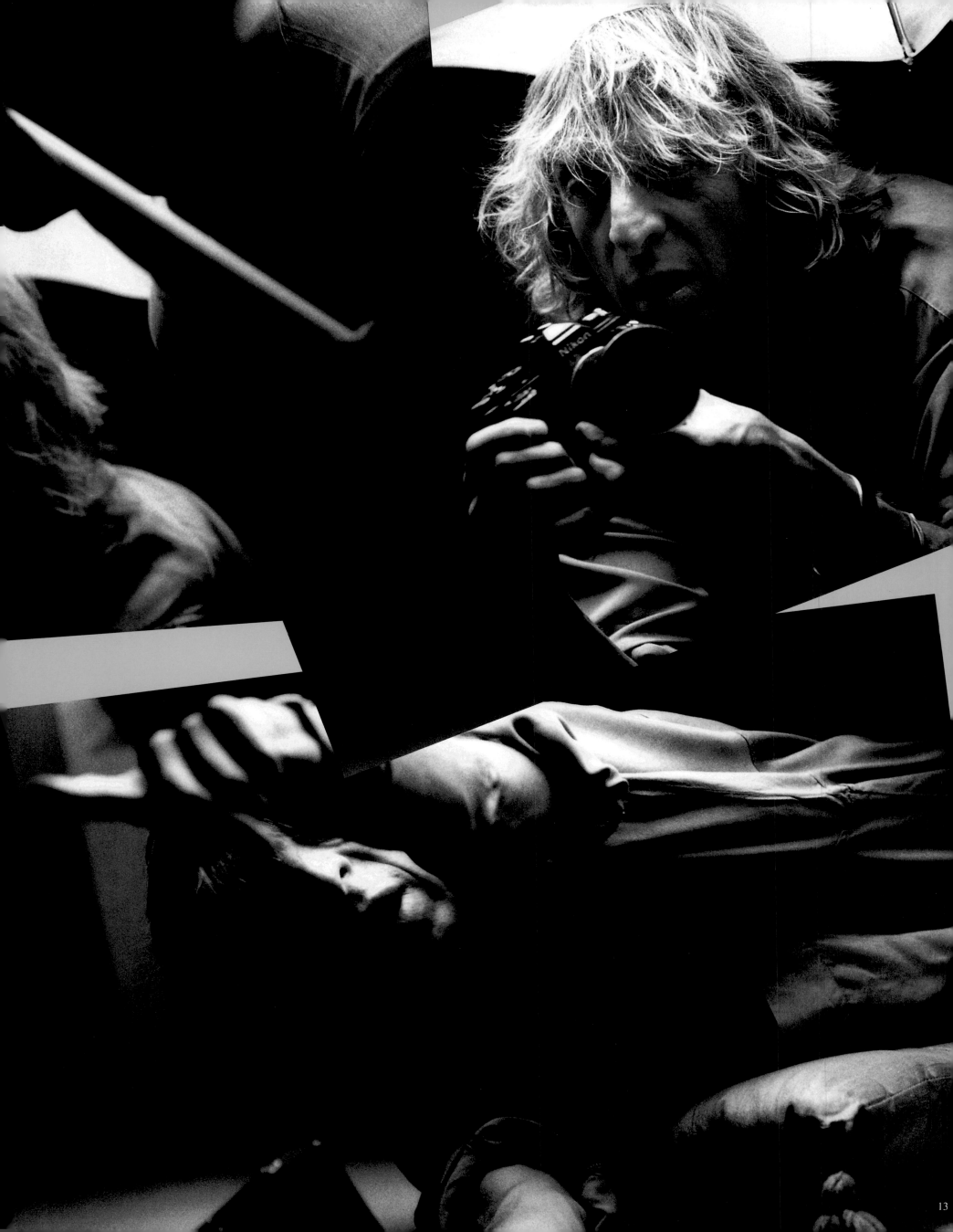

competition and work synergistically in a creative alliance.

An additional problem that often came up in the session was a misunderstanding that being photographed means the photographer does all the work. So I had to deal with a certain amount of inertia or an attitude of, "I'll just stand here and you do it." I would say to people, "I need more from you. If you don't put your energy into the lens, it won't be in the shot. I can't do it for you!" I needed a total commitment on their part to put out without restraint, or it just didn't happen. I would ask, "Are you holding back?" Often they would get that they were, and if they let go, there would be a surge in the energy that clearly translated onto the film. Then there were times that as I approached a session, knowing the level of emotional intensity and vulnerability it demanded, and not feeling up to it, I would hold back. Once the session started, however, and there was no 'juice' to it, it was obvious that nothing short of a total commitment on my part would work either.

Another resistance that I would see coming up in the session was that people would start to judge themselves and begin to shut down. I was aware in my own case, that when my inner voice went into the critic, I had to actively reject it, or I would get stuck in my own inhibition and spontaneity became impossible. So I would say to people, "You have to be willing to be the fool, to be the genius." Part of my role was to hold a resonance, to be there to say, "It's okay. We are on course, and if we don't risk, we will never get beyond just being careful."

It was fascinating to observe that when people were in the critic part of themselves, their faces would change, their body tension would increase, shoulders would tend to hunch, breathing would become constricted, and emotional expressiveness would become less free. I commonly had to remind people to remember to breathe. I would say, "If you are worried about how you look, I will just get shots of you looking worried," and often they would get the humor of it and just drop it.

Sometimes at the beginning of the session I would say, "Stand there and look in the lens," and I would shoot a head shot. I would tell them, "You don't have to feel looked at. You can do the looking." At the end of the session, I'd do the same shot again, and they would be right there, looking at me from a totally different emotional place, and the image would be much ▶

The session was an opportunity to experience the unique processes and creative brillance of the people I worked with. When we worked together in a successful creative alliance, there was a beautiful emotional intimacy, a sense of fulfillment and mutual appreciation. I wanted people to take away from the session the feeling that it did not have to be a struggle, even though it was demanding and challenging. ∎

more powerful and alive.

So I was determined to function in the session with as little judgment as I could, not always an easy task, but a valuable ideal to aim for. Also, in a more subjective sense, I was eventually able to see that my control came out of the judgements that I projected onto my own emotions. If I allowed my emotions to be just a quality of energy that I was experiencing without judging them as weak or bad, then I could express them more openly.

With my understanding that the creative process has within its essence an implicit uncertainty, I became more open and willing to enter into the uncertainty and chaos of it. Initially I thought that by understanding every step of the session conceptually, I could get perfect control, and that would guarantee the success of the session. Later I was able to see that there are no guarantees, and that not only was perfection

impossible, but it was really a way to avoid the discomfort of uncertainty. Unless I was willing to be forgiving of the mistakes and go for the fun of what I was doing, I ran the risk of sucking the life and the joy out of what I was attempting to create.

Also, when I first began to shoot, I had no sense that there was a hidden form or a structure to what I did. Subsequently it became evident that there were many parallel and indentifiable processes taking place simultaneously. In recognizing that in essence I wanted to go from 'resistance' to freedom, it became apparent that the session could go in one of two fundamental directions. If we were able to break through, there was a progressive deepening of intimacy and trust into a state of freedom and spontaneity. If we did not break through, the session got stuck in the resistance, and the vitality died. Recognizing these patterns and structures was valuable in that it could give me a

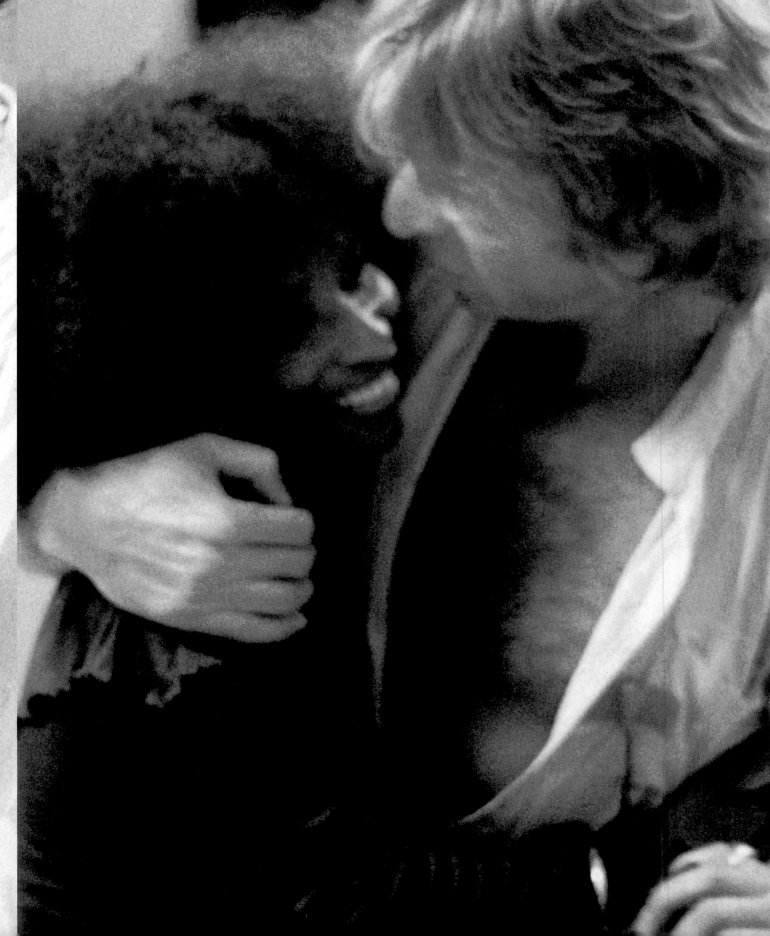

15

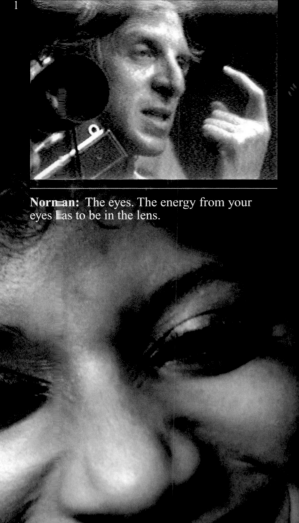

1

Norman: The eyes. The energy from your eyes has to be in the lens.

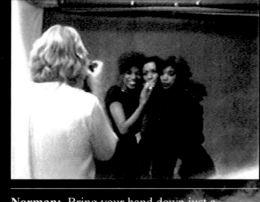

2

Norman: Bring your hand down just a fraction so I can see your lips and look at me. Look at me and relax. That's it!

3

Norman: Okay, that's it. There. I want to see six eyes…

I recorded sequences of events in an almost cinematic way, responding to the rapid succession of body language cues and fleeting emotional changes. Taking the camera away as I was shooting and talking to them invited them to relate to me and not to the camera. "This is just a box with glass in front of it." I would tell them. Looking at a face rather than a lens focused people on the communication, and they could let go of the self-consciousness of being looked at. ∎

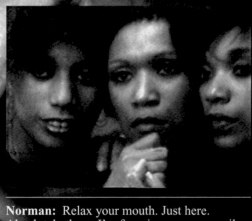

4

Norman: Relax your mouth. Just here. Absolutely there. I'm focusing on your pupils. Great! Hold it. Hold it. There it is.

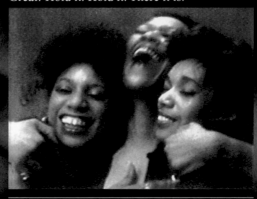

5

(The Pointers break loose, Norman shooting rapid fire.)

16

sense of what was going on, what direction I was headed, and I could take action accordingly. It was important as always, however, to understand that the process was essentially a projection of my own preconceptions and insecurities, and not something that every artist needed. By the time Tina Turner had walked across the floor to the platform we had built for her, she was in total command of the session. Her sense of creative authority, instinct, and timing was breathtaking, and all I had to do was keep pace and shoot what was unfolding.

Initially I thought directing was about the actions I took, but later I was to understand that it is equally about listening, receiving, and responding to what is happening. The more I was able to be respectful of others, to hear and see them and let them be visible, the more I was able to dance with the beautiful and subtle cycles of giving and receiving, of directing and allowing.

And then there is Love, a taboo area for many to talk about, but nevertheless an unspoken dynamic of the Session. The word cannot be spoken for fear of derision, so I tell them, "That's great. You've got it! Great!" and the message is communicated, camouflaged, but loving nevertheless. As I let go of my old images of love, I began to see that love lives and breathes in the courage to be vulnerable, to be committed to the other's well-being, to respect and to be honest with each other. As I was able to look at it from that perspective, I could see that we were acting out of, and giving love in the context of the session.

Feeling that still photography did not fully capture the intensity and depth of what we were doing, and with the intention of making a feature length film, I began early on (mid 1975) to bring film crews into my sessions. Over a 15 year period we filmed and recorded dialog and performances in hundreds of sessions. Now I was experiencing more subjectively the emotional intensity of what it was like to be in front of the camera. It was to take me close to five years to feel relatively at ease and to forget the presence of the camera.

Looking back at the thousands of feet of film shot in the sessions, perhaps the most evident quality that comes through was the huge sense of fun, playfulness, and laughter. The beauty and the fulfillment of it was that I could work and play at the same

Inset Frames (1-8) Reproduced from Videotape of Pointer Sister's Session 1982.

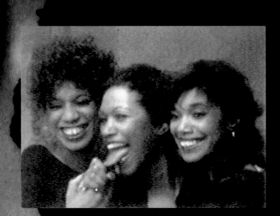

Norman: Great! Great! Keep going!

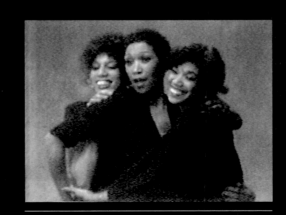

Norman: We got it! I'm going to stop at this point. (*The Pointers cheer!*)

Norman: It's a total pleasure.
Pointers: You are the best!

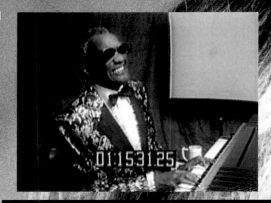

01:15:31.25

Norman: Now… What about the voice?
Ray: Well… My voice… that's different. We can't talk about my voice because my voice is something that I never tried to analyze. I've always had my voice like you've always had yours. I've always tried to emulate or appreciate sounds. Meaning what, meaning I've been trying to sing. If you can sing what's in your heart and keep time… that's it.

01:15:44.26

Norman: Yes.
Ray: (*Playing piano, humming, then singing.*) See it's easy to sing…
Norman: Yes.
Ray: Very easy.

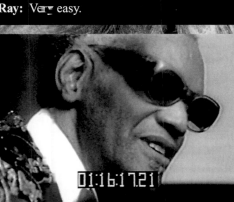

01:16:17.21

Norman: Oh yes…
Ray: I just made that up, see. That ain't even a song, ain't even nothin'… but ya… that's the thing about… I can just get a feelin'… jus'… I may not sing anything that makes sense, but I can sing notes.
Norman: But you sing out of your heart.
Ray: That is… you got it.
Norman: And that's where it happens, you see.
Ray: You got it… That's it… S'all I know.
Norman: Yes.
Ray: (*playing piano and singing.*) All I know, baby there'll be no peace — here I go — There'll be… There'll be no peace without all men as one (*talking*). See how easy it is to sing? Nothin' to it… You can do it!!

01:18:08.09

Norman: You wouldn't want to hear my notes.
Ray: Oh yes, I would…
Norman: But you see, what you do is that, through your art, you absolutely, if it comes through your heart the way it does, it resonates in other people in the same place.

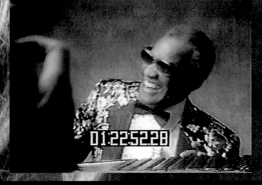

01:22:09.22

Ray: It's the only way I can make you believe, so if I'm singing a sad song, I become sad…
Norman: Right.

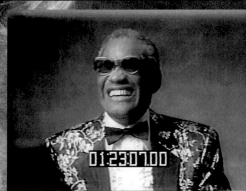

01:22:52.28

Ray: I become happy when I, when I, when I'm into (*Ray begins to boogie on the keyboard… Talking.*) You know what I mean…

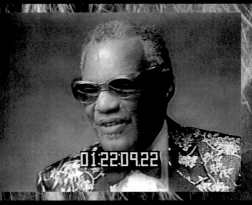

01:23:07.00

Norman: Yes.
Ray: So everything has its place, you know, but the name of the game is to be able to get the sound, get the feelin', get the mood of whatever you're doing… And that's what I do! Now you got it.
Ray: Yes, it does.
Norman: That's great!
Ray: It really does, brother.

01:18:14.10

Norman: That makes life very simple.
Norman: Well, you're such a lovely man…
Ray: Thanks.
Norman: Because you really project all of that stuff, and it does, it's healing in a wonderful way, really… I don't know what else to say.

time. I invited friends and guests who became an integral part of the dynamic. We could hang out, communicate, have fun, and experience private performances by truly inspiring artists. Studio life had a scintillating sense of expectation and excitement. "Who was next?" "What was it like to play and create with Tina Turner or Ray Charles or Joni Mitchell?"

I am photographing Ray Charles. We talk and he sings. I am profoundly moved by his vitality and joy, which uplift all of us in the room. As I am shooting, it strikes me that the creative person can be a healer, and that through our creative expression, we have the capacity to heal ourselves and those around us.

So what is this strange and mystical thing called the 'creative urge' that has driven me for so much of my life? Through creativity I sense a way to access the subconscious and unconscious aspects of myself, and in doing so, to plumb the depths and express a deeper urge. At the core of myself I am driven by an urge to heal the past, and to bring about through conscious action a lessening of the pain and a positive change in the world around me. But in those depths there are demons I must encounter. I see that when my creativity is motivated by a desire to get praise and the approval of others, it degenerates into a way to take rather than to give. When I am creating *out of* love rather than *for* the love, then it becomes a powerful force that can inspire and create true change. Also, when the product of my creativity carries the hidden agenda of vindicating me in the eyes of the world, then creativity loses its joyful and fulfilling nature.

So the session became for me more than just a vehicle for taking photographs. It became its own unique form in which I could enter into a personal and creative relationship with others and explore a new subjective paradigm of relating. In retrospect, I see that I have been driven not only to express the creative side of me, but to explore the dynamics of my growth and potential as a human being. The session was in many ways a reflection of what I had to learn the most. In letting go of many of the limitations of my past, I have become more willing to risk emotional intimacy and partnership.

It is now eight years since I moved into a new arena of full-time filmmaking, and the principles that worked in the session appear to be just as valid and effective in directing actors. I have come to see the value of creativity as a necessity for a fully lived life, to respect people more, and to value their unique processes more profoundly. My career as a photographer spanned the 70's and the 80's, and the world of the 90's is a different place, and I am a different person. I have come, in one sense, full circle, to see that healing is not about fixing, but about changing, and creativity has been for me a valuable journey of growth and change.

1976

Norman: How are you feeling?
Lily: I'm feeling… you know, I'm feeling…
Norman: It's got to be the truth. It doesn't matter where you're at.
Lily: Ahh… Okay, I feel… I like the way I feel… I can't… Ah, (*pretending seriousness*) I'm in a particular space.
Norman: Yes…

Lily: That doesn't allow… ah, like I don't feel really centered so that I can put something out, something… I know, because I am a performer. So that I know what I'm putting out, I can't put that out right now.
Norman: What we did is take your act away.
Lily: (*teasing*) You did.

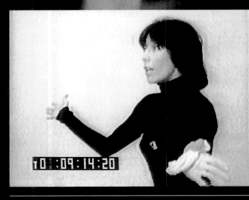

Norman: Which is okay… If you weren't…
Lily: You guys… Hey… Hey, wait… people. Hey… Hey… people, wait a second…
Norman: (*laughing*) I need a wide-angle lens, hold on…
Lily: Hey, people… hey… I don't need it… Hey (*continuous laughter*), some of us have acts, you know, because we *like* to have them.

Later

Norman: How do you feel?
Lily: I feel okay… I like this… You know, I have this fantasy that, like, we're gonna penetrate my core.

Norman: Stay in your space. We want to make you look real sexy…
Lily: Gamine?
Norman: Yes, gamine, beautiful. Okay, you have to put your glass down.
Lily: Okay, I can't because, see, my hair is not right, it's never going to come out exactly right, perfect, because… I let them cut the front of my hair today, and it's just not right.
Norman: These are the excuses for what? I wasn't quite sure.
Lily: These are the excuses for not being able to project sexuality.

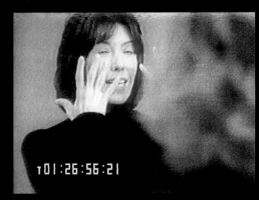

Norman: Why don't you just ruffle it?
Lily: That doesn't work. It makes my hair get funny.
Norman: How about some wind?
Lily: Wind's no good, because then my eyes are very sensitive to wind… and they, ah… because my eyes are real sensitive right now and I want to shut them against, I want to shut them against the lights and the sounds and the sights.
Norman: Okay, why don't you close them for a bit.

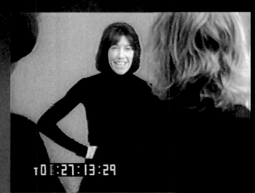

Lily: I don't feel real, you know, my eyes…
Norman: Okay, close your eyes.
Lily: I feel more comfortable with them closed.
Norman: Close them.

8

`T01:30:37:06`

Norman: Your face is changing by the moment.
Lily: Is it?
Norman: Yeah.

9

`T01:30:15:23`

Lily: I can feel little ions moving around… like nose ions are exchanging themselves for cheek ions. (*laughter*)
Norman: I'm going to leave you there for a moment and change film, so just hang in.
Lily: All right.

1986

1

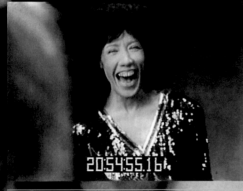

`20:54:55.16`

Lily: My hair look okay? Fluffy enough?
Norman: Hah! Have I heard this before, hah, hah.
Lily: Who would know we would be good archival material… (laughter) I mean, you know, it's going on, we've gone on a long time, so that's good…

2

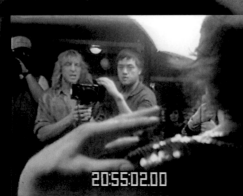

`20:55:02.00`

Norman: Nine… Nineteen Seventy-six…
Lily: This shoulder pad is like slightly fatter than this one.

3

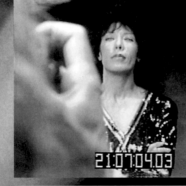

`21:07:04.03`

Norman: Look in the lens… Lift your head up… up, up, up, (*music*) dance, baby!
Lily: You know, if I dance too much, then I get out of, you know, like…
Norman: Your hair falls a bit.

4

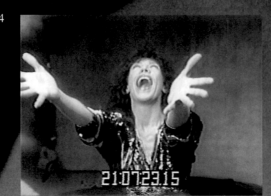

`21:07:23:15`

Lily: You know, we even used that shot like this, did you ever see it?
Norman: No… I never saw it…
Lily: We used it several times. People have printed it, ya know, it was a little out of focus, but…
Norman: Yeah, let's do it, that's great… Oh, I love that shot…
Lily: A lot of people used it. You know, all that dancing and everything.

5

`21:06:49:01`

Lily: Want me to stay in my space?
Norman: (*laughs*) Keep going…

6

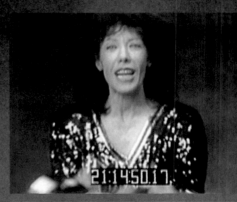

`21:14:50:17`

Lily: The bad part about all of this is, you know, some of your best shots… like your eyes, will be, half closed.
Norman: Well, ya have to do it that way to get the good ones in between… Okay… keep going… Great!

(*Lily laughs and starts to dance*)

Inset Frames (1-9) Reproduced from Film of Session 1976, Cinematographer: Michael Murphy. Inset Frames (1-6 Right page bottom) Videotape of Session 1986, Cinematographer: Neil Reichline.

21

1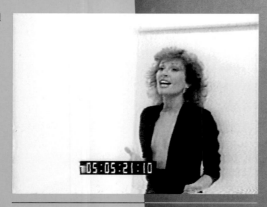

Roz: I'm gonna punch you out before the night is over, Norman. I hope you realize that.

2

Norman: I don't have any pain sensation at all. Shake your head, okay, terrific, terrific… trust… Trust and believe.

3

Roz: In who?

4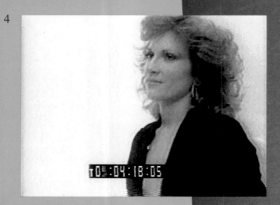

Norman: Me.
Roz: I've heard that before.

5

Norman: (*Spraying Roz with water*) I've been waiting for this.

6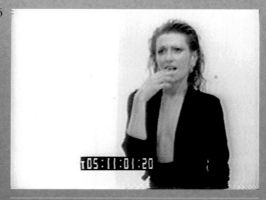

Norman: O.K. now, relax. Great, great, great, very vulnerable, more water.

7

Norman: More water on her hair… let the water drip down her face.

8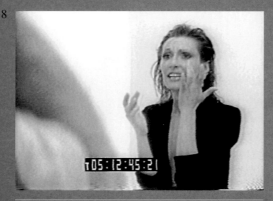

Roz: Naaaao… I don't need no more water, you fucker!!

9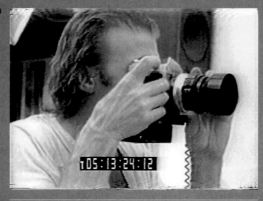

Norman: Your hair… it's dry underneath… just get it wet… terrific… great… fabulous! Stay in the lens!

10

Norman: Okay, more water!

11

Roz: If I get some, he gets some!!

12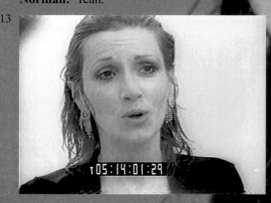

Roz: I feel you're taking advantage of me.
Norman: Yeah.

13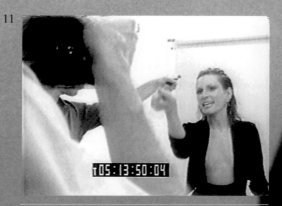

Roz: Norman… Nor… Man… Wooah… (*singing*)

14

Norman: No… look in the lens.

15

(*Roz lets go*)
Norman: Got it! Got it! Got it!

Inset Frames (1-15) Reproduced from film of Roz Kelly Session (aka Pinky Tuscadero, the sexy motorcycle queen in the hit TV show "Happy Days"), 1976.

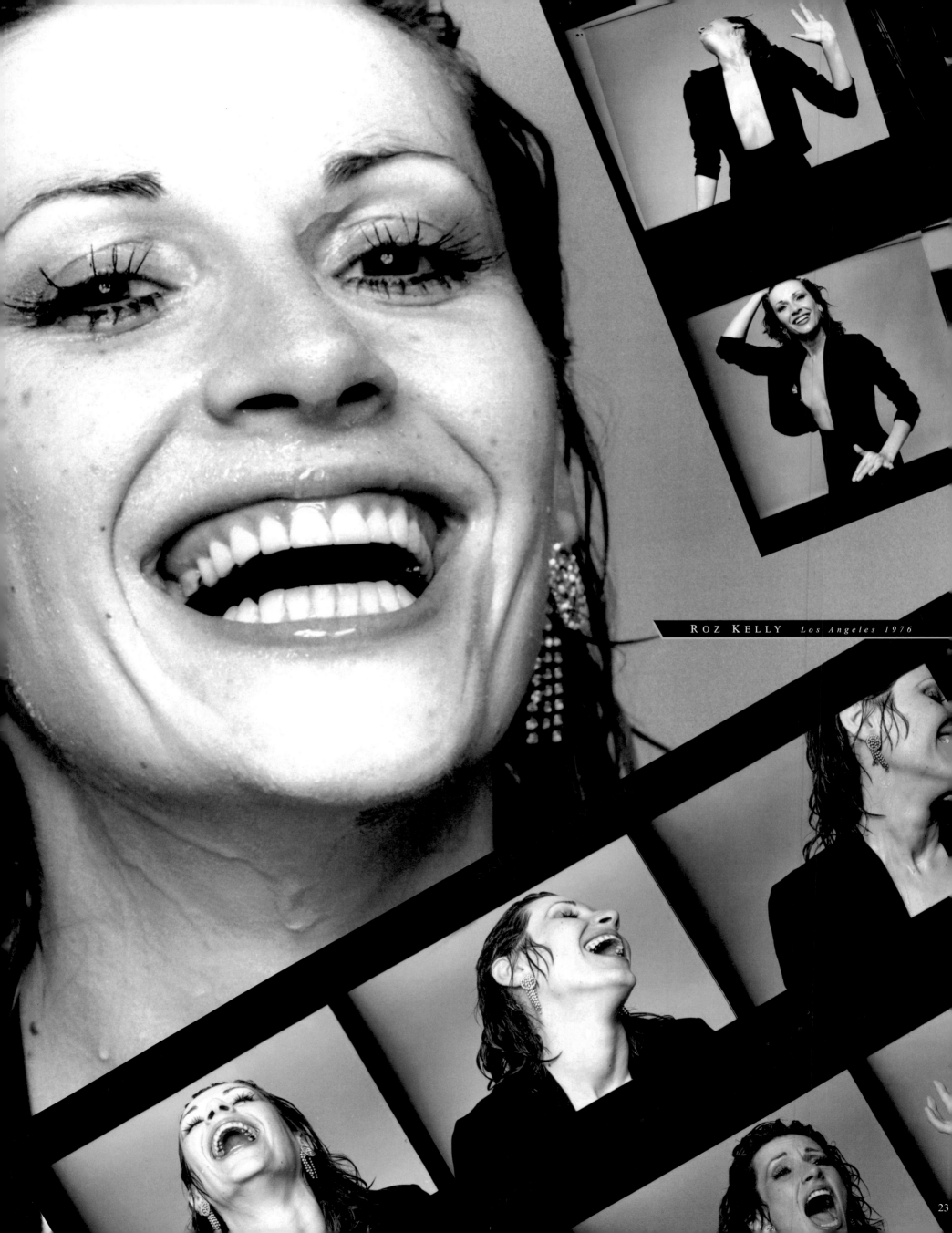

23

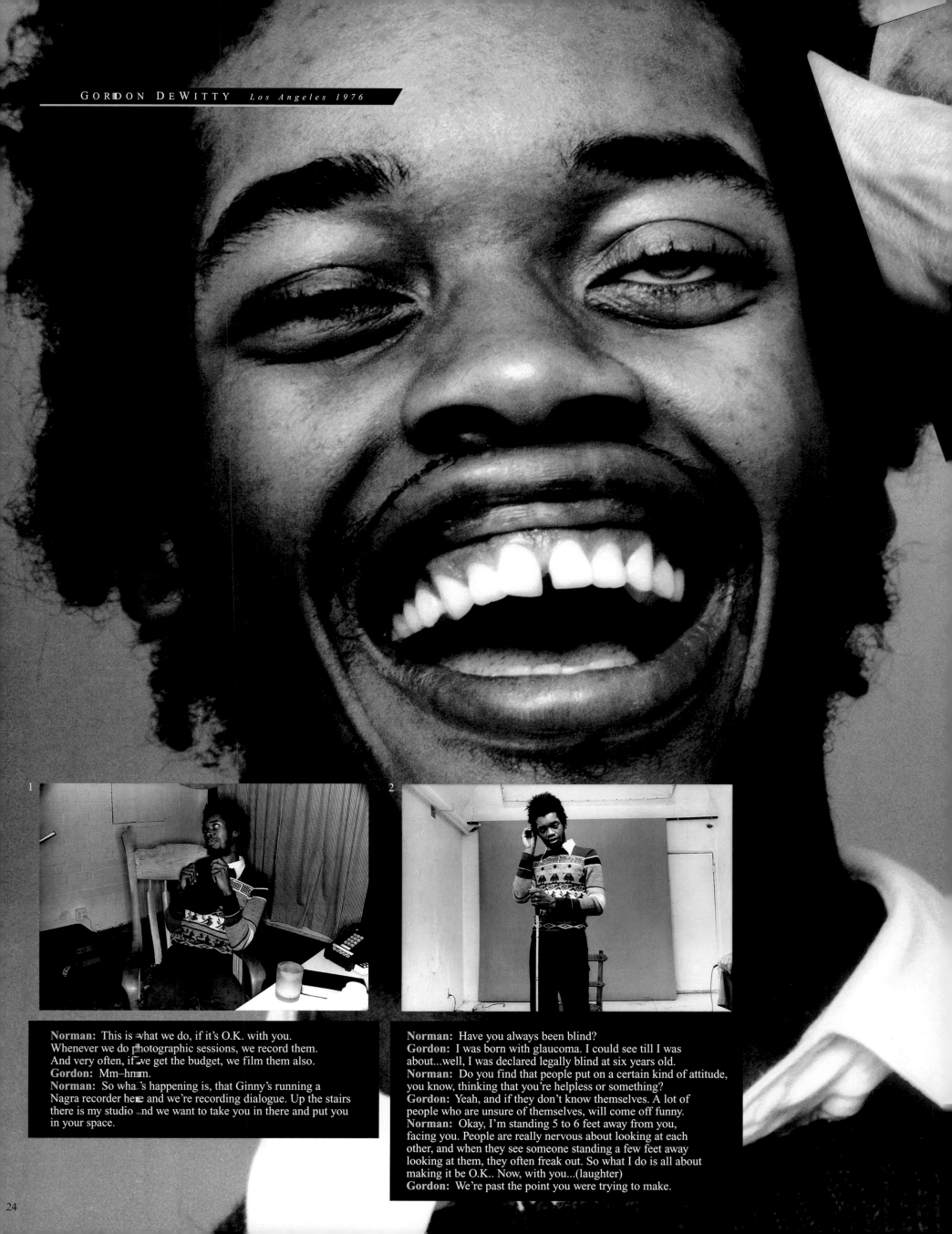

1

2

Norman: This is what we do, if it's O.K. with you.
Whenever we do photographic sessions, we record them.
And very often, if we get the budget, we film them also.
Gordon: Mm–hmm.
Norman: So what's happening is, that Ginny's running a
Nagra recorder here and we're recording dialogue. Up the stairs
there is my studio and we want to take you in there and put you
in your space.

Norman: Have you always been blind?
Gordon: I was born with glaucoma. I could see till I was
about...well, I was declared legally blind at six years old.
Norman: Do you find that people put on a certain kind of attitude,
you know, thinking that you're helpless or something?
Gordon: Yeah, and if they don't know themselves. A lot of
people who are unsure of themselves, will come off funny.
Norman: Okay, I'm standing 5 to 6 feet away from you,
facing you. People are really nervous about looking at each
other, and when they see someone standing a few feet away
looking at them, they often freak out. So what I do is all about
making it be O.K.. Now, with you...(laughter)
Gordon: We're past the point you were trying to make.

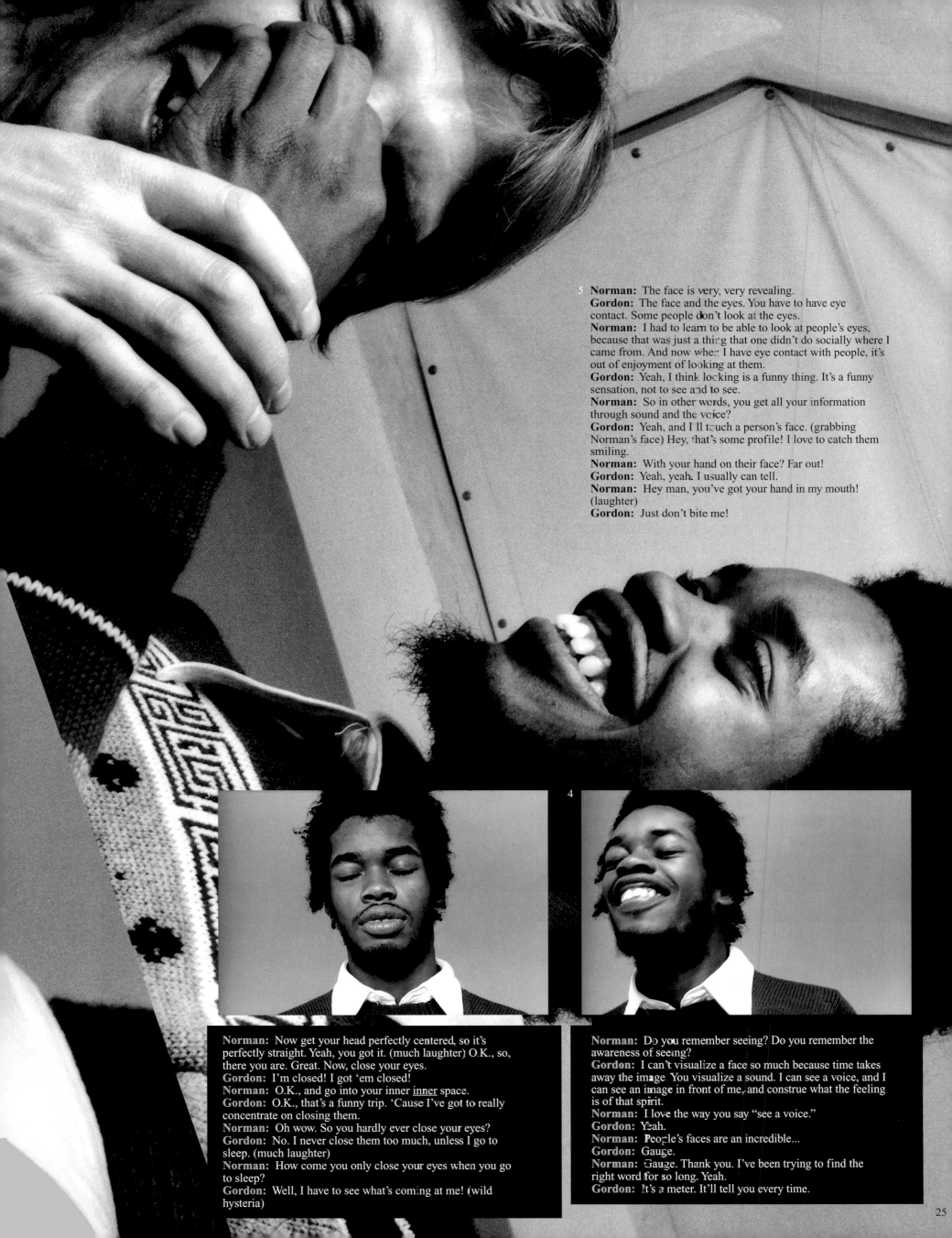

Norman: The face is very, very revealing.
Gordon: The face and the eyes. You have to have eye contact. Some people don't look at the eyes.
Norman: I had to learn to be able to look at people's eyes, because that was just a thing that one didn't do socially where I came from. And now when I have eye contact with people, it's out of enjoyment of looking at them.
Gordon: Yeah, I think looking is a funny thing. It's a funny sensation, not to see and to see.
Norman: So in other words, you get all your information through sound and the voice?
Gordon: Yeah, and I'll touch a person's face. (grabbing Norman's face) Hey, that's some profile! I love to catch them smiling.
Norman: With your hand on their face? Far out!
Gordon: Yeah, yeah. I usually can tell.
Norman: Hey man, you've got your hand in my mouth! (laughter)
Gordon: Just don't bite me!

Norman: Now get your head perfectly centered, so it's perfectly straight. Yeah, you got it. (much laughter) O.K., so, there you are. Great. Now, close your eyes.
Gordon: I'm closed! I got 'em closed!
Norman: O.K., and go into your inner <u>inner</u> space.
Gordon: O.K., that's a funny trip. 'Cause I've got to really concentrate on closing them.
Norman: Oh wow. So you hardly ever close your eyes?
Gordon: No. I never close them too much, unless I go to sleep. (much laughter)
Norman: How come you only close your eyes when you go to sleep?
Gordon: Well, I have to see what's coming at me! (wild hysteria)

Norman: Do you remember seeing? Do you remember the awareness of seeing?
Gordon: I can't visualize a face so much because time takes away the image. You visualize a sound. I can see a voice, and I can see an image in front of me, and construe what the feeling is of that spirit.
Norman: I love the way you say "see a voice."
Gordon: Yeah.
Norman: People's faces are an incredible...
Gordon: Gauge.
Norman: Gauge. Thank you. I've been trying to find the right word for so long. Yeah.
Gordon: It's a meter. It'll tell you every time.

25

▶ **Norman:** I thought I was a nice guy.

Joni: Oh, I love you.

Norman: Oh, good.

Joni: I do. I enjoyed it all. But I thought after the first session I felt like, violated? You know, your film shows almost with pride people hit that low. You know what I mean? So, that was my disagreement that... But then you're vulnerable, you know. One of the ways I learned to deal with it was I thought, Okay, the pictures were good, they were ultra good. The process must be made enjoyable. If I'm a pawn in this game and it will not be enjoyable 'cause I'm going to hit that bloody pocket again and I'm not going for that pocket, so that means that I have to come in with a concept up front. Then that way we won't hit that pocket. We'll hit little ones but we won't hit bad ones where I wanna cry. I don't wanna cry. That's not my favorite thing to do you know. (*laughs*)

Norman: It's an interesting thing, you see, 'cause everyone goes through a resistance at a certain point because the camera absolutely, it's this thing. I don't know which particular aboriginal group says this...

Joni: It steals your soul.

Norman: It steals your soul.

Joni: It does.

Norman: What it does is, it picks up your energy, and it sees behind the defense that people put up. My experience is that the camera is a weapon, it is a threat, it has the potential to go behind the persona and show what the person is trying to hide. And so it is terrifying for people. And when I started filming, I was terrified when the movie camera was on me. It took me 5 years to be able to say, "I don't care if it's on or not." And to be able to sustain who I am camera or no camera.

Joni: But a lot of people don't get over that. That's tremendous optimism and tremendous sadism. Because you should have learned after about 30 sessions that people just don't get over that hump. And most people can't come back.

Norman: Absolutely, and I understand those feelings, and the thing I would have to deal with is that some people used to come in and go, "I don't have to do anything. I'll just stand here and you take my picture." And I'd have to say, "Look, you have to put out. This is a two-way process. I know I'm coming at you with this huge amount of stuff, but there's a hidden logic to it." It does have an underlying reasonableness because there is a point where people do need to let go. Every time I did a session, there was a part of me that hated it and another part that was intrigued, because I knew the dynamic that it started to create between us forced this kind of intensity. It was never an experience that didn't have an intensity. So how do you challenge the person to keep going without making the challenge a hostile act?

Joni: That's an interesting relationship.

Norman: And the whole idea was, how can you dance together so that there's a time when you push and then there's a time when you step back. Hopefully you get to a point where there's an effortlessness. Now I think that we did that on occasion. ▶

▶ **Joni:** I think we were great together.

Norman: Yeah, it was very exciting. When I'm seeing it happening and basically what I'm feeling is, 'Be there at the right moment to get it, there's a beat to it.' It's an absolute cadence of... and when you hit a note— bang, it's like a beat of music. About the creative process, every time you do it, it's new and there's a strange kind of combination of inertia and excitement. I don't know what it's like for you on stage. But when you've gotta go on stage, don't you go through that moment of push-pull with yourself?

Joni: It's been so long, Norman. (*laughs*) I don't remember.

Norman: Well, think back. (*laughs*)

Joni: I remember there were stages when I went gladly out, and I really enjoyed it in the beginning before I had a record deal. I was a real ham as long as I was on the club circuit. When I hit the big stage...

Norman: And there was all that expectation...

Joni: Yeah. And all that gets in the way of it. There were times my knuckles were white from the beginning to the end of the concert, and I'd hate it, and I finally quit.

Norman: What about your writing? How does that come?

Joni: All different.

Norman: I mean, do you wake up in the morning with whole pieces in your head, or do you sit down with a concept in mind and work it through.

Joni: It's more like that. Usually I've got a melody and the melody has an architecture. It has a lot of chordal movements. This plateau here has long enough lines that it will contain some description and has a certain mood to it. Here is the apex of the movie, the climactic point. Then there's the reiteration period. You have the skeleton of the drama, because my music is theatrical.

Norman: So you write your music first and bring your words in after?

Joni: Yes.

Norman: So it sounds to me that you have an architectural form. Is that what you say, a personal architectural form?

Joni: Yes.

Norman: That developed what, over the years? You did it intuitively first?

Joni: Intuitively of everything I ever admired, which was very diversified. And also, like you're walking along and you're feeling good, and all of a sudden a memory hits you, hmmm, your whole body changes. So the chords are ▶

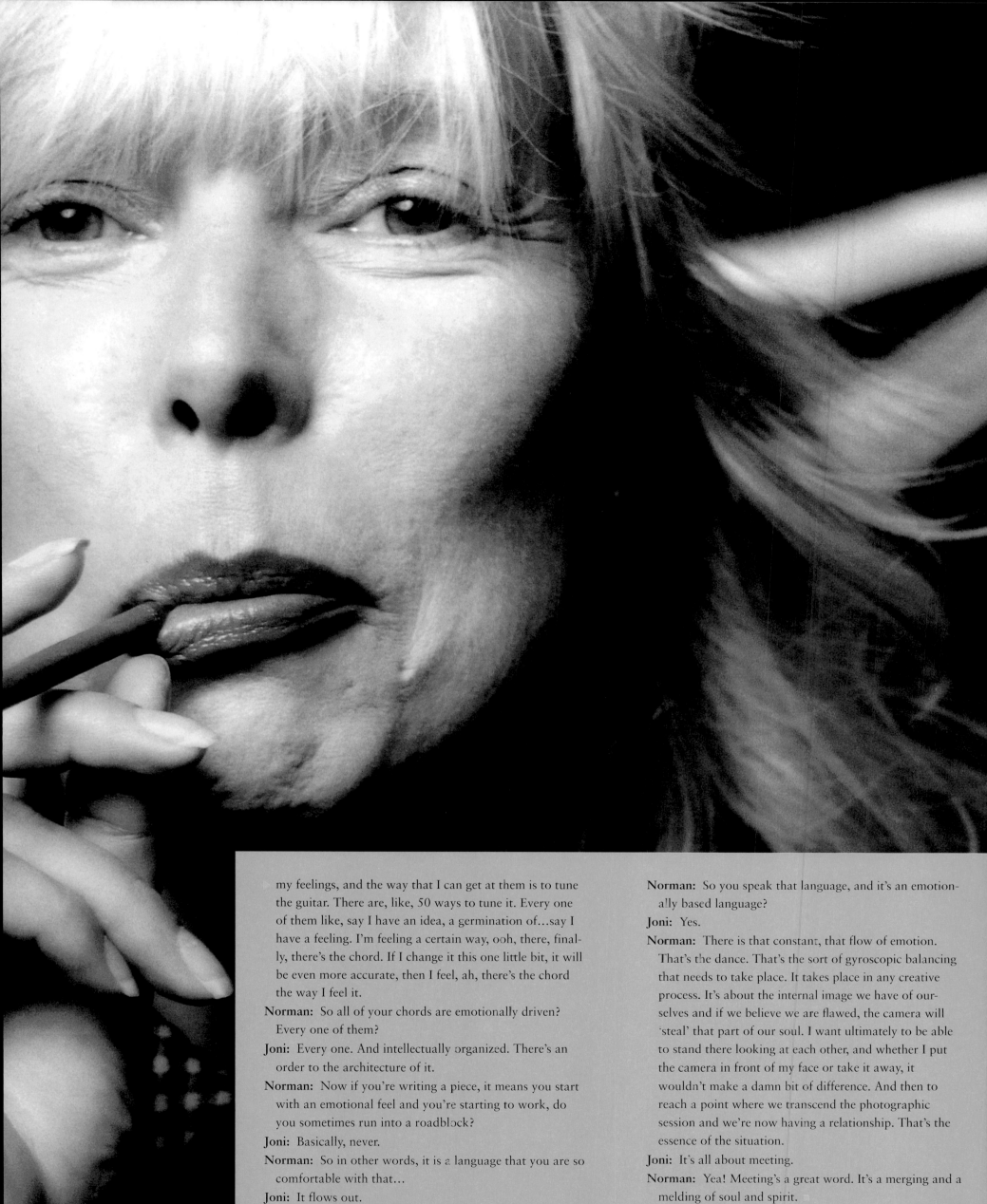

my feelings, and the way that I can get at them is to tune the guitar. There are, like, 50 ways to tune it. Every one of them like, say I have an idea, a germination of...say I have a feeling. I'm feeling a certain way, ooh, there, finally, there's the chord. If I change it this one little bit, it will be even more accurate, then I feel, ah, there's the chord the way I feel it.

Norman: So all of your chords are emotionally driven? Every one of them?

Joni: Every one. And intellectually organized. There's an order to the architecture of it.

Norman: Now if you're writing a piece, it means you start with an emotional feel and you're starting to work, do you sometimes run into a roadblock?

Joni: Basically, never.

Norman: So in other words, it is a language that you are so comfortable with that...

Joni: It flows out.

Norman: So you speak that language, and it's an emotionally based language?

Joni: Yes.

Norman: There is that constant, that flow of emotion. That's the dance. That's the sort of gyroscopic balancing that needs to take place. It takes place in any creative process. It's about the internal image we have of ourselves and if we believe we are flawed, the camera will 'steal' that part of our soul. I want ultimately to be able to stand there looking at each other, and whether I put the camera in front of my face or take it away, it wouldn't make a damn bit of difference. And then to reach a point where we transcend the photographic session and we're now having a relationship. That's the essence of the situation.

Joni: It's all about meeting.

Norman: Yea! Meeting's a great word. It's a merging and a melding of soul and spirit.

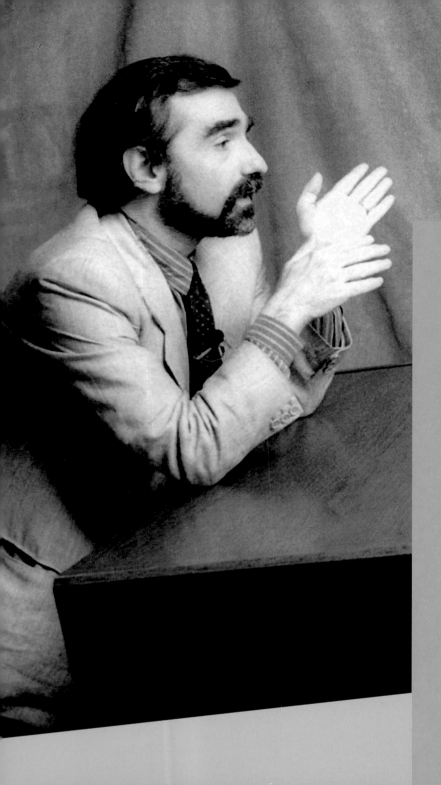

explore myself. I think it's a matter of trying to get through to the truth of myself.

Norman: So as part of the creative act it becomes a positive and non-judgemental handling of what would normally be a negative expression.

Scorsese: Right. That's very important, being positive about a character that everybody thinks of as negative. It's an interesting concept. How do we live with each other? Can we forgive? Or what is forgiveness in the first place?

Norman: Absolutely there is an ability to see beneath the surface that comes with forgiveness. What makes a good director? In your…

Scorsese: Patience. Not that I have it. I'm the most impatient, but what I've learned is to go the opposite way and have the patience whether I like it or not. Also, every time I make a picture, I realize that I know very little. And it's a re-educating process all the time. Never walk on the set thinking you know it all. You're finished. Something's gonna teach you something new. Every day, every minute.

Norman: Are you a nice guy to work with?

Scorsese: Oh yeah, I'm great.

Norman: (laughs) No, seriously. I mean in terms of if you're not getting something from an actor…

Scorsese: Oh no, I never… I never use any kind of… uh… I don't like it. I hate confrontations. I hate it. I hate arguments… and I argue all the time anyway. But I hate – hate when people… What gets me very nervous and the worst thing you can do on a picture with me is, like, scream and yell and throw things. I can't… I have to leave. I leave. Can't do it.

Norman: No. But in other words, you don't— you don't ever do it?

Scorsese: No, no, no, no.

Norman: But you get in arguments?

Scorsese: (with a knowing look) Discussions we call it.

MARTIN SCORSESE *New York 1986*

Norman: (shooting at the same time) Do you have a form behind what you do? I spend so much time working and interacting with creative people. What I find often is a performer will go on, and it looks like what they do is absolutely effortless. But when you really get down to talking to them, they have a form, a structure at the core of what they do.

Scorsese: Yeah, I don't know how they do it. What an actor does always fascinates me. It fascinates me. I'm in great awe of them. I respect it a great deal because it's always constantly… they live through that, you know? Especially when you mix a non-actor with actors and you get some incredible things. You get a sense of reality and poignancy that's hard to say. But the best thing I could say about actors is that, I have to believe what they're saying.

Norman: OK. So that's your form. I notice that you often explore the dynamics of characters that are social outcasts. What is that about?

Scorsese: I know the question, and what comes to mind is the concept of the responsibility of being honest. In other words, dealing with what I feel honestly and trying to get that on film, with the most truth. The most honesty as possible. My point was, who could really judge these people? I can't make a judgement on them. 'Cause if I had the same feelings, what am I? It's the only way I can

BOB FOSSE *New York 1986*

Norman: You know that's something that fascinated me about stuff that I've read about you, where you were very open in describing how in one moment you feel confident, and in the other moment you feel like you're going to be found out.

Fosse: Absolutely. It really is common. I think that we all feel mistakes down deep. Gonna get caught.

Norman: Someone finally points a finger at you and says everything you've ever done is really a lot of bullshit. Is that a— that's a fear.

Fosse: And you confess, "Yes, it is." I always feel when I'm starting a movie like I'm a real amateur. Like how do I do this? Somebody tell me what to do. I have the same thing with the dance. Should I step on my right foot or my left? I can only be 50% wrong, you know? But boy, sometimes I stand there like I'm in a catatonic state. I don't know which hand should I move, where should I go? I really truly get scared. I mean I'm not talking, you know, just humble or anything. I throw up every morning. If I don't throw up, I think uh-oh, I'm getting overconfident. That's true.

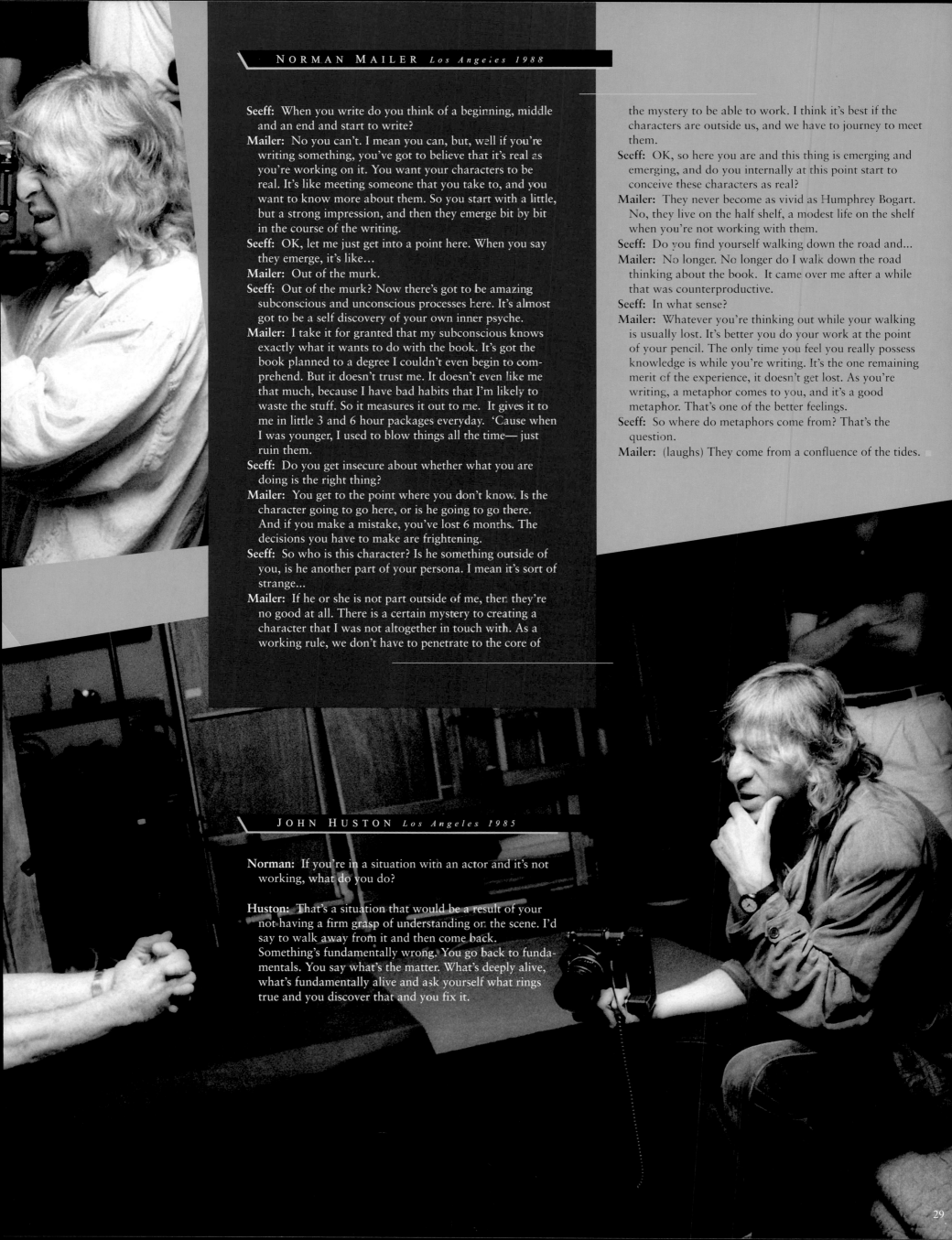

Seeff: When you write do you think of a beginning, middle and an end and start to write?

Mailer: No you can't. I mean you can, but, well if you're writing something, you've got to believe that it's real as you're working on it. You want your characters to be real. It's like meeting someone that you take to, and you want to know more about them. So you start with a little, but a strong impression, and then they emerge bit by bit in the course of the writing.

Seeff: OK, let me just get into a point here. When you say they emerge, it's like...

Mailer: Out of the murk.

Seeff: Out of the murk? Now there's got to be amazing subconscious and unconscious processes here. It's almost got to be a self discovery of your own inner psyche.

Mailer: I take it for granted that my subconscious knows exactly what it wants to do with the book. It's got the book planned to a degree I couldn't even begin to comprehend. But it doesn't trust me. It doesn't even like me that much, because I have bad habits that I'm likely to waste the stuff. So it measures it out to me. It gives it to me in little 3 and 6 hour packages everyday. 'Cause when I was younger, I used to blow things all the time— just ruin them.

Seeff: Do you get insecure about whether what you are doing is the right thing?

Mailer: You get to the point where you don't know. Is the character going to go here, or is he going to go there. And if you make a mistake, you've lost 6 months. The decisions you have to make are frightening.

Seeff: So who is this character? Is he something outside of you, is he another part of your persona. I mean it's sort of strange...

Mailer: If he or she is not part outside of me, then they're no good at all. There is a certain mystery to creating a character that I was not altogether in touch with. As a working rule, we don't have to penetrate to the core of the mystery to be able to work. I think it's best if the characters are outside us, and we have to journey to meet them.

Seeff: OK, so here you are and this thing is emerging and emerging, and do you internally at this point start to conceive these characters as real?

Mailer: They never become as vivid as Humphrey Bogart. No, they live on the half shelf, a modest life on the shelf when you're not working with them.

Seeff: Do you find yourself walking down the road and...

Mailer: No longer. No longer do I walk down the road thinking about the book. It came over me after a while that was counterproductive.

Seeff: In what sense?

Mailer: Whatever you're thinking out while your walking is usually lost. It's better you do your work at the point of your pencil. The only time you feel you really possess knowledge is while you're writing. It's the one remaining merit of the experience, it doesn't get lost. As you're writing, a metaphor comes to you, and it's a good metaphor. That's one of the better feelings.

Seeff: So where do metaphors come from? That's the question.

Mailer: (laughs) They come from a confluence of the tides.

JOHN HUSTON *Los Angeles 1985*

Norman: If you're in a situation with an actor and it's not working, what do you do?

Huston: That's a situation that would be a result of your not having a firm grasp of understanding on the scene. I'd say to walk away from it and then come back. Something's fundamentally wrong. You go back to fundamentals. You say what's the matter. What's deeply alive, what's fundamentally alive and ask yourself what rings true and you discover that and you fix it.

1

THE BAND
*1969 Woodstock
(Richard Manuel, Garth
Hudson, Robbie Robertson,
Levon Helm, Rick Danko)*

2

ROBERT MAPPLETHORPE
& PATTI SMITH
1969 New York City

3

JAMES TAYLOR
1969 Martha's Vineyard

4

KEITH RICHARDS
& MICK JAGGER
1971 Los Angeles

5

THE ROLLING STONES
*1971 Los Angeles
"Exile On Main Street"
(Mick Jagger, Keith Richards,
Mick Taylor, Bill Wyman,
Charlie Watts)*

6

"MAMA" CASS
ELLIOT
1974 Los Angeles

EVERLY BROTHERS
*1971 On Tour in South Carolina
(Don Everly, Phil Everly)*

7

FRANK ZAPPA
1976 Los Angeles

8

JONI MITCHELL
1975 & 1976, Los Angeles

9

RICKIE LEE JONES
1978 Los Angeles

10

CHER &
GREGG ALLMAN
1977 Los Angeles

11

JOHNNY MATHIS
1976 Los Angeles

12

KISS
*1975 Los Angeles
(Gene Simmons, Peter Criss,
Paul Stanley, Ace Frehley)*

13

DAVID LEE ROTH
1979 Los Angeles

14

VAN HALEN
*1979 Los Angeles
(David Lee Roth, Alex Van
Halen, Eddie Van Halen,
Michael Anthony)*

15

JEFFERSON STARSHIP
*1978 San Francisco
(Craig Chaquico, Grace Slick,
David Freiberg, Pete Sears,
Paul Kantner, Marty Balin,
John Barbata)*

16

TALKING HEADS
*1979 New York City
(Tina Weymouth,
Chris Frantz, David
Byrne, Jerry Harrison)*

BOOMTOWN RATS
*1979 Los Angeles
(Gerry Cott, Bob Geldof,
Garry Roberts, Johnnie Fingers,
Simon Grove, Pete Briquette)*

17

DEVO
*1979 Los Angeles
(Jerry Casale, Bob Mothersbaugh,
Mark Mothersbaugh, Bob Casale,
Alan Myers)*

18

DAVID CROSBY
1985 Los Angeles

19

AEROSMITH
*1988 Los Angeles
(Joe Perry, Tom
Hamilton, Steven Tyler,
Joey Kramer, Brad Whitford)*

20

AEROSMITH
*1988 Los Angeles
(Steven Tyler & Joe Perry)*

21

FOREIGNER
*1978 New Orleans
(Mick Jones, Ian McDonald,
Lou Gramm, Al Greenwood,
Dennis Elliot, Ed Gagliardi)*

DOOBIE BROTHERS
*1979 Los Angeles
(Cornelius Bumpus, John
McFee, Keith Knudsen, Michael
McDonald, Patrick Simmons,
Willie Weeks, Chet McCracken,
Bobby LaKind)*

22

BLONDIE
*1979 New York City
(Clement Burke, Nigel Harrison,
Frank Infante, Jimmy Destri, Chris
Stein, Deborah Harry)*

23

TIM BUCKLEY
1973 Los Angeles

24

JOHN MELLENCAMP
1979 Los Angeles

25

PETER FRAMPTON
1981 Los Angeles

ANDY GIBB
1980 Los Angeles

26

RON WOOD
1979 Los Angeles

RINGO STARR
1986 Nassau, Bahamas

27

HERB ALPERT &
LANI HALL
1979 Los Angeles

28

BILL WITHERS
1973 Los Angeles

LEO KOTTKE
1973 Los Angeles

29

POINTER SISTERS
*1982 Los Angeles
(June, Ruth, Anita)*

30

POINTER SISTERS
1993 Los Angeles

31

CHAKA KHAN
1977 Los Angeles

32

SANTANA
*1974 San Francisco
(Raul Rekow, Chris Rhyne,
Greg Walker, Carlos Santana,
Chris Solberg, Graham Lear, Pete
Escovedo, Armando
Peraza, David Margen)*

RUFUS
*1977 Los Angeles
(Kevin Murphy, Nate Morgan,
Chaka Khan, André Fischer, Bobby
Watson, Tony Maiden)*

33

CLAUDIA LENNEAR
1972 Los Angeles

34

GLADYS KNIGHT
& THE PIPS
*1981 Los Angeles
(Merald "Bubba" Knight Jr.,
Edward Patten, William Guest)*

35

BOBBY WOMACK
1981 Los Angeles

36

SARAH VAUGHAN
1981 Los Angeles

37

WHITNEY HOUSTON
1990 Los Angeles

38

MARC BOLAN (T. Rex) &
"THE" GLORIA JONES
1974 Los Angeles

39

JIMMY CLIFF
1975 Los Angeles

IKE TURNER
1975 Los Angeles

40

RAY CHARLES
1985 Los Angeles

41

AL JARREAU
1982 Los Angeles

PHOEBE SNOW
1976 Los Angeles

42

ALBERT KING
1976 Los Angeles

43

ISAAC HAYES
1977 San Francisco

44

IKE & TINA TURNER
1975 Los Angeles

45

TINA TURNER
1983 Los Angeles

46

TINA TURNER
1983 Los Angeles

47

CARLY SIMON
1974 Los Angeles

48

CARLY SIMON
1978 Martha's Vineyard

49

INXS
1988 Chicago
(Garry Beers, Kirk Pengilly,
Tim Farriss, Michael Hutchence,
Jon Farriss, Andrew Farriss)

50

EAGLES
1976 Los Angeles
(Don Henley, Don Felder, Glenn
Frey, Bernie Leadon, Randy
Meisner)

51

JOHNNY ROTTEN
1984 Los Angeles

52

THE RAMONES
1977 New York City
(Johnny, Joey, Dee Dee, & Tommy)

53

PETER ALLEN
1976 Los Angeles

54

JENNIFER WARNES
1992 Los Angeles

55

DAVID SOUL
1978 Los Angeles
CHI COLTRANE
1981 Los Angeles

56

THE JUDDS
(Naomi Judd, Wynonna Judd)
1983 Nashville
EARL SCRUGGS &
TOM T. HALL
1982 Nashville

57

HOYT AXTON
1976 Nashville
GLEN CAMPBELL
1978 Lake Tahoe

58

MERLE HAGGARD
1981 Nashville

59

CRYSTAL GAYLE
1981 Nashville

60

JOHNNY CASH
1978 Nashville

61

TAMMY WYNETTE
1978 Nashville

62

WILLIE NELSON
1979 Las Vegas

63

FURRY LEWIS
1974 Memphis

64

SLEEPY JOHN ESTES
1974 Memphis

65

CURTIS MAYFIELD
1979 Los Angeles

66

JACO PASTORIUS
1984 Los Angeles

67

EARL KLUGH
1978 Los Angeles
EGBERTO GISMONTE
1981 New York City

68

JOHN LEE HOOKER
1971 Oakland, CA
VASSAR CLEMENTS
1977 Nashville

69

DAVID OLIVER
1977 Los Angeles
DENNIS BROWN
1983 Los Angeles

70

BILL GRAHAM
1979 San Francisco
BERRY GORDY JR.
1990 Los Angeles

71

SHERRY LANSING
1980 Los Angeles
PETER GUBER,
DONNA SUMMER &
NEIL BOGART
1976 Los Angeles

72

QUINCY JONES
MARTINA JONES
1984 Los Angeles

73

STEVE MARTIN
1977 Los Angeles

74

STEVE MARTIN
1977 Los Angeles

75

LILY TOMLIN
1976 Los Angeles

76

LILY TOMLIN
1985 & 1986 Los Angeles

77

JOHN BELUSHI
1981 Los Angeles

78

JUNE LOCKHART
1980 Los Angeles
ALAN ALDA
1979 Los Angeles

79

JANE FONDA
1979 Los Angeles

80

JOHN TRAVOLTA
1976 Los Angeles

81

DENNIS HOPPER
1989 Los Angeles

82

JODIE FOSTER
1976 Los Angeles

83

MARSHA MASON
1979 Los Angeles

84

KATEY SAGAL
1985 Los Angeles

85

ALFRE WOODARD
1988 Los Angeles
RAE DAWN CHONG
1986 Los Angeles

86

SUE KIEL SEEFF
1989 Los Angeles
LOIS CHILES
1989 Los Angeles

87

RICHARD CHAMBERLAIN
1976 Los Angeles
MARJOE GORTNER
1974 Los Angeles

88

JOHN HUSTON
1985 Los Angeles

89

BILLY WILDER
1986 Los Angeles

90

JIM HENSON
1986 New York City
RIDLEY SCOTT
1985 Los Angeles

91

MARTIN SCORSESE
1986 Los Angeles

92

NICK ROEG &
CANDY CLARK
1976 Los Angeles

93

BOB FOSSE
1986 Los Angeles

94

EUGENE IONESCO
1982 (photos taken during
his trip to Stages Theatre
Center, Hollywood when he
was Artist-in-Residence)
JOYCE CAROL OATES
1988 New York City

95

NORMAN MAILER
1988 Los Angeles

96

JACH PURSEL
CHANNELING
"LAZARIS"
1988 Los Angeles

97

RAM DASS
1976 Los Angeles
TIMOTHY LEARY
1976 Los Angeles

98

HUGH HEFNER
1978 Los Angeles
STEVE JOBS
1984 Cupertino, CA

99

KEN NORTON
1977 Los Angeles
JOE NAMATH
1977 Los Angeles

100

SIR FRANCIS CRICK
1982 LaJolla, CA

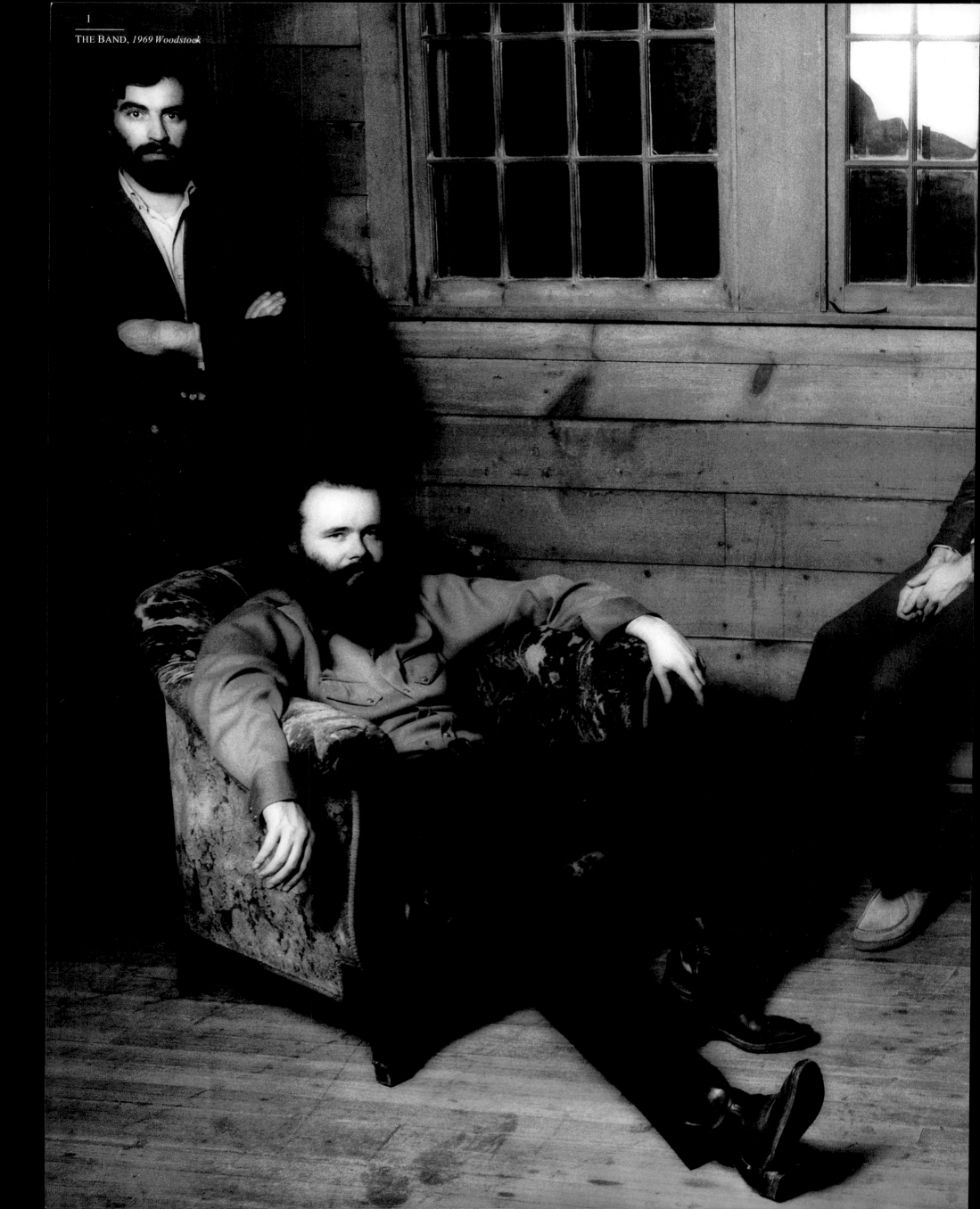

THE BAND, *1969 Woodstock*

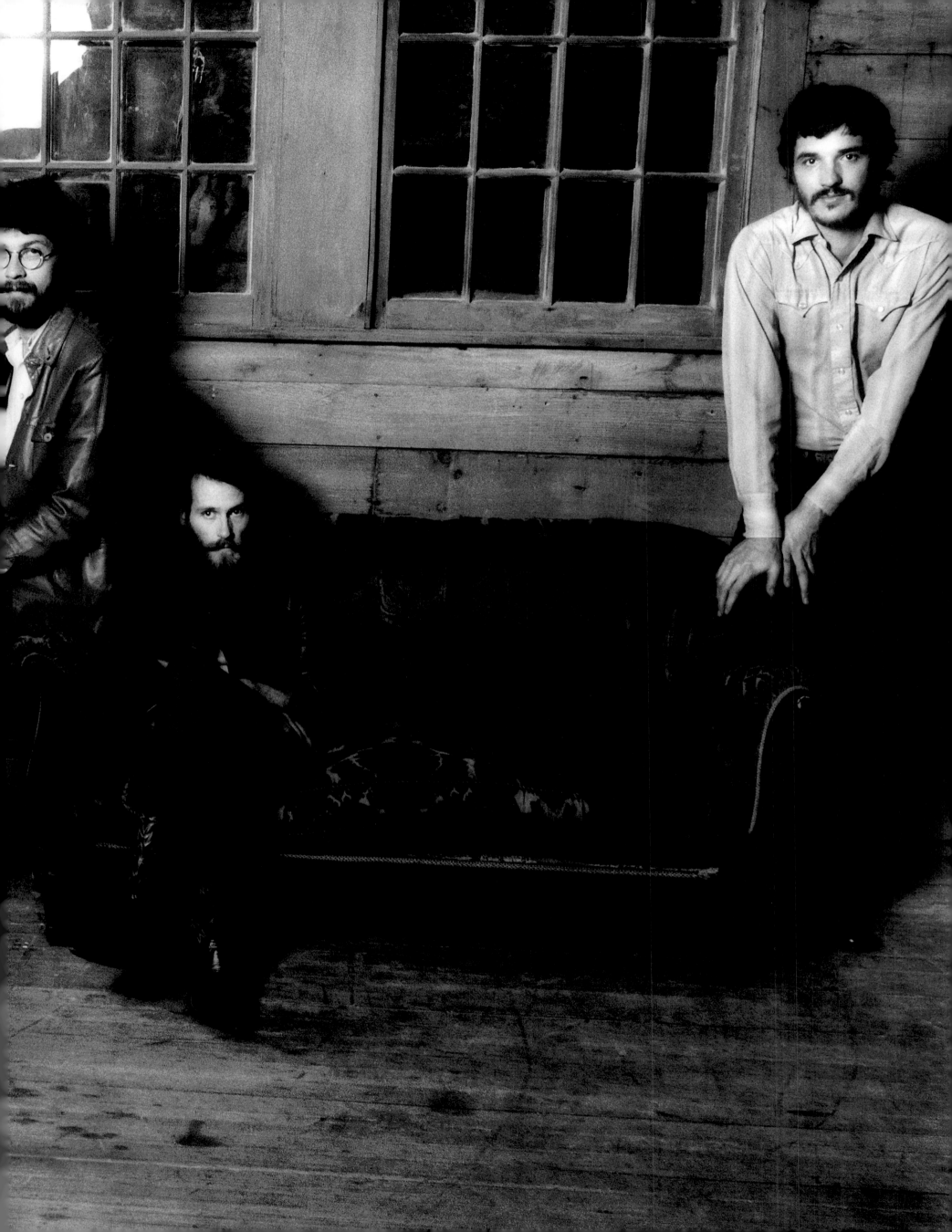

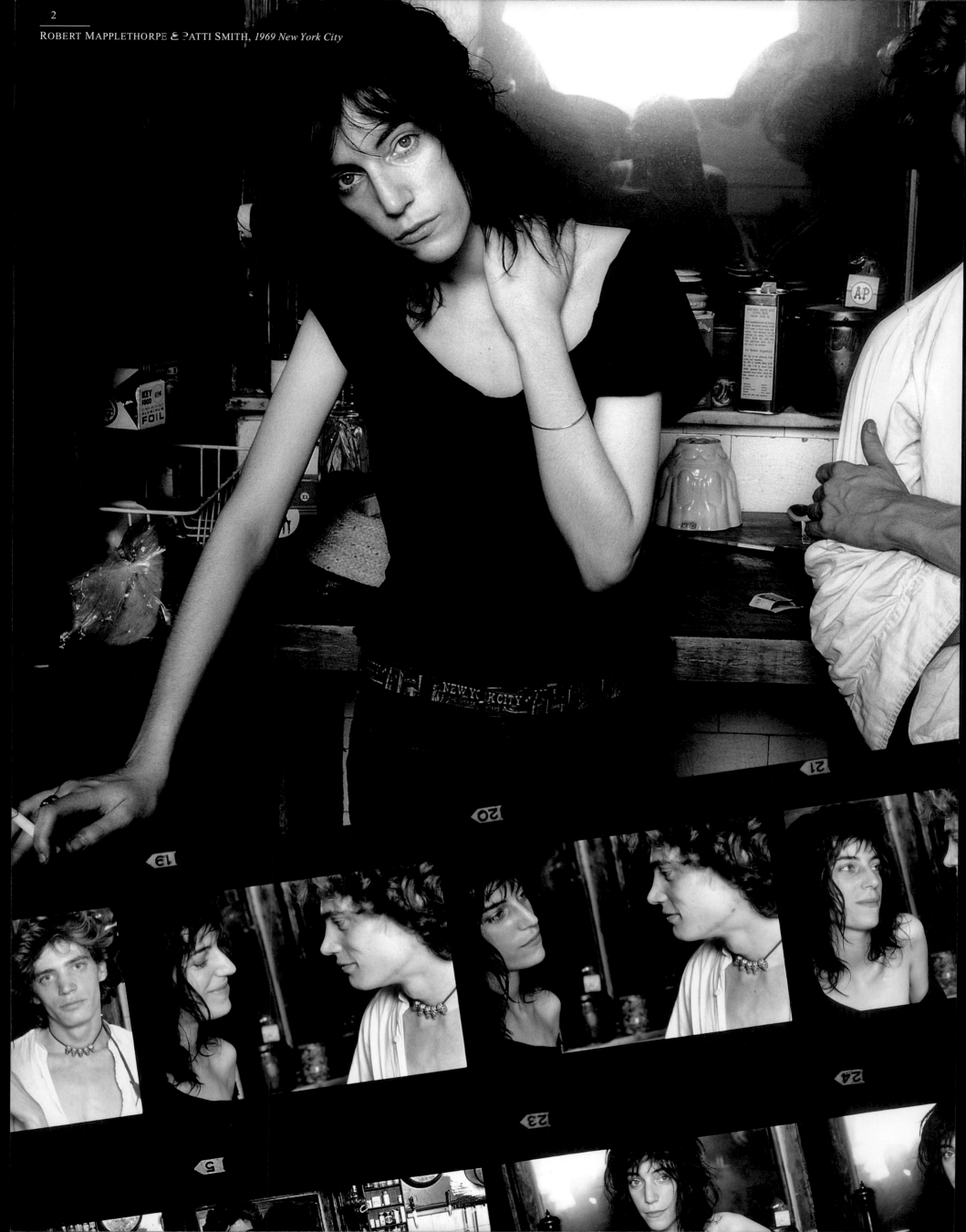

ROBERT MAPPLETHORPE & PATTI SMITH, *1969 New York City*

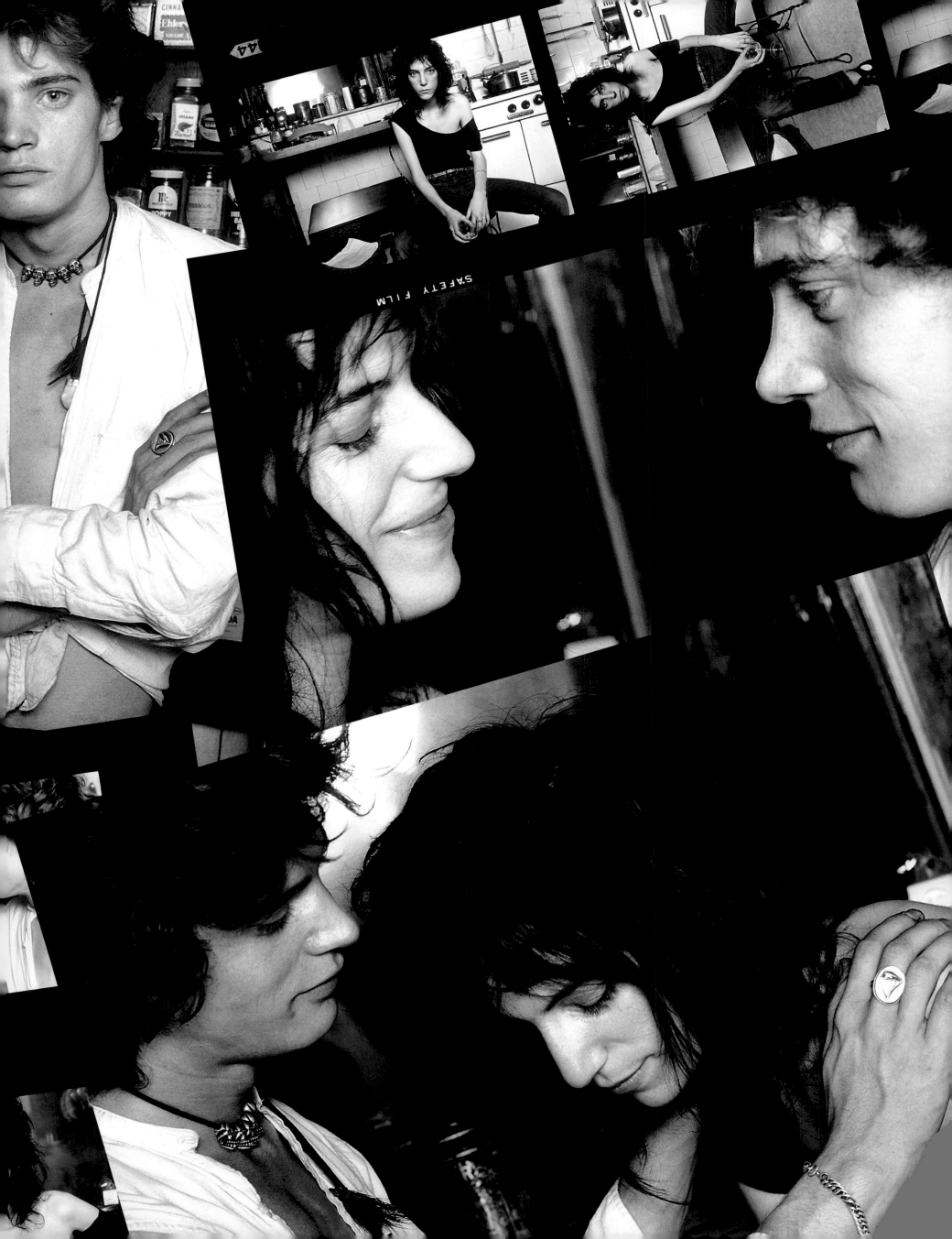

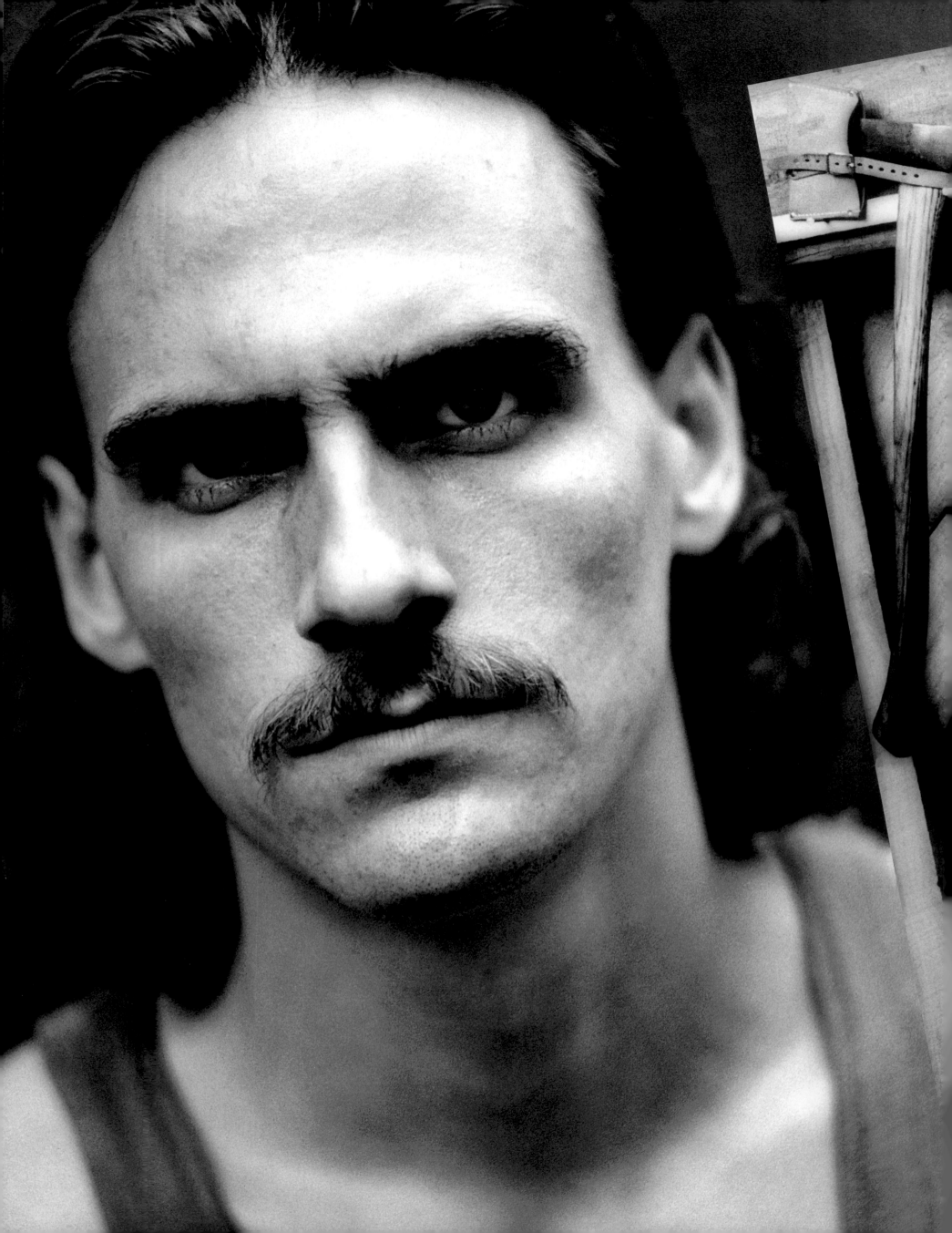

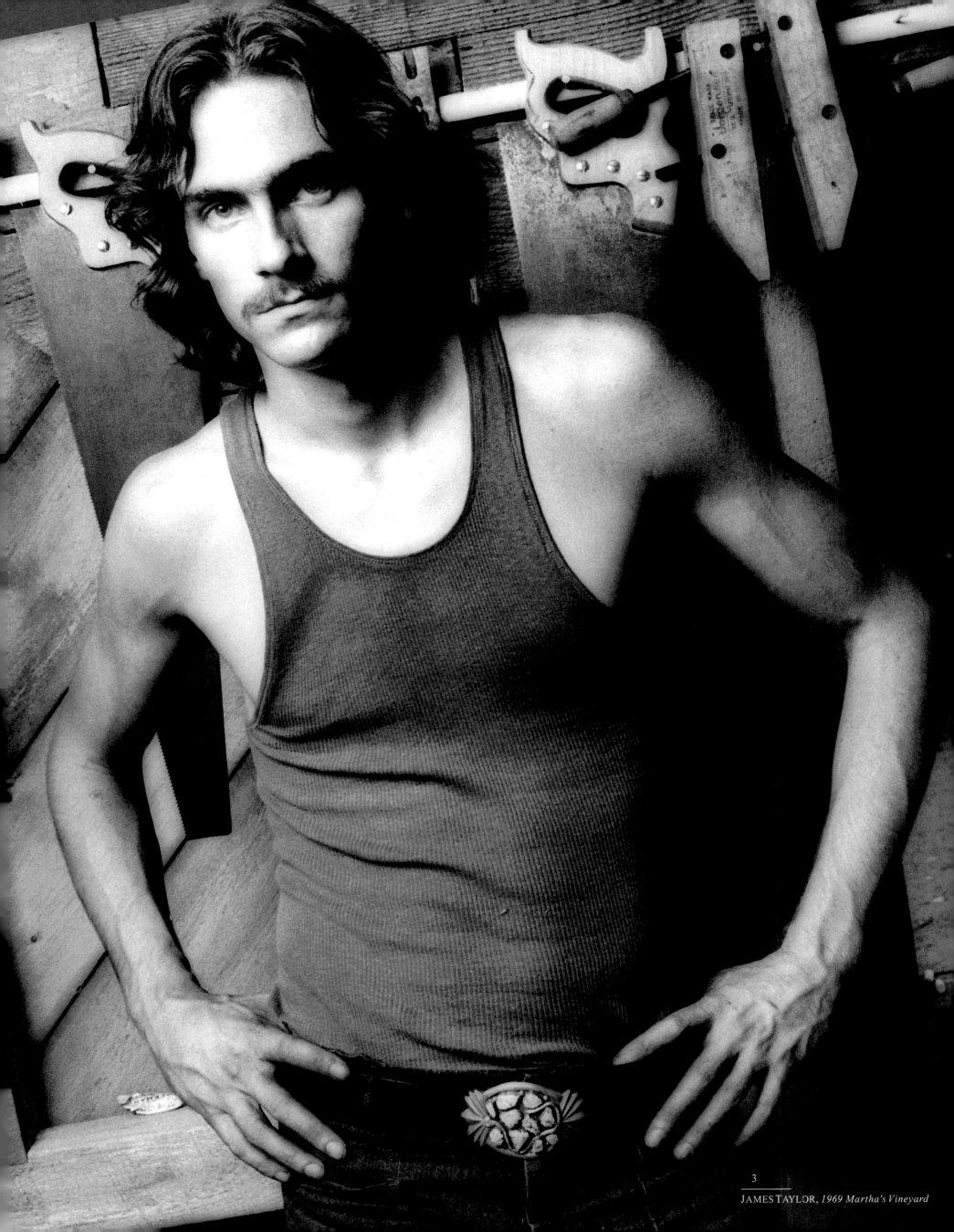

3

JAMES TAYLOR, *1969 Martha's Vineyard*

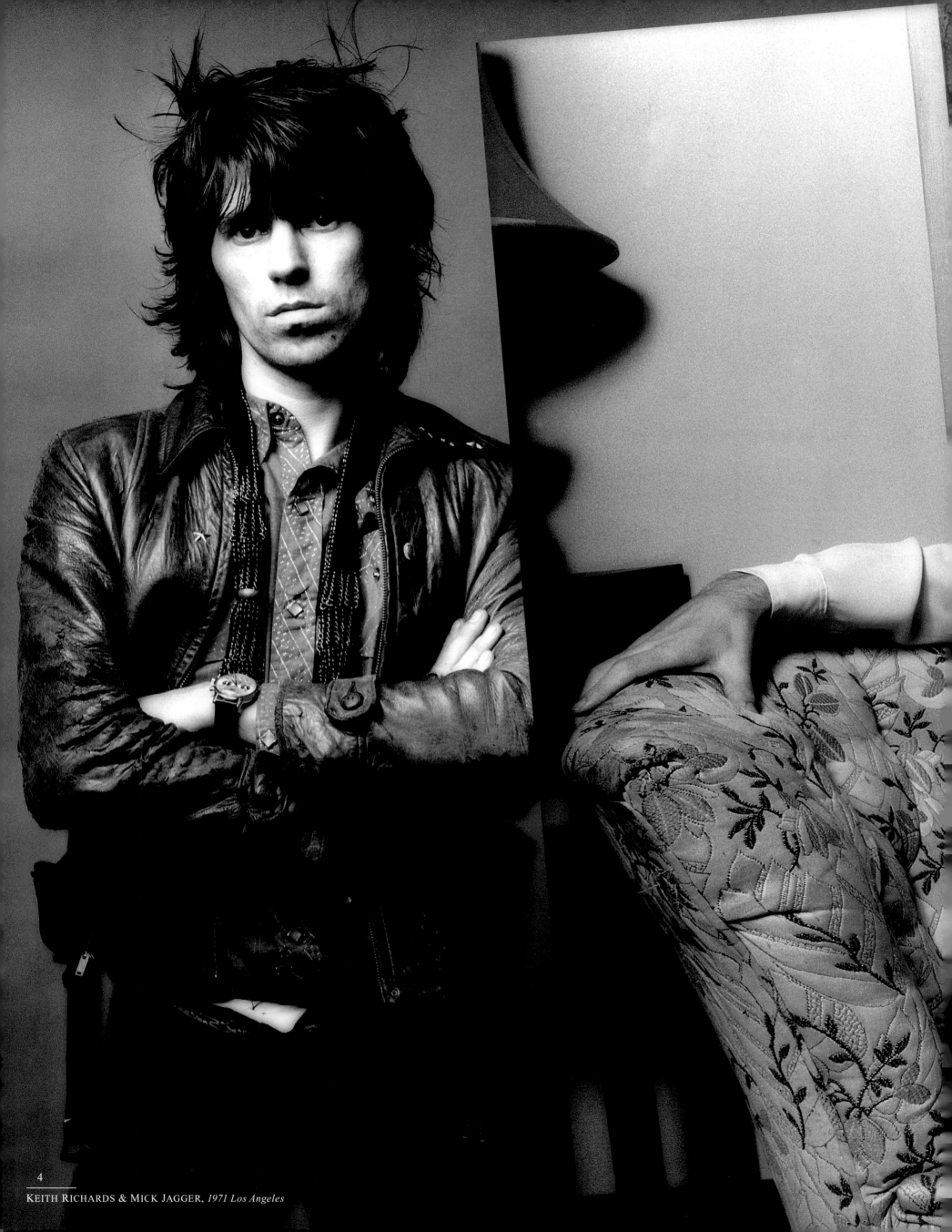

KEITH RICHARDS & MICK JAGGER, *1971 Los Angeles*

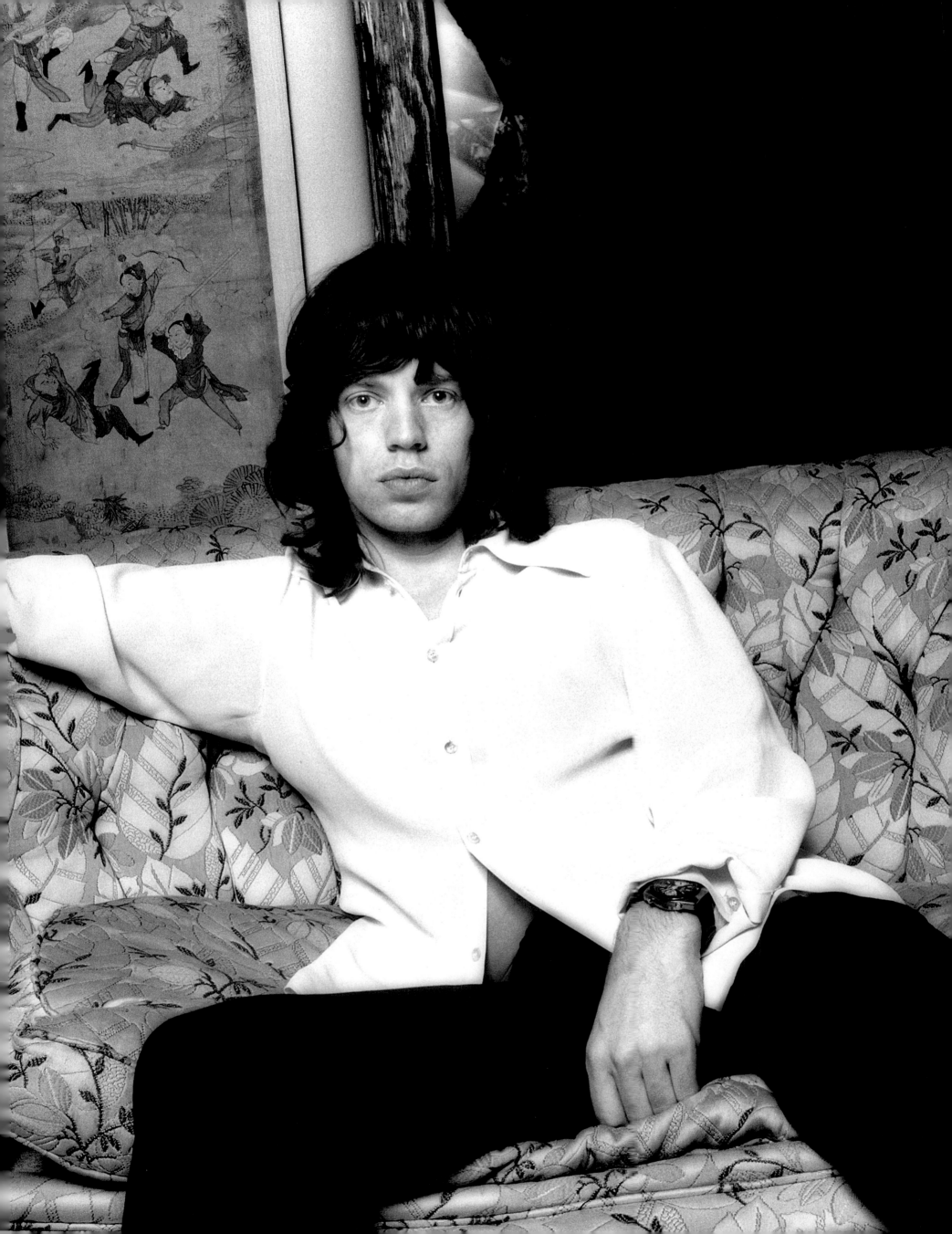

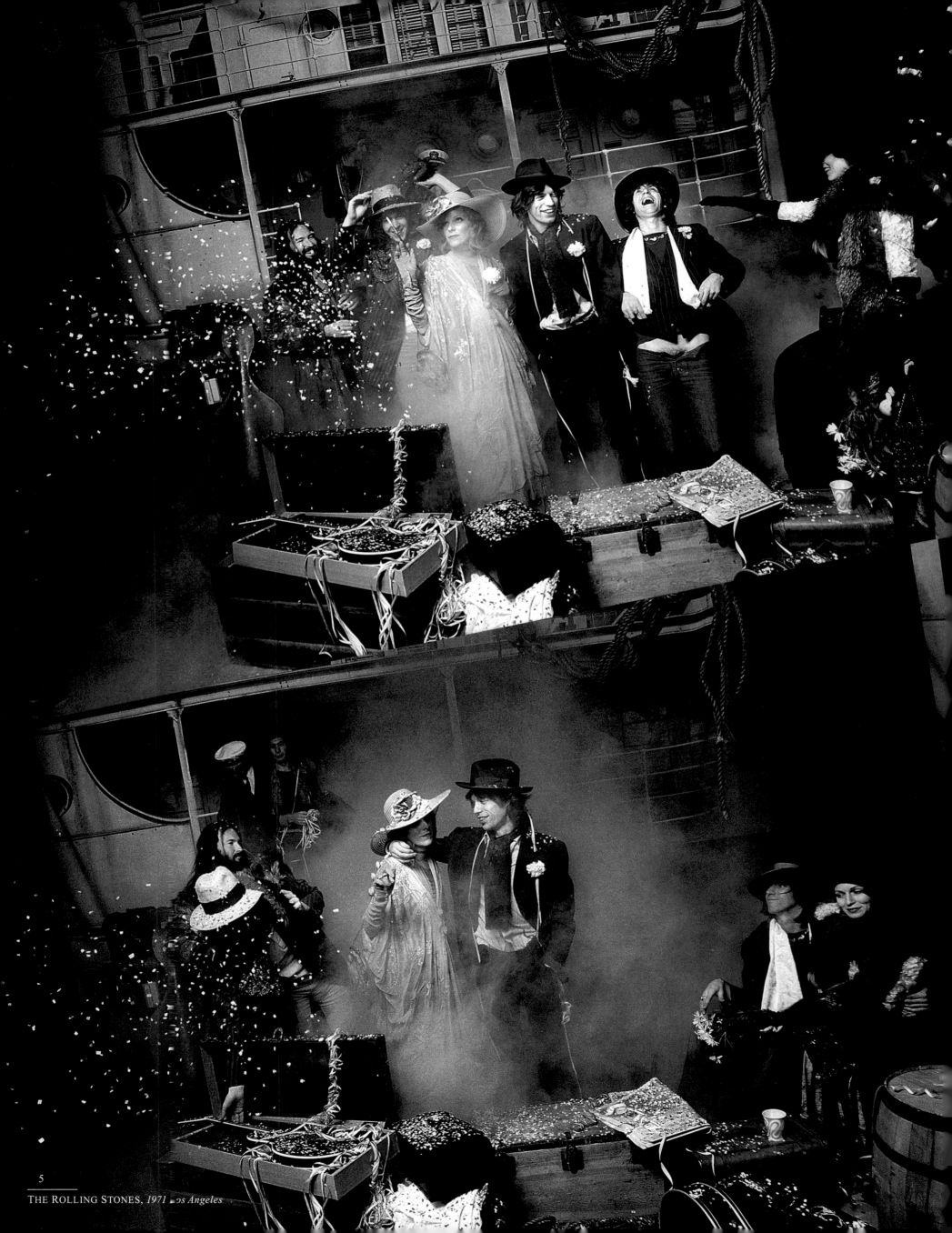

THE ROLLING STONES, *1971* Los Angeles

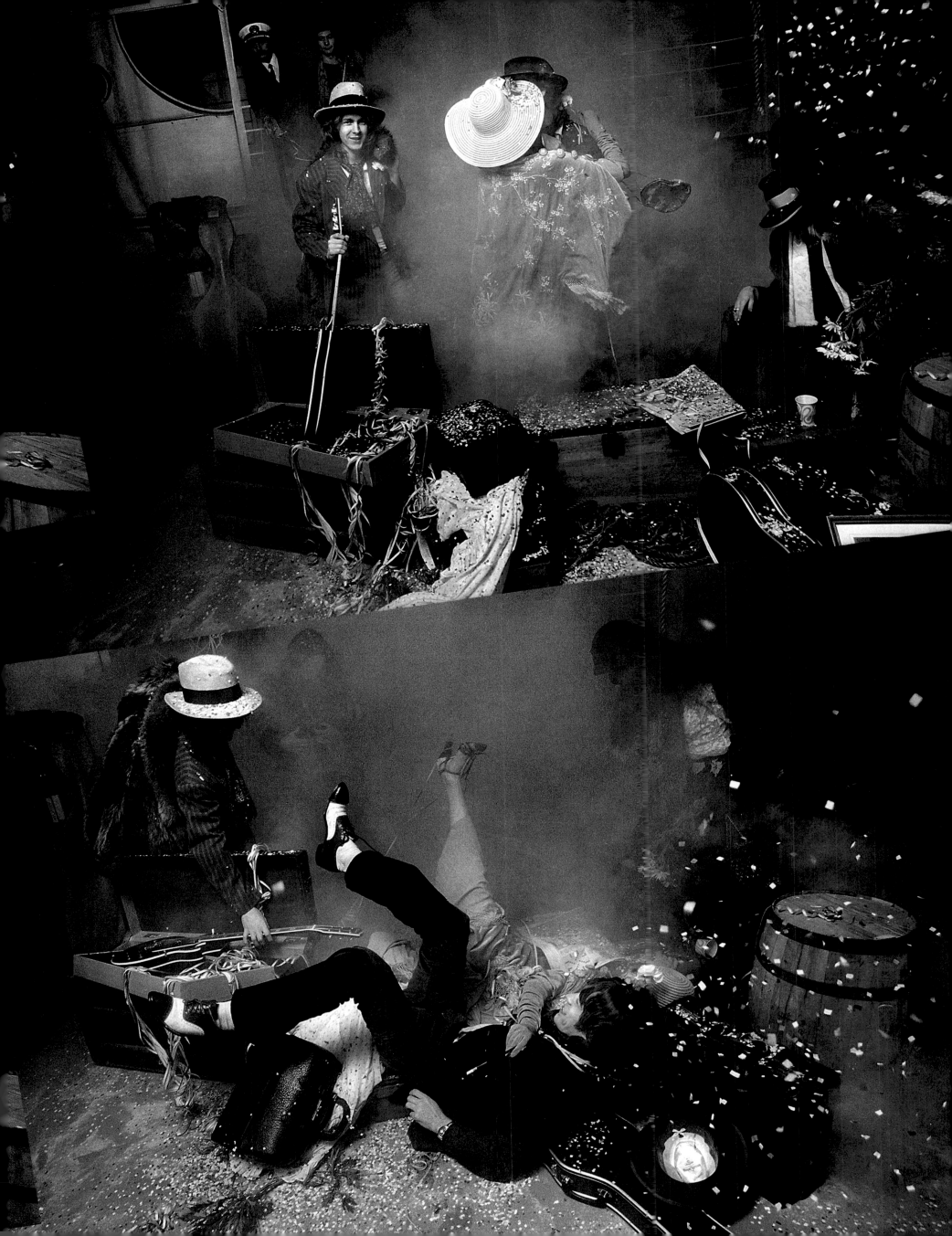

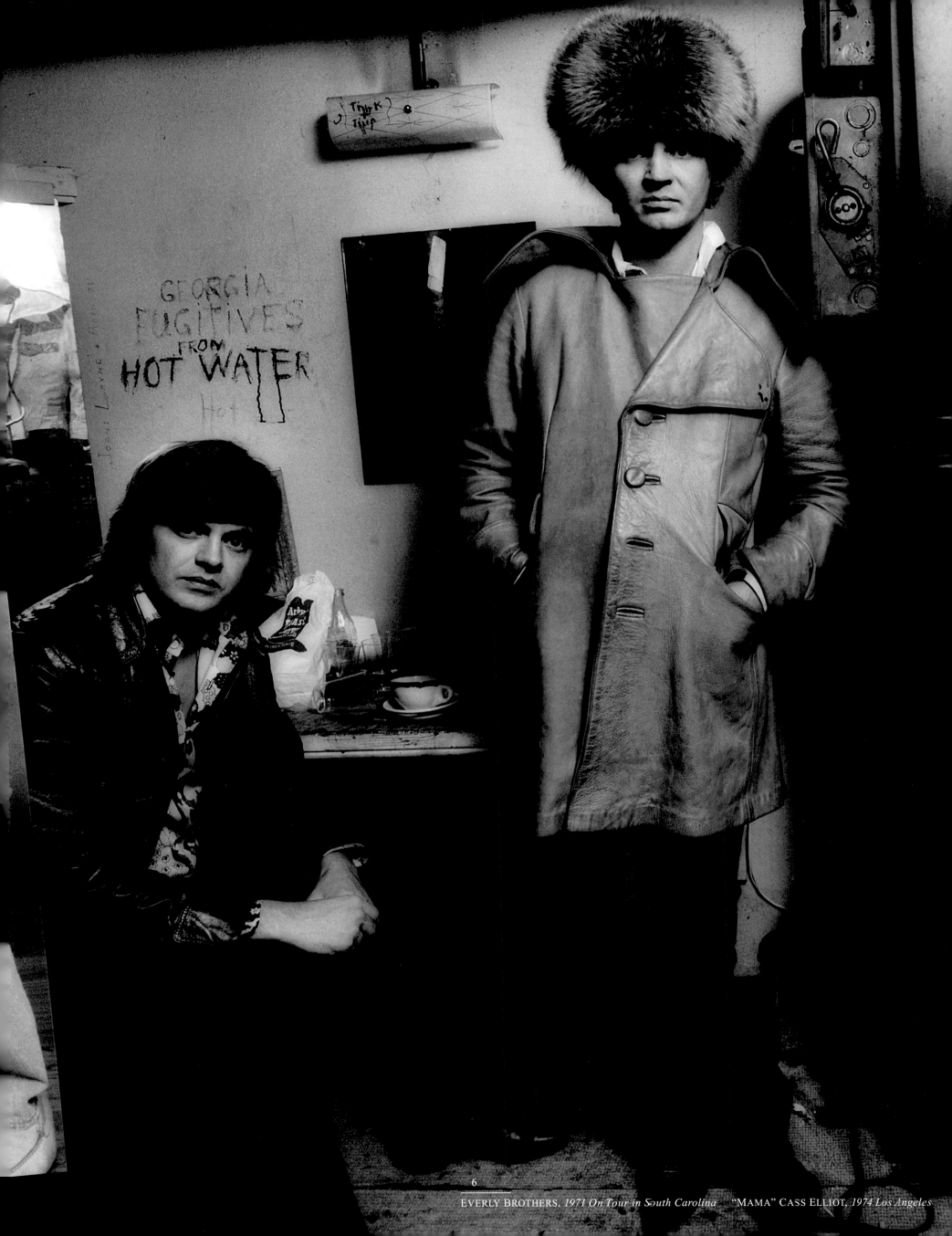

GEORGIA
FUGITIVES
FROM
HOT WATER

EVERLY BROTHERS, *1971 On Tour in South Carolina* "MAMA" CASS ELLIOT, *1974 Los Angeles*

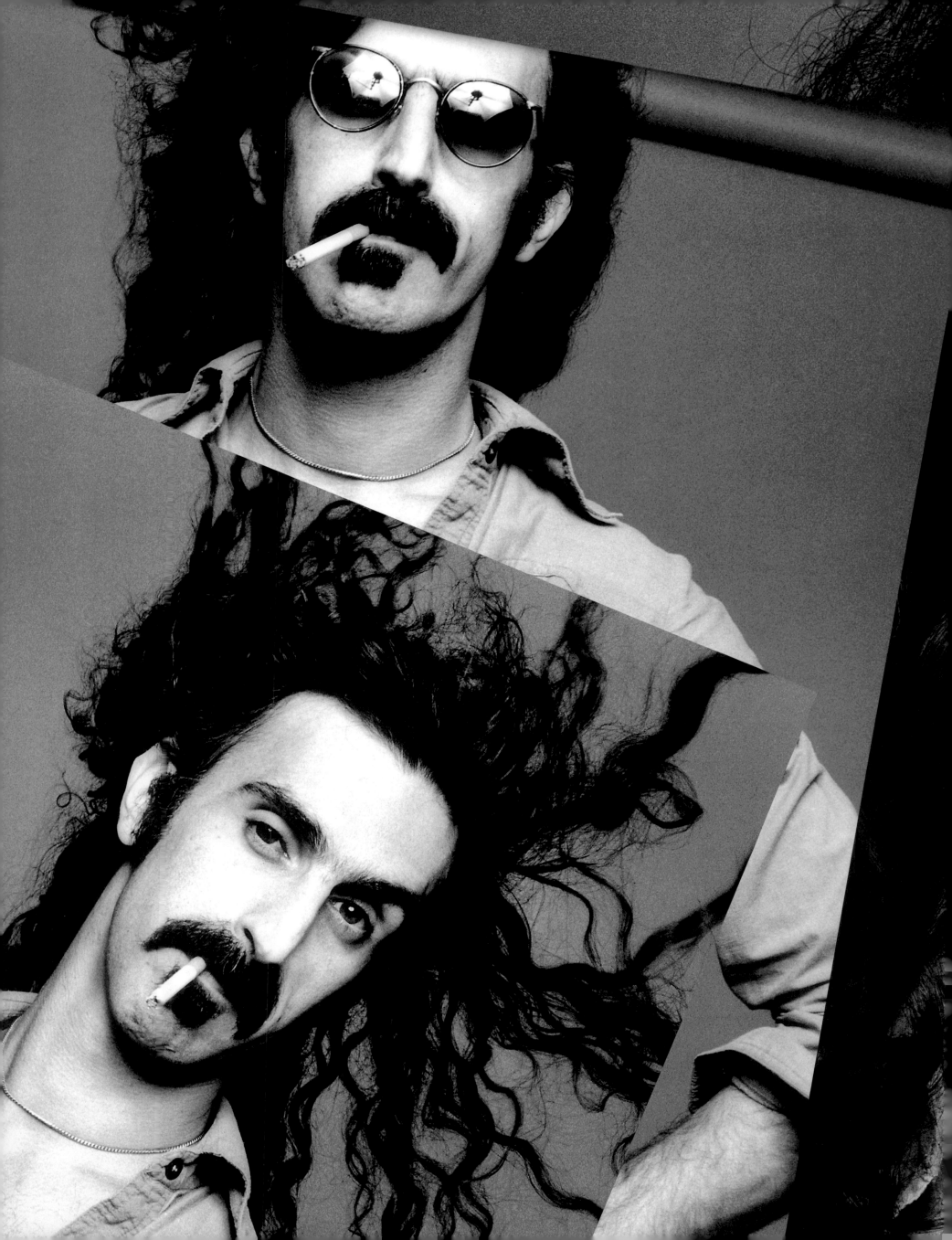

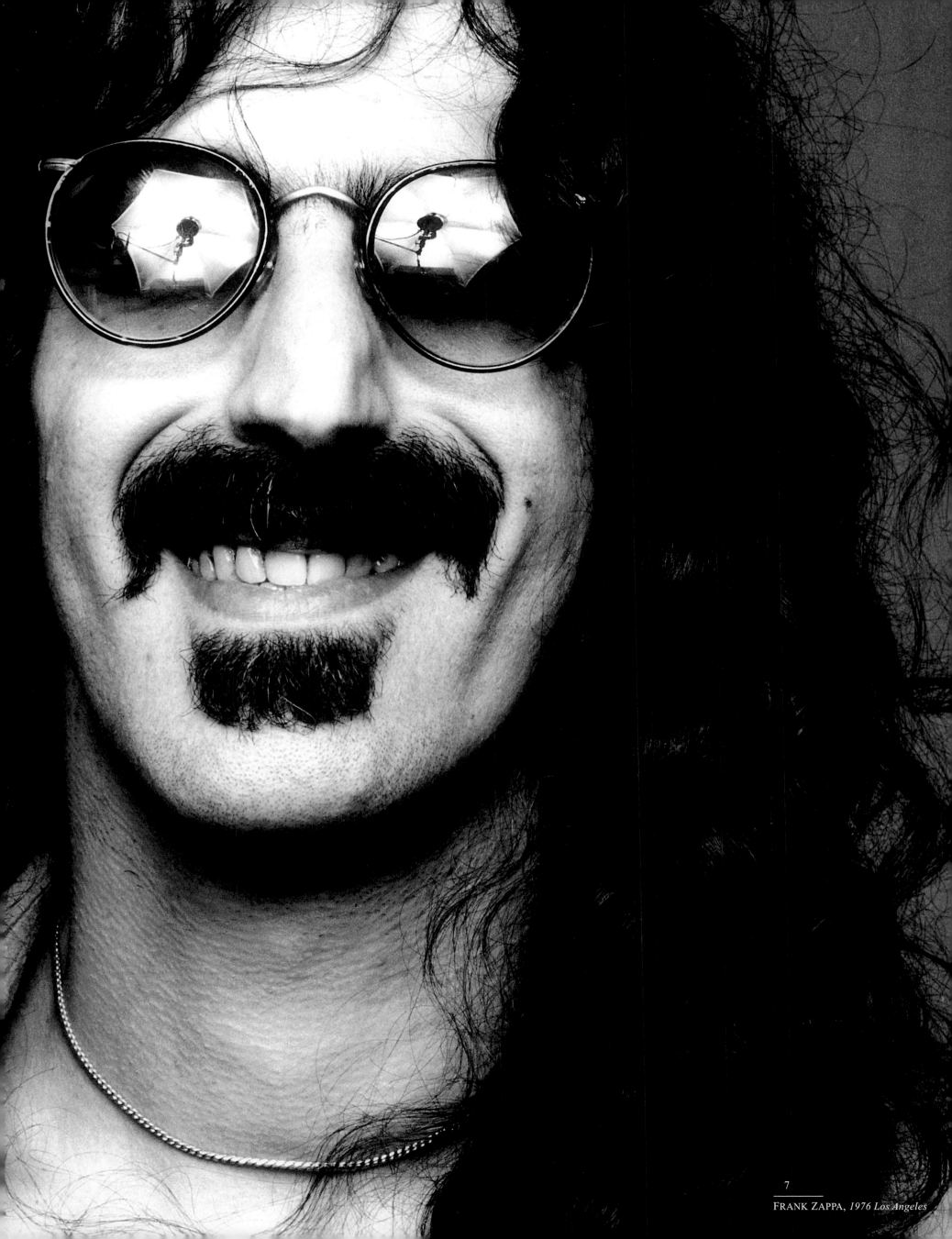

FRANK ZAPPA, *1976 Los Angeles*

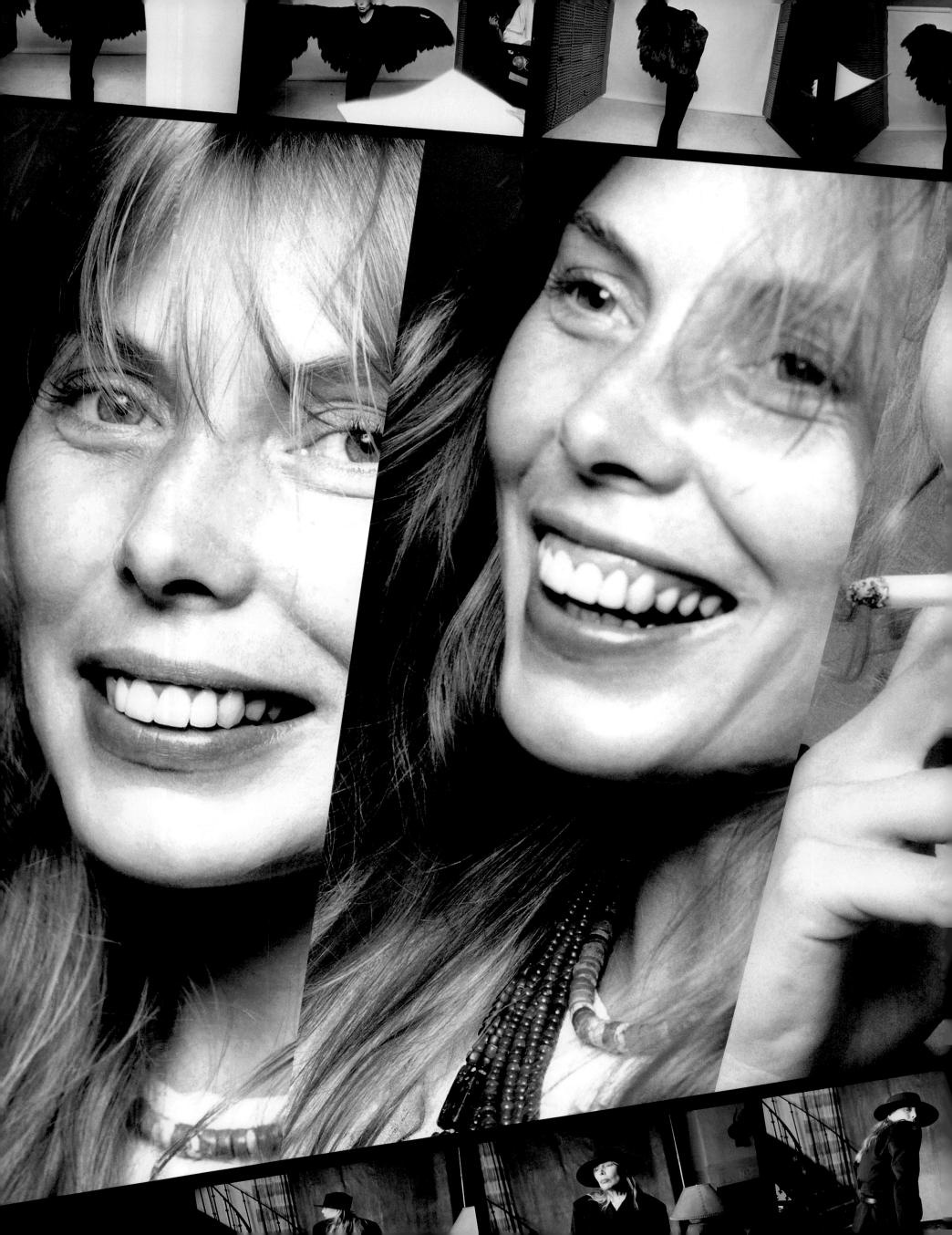

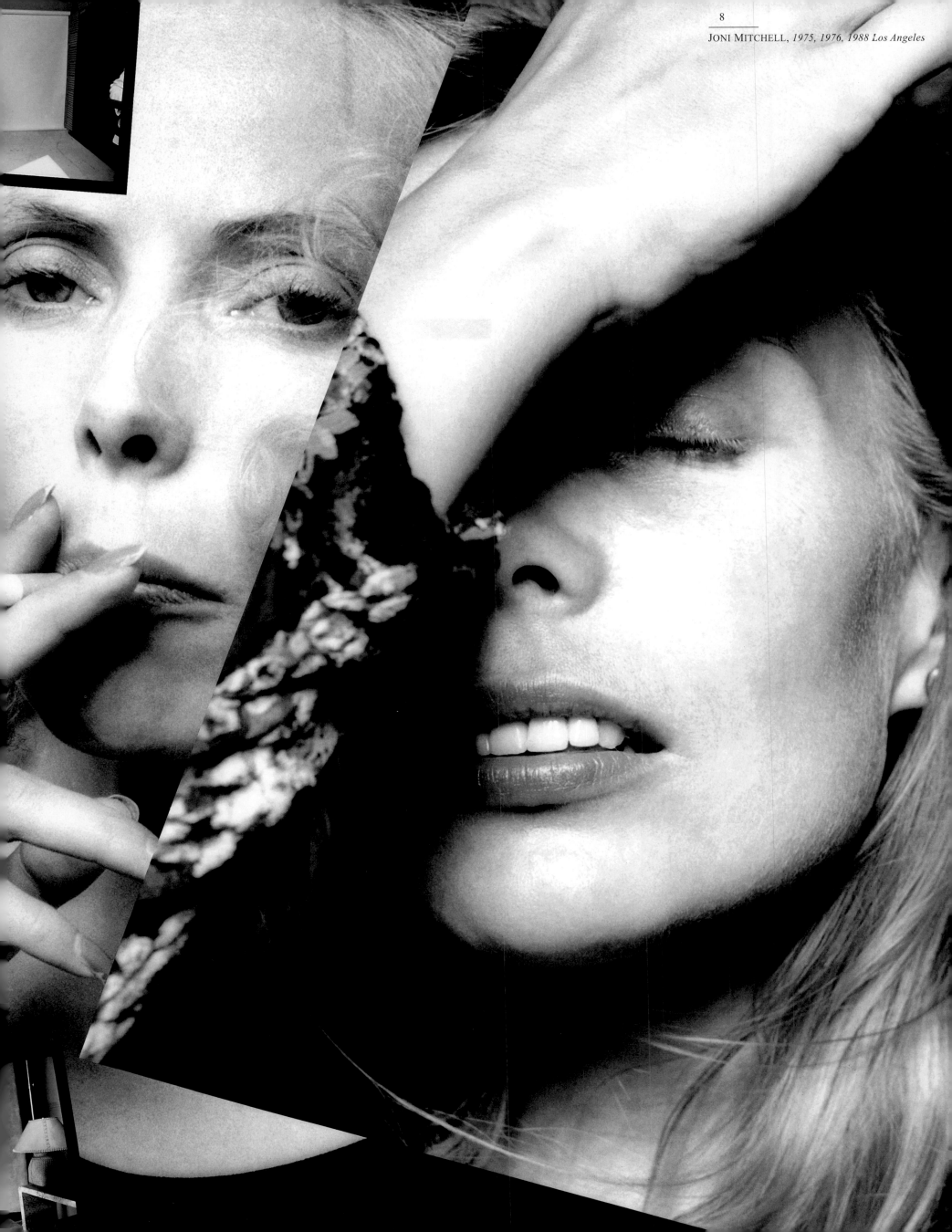

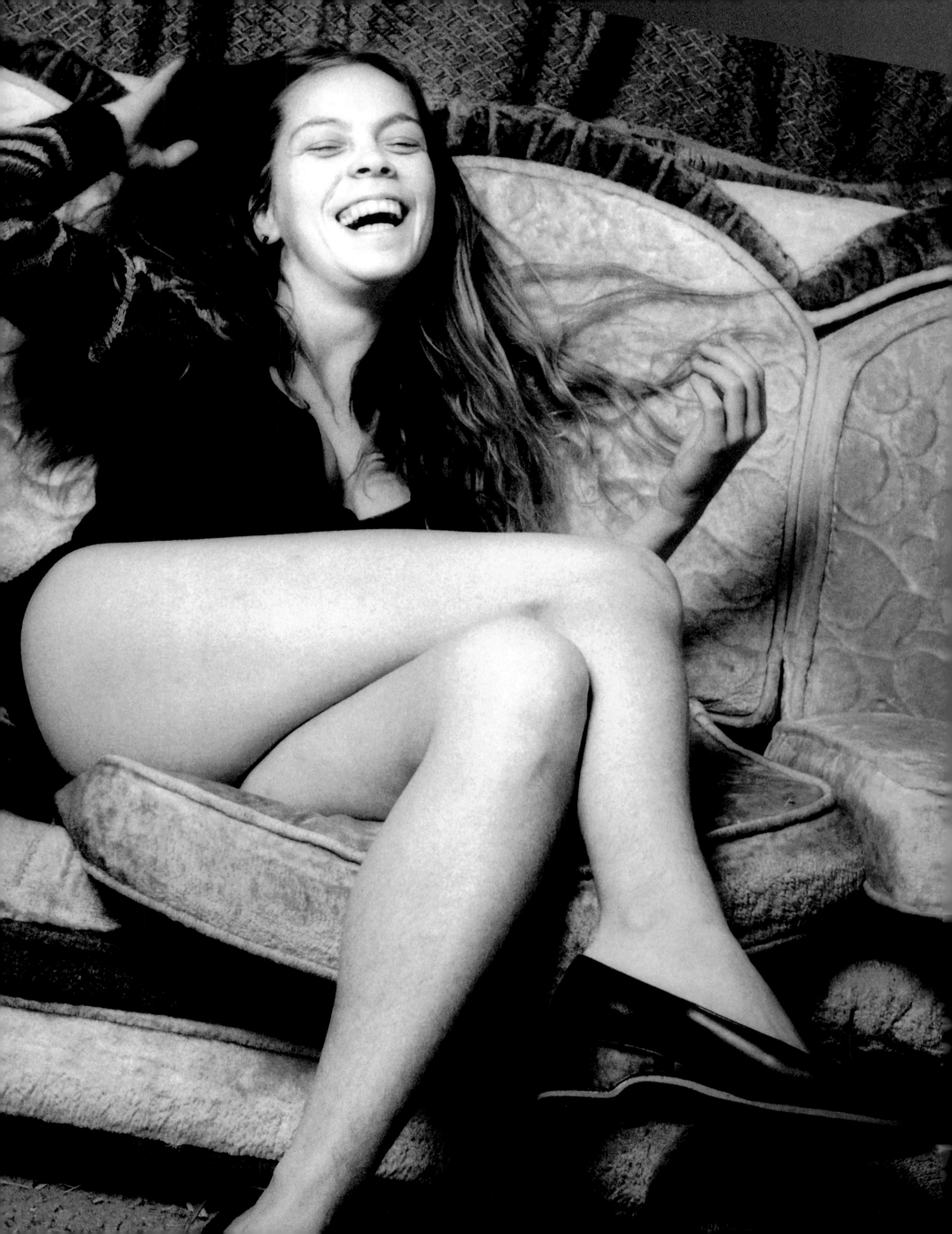

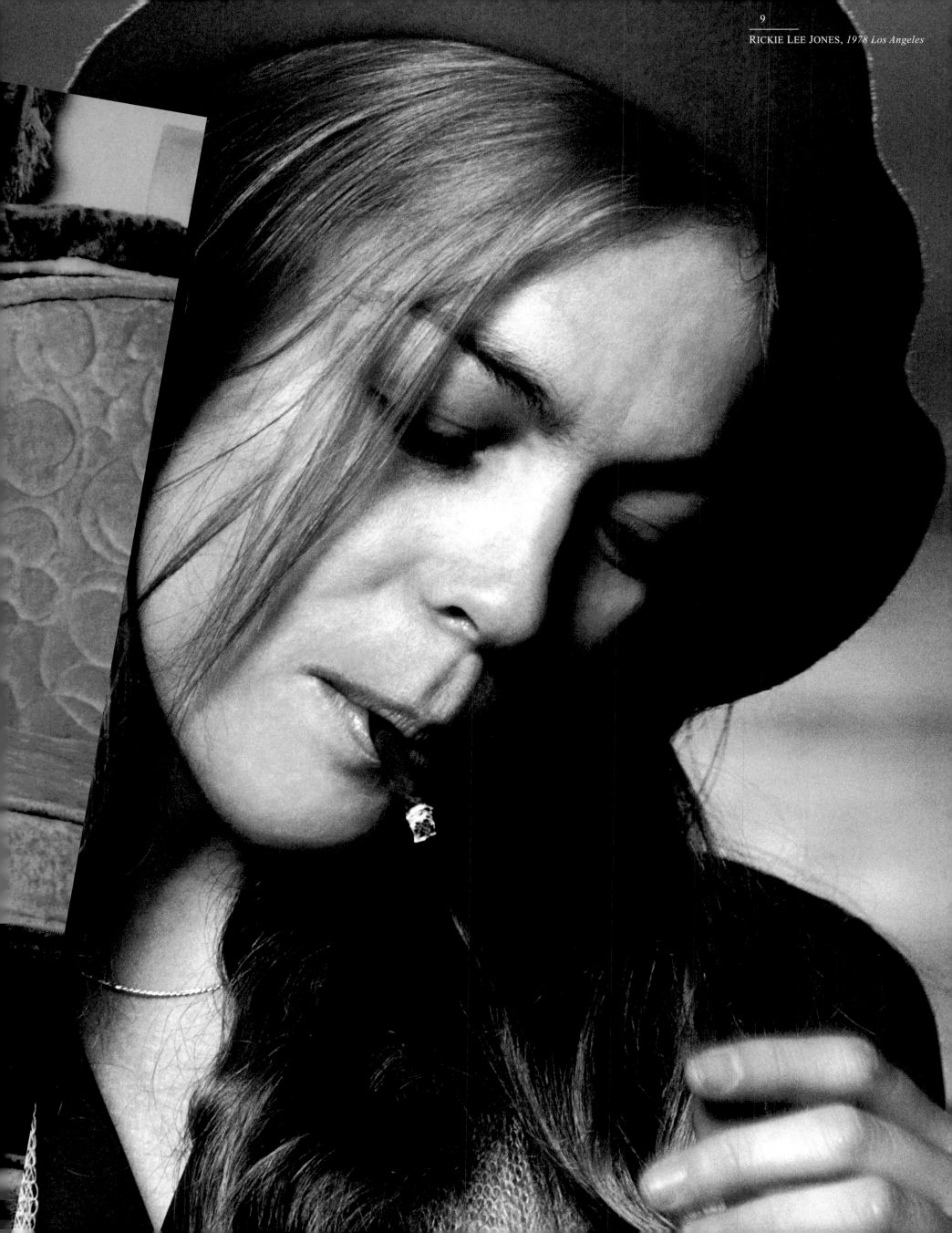

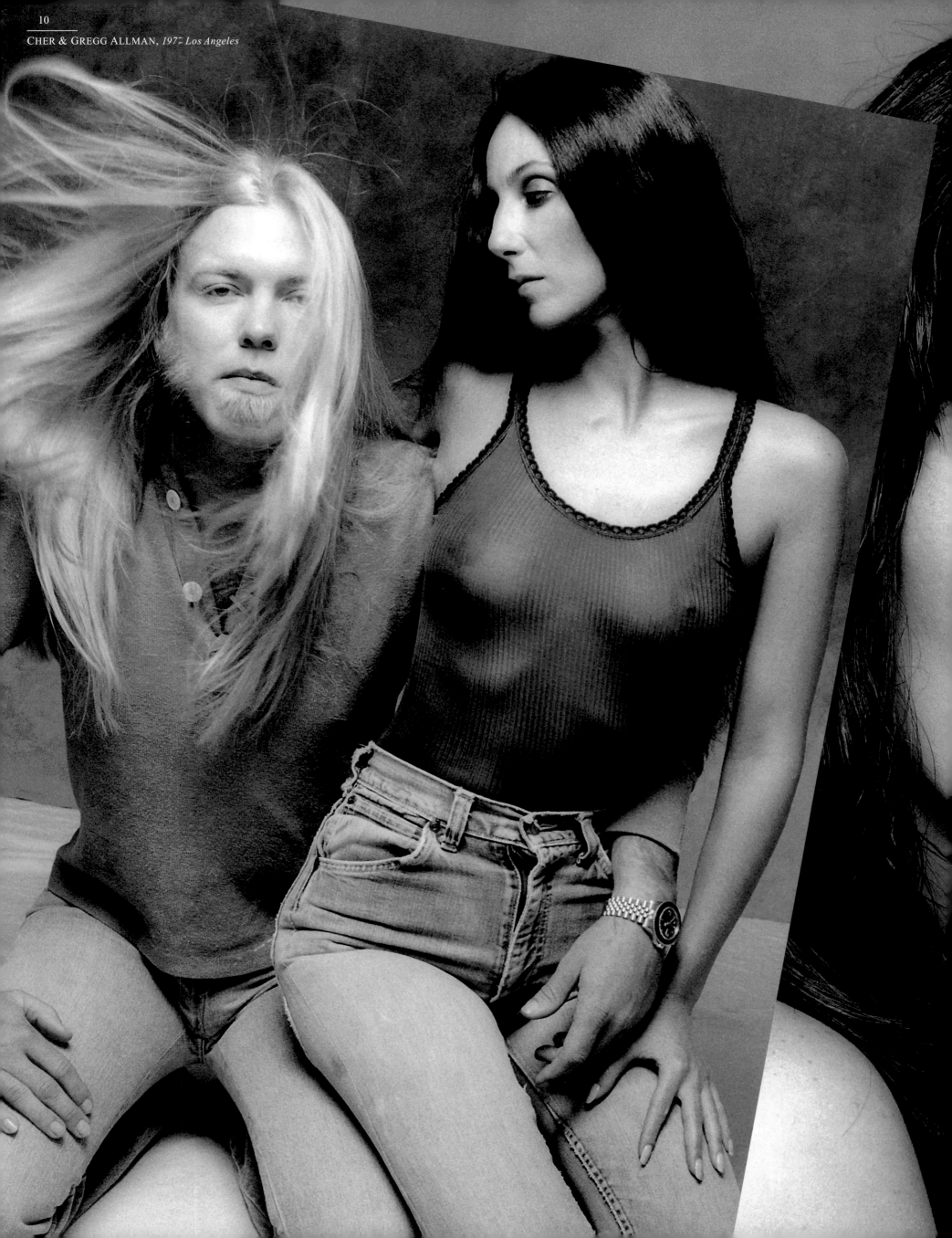

CHER & GREGG ALLMAN, *197- Los Angeles*

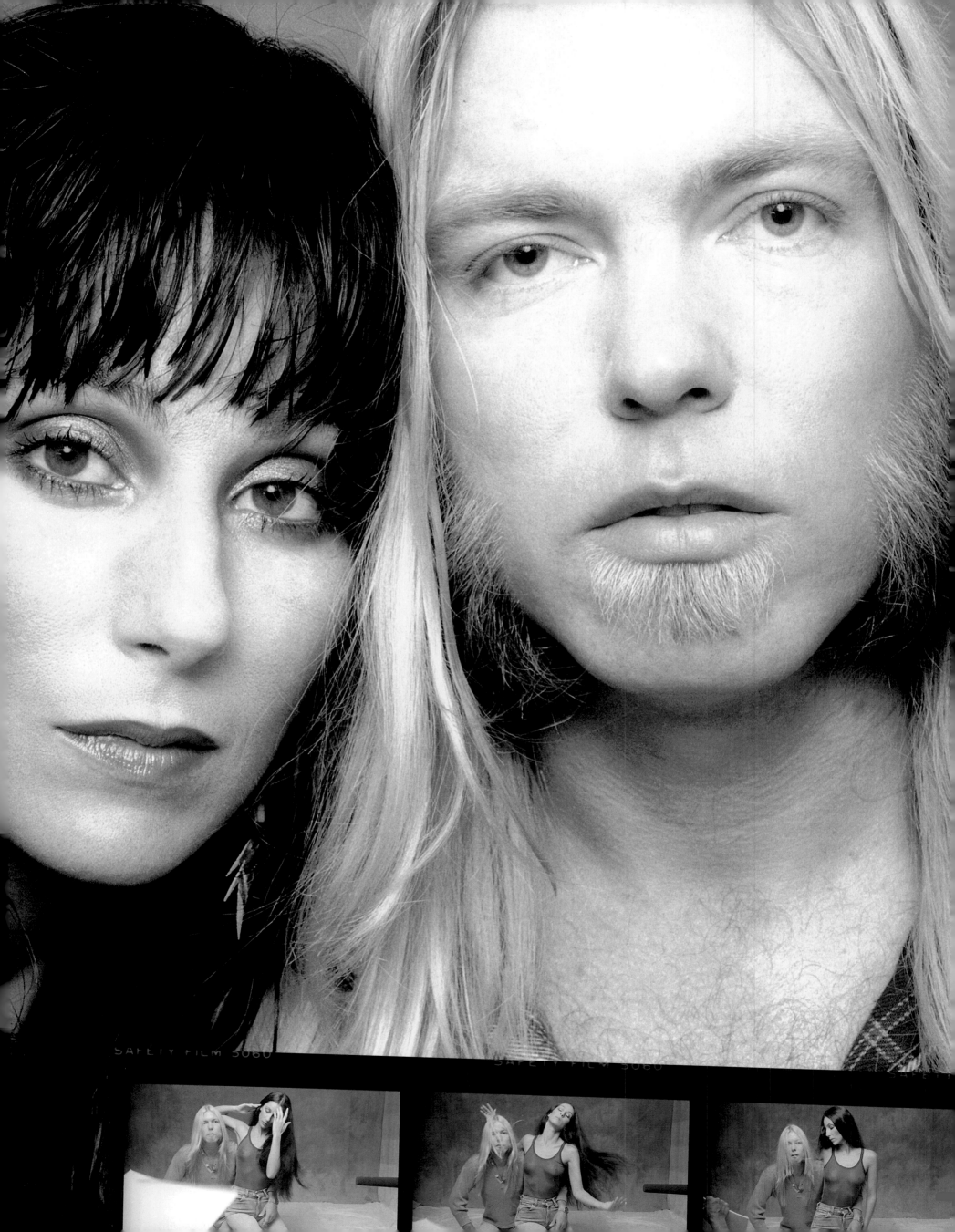

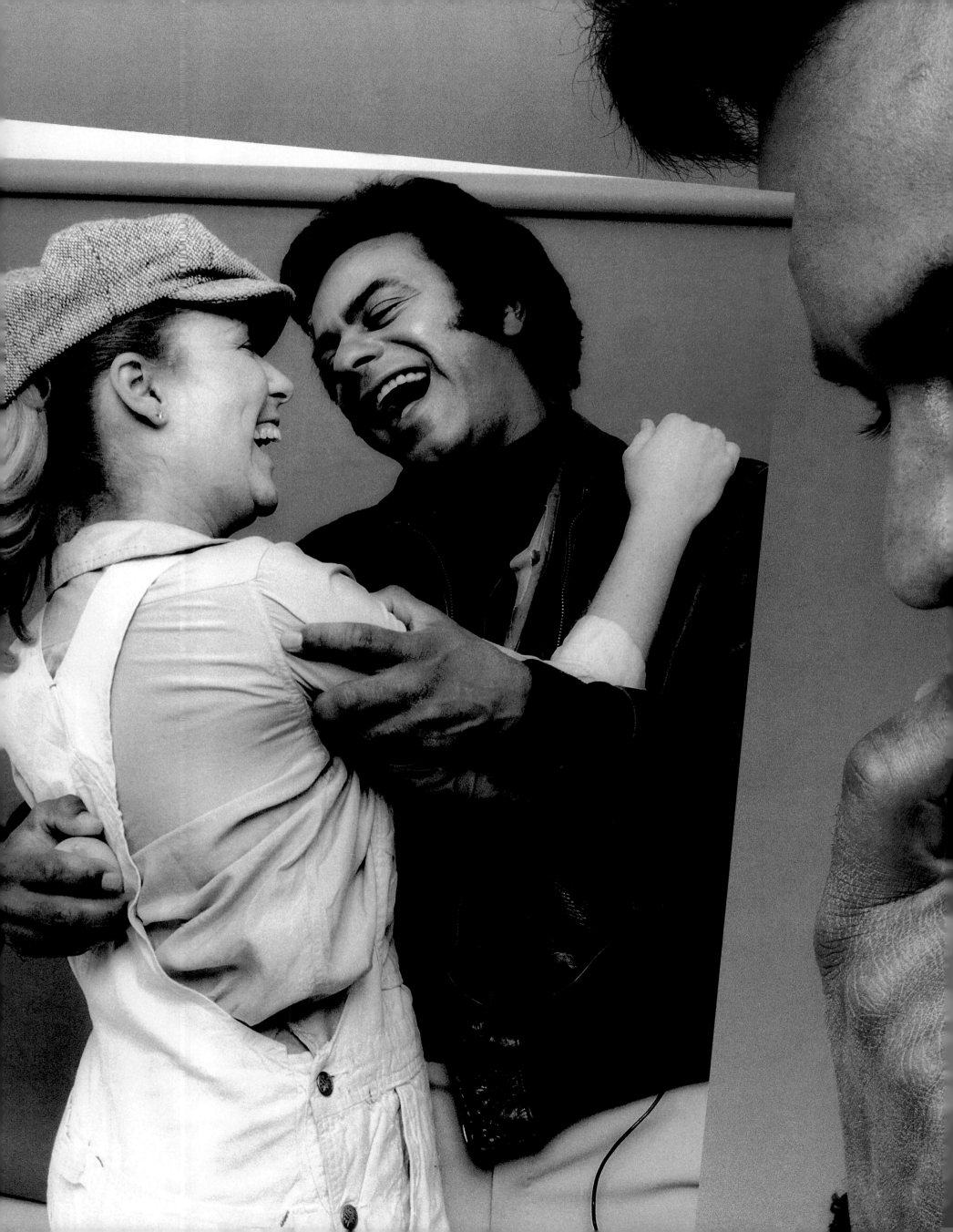

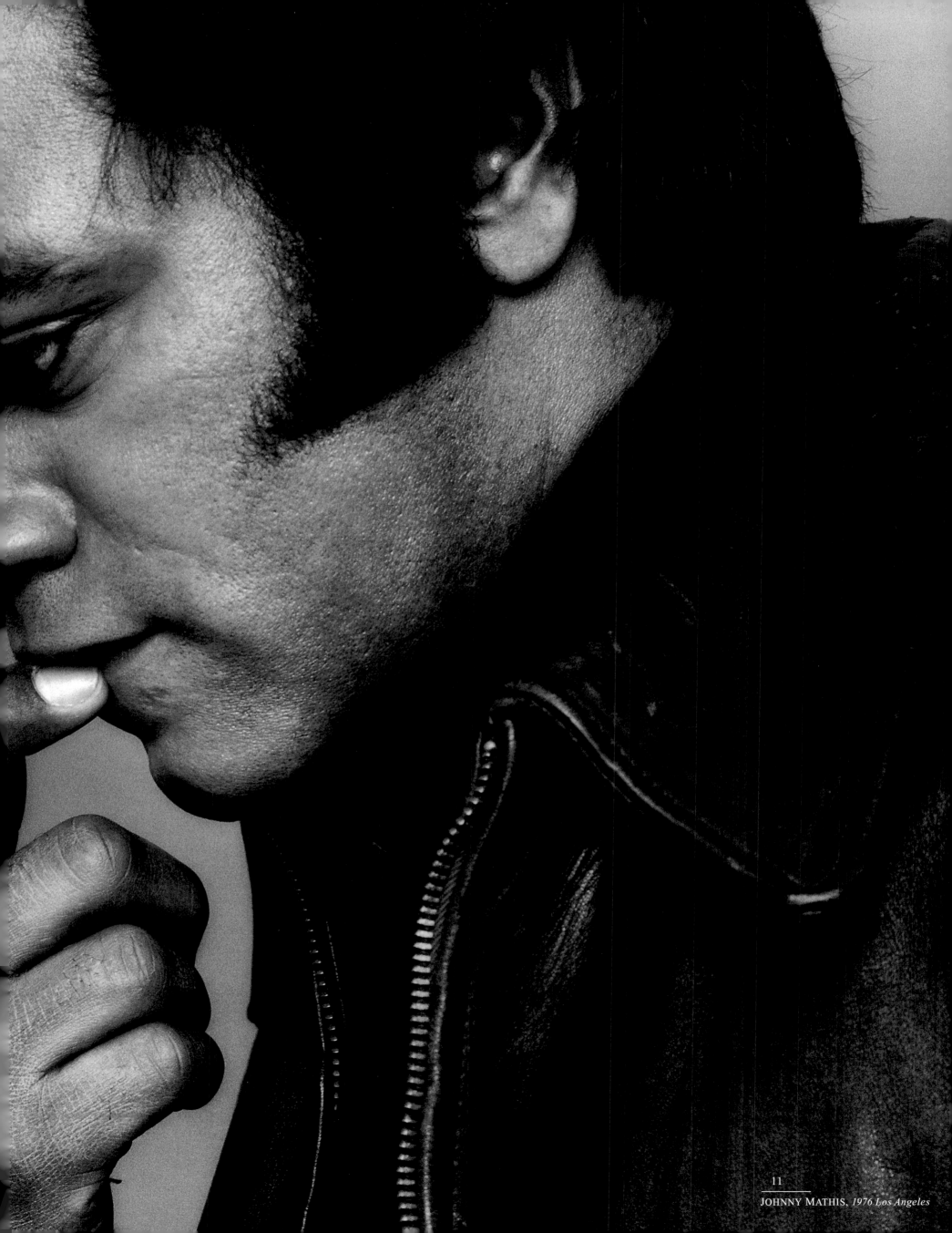

11

JOHNNY MATHIS, *1976 Los Angeles*

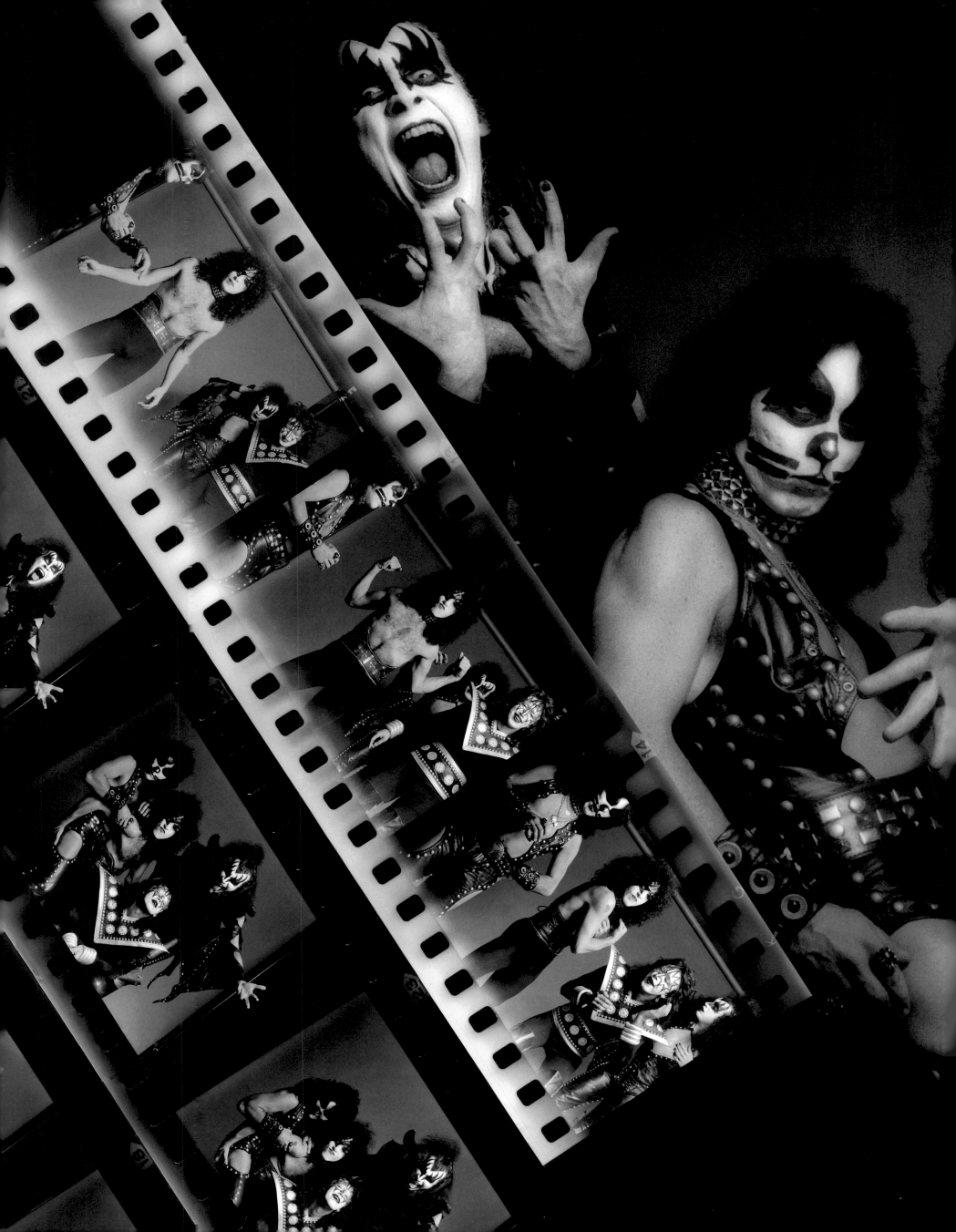

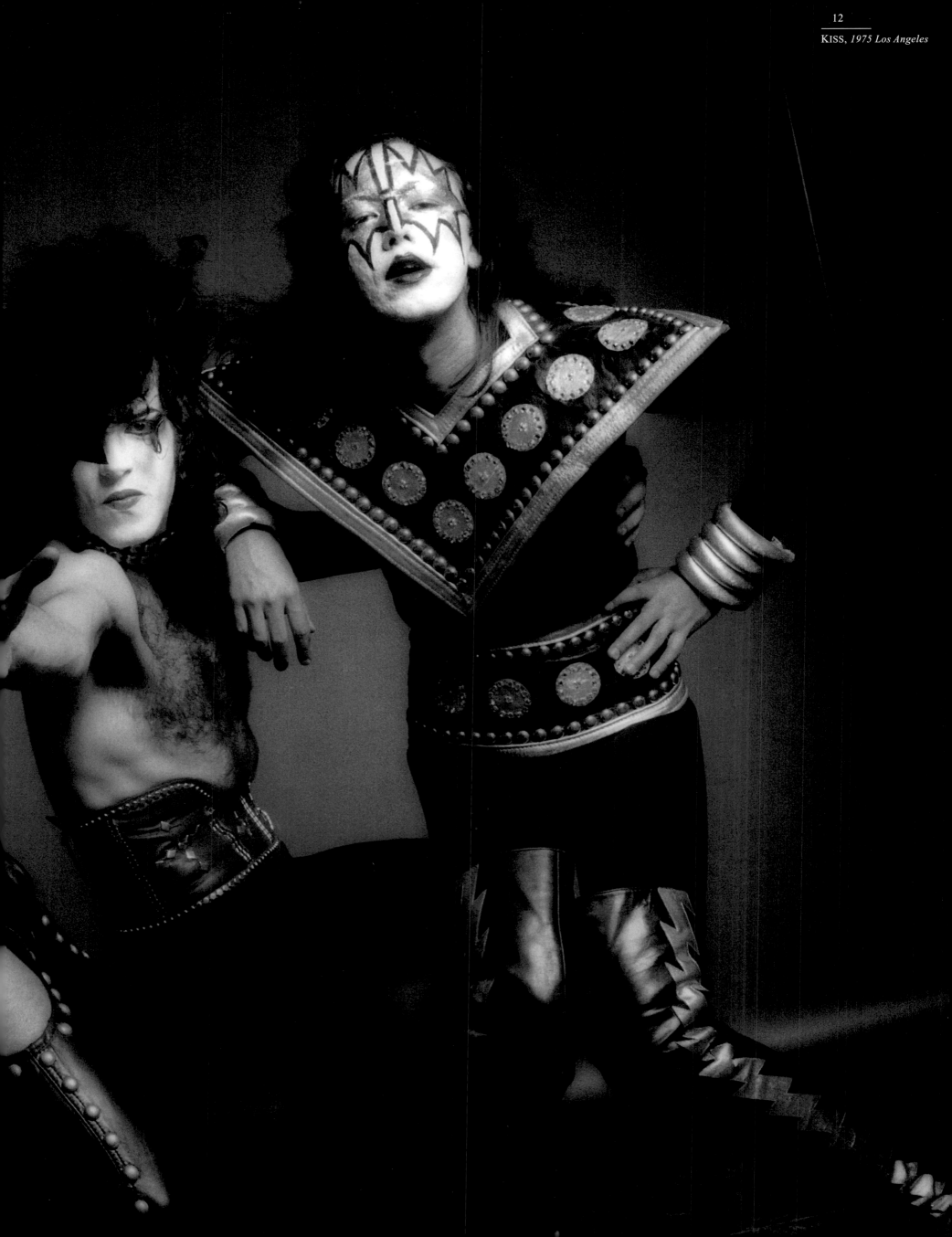

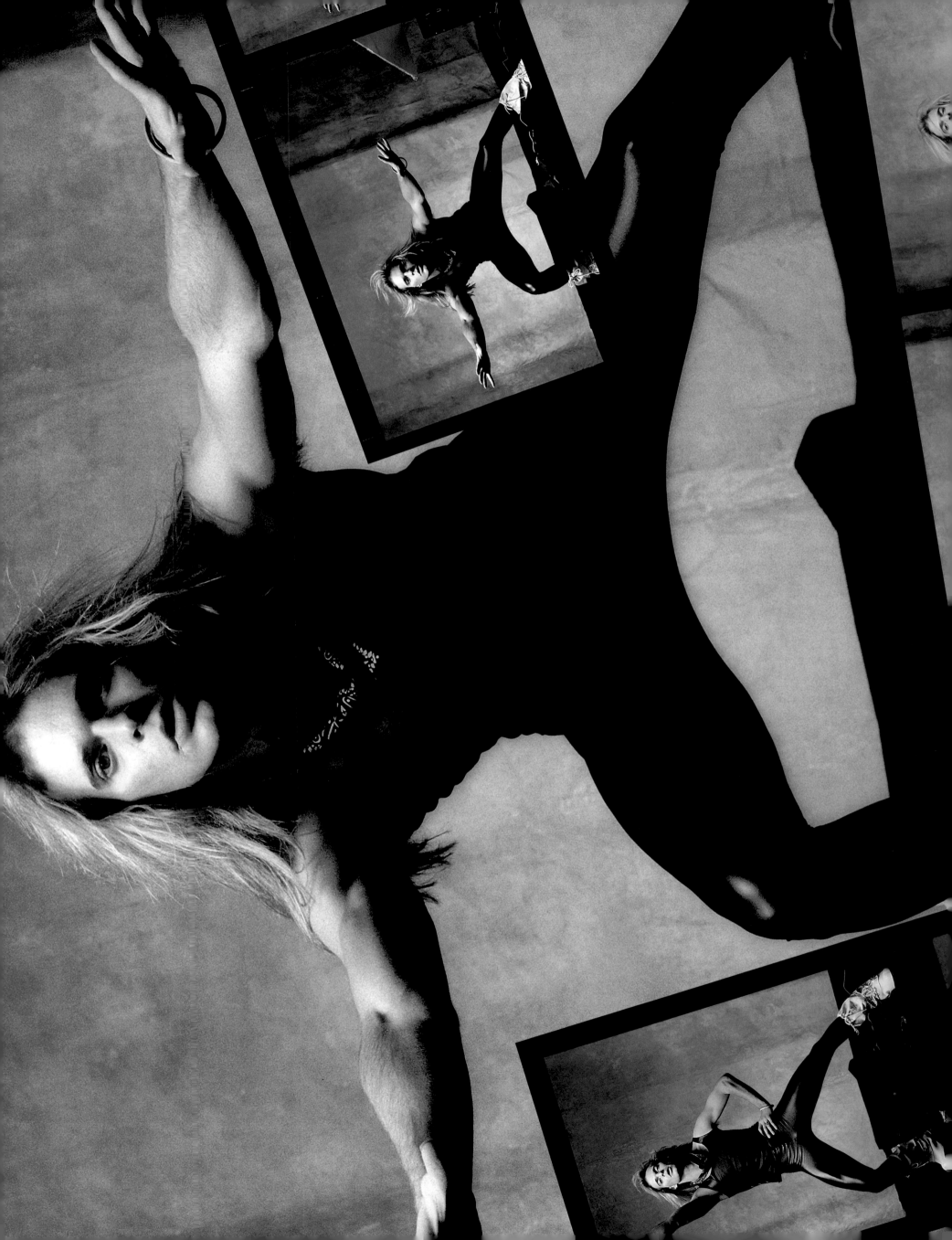

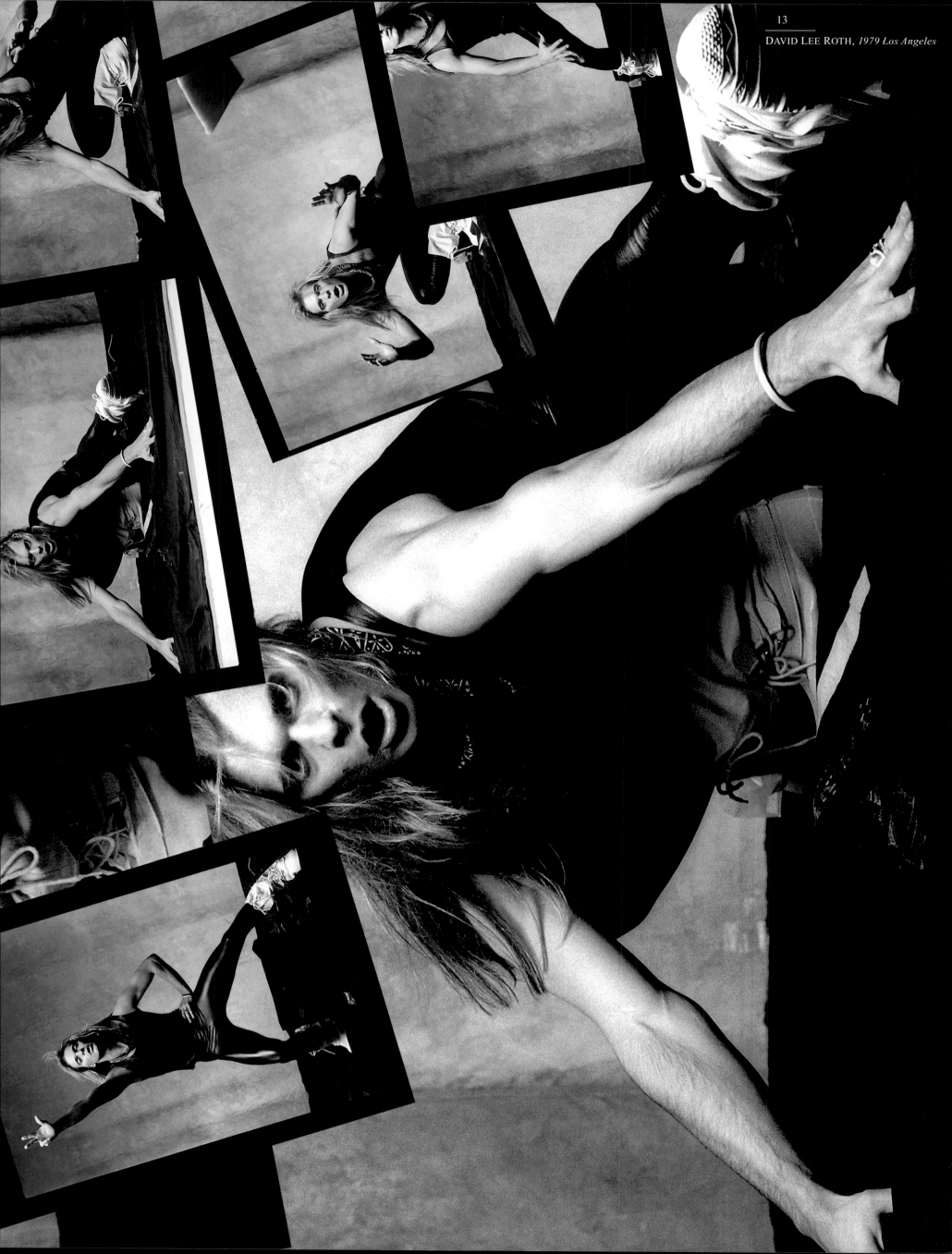

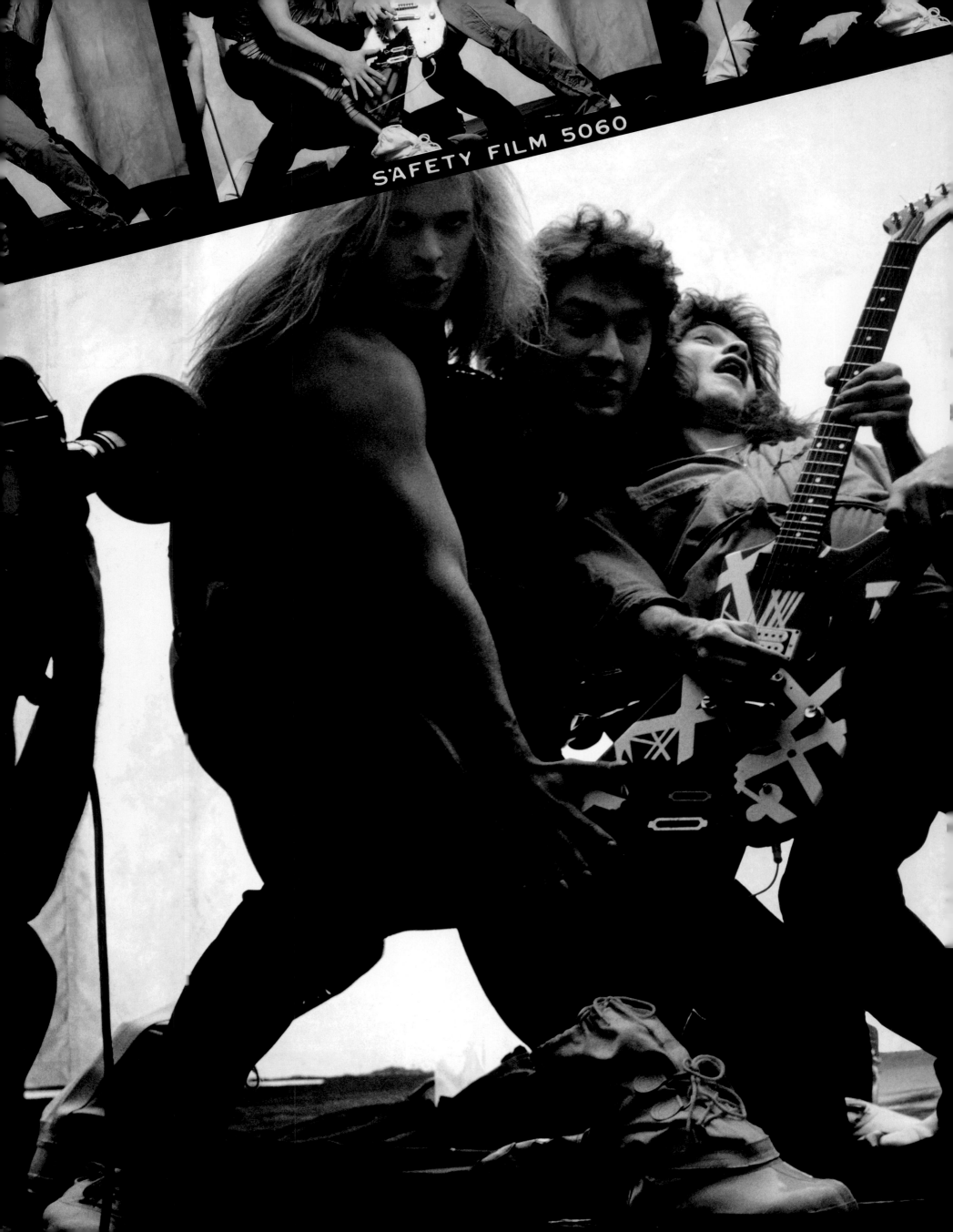

SAFETY FILM 5060

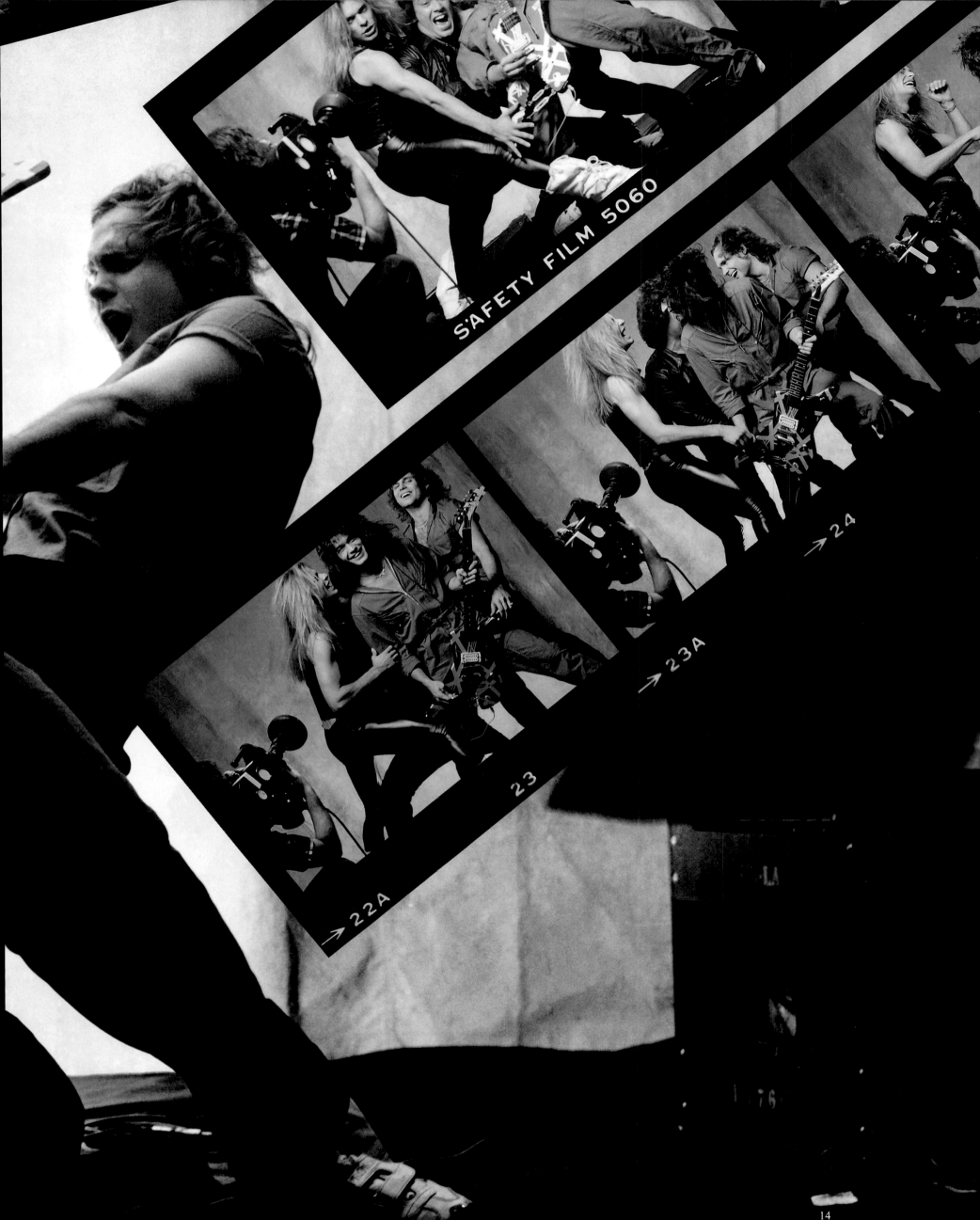

SAFETY FILM 5060

→ 24

→ 23A

23

→ 22A

14

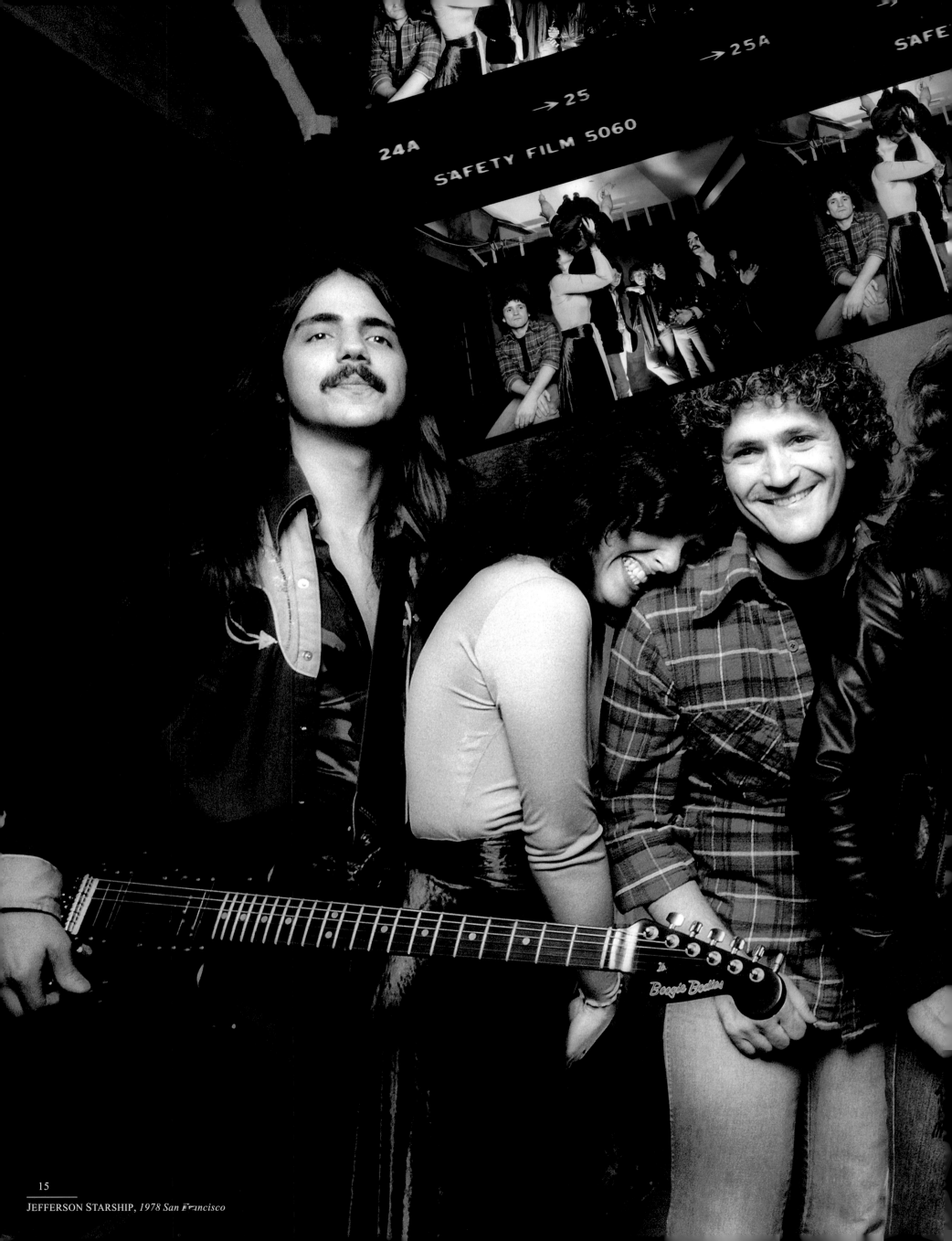

15

JEFFERSON STARSHIP, *1978 San Francisco*

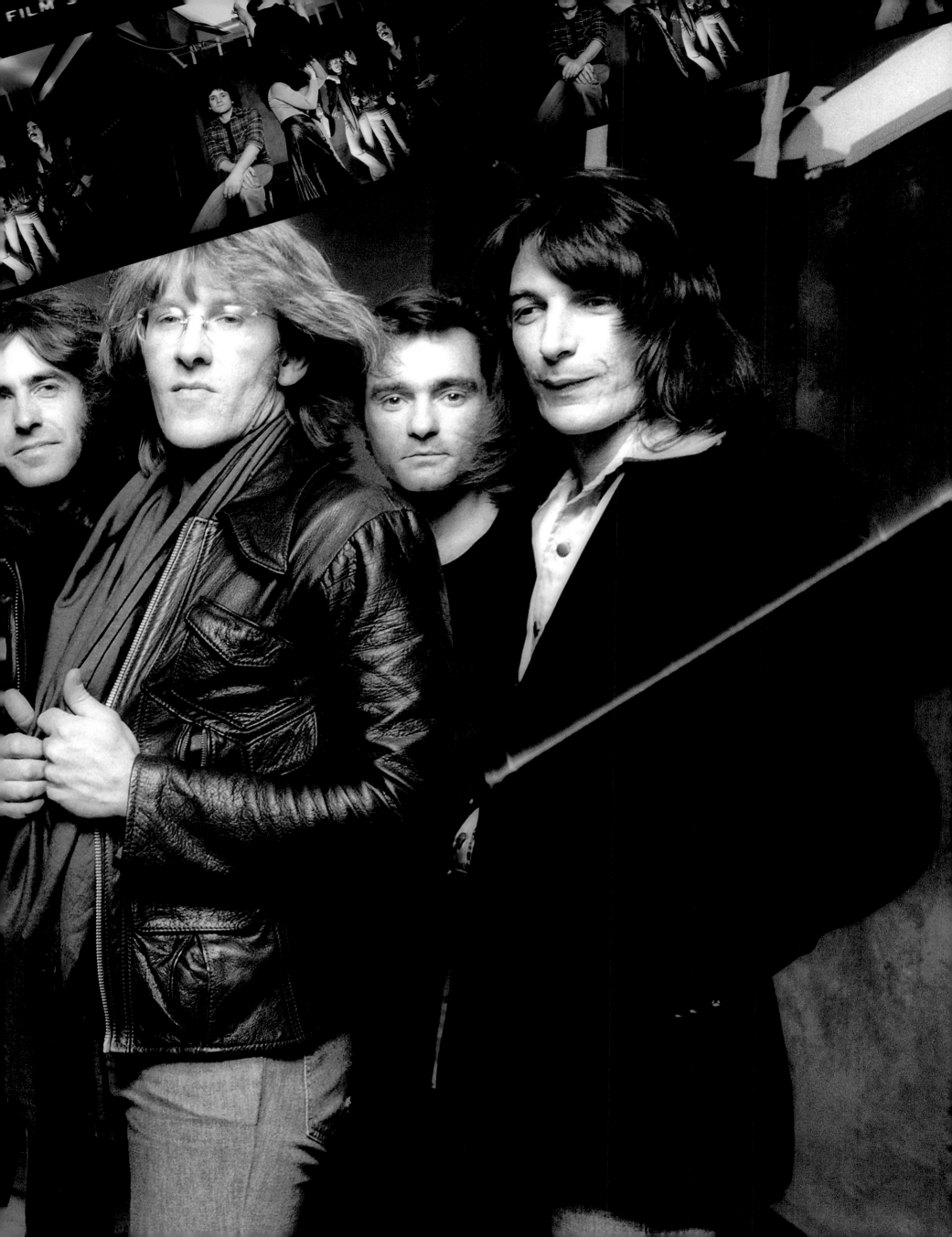

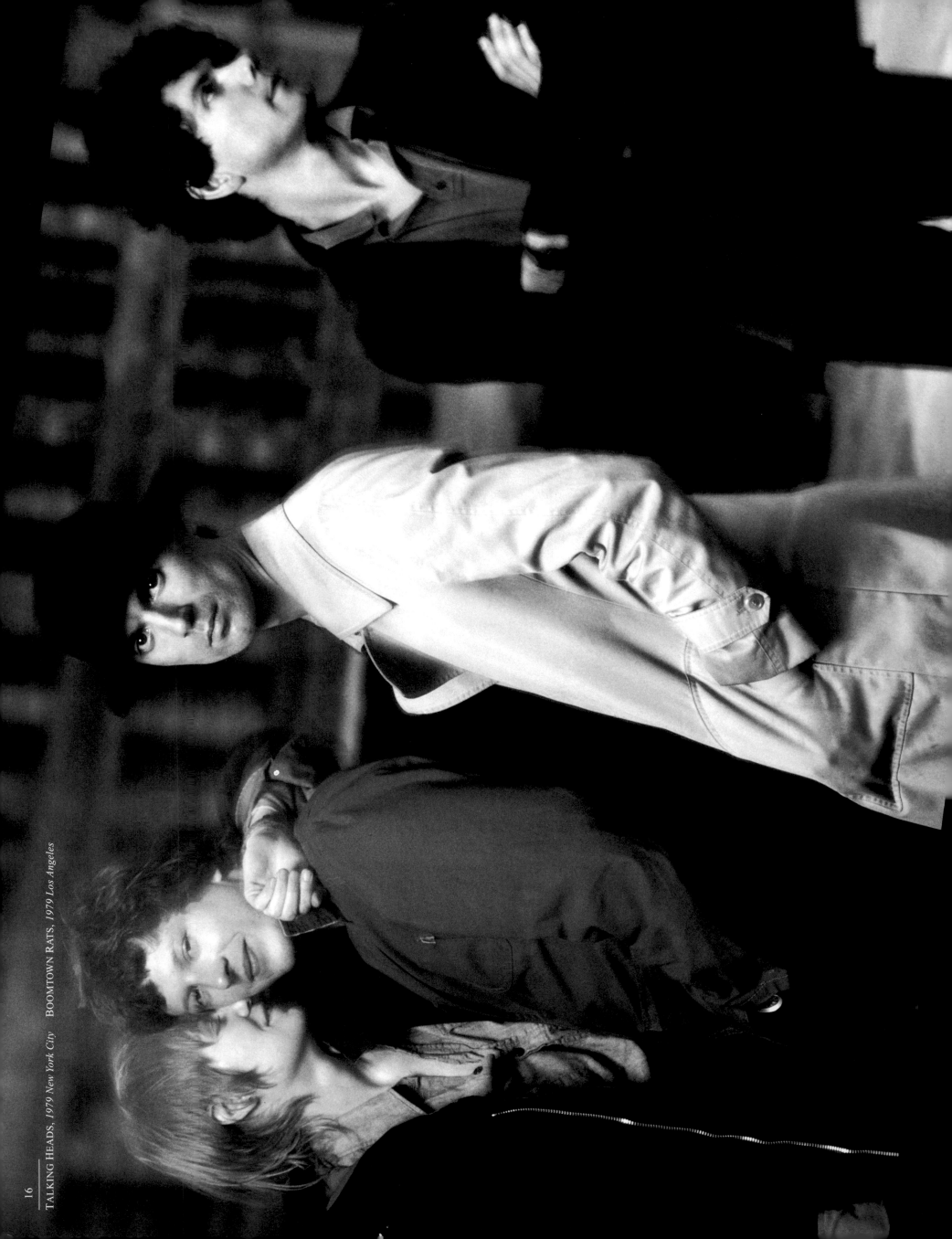

TALKING HEADS, *1979 New York City* BOOMTOWN RATS, *1979 Los Angeles*

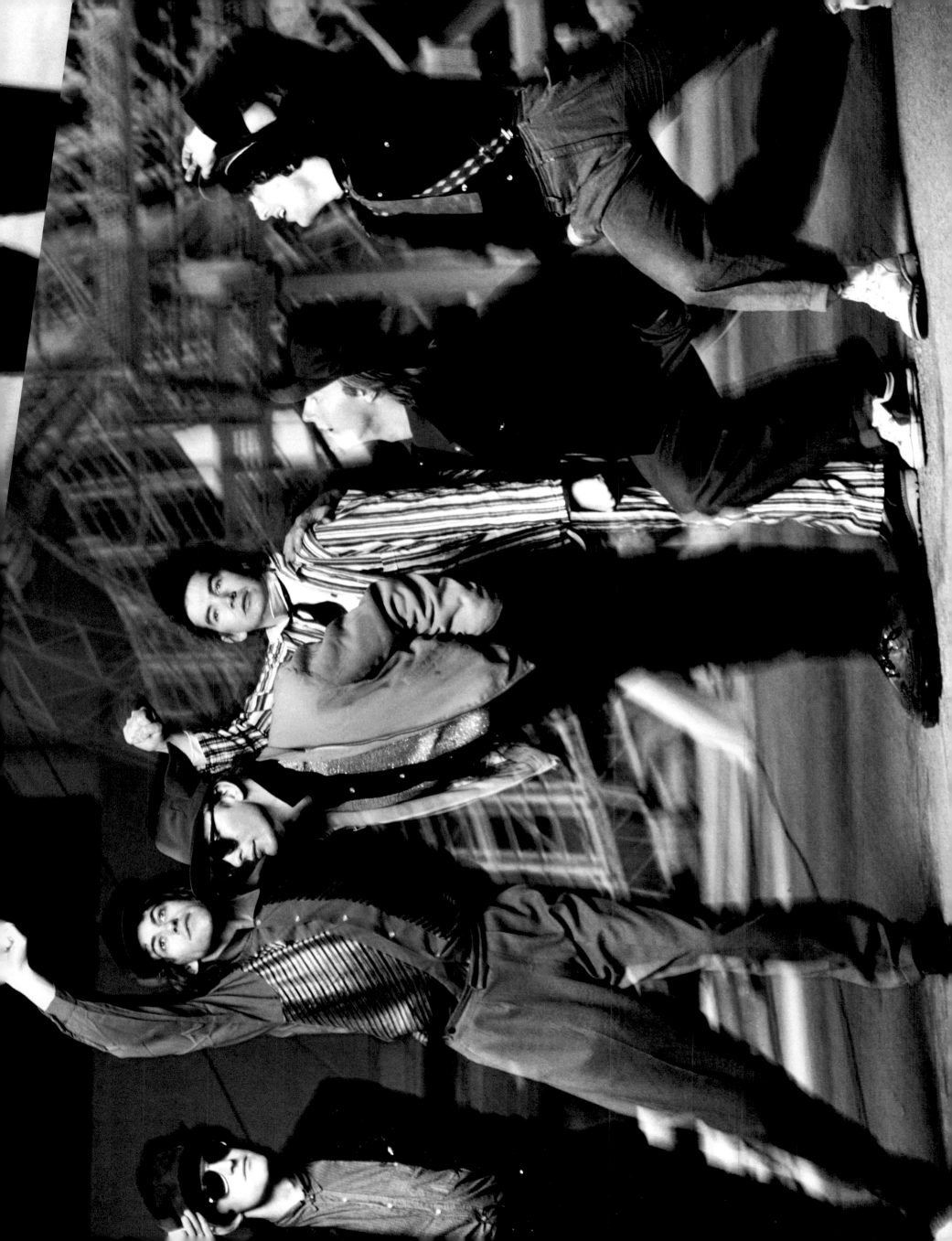

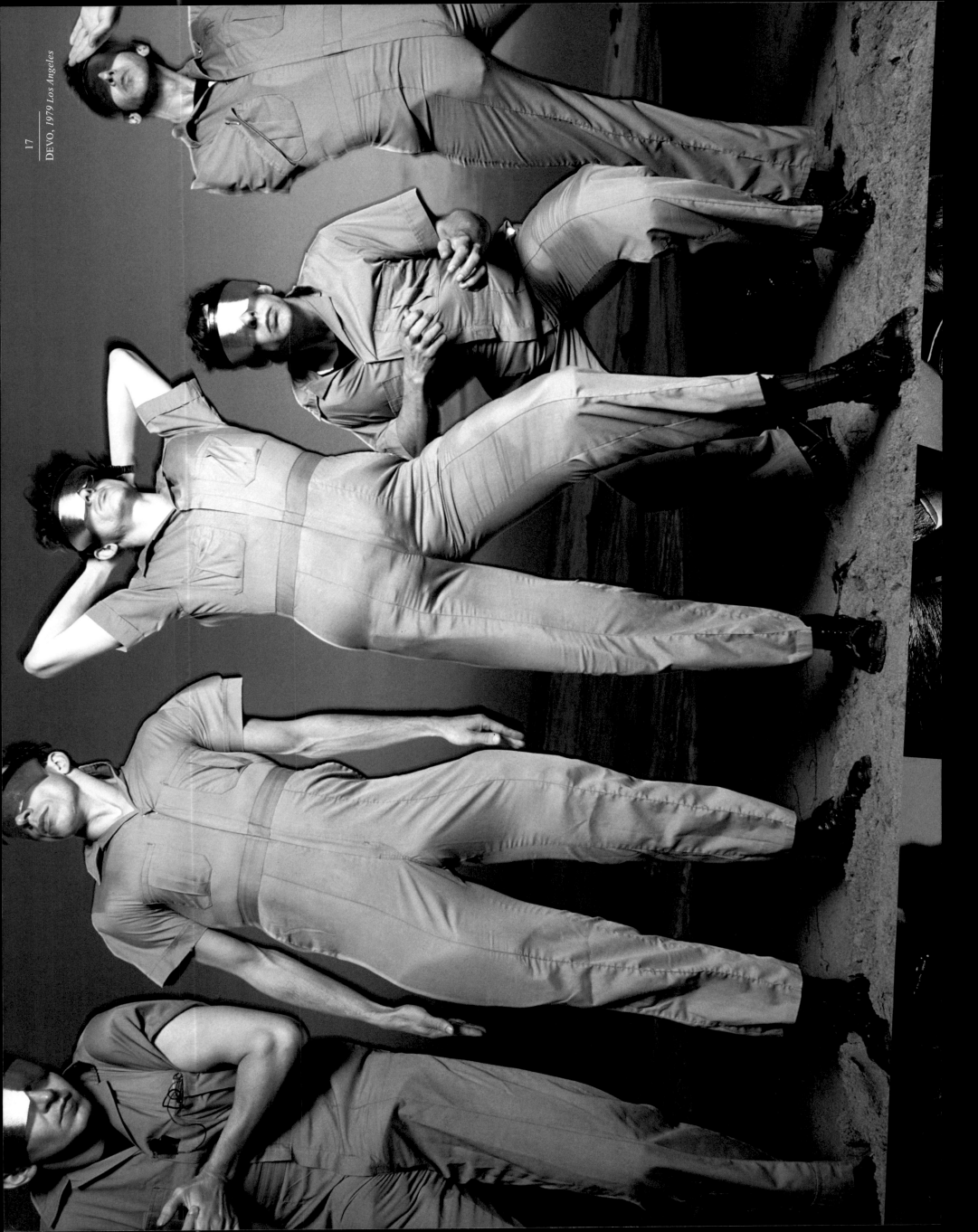

DEVO, 1979 Los Angeles

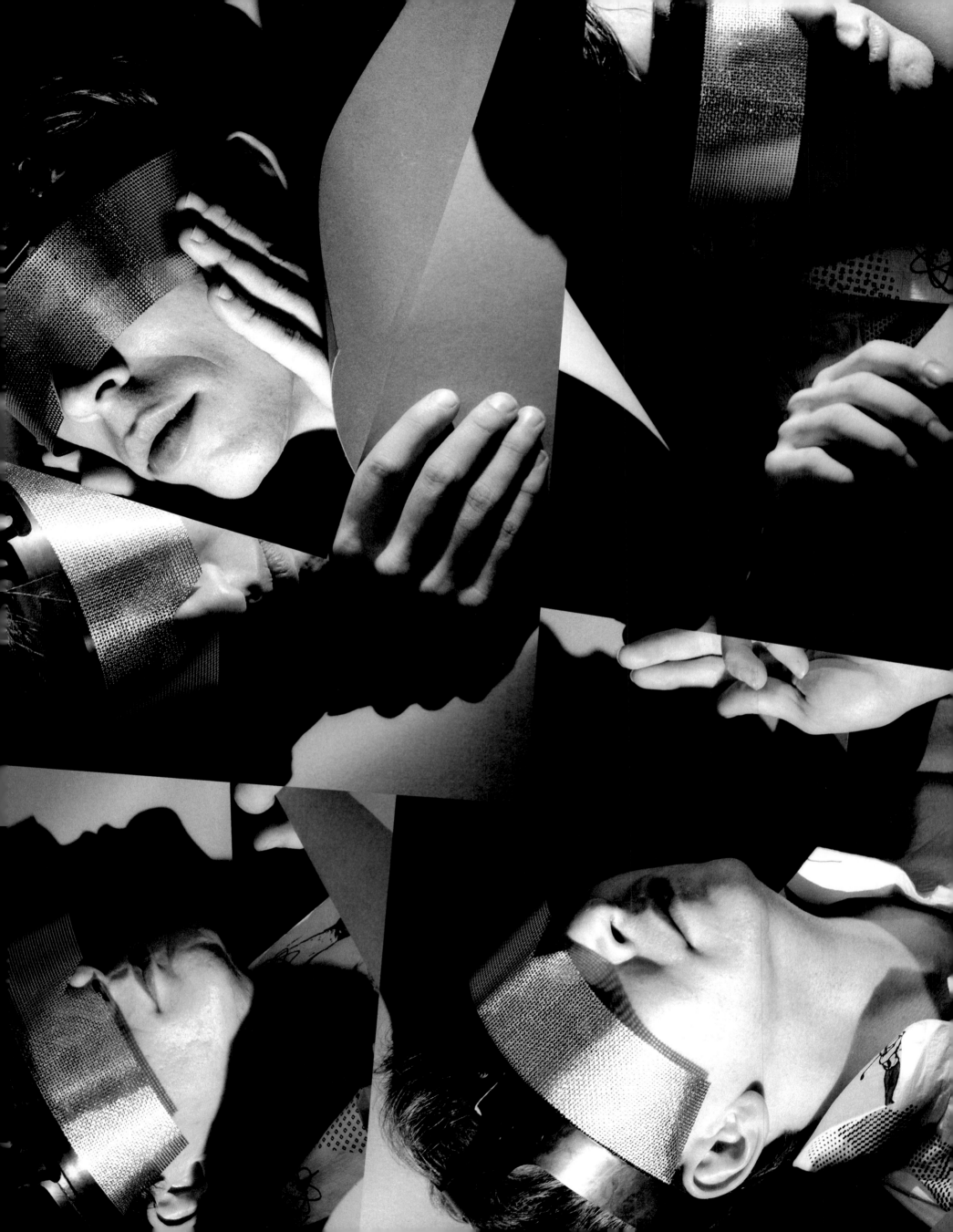

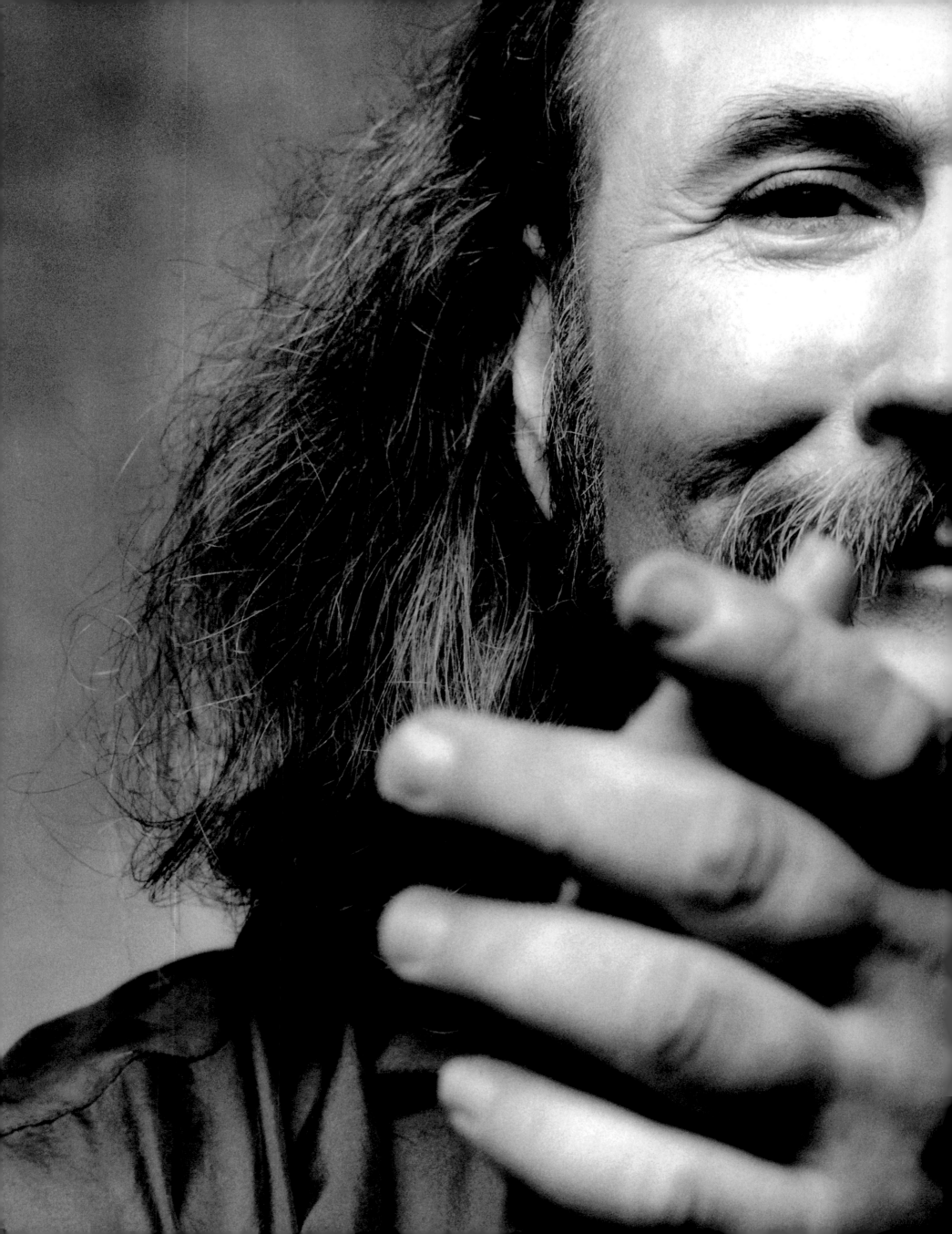

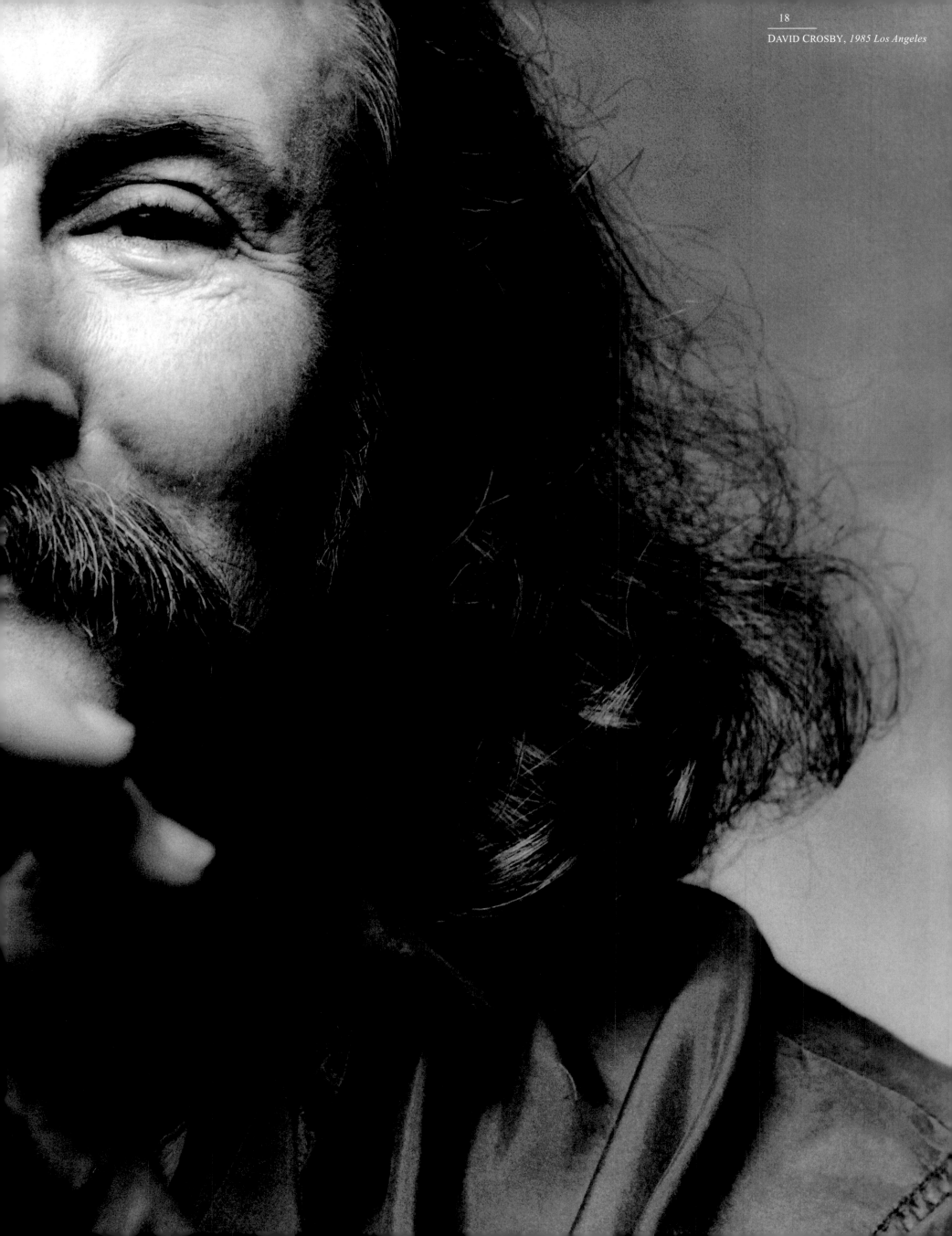

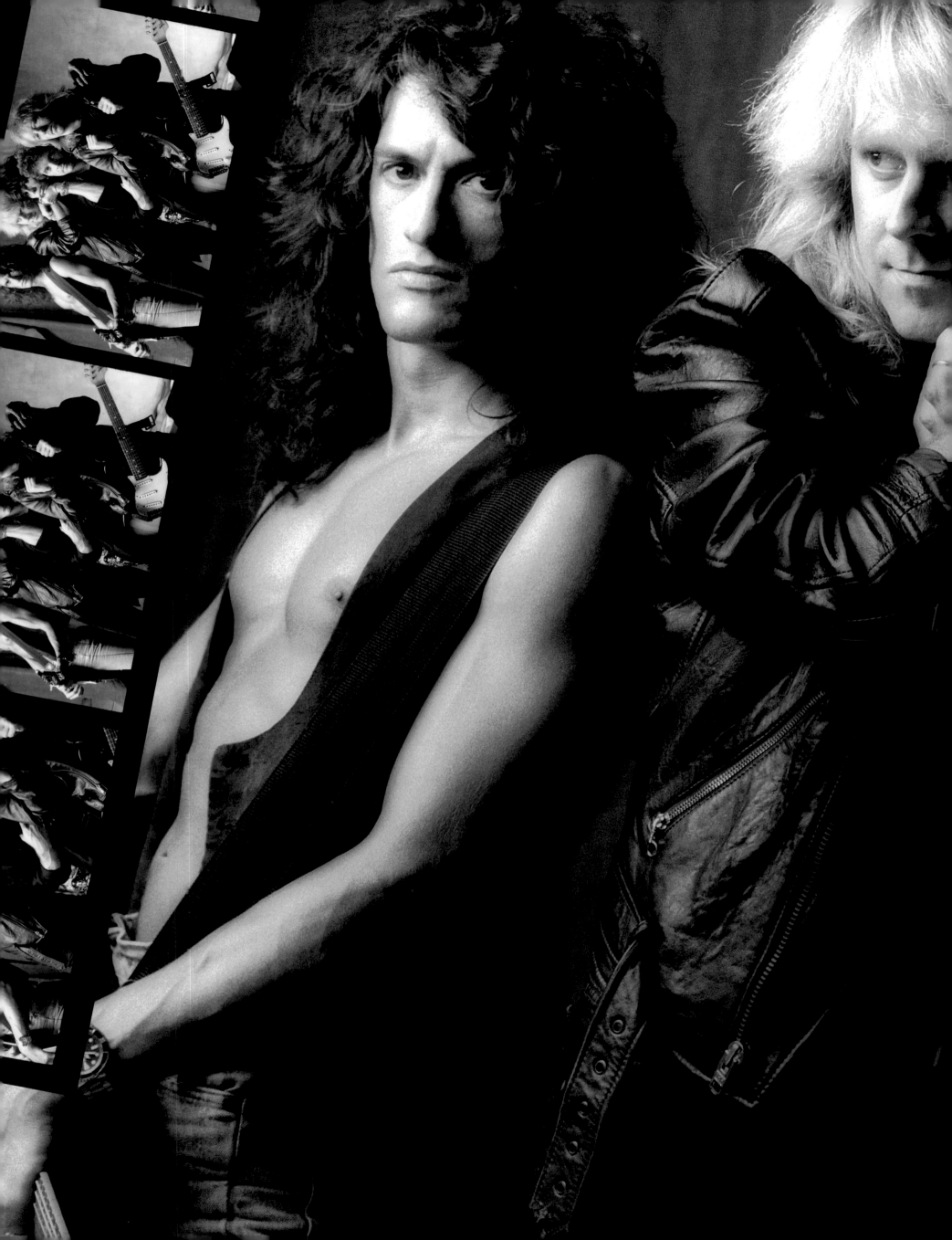

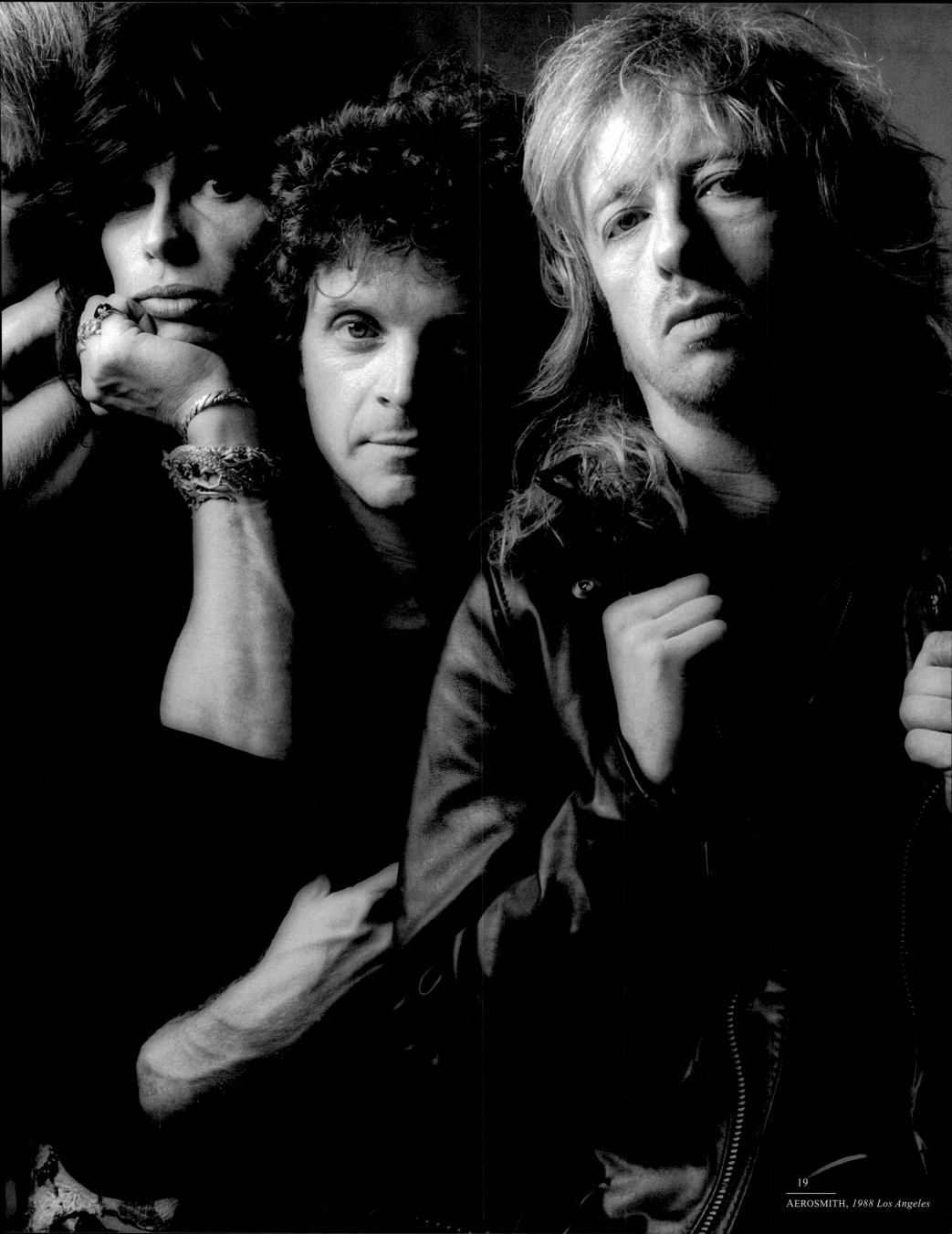

19

AEROSMITH, *1988 Los Angeles*

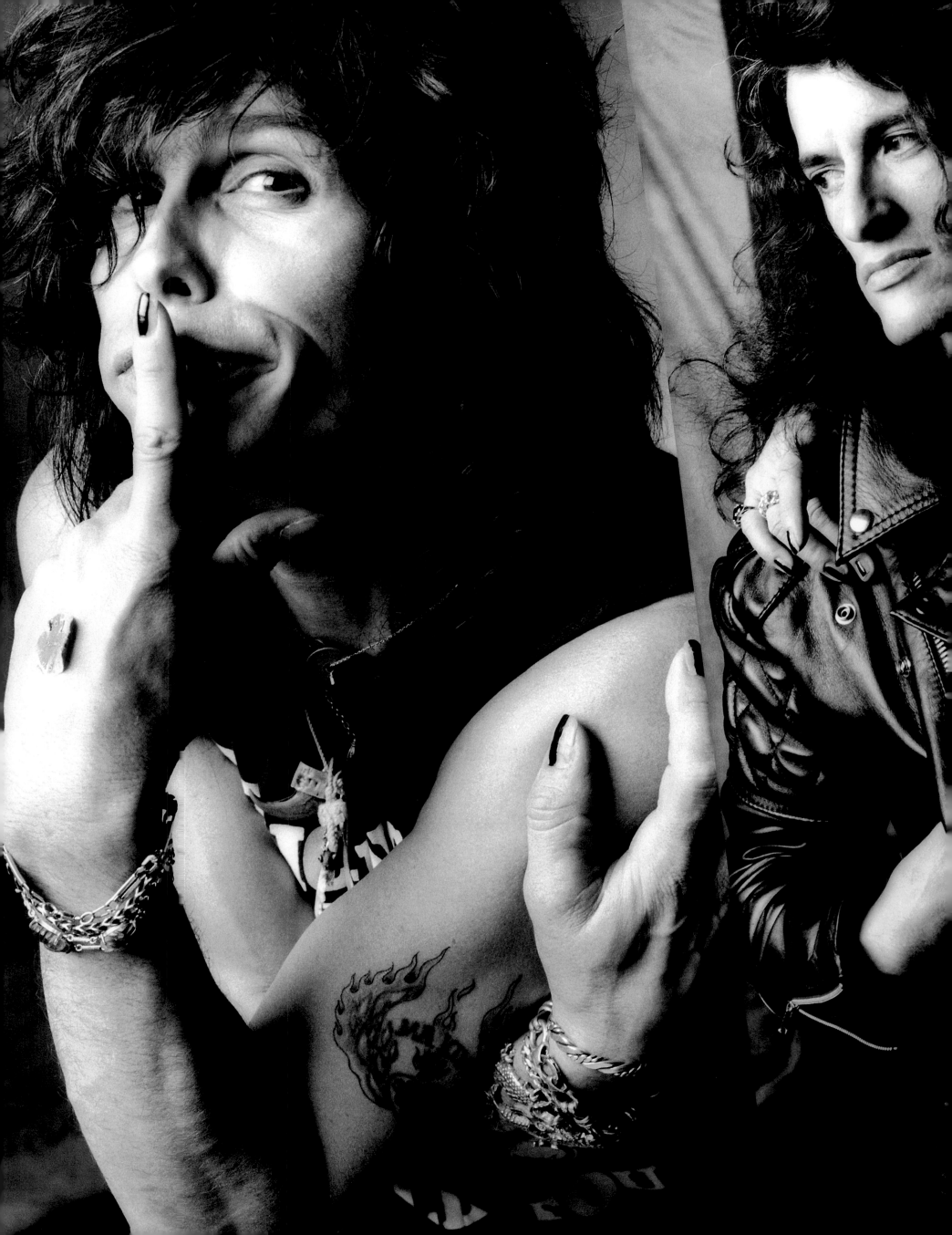

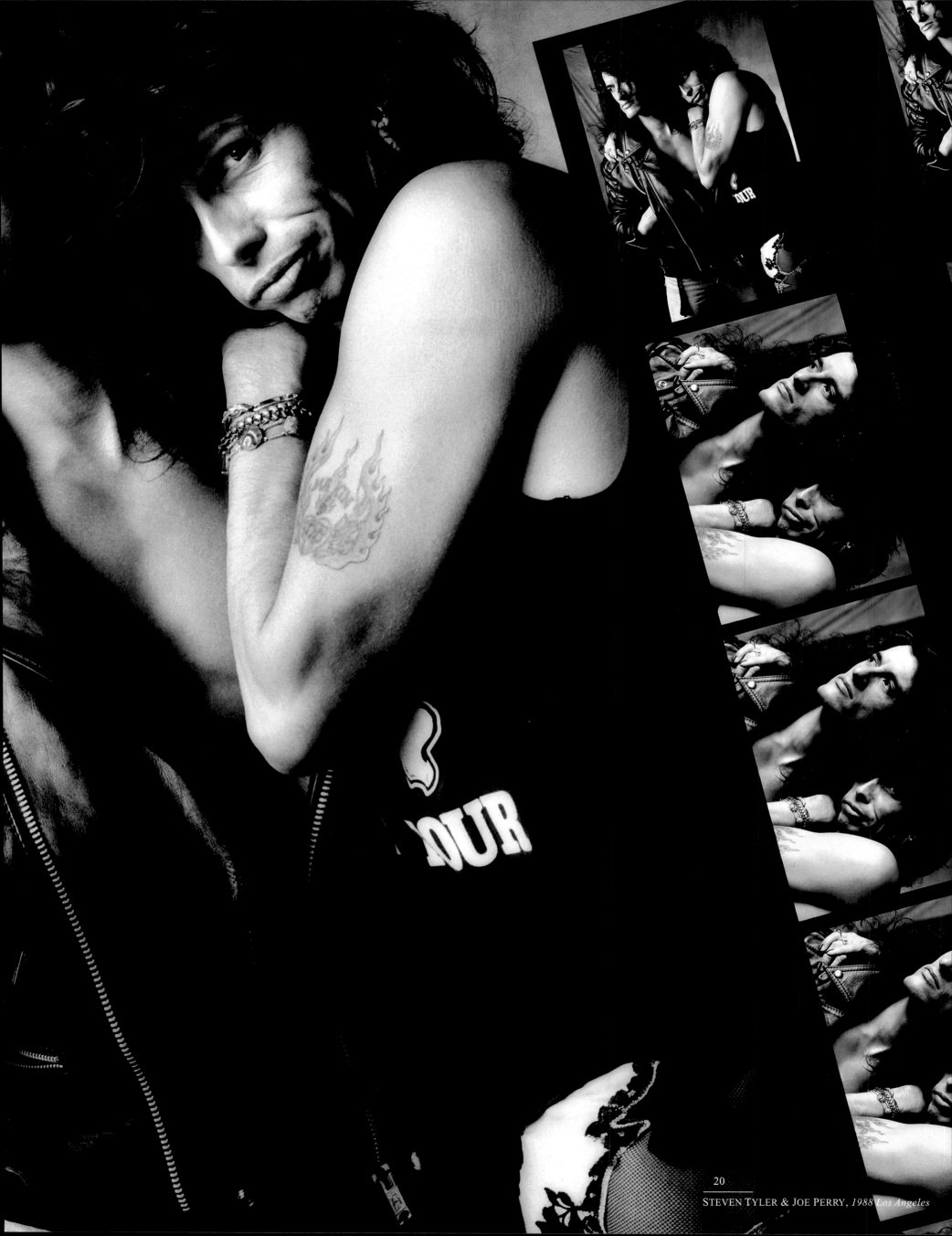

20

STEVEN TYLER & JOE PERRY, *1988 Los Angeles*

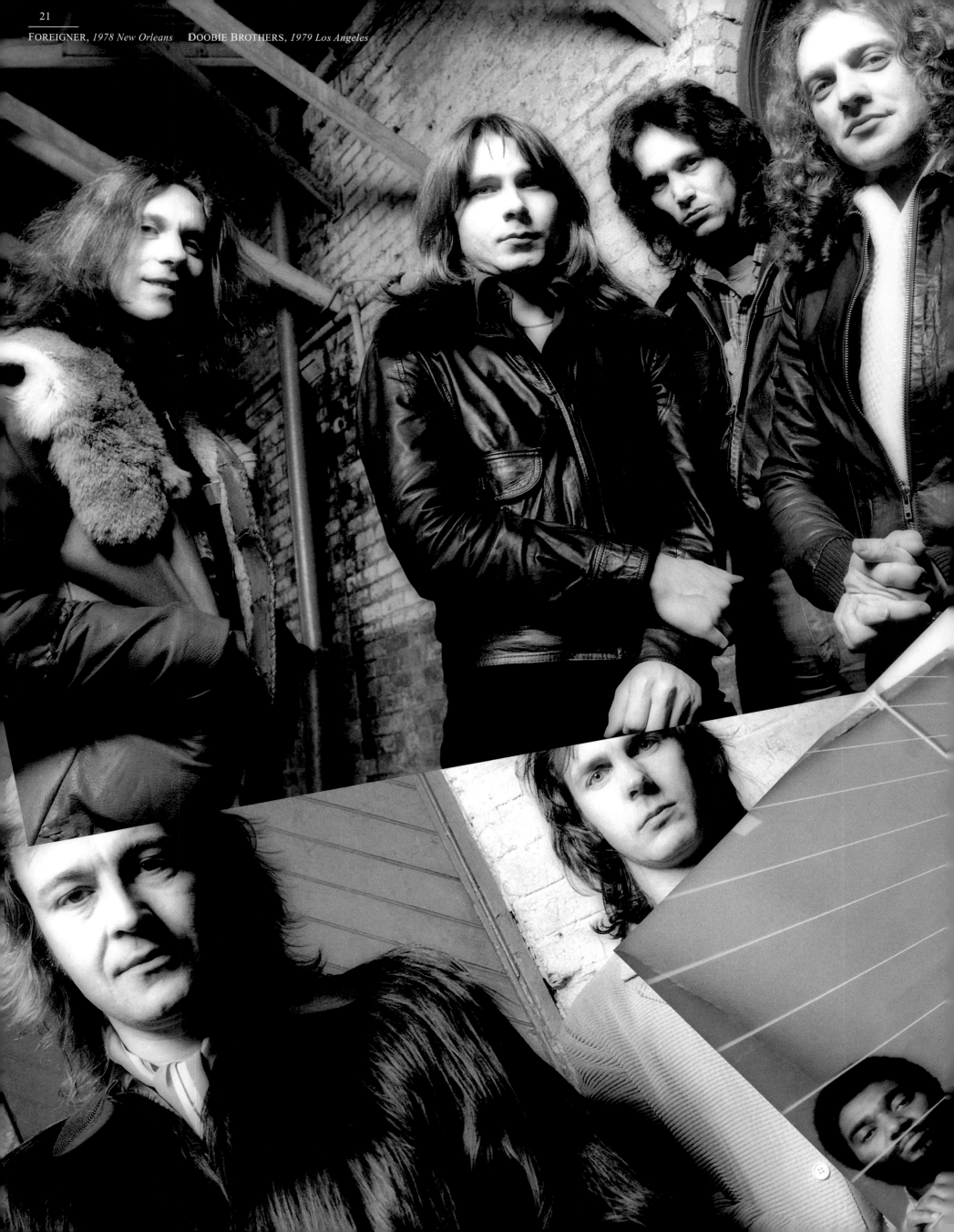

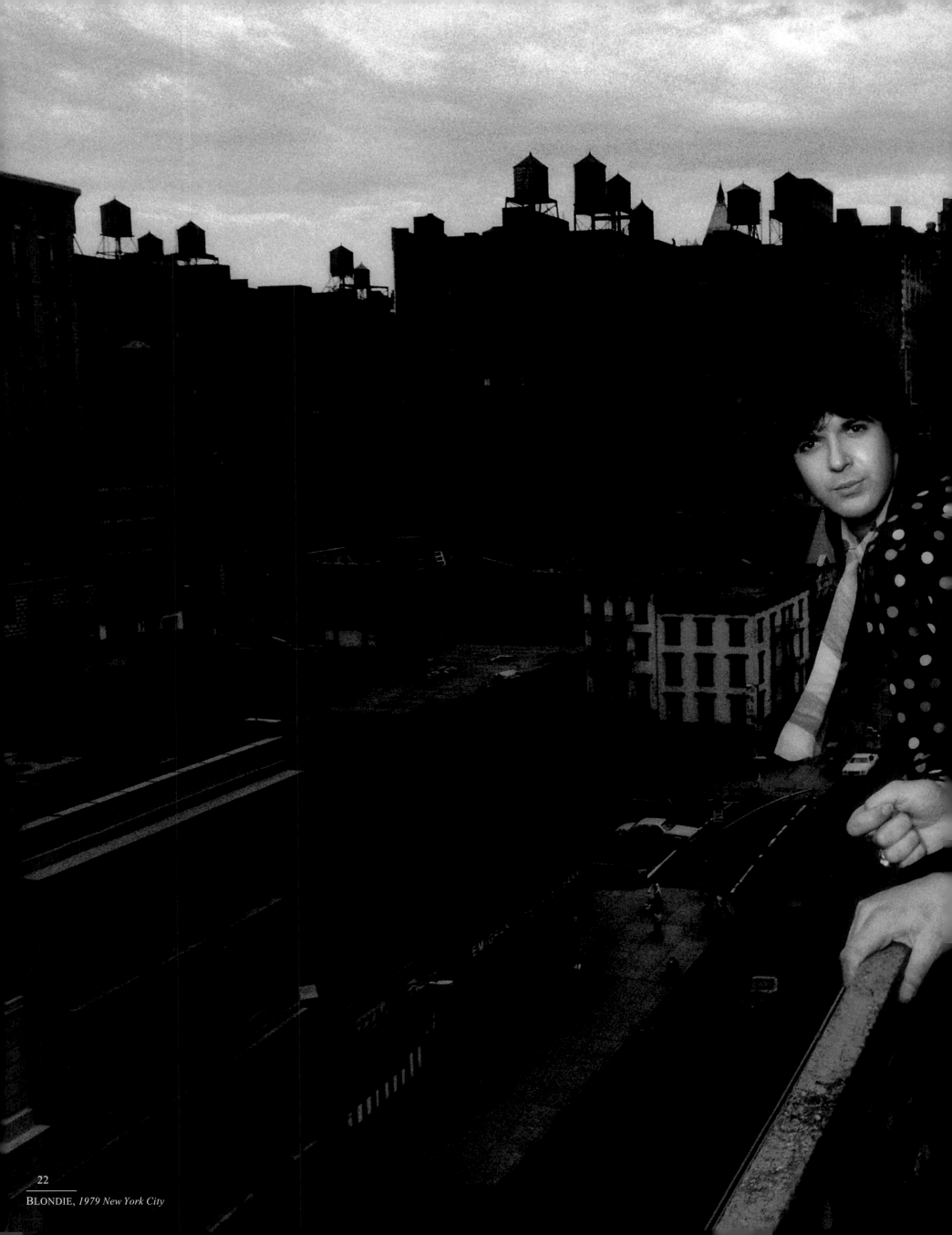

BLONDIE, *1979 New York City*

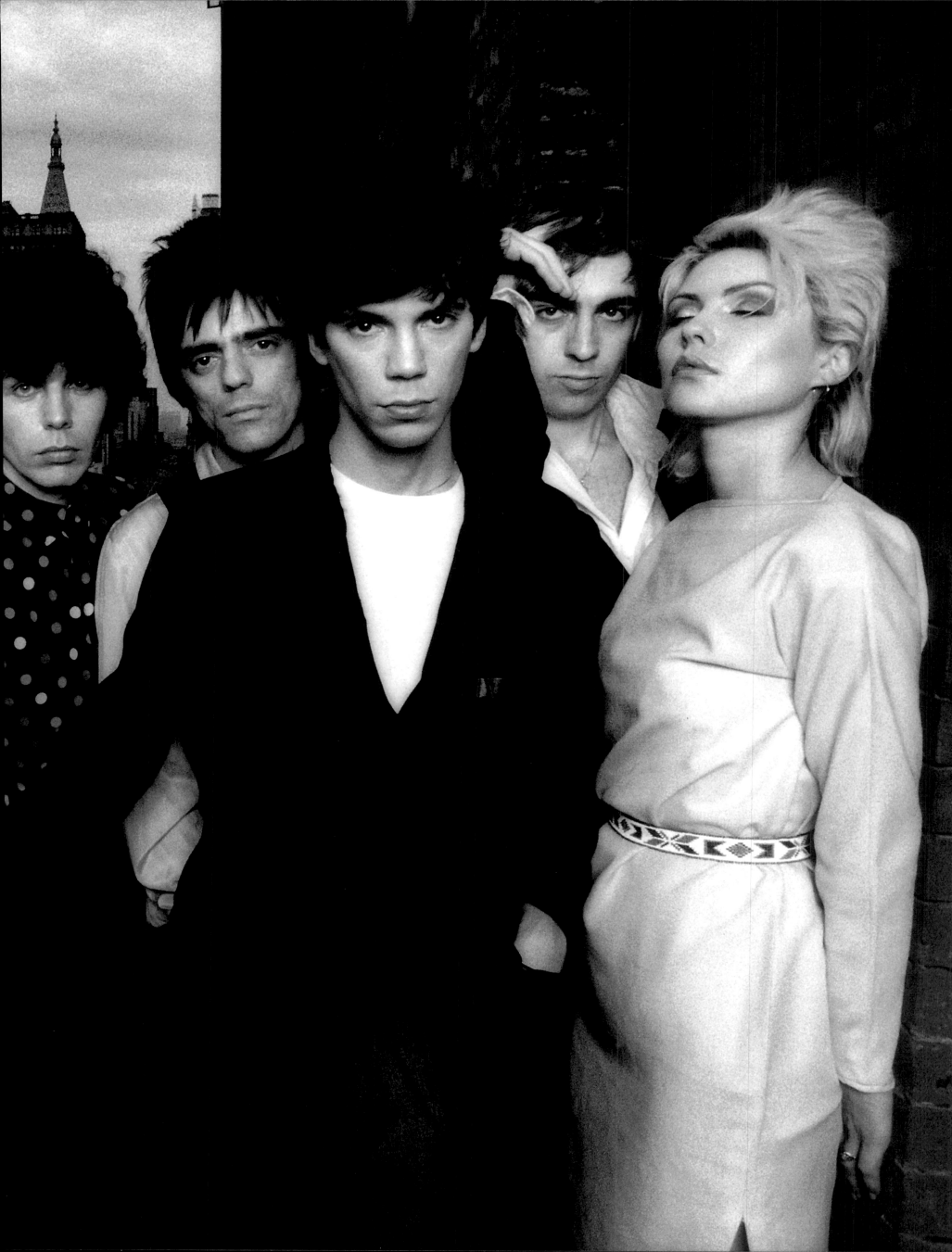

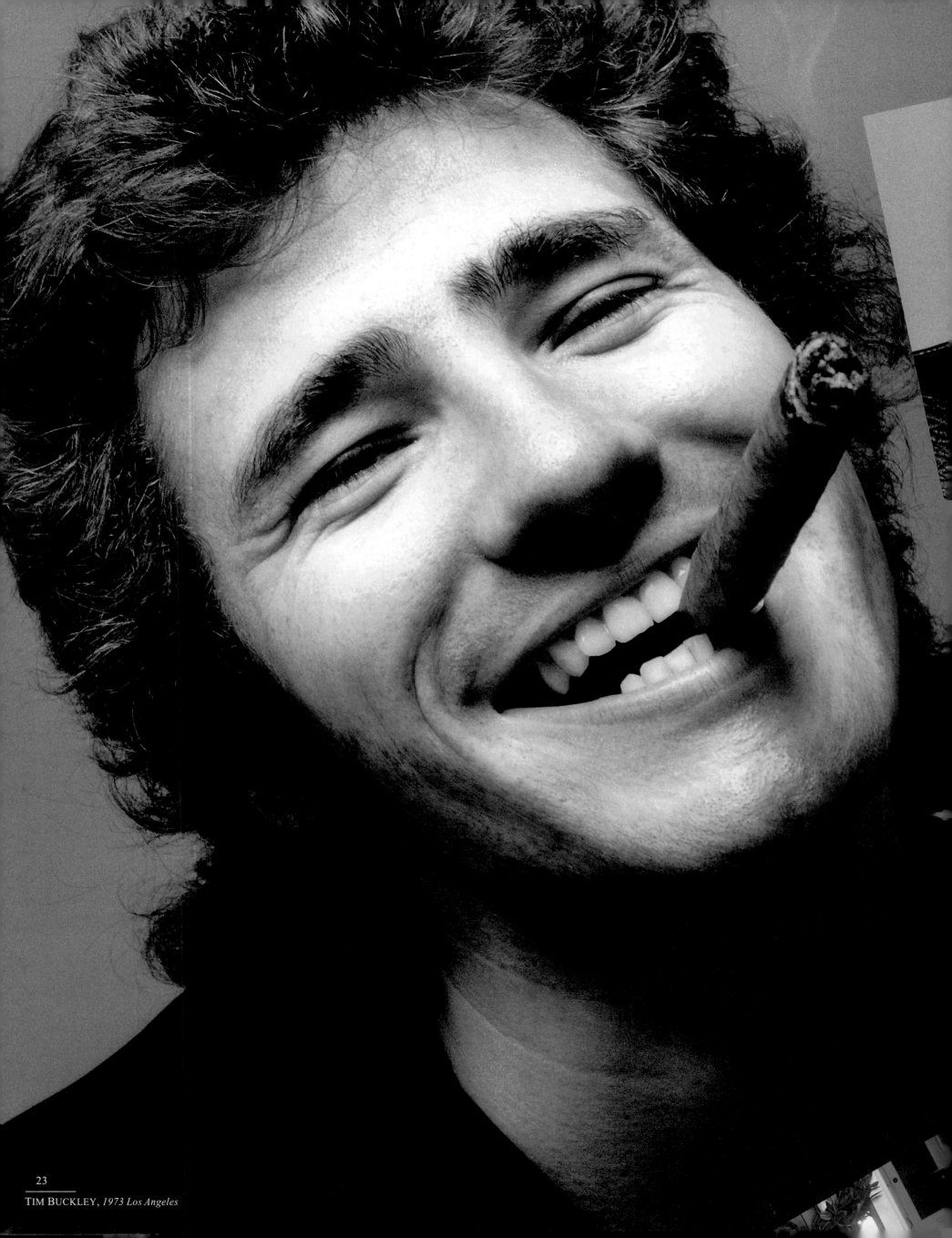

23

TIM BUCKLEY, *1973 Los Angeles*

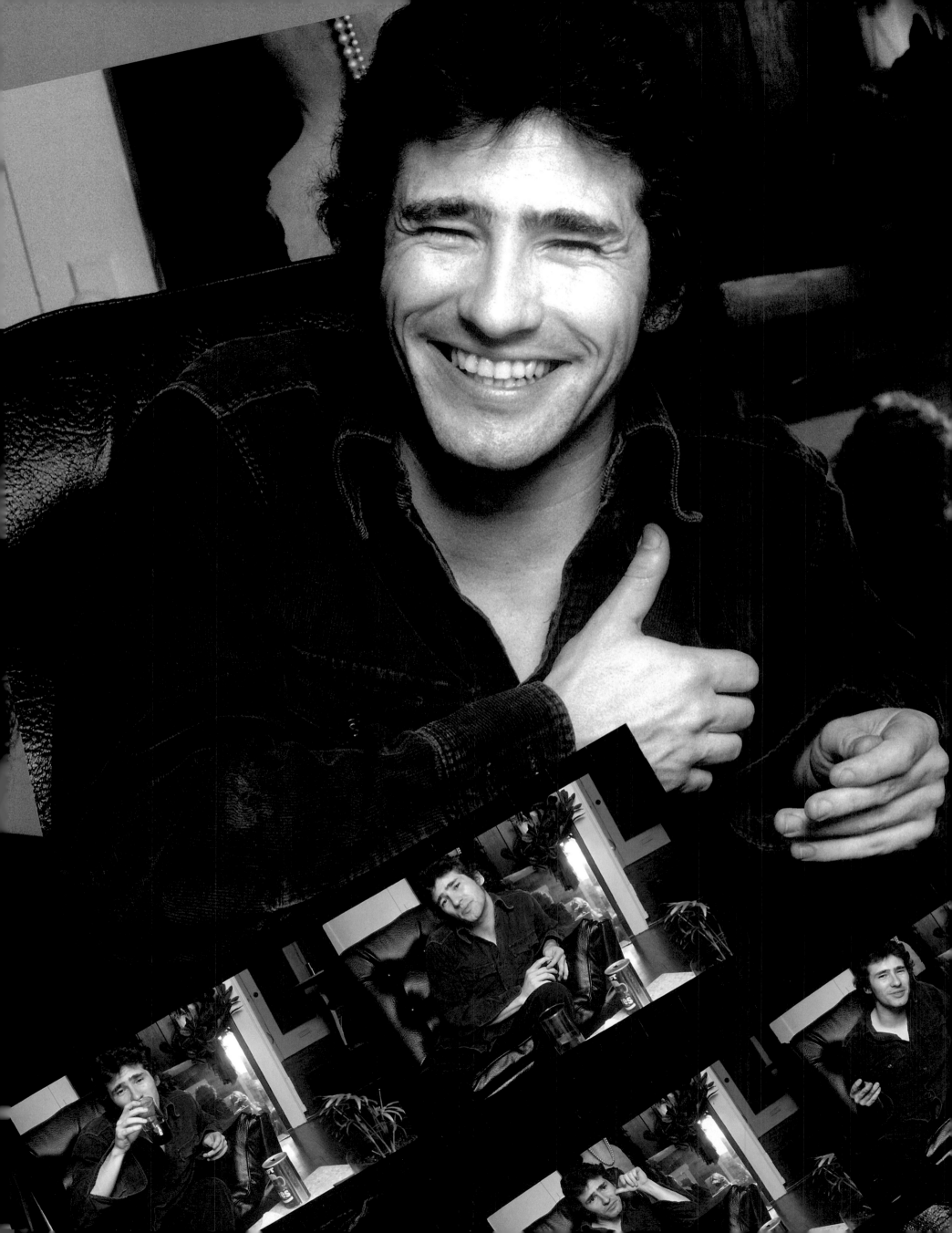

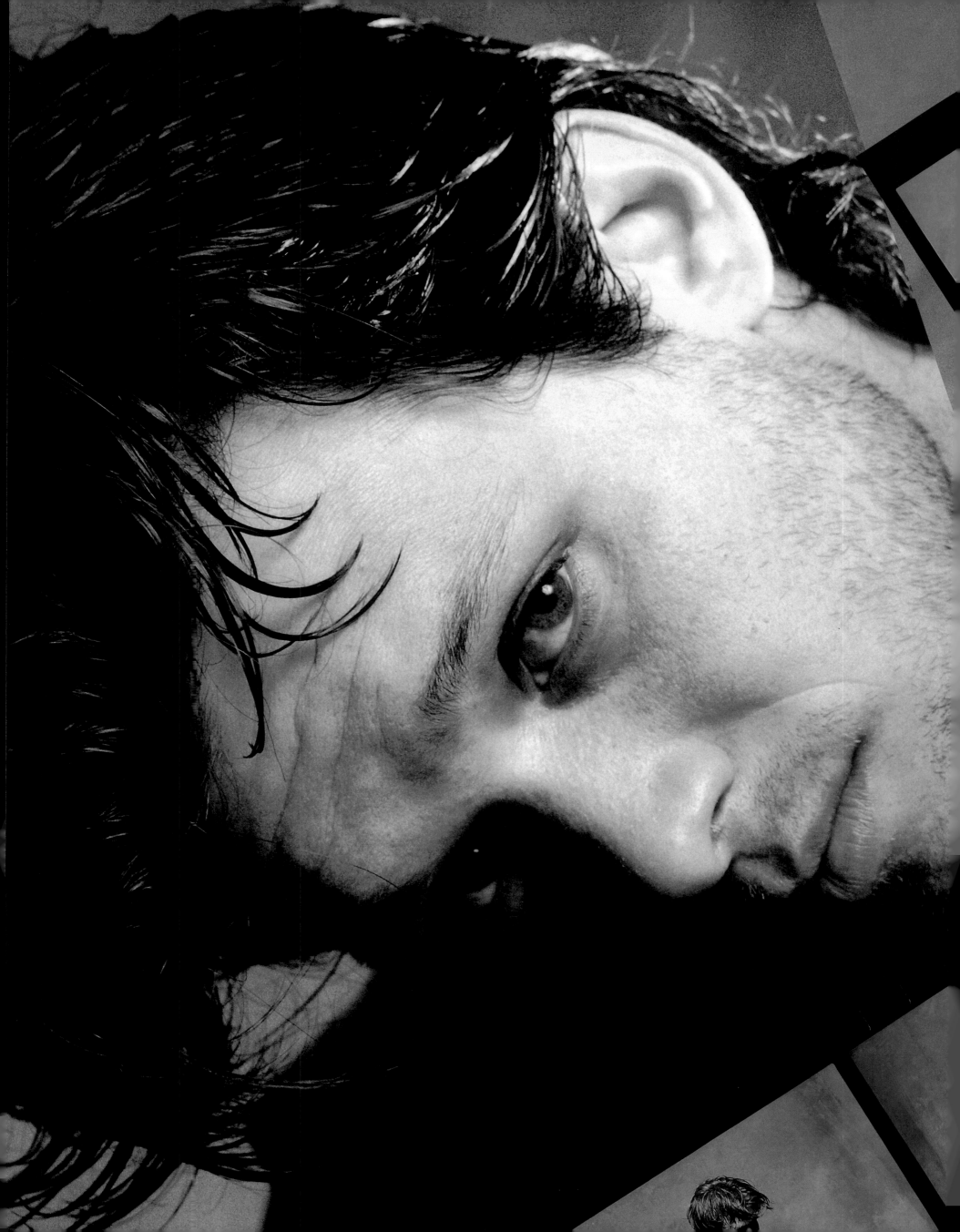

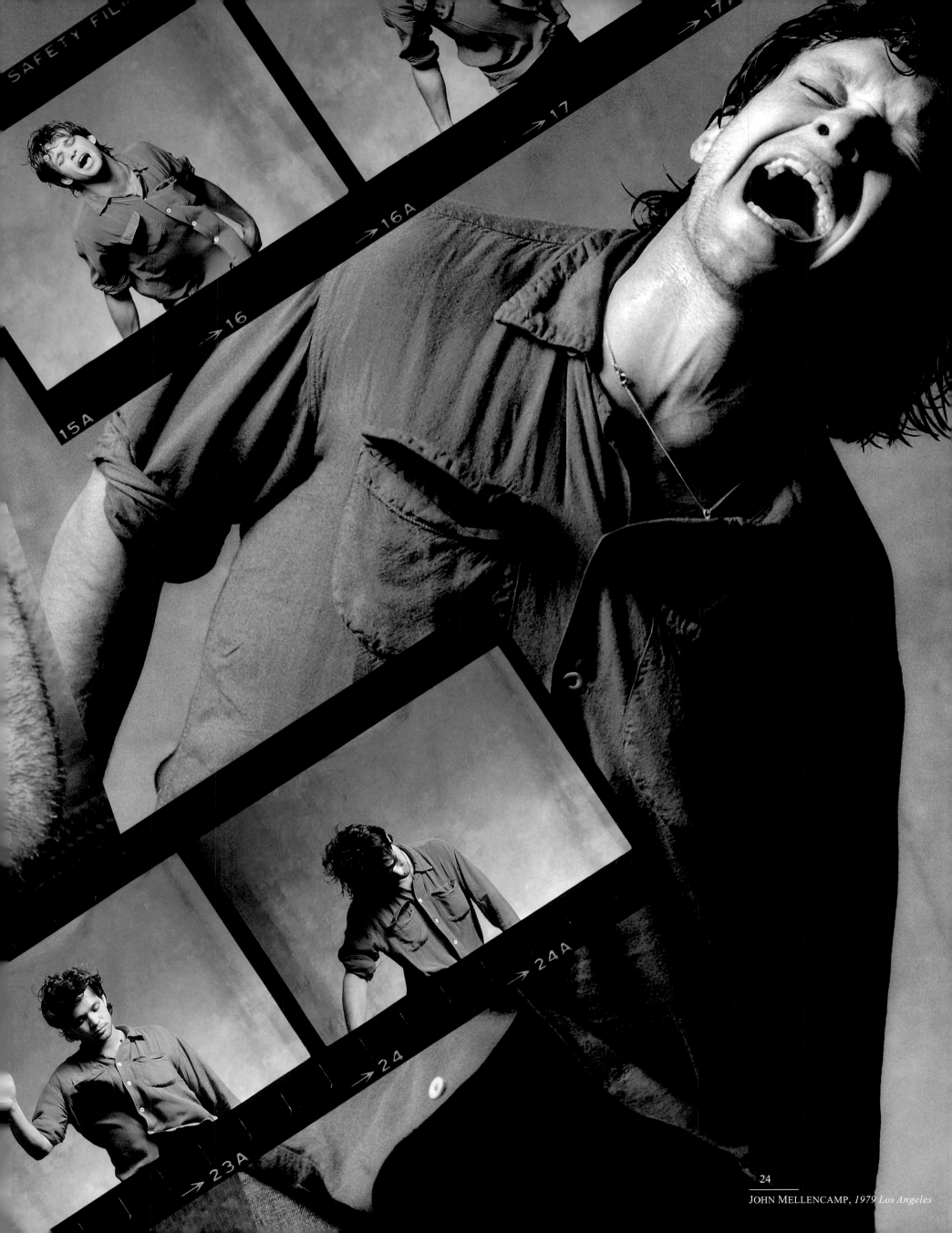

JOHN MELLENCAMP, *1979 Los Angeles*

24

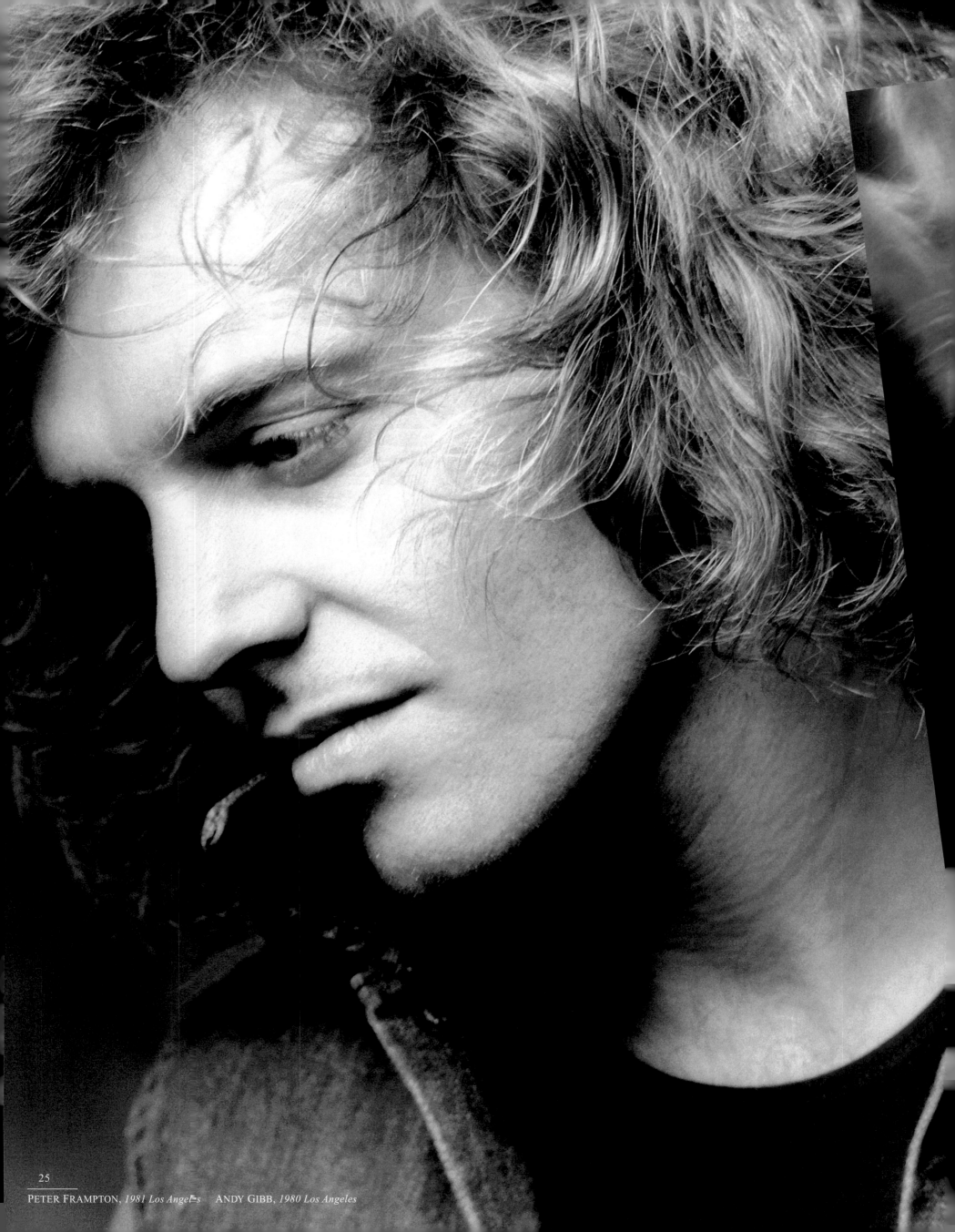

PETER FRAMPTON, *1981 Los Angeles* · ANDY GIBB, *1980 Los Angeles*

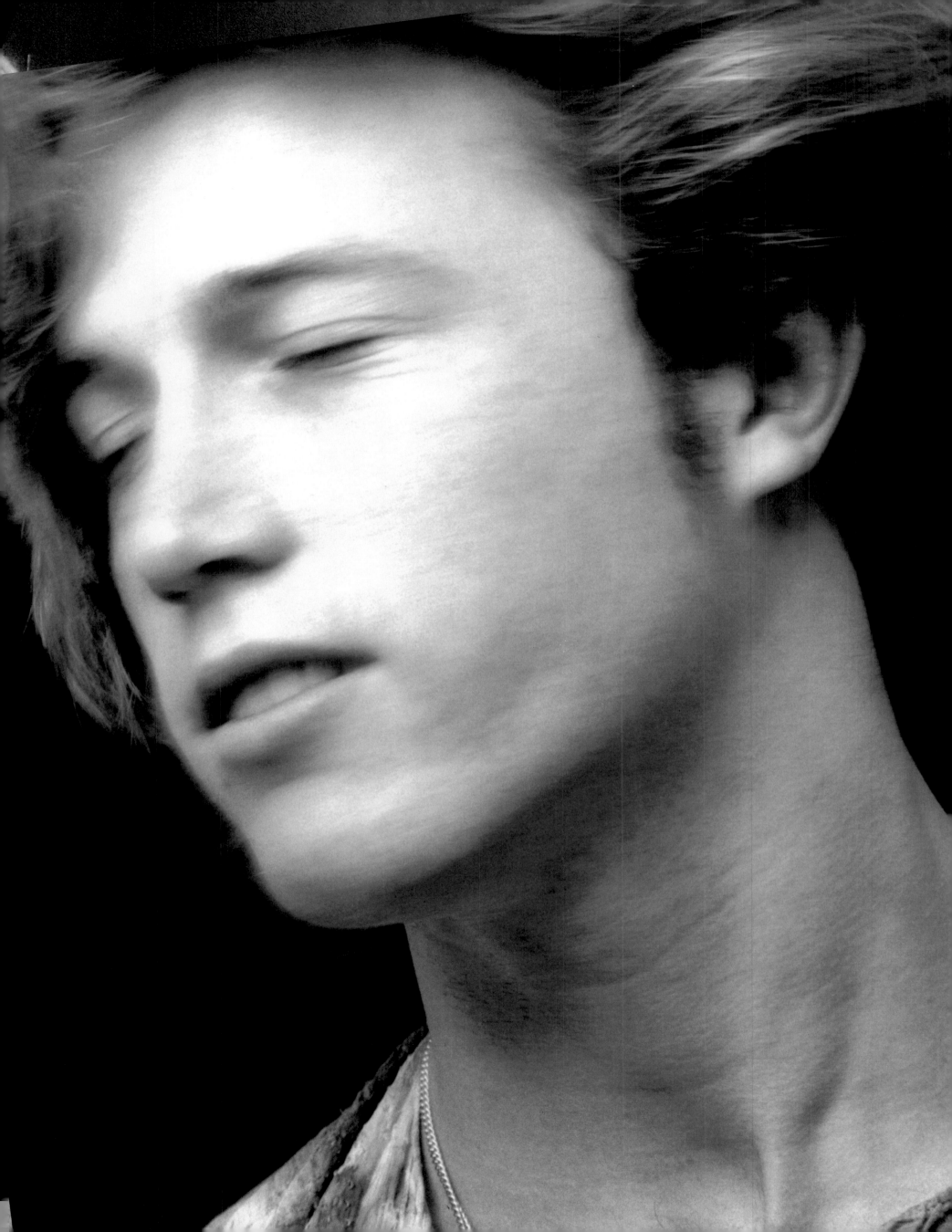

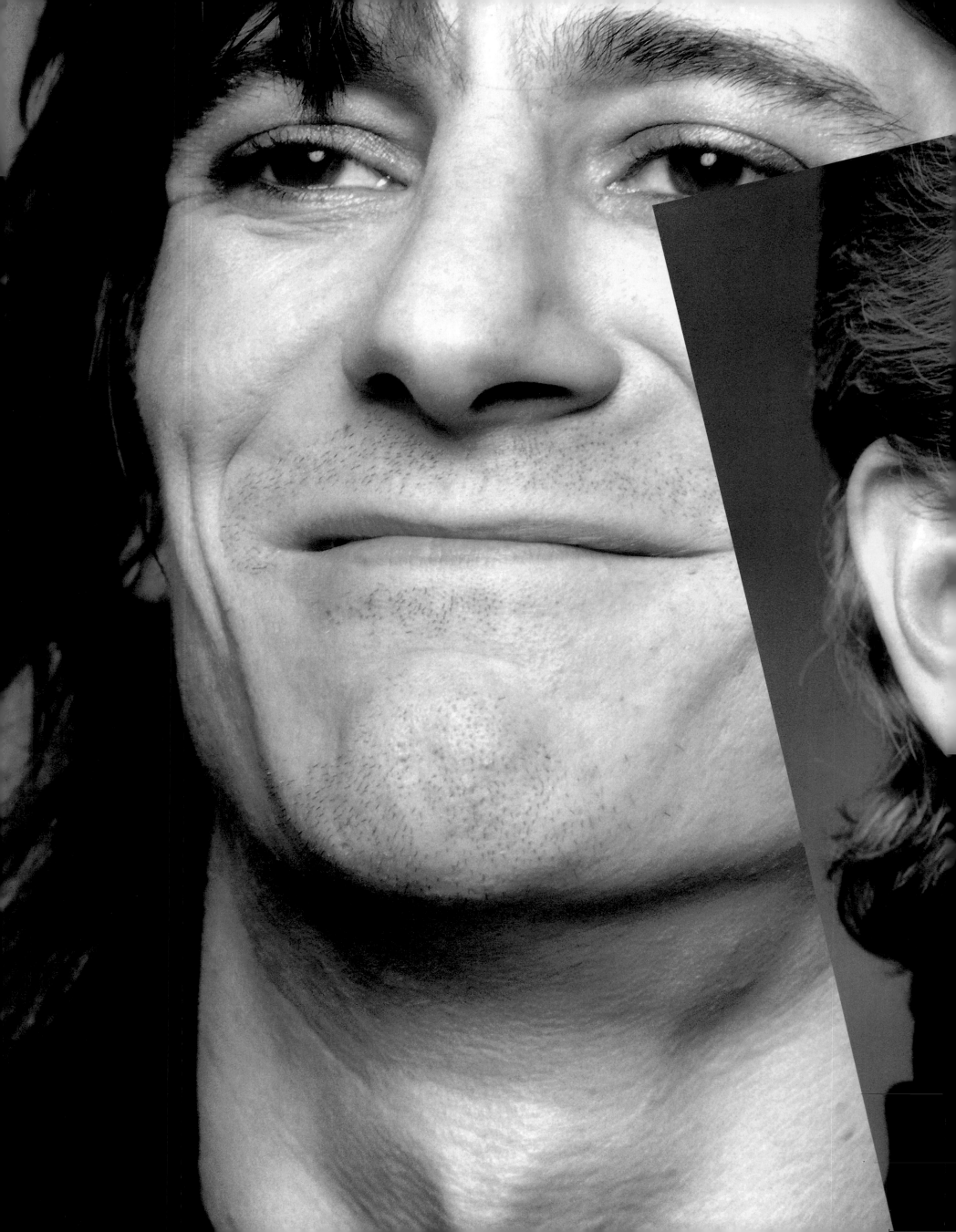

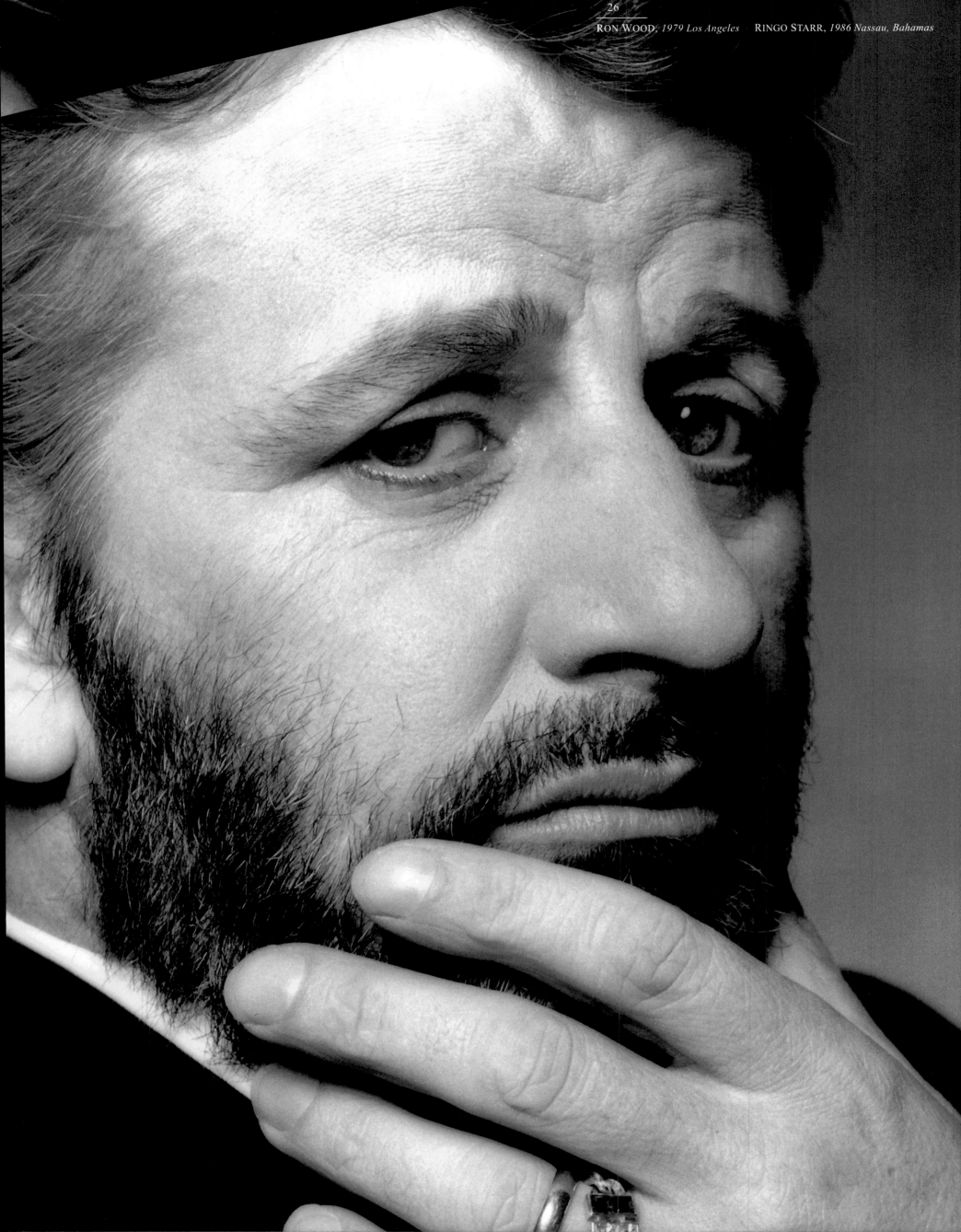

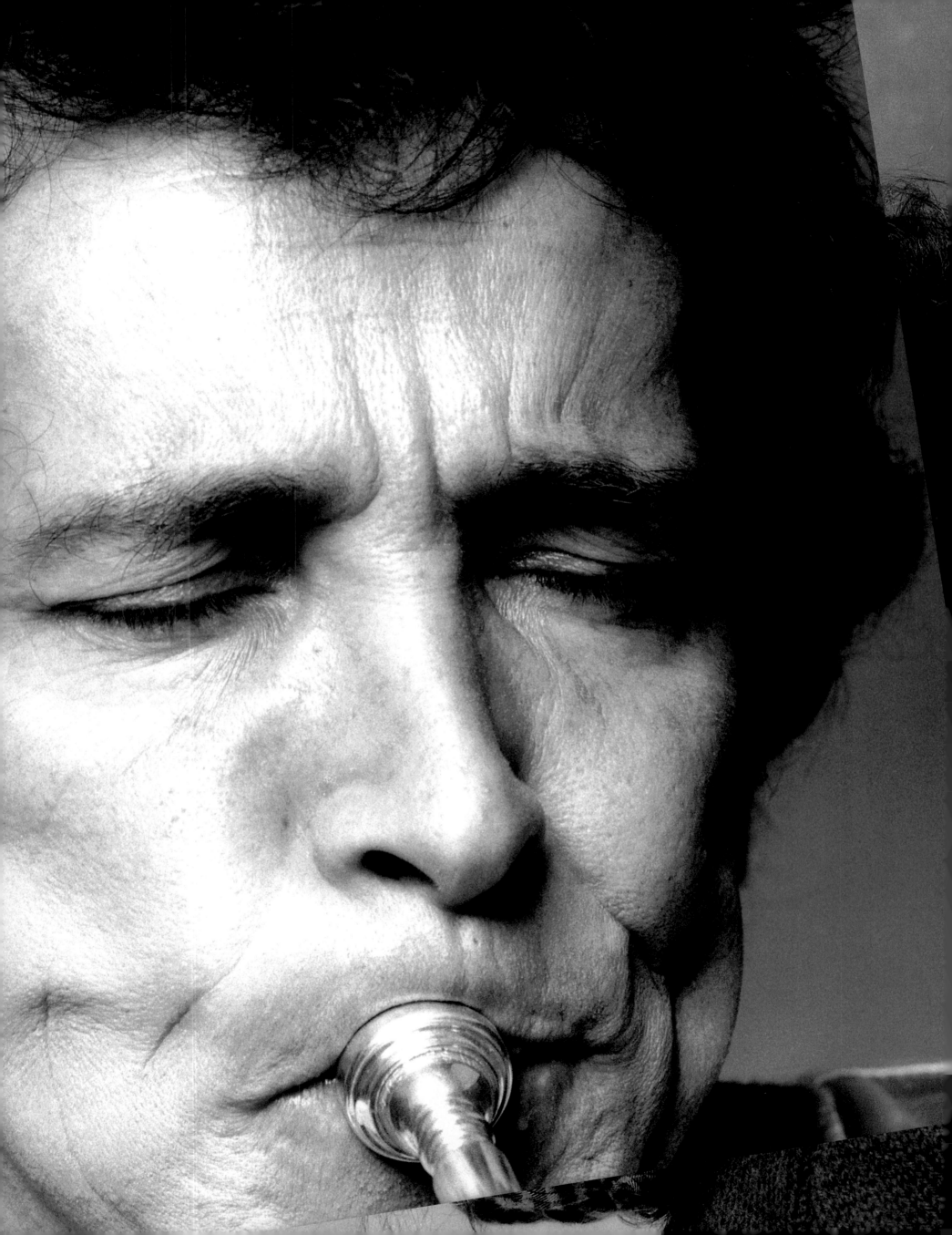

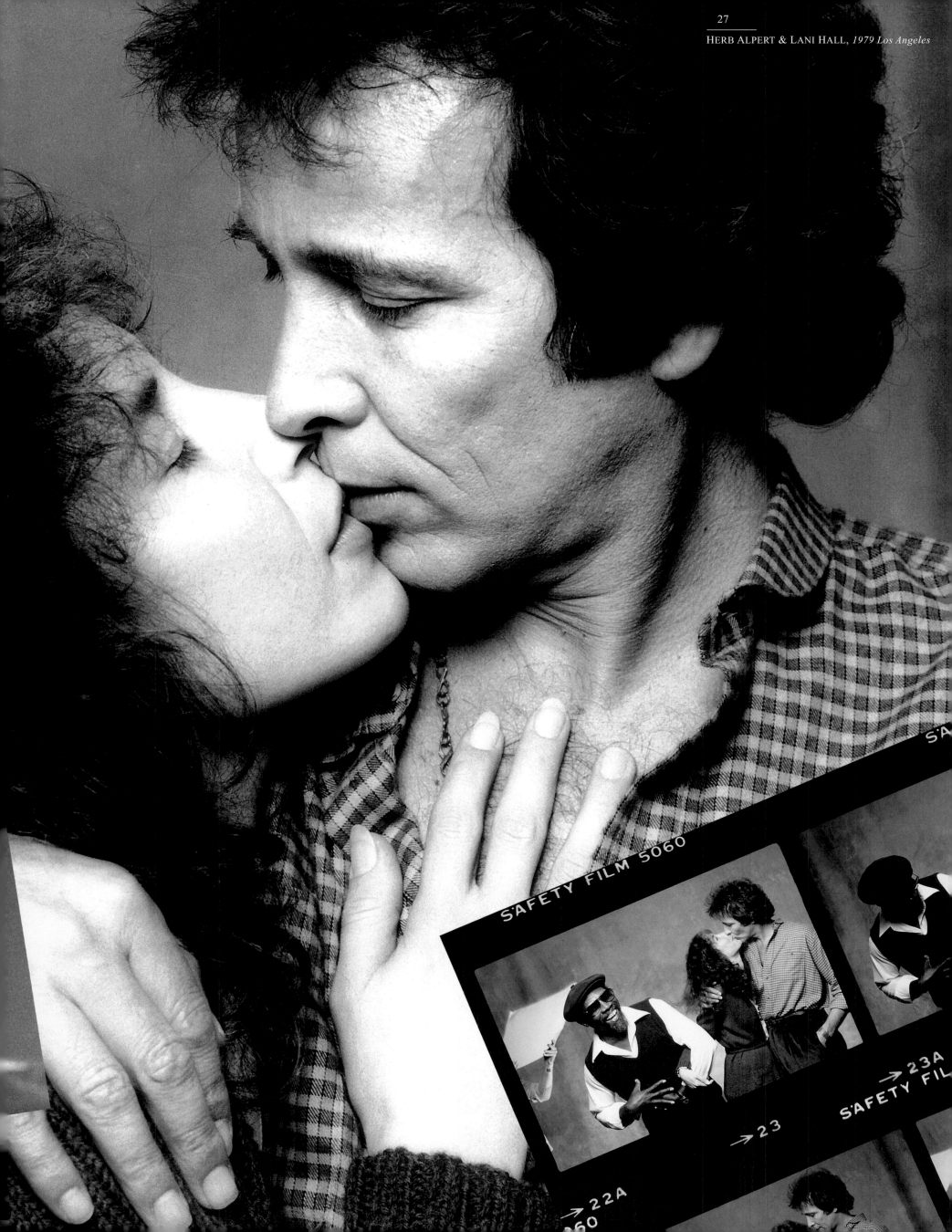

+'JUSTMENTS

BILL WITHERS

Life like most precious gifts that come with the responsibility of upkeep. We each have the responsibility of arranging our own pieces to best benefit our survival. We have a choice of believing or not believing in things like God, friendship, marriage love, lust or any number of simple but complicated things. We will make some mistakes both in judgement and in fact. We will help some situations and hurt some situations. We will help some people and hurt some people and be left to live with it either way. We must then make some adjustments or as the old people back home would call them... "'JUSTMENTS."

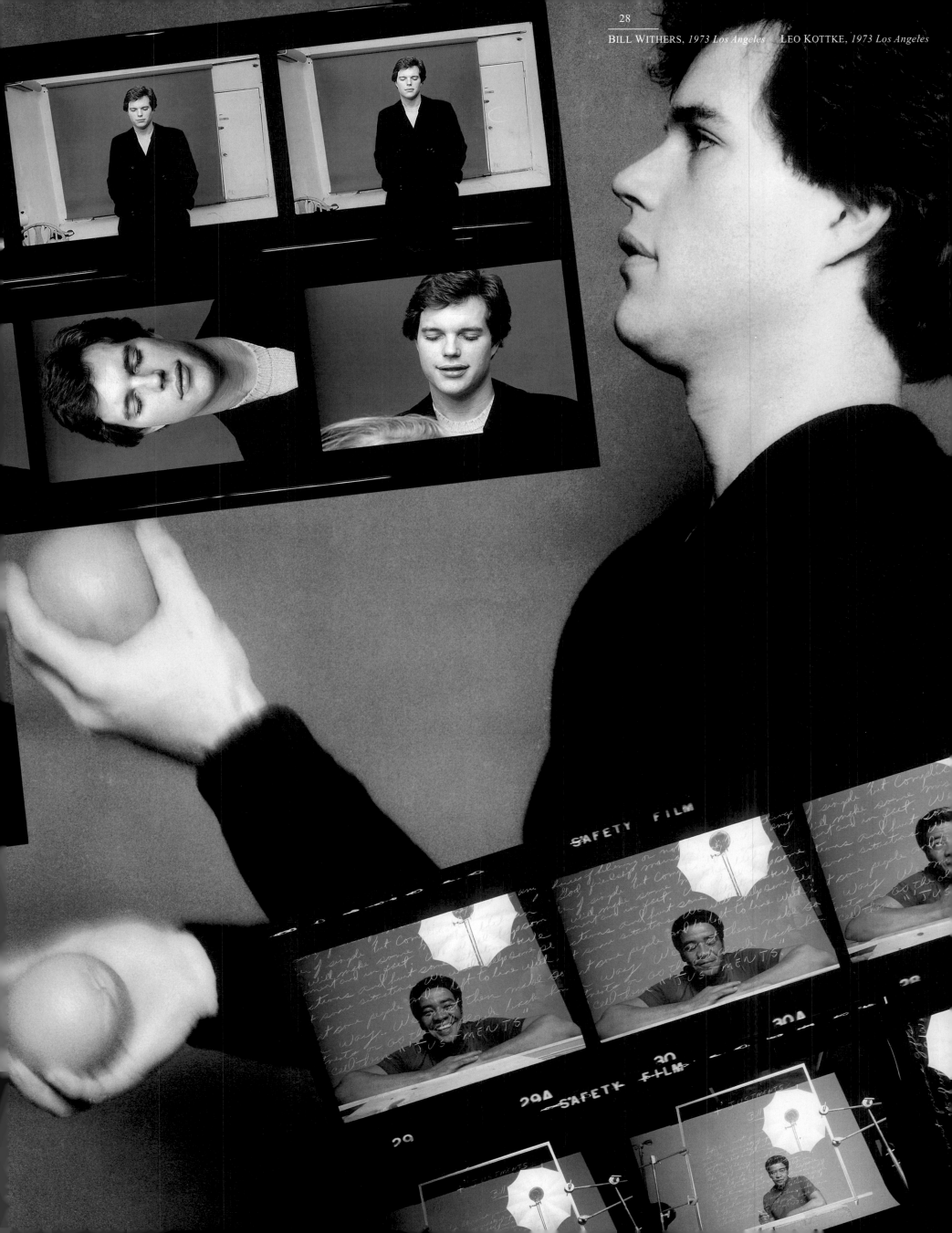

POINTER SISTERS, *1982 Los Angeles*

→8

→8A →9 →9A →10
SAFETY FILM 5060 SAFET

M 5060

3A →14 →14A →15 →15A →

SAFETY FILM 5060

→19A →20 →20A
SAFETY FILM 5060 SAFETY FILM 5060

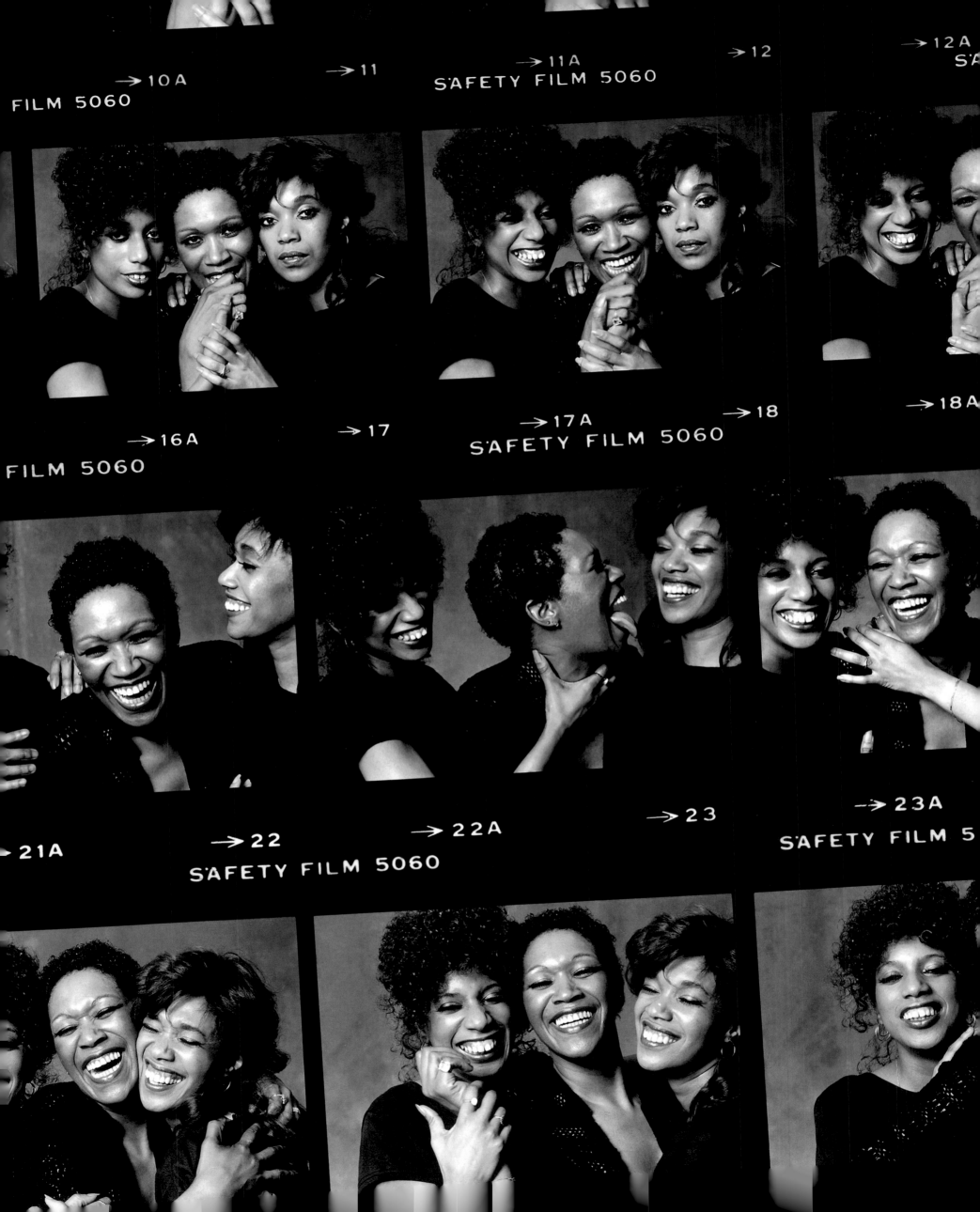

POINTER SISTERS, *1993 Los Angeles*

2 TMX

20

5052 TMX

21

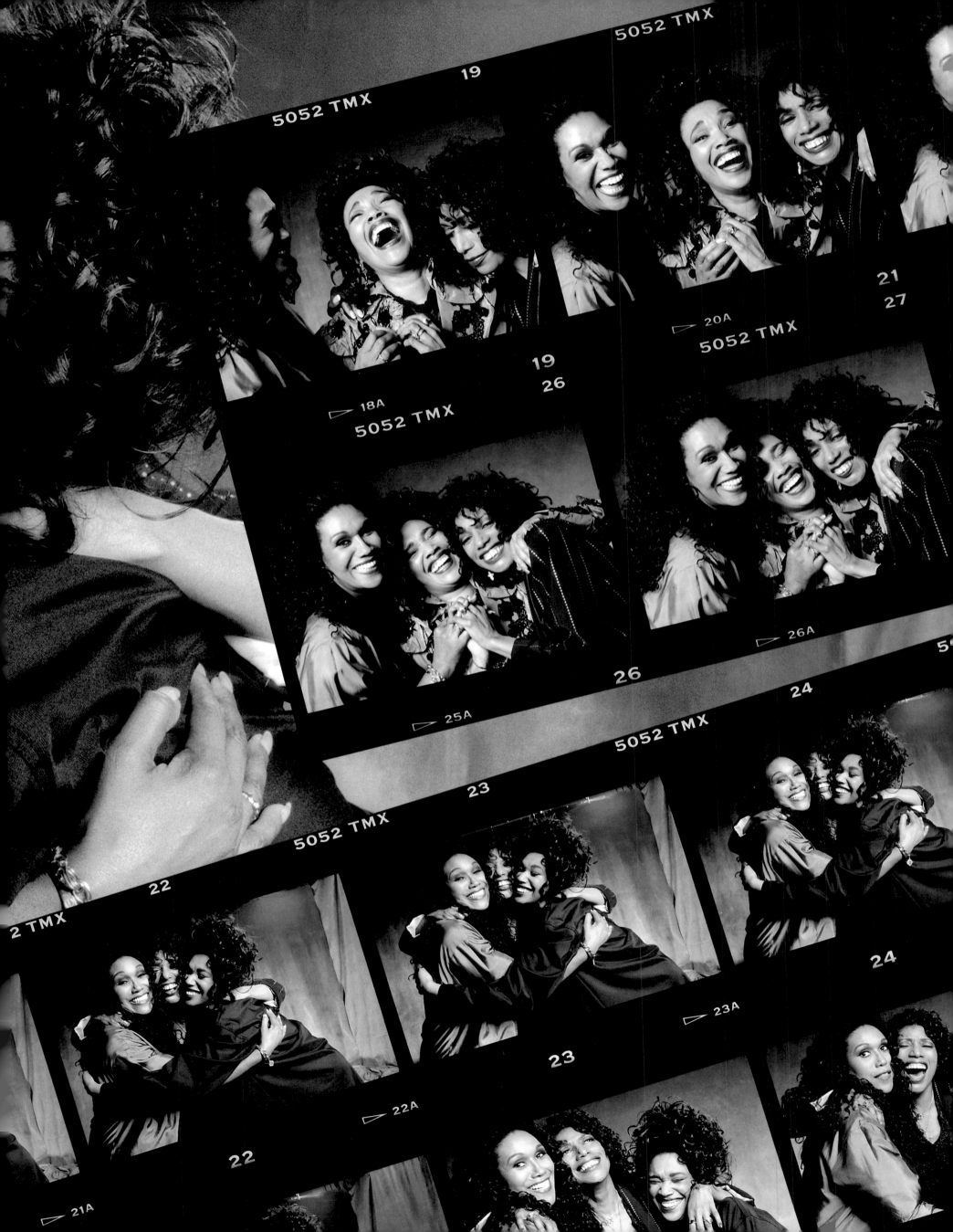

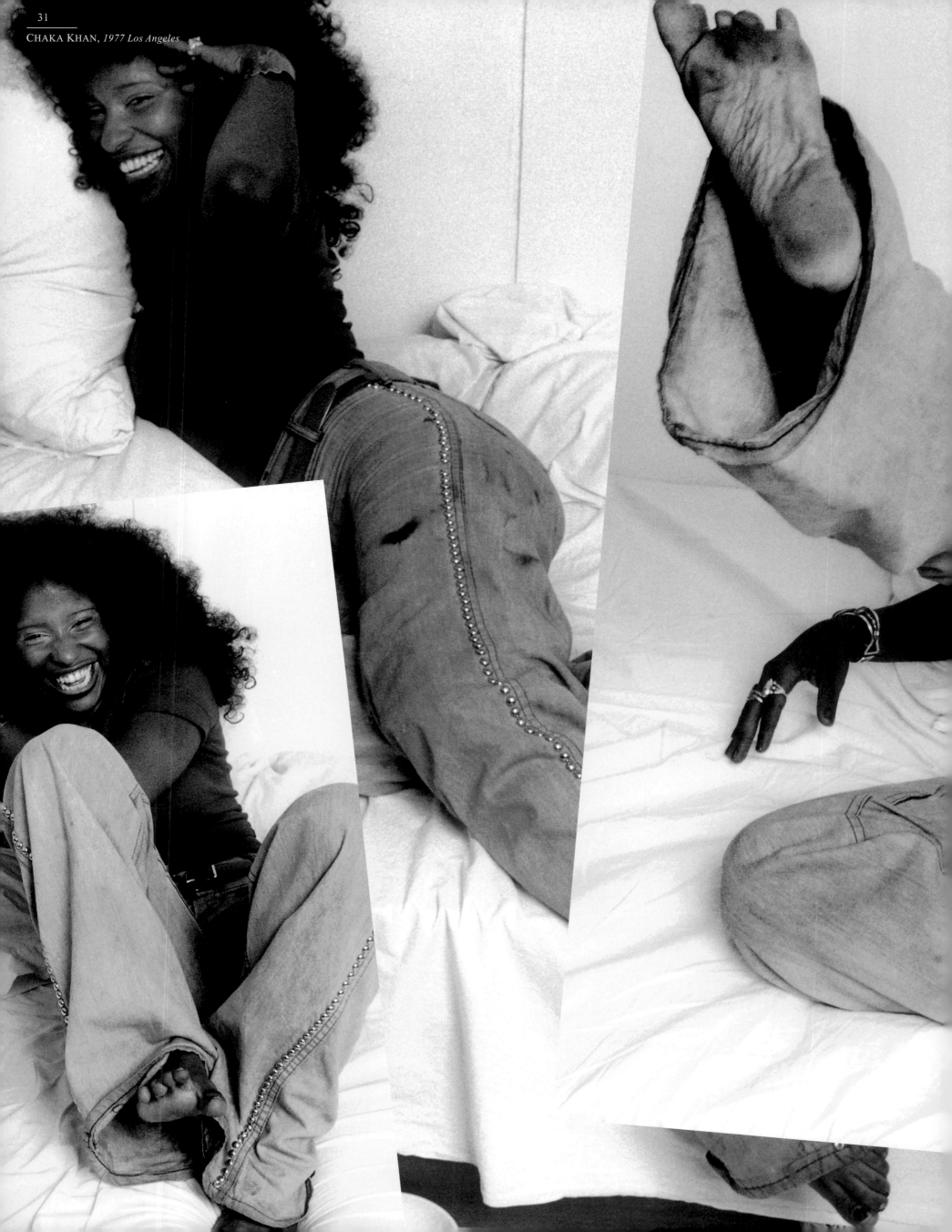

CHAKA KHAN, *1977 Los Angeles*

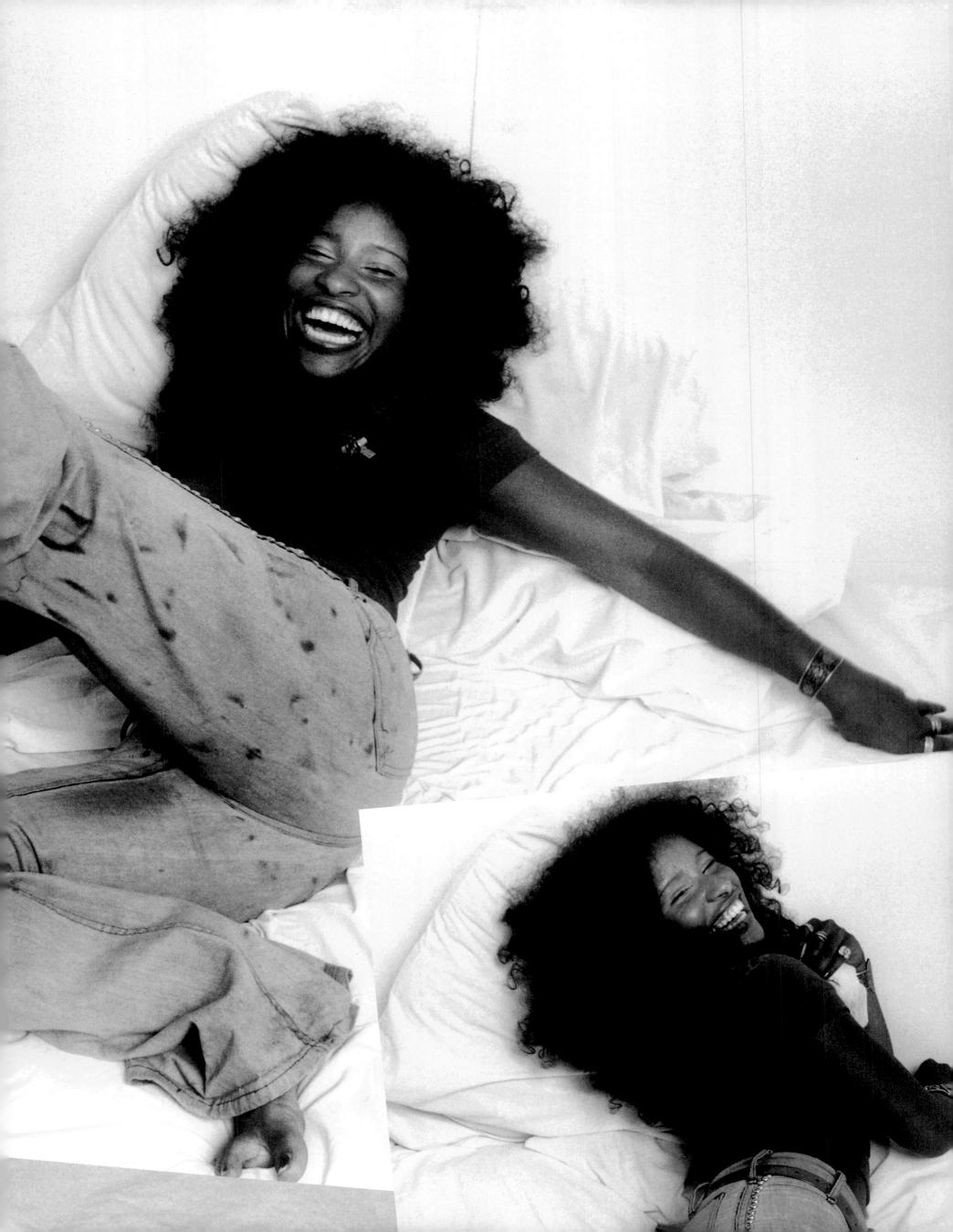

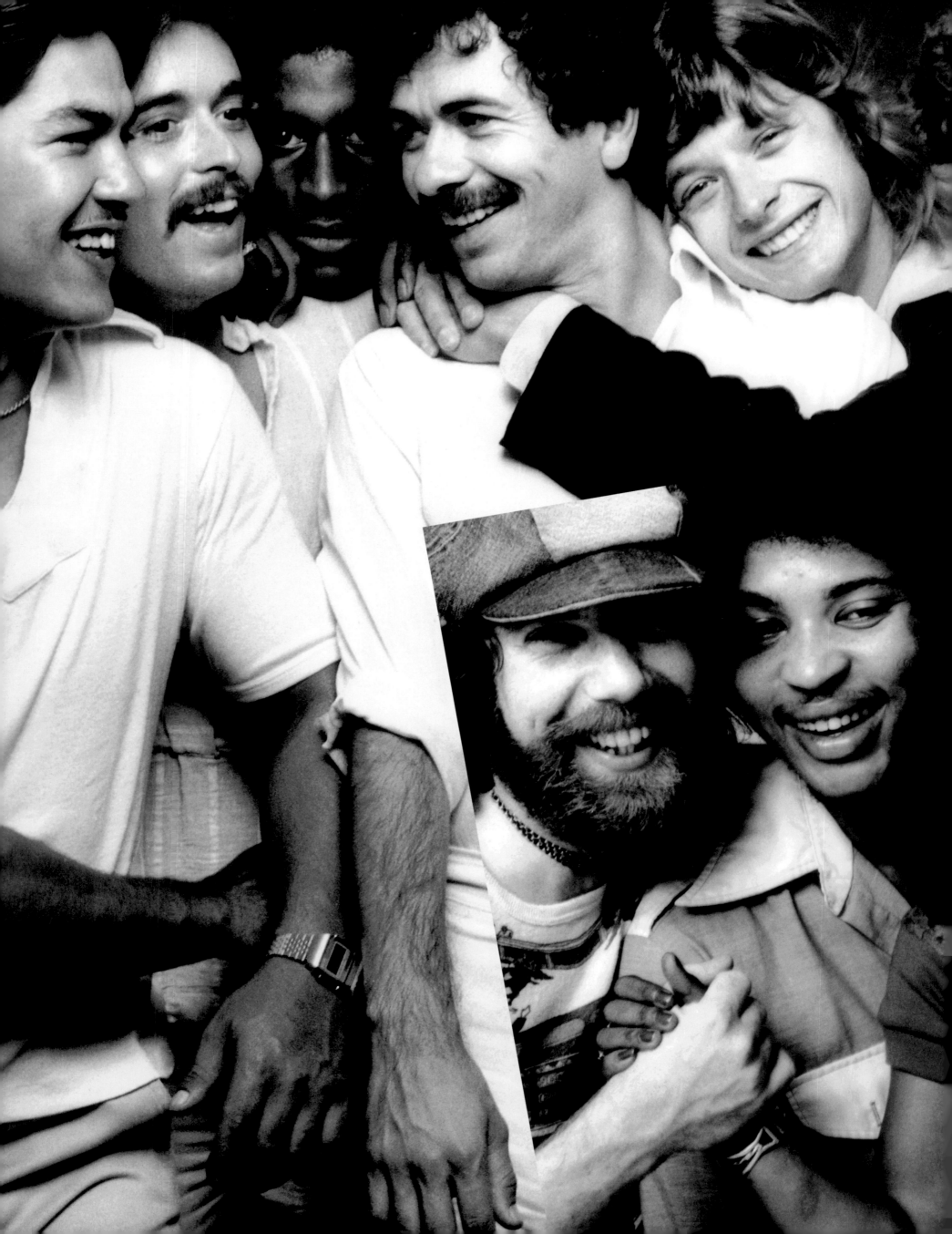

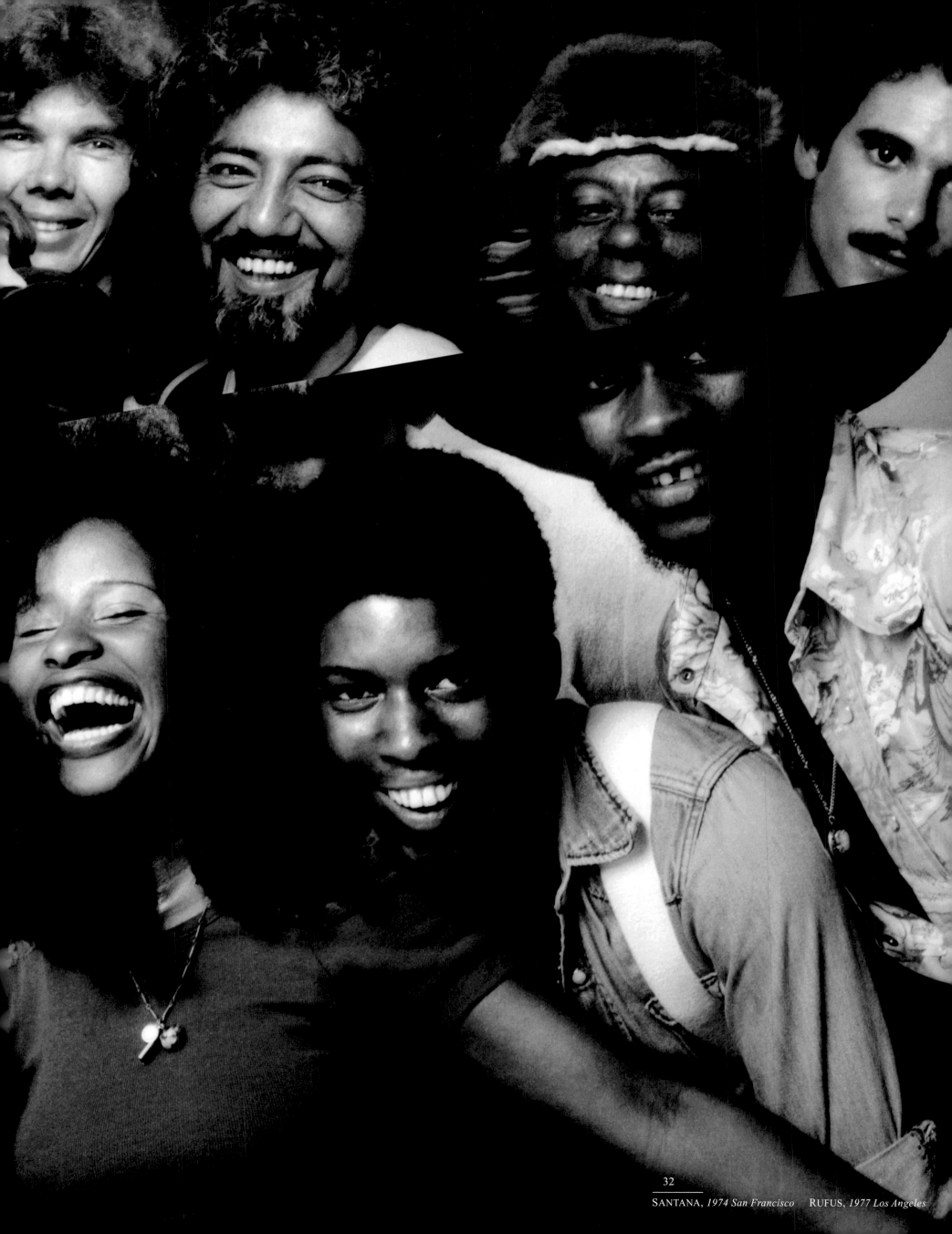

SANTANA, *1974 San Francisco* RUFUS, *1977 Los Angeles*

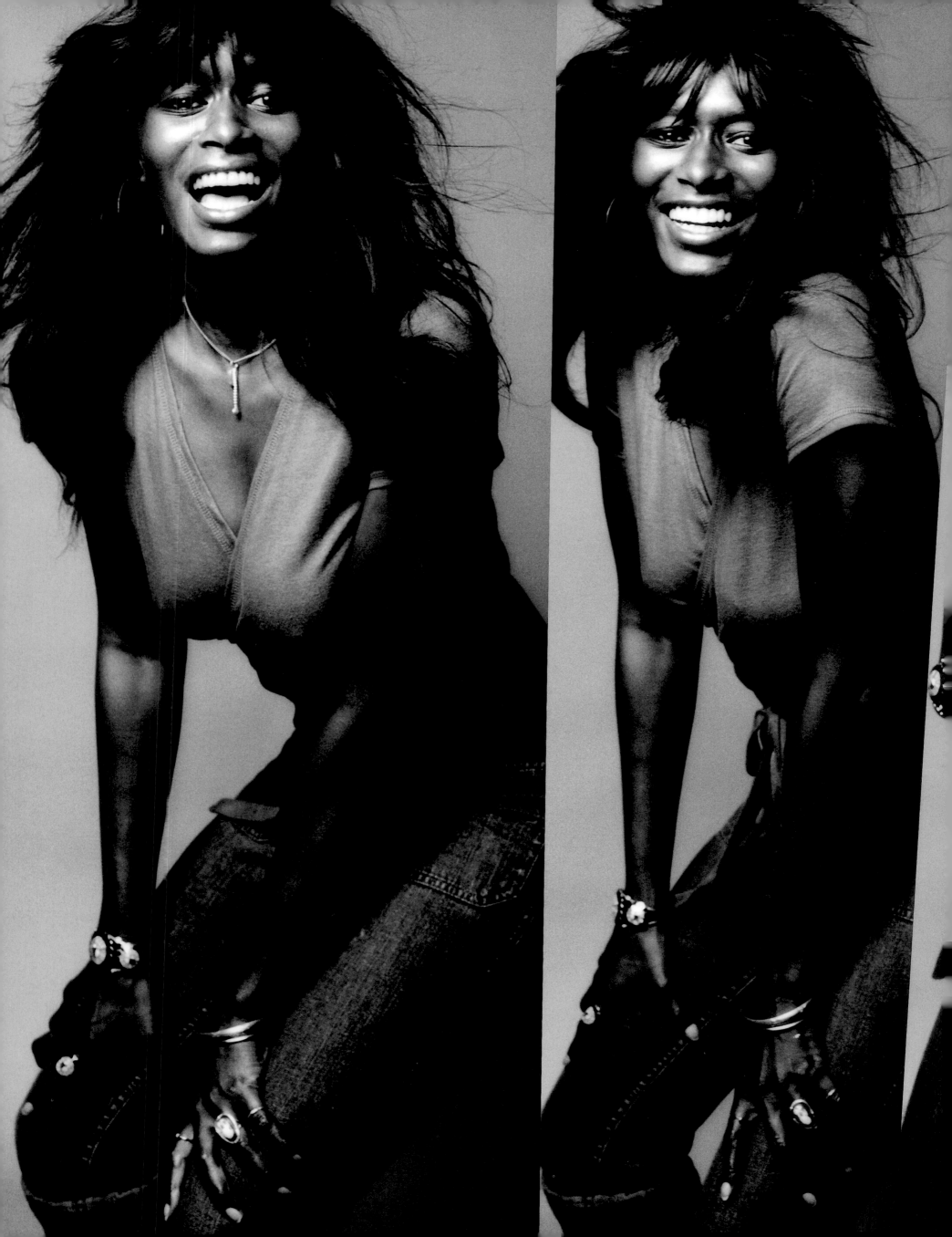

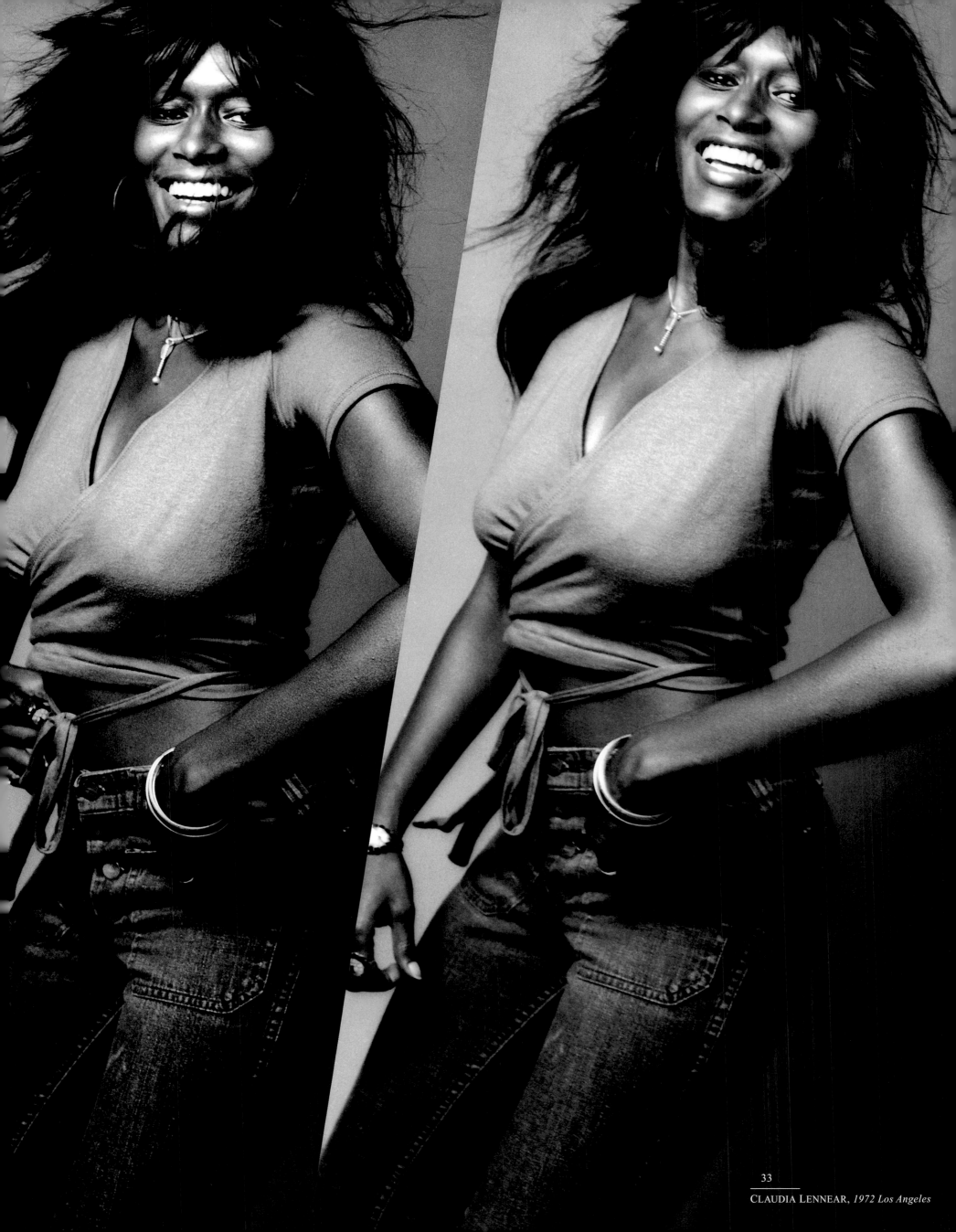

CLAUDIA LENNEAR, *1972 Los Angeles*

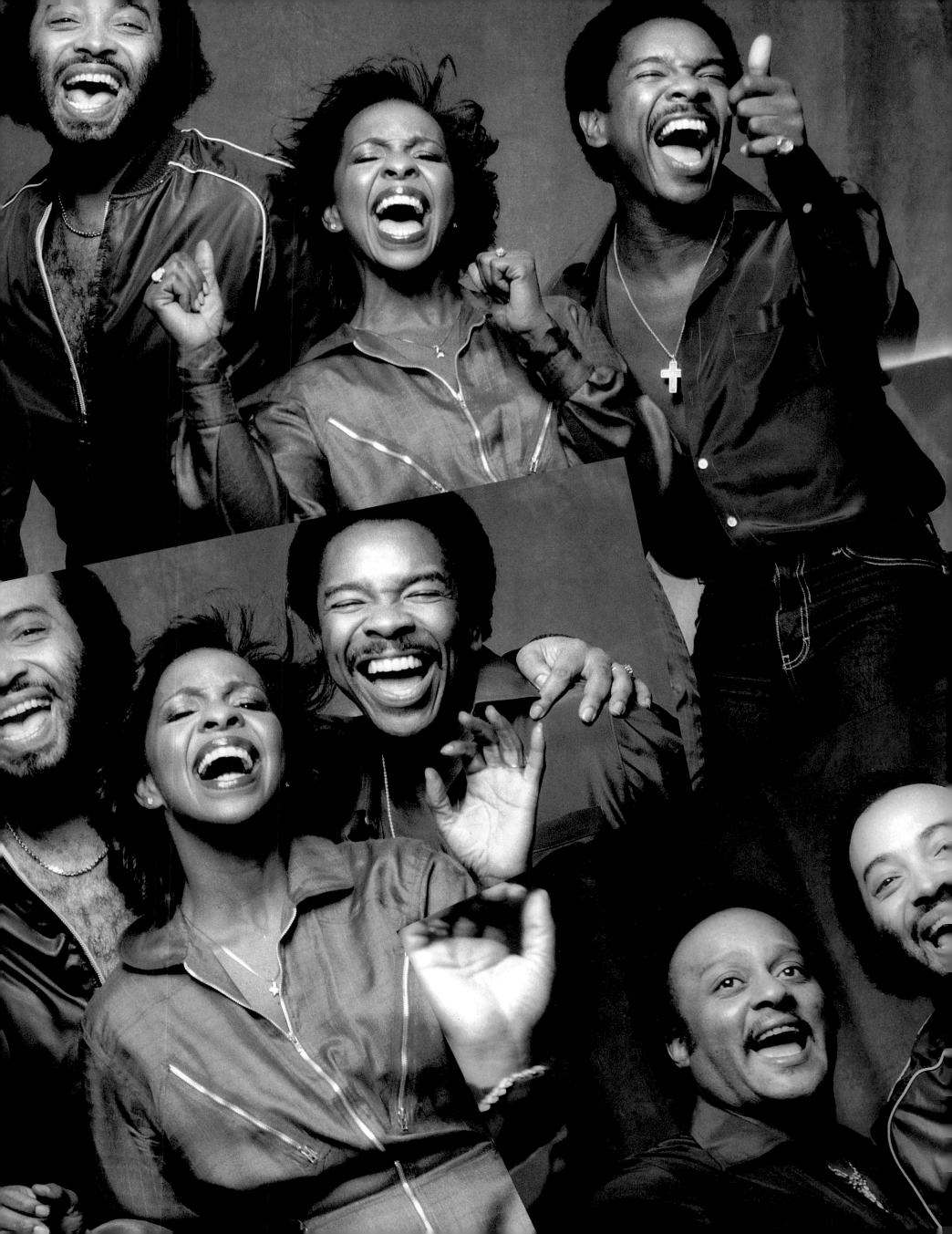

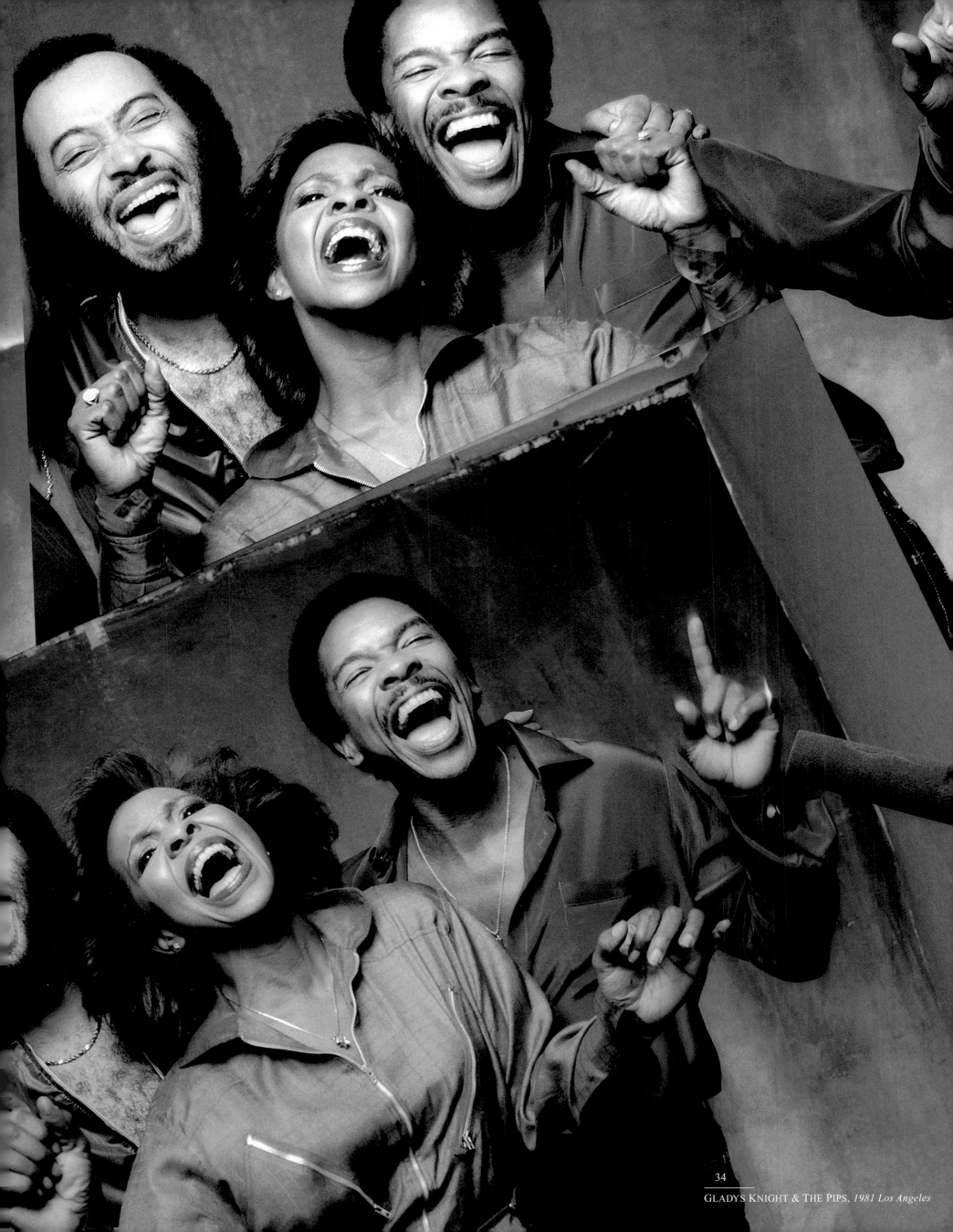

34

GLADYS KNIGHT & THE PIPS, *1981 Los Angeles*

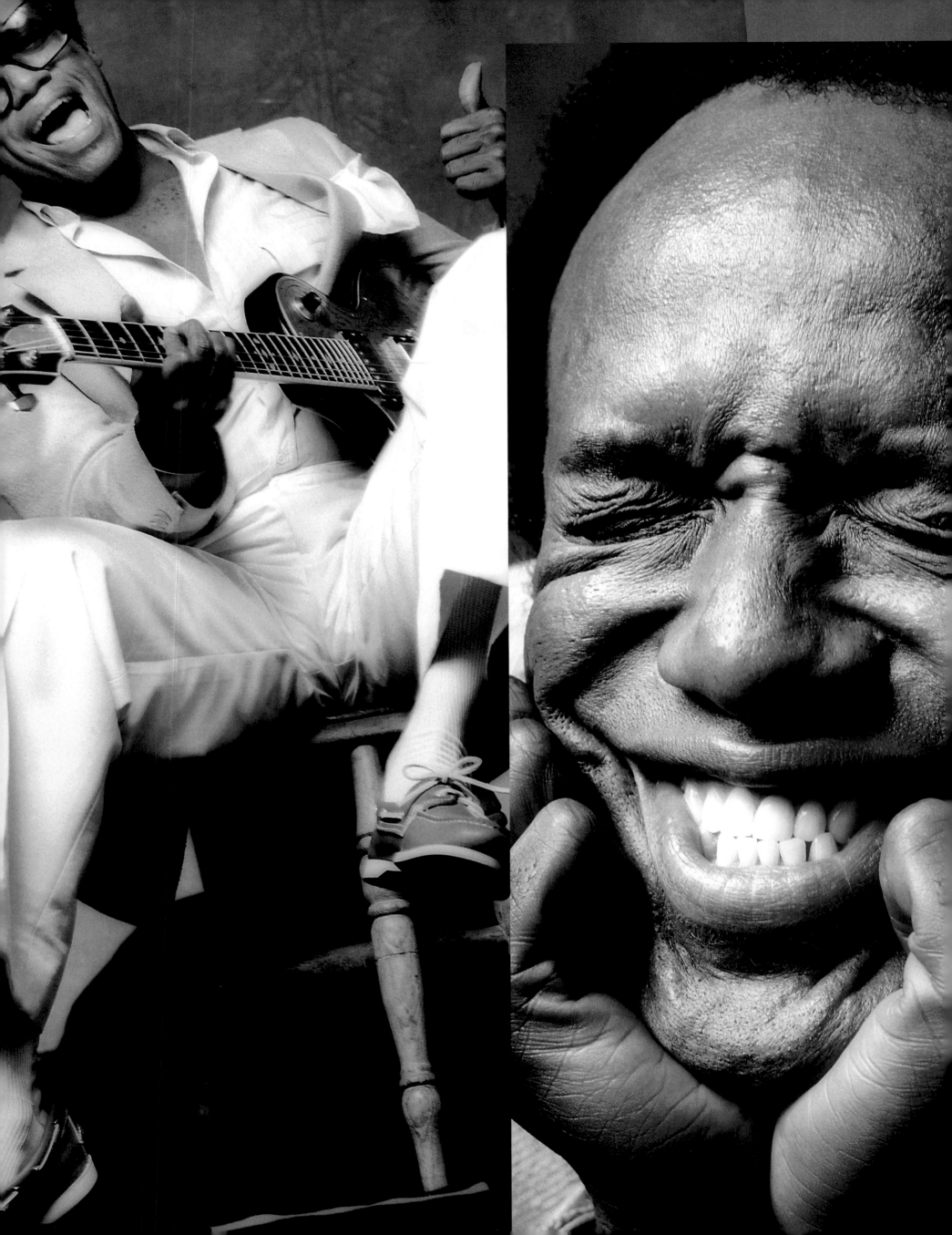

BOBBY WOMACK, *1981 Los Angeles*

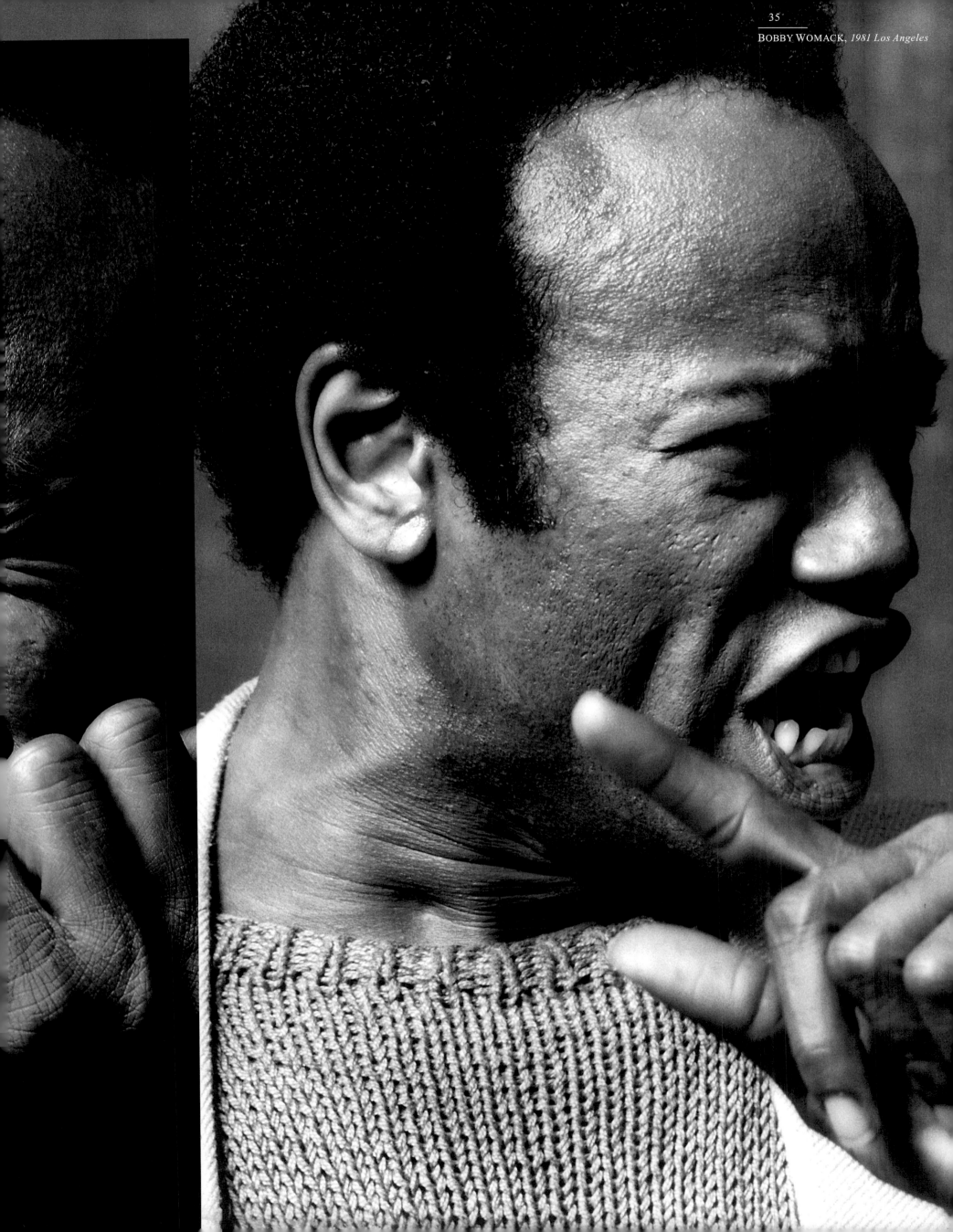

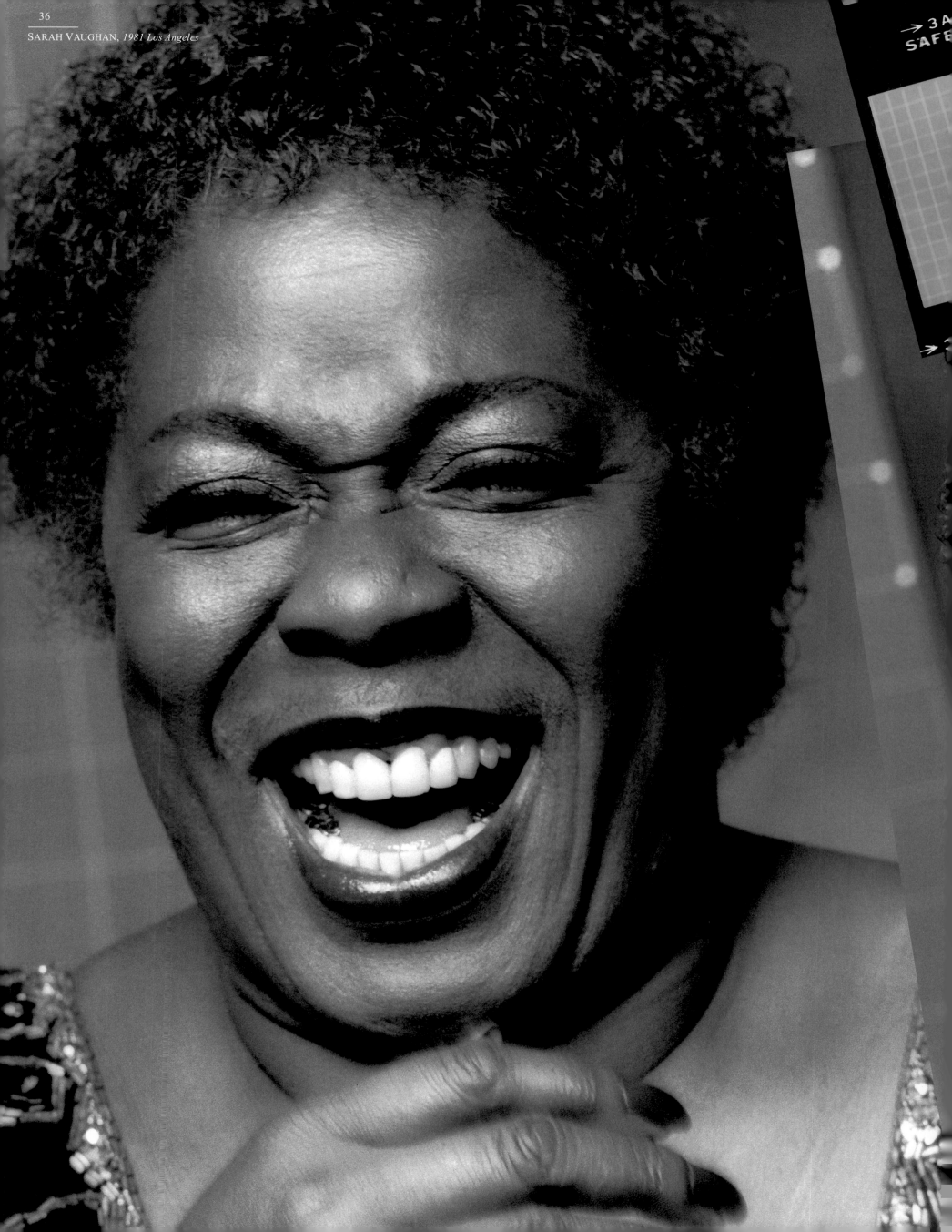

SARAH VAUGHAN, *1981 Los Angeles*

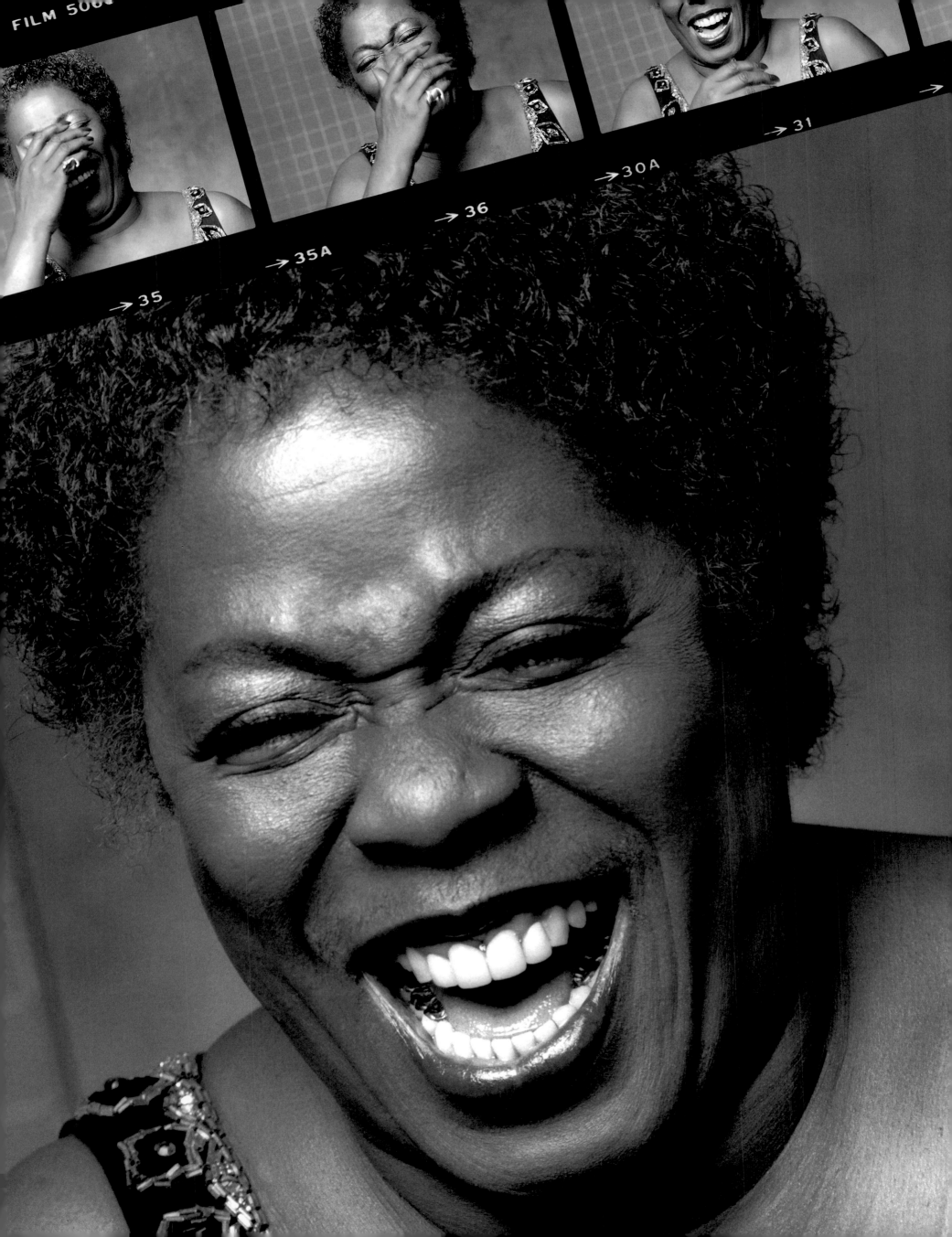

FILM 500

→ 35 →35A →36 →30A →31

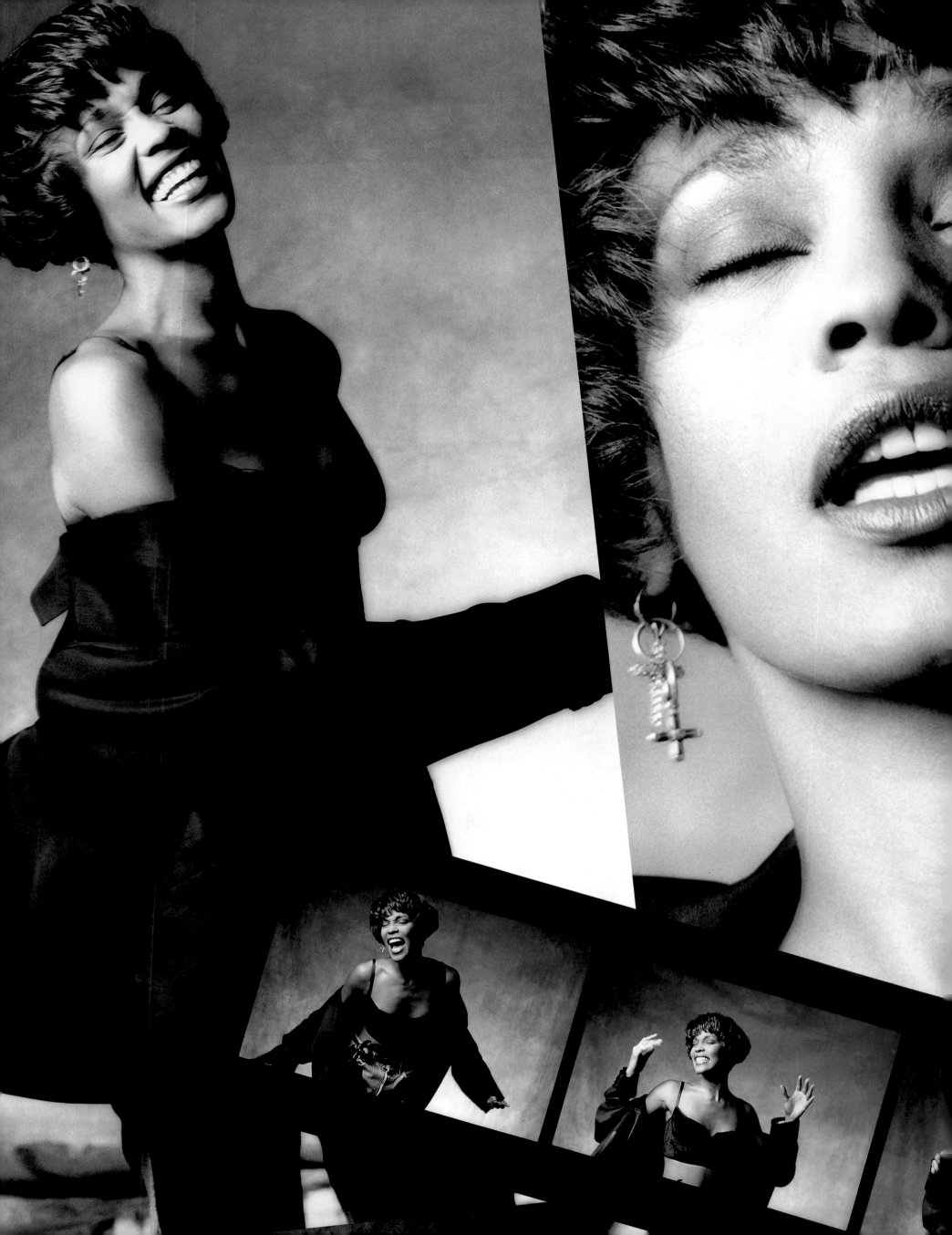

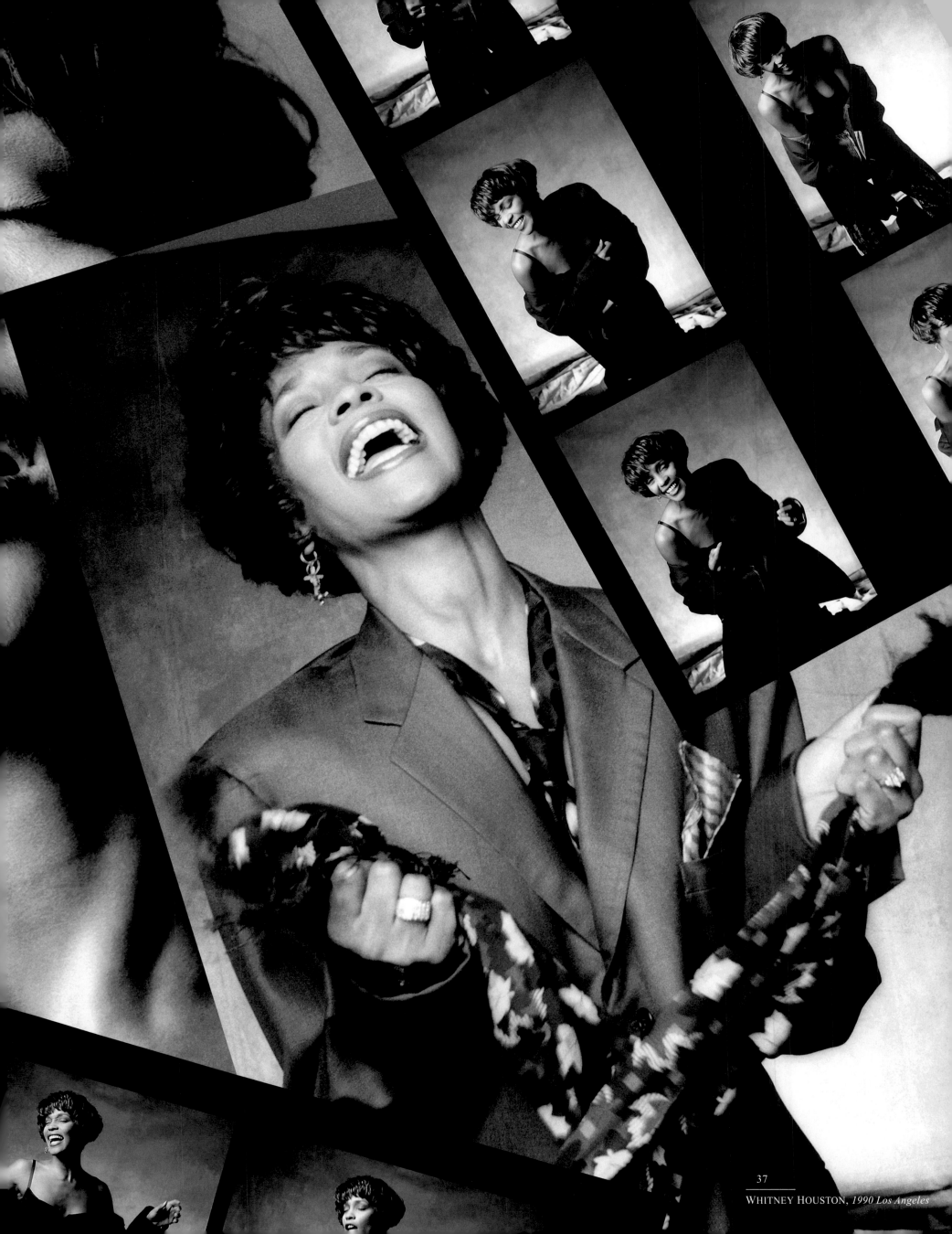

37

WHITNEY HOUSTON, 1990 Los Angeles

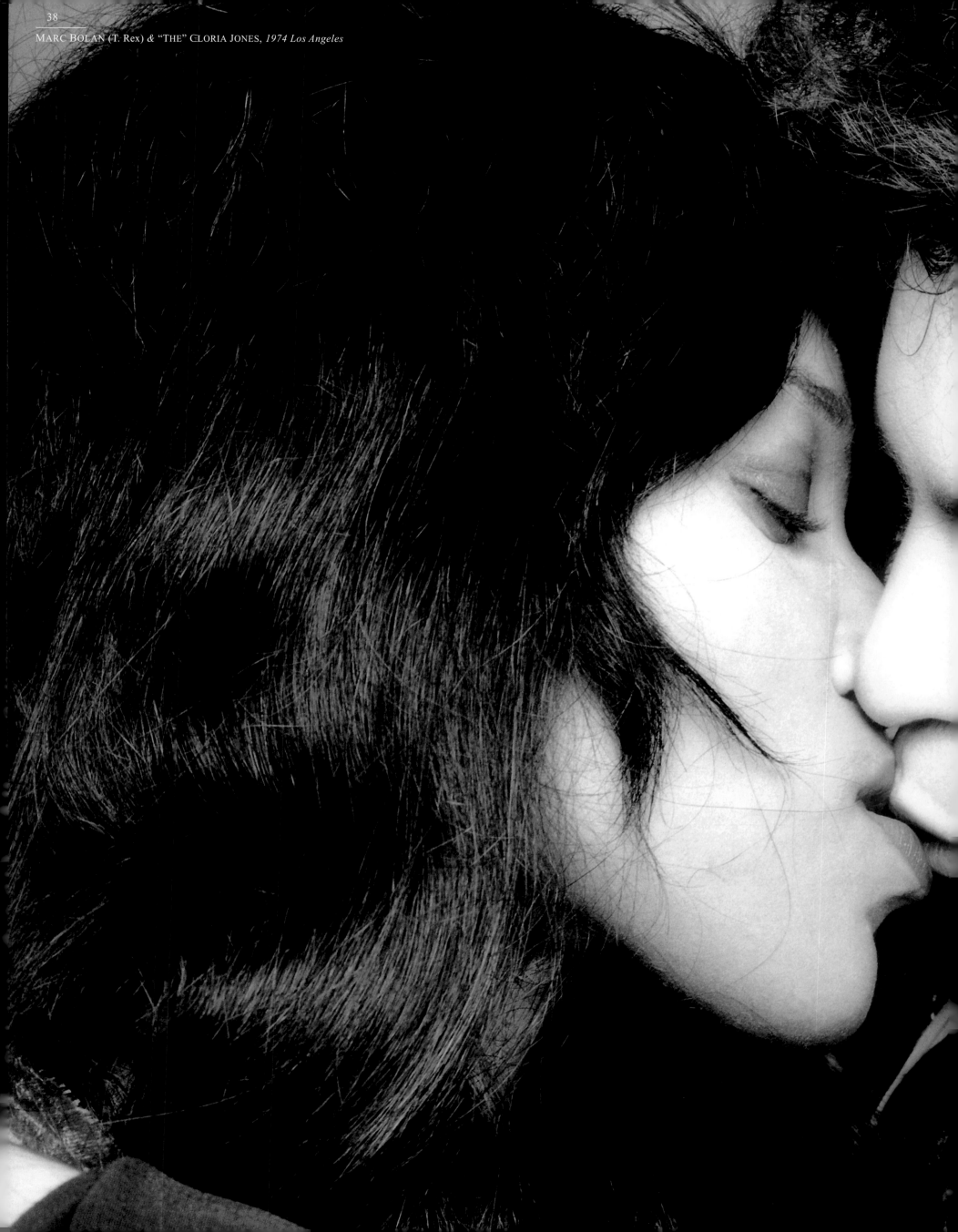

MARC BOLAN (T. Rex) & "THE" GLORIA JONES, *1974 Los Angeles*

JIMMY CLIFF, *1975 Los Angeles* IKE TURNER, *1975 Los Angeles*

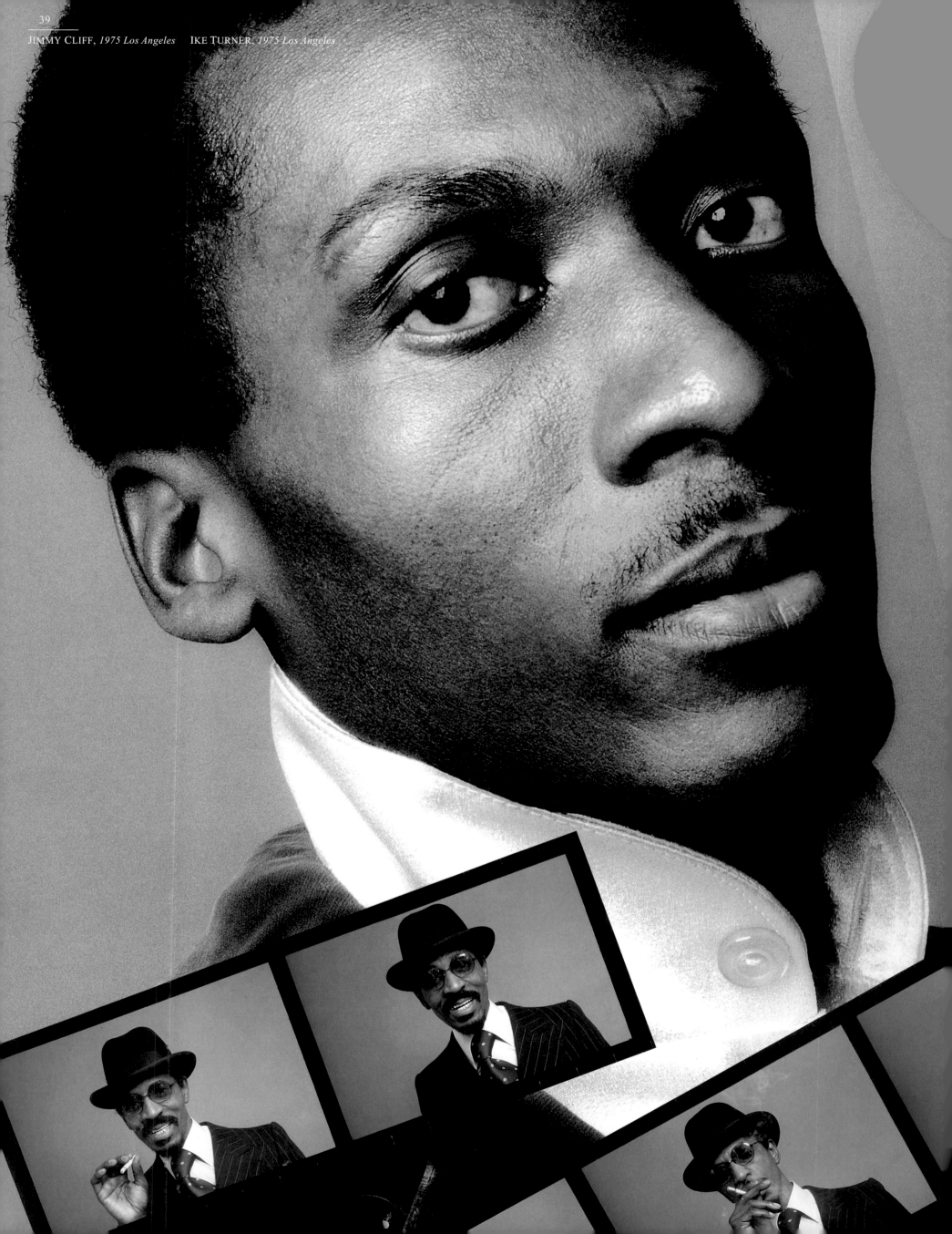

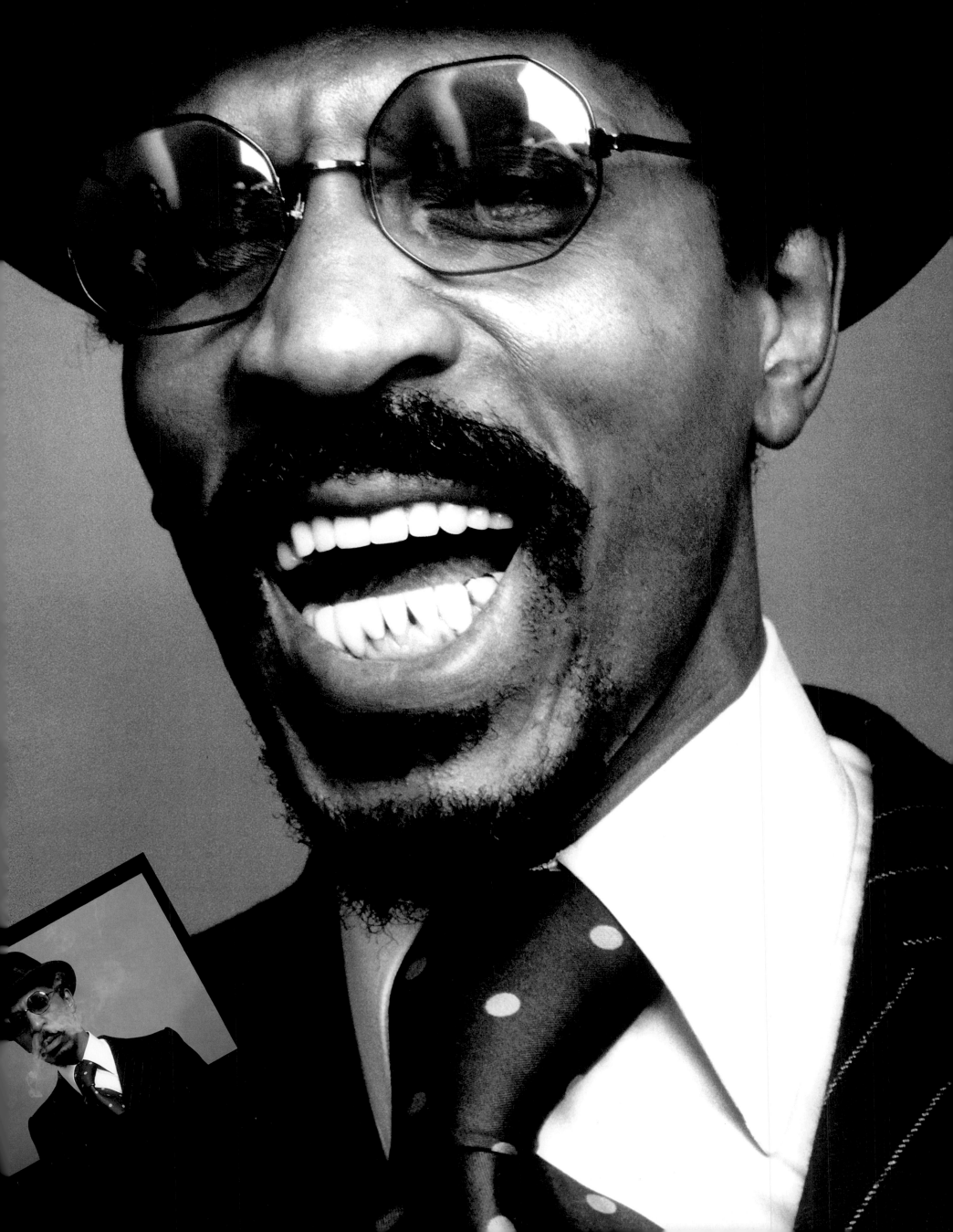

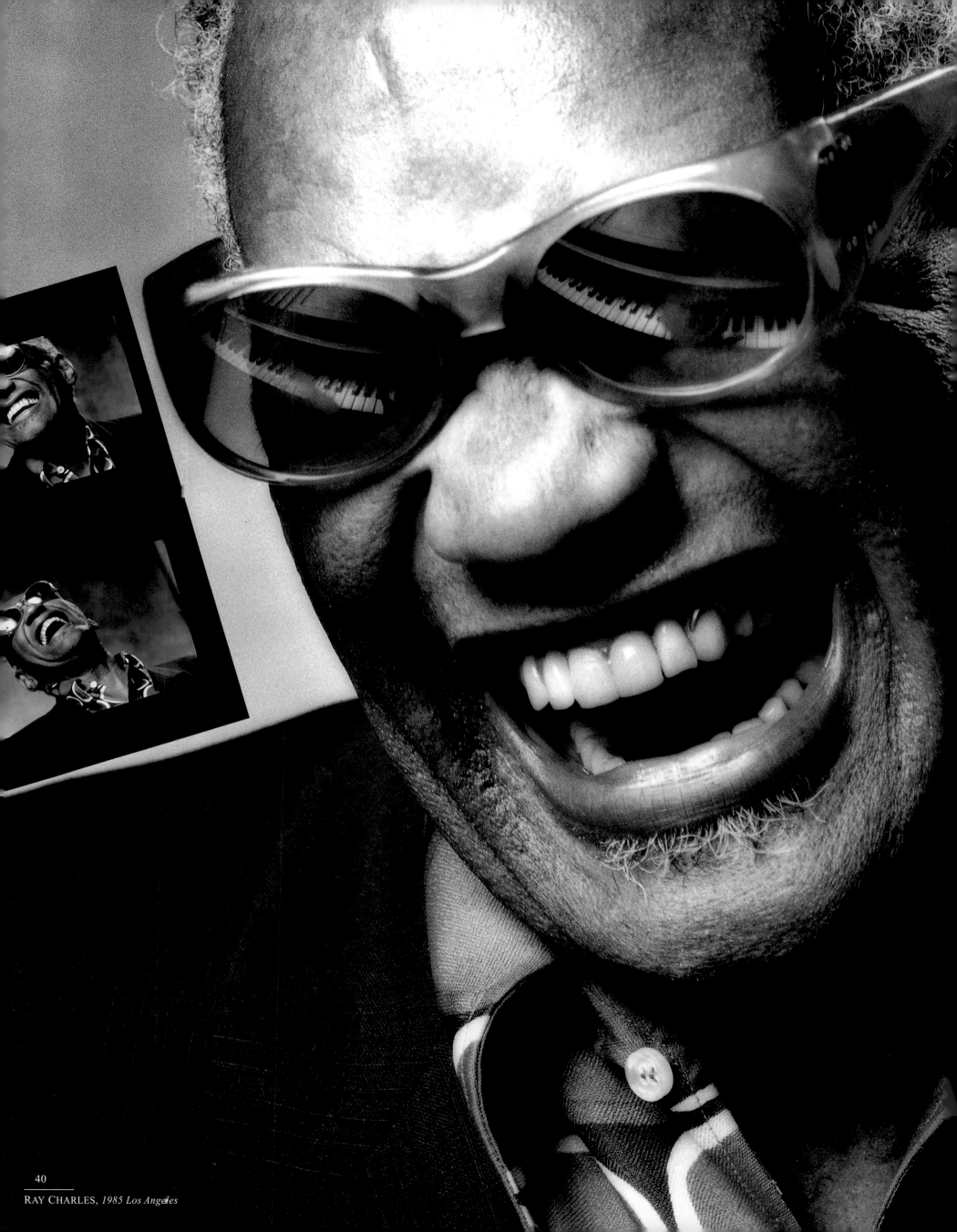

RAY CHARLES, *1985 Los Angeles*

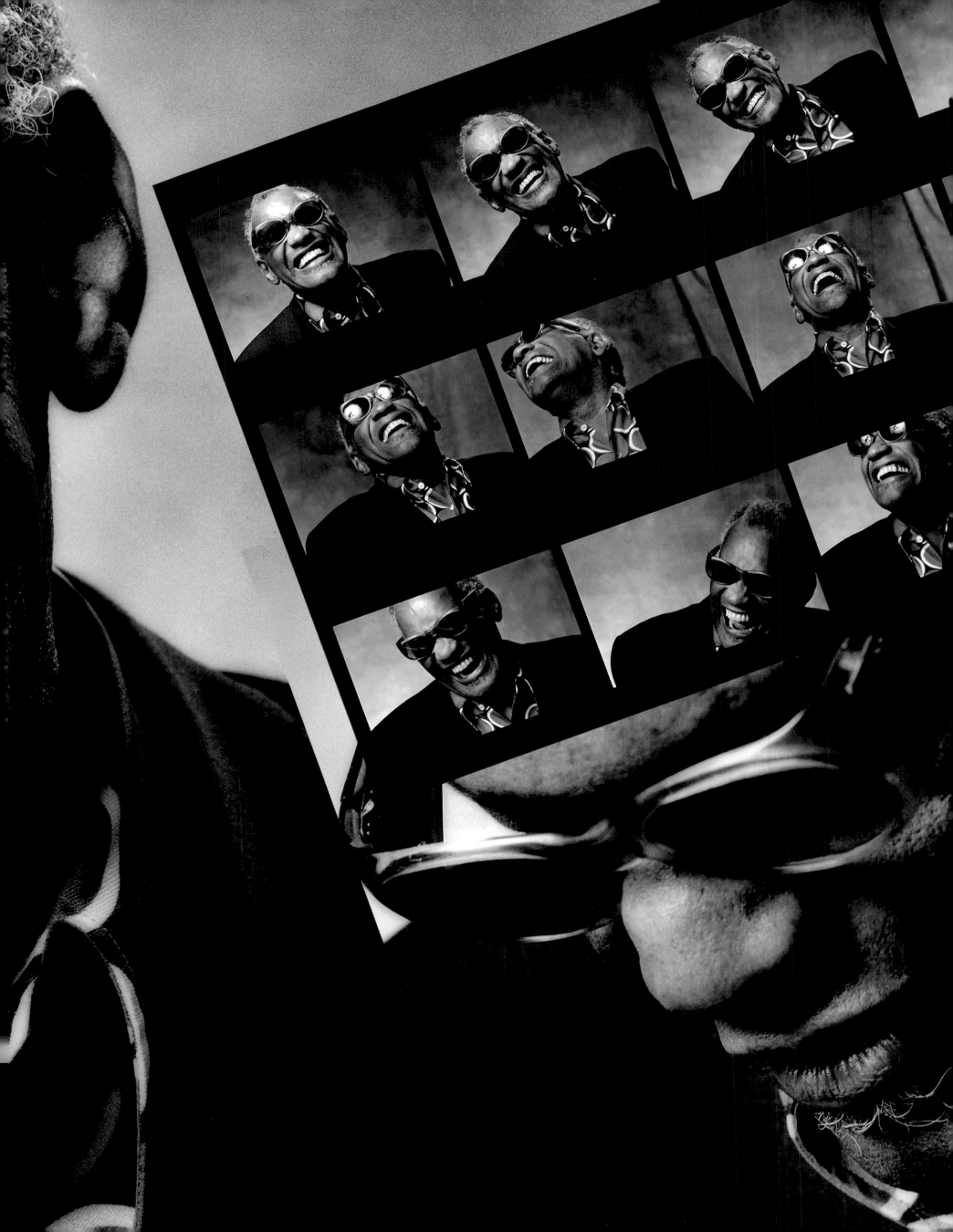

41

AL JARREAU, *1982 Los Angeles* PHOEBE SNOW, *1976 Los Angeles*

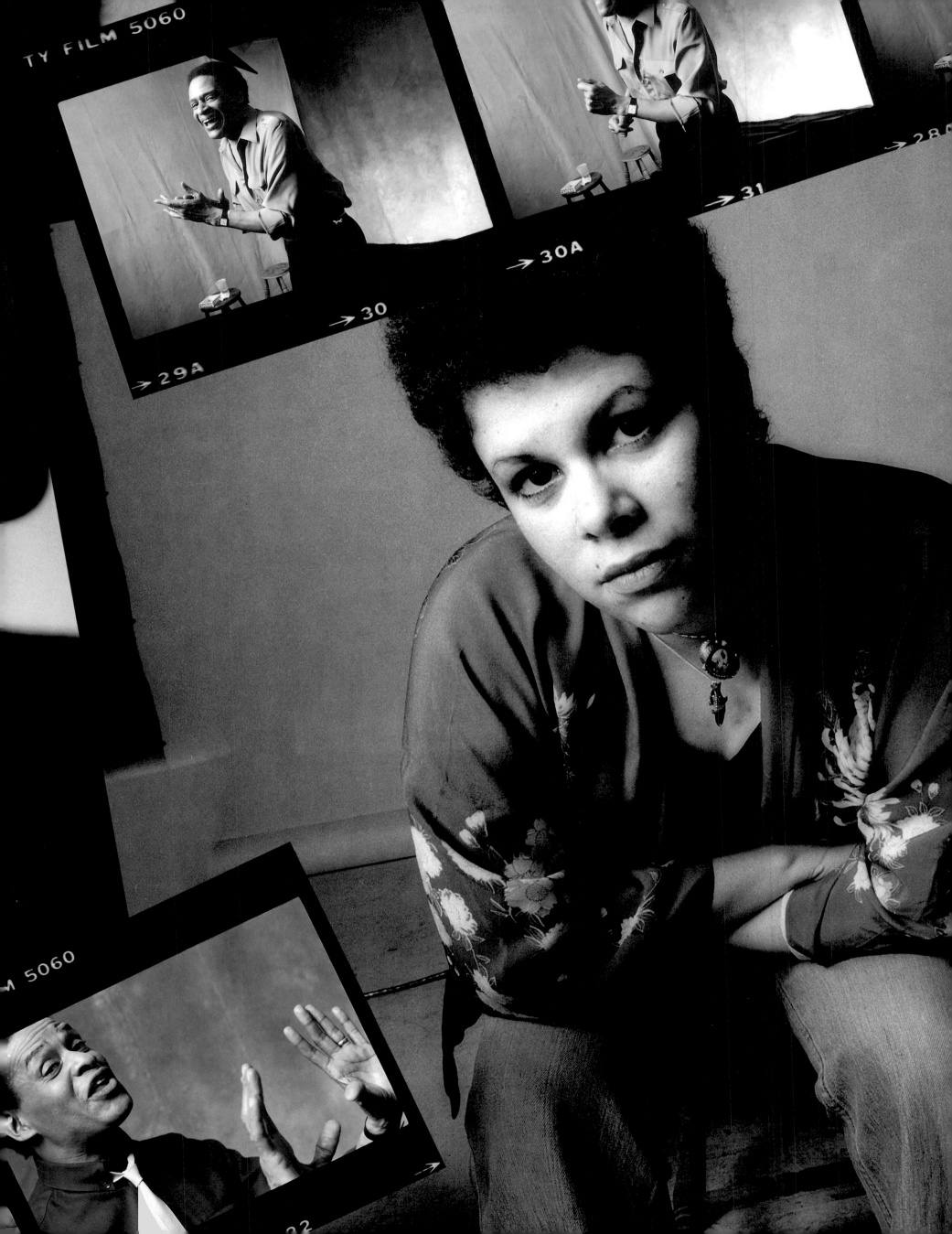

ALBERT KING, *1976 Los Angeles*

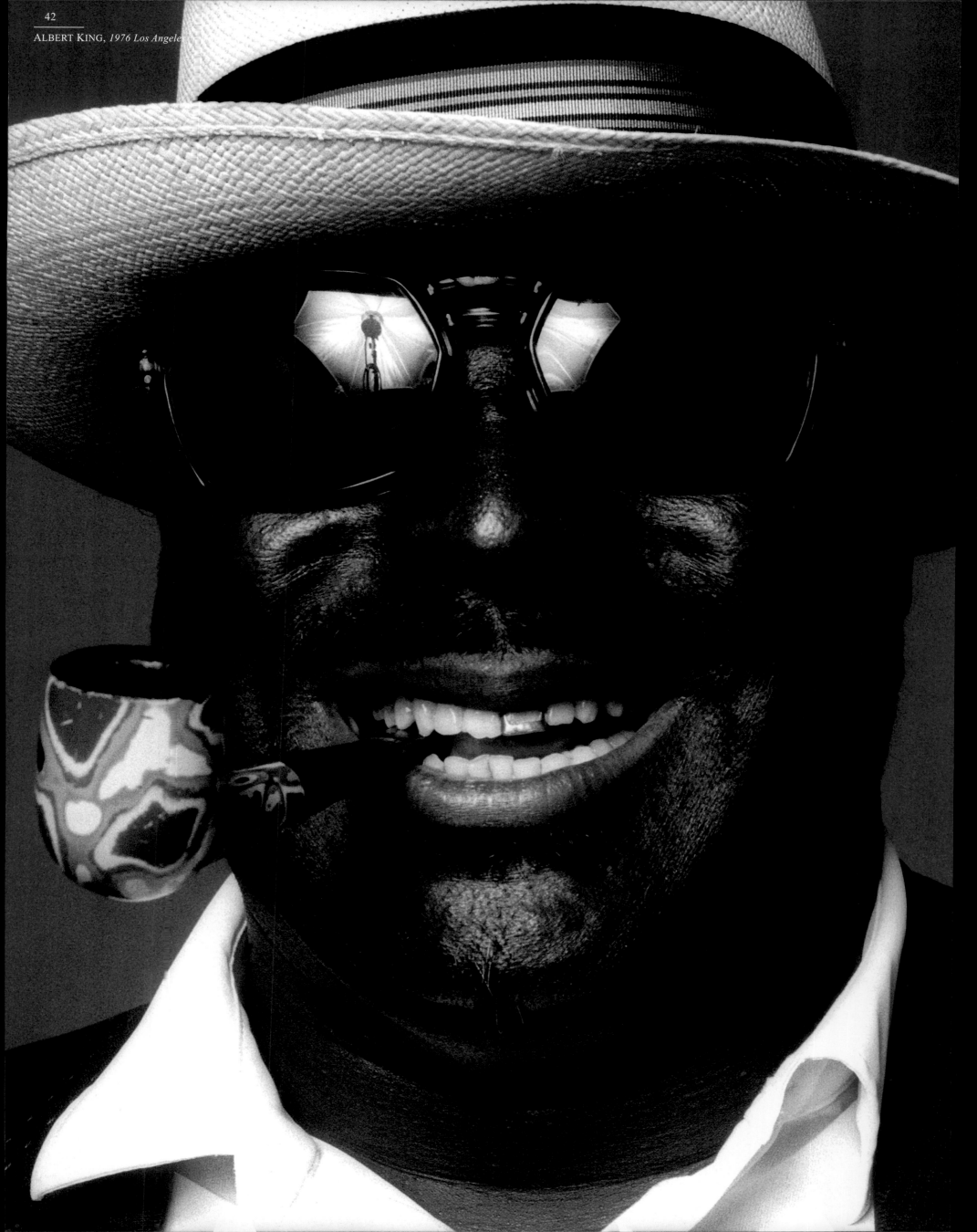

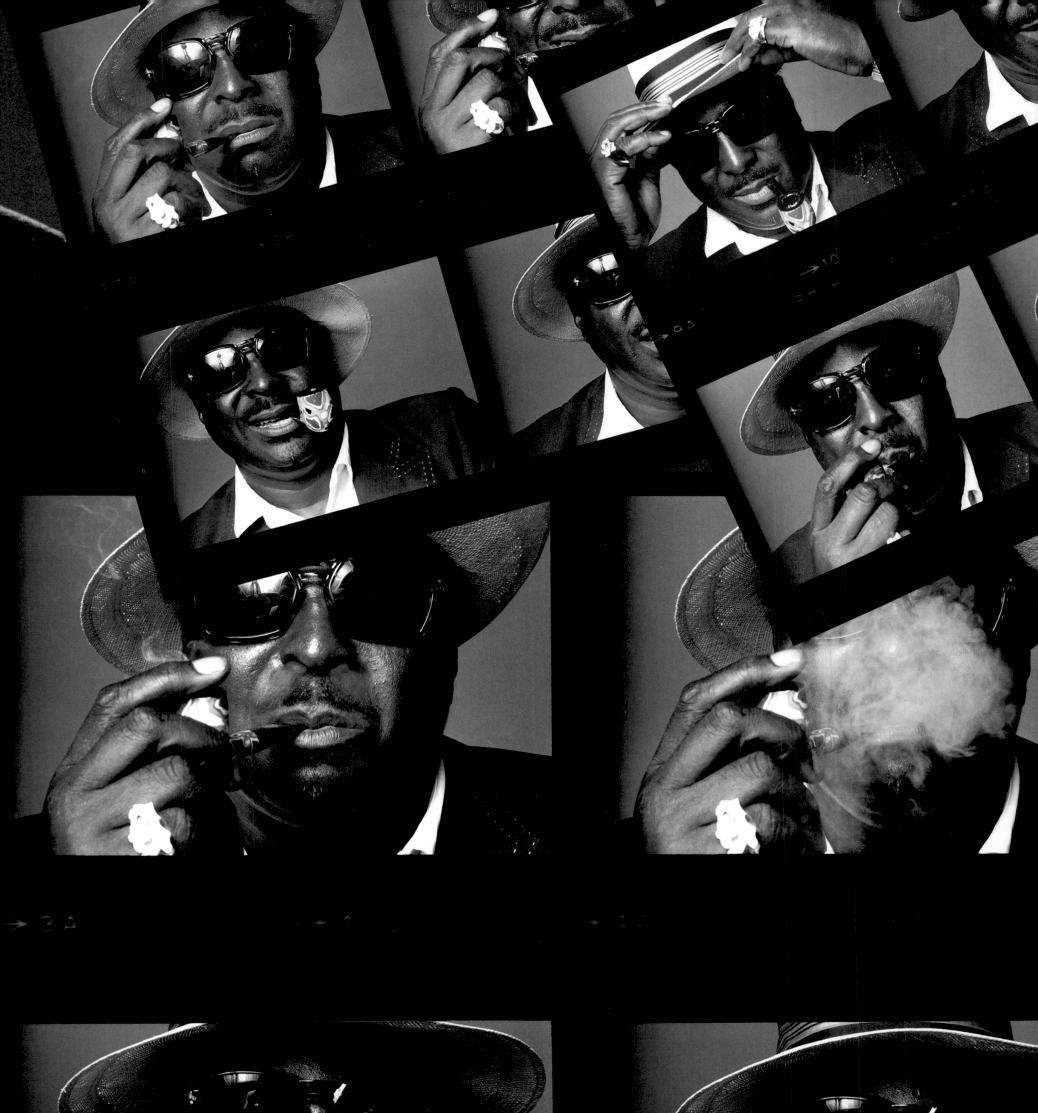

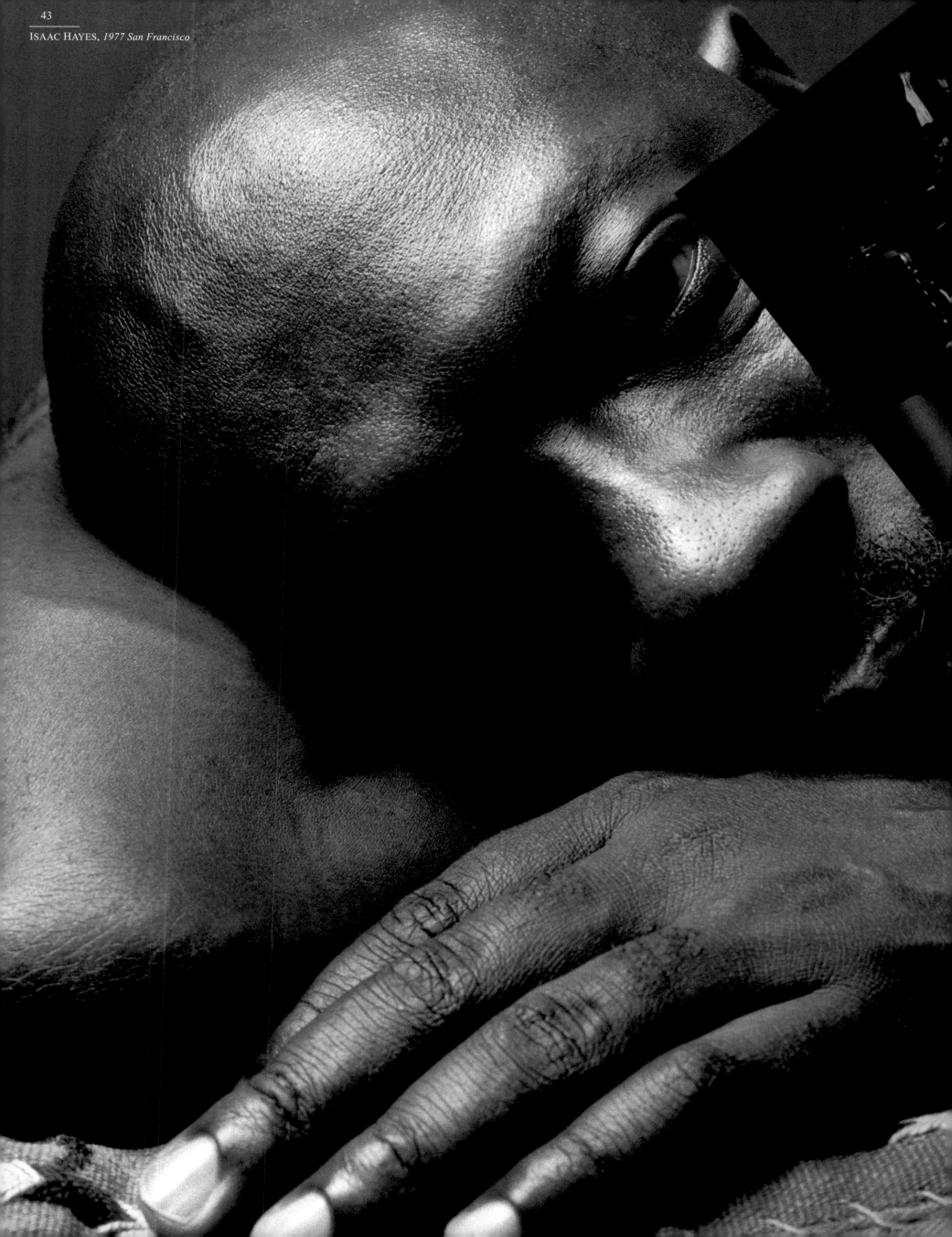
ISAAC HAYES, *1977 San Francisco*

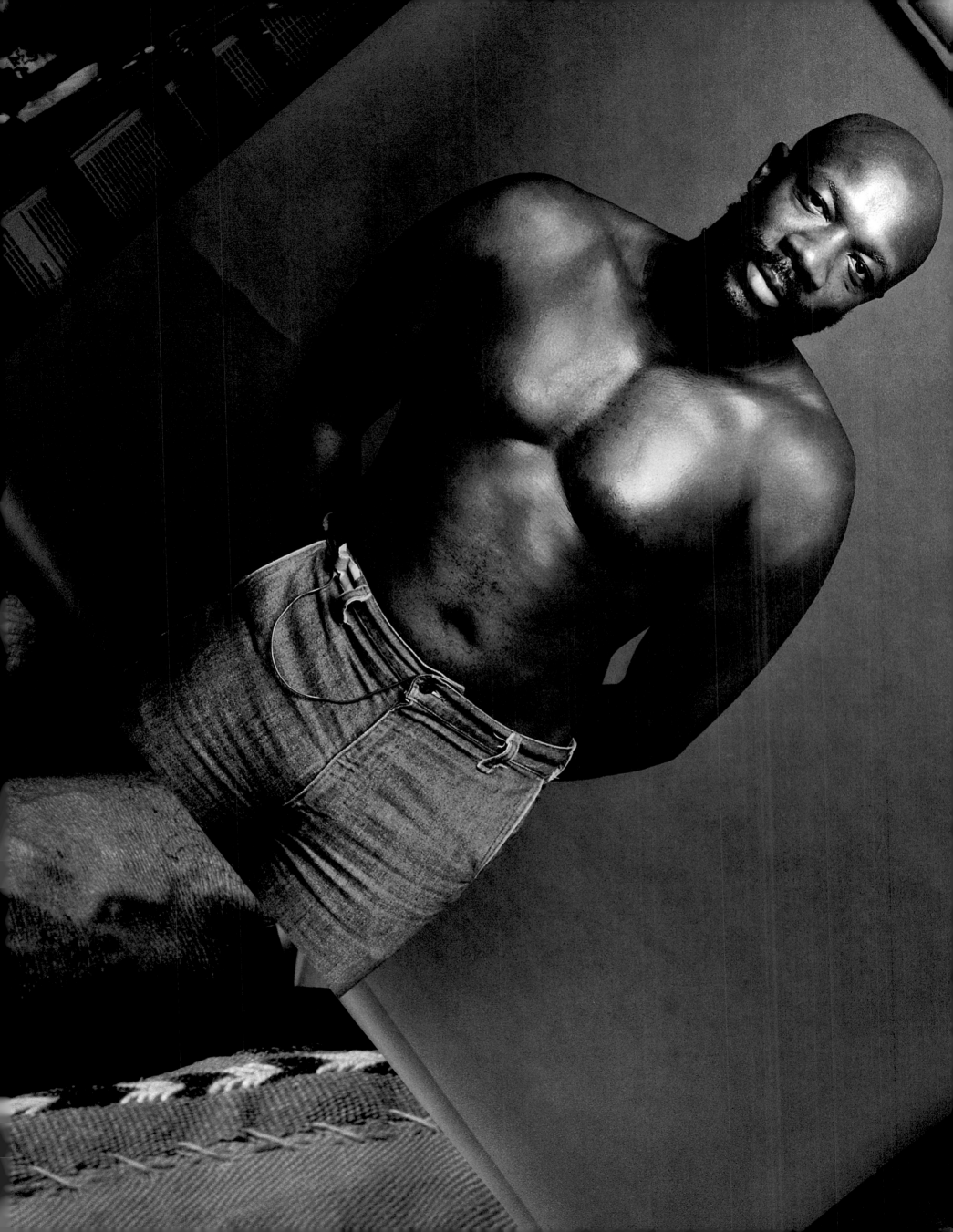

IKE & TINA TURNER, *1975 Los Angeles*

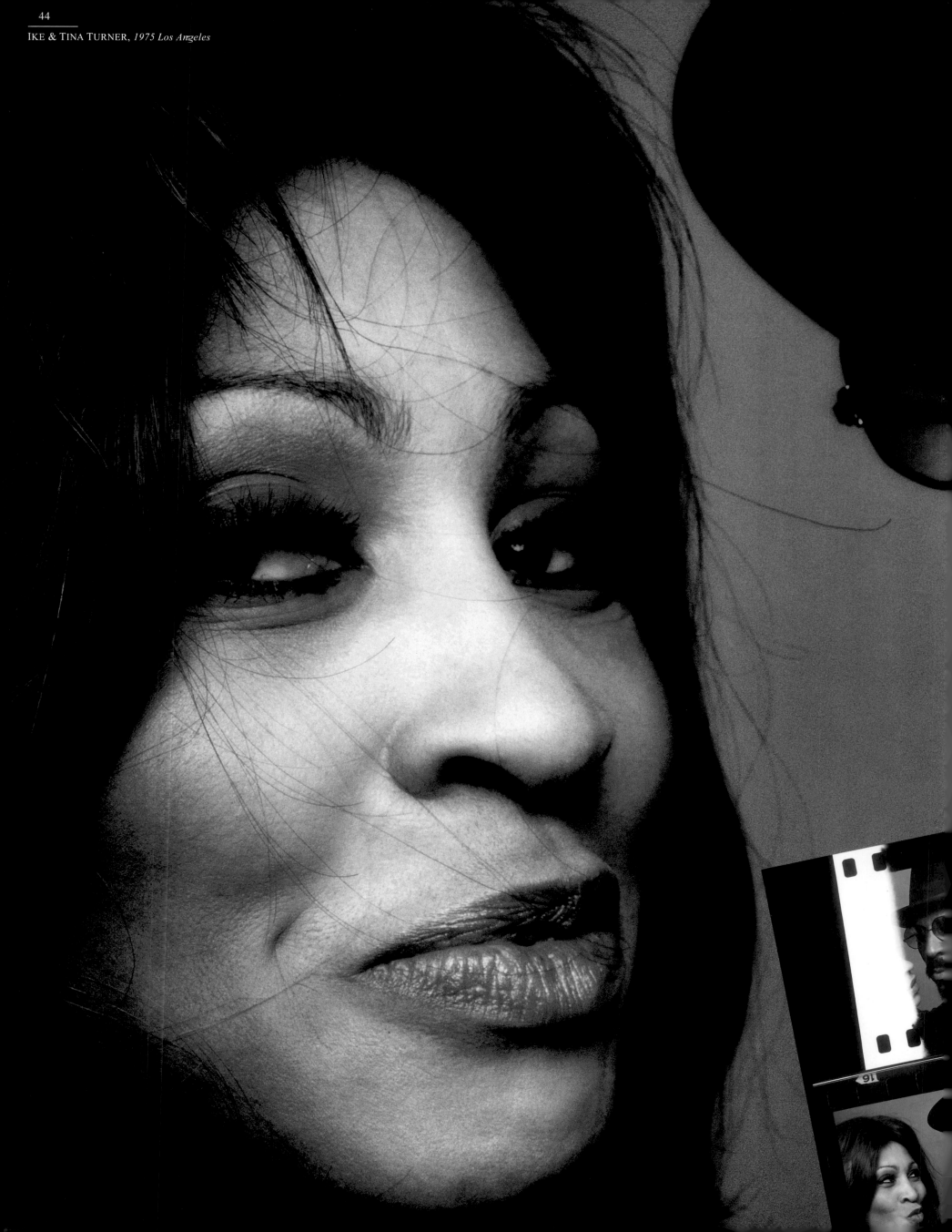

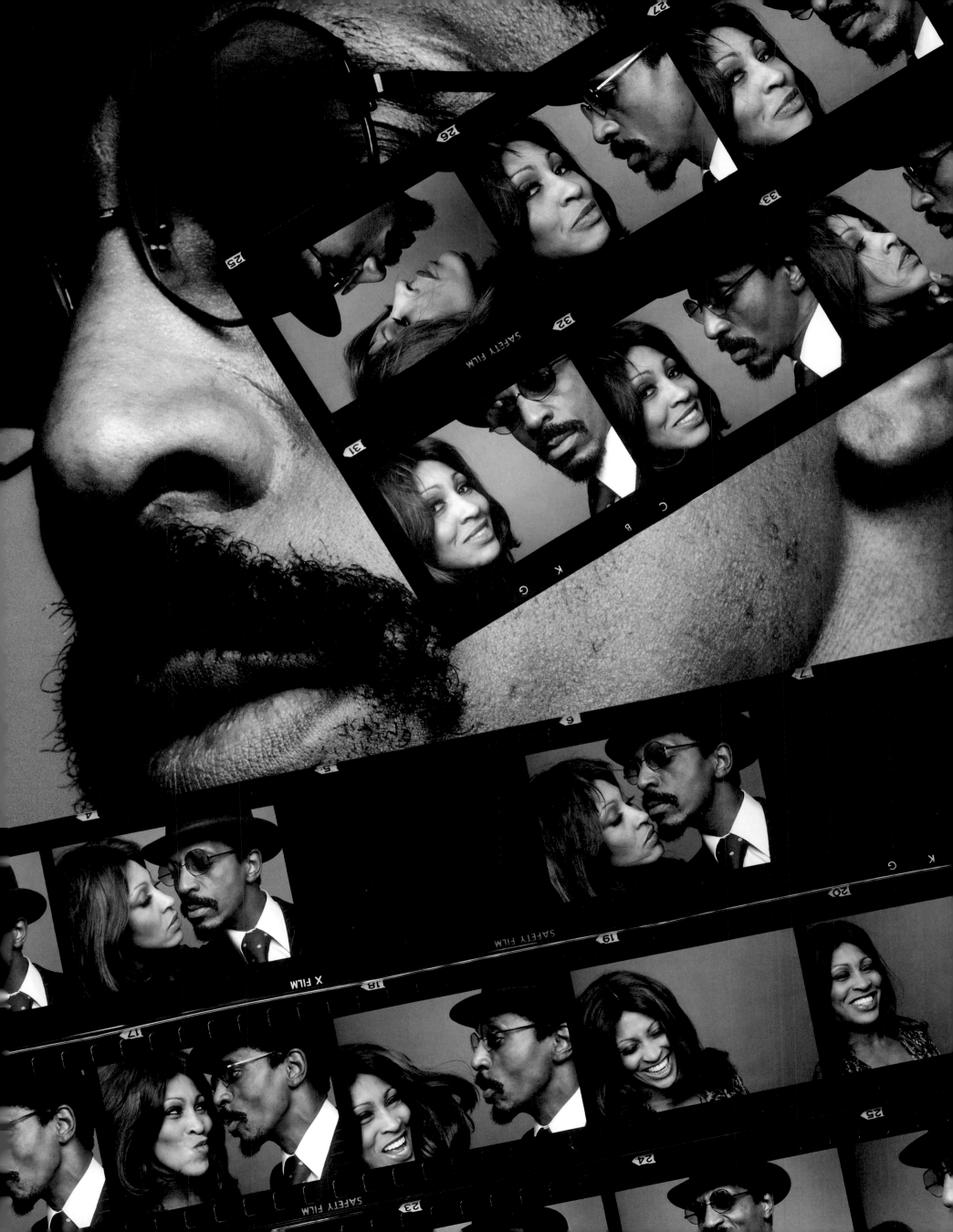

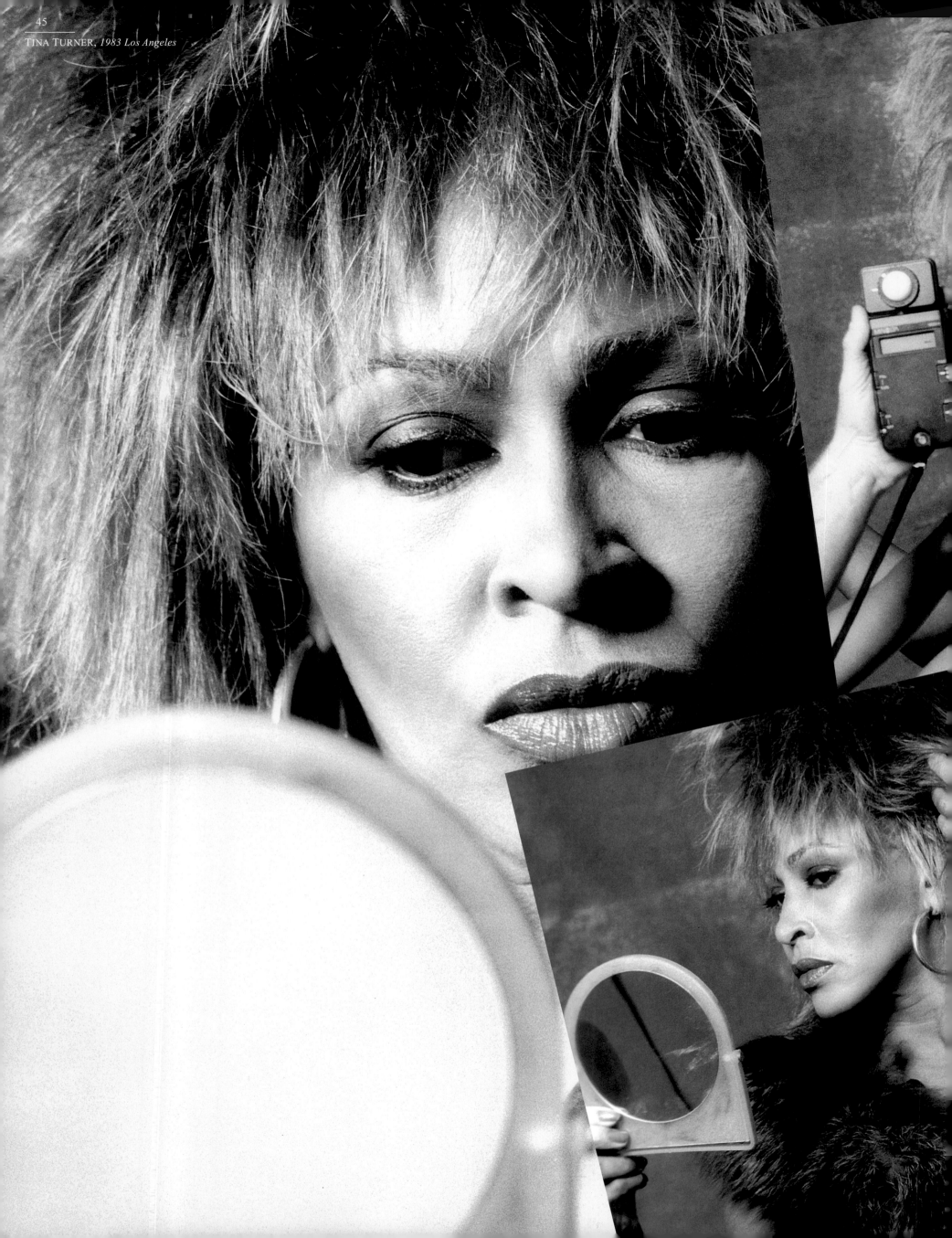

TINA TURNER, *1983 Los Angeles*

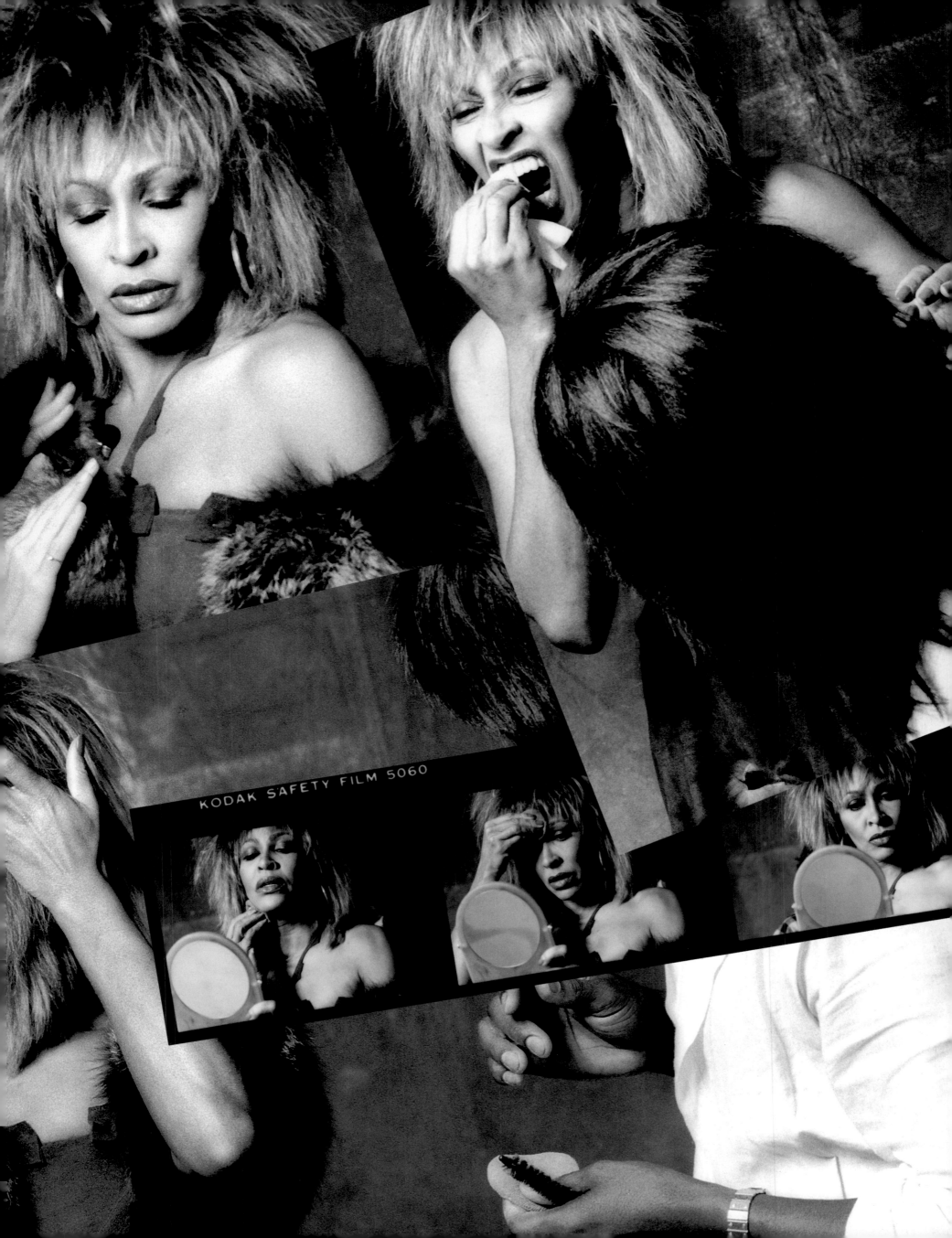

KODAK SAFETY FILM 5060

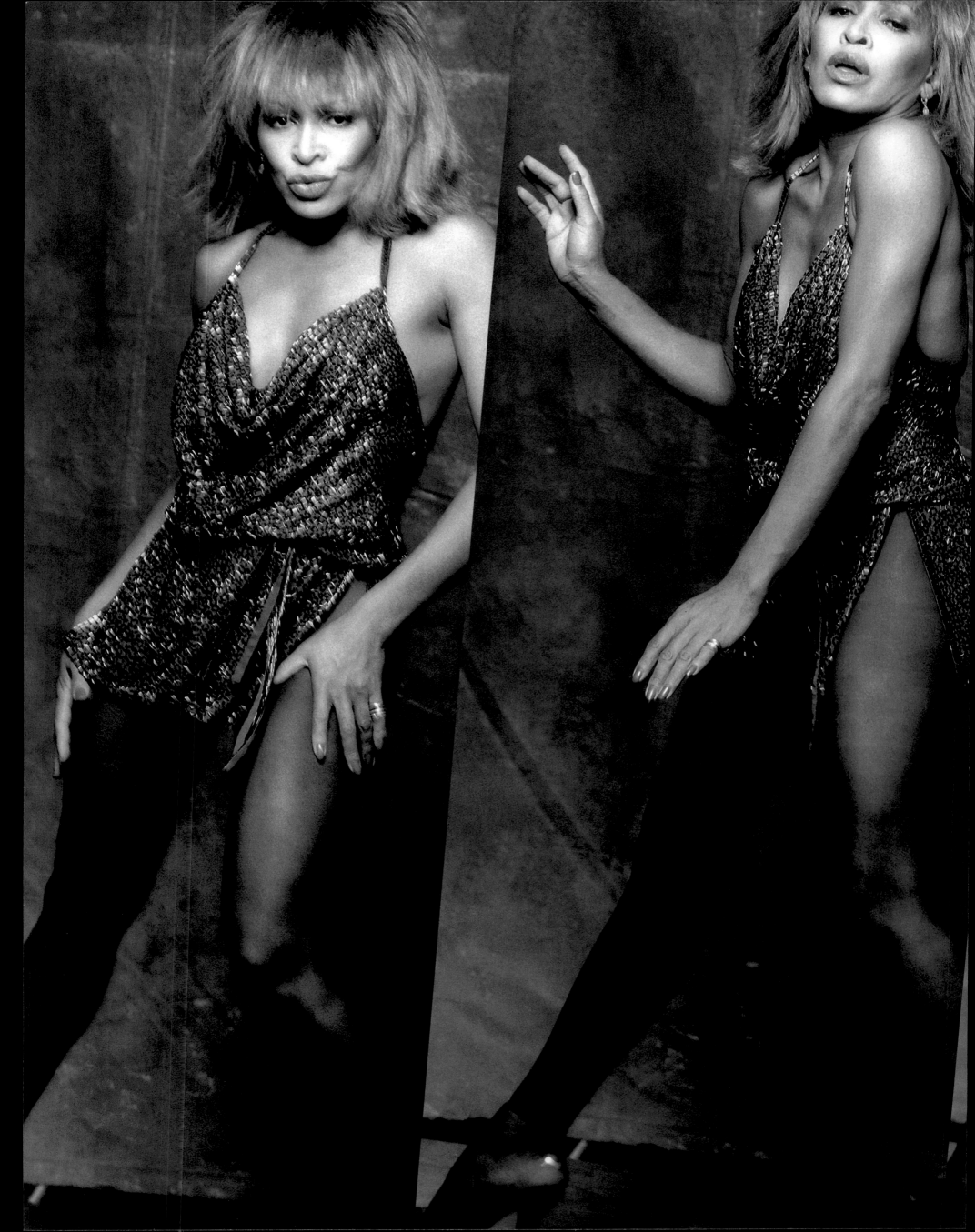

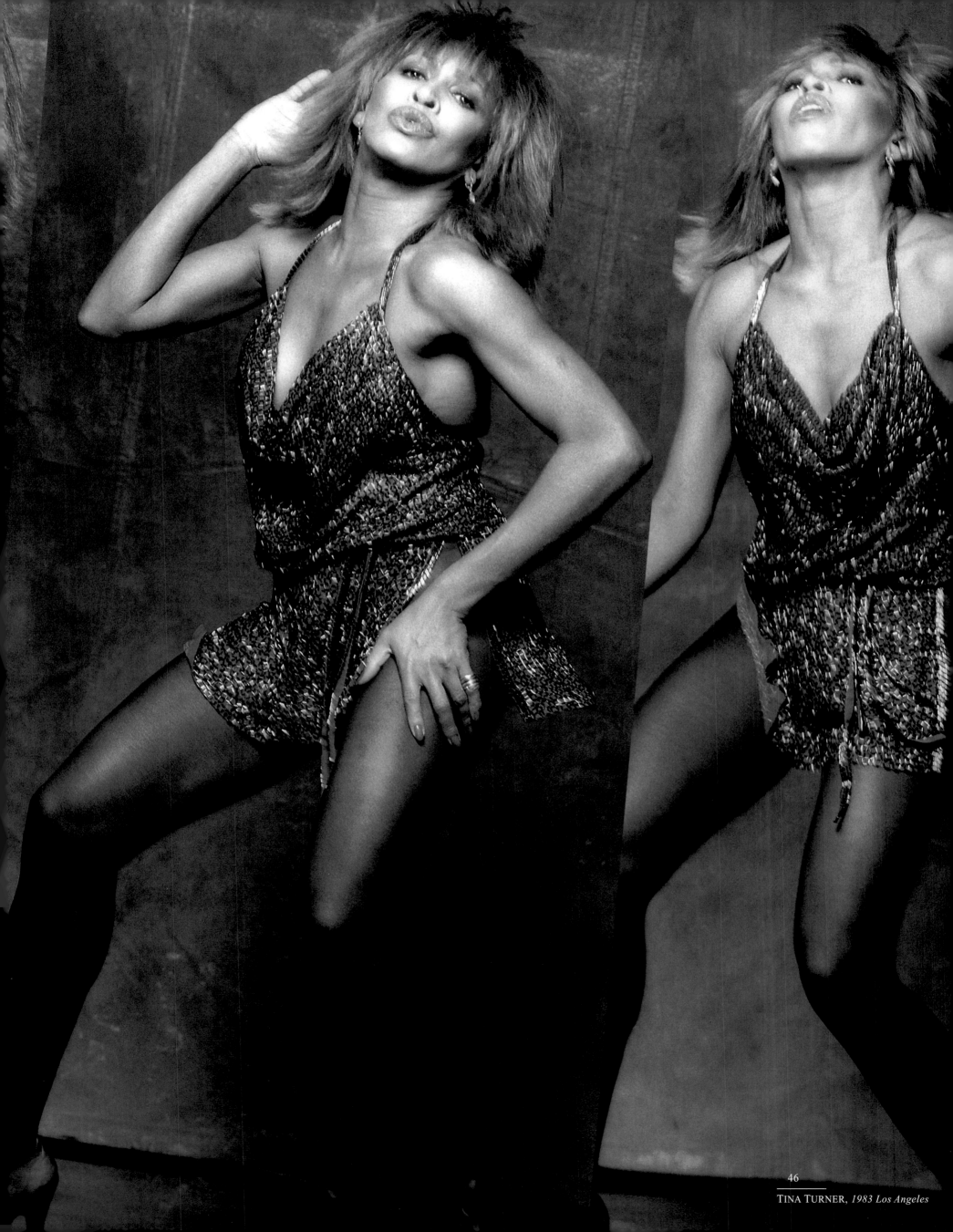

46
TINA TURNER, *1983 Los Angeles*

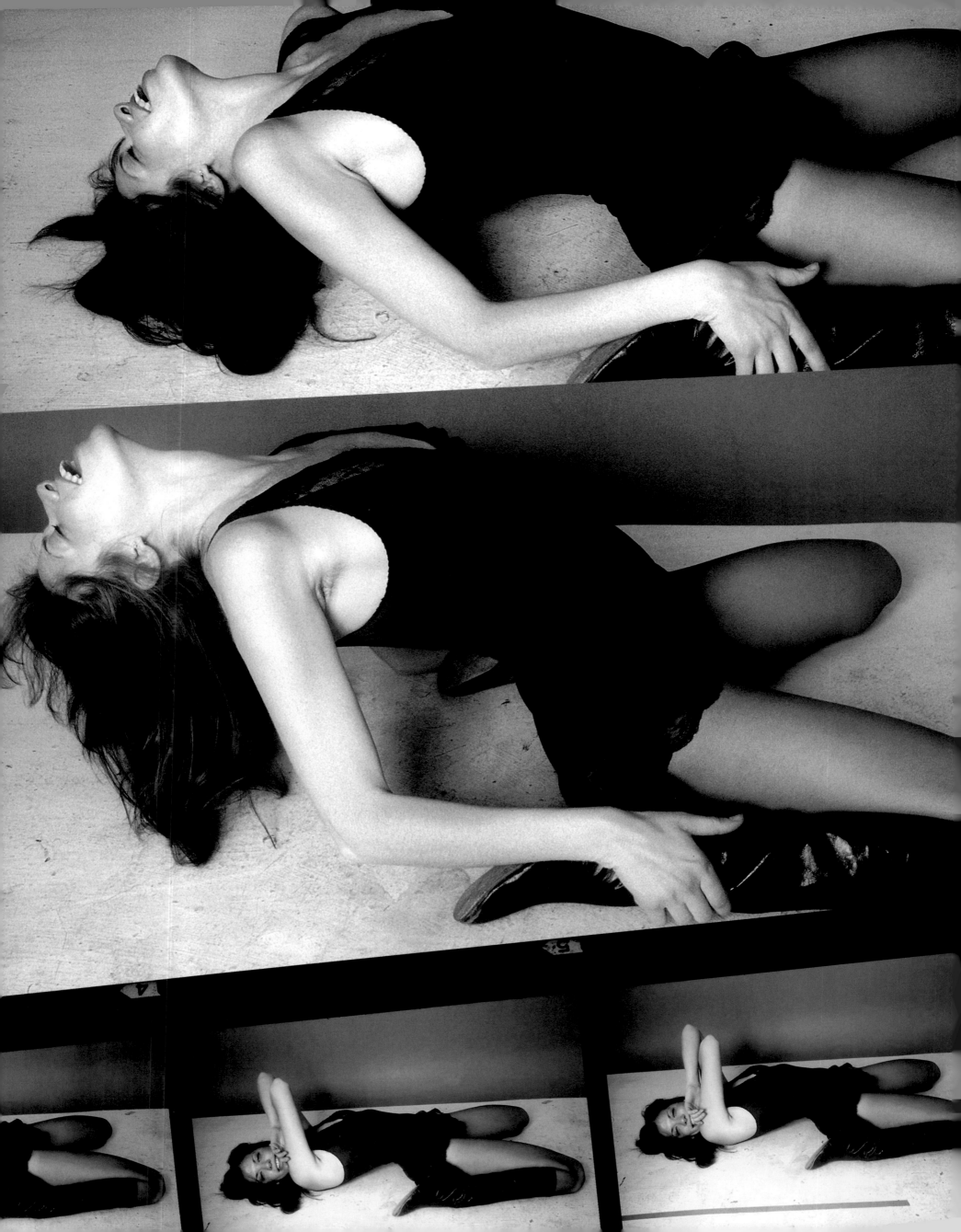

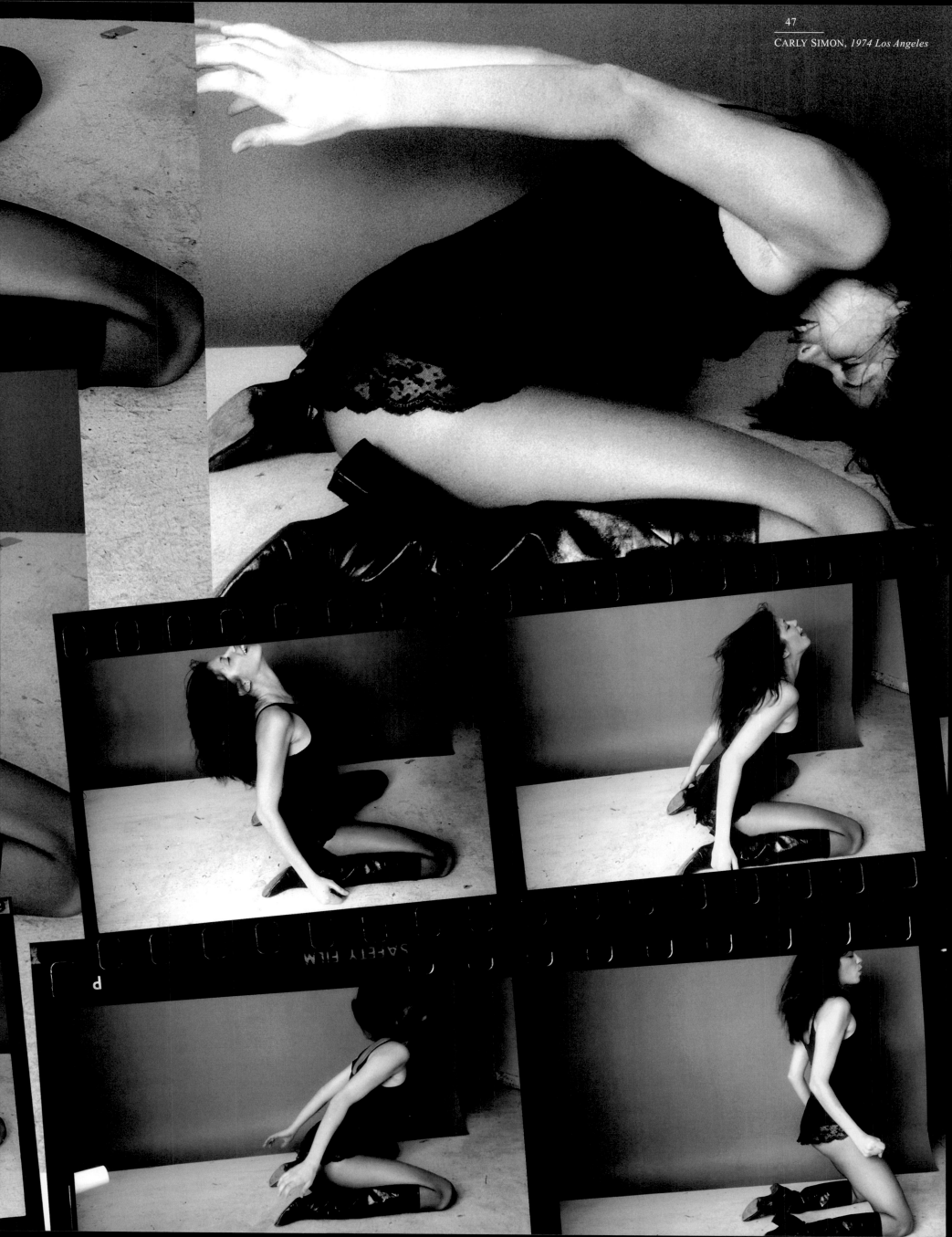

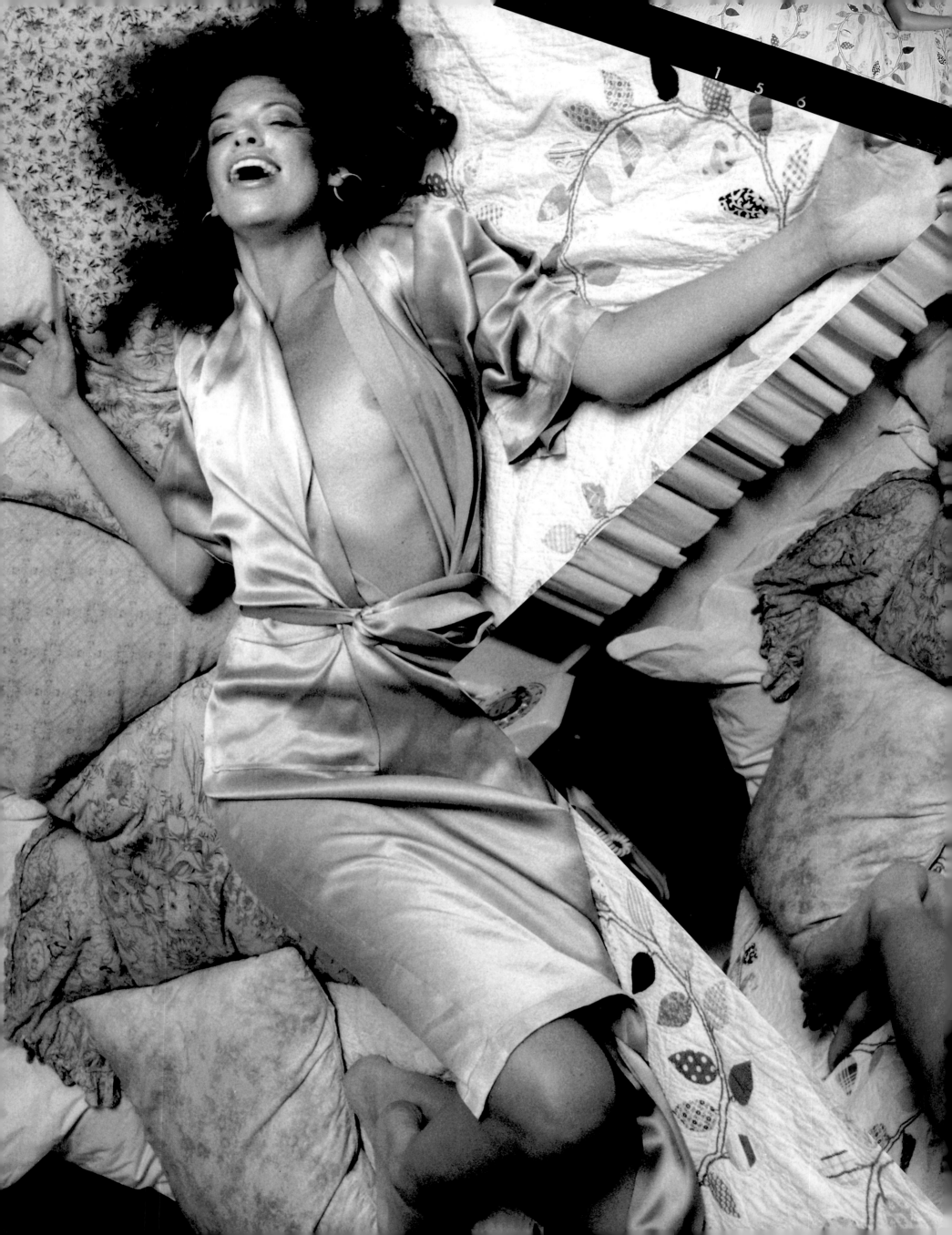

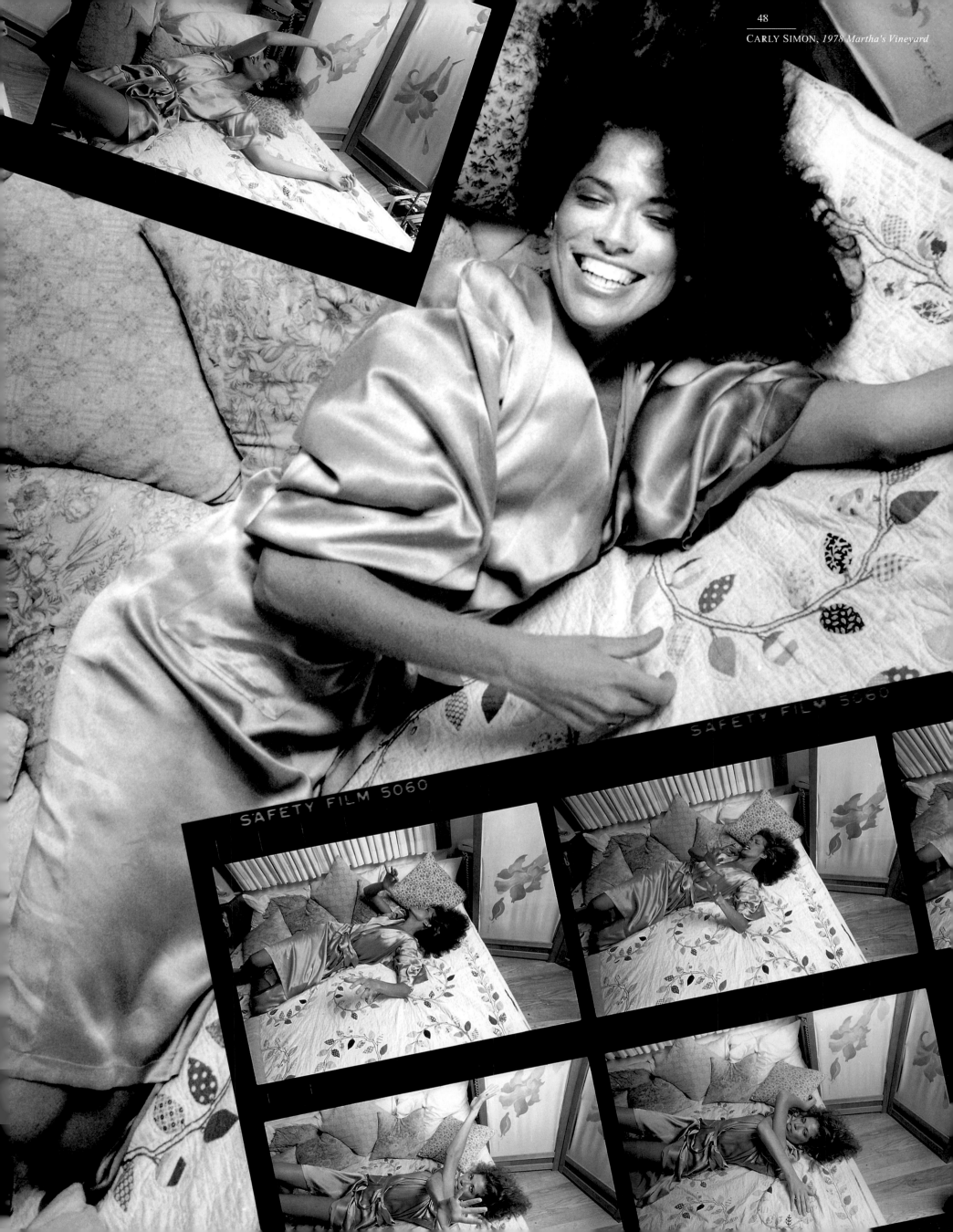

CARLY SIMON, *1978 Martha's Vineyard*

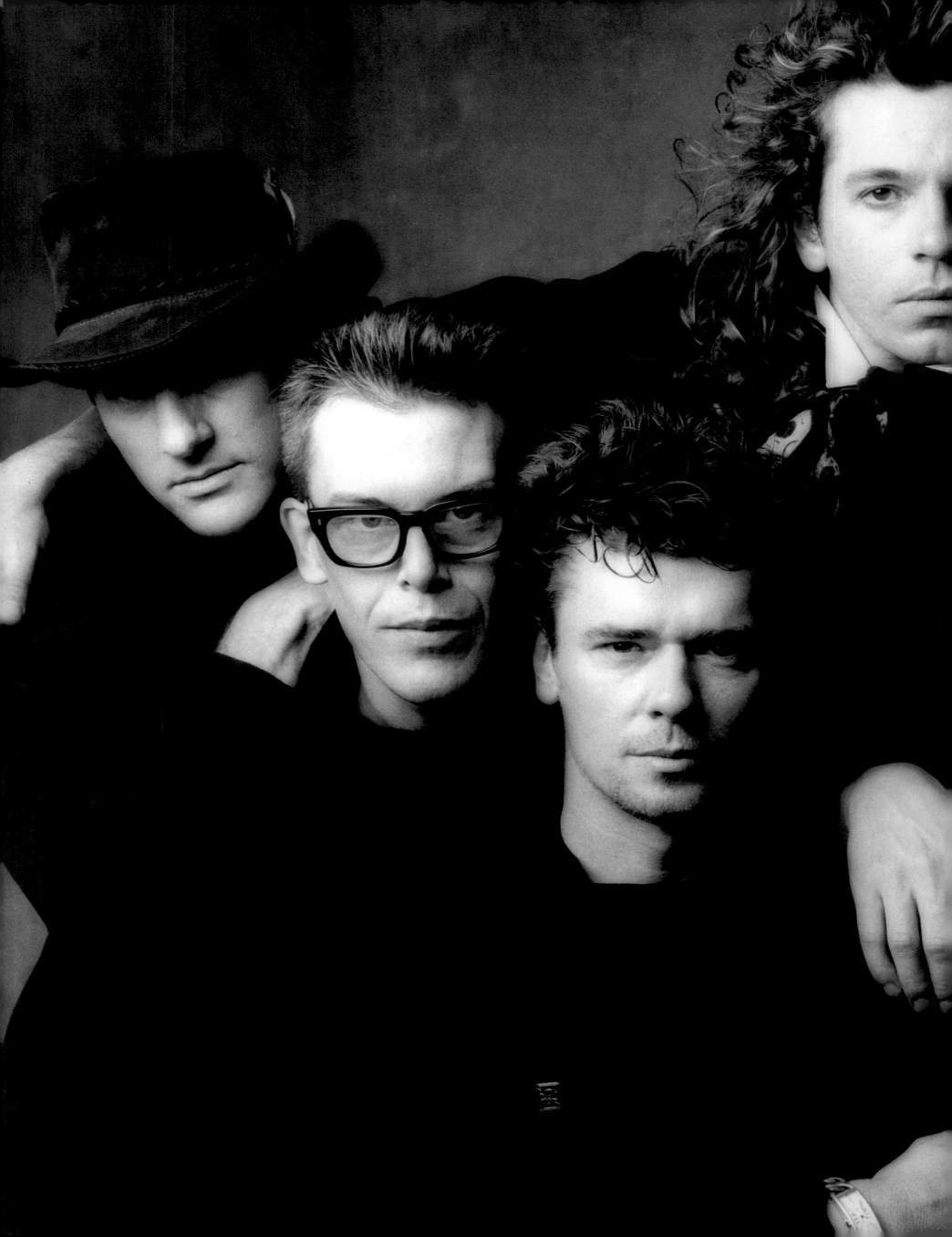

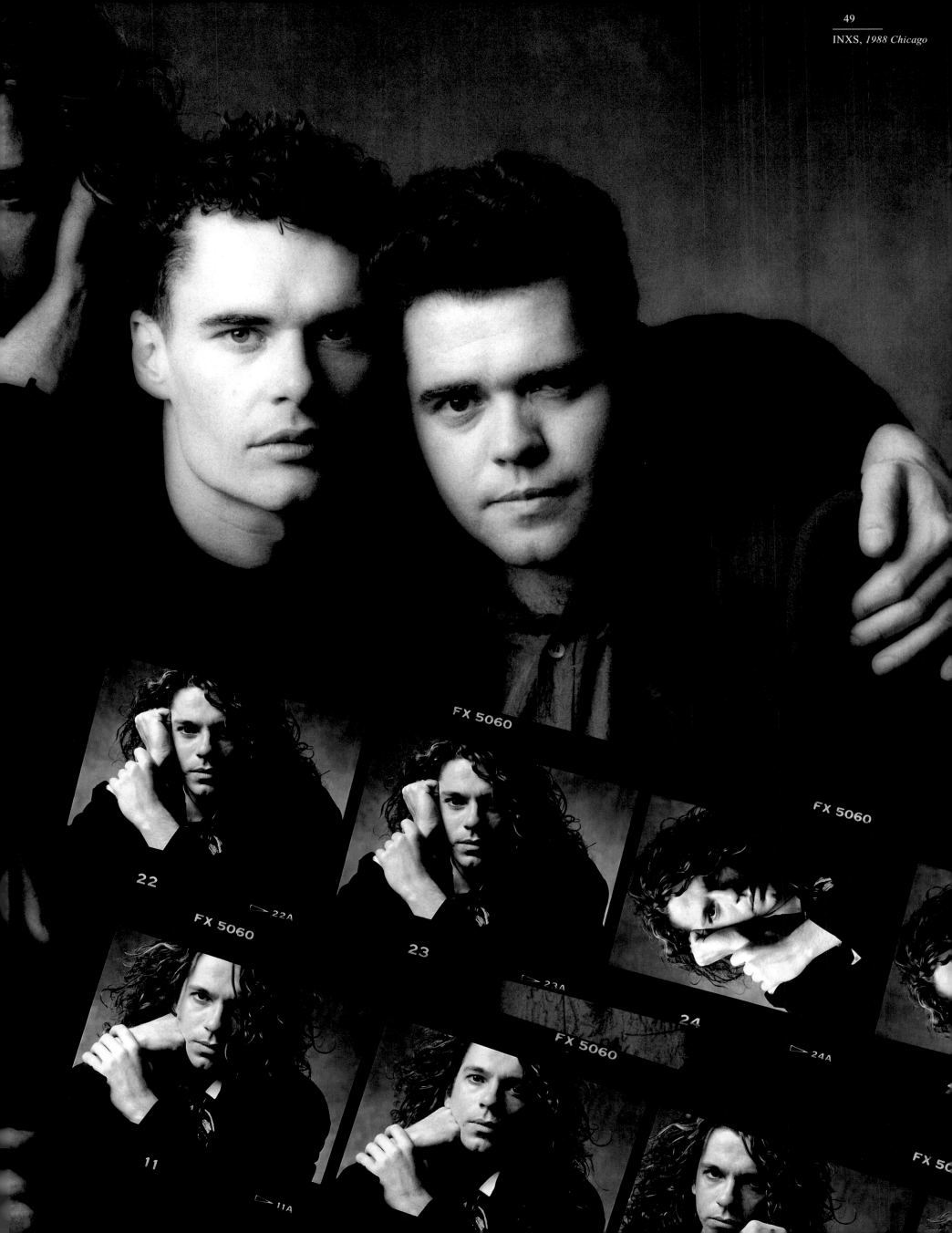

INXS, *1988 Chicago*

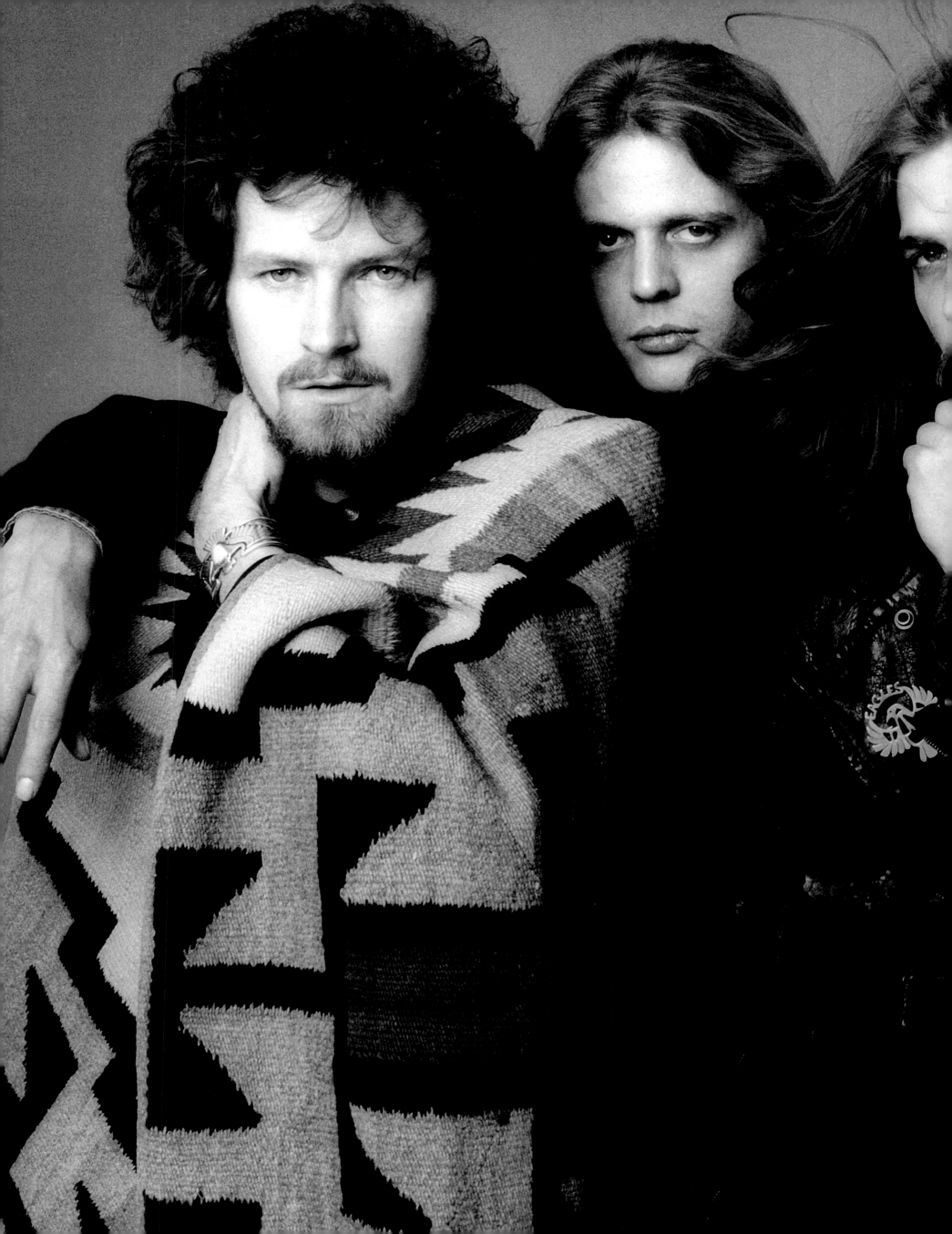

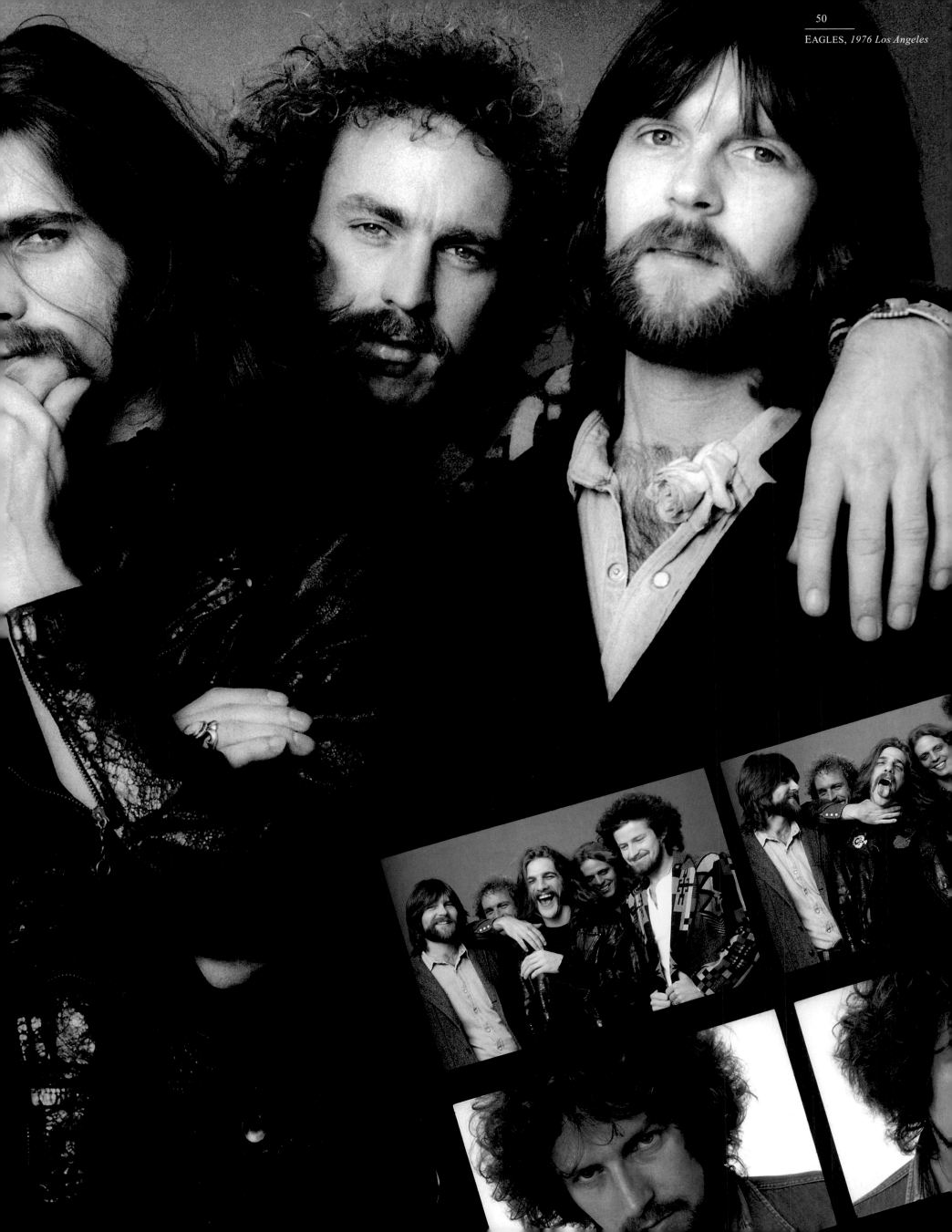

EAGLES, *1976 Los Angeles*

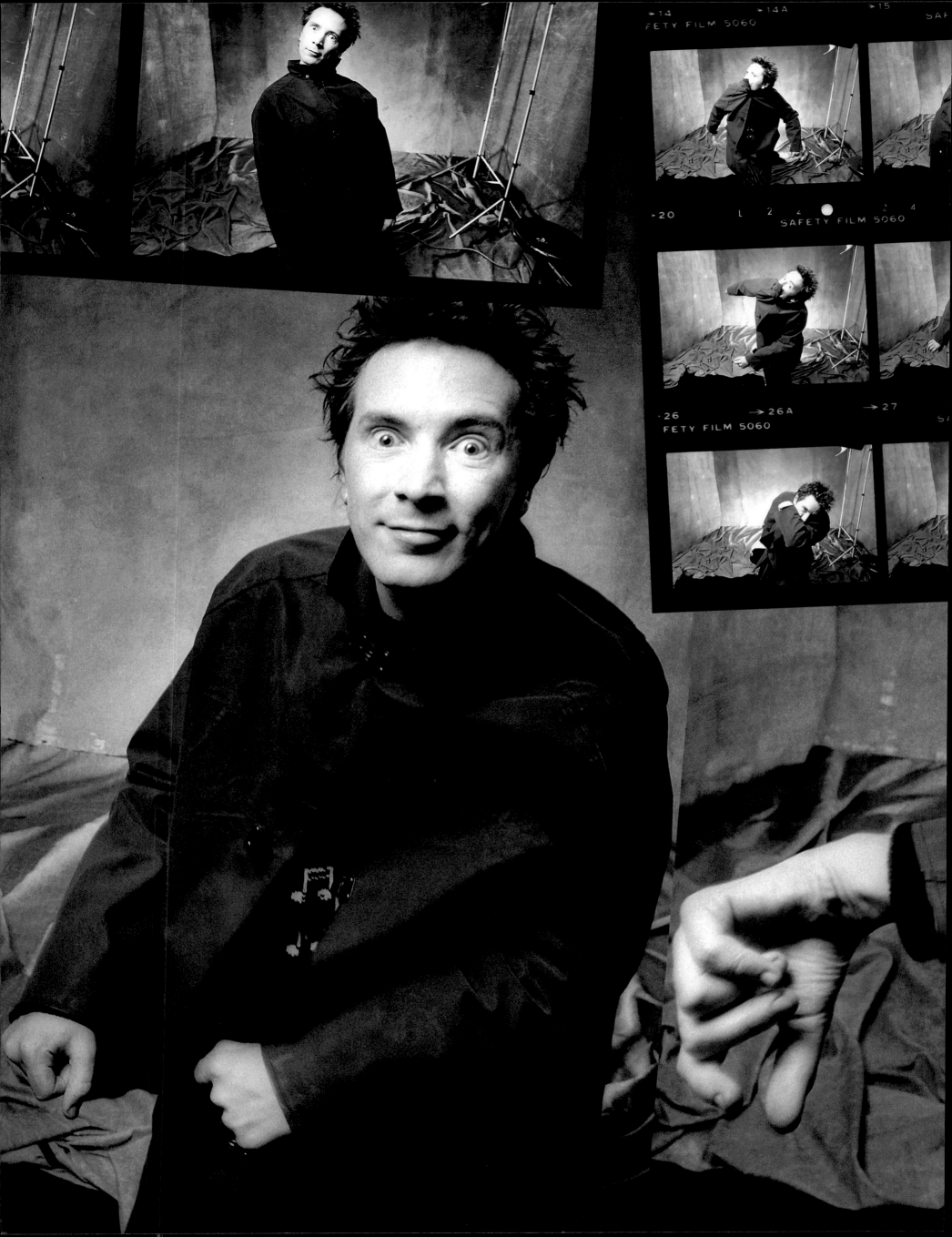

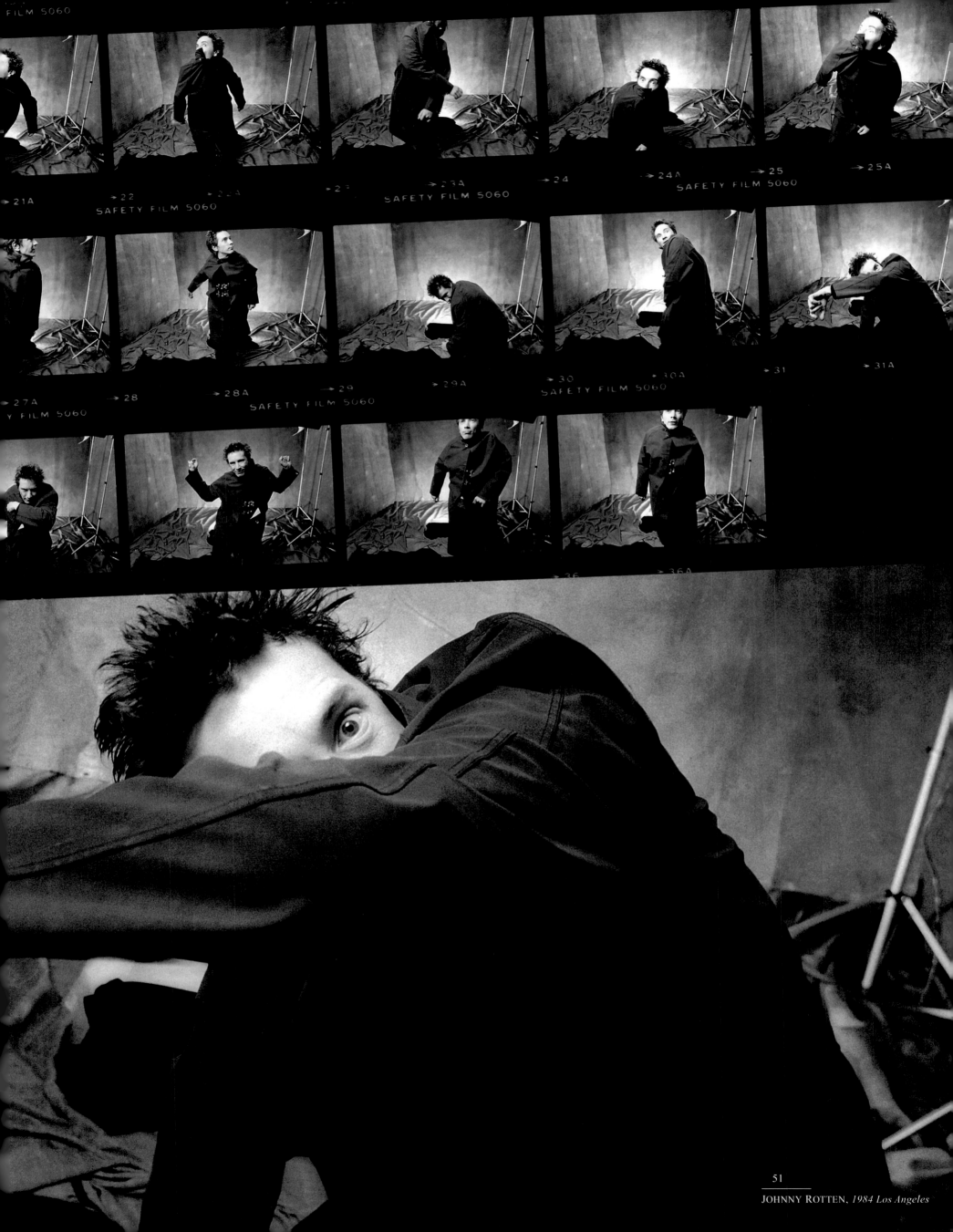

51

JOHNNY ROTTEN, *1984 Los Angeles*

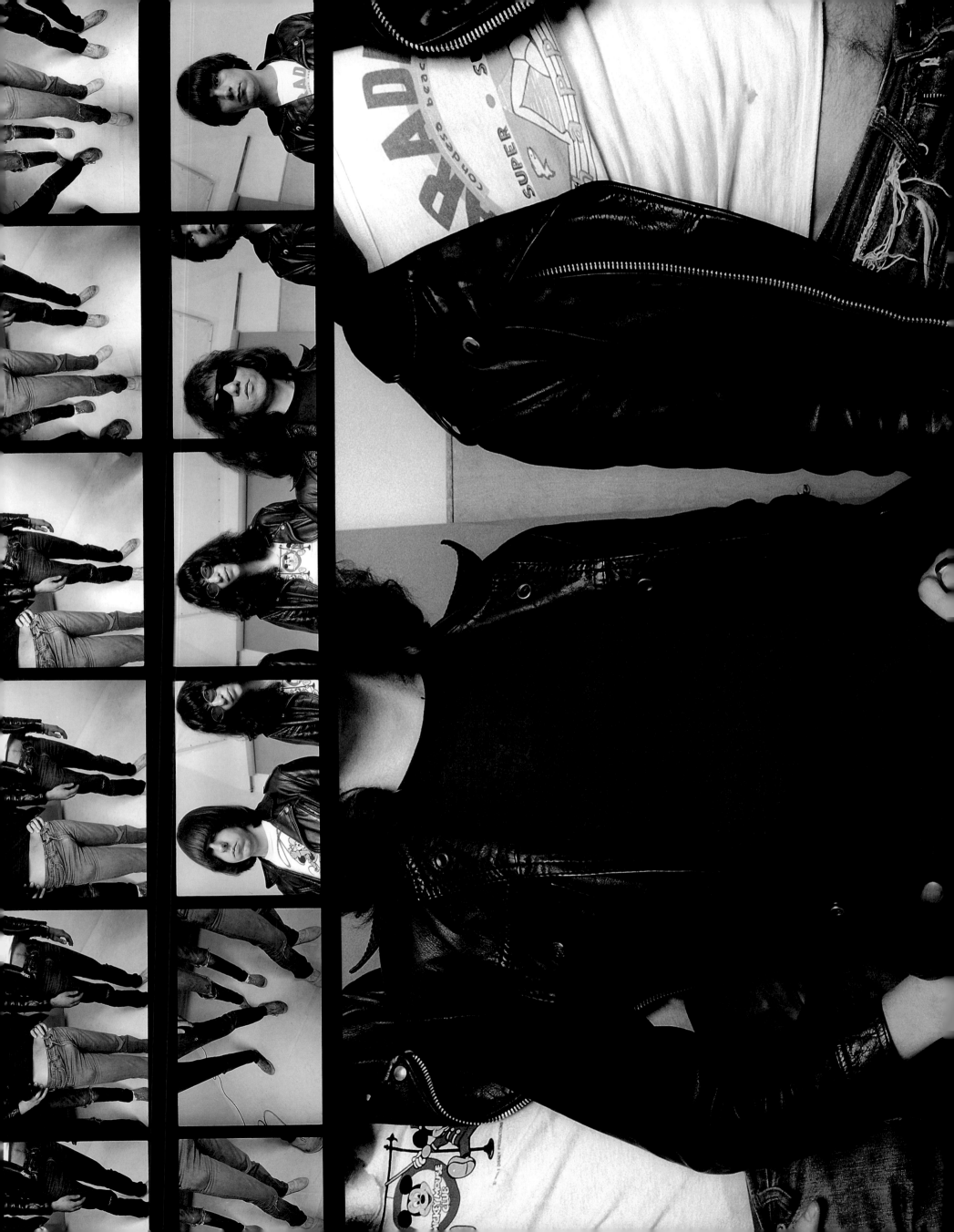

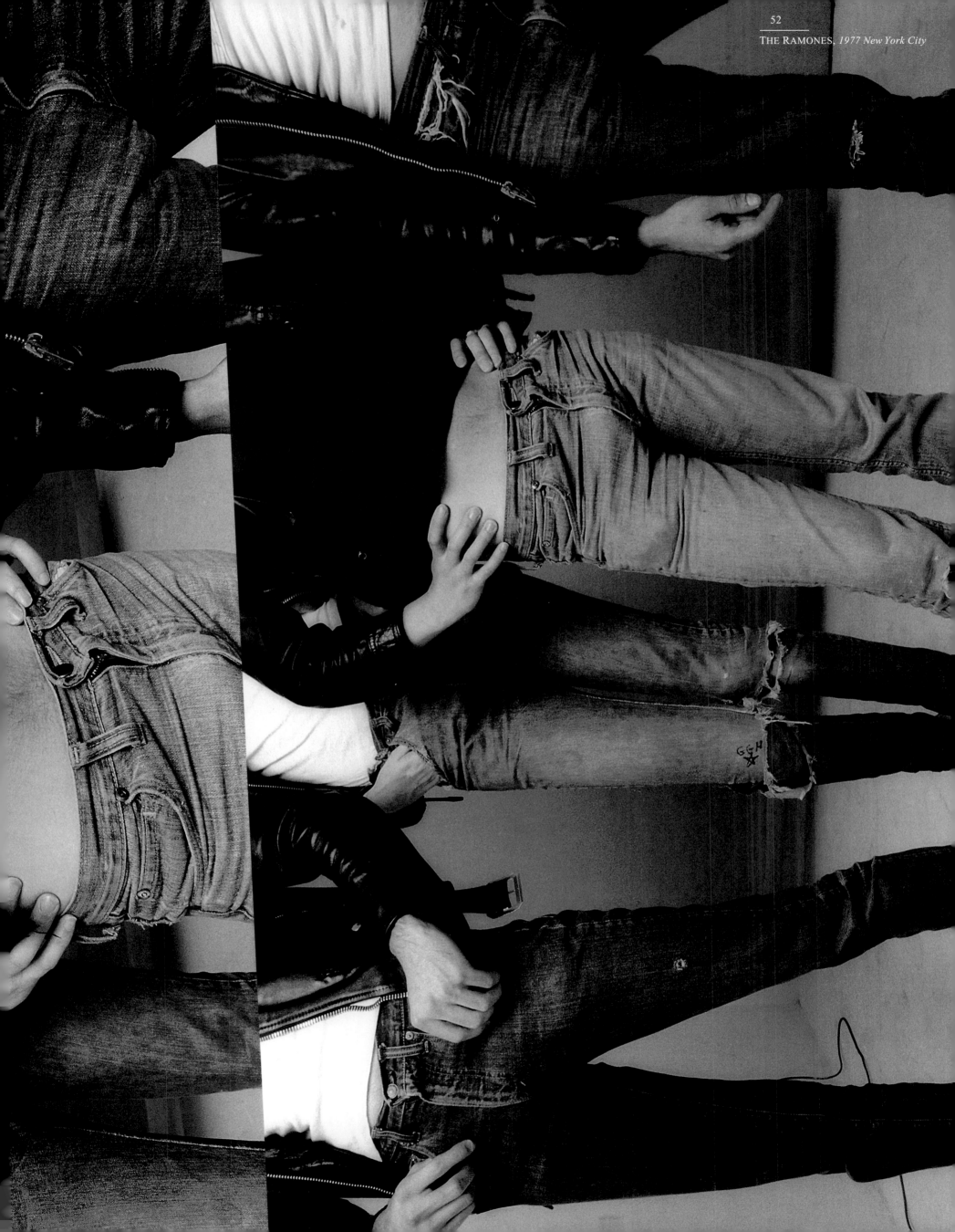

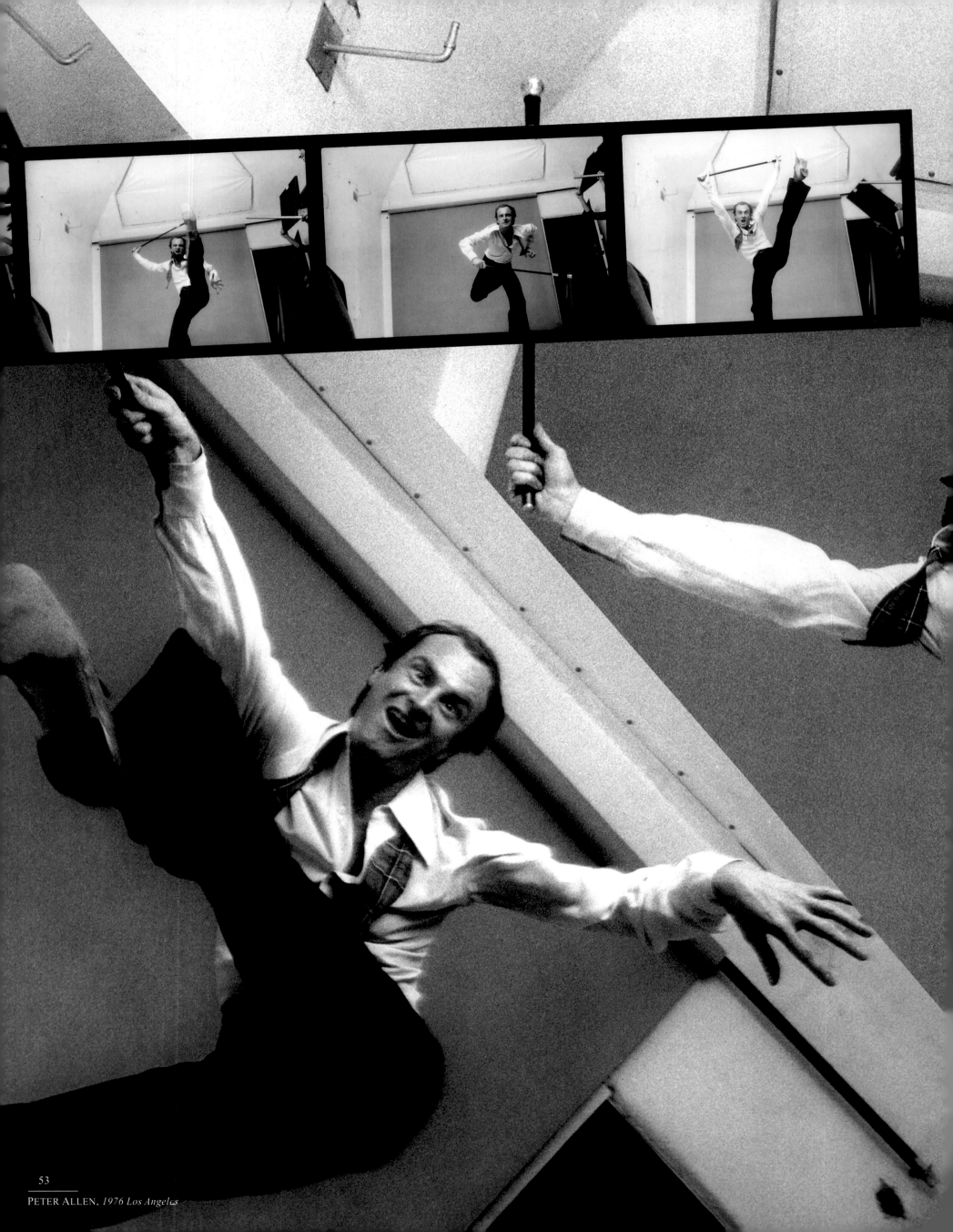

53

PETER ALLEN, *1976 Los Angeles*

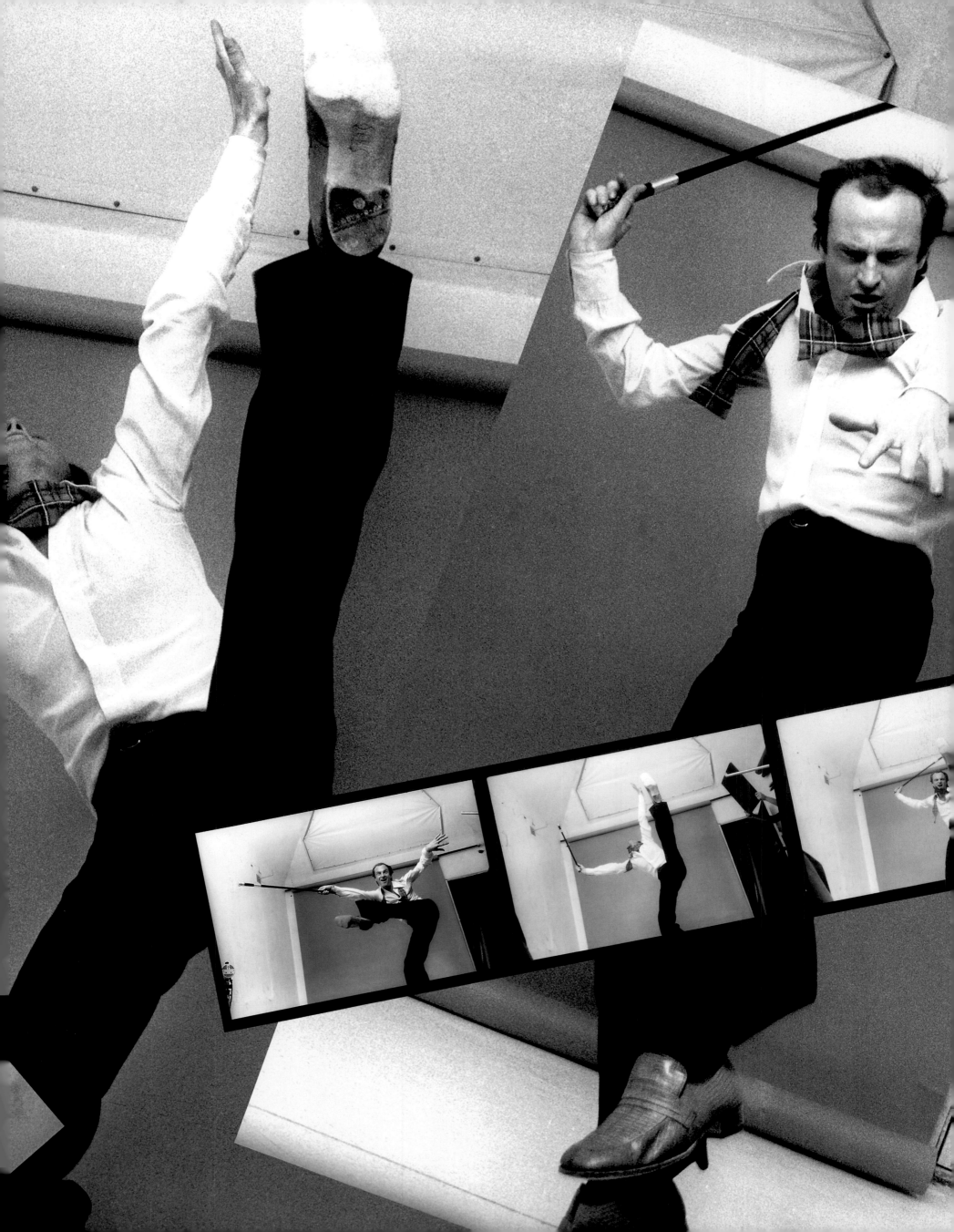

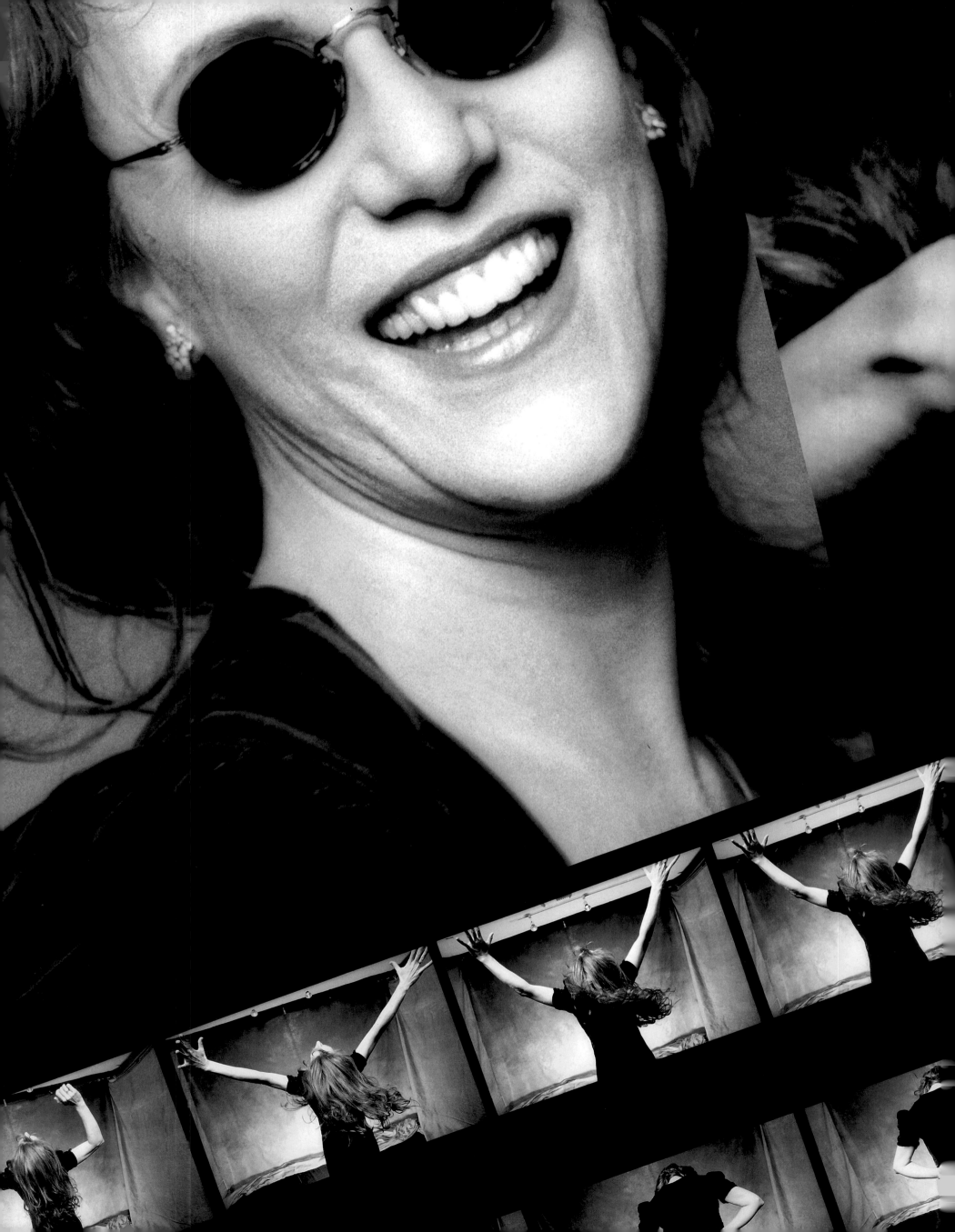

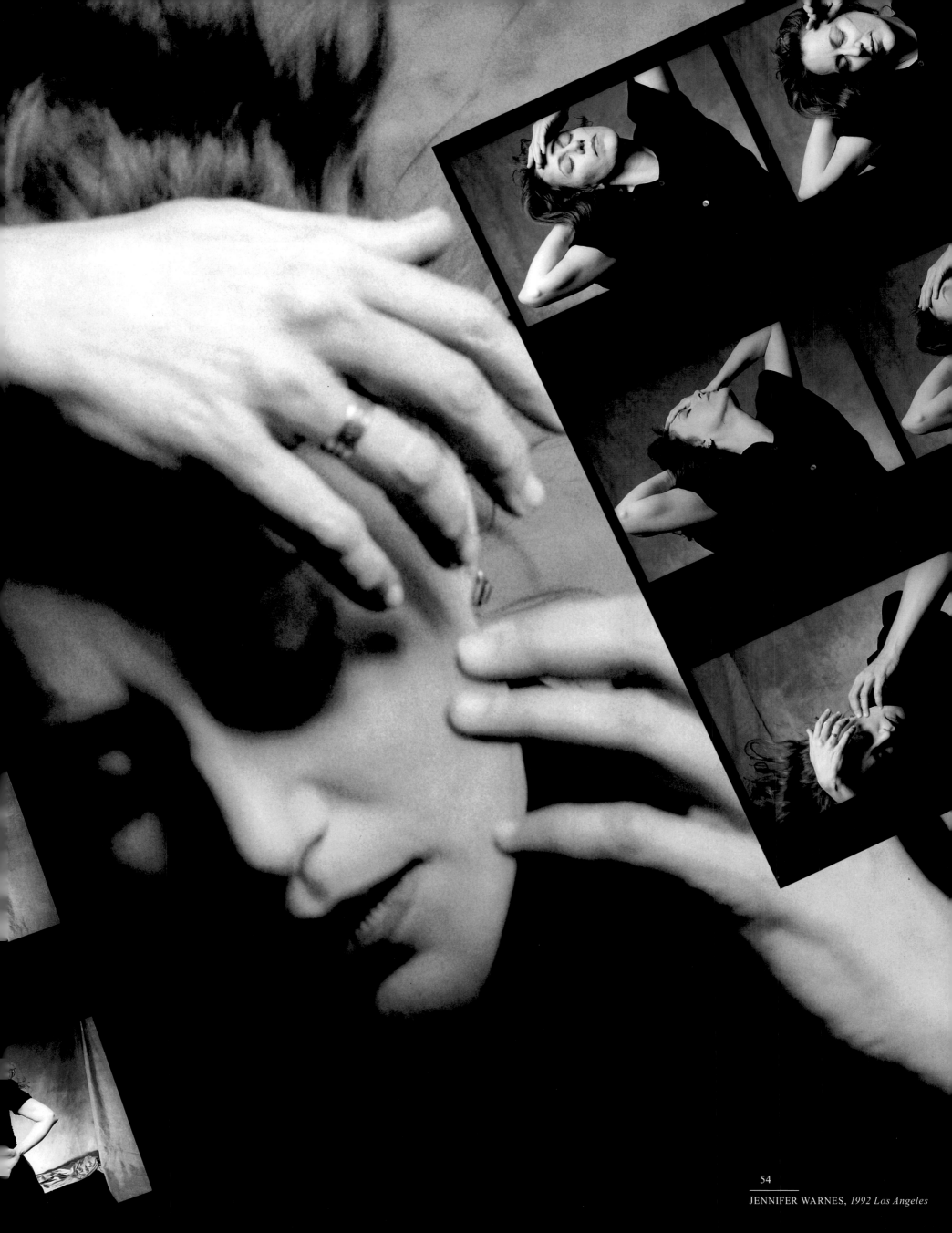

54

JENNIFER WARNES, *1992 Los Angeles*

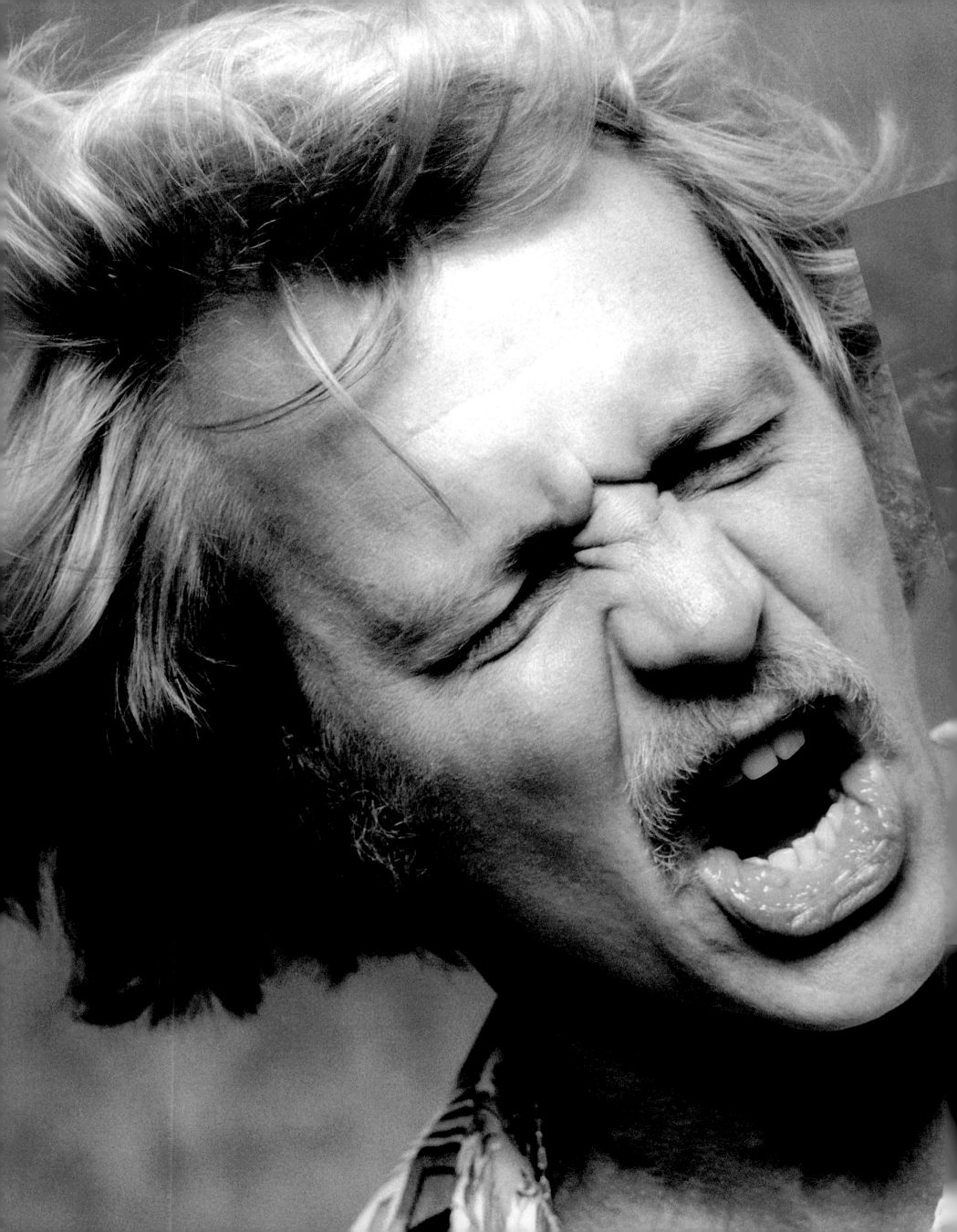

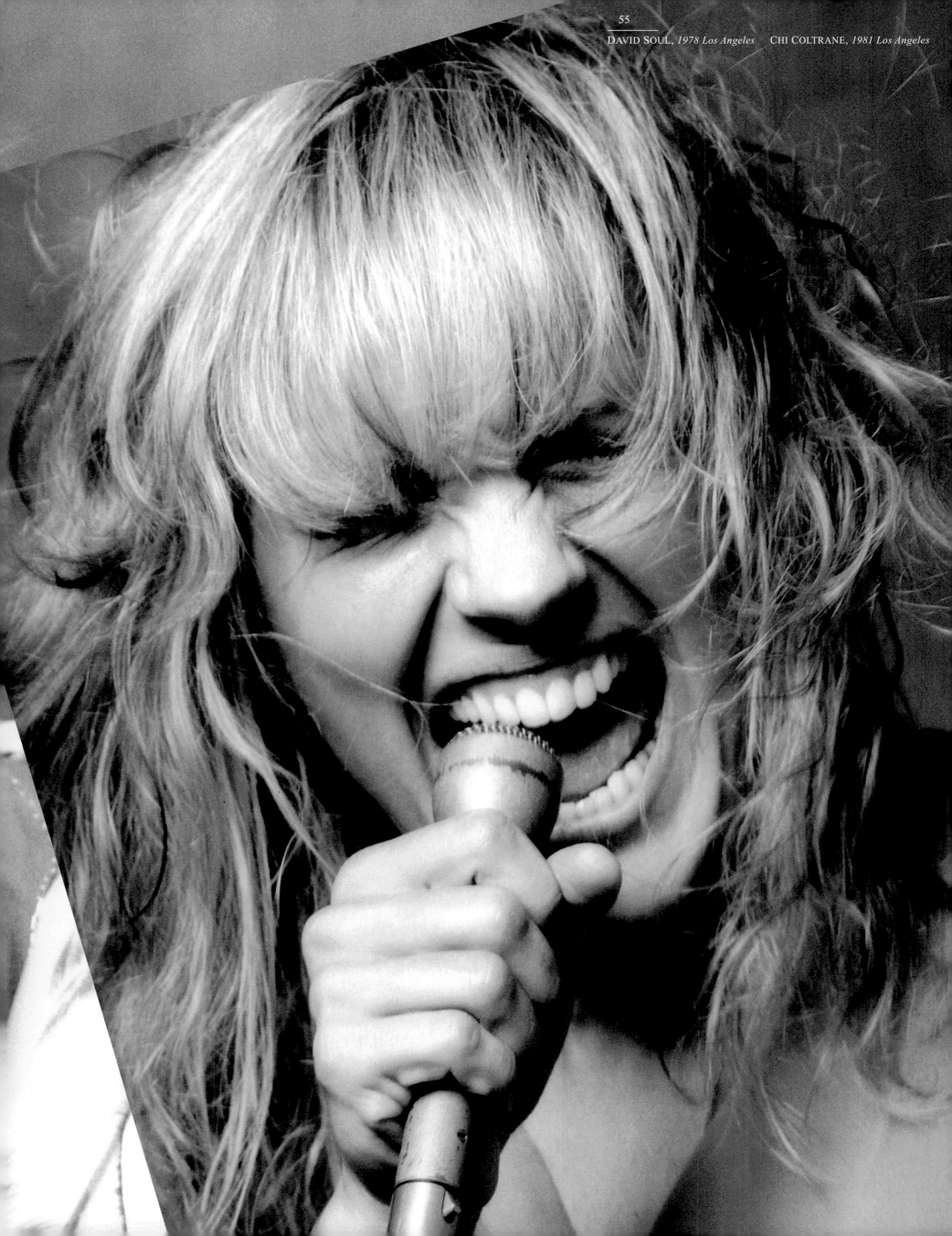

DAVID SOUL, *1978 Los Angeles* CHI COLTRANE, *1981 Los Angeles*

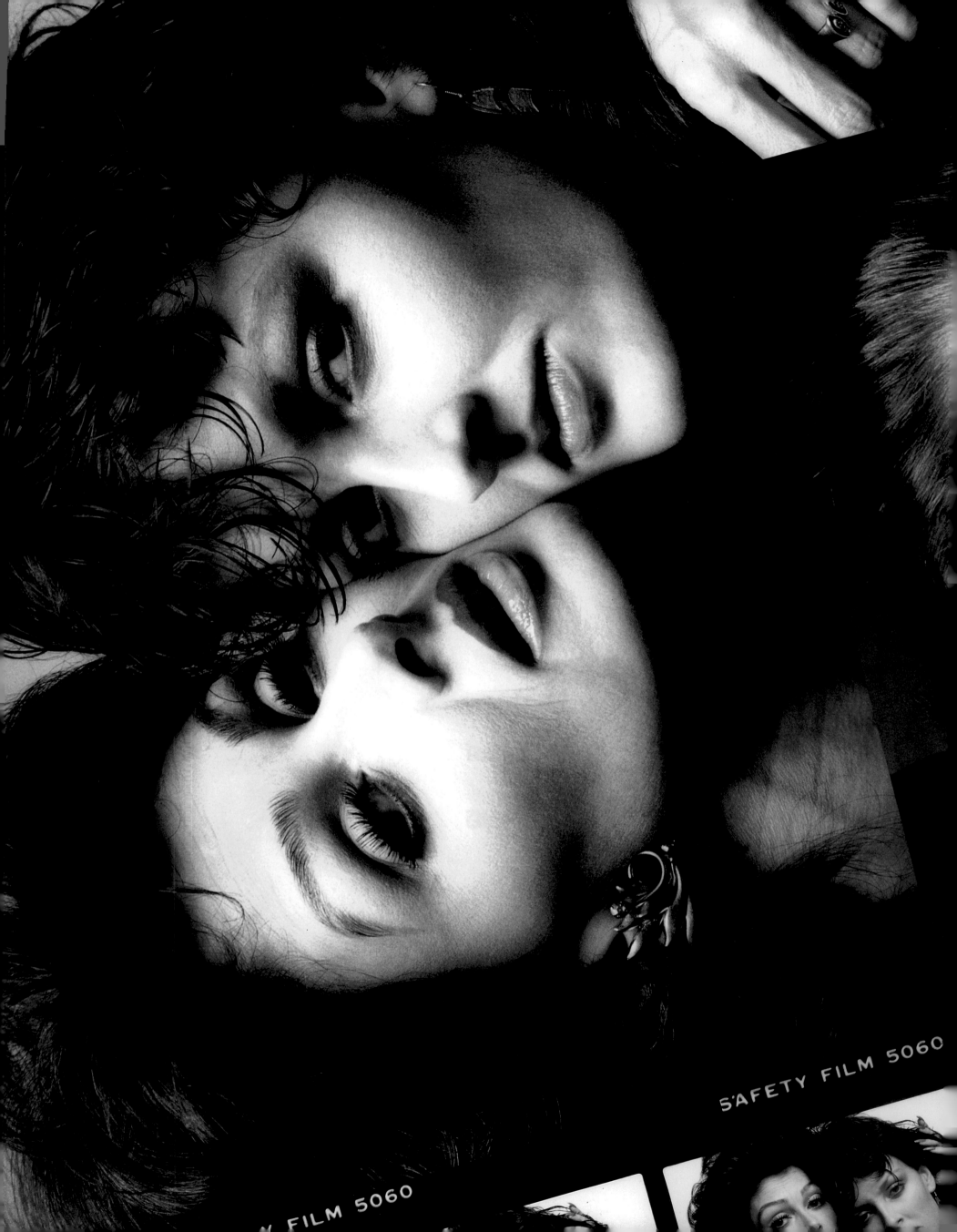

SAFETY FILM 5060

FILM 5060

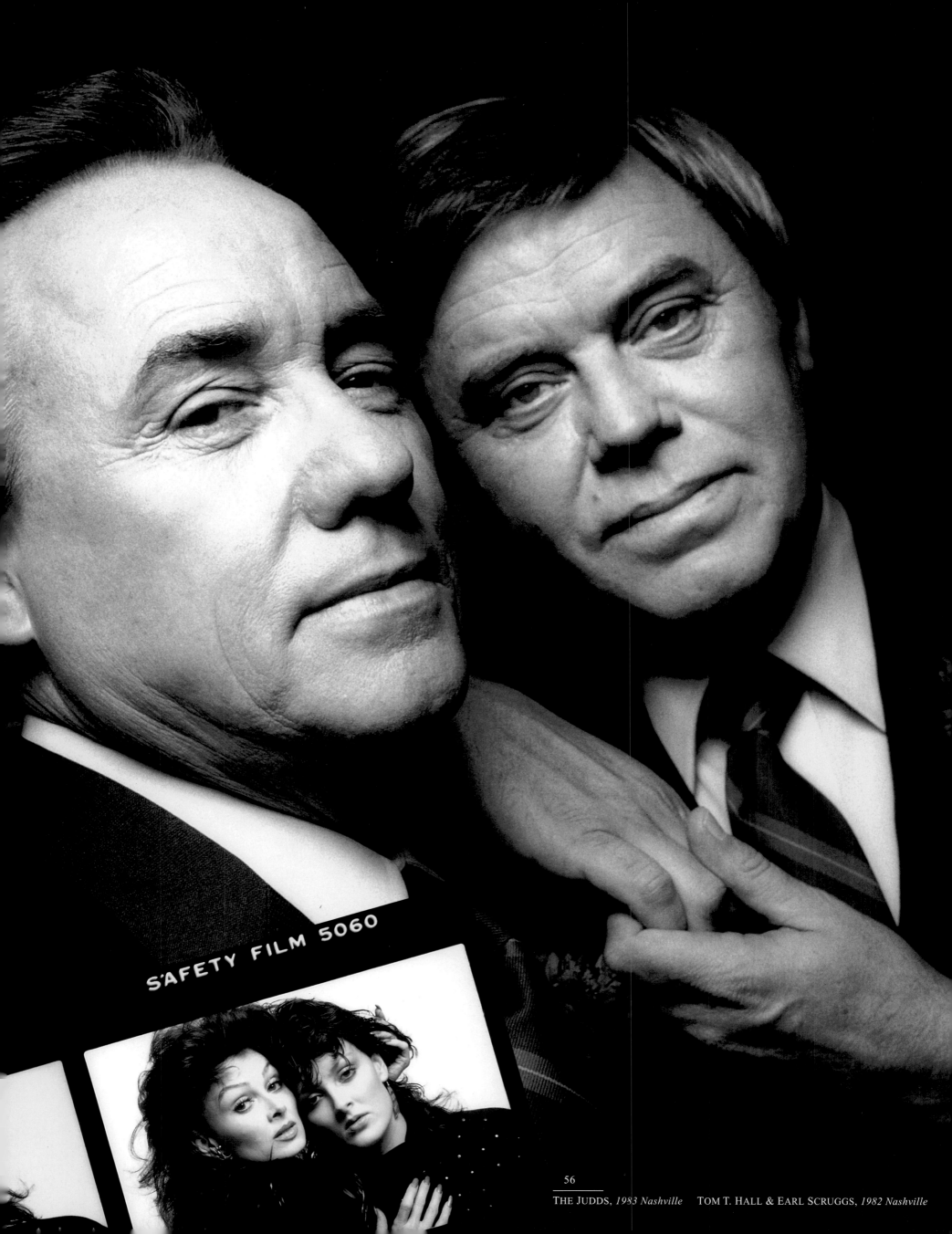

SAFETY FILM 5060

56

THE JUDDS, *1983 Nashville* TOM T. HALL & EARL SCRUGGS, *1982 Nashville*

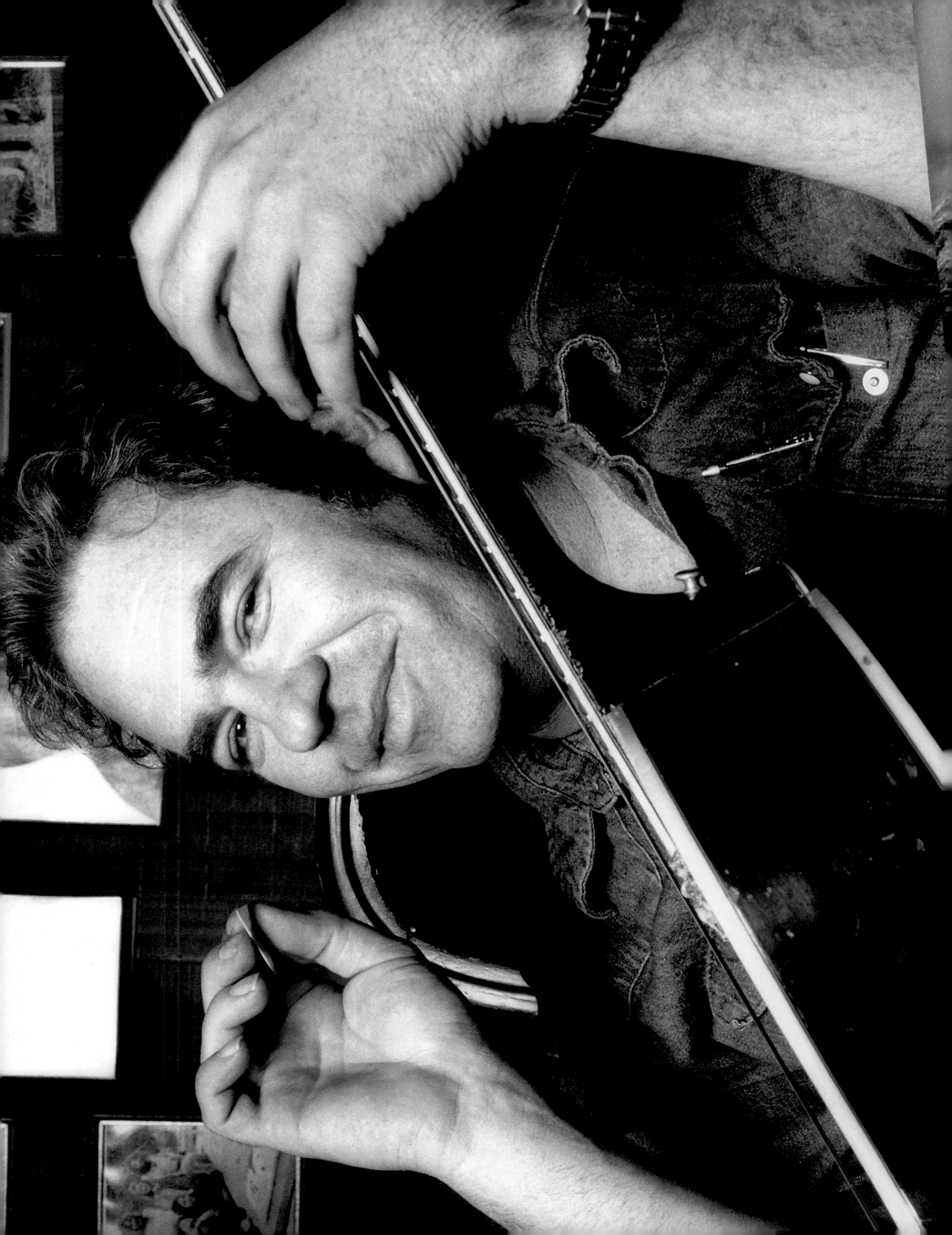

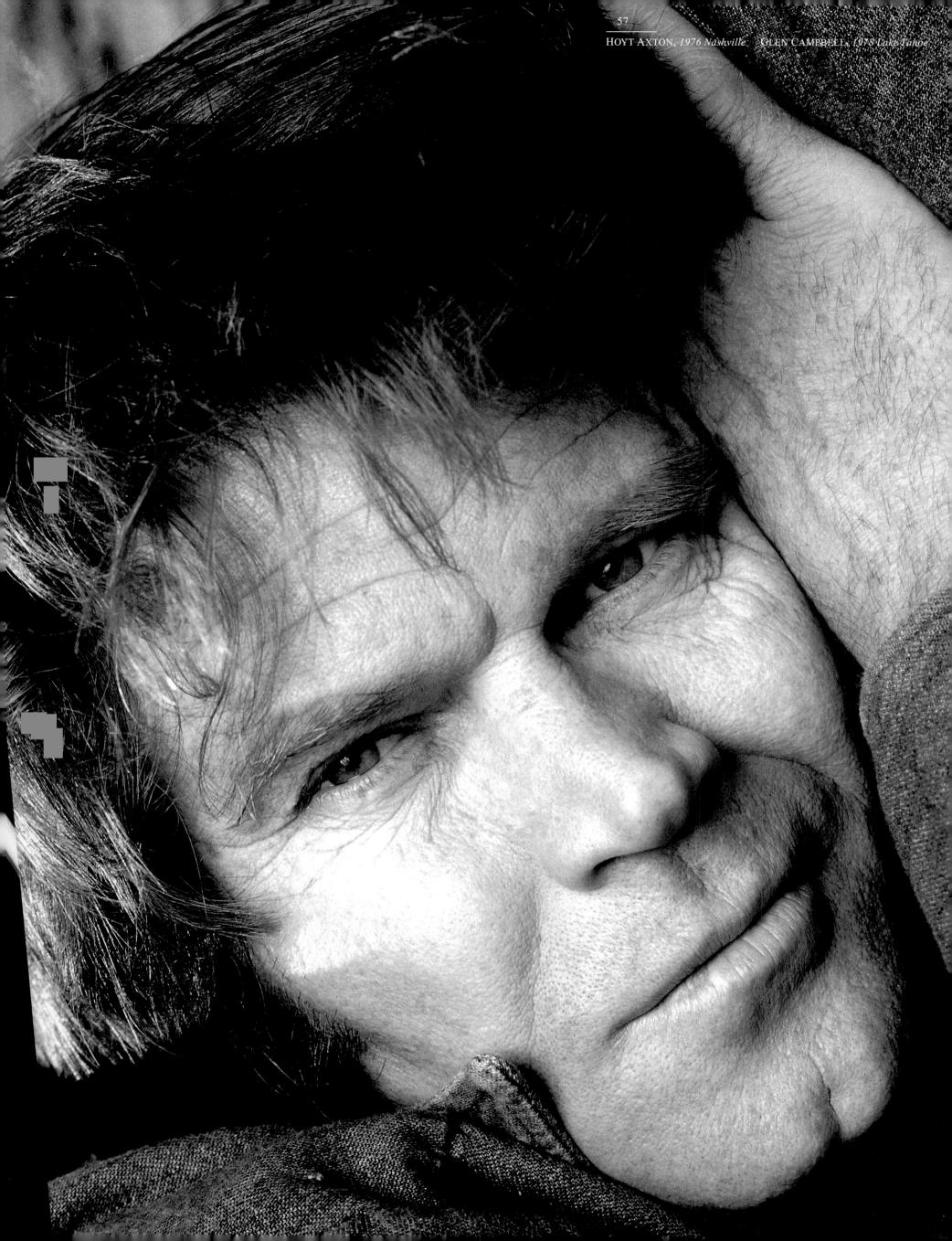

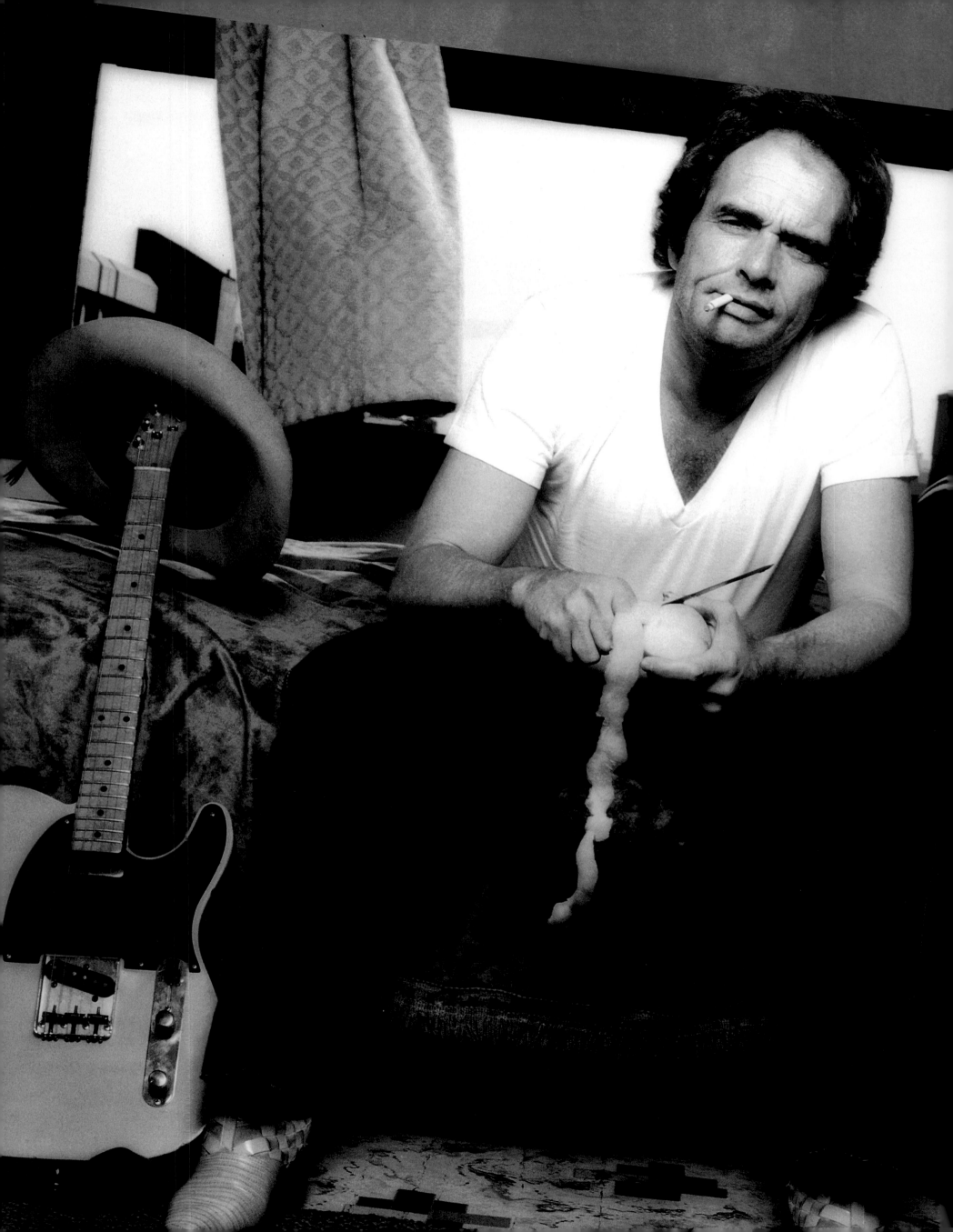

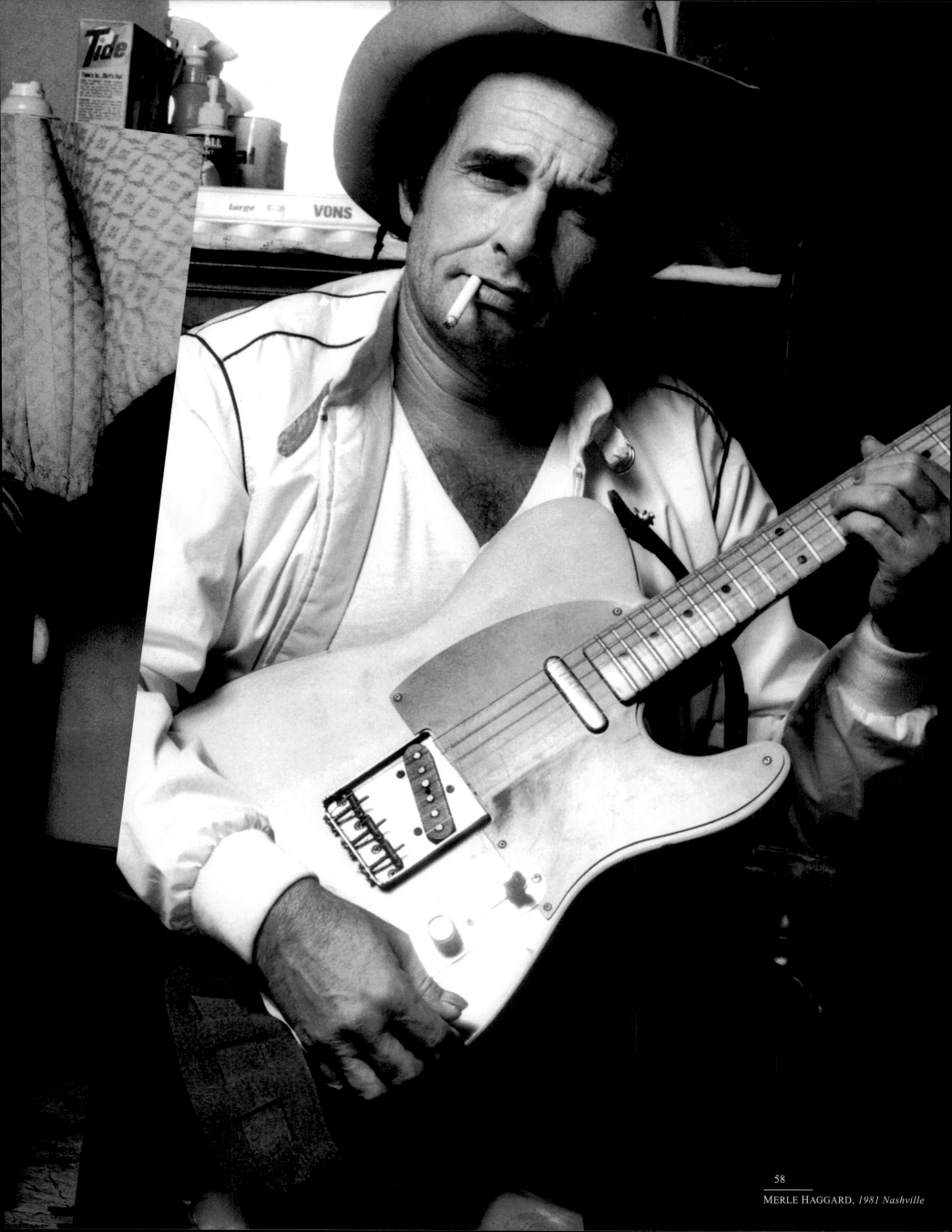

MERLE HAGGARD, *1981 Nashville*

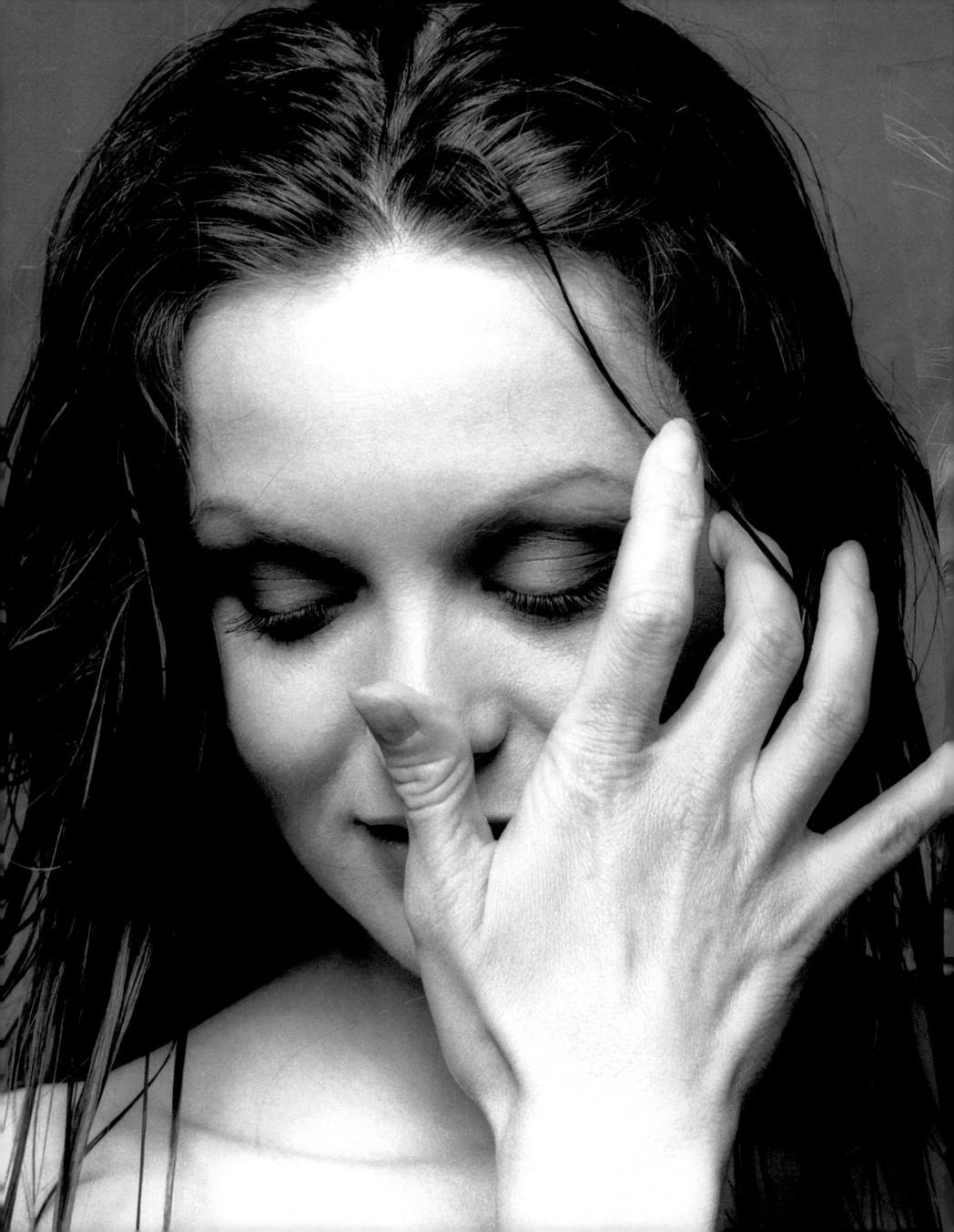

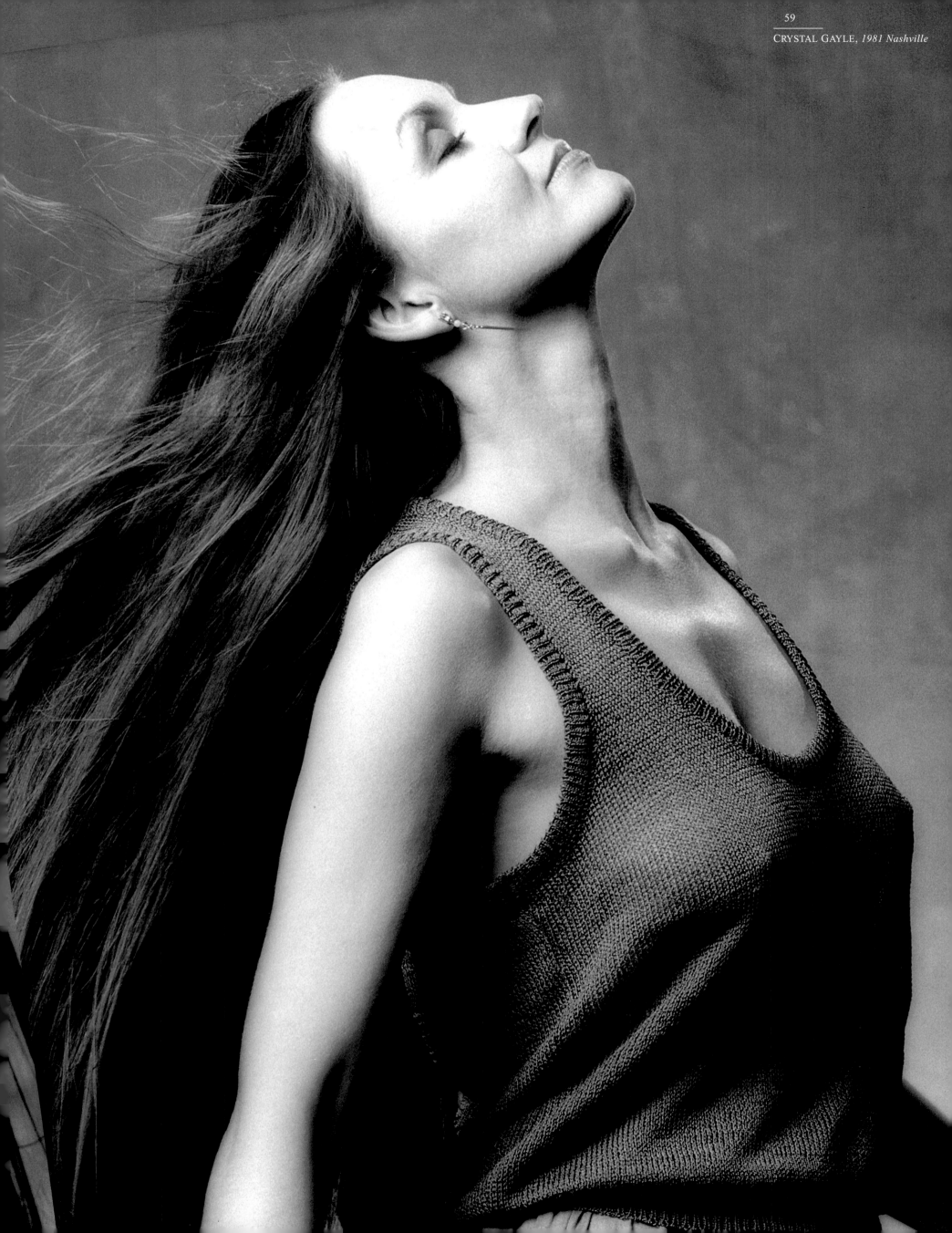

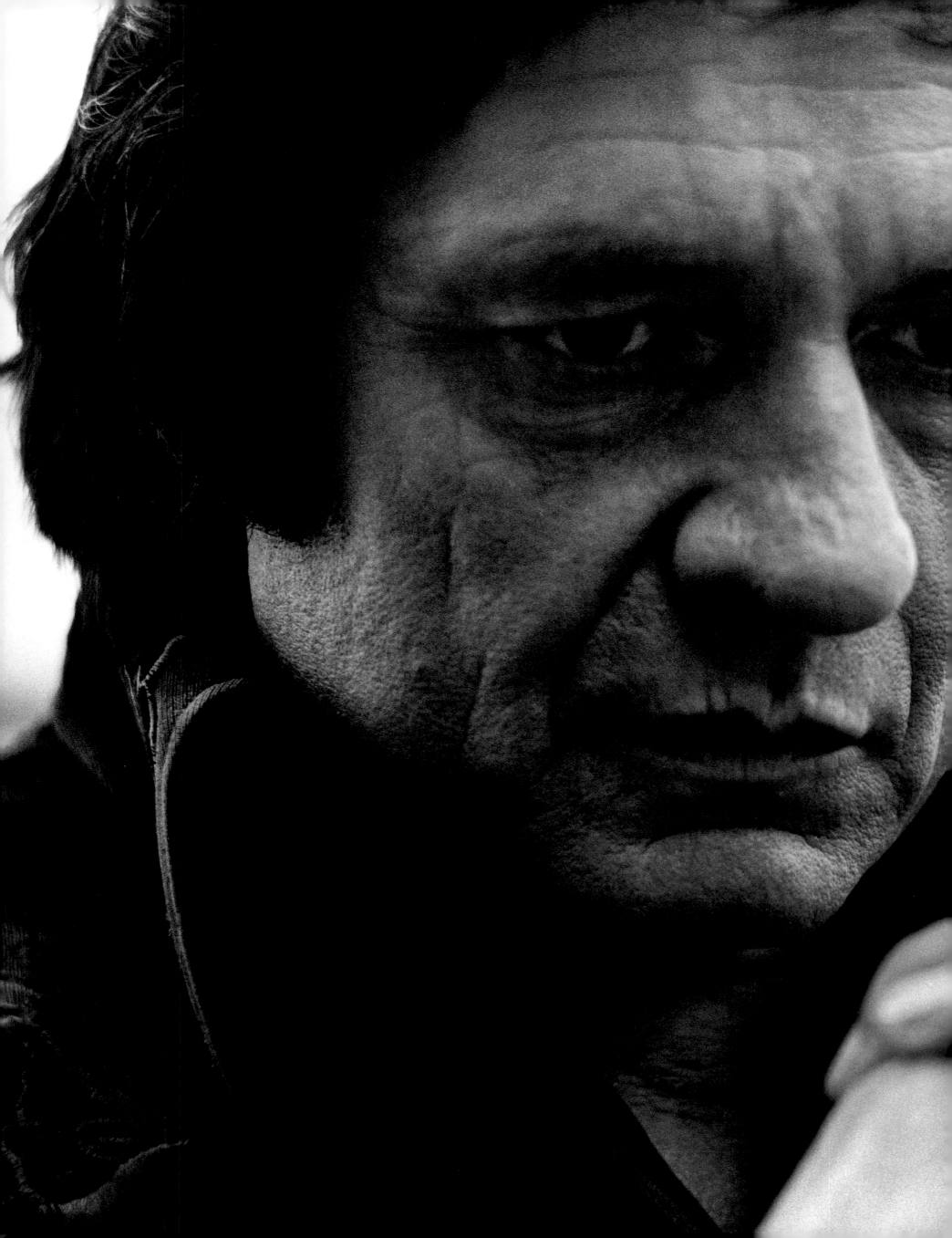

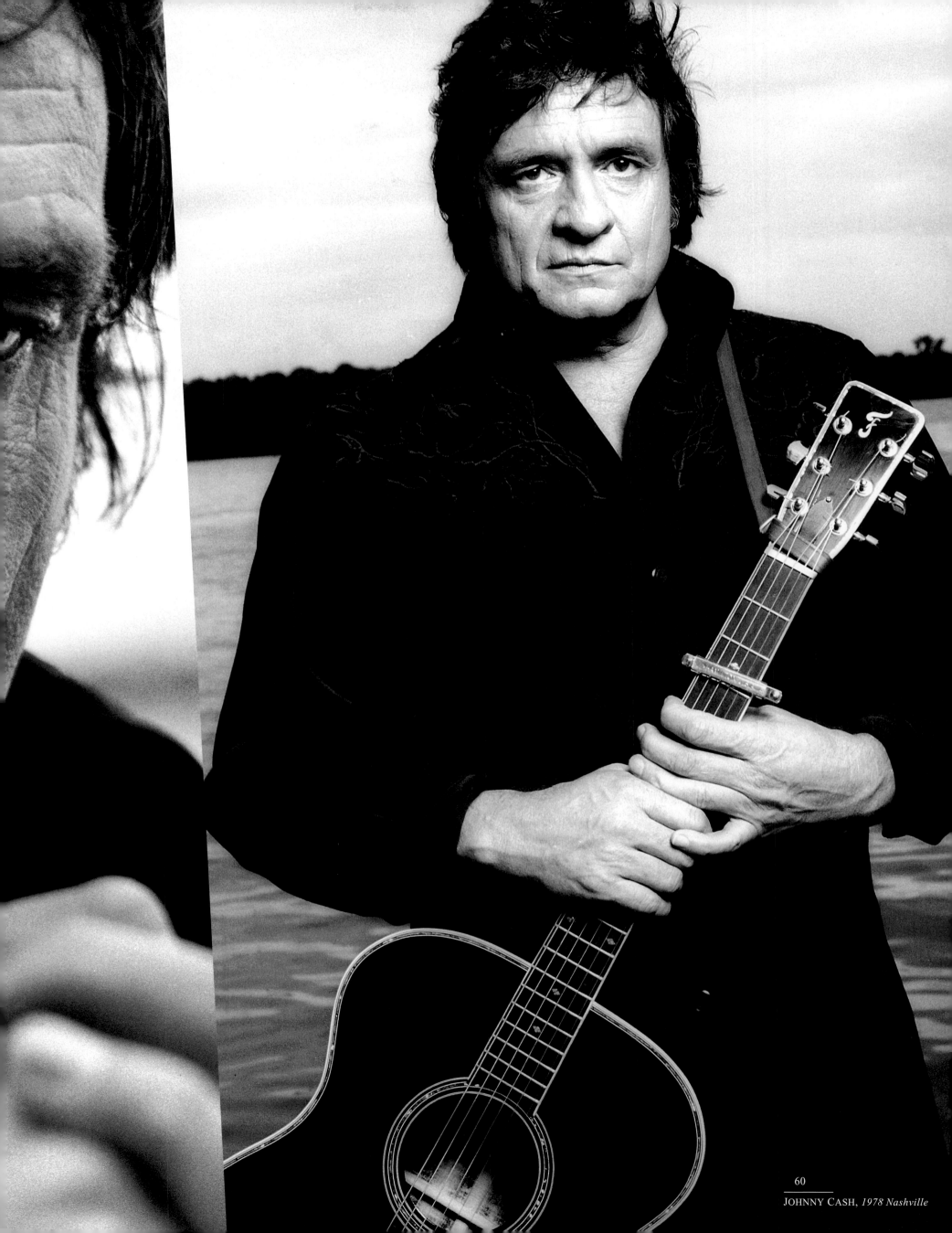

60

JOHNNY CASH, *1978 Nashville*

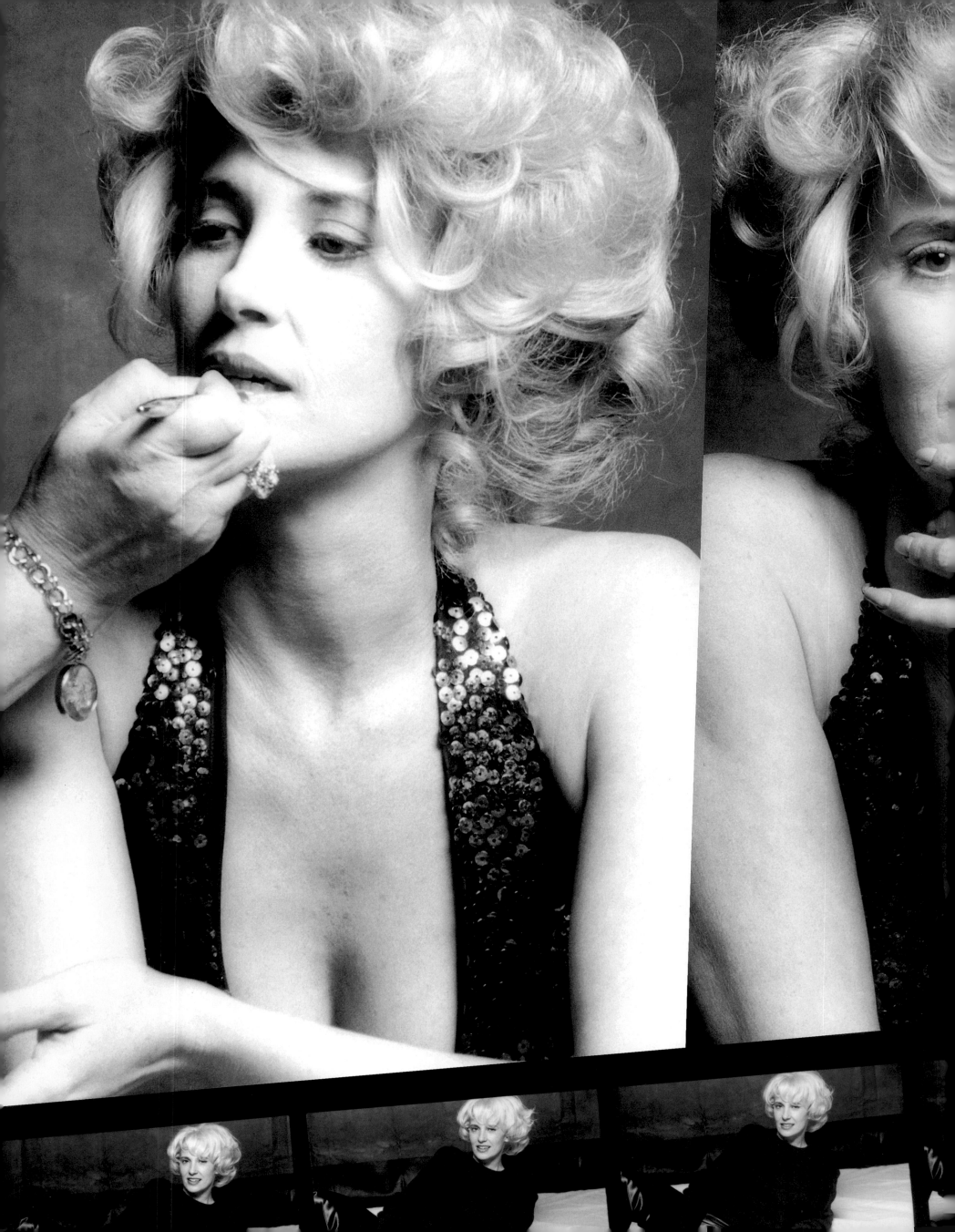

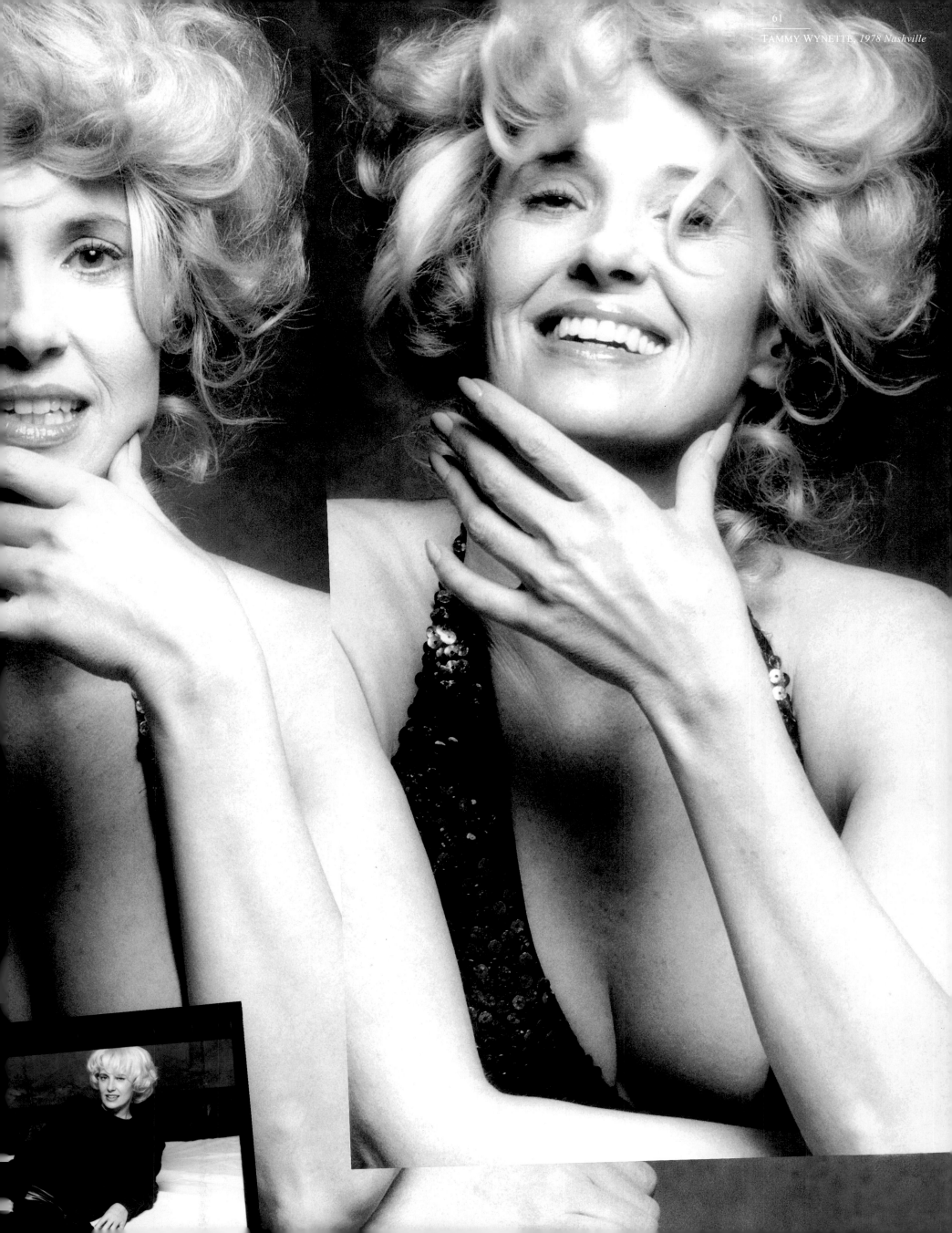

TAMMY WYNETTE, *1978 Nashville*

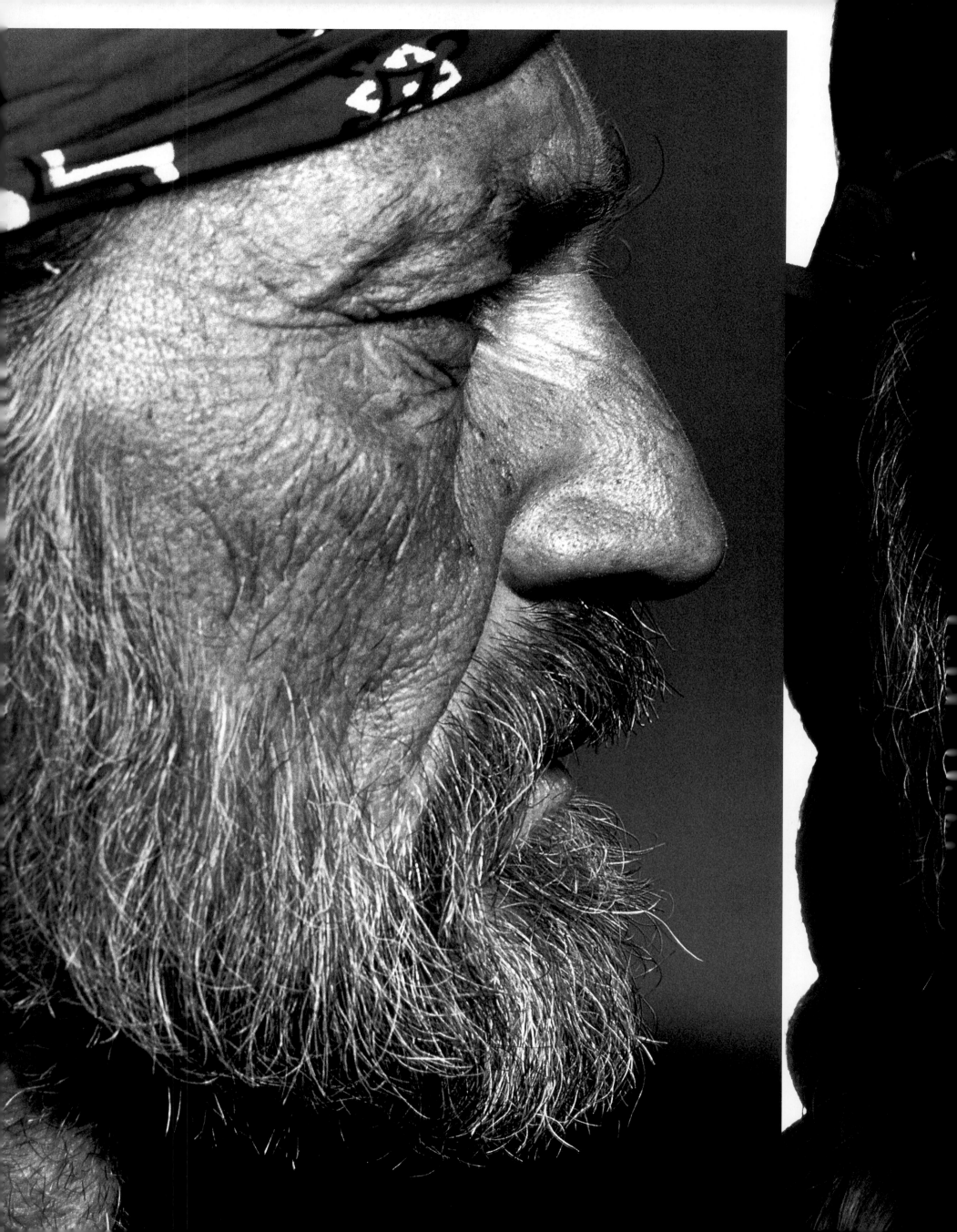

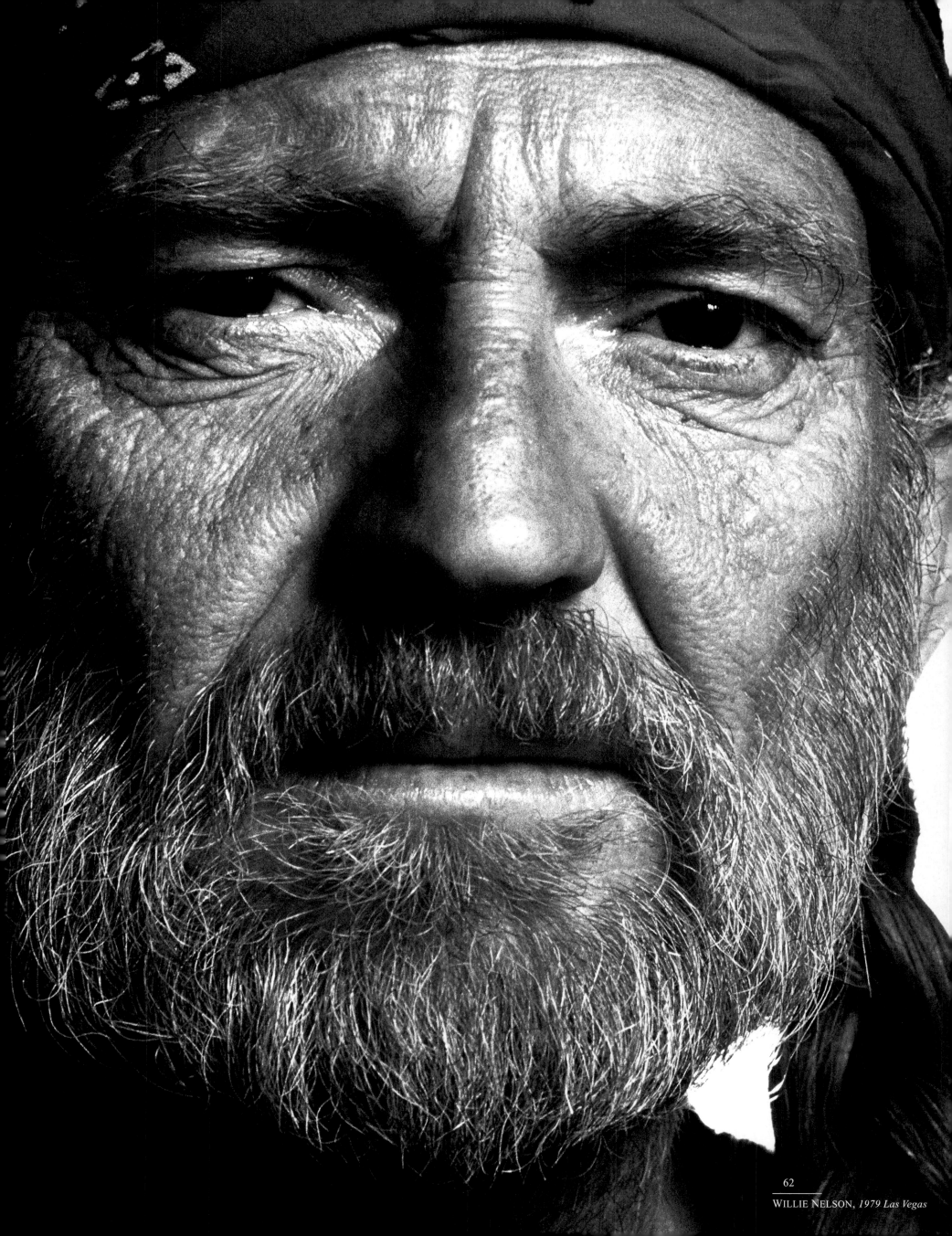

WILLIE NELSON, *1979 Las Vegas*

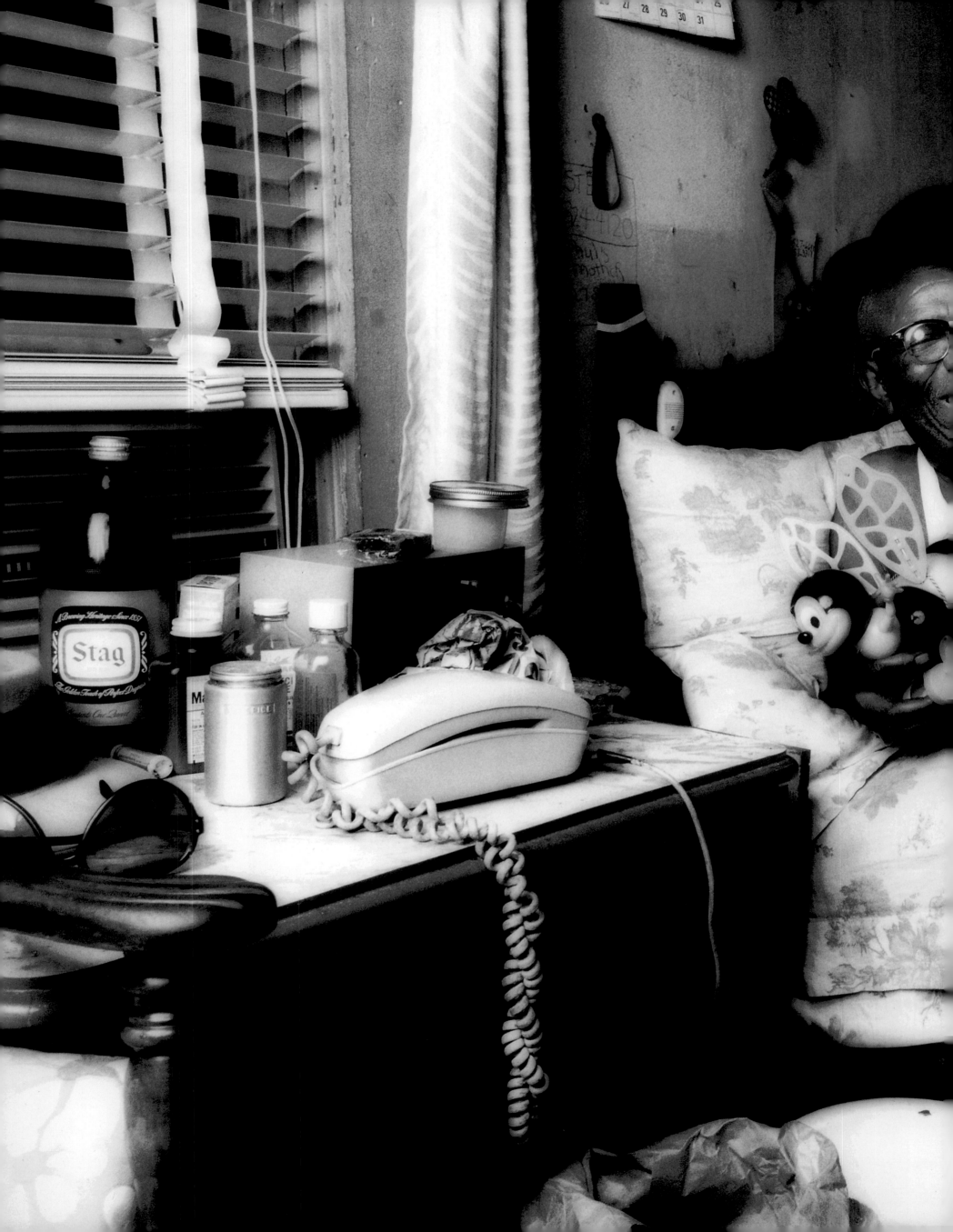

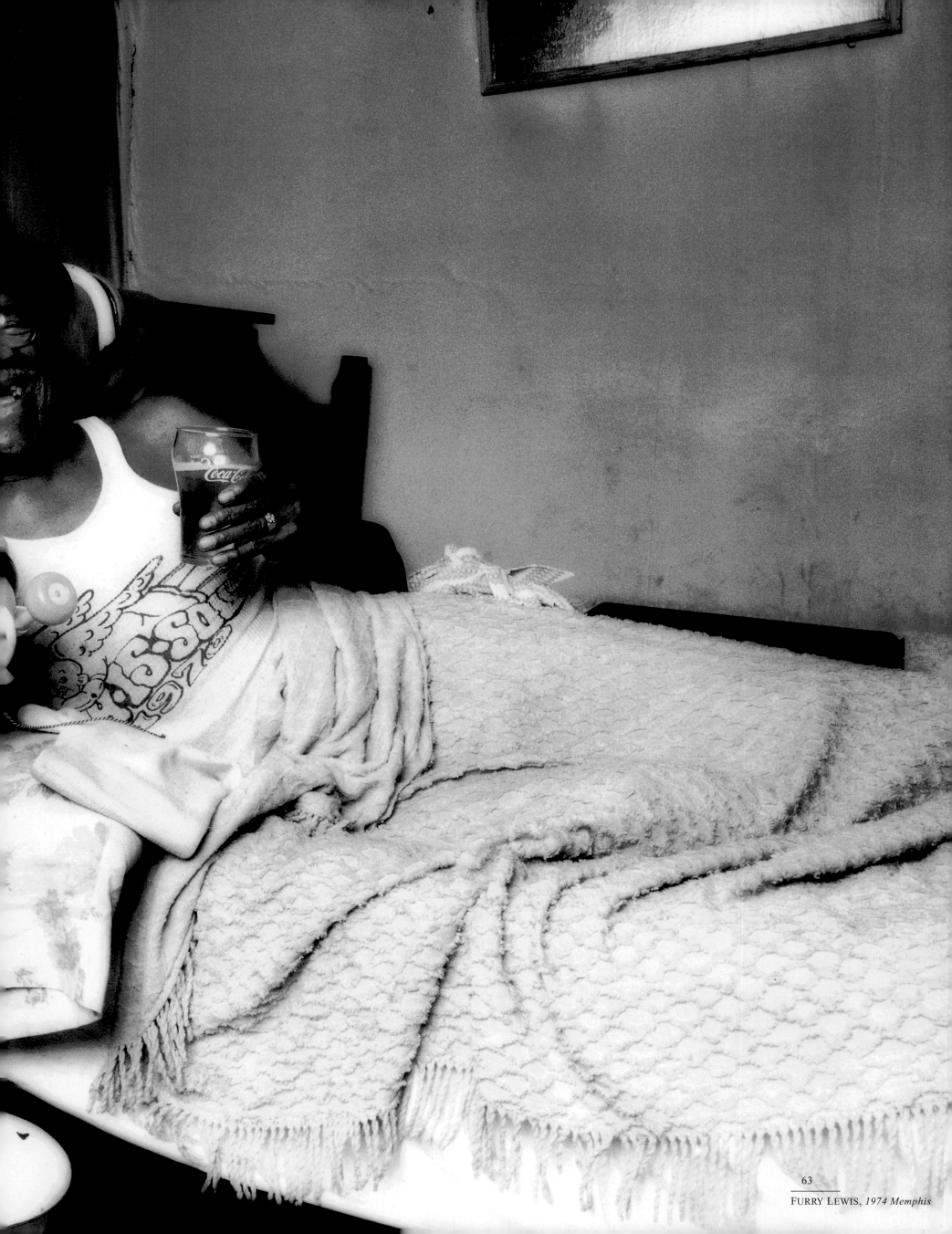

FURRY LEWIS, *1974 Memphis*

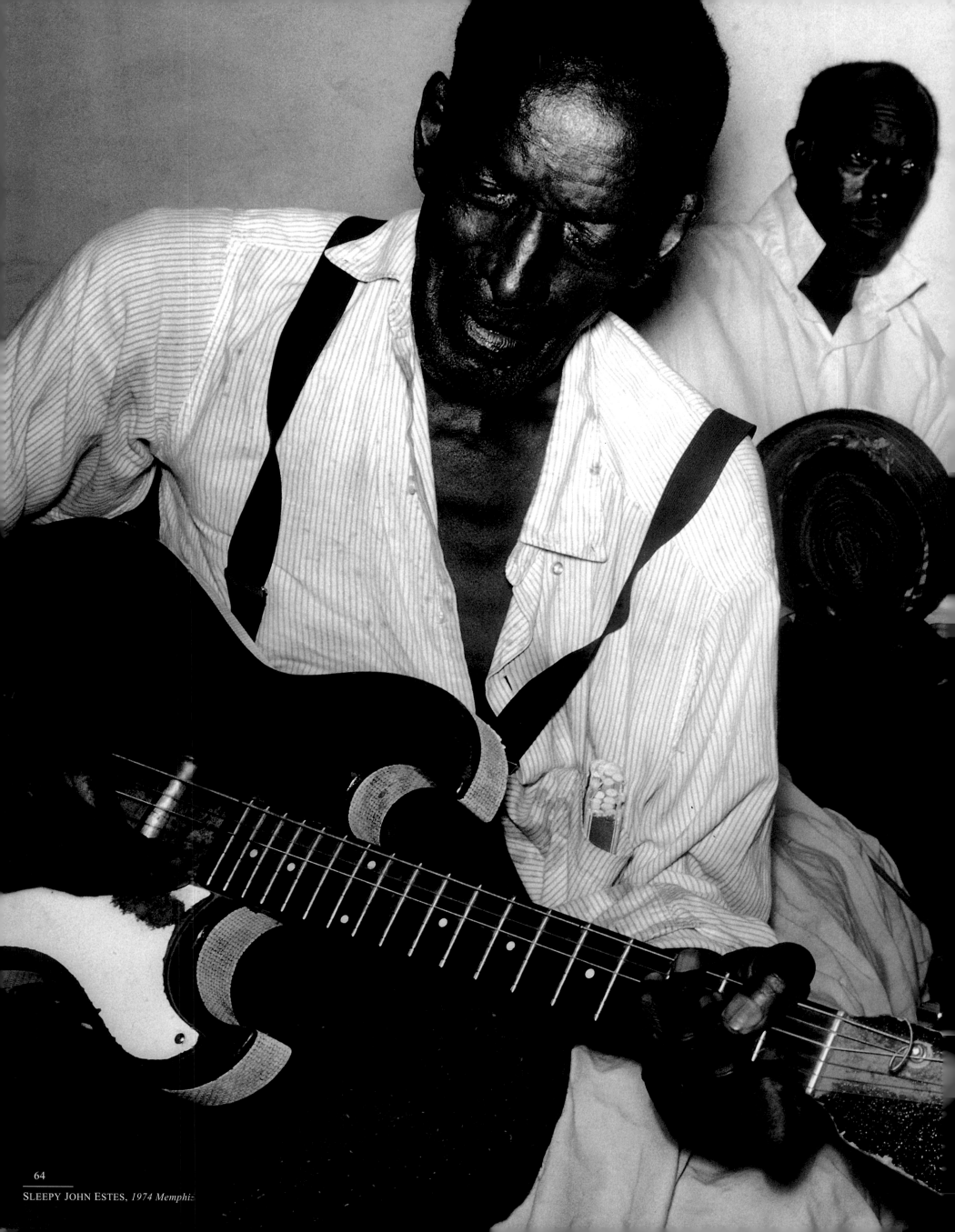

SLEEPY JOHN ESTES, *1974 Memphis*

CURTIS MAYFIELD, *1979 Los Angeles*

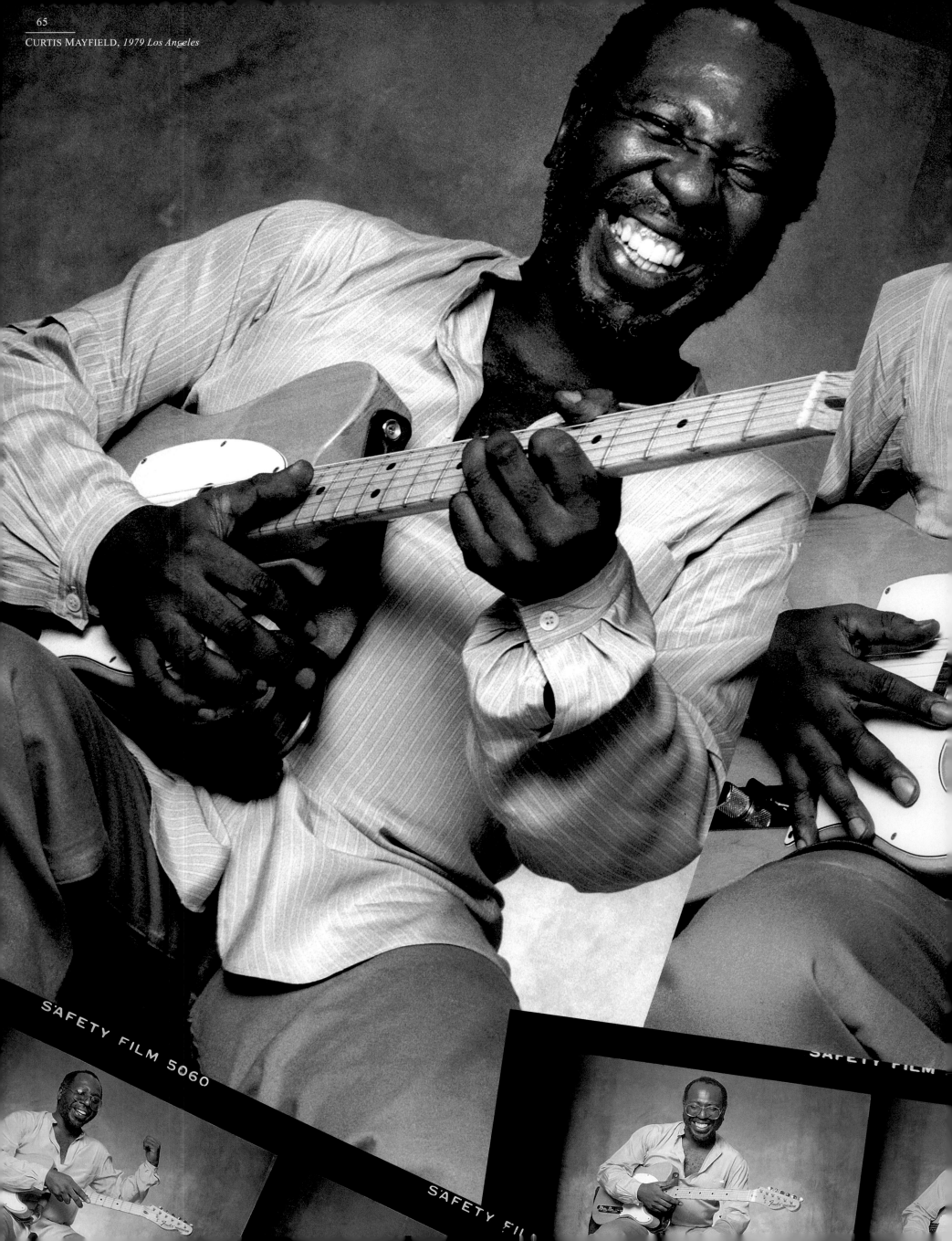

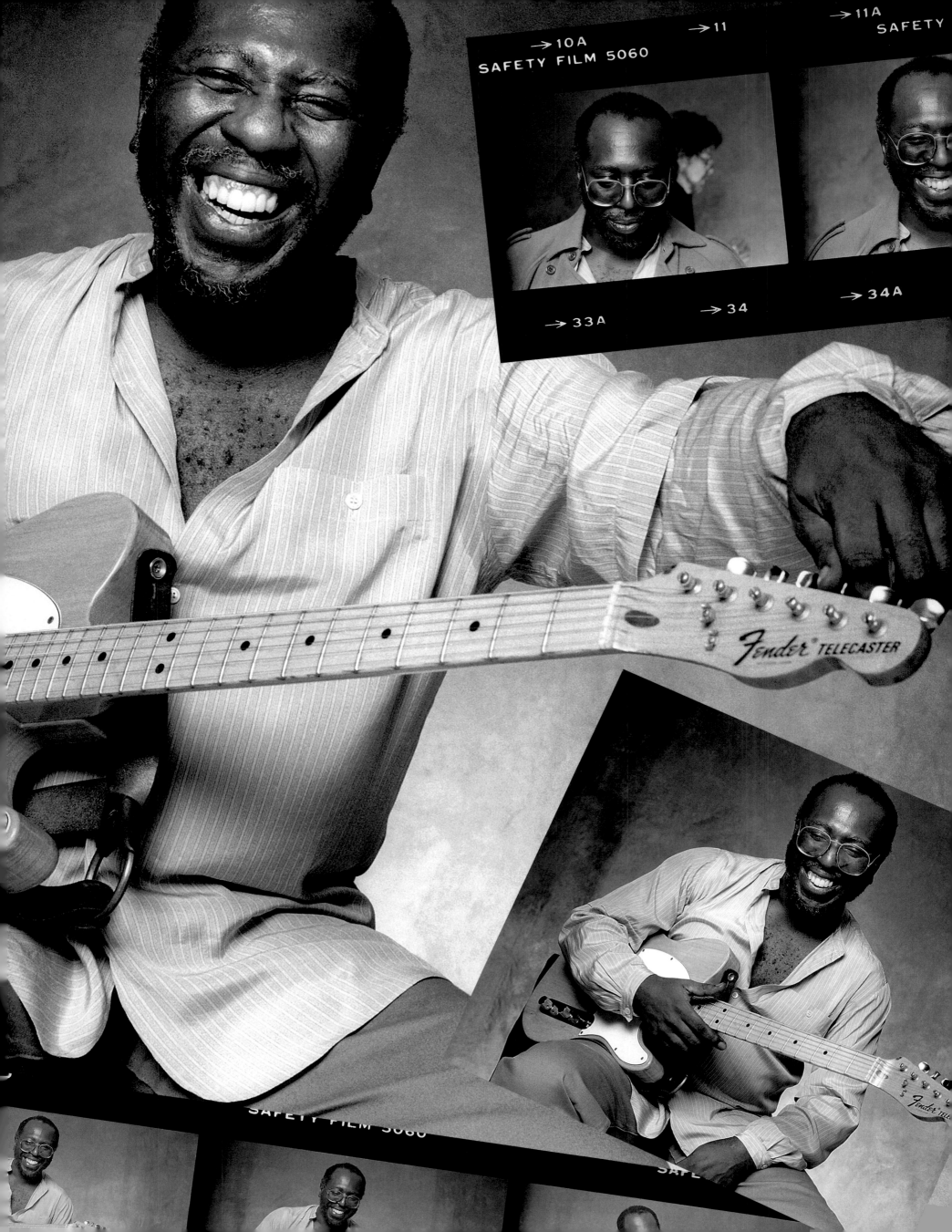

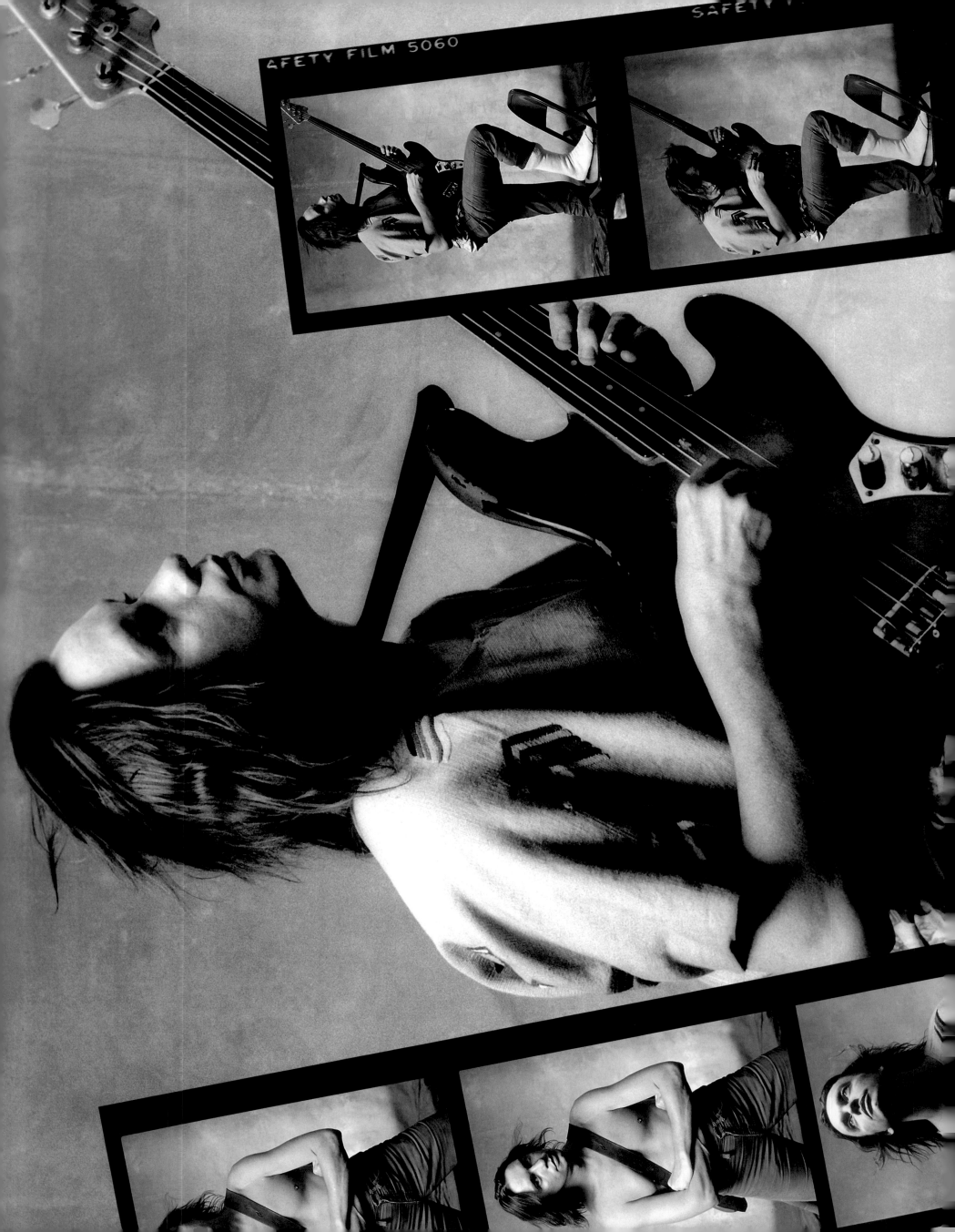

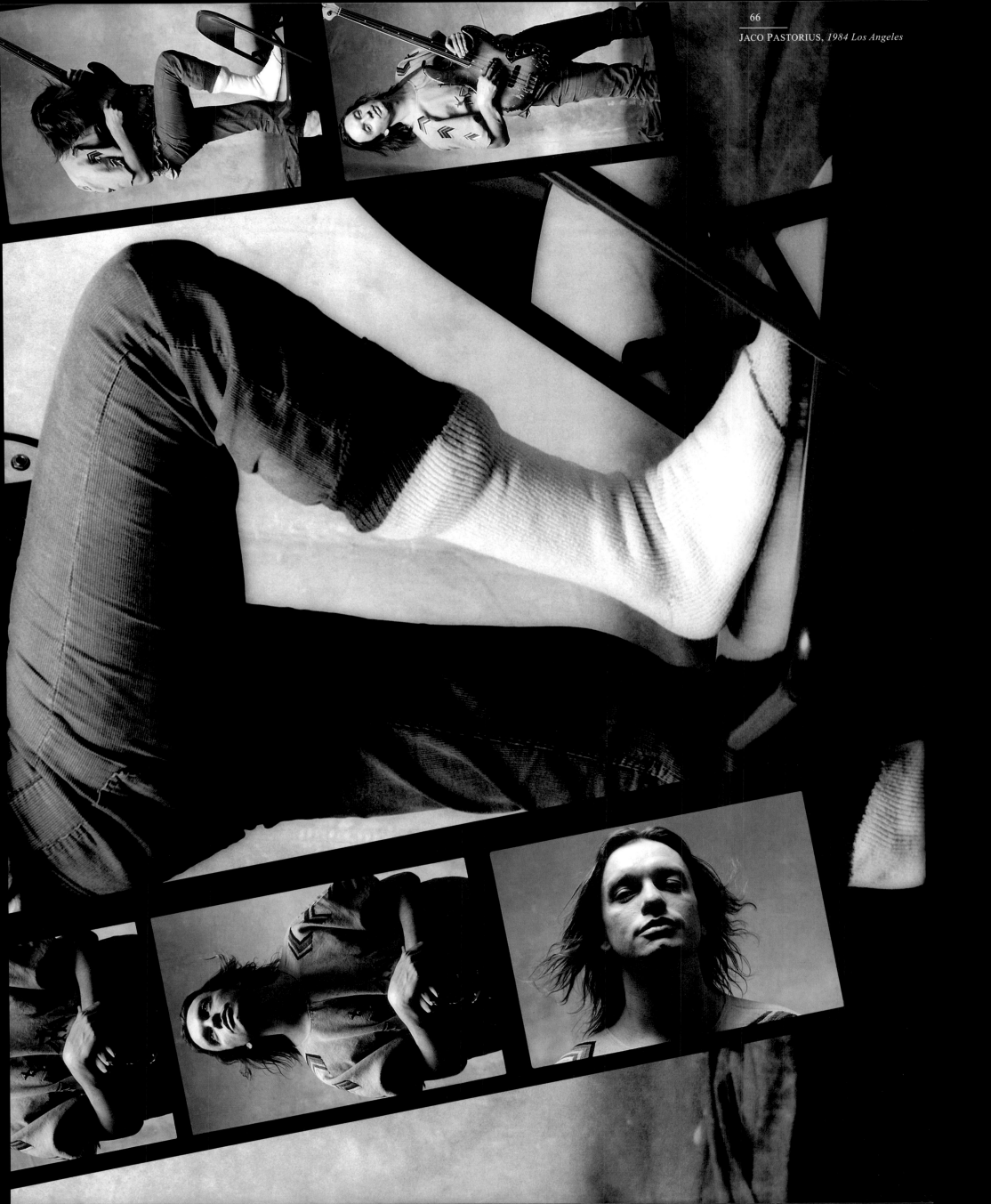

EARL KLUGH, *1978 Los Angeles* EGBERTO GISMONTI, *1981 New York City*

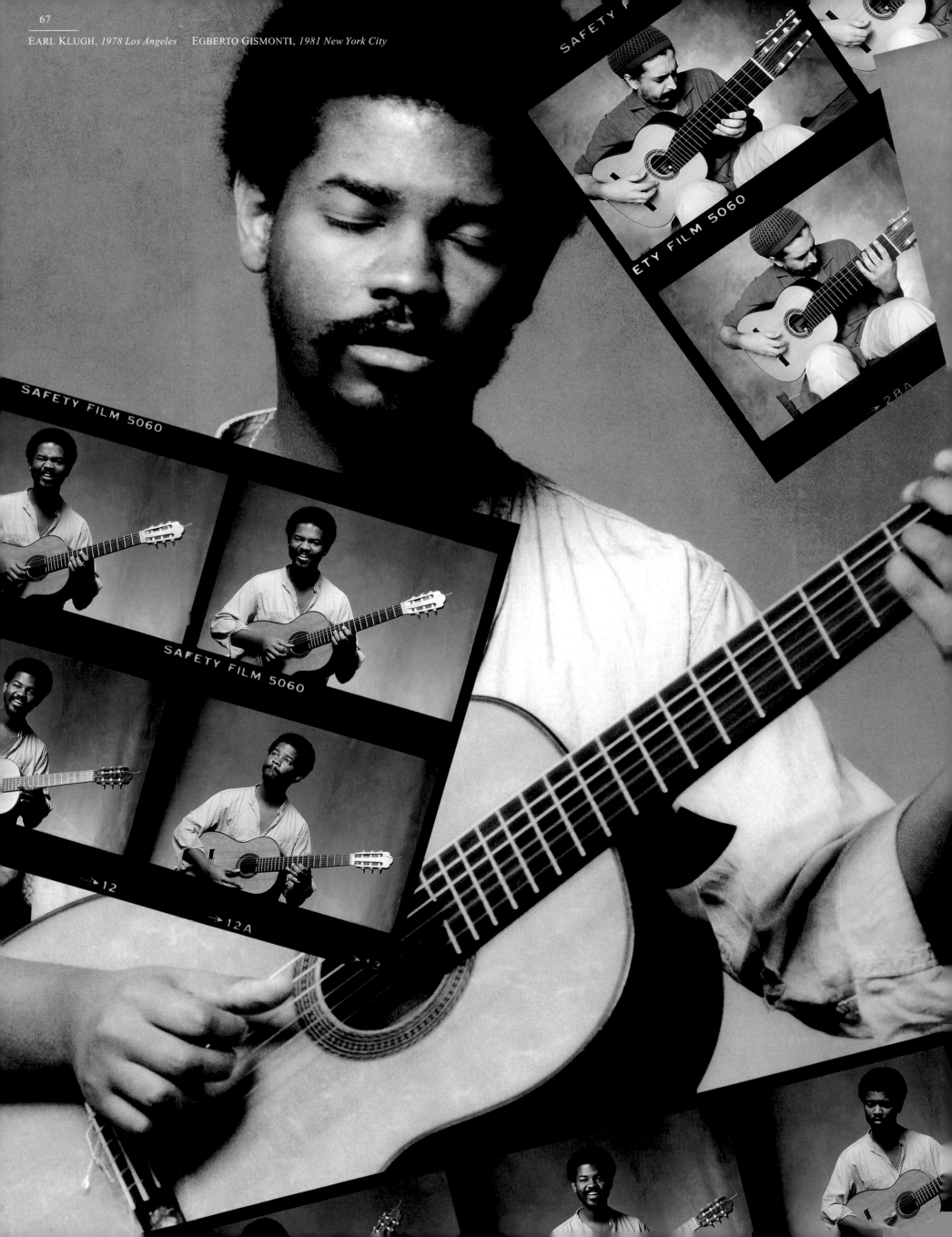

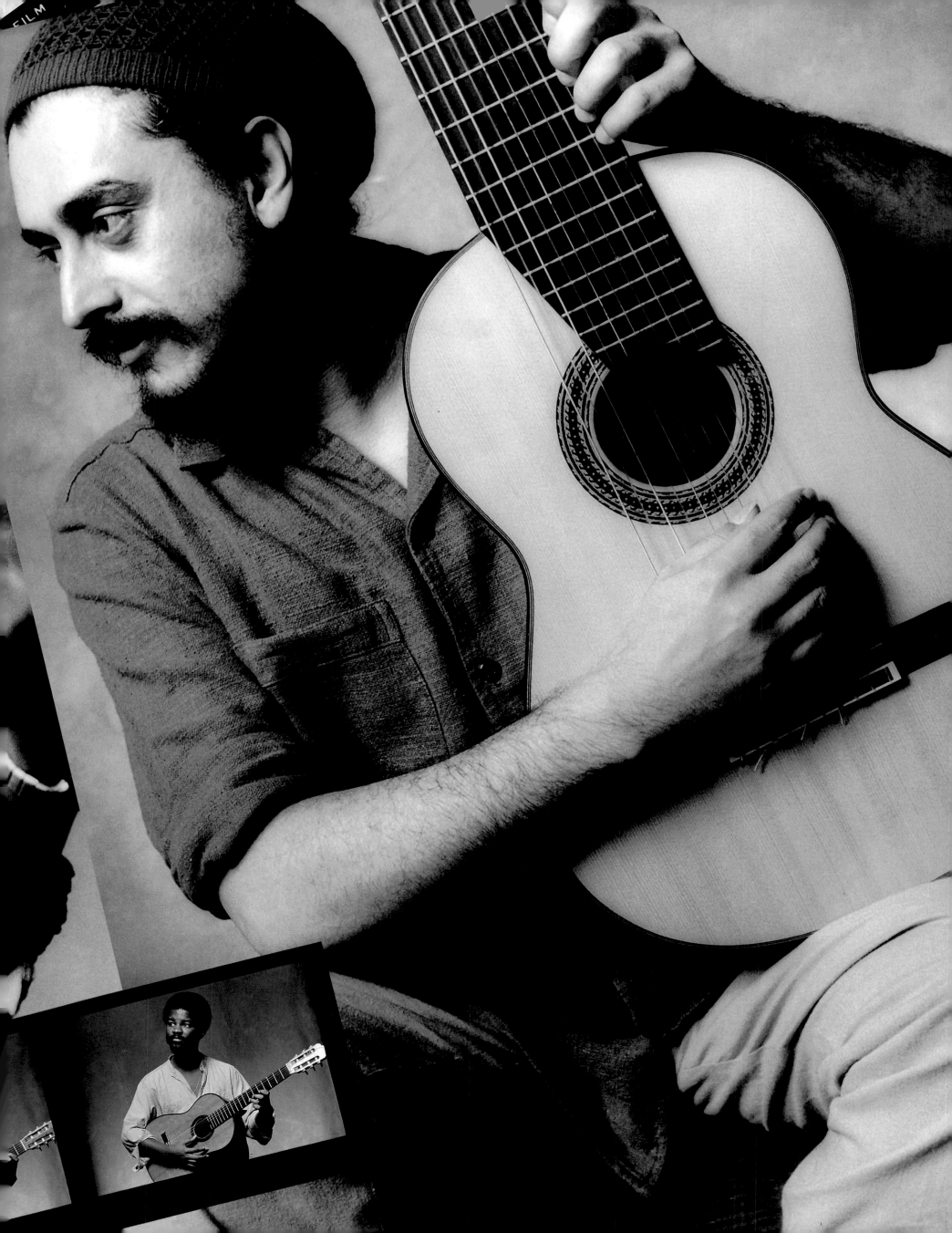

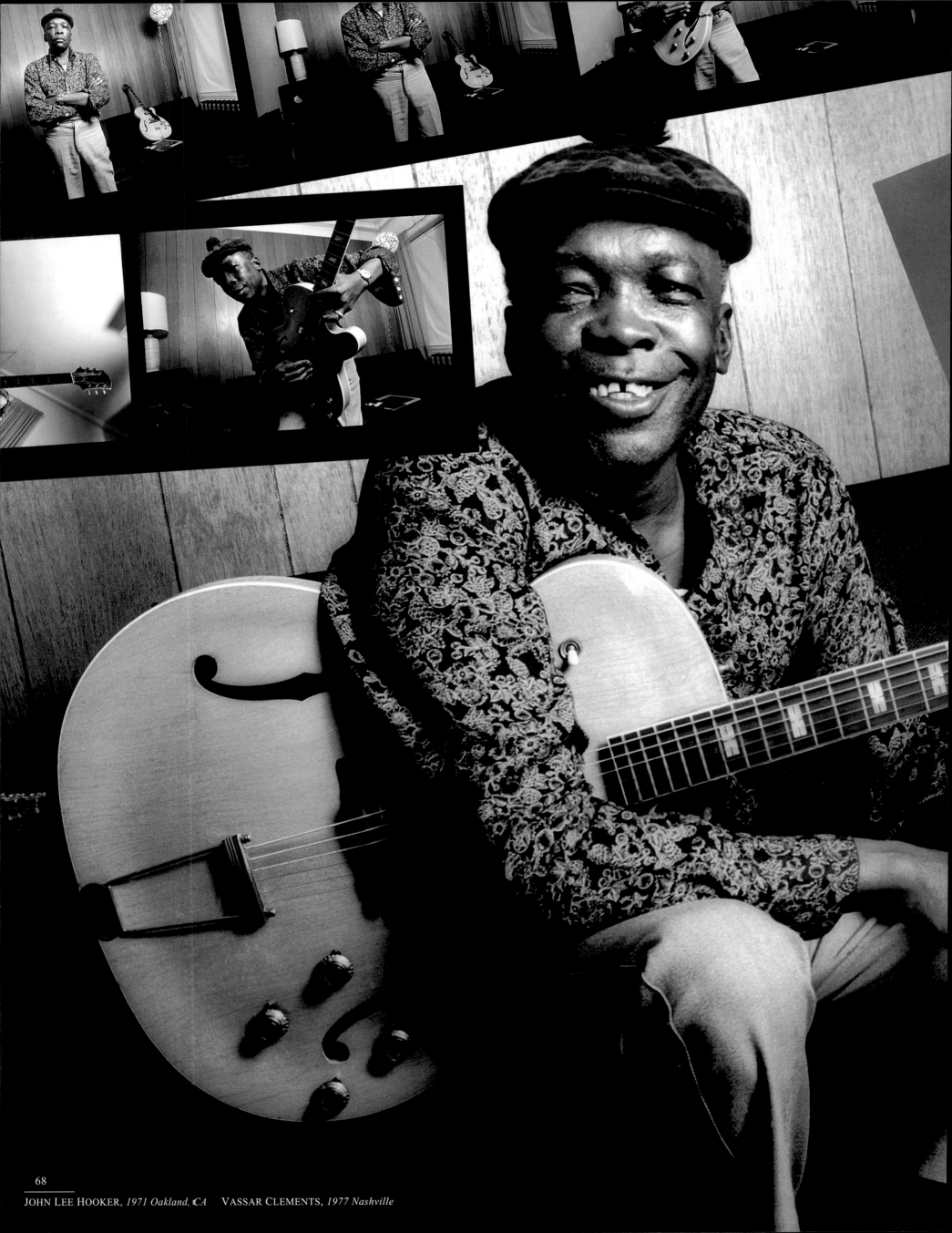

JOHN LEE HOOKER, *1971 Oakland, CA* VASSAR CLEMENTS, *1977 Nashville*

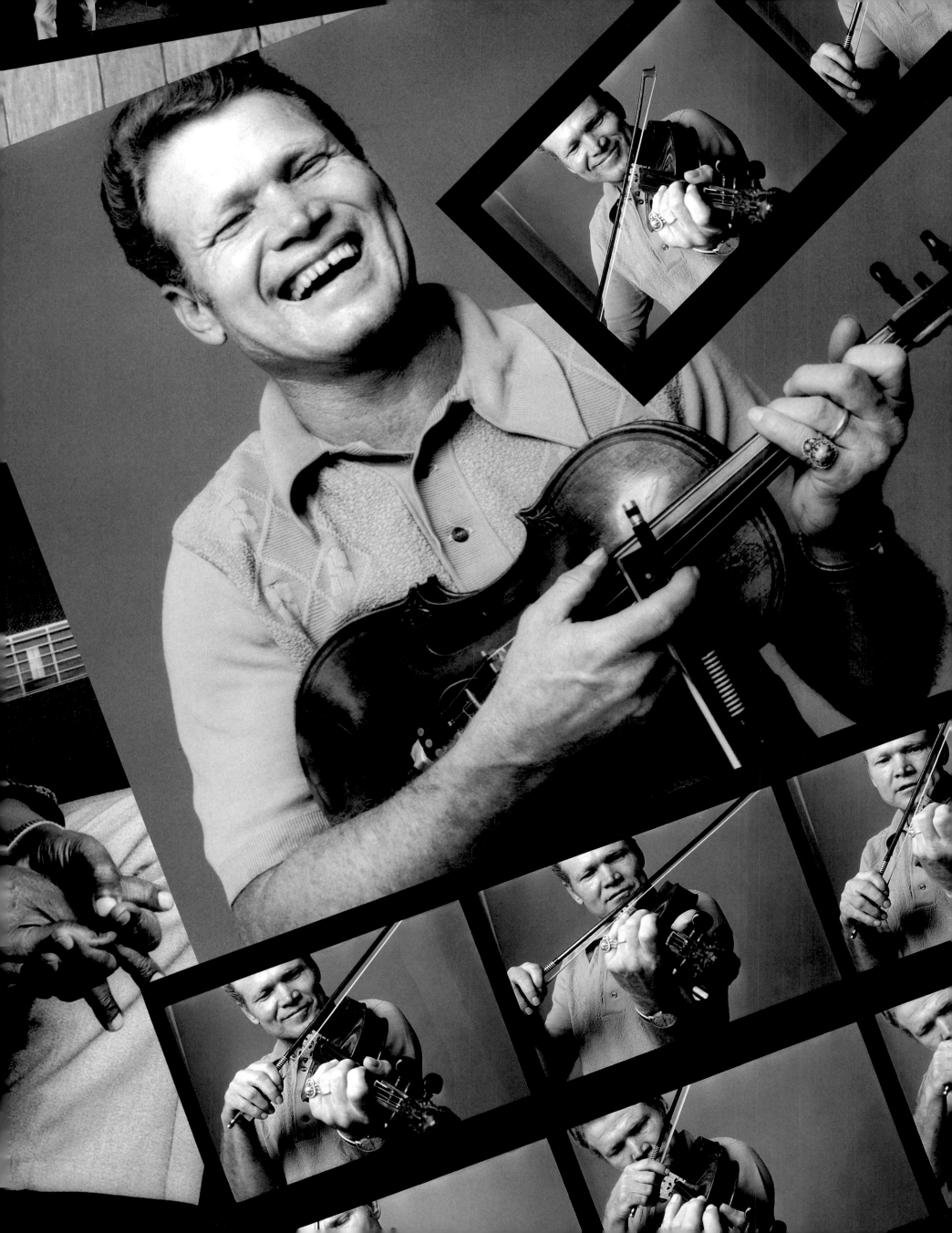

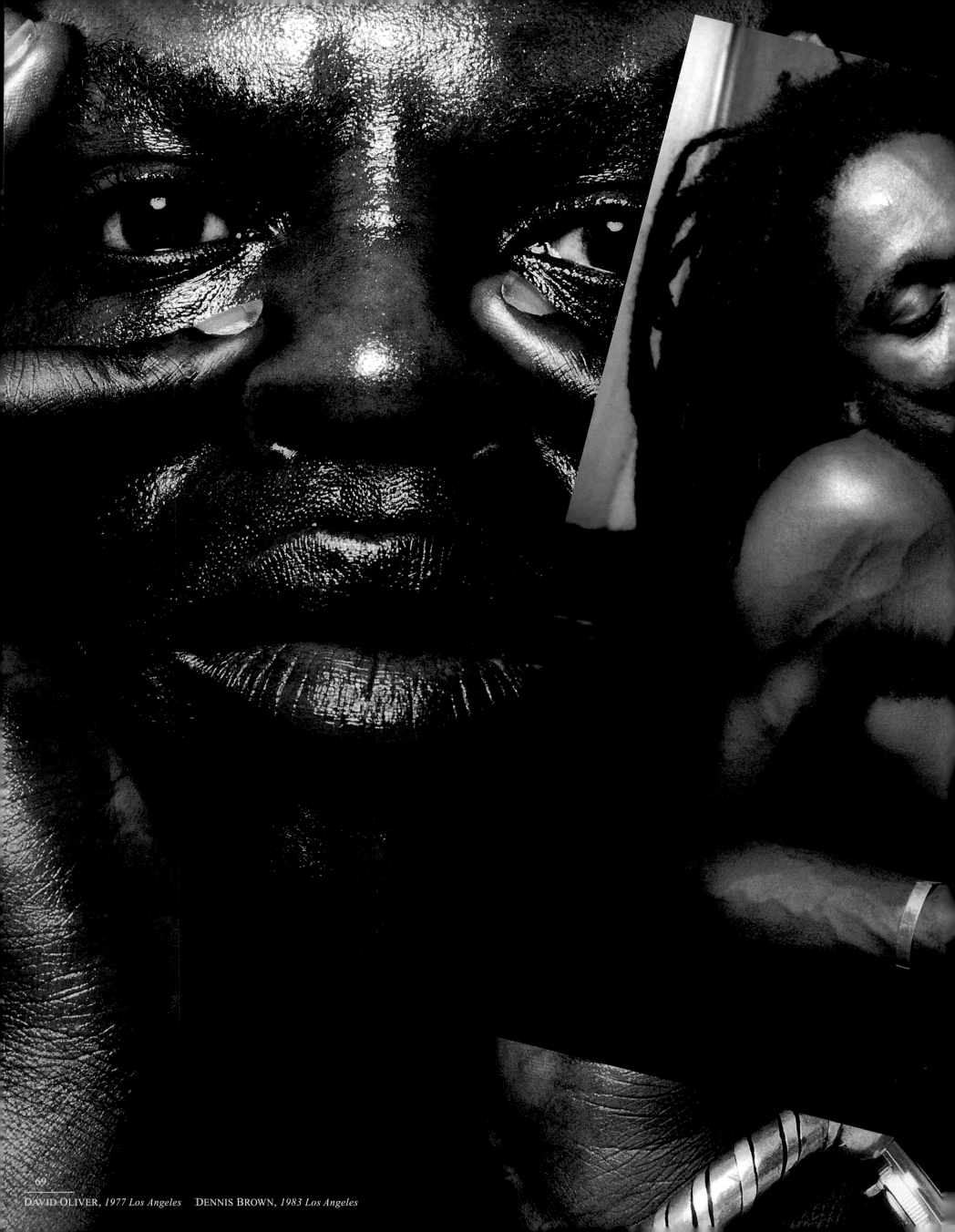

69

DAVID OLIVER, *1977 Los Angeles* DENNIS BROWN, *1983 Los Angeles*

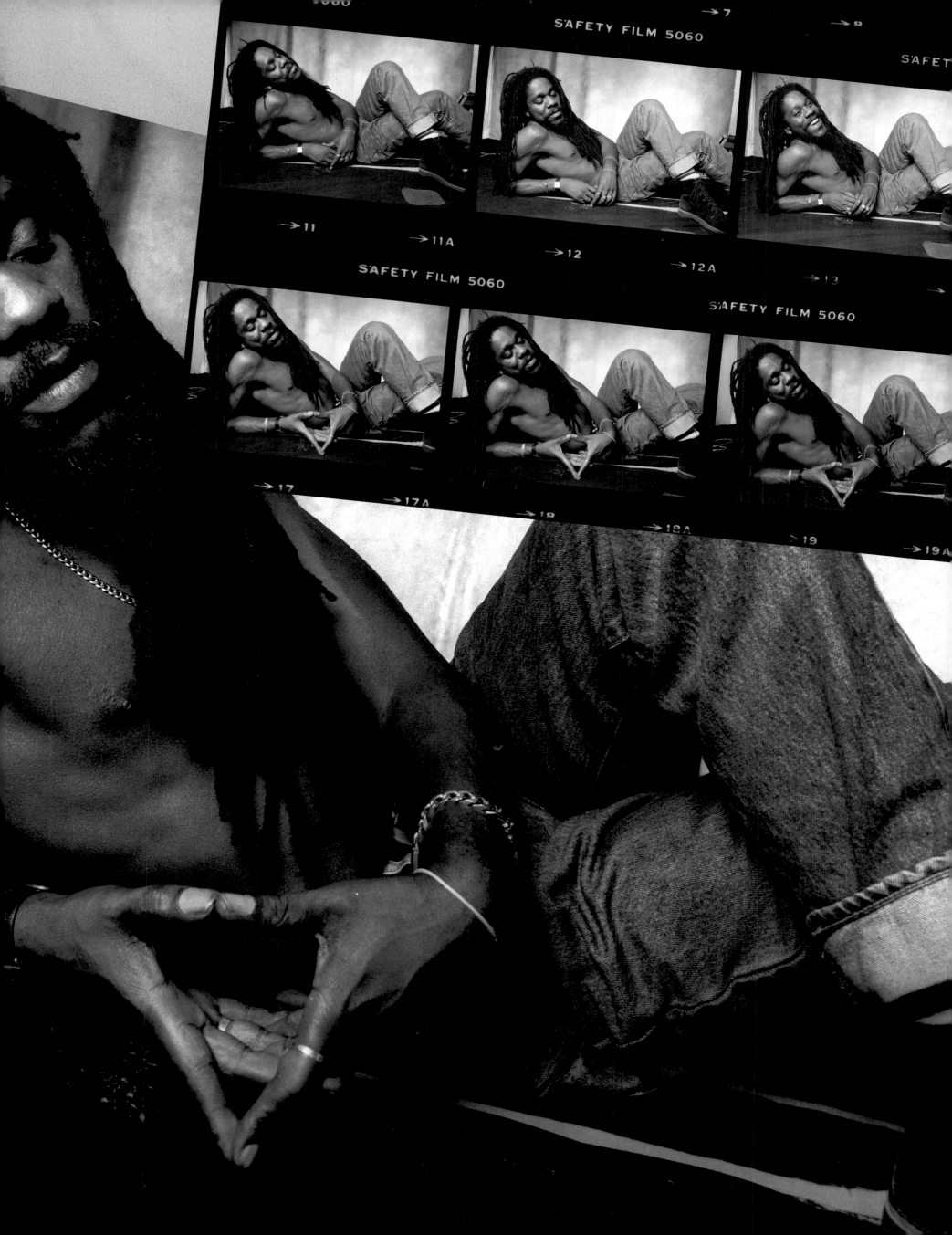

SAFETY FILM 5060

→7 →8 SAFETY FILM 5060

SAFETY FILM 5060

→11 →11A →12 →12A →13

SAFETY FILM 5060

→17 →17A →18 →18A →19 →19A

BILL GRAHAM, *1979 San Francisco* BERRY GORDY JR., *1990 Los Angeles*

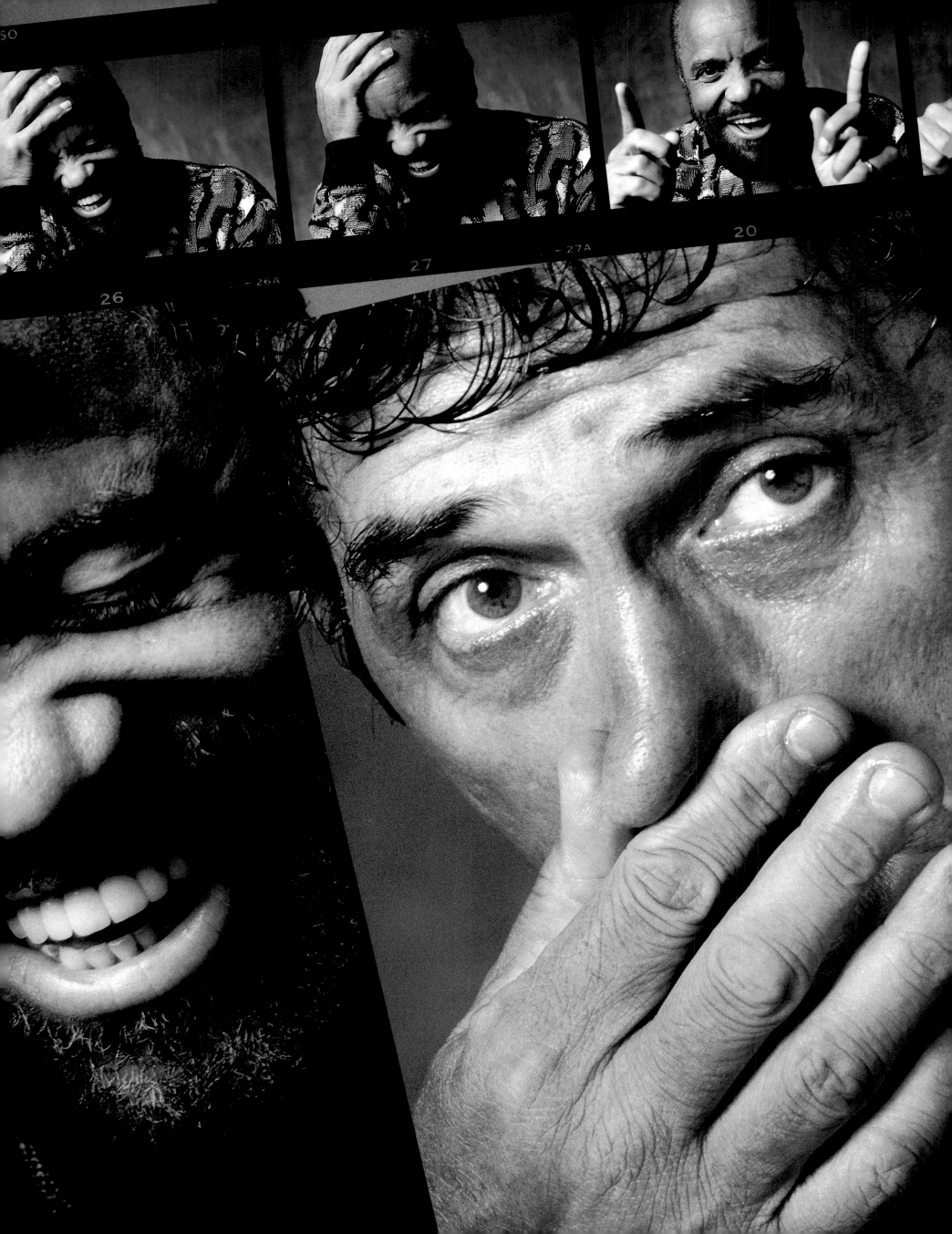

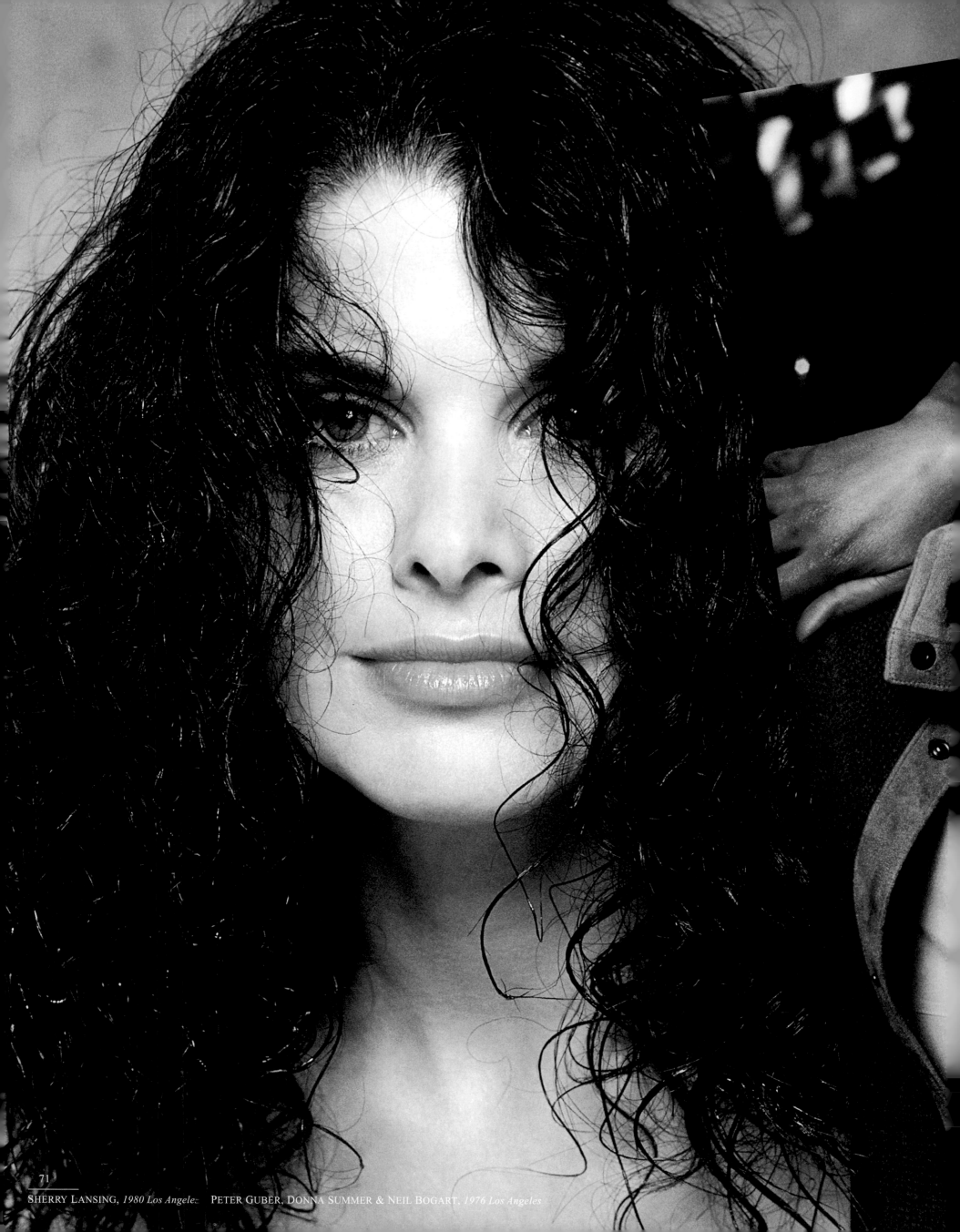

Sherry Lansing, *1980 Los Angeles* Peter Guber, Donna Summer & Neil Bogart, *1976 Los Angeles*

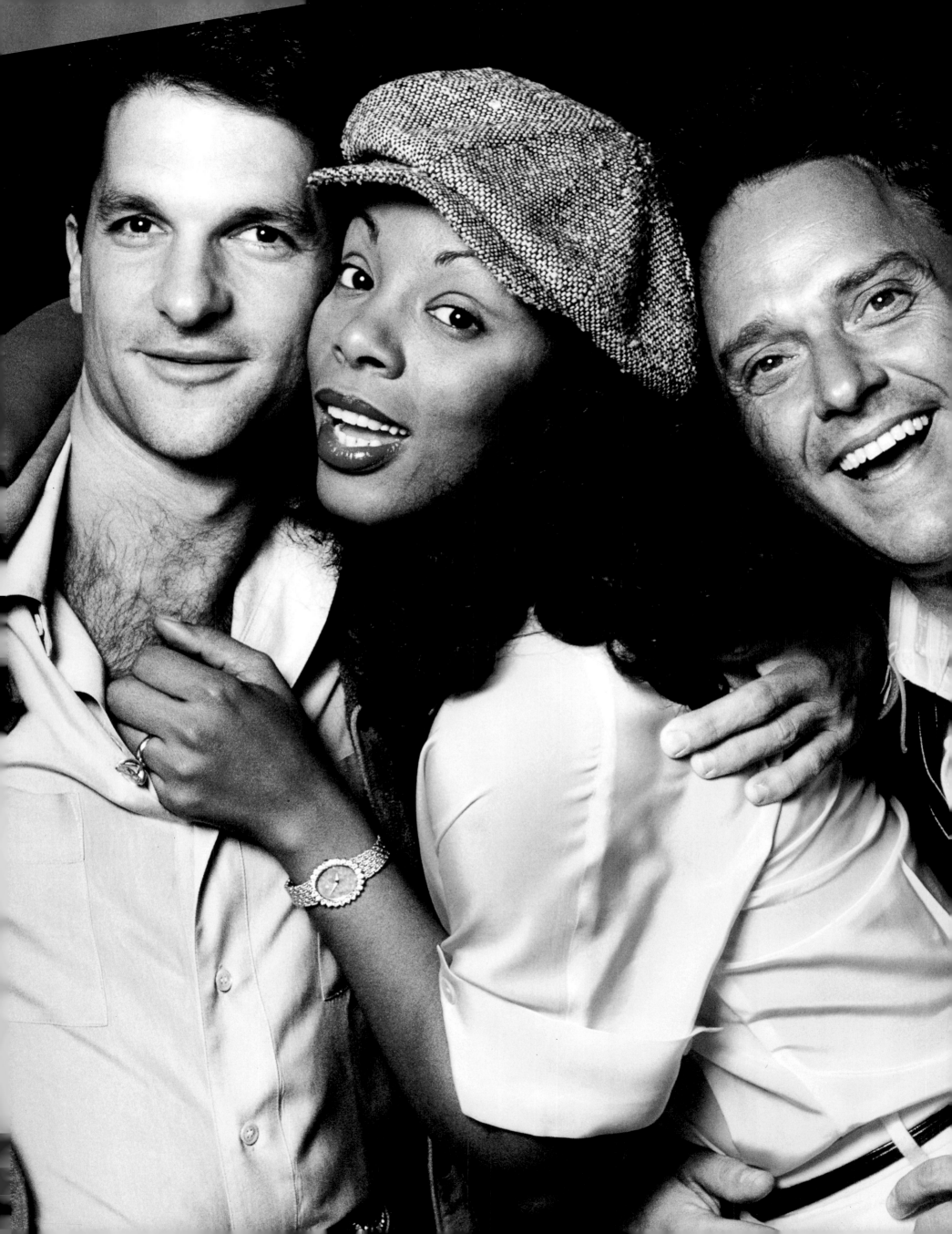

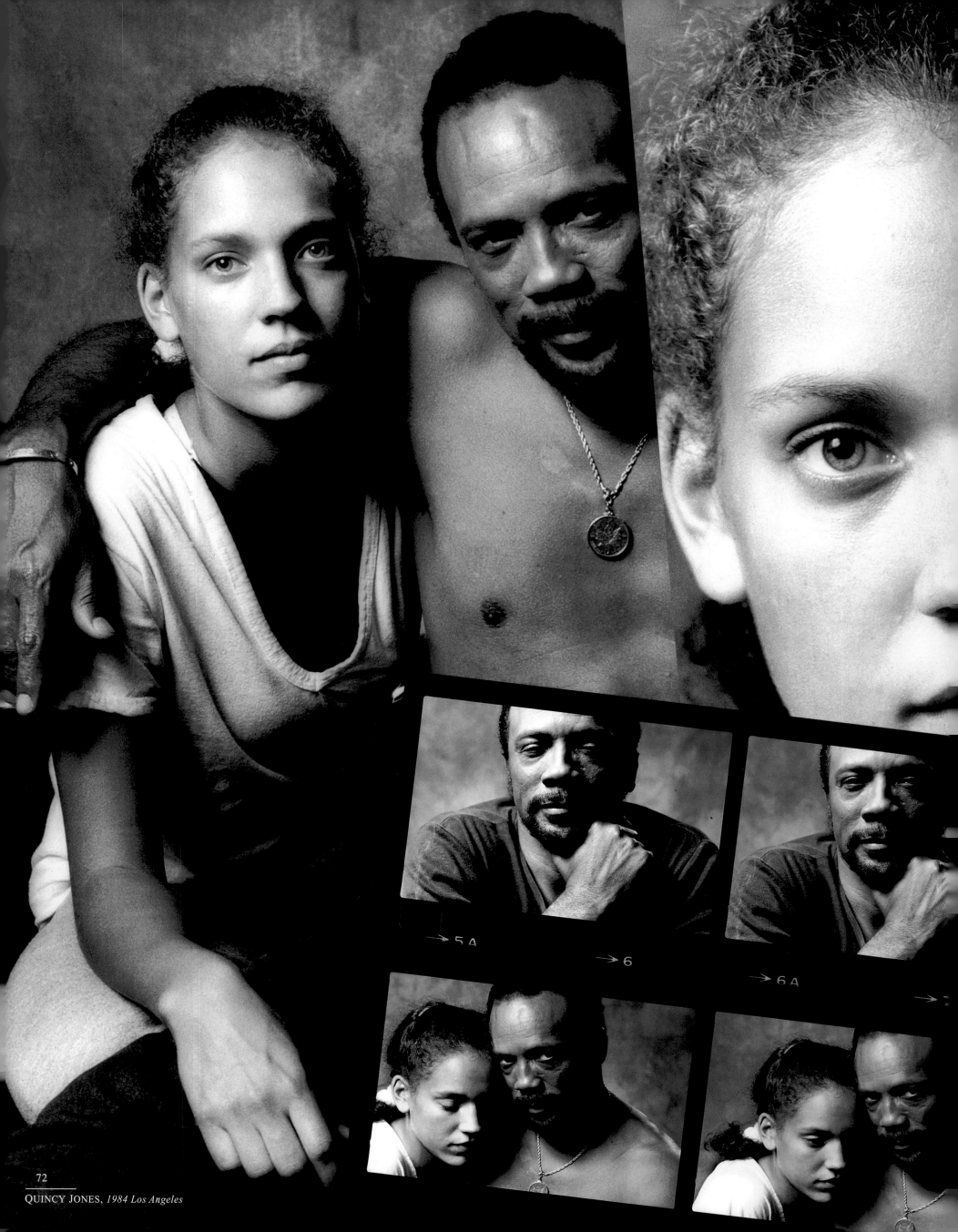

QUINCY JONES, *1984 Los Angeles*

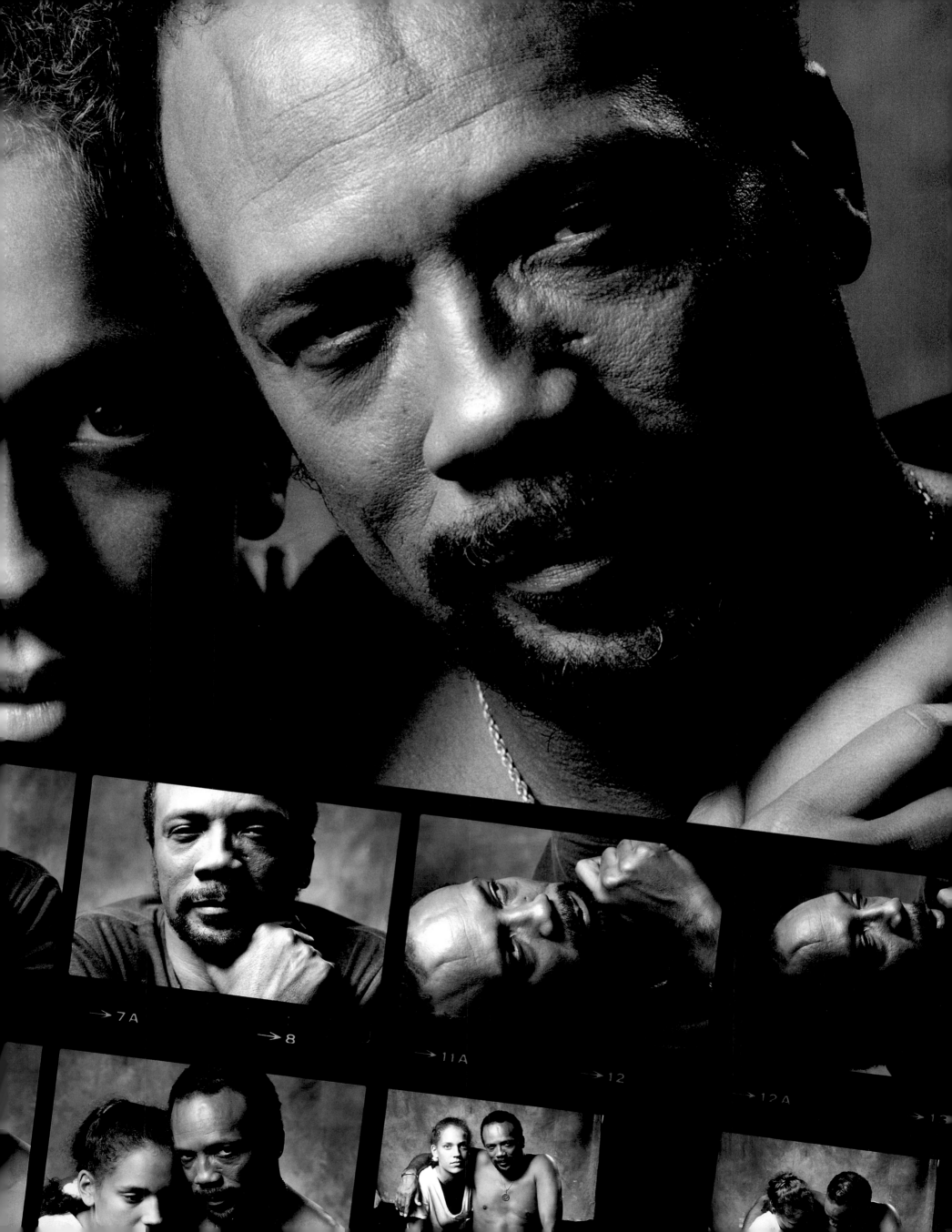

STEVE MARTIN, *1977 Los Angeles*

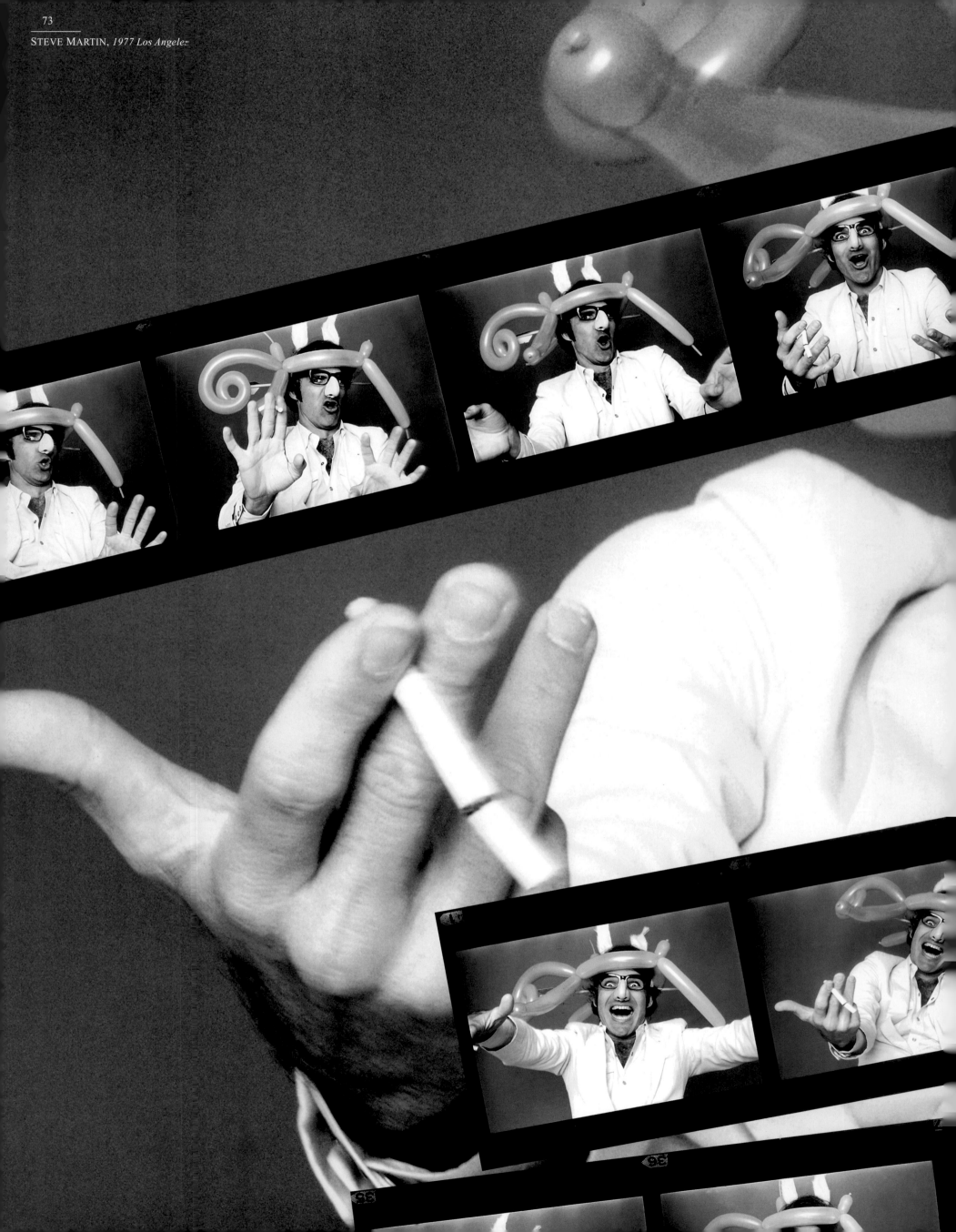

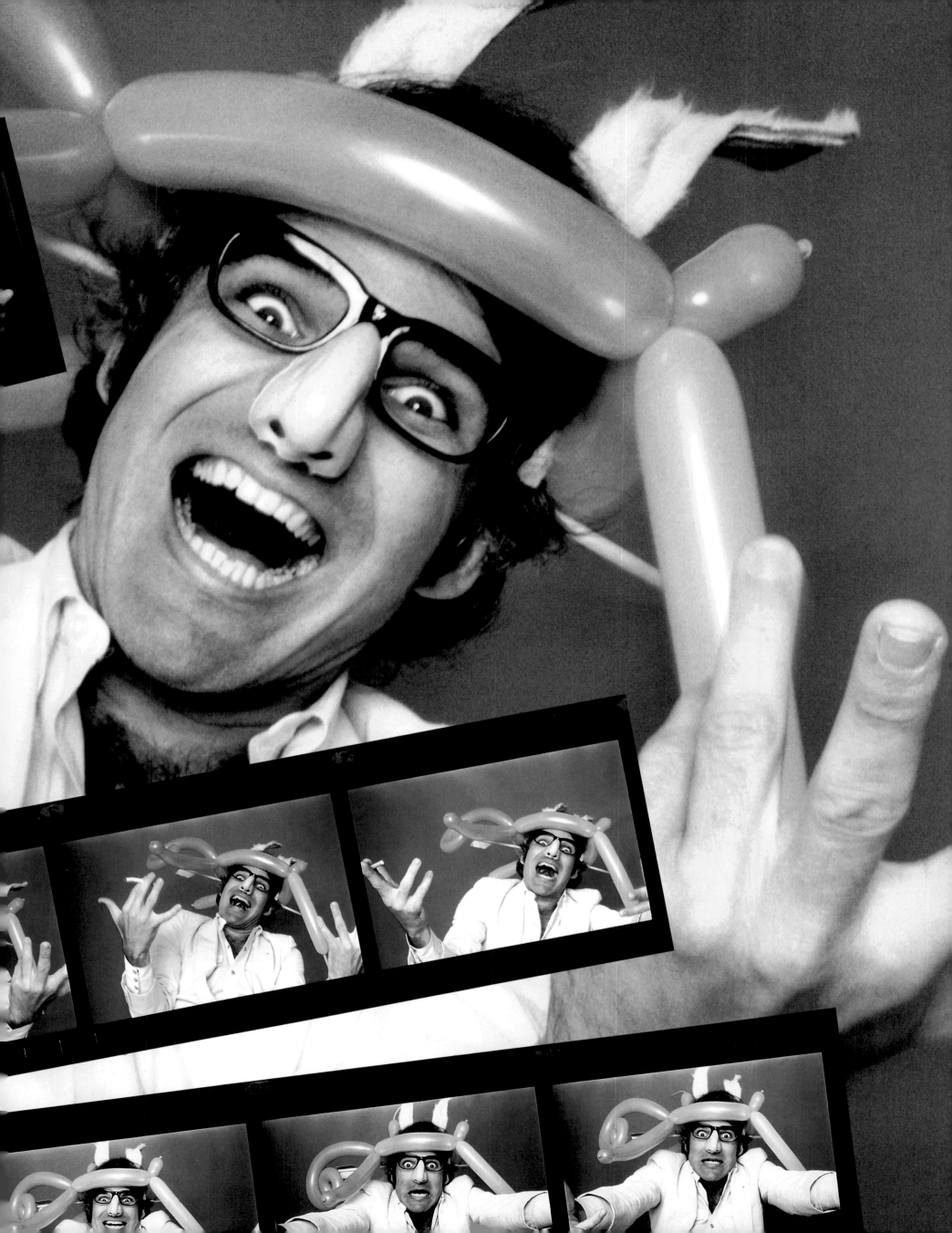

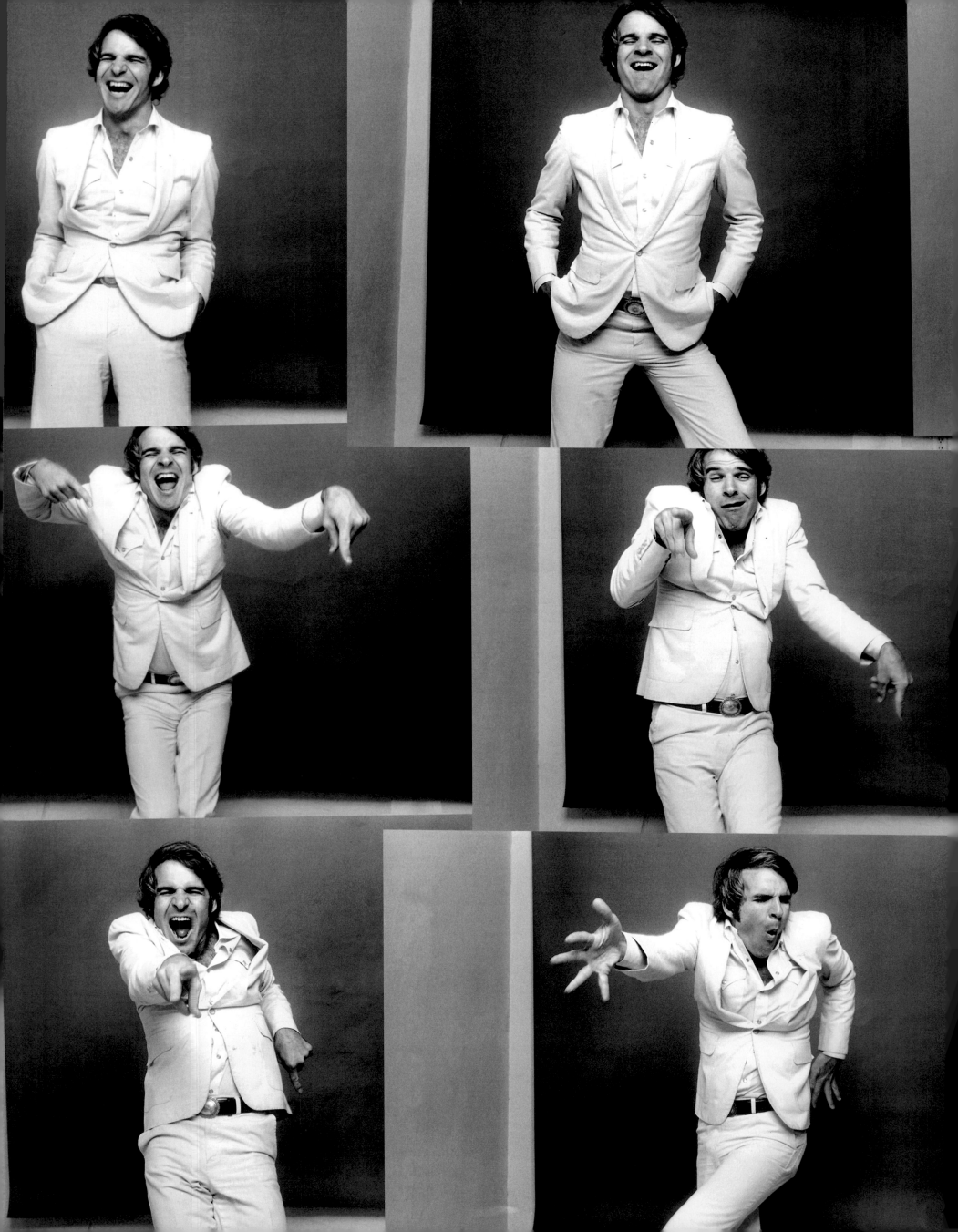

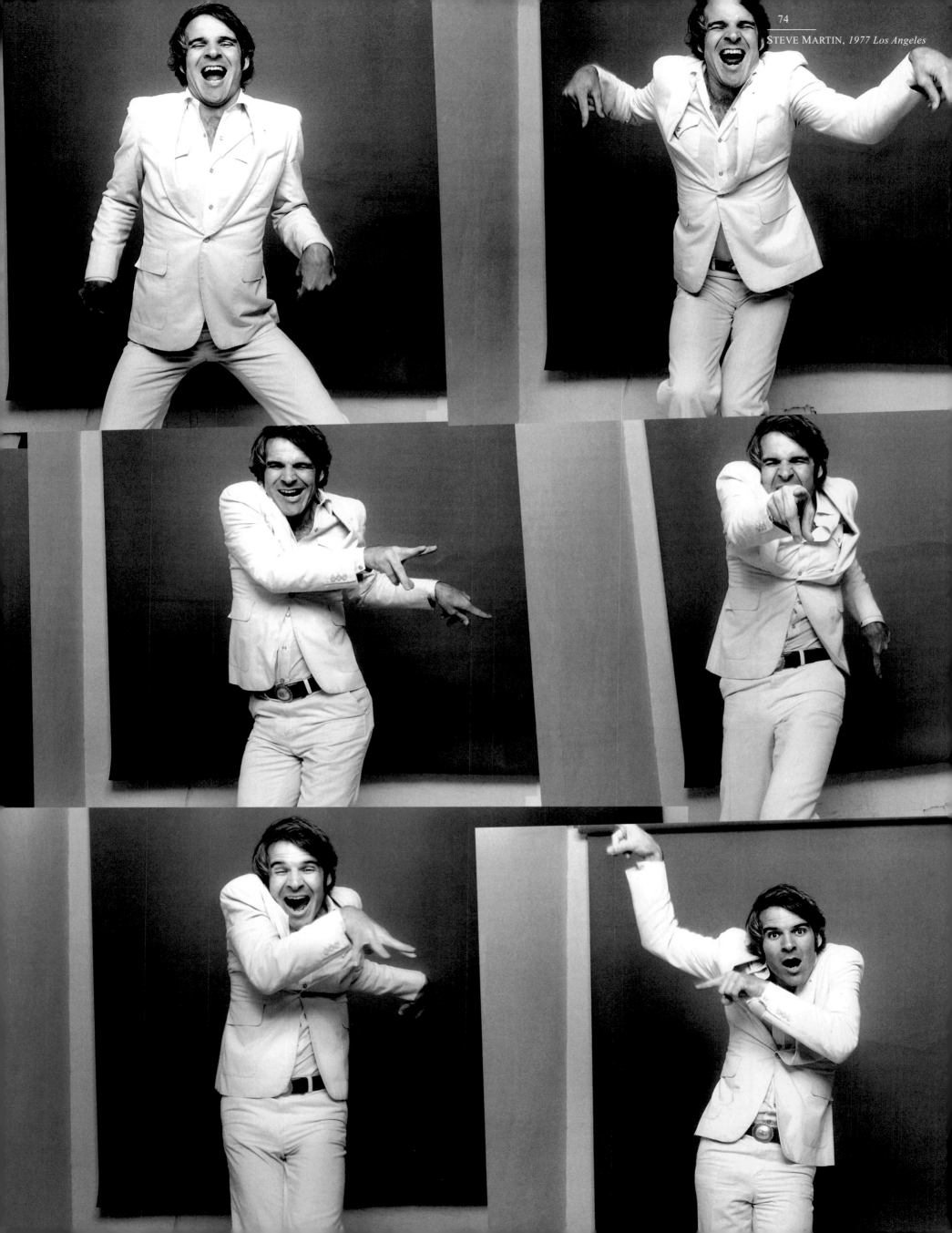

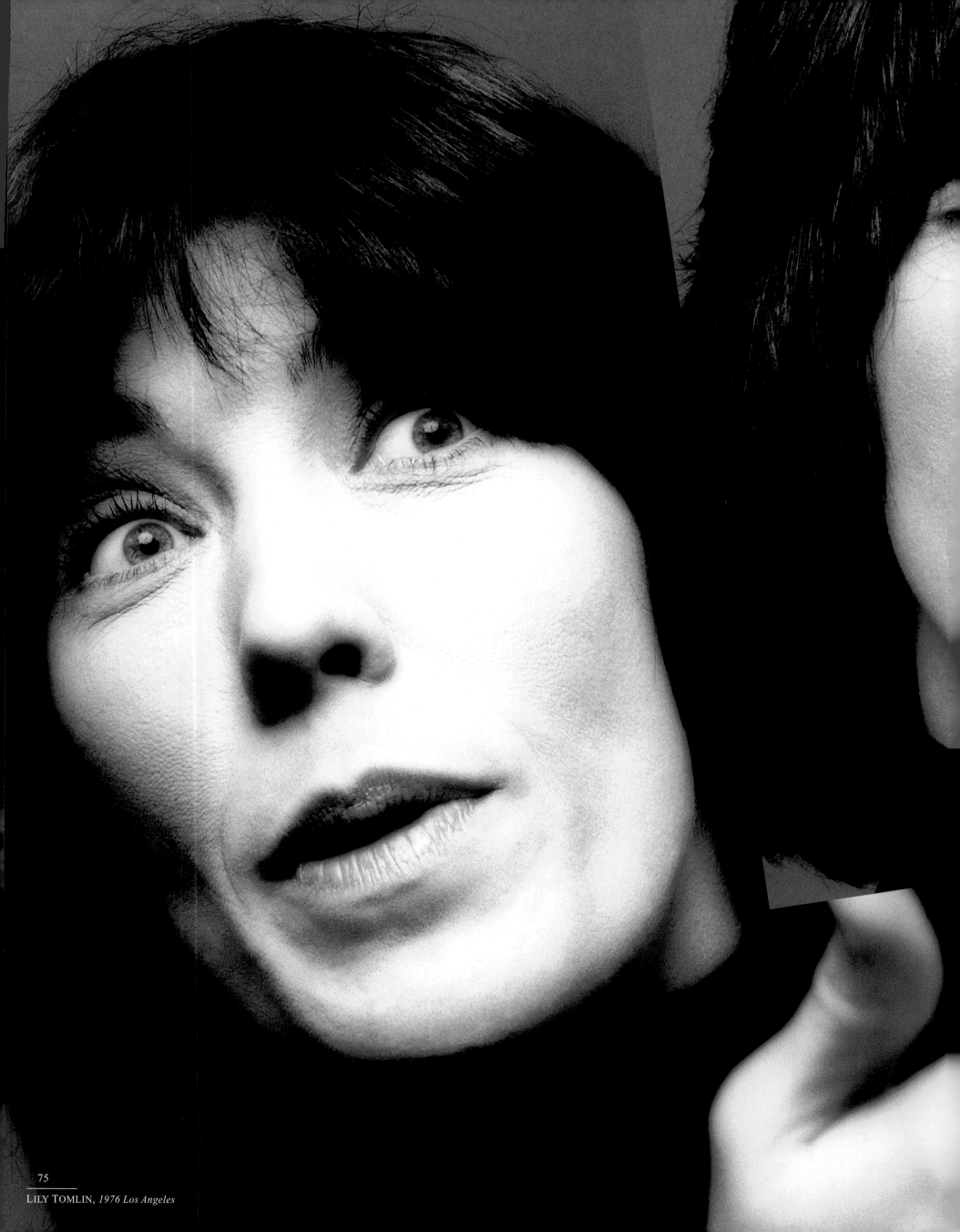

LILY TOMLIN, *1976 Los Angeles*

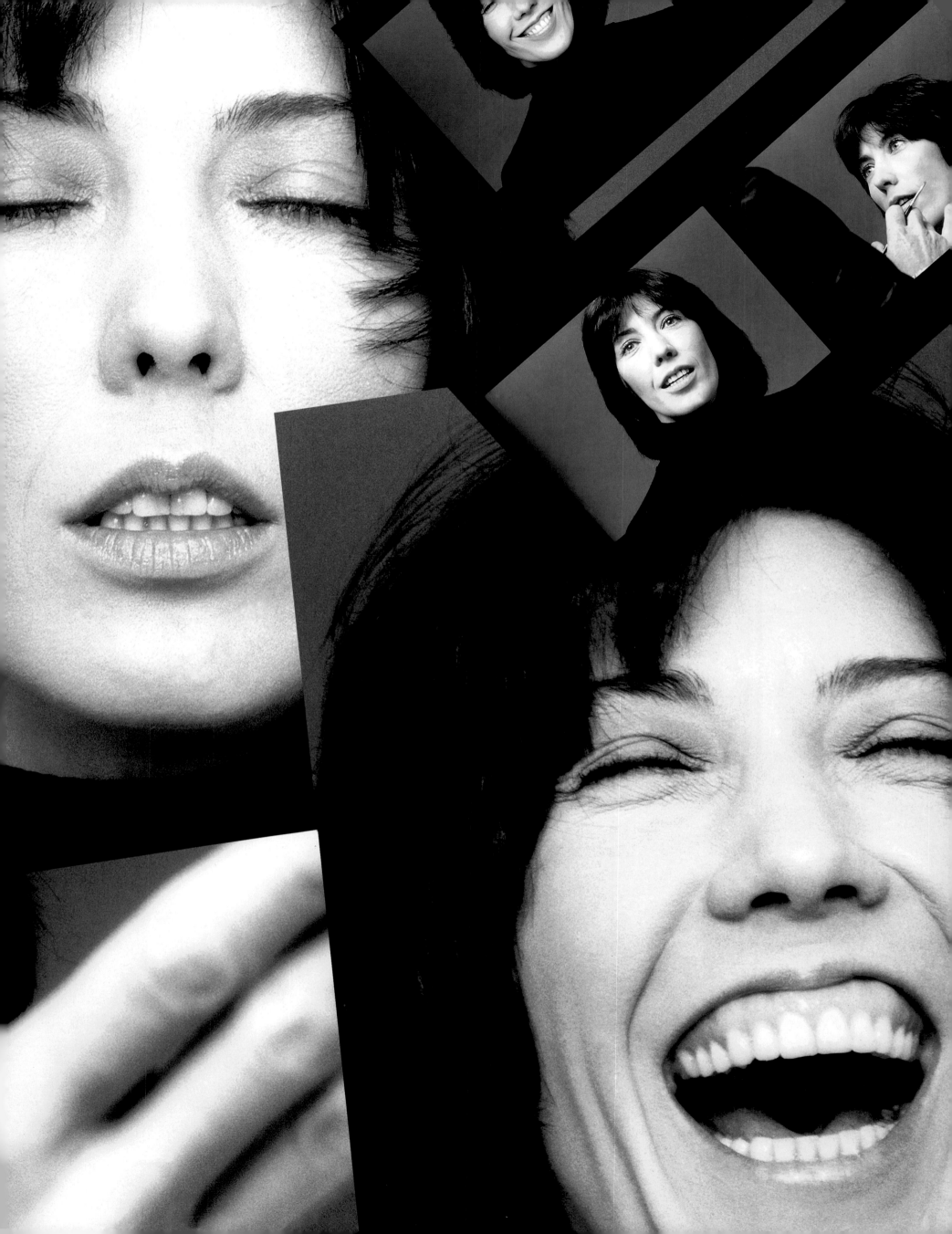

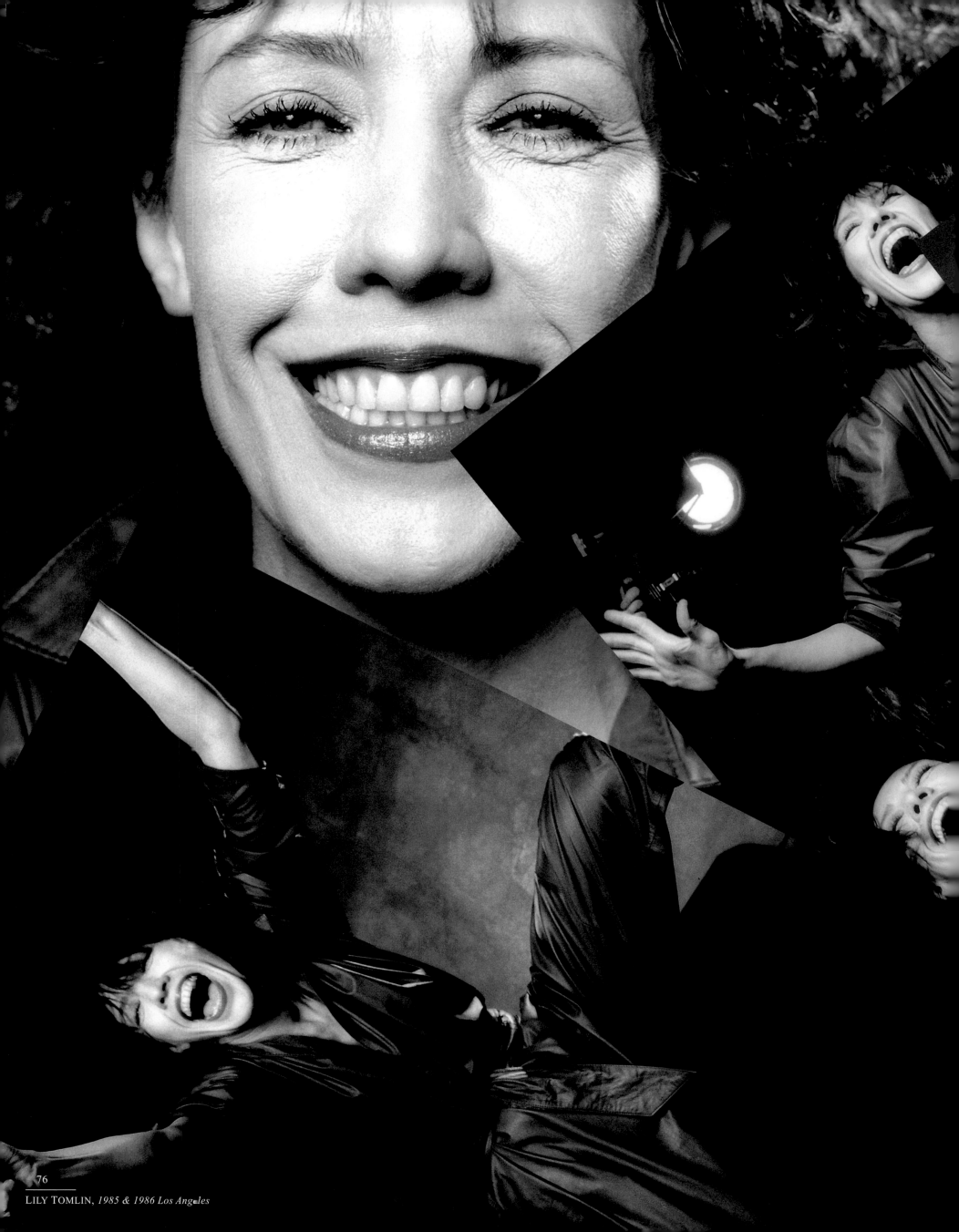

LILY TOMLIN, *1985 & 1986 Los Angeles*

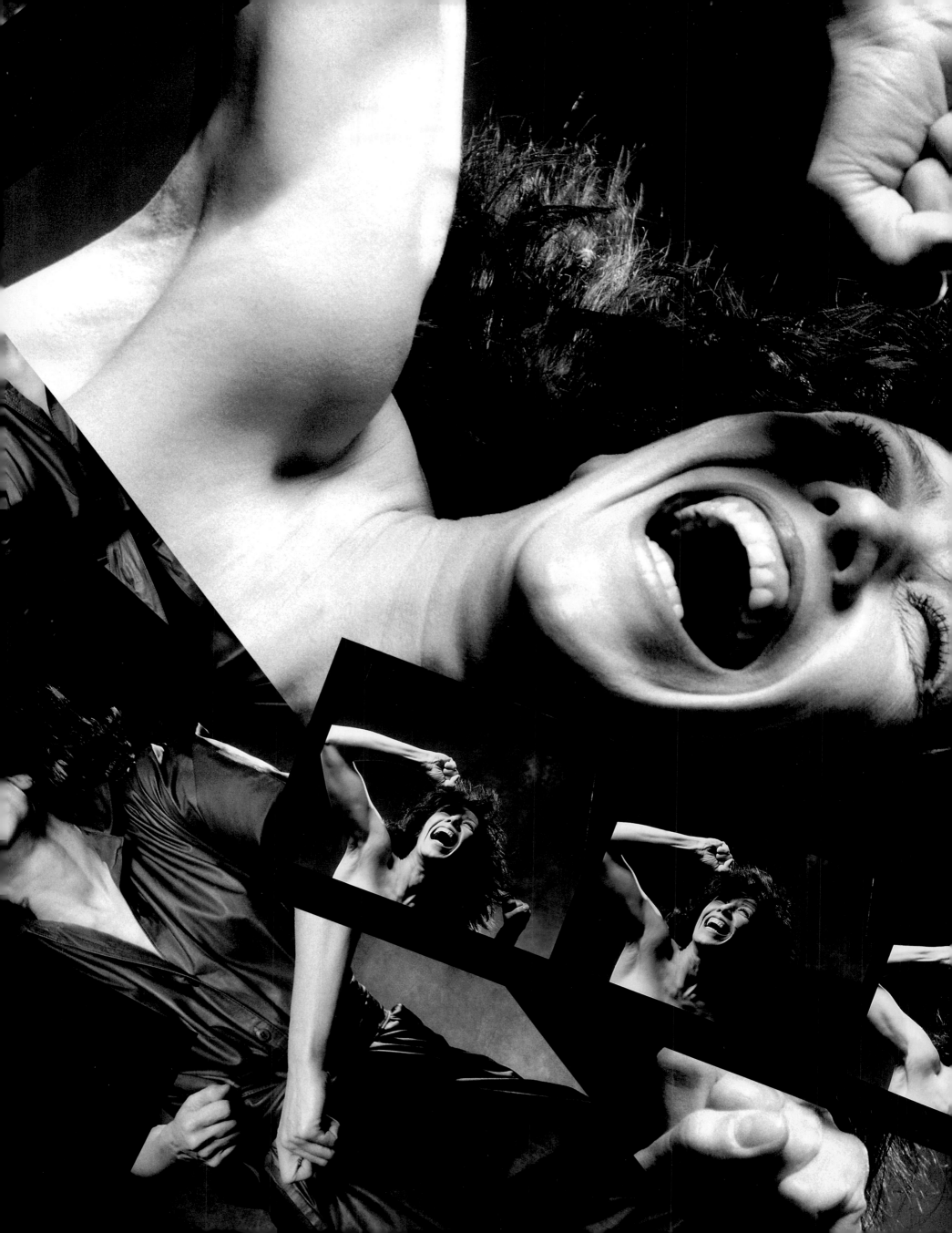

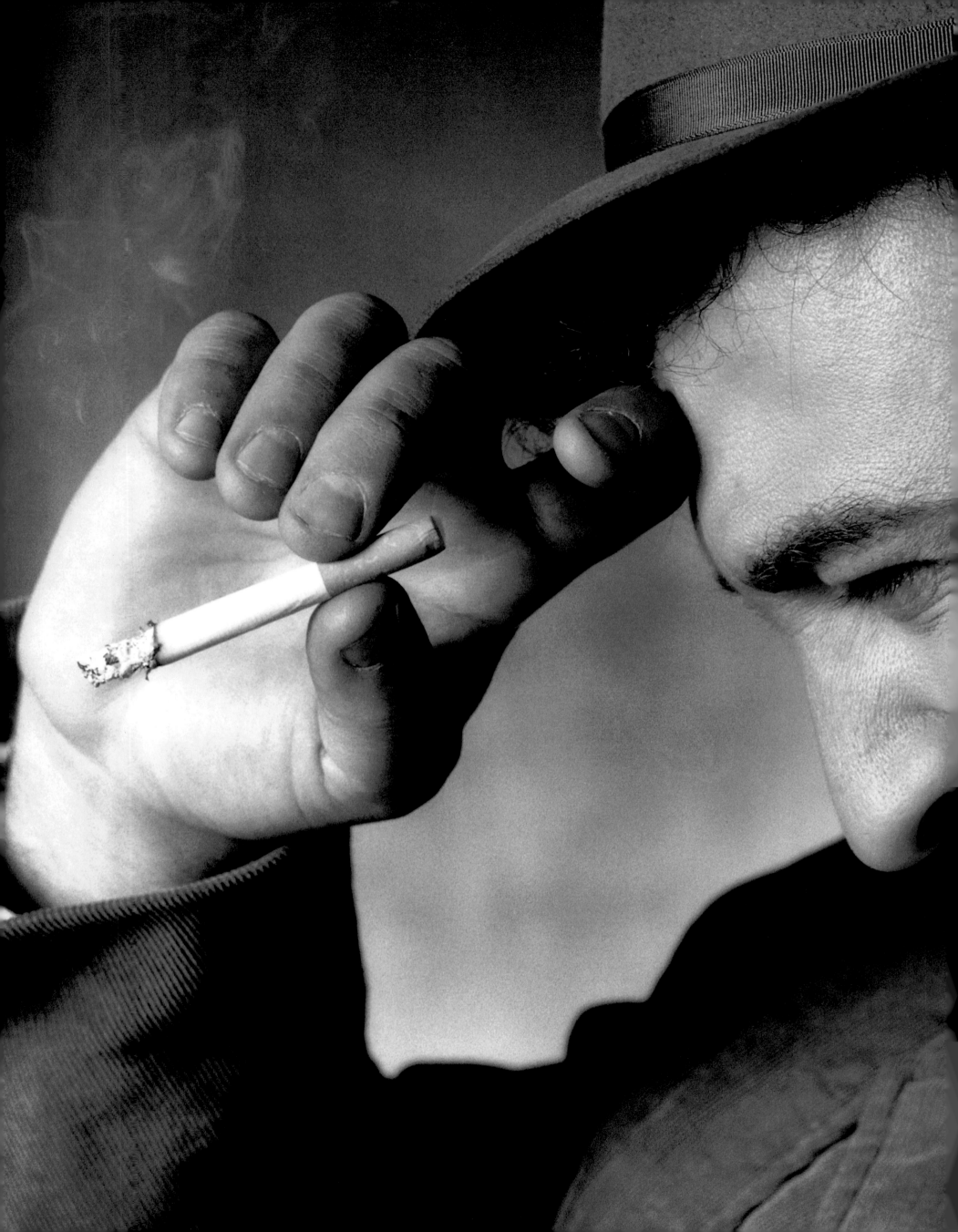

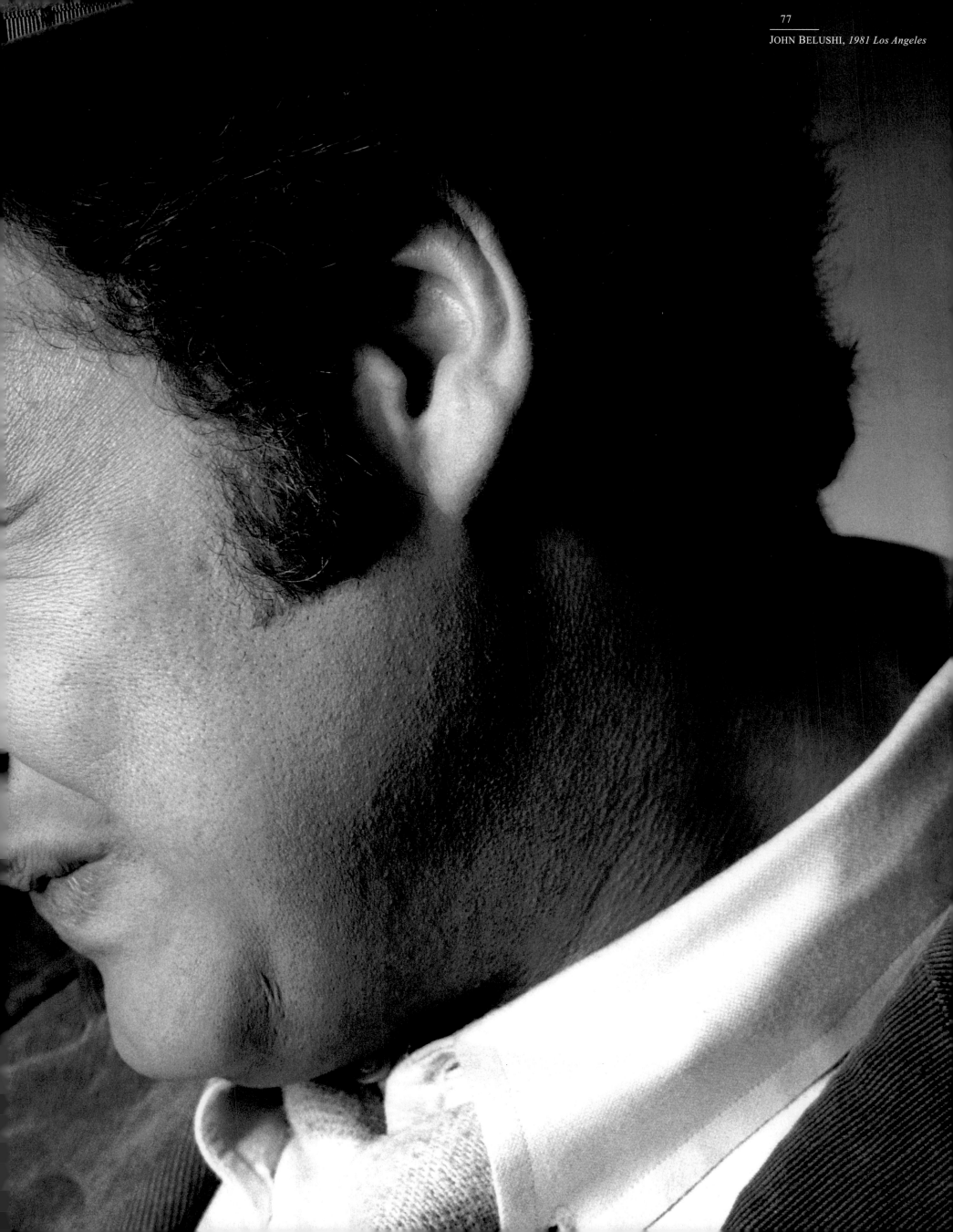

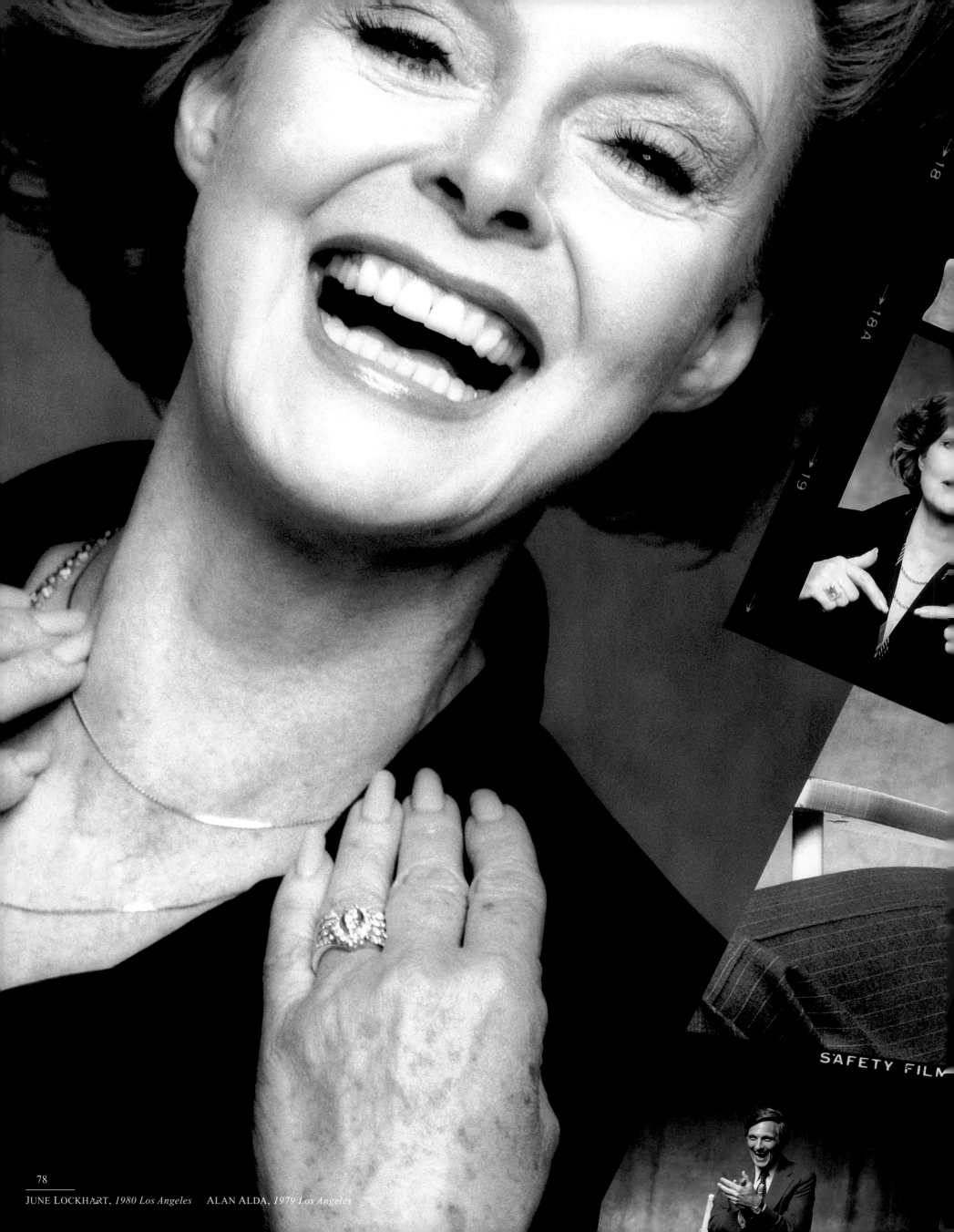

JUNE LOCKHART, *1980 Los Angeles* ALAN ALDA, *1979 Los Angeles*

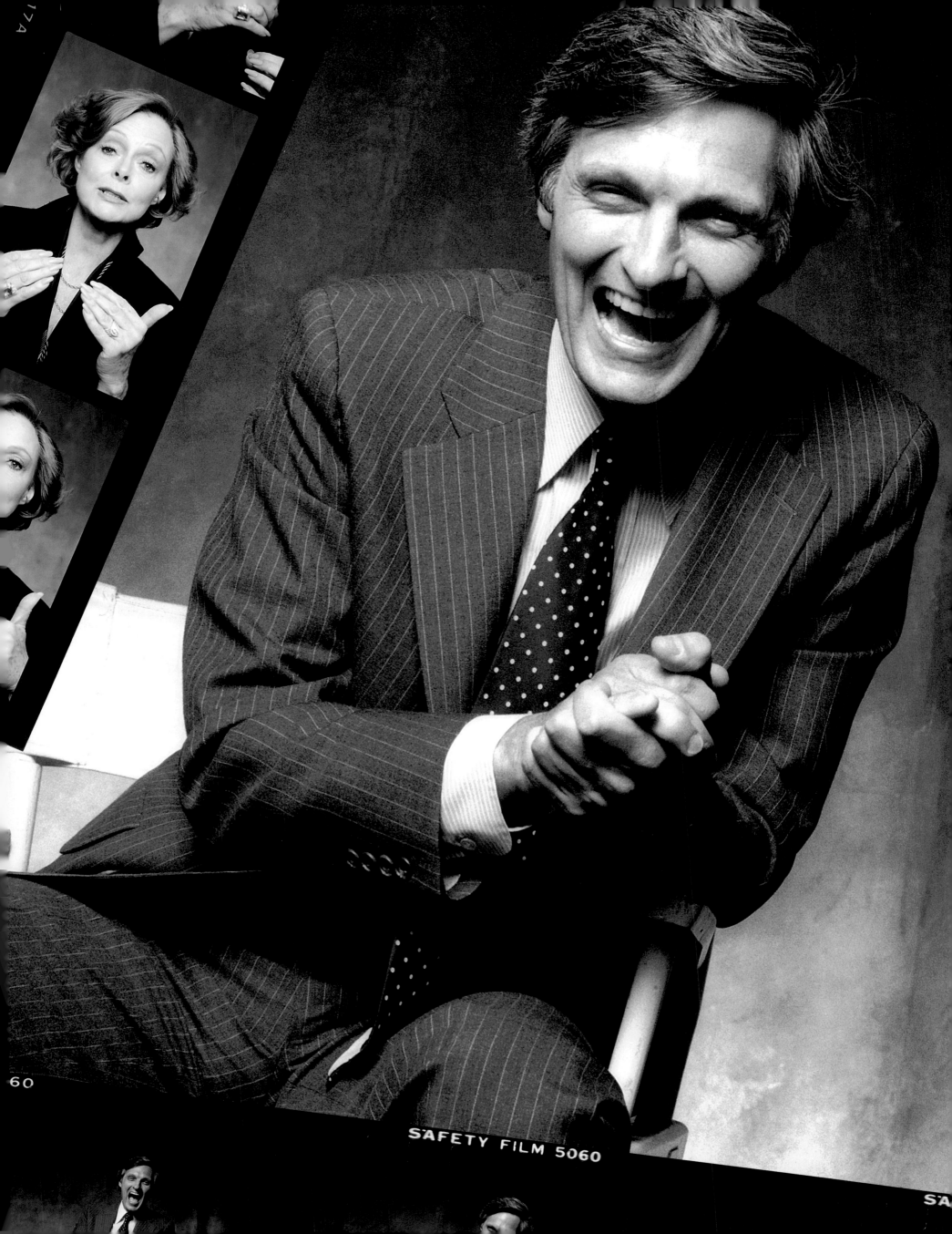

SAFETY FILM 5060

JANE FONDA, *1979 Los Angeles*

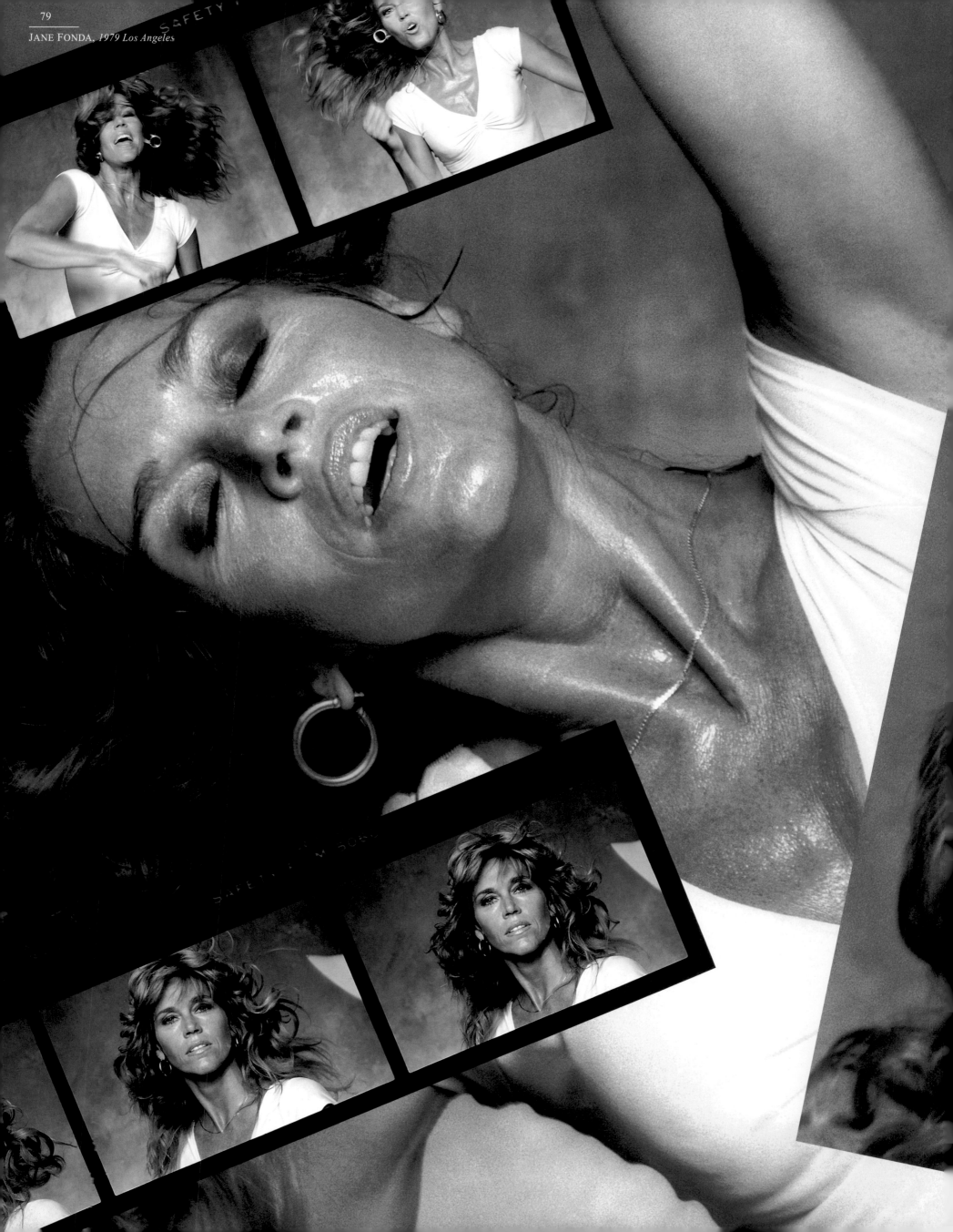

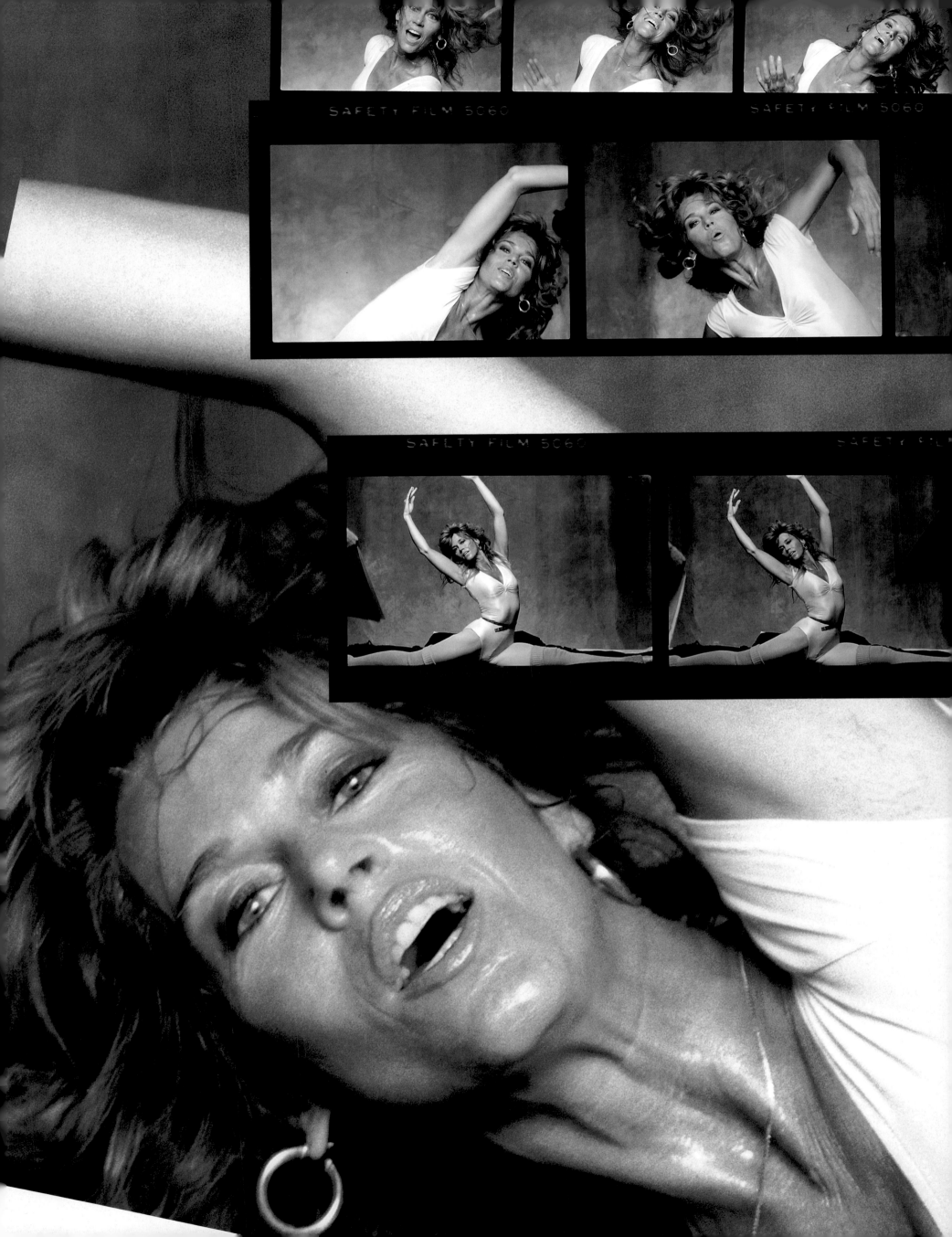

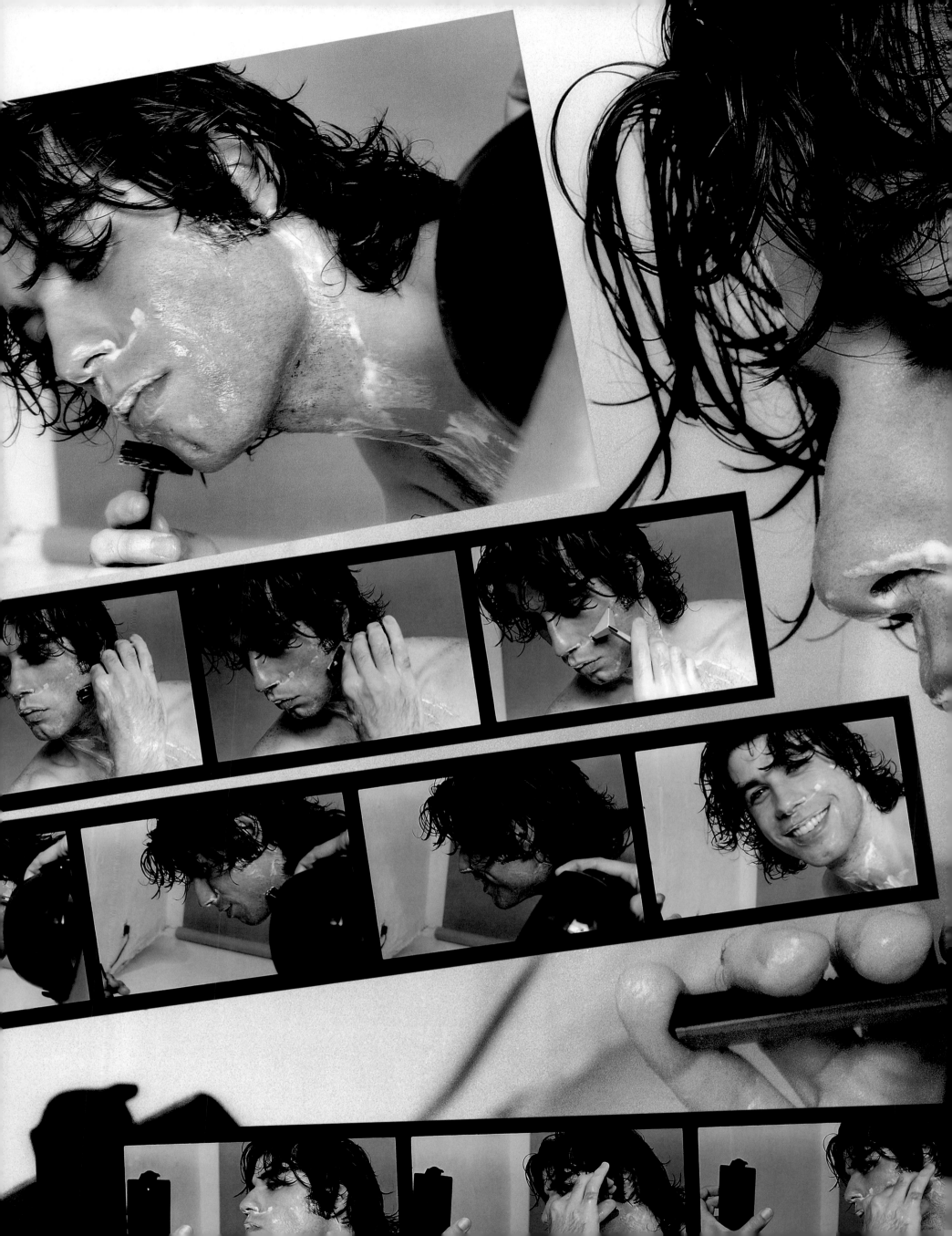

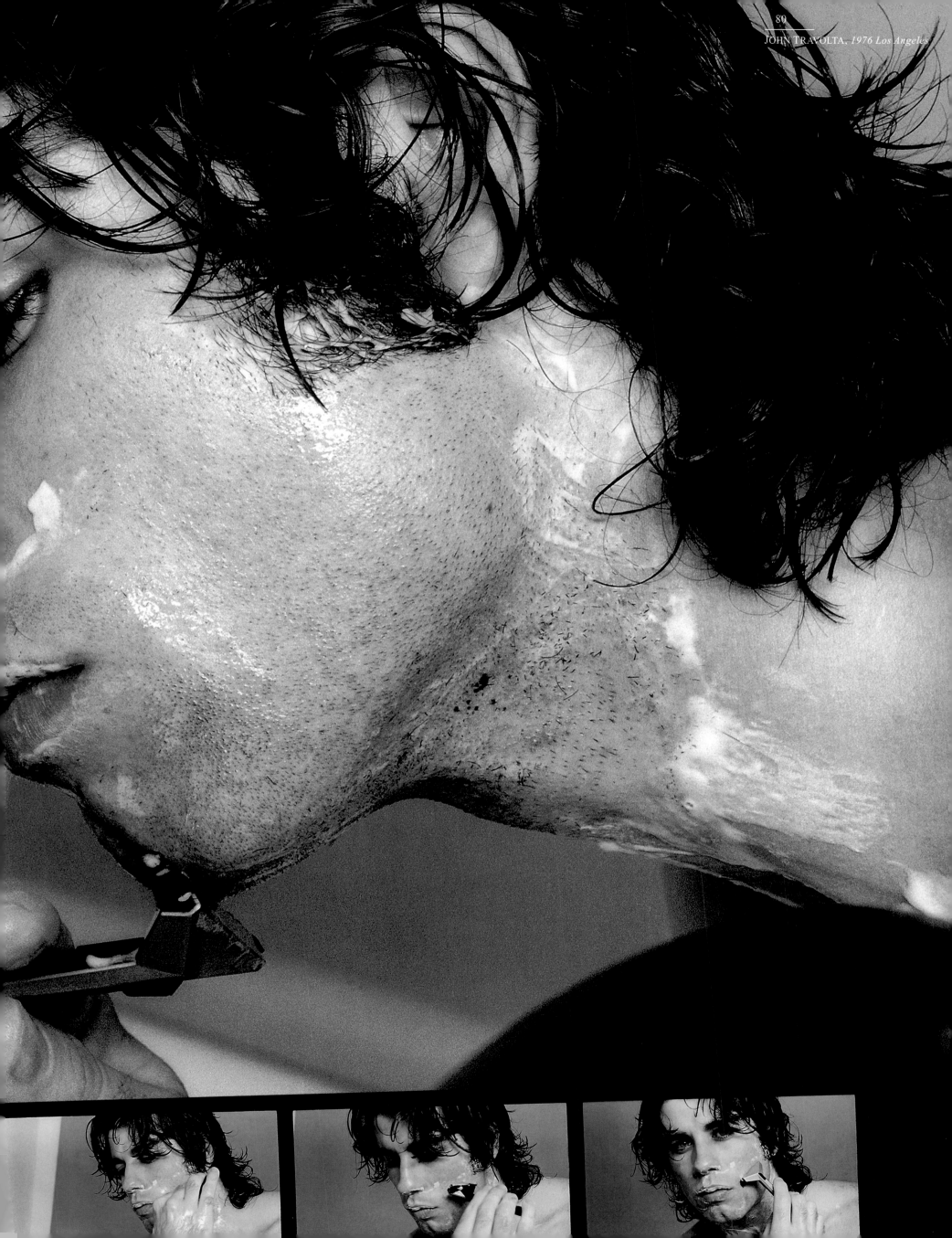

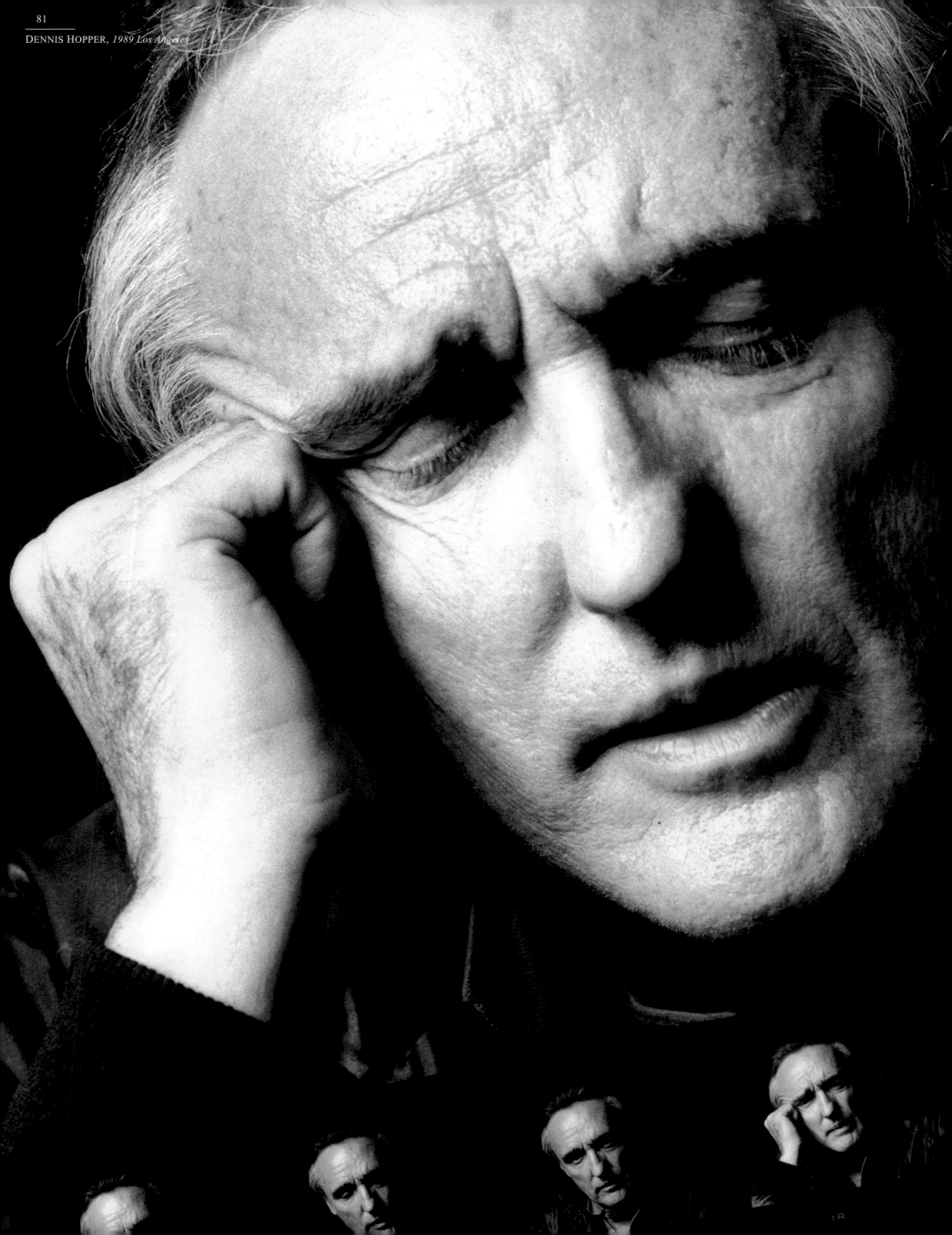

DENNIS HOPPER, *1989 Los Angeles*

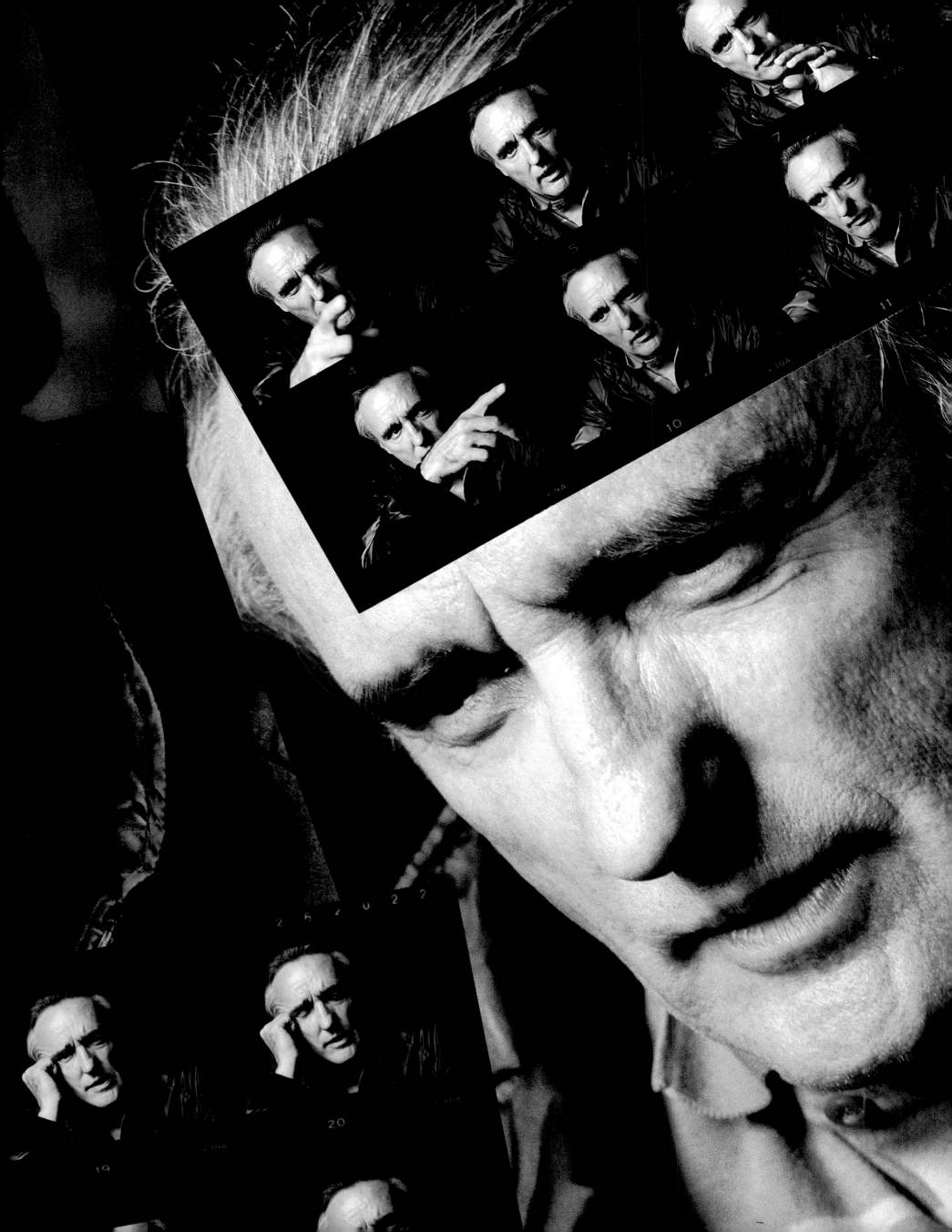

JODIE FOSTER, *1976 Los Angeles*

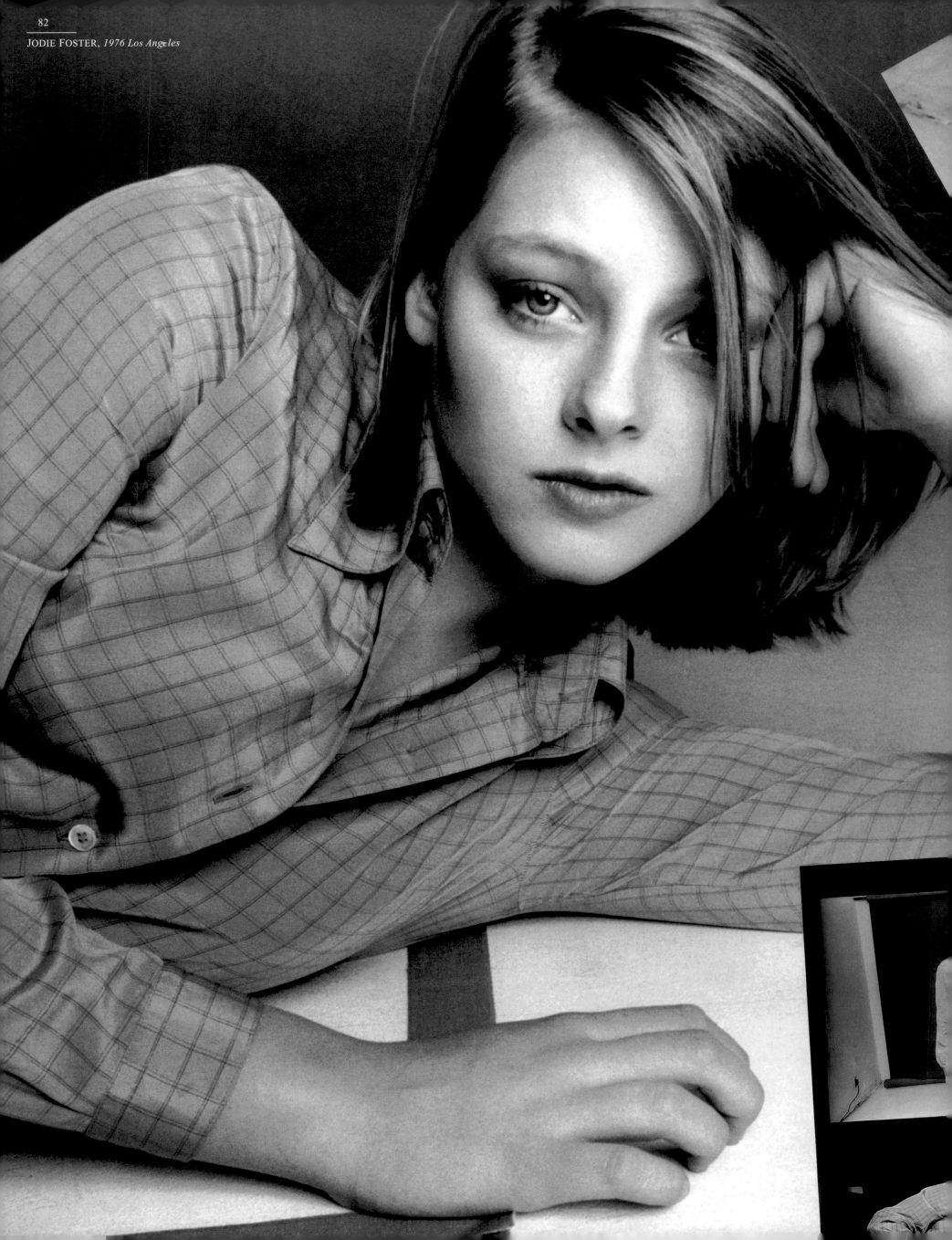

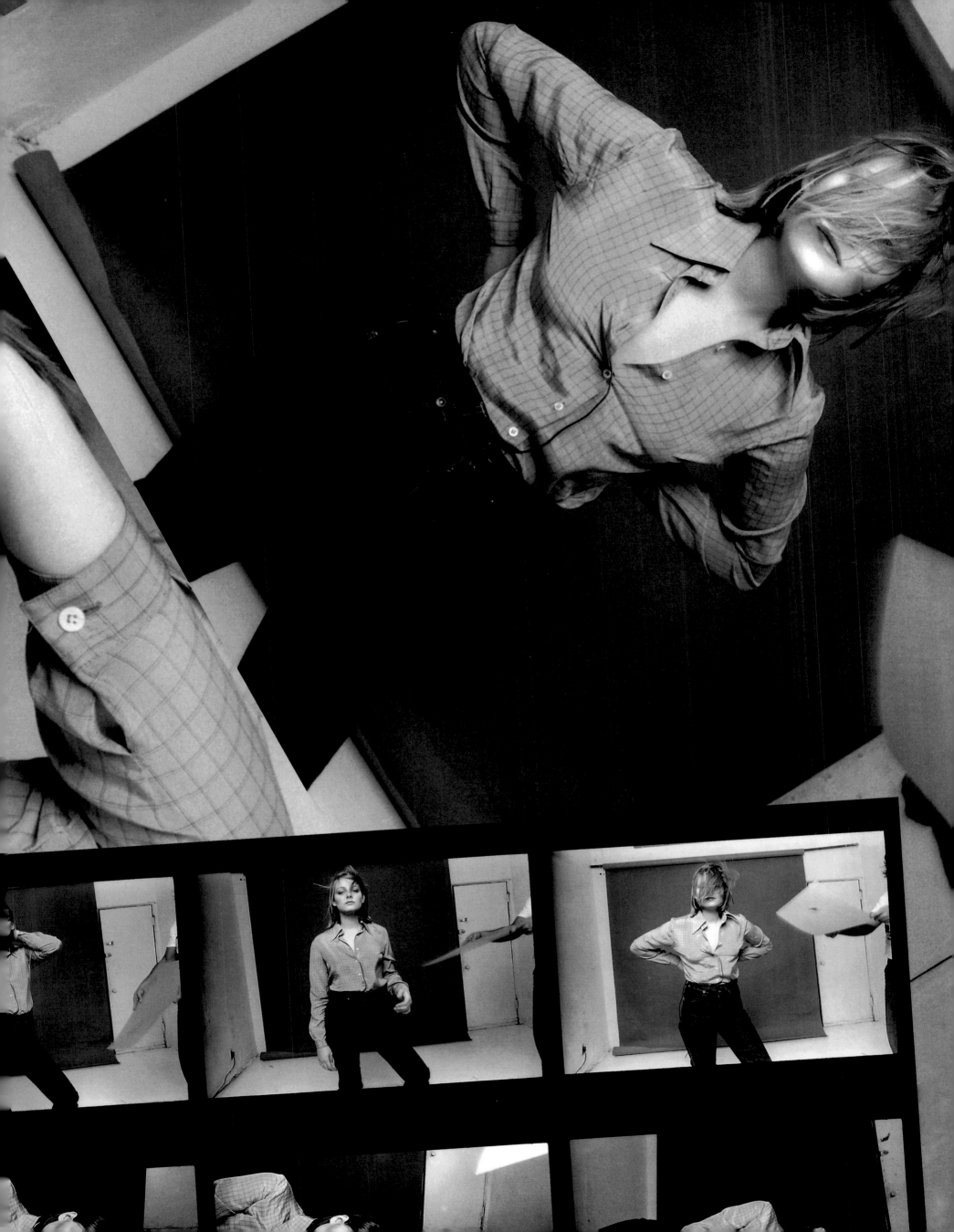

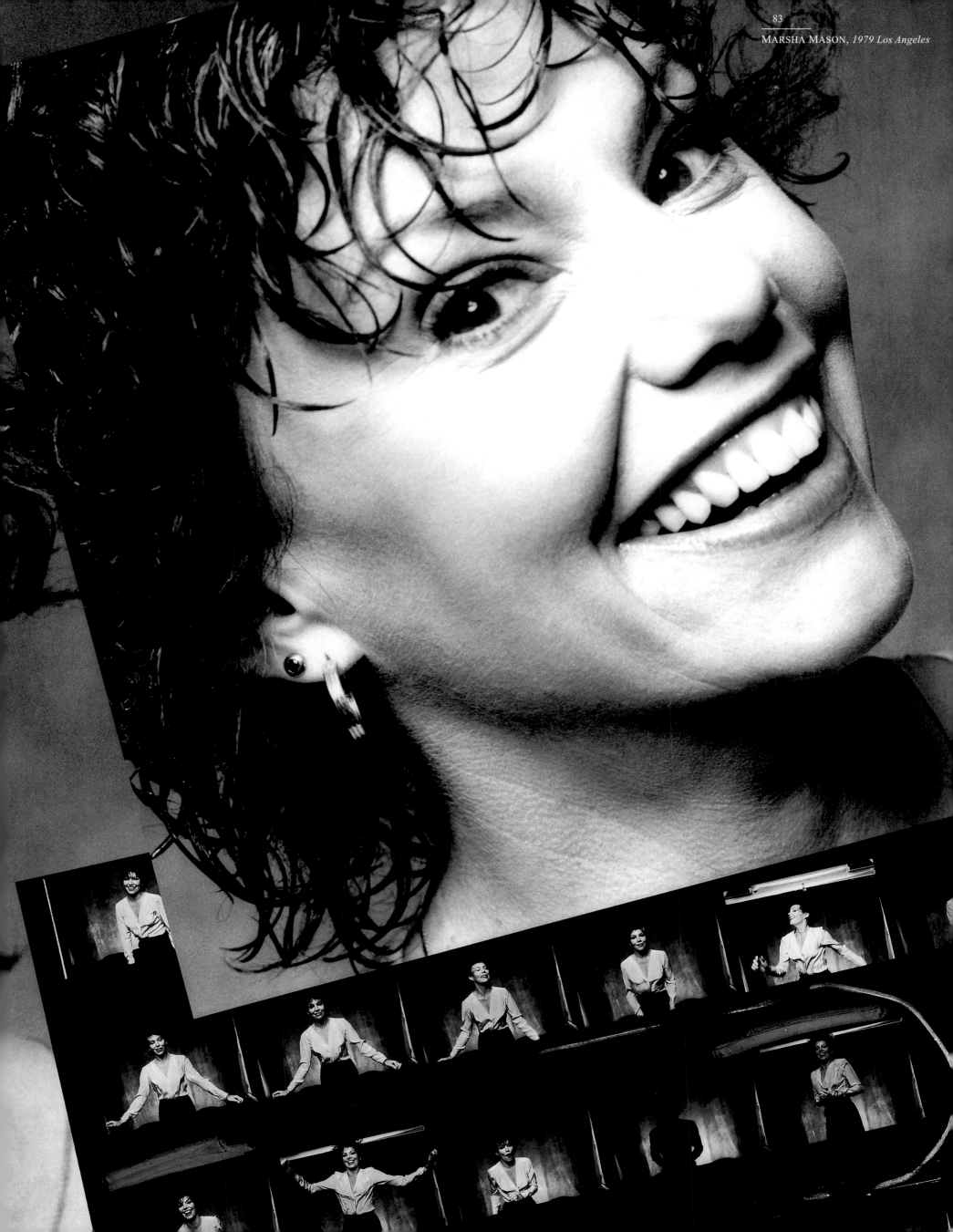

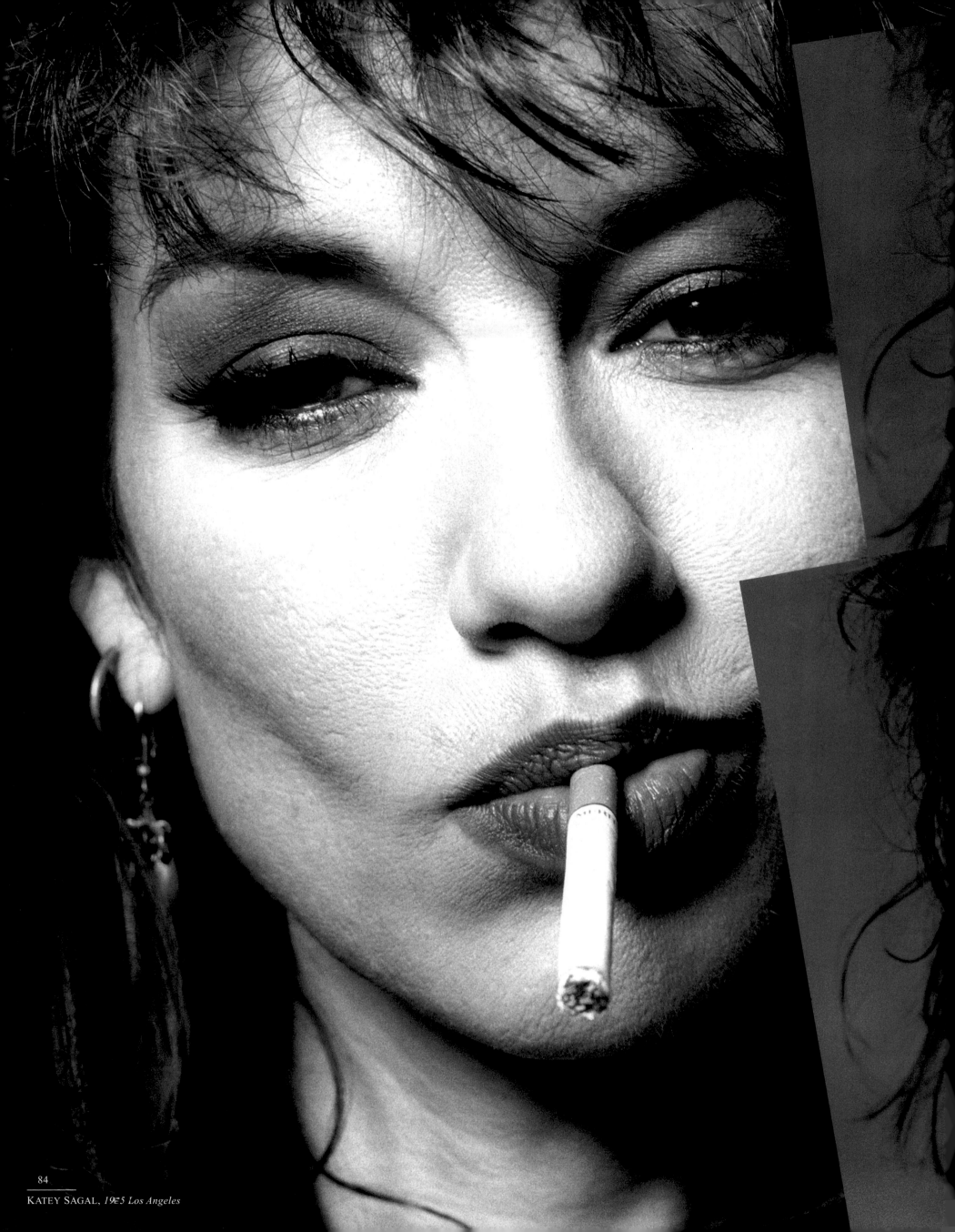

KATEY SAGAL, *1975 Los Angeles*

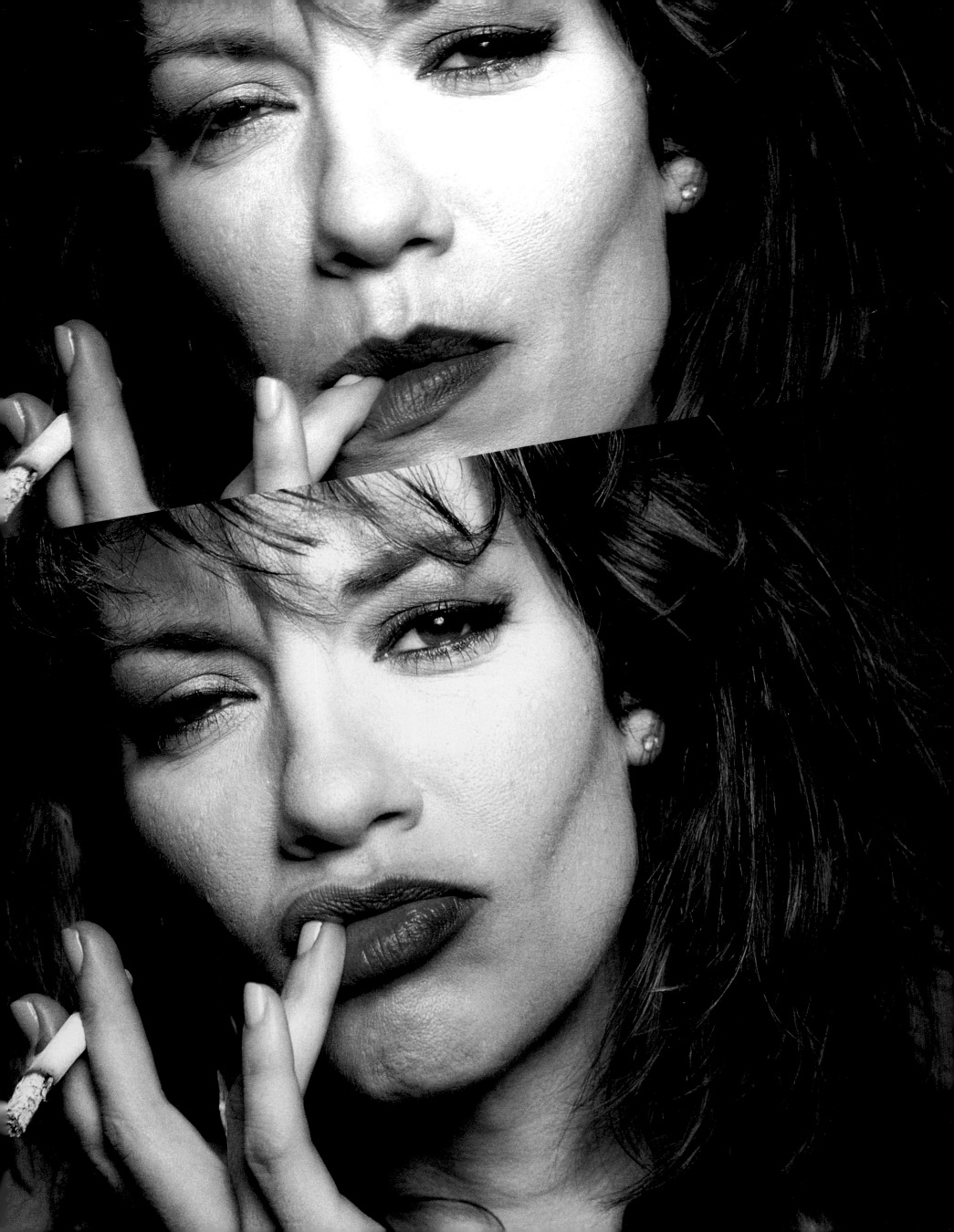

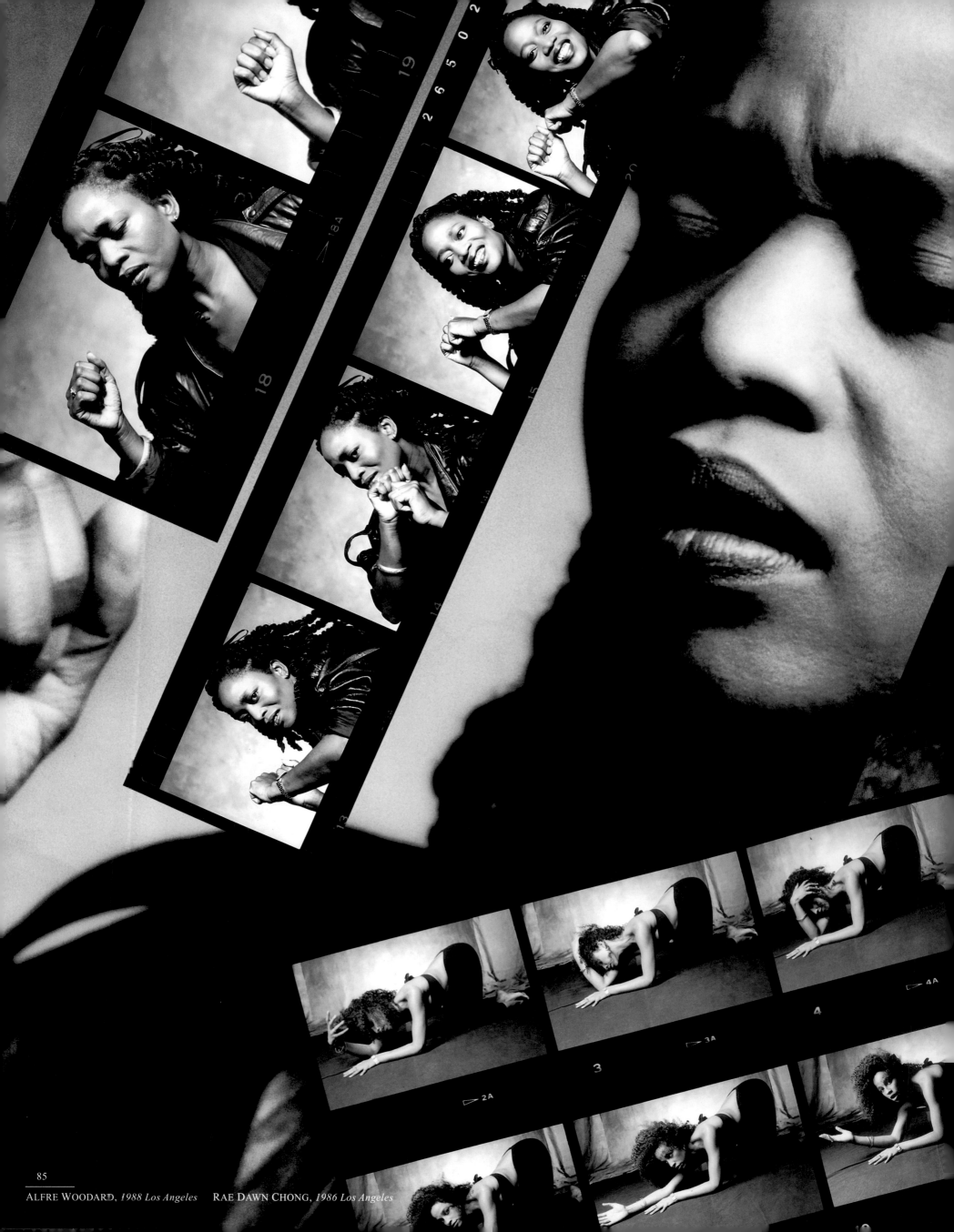

85

ALFRE WOODARD, *1988 Los Angeles* RAE DAWN CHONG, *1986 Los Angeles*

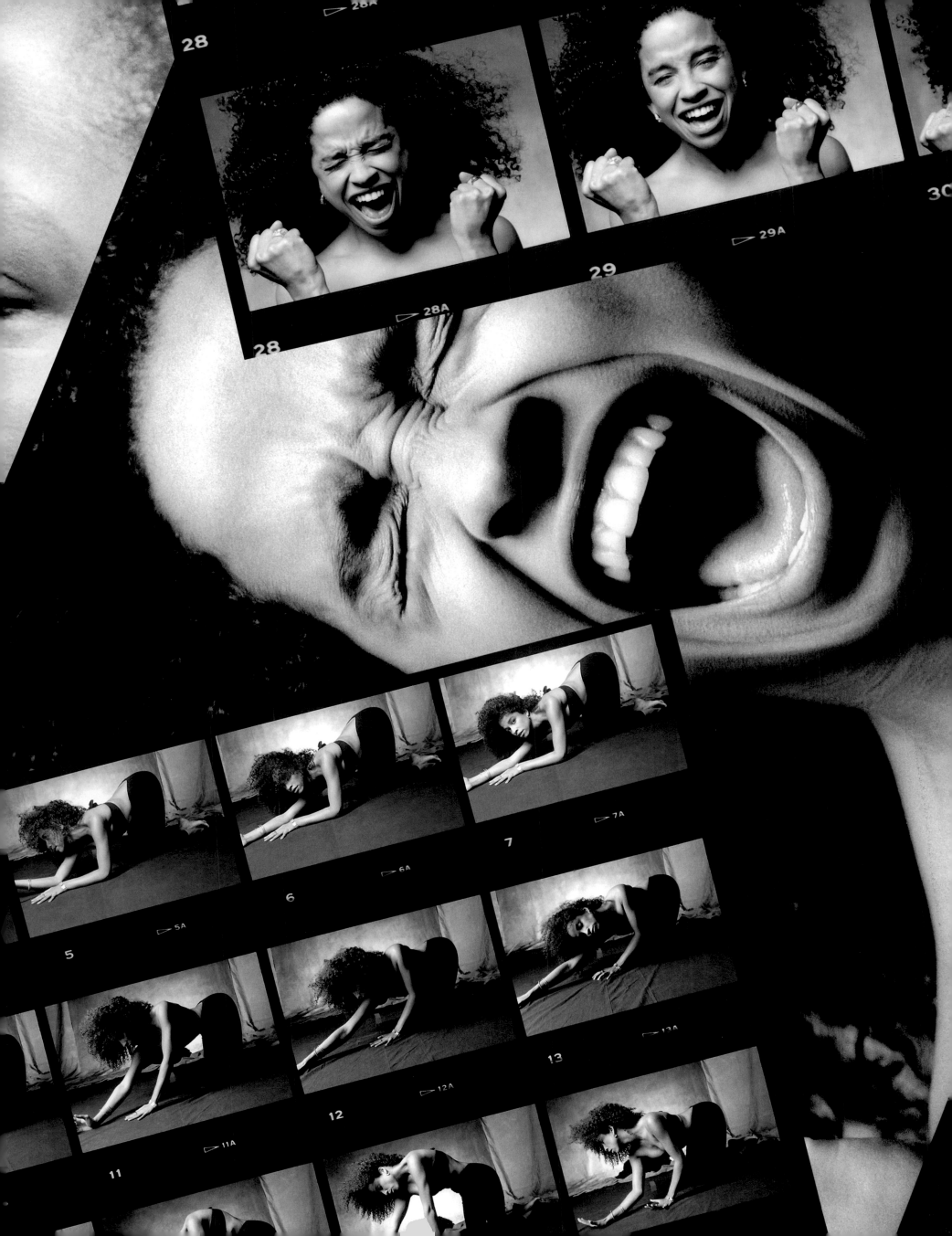

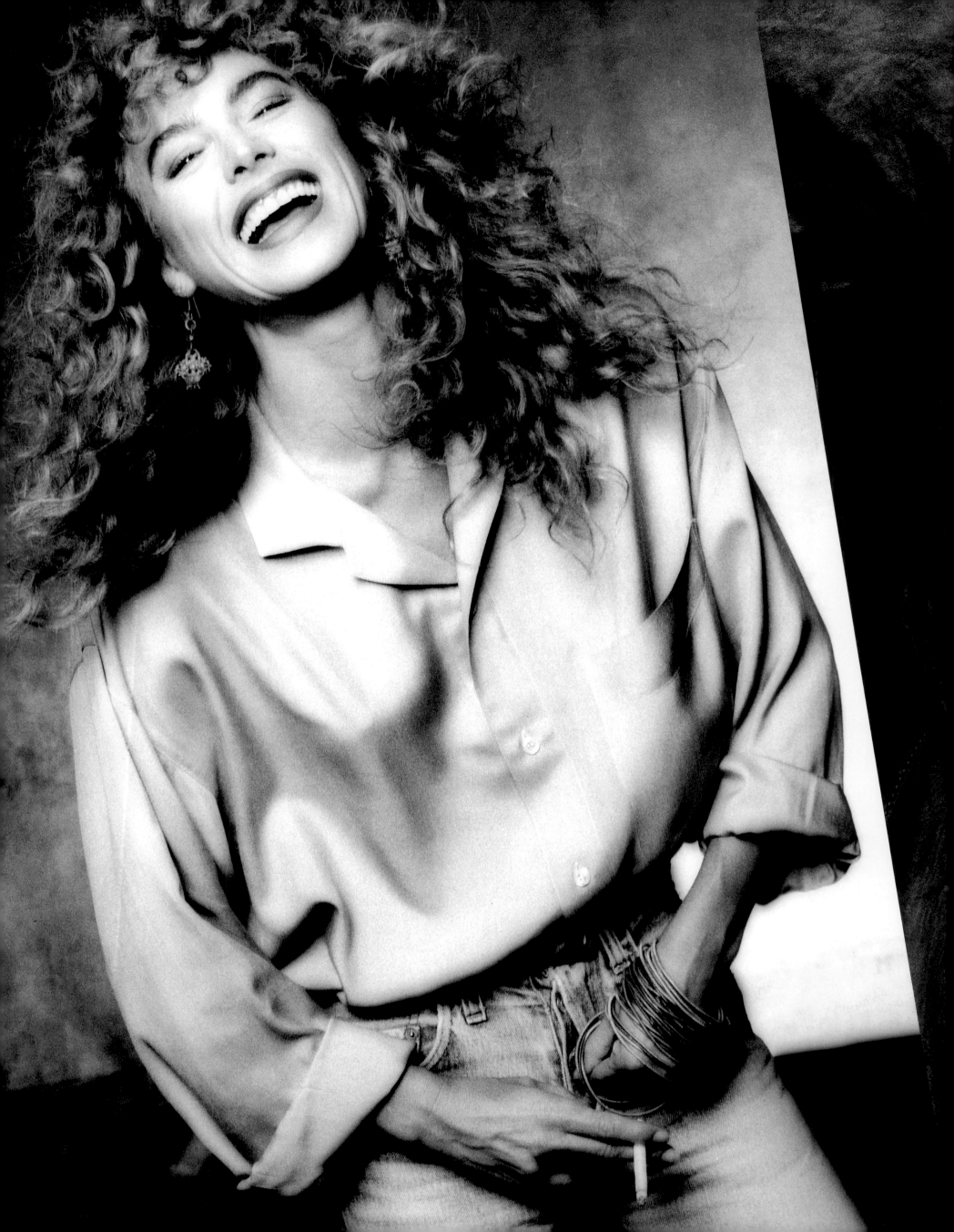

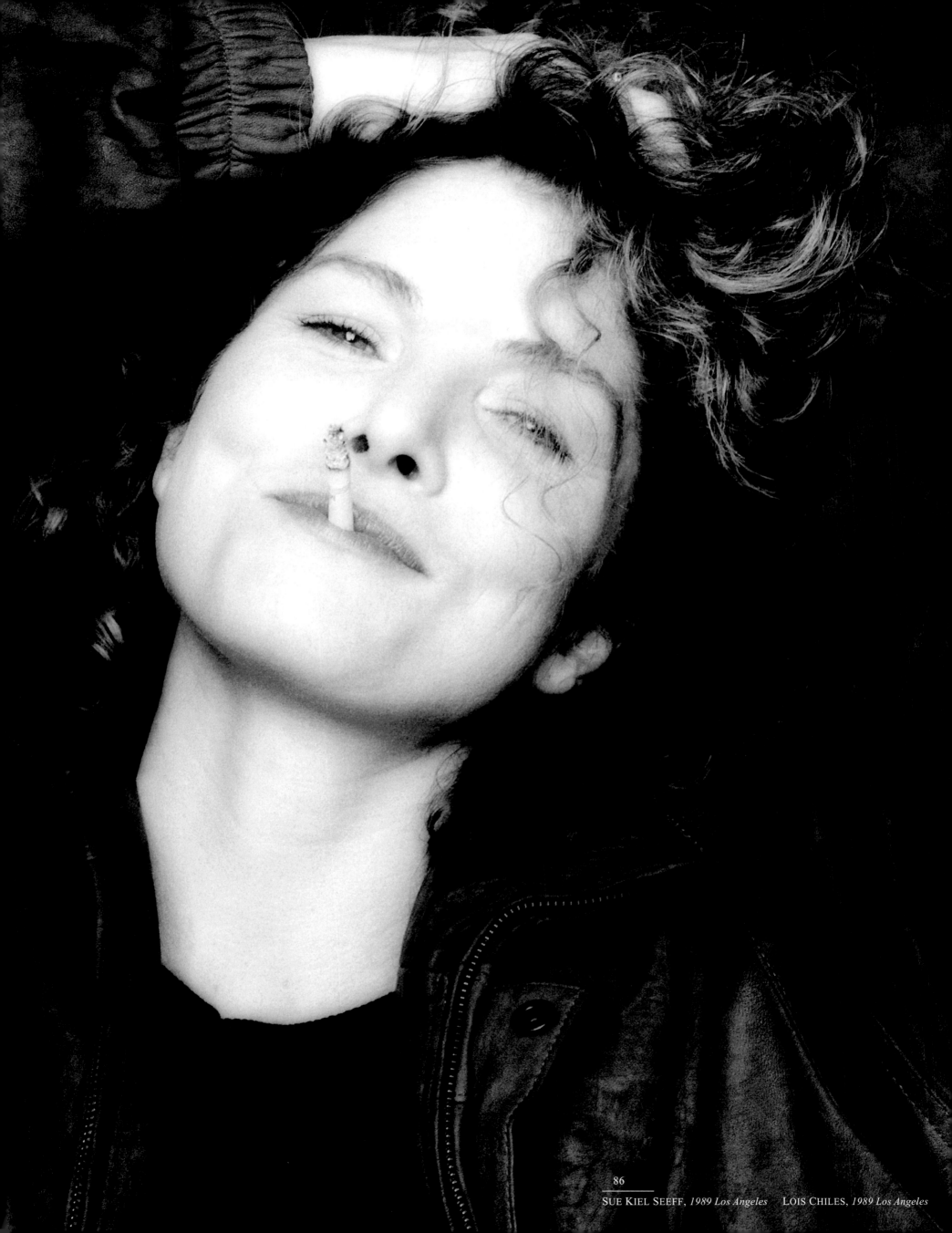

SUE KIEL SEEFF, *1989 Los Angeles* LOIS CHILES, *1989 Los Angeles*

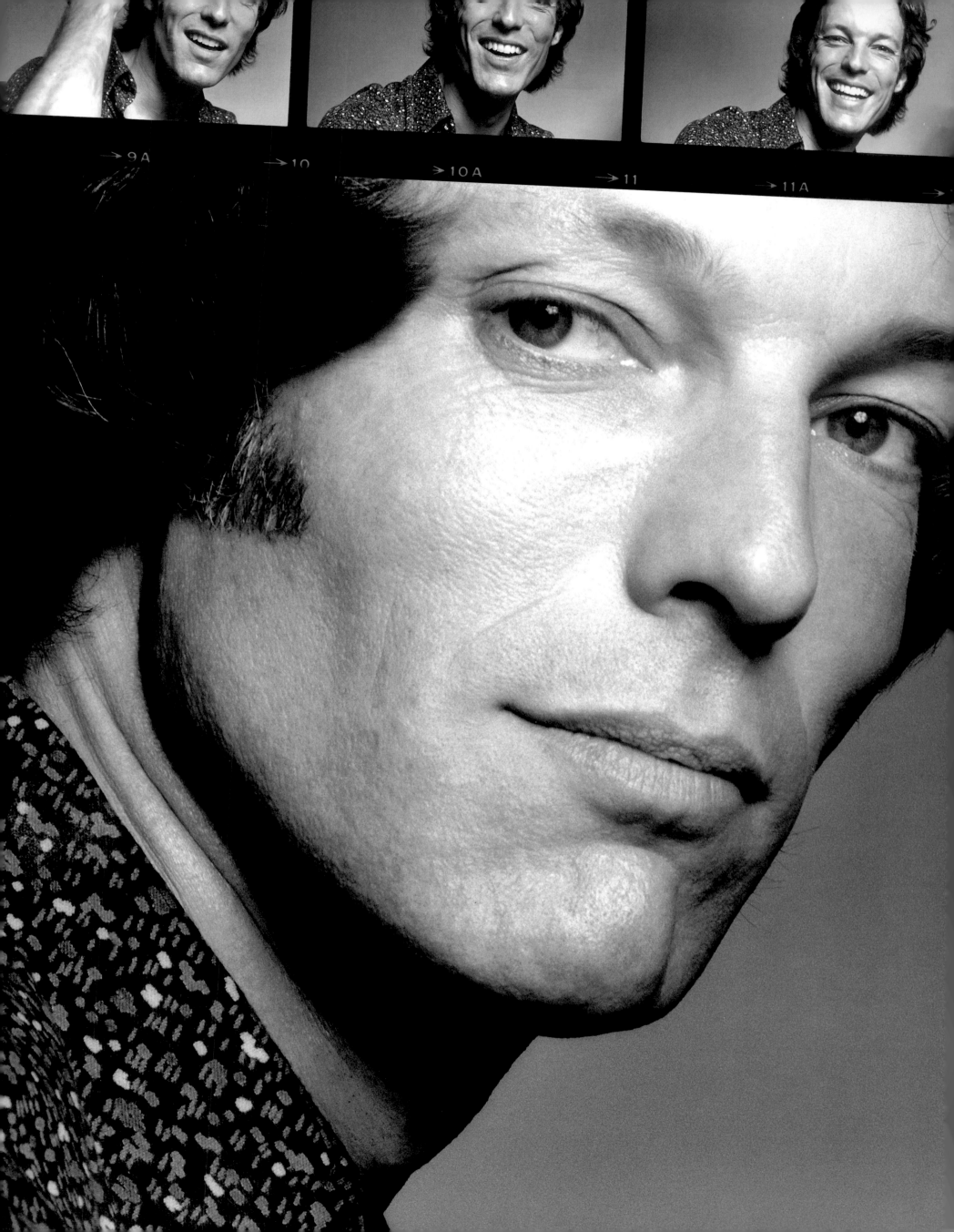

9A → 10 → 10A → 11 → 11A →

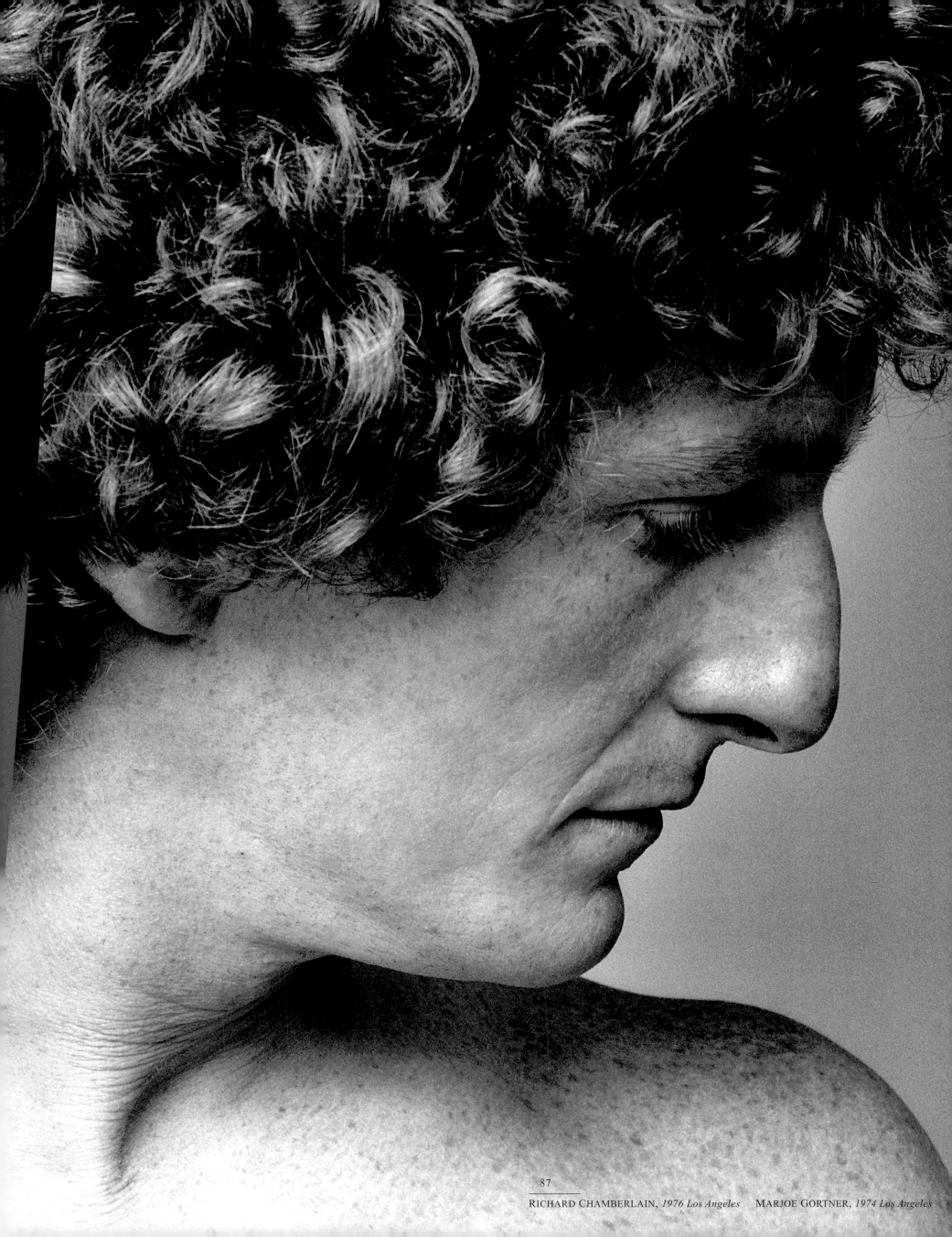

87

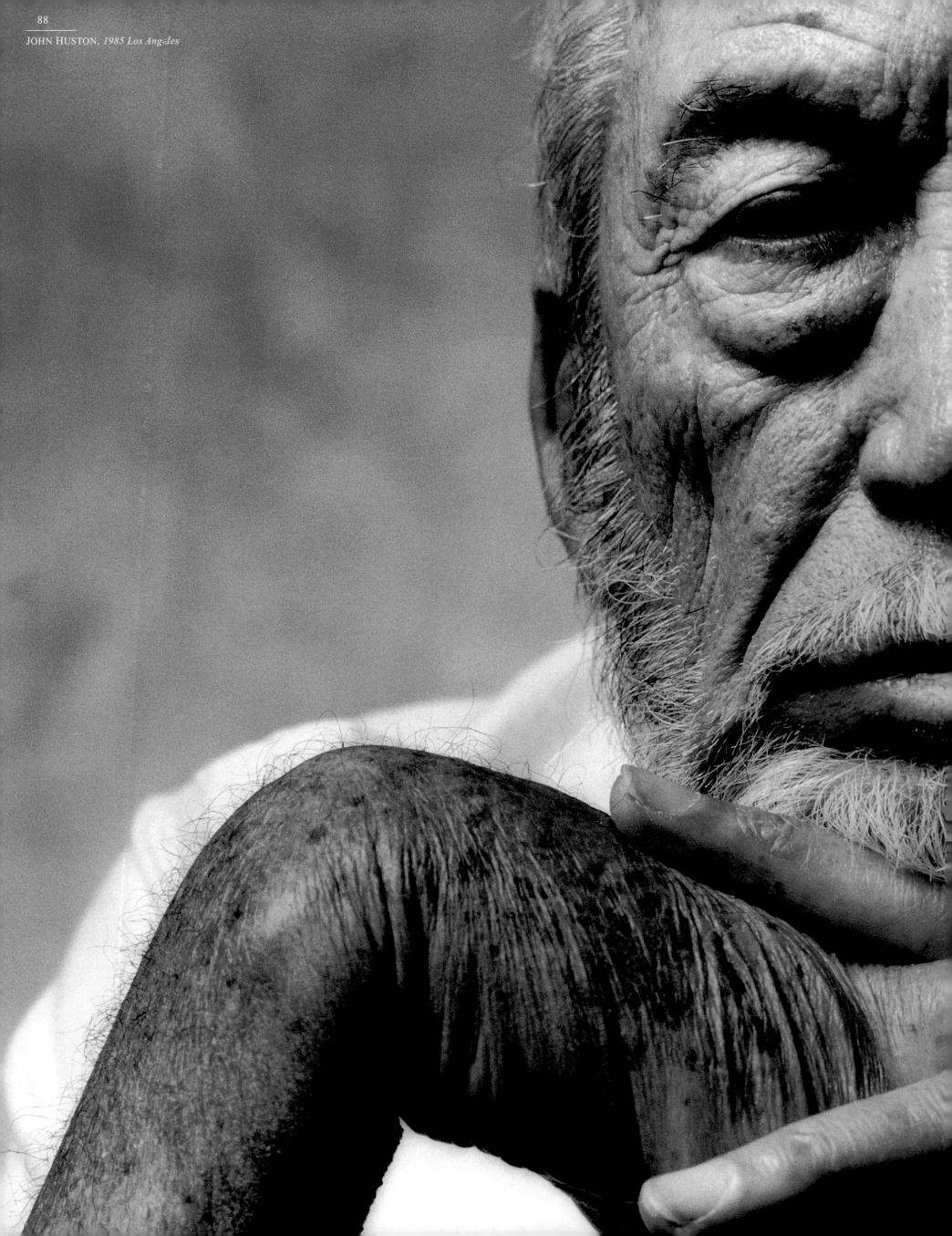

JOHN HUSTON, *1985 Los Angeles*

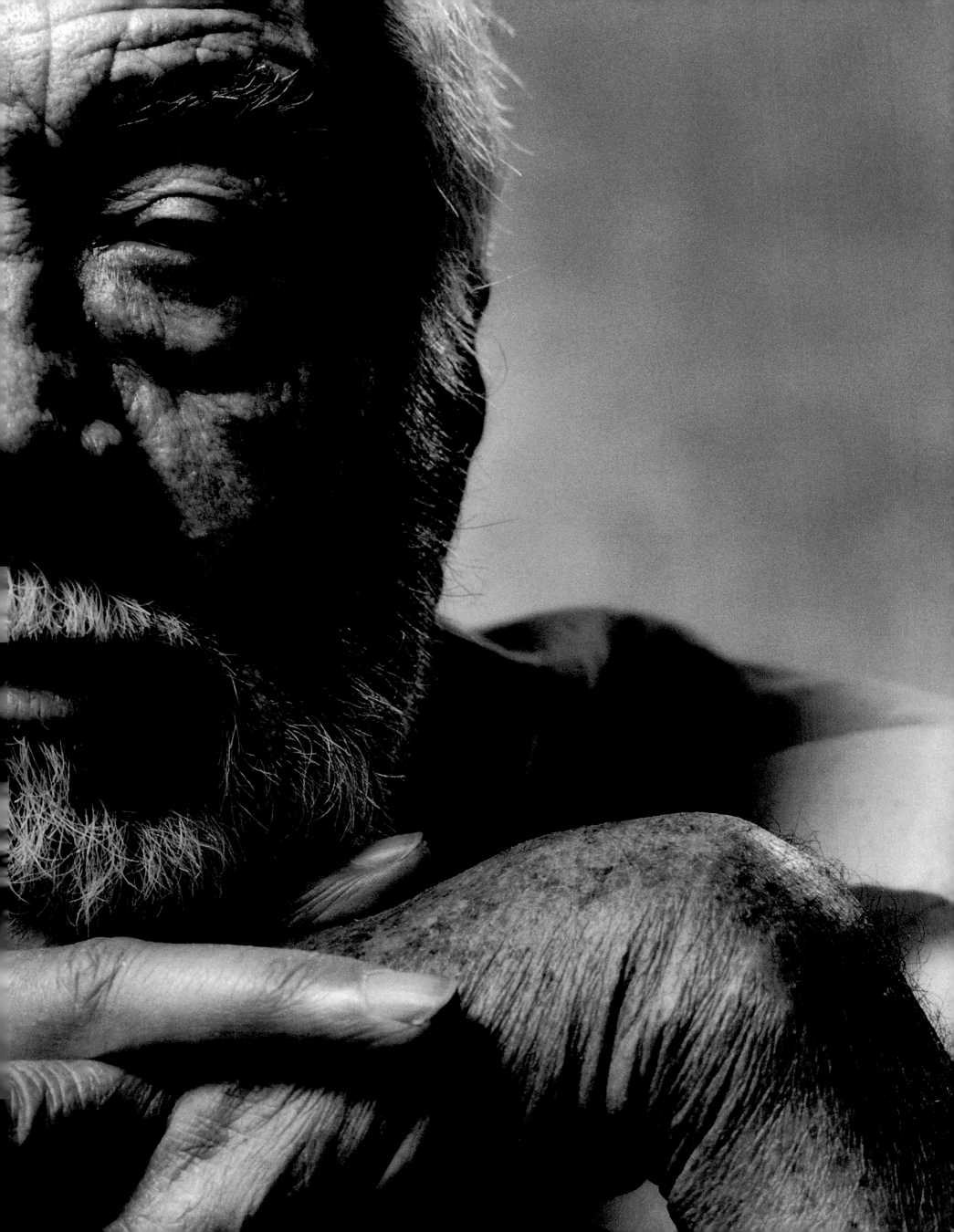

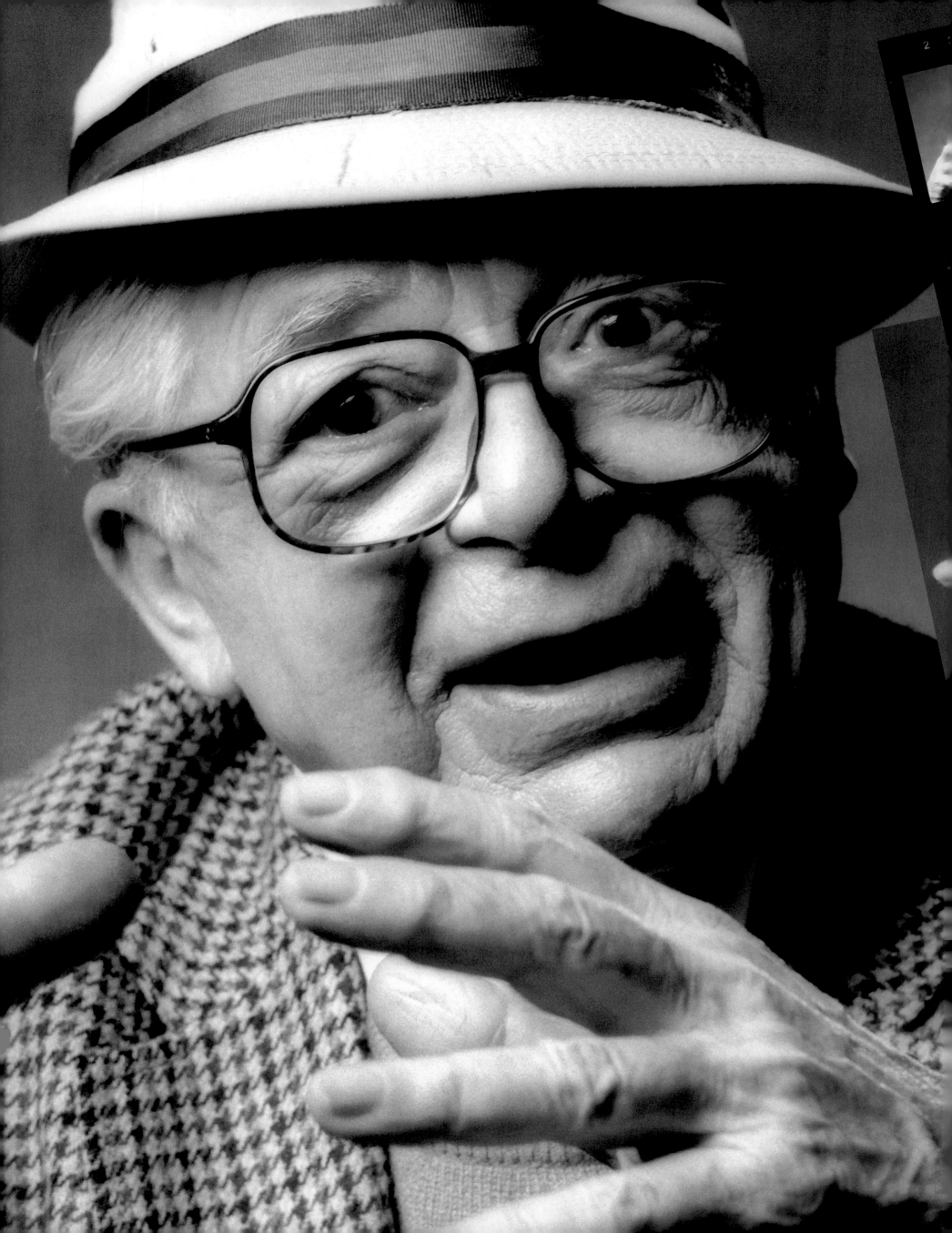

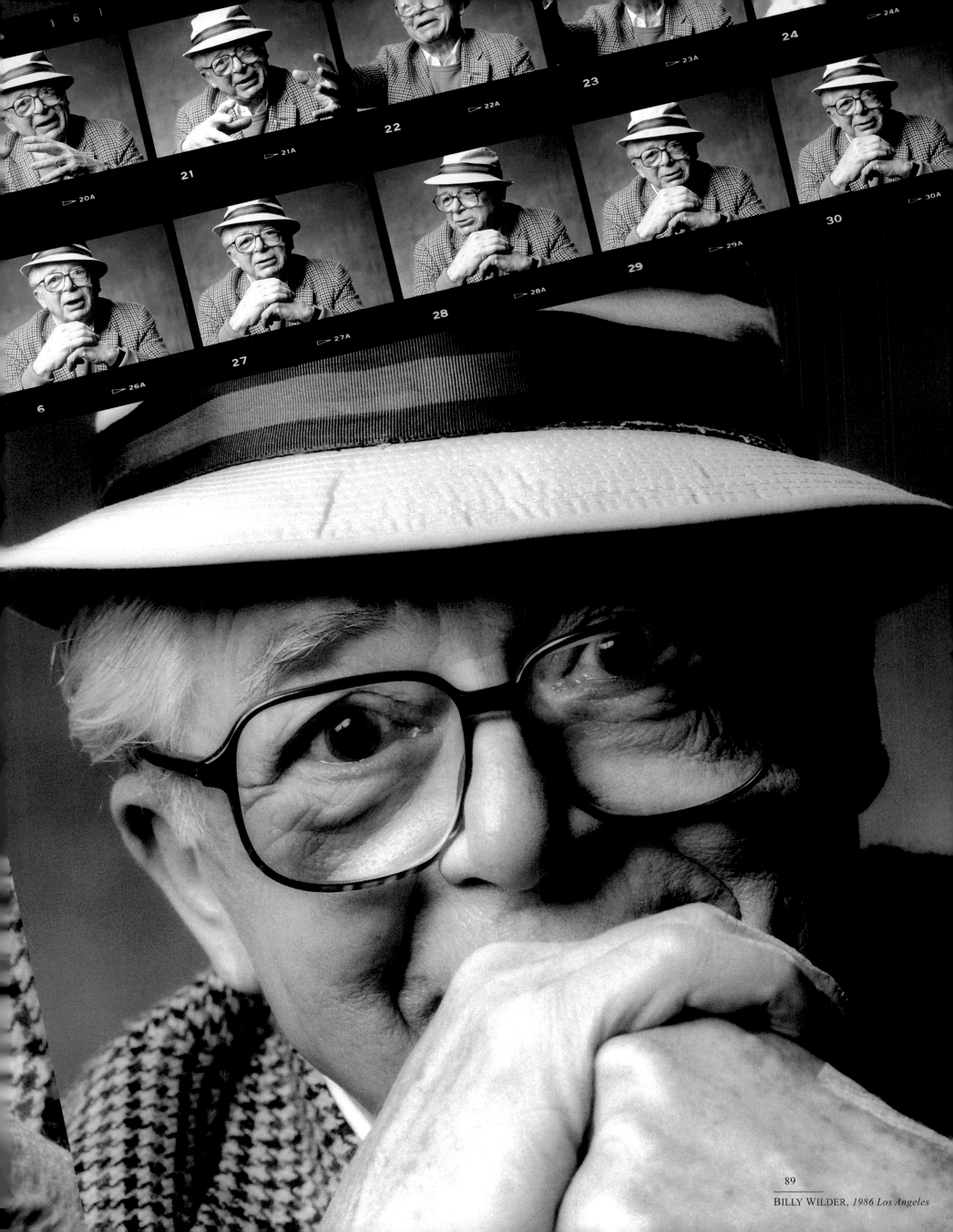

BILLY WILDER, *1986 Los Angeles*

19

▷ 19A

20

23

▷ 32A

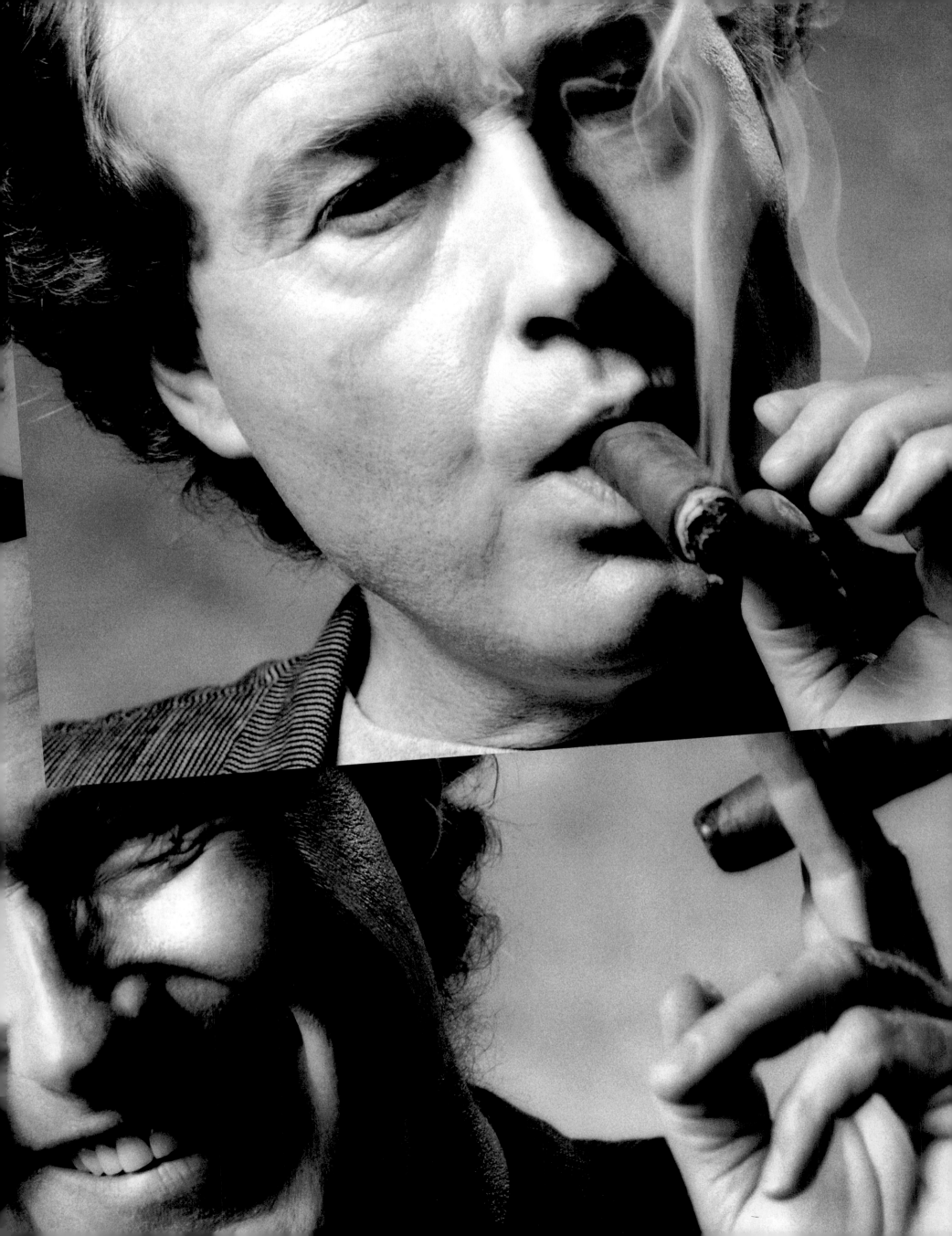

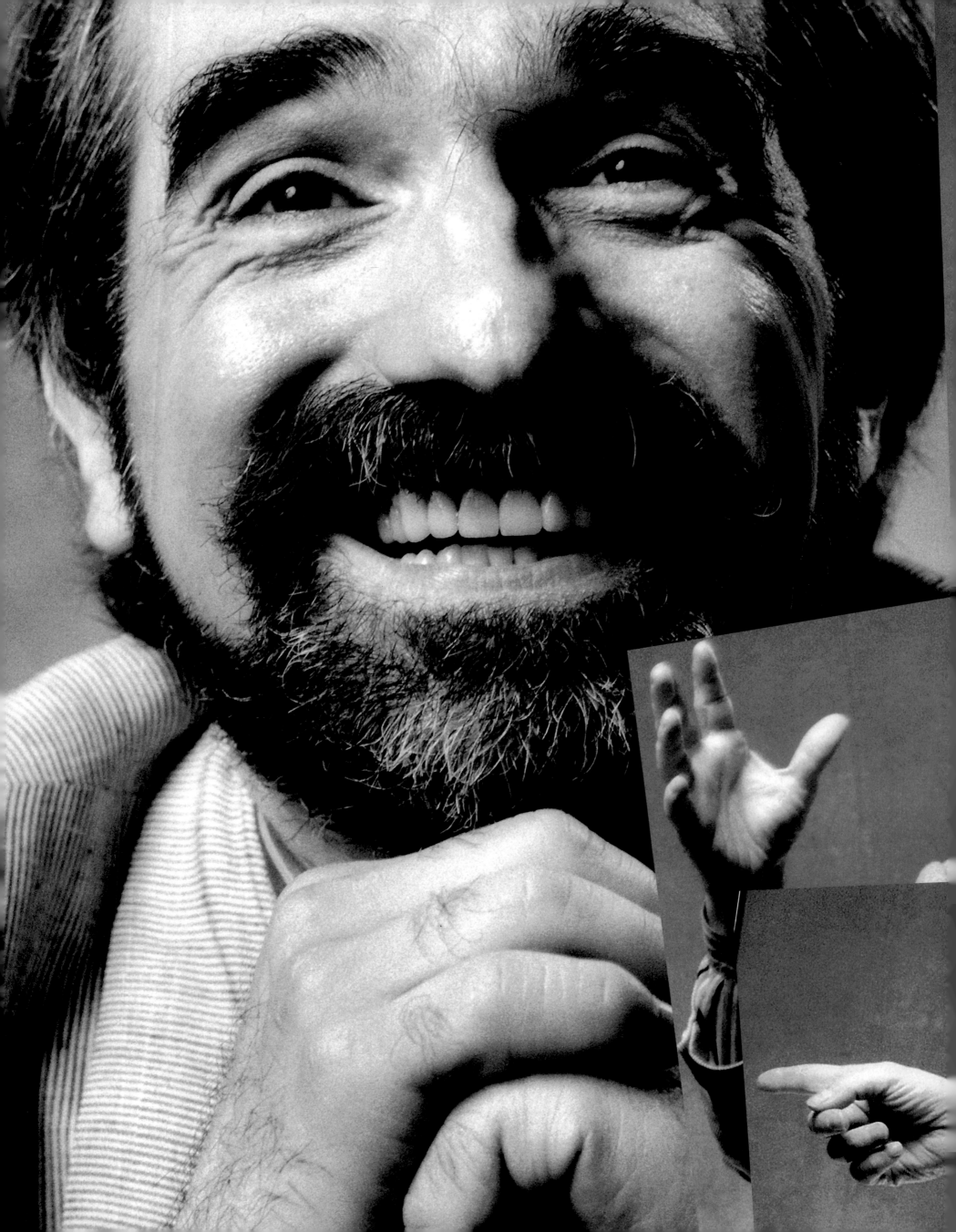

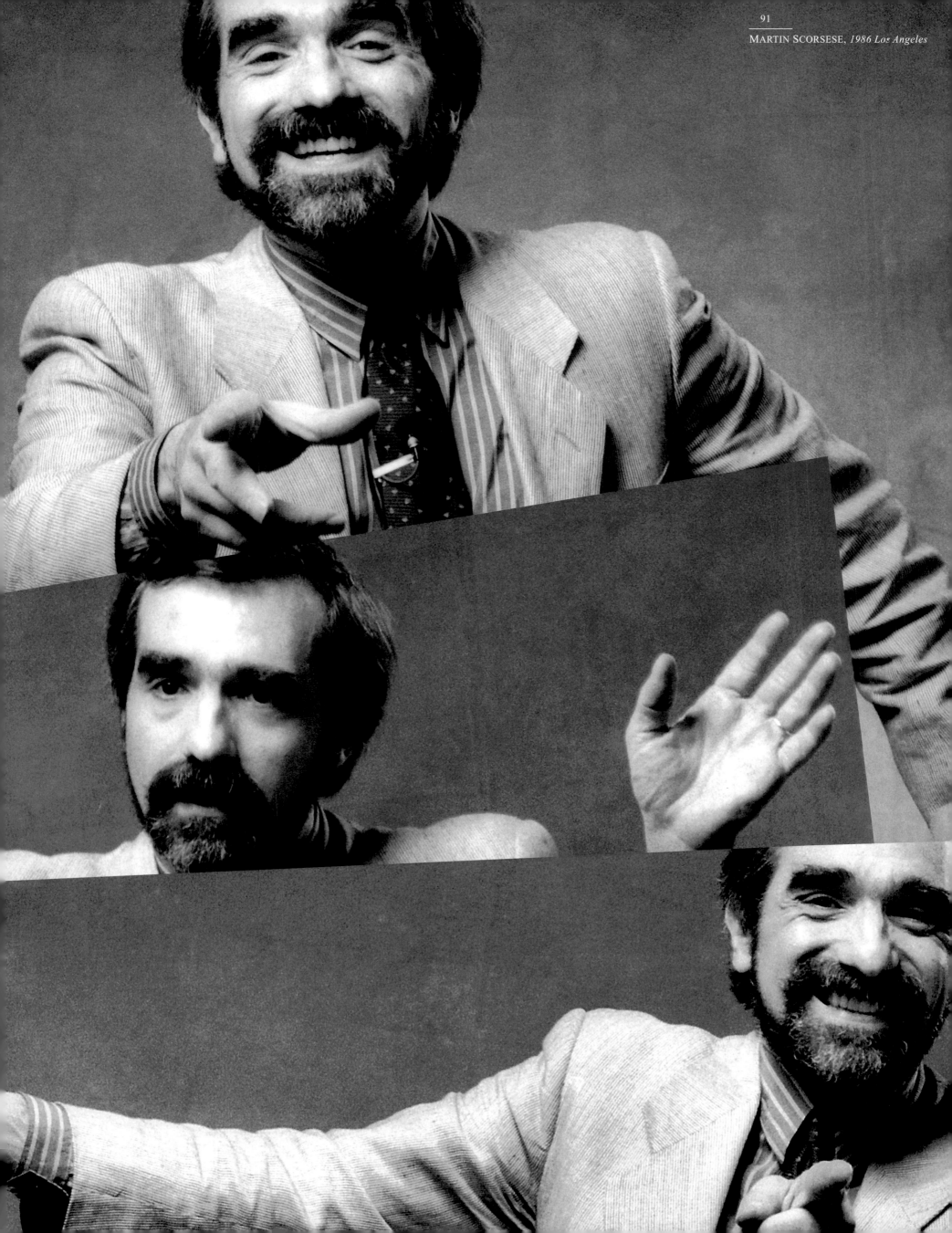

MARTIN SCORSESE, *1986 Los Angeles*

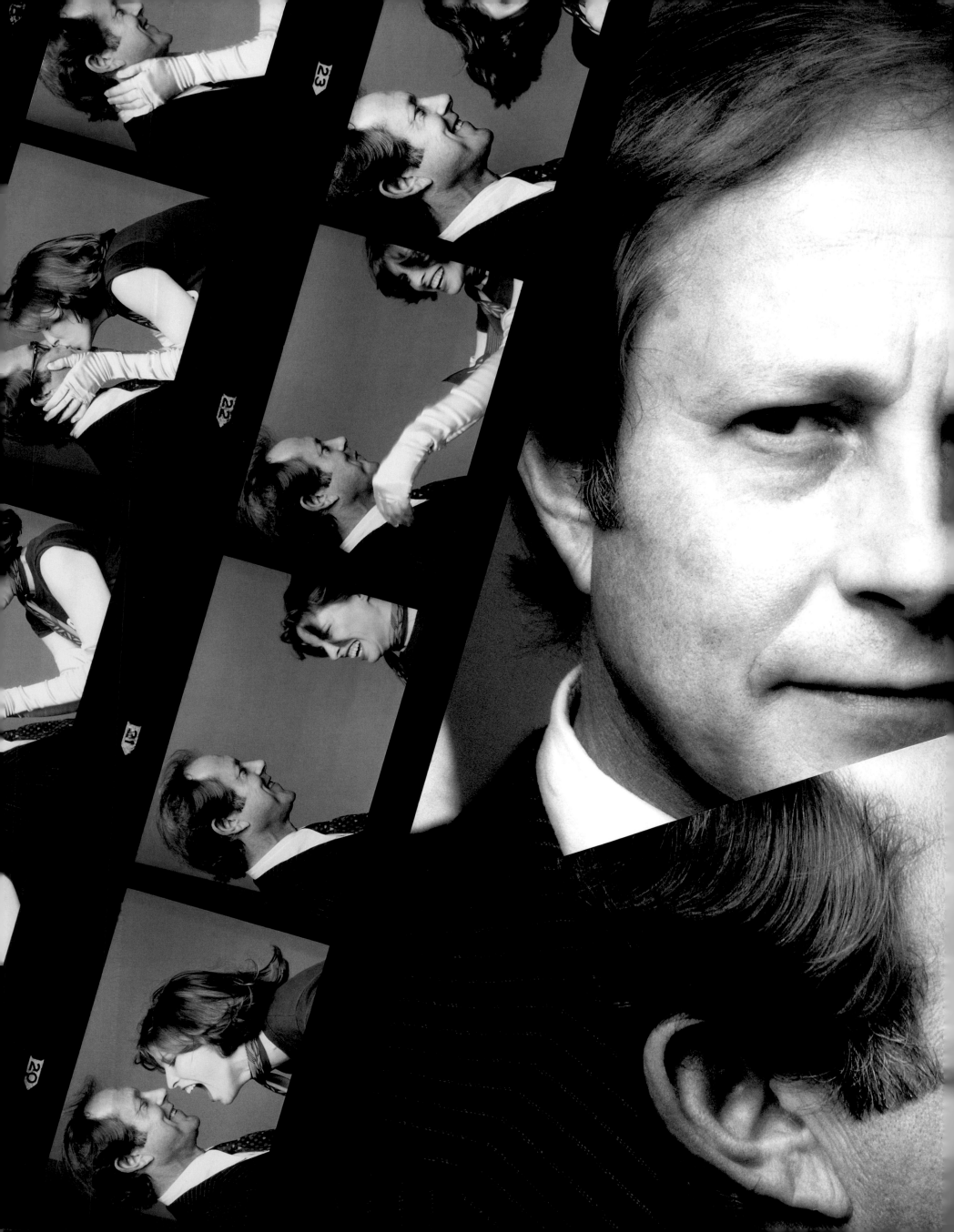

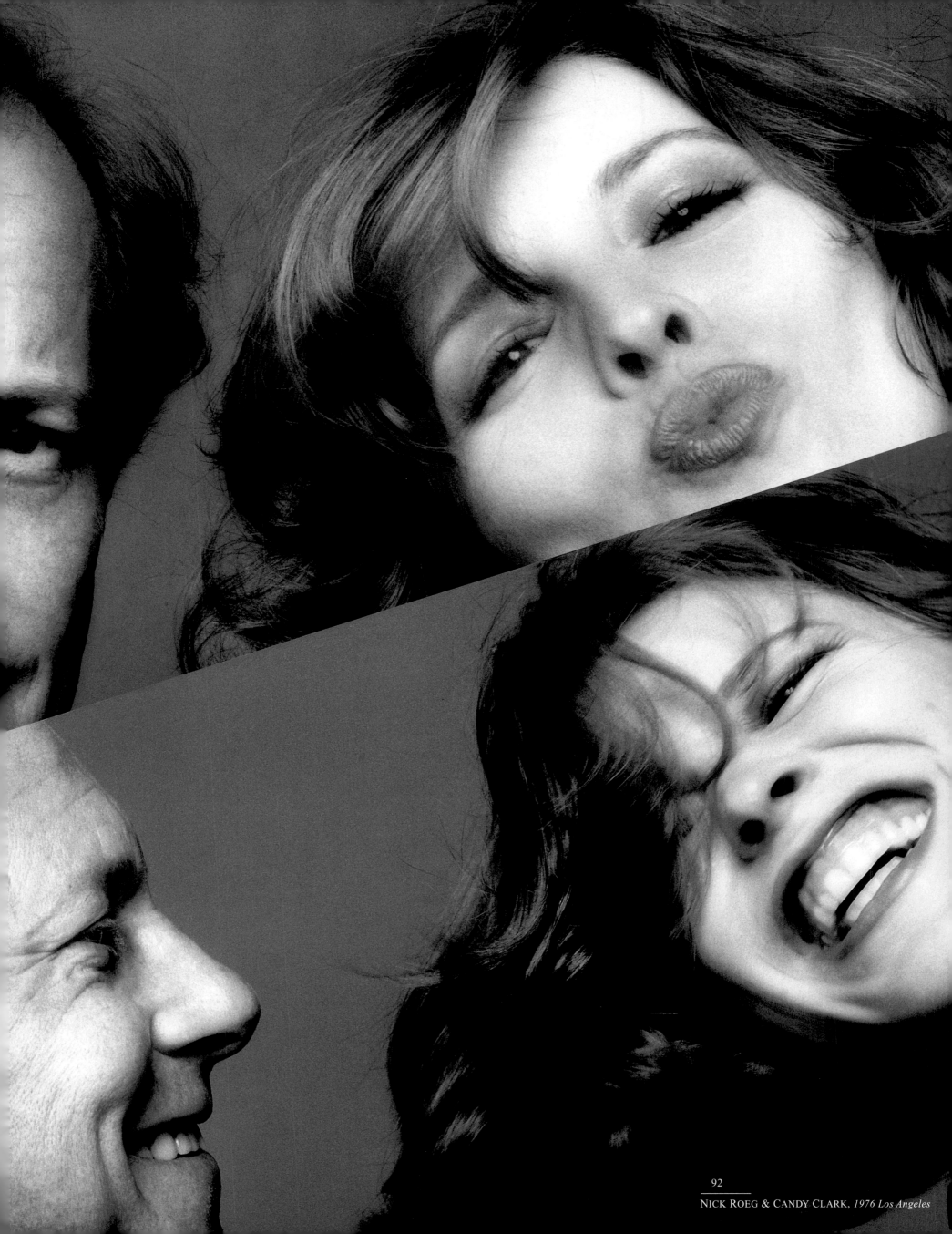

NICK ROEG & CANDY CLARK, *1976 Los Angeles*

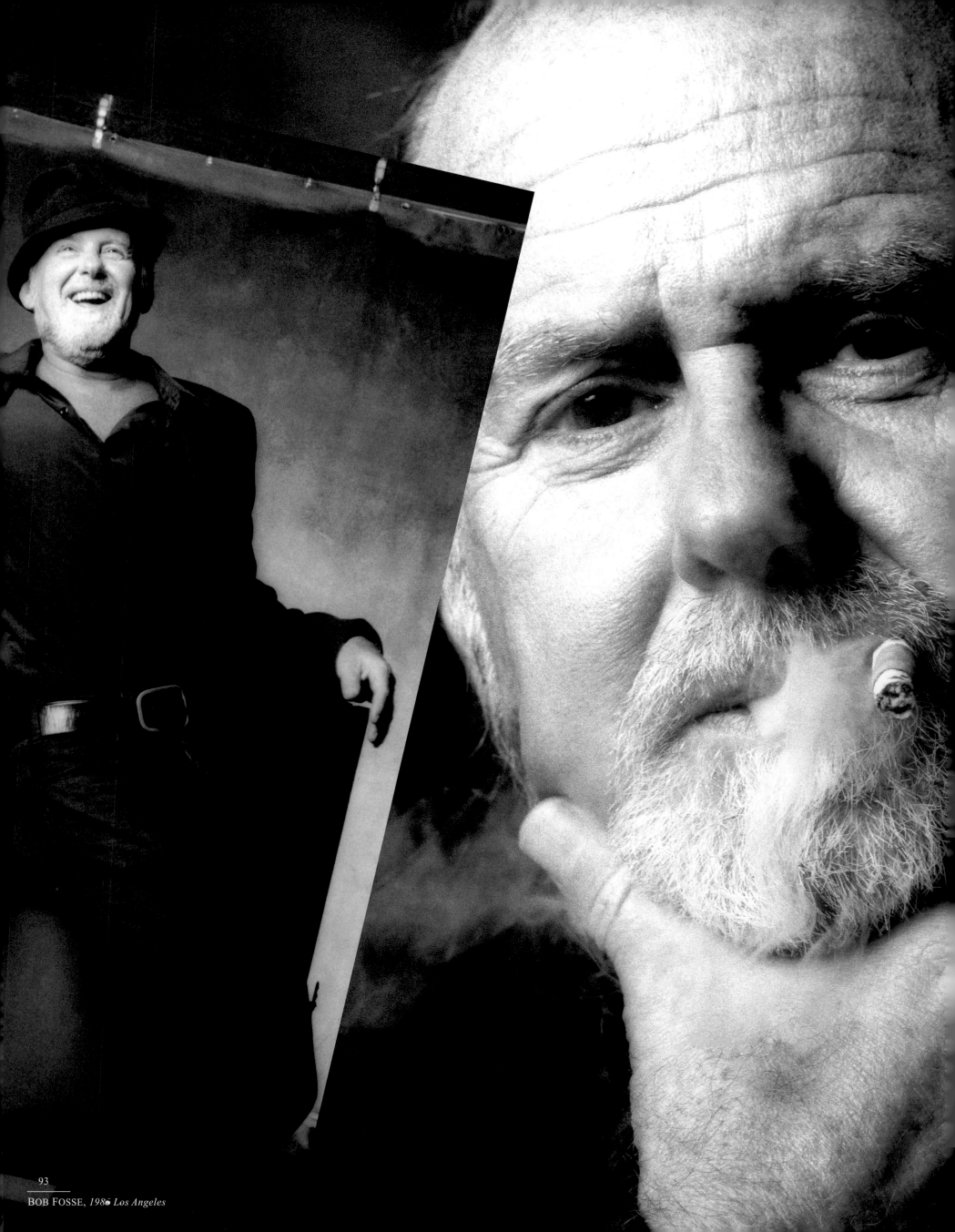

BOB FOSSE, 198■ *Los Angeles*

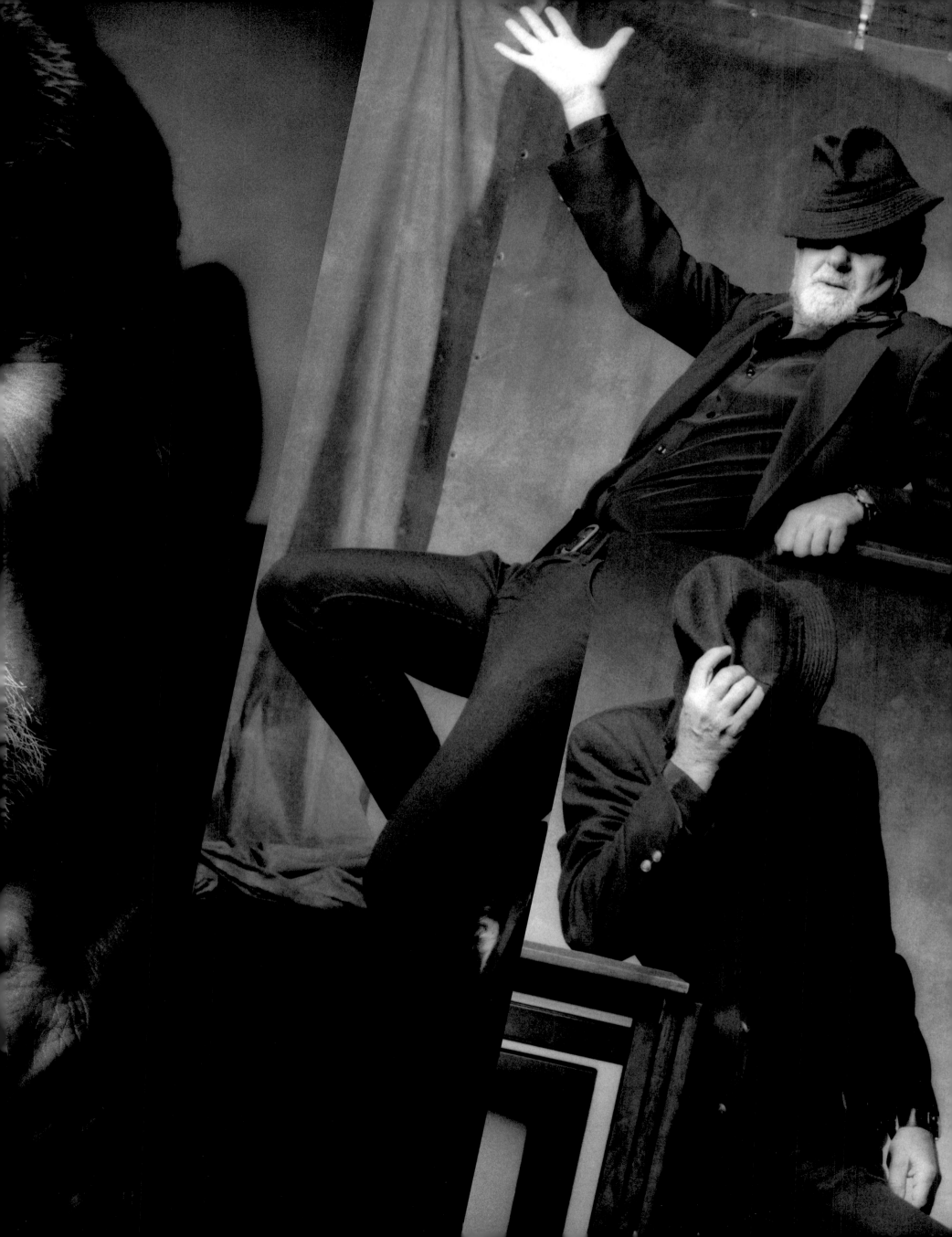

EUGENE IONESCO, *1982 Los Angeles* JOYCE CAROL OATES, *1988 New York City*

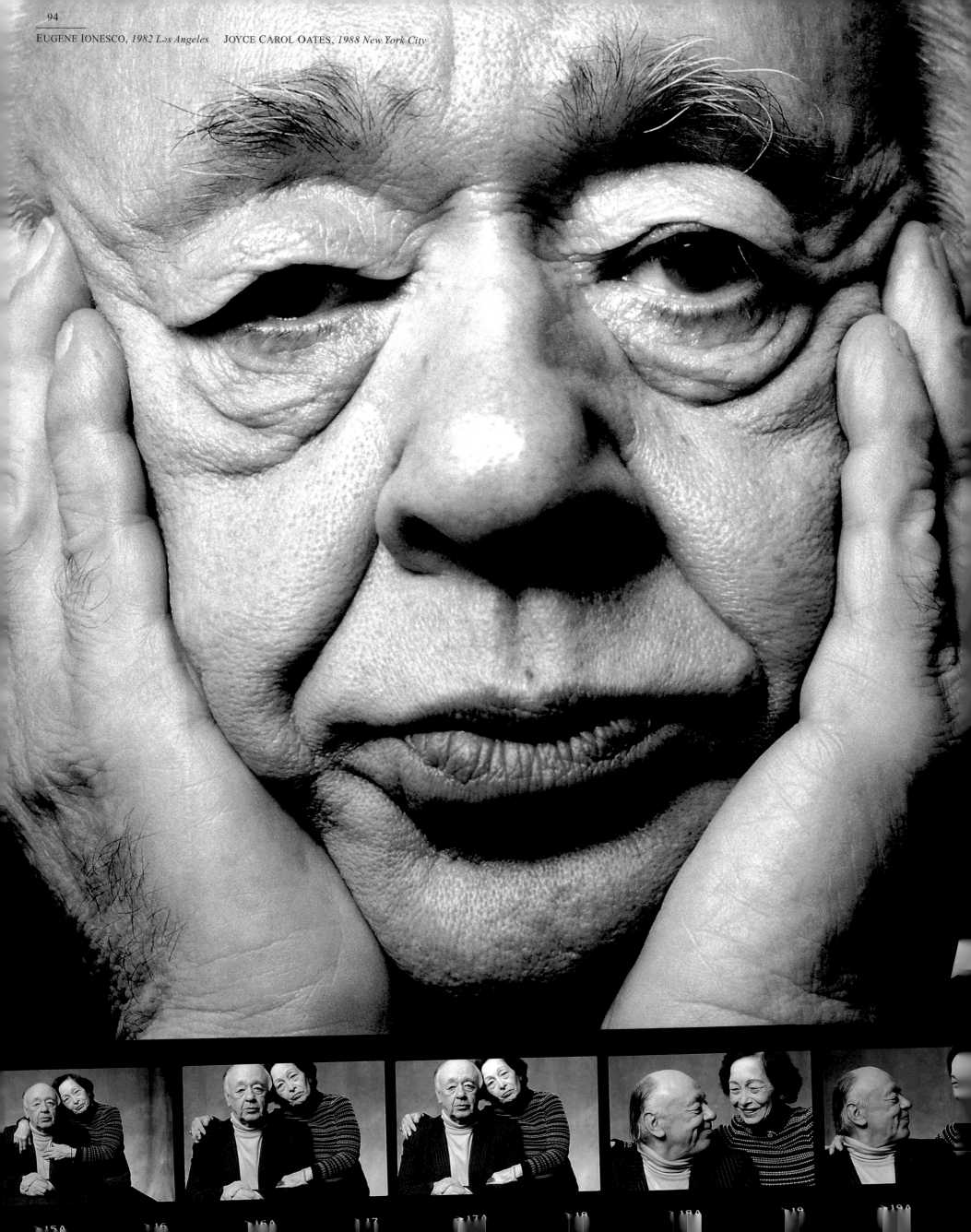

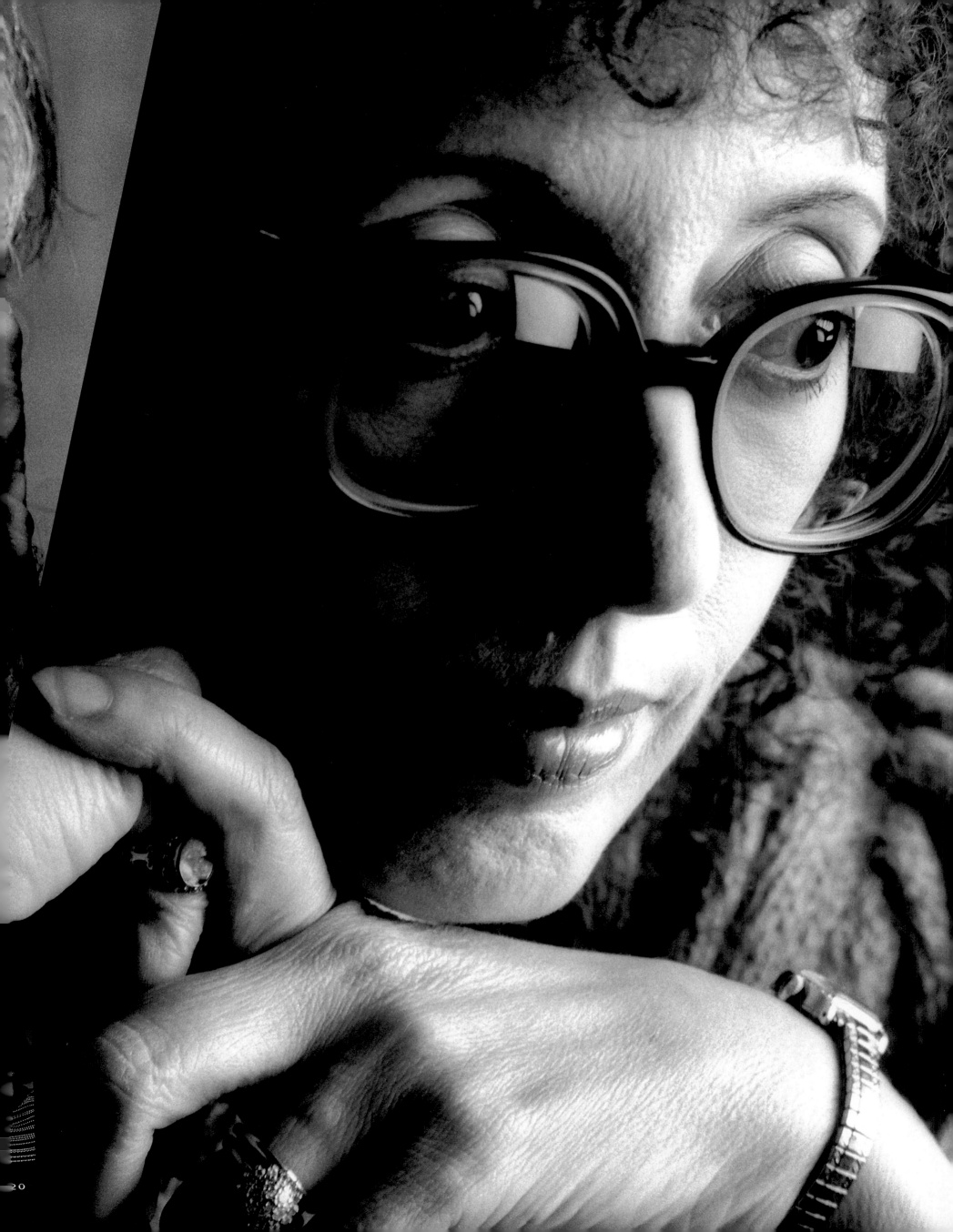

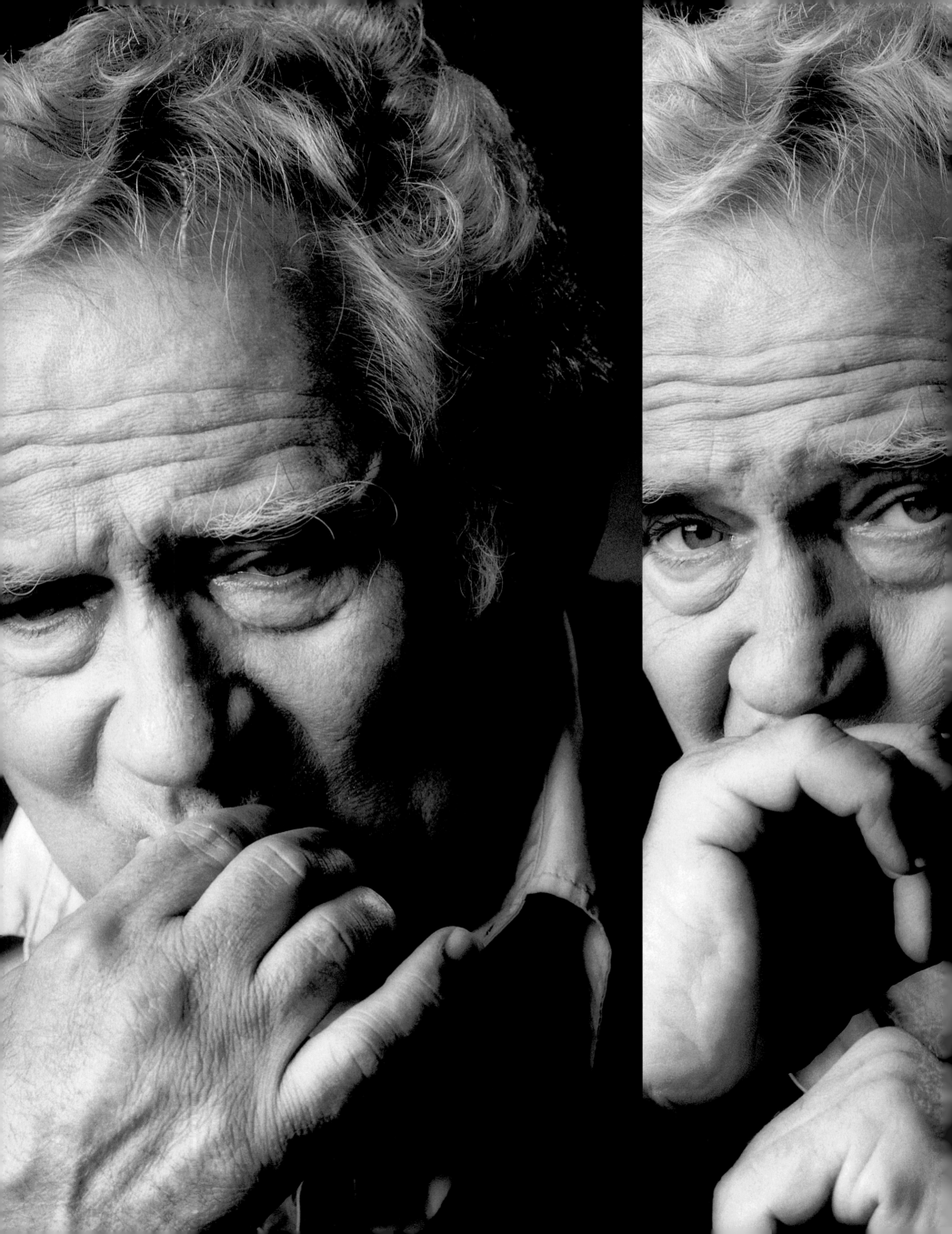

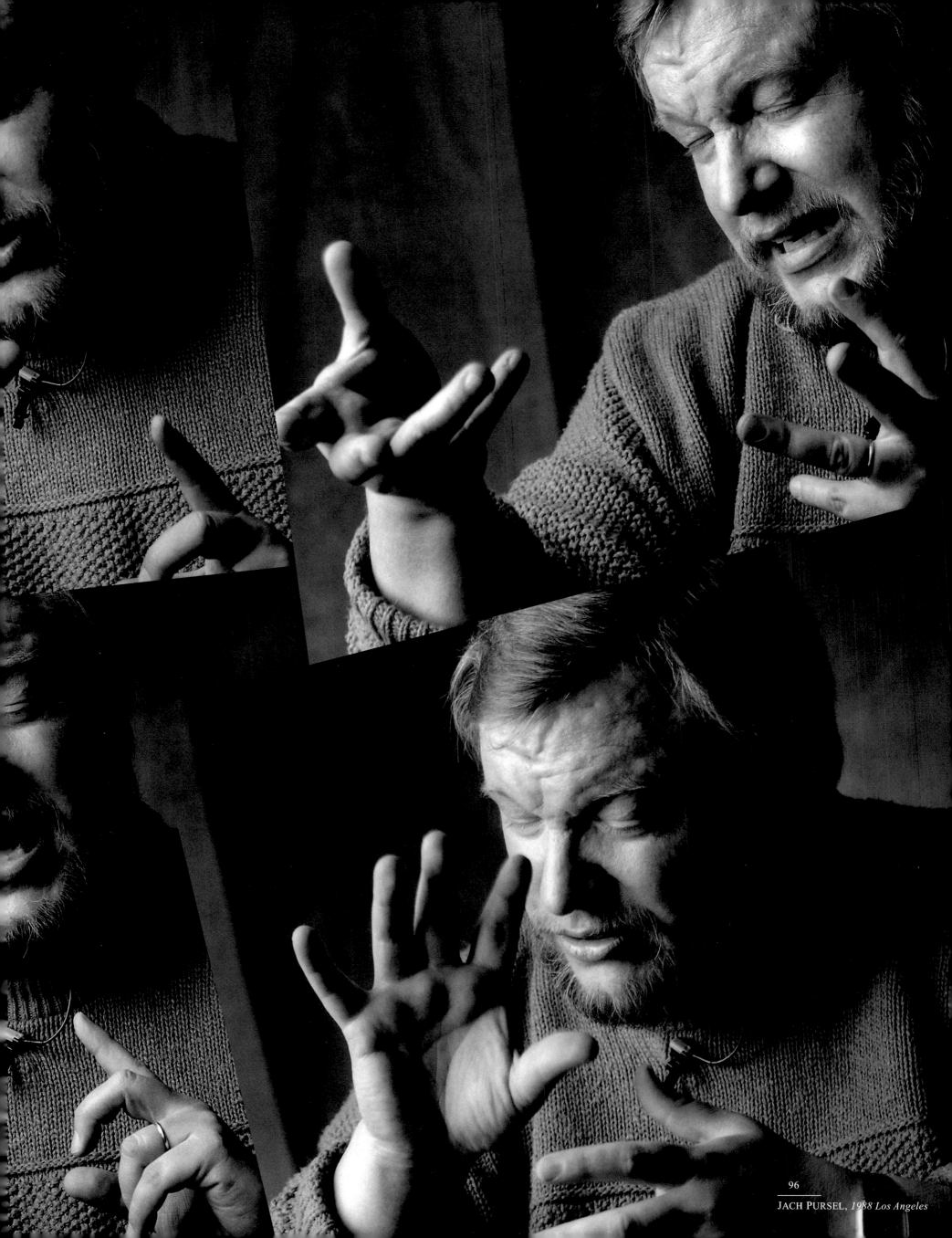

96
JACH PURSEL, *1988 Los Angeles*

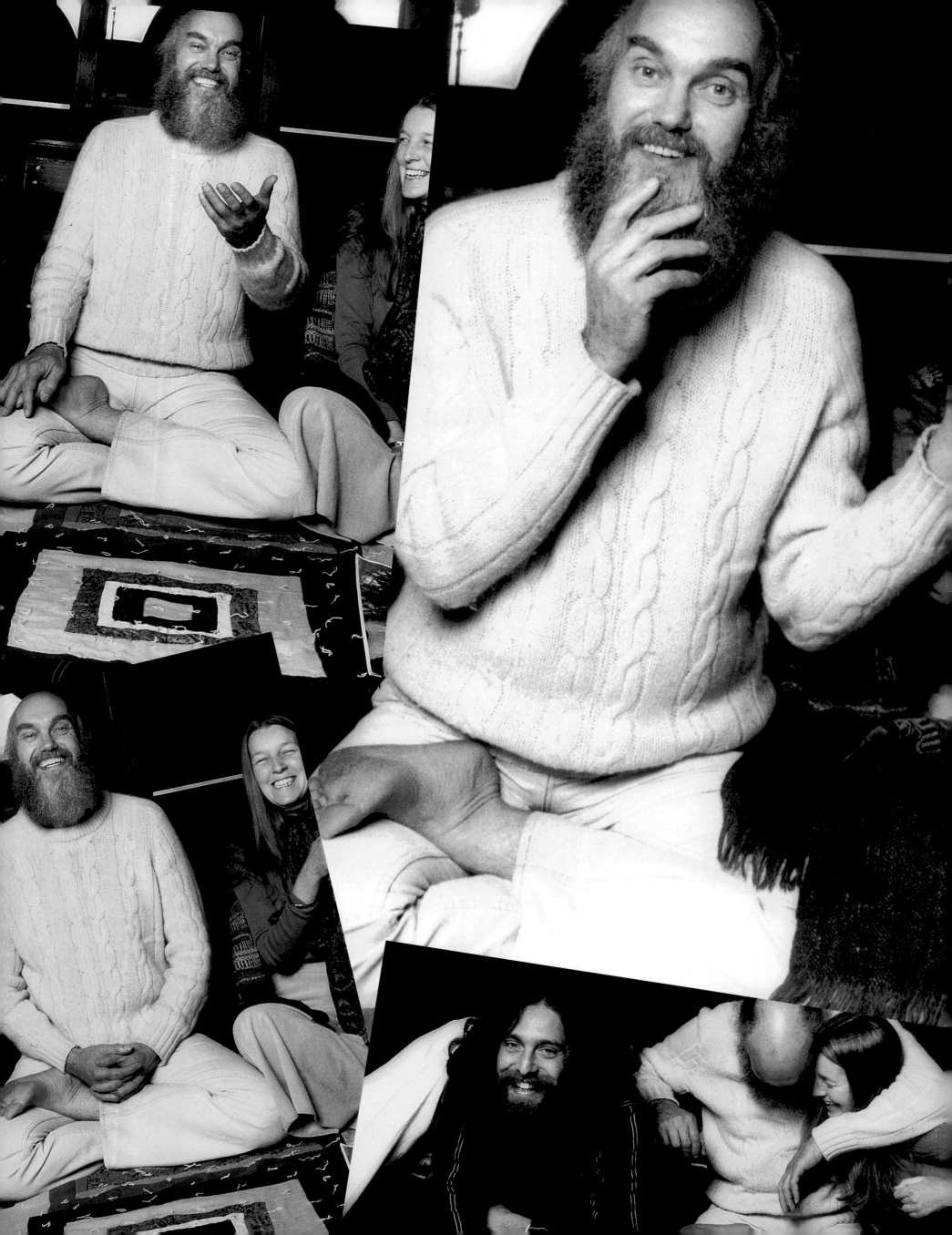

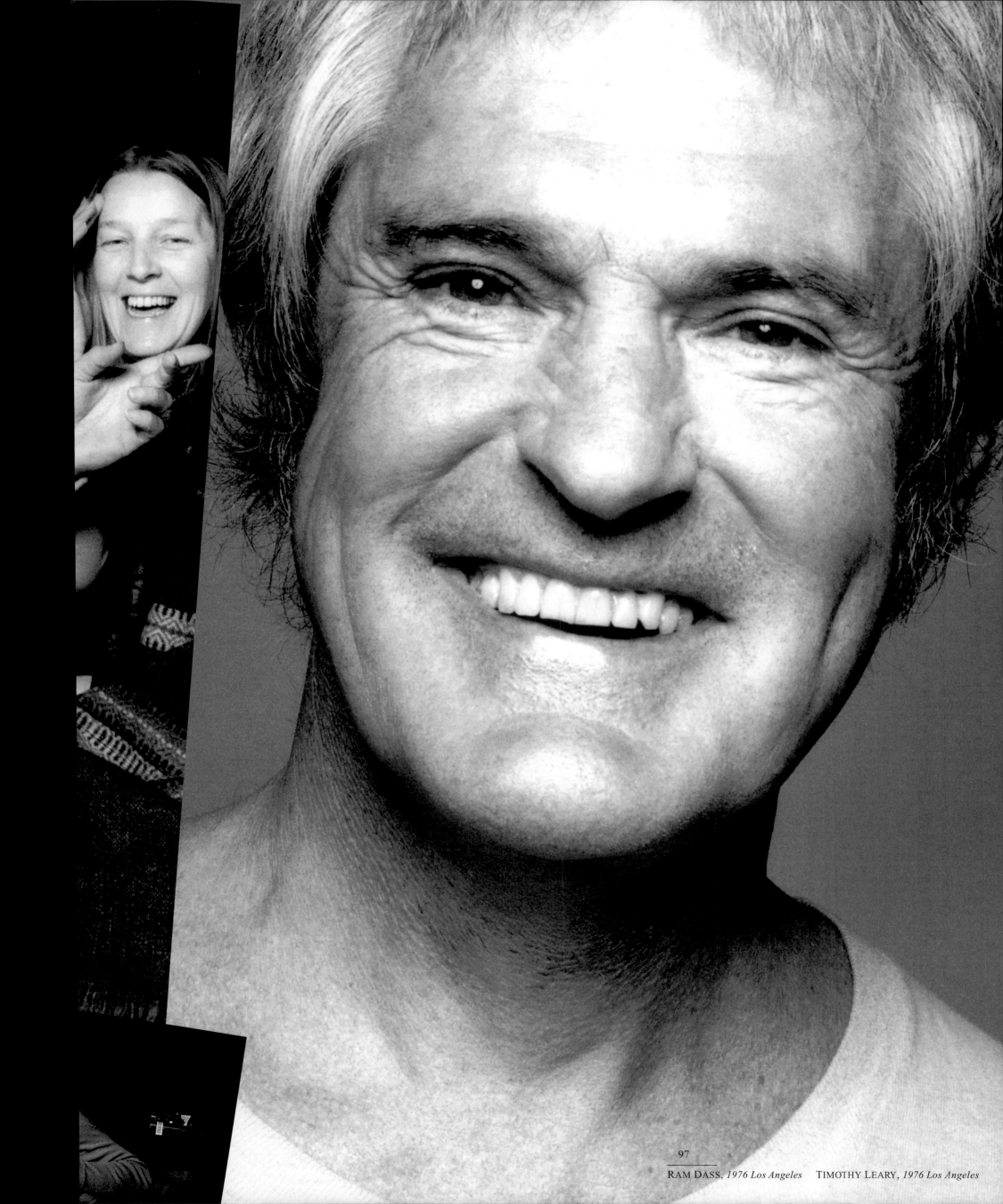

RAM DASS, *1976 Los Angeles* TIMOTHY LEARY, *1976 Los Angeles*

HUGH HEFNER, *1978 Los Angeles* STEVE JOBS, *1984 Cupertino, CA*

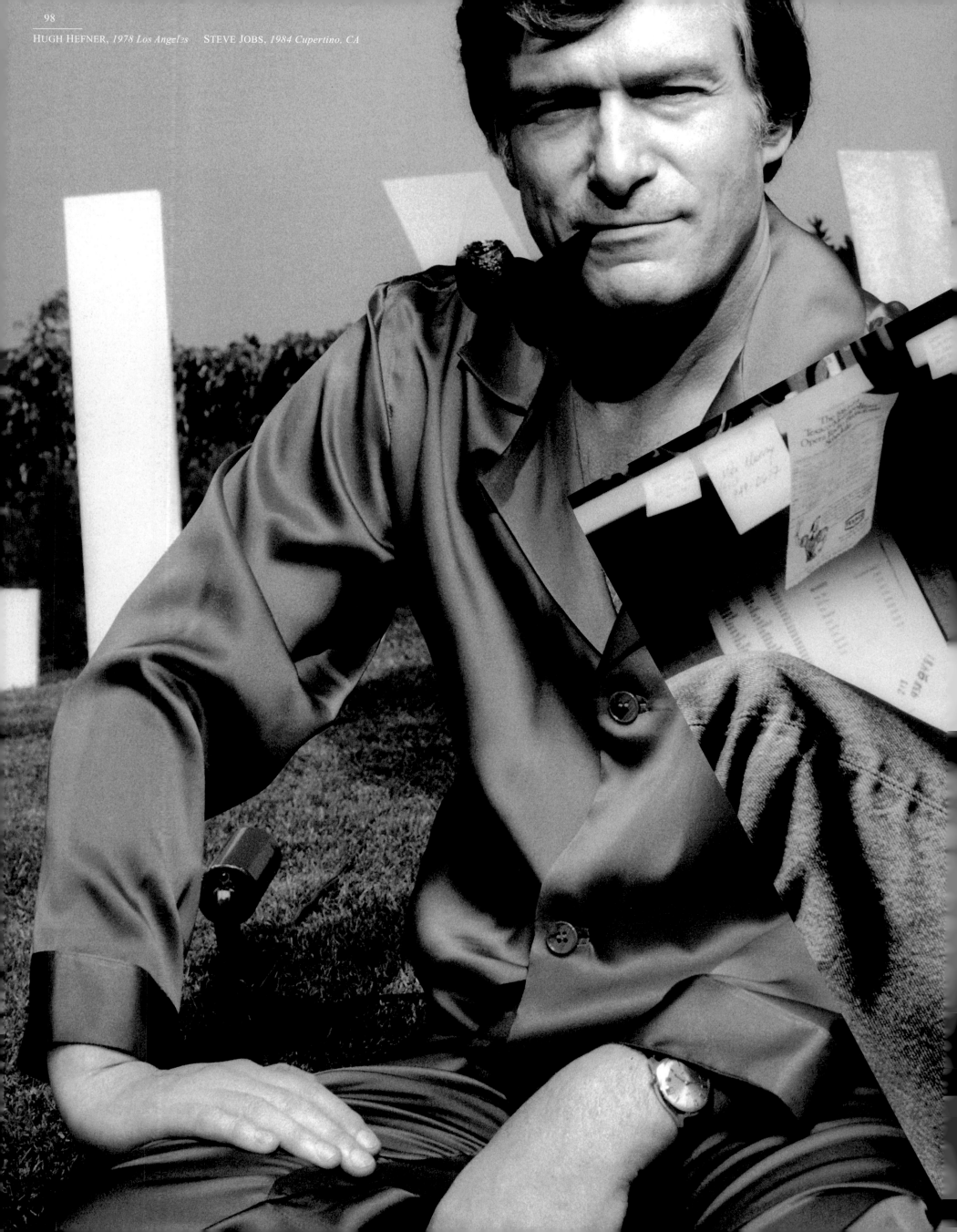

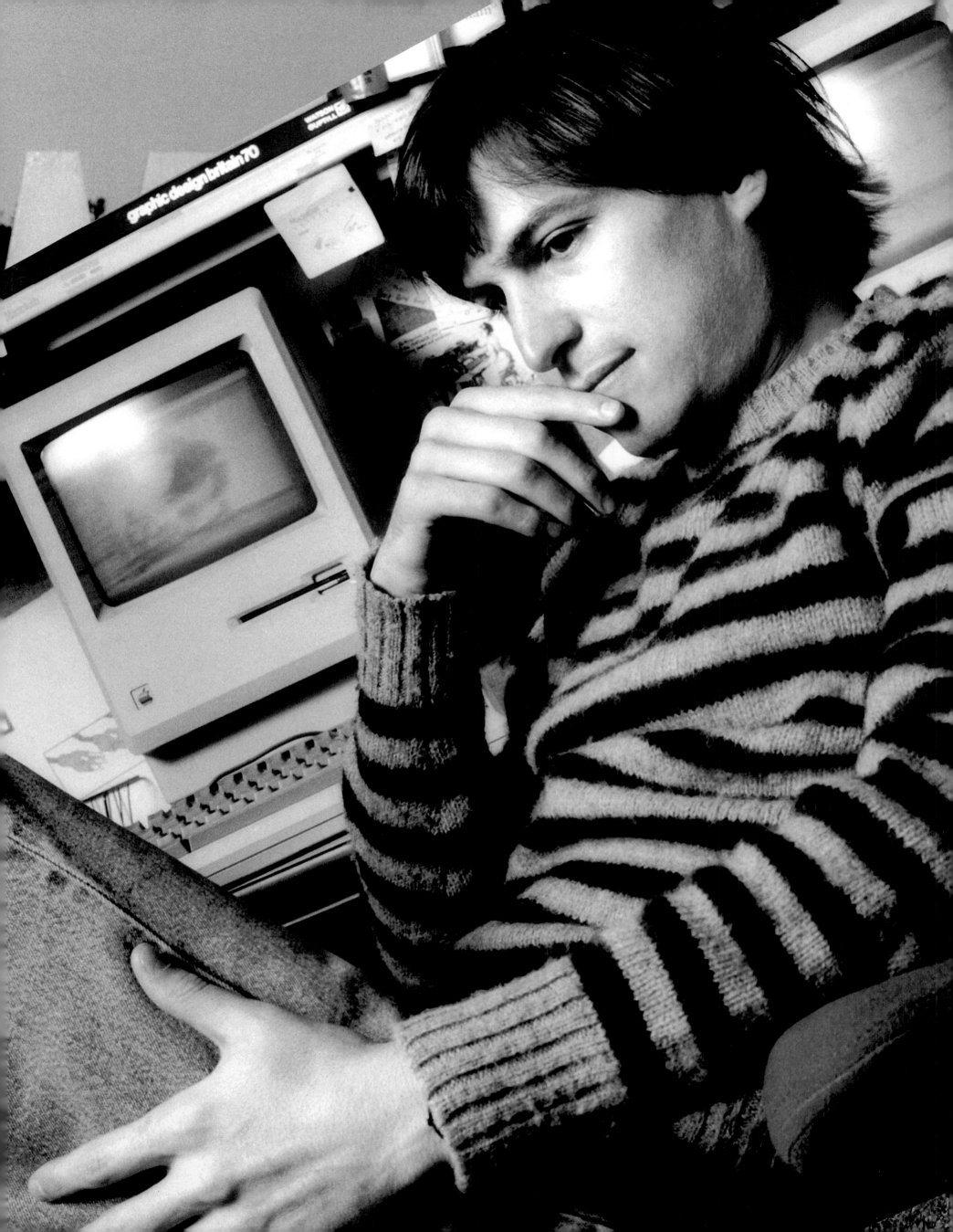

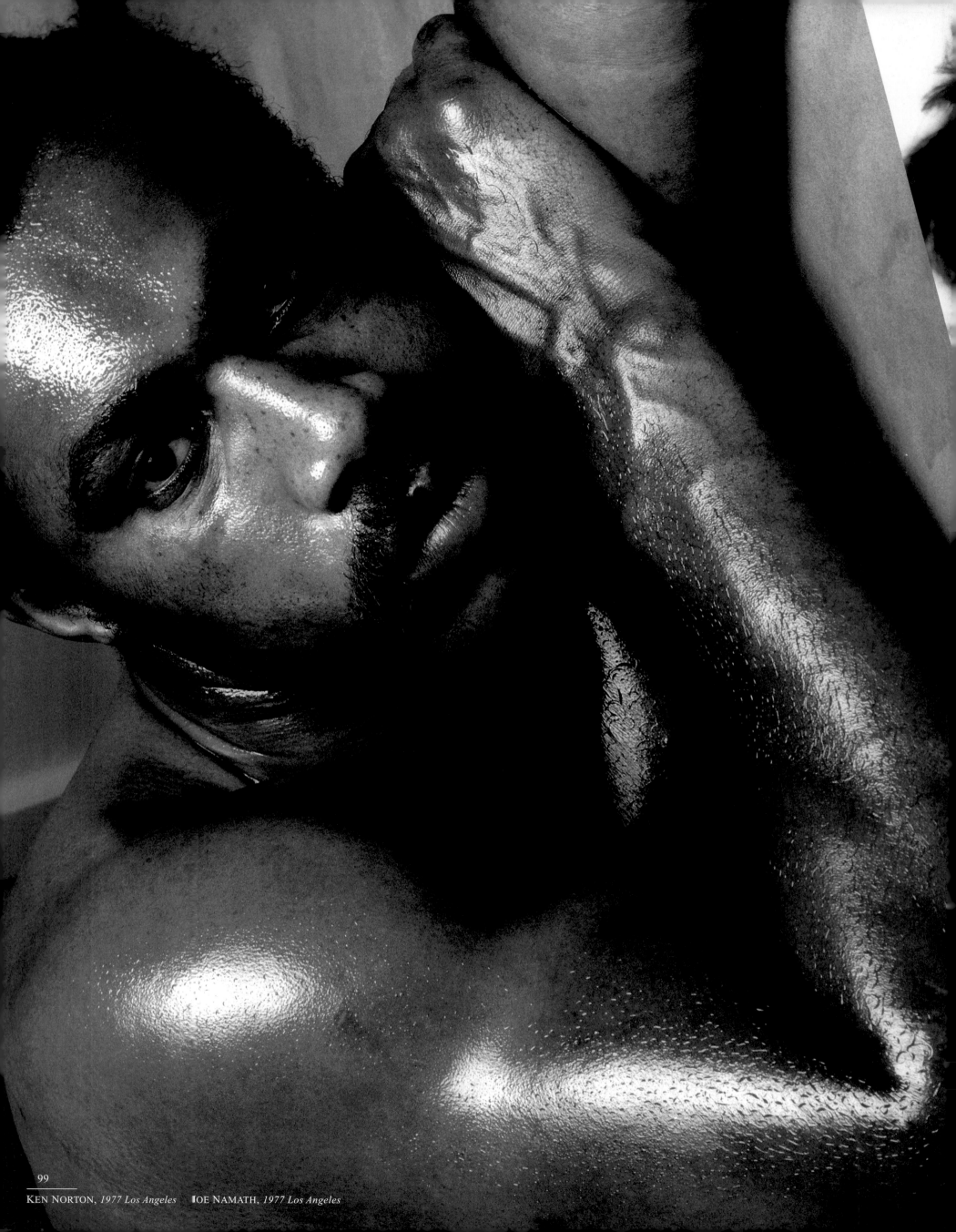

KEN NORTON, *1977 Los Angeles* JOE NAMATH, *1977 Los Angeles*

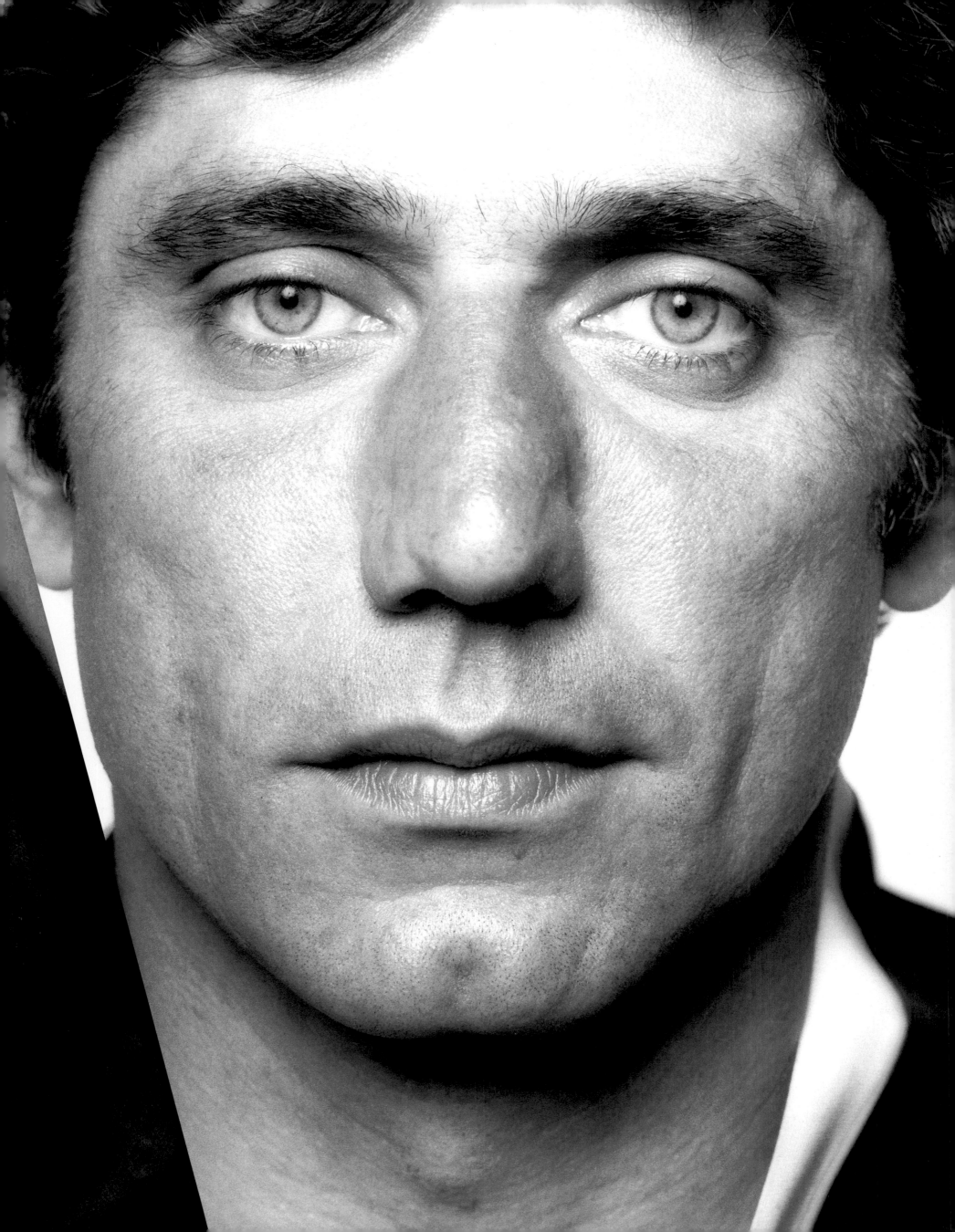

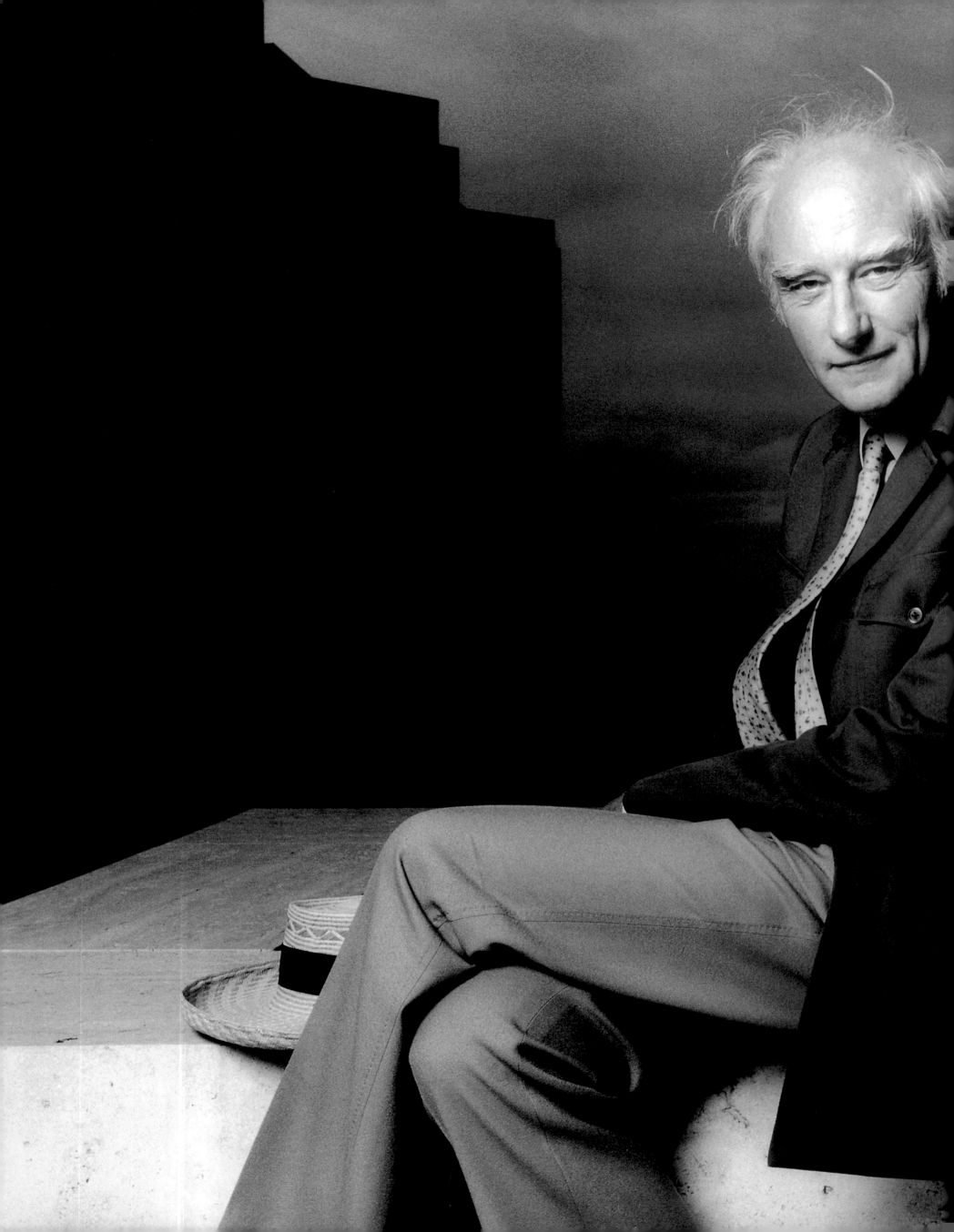

SIR FRANCIS CRICK, *1982 LaJolla, CA*

1

The Band's first big break came in 1965 when Bob Dylan chose them to tour with him as his backing band. But it was not until their brilliant, gospel-tinged rockabilly debut album *Music from the Big Pink* (1968), that the group, comprised mainly of country-influenced Canadians, rocketed into American musical history with their unique sound, masterful vocals, and remarkable breadth of musical virtuosity. This was followed by a string of classics: *The Band*, their second album, *Stage Fright*, and *Rock of Ages*. In mid-1976, the group announced it would disband after a final cross-country tour. The movie *The Last Waltz*, documenting the concert series and directed by Martin Scorsese, was released in 1978. The group was inducted into the Rock and Roll Hall of Fame in 1994.

2

A freewheeling manipulation of the photographic image and an unapologetic exploration of the homoerotic themes of his subculture combined to elevate photographer/artist **Robert Mapplethorpe** to a meteoric notoriety in the mid-80's. The fact that Mapplethorpe photographed what interested him created an art world scandal, and resulted in an impassioned, humorous, and sometimes vitriolic media debate on the perplexing issue of "what is legitimate art?" Despite the controversies surrounding his subject matter, Mapplethorpe's refined eye and economy of vision produced images that reflected a romantic, idealized, and evocative sense of beauty. His work has become part of the permanent collections of major museums internationally. Mapplethorpe died of AIDS in 1989.

2

Writer, poet, rock performer, **Patti Smith** in her own words "wasn't born to be a spectator." One of the more unlikely cult stars to come out of the New York subculture in the early 70's, she had a delicate, skinny pallor and an androgenous look that belied the idiosyncratic irreverence, power, and sexuality of her poetry as rock. Noteworthy are her critically acclaimed albums *Horses* (1975) and *Easter* (1978). Smith also published more than a half dozen books of poetry, including, *Seventh Heaven* (1971), *Kodak* (1972) and *Babel* (1978). She was born in 1946 in Chicago.

3

Uncompromising perseverance, sincerity, and commitment to his vision have lifted **James Taylor** from crippling despair and on to a personal and creative maturation that continues to accrue critical respect. With a voice ranging from a low-key, compelling spareness to down-home bluesy, and with an acoustic guitar style combining folk, traditional, R&B, and jazz, Taylor spearheaded the singer-songwriter boom of the early 70's. His prolific songwriting has produced many modern standards beginning with his folk-pop breakthrough album *Sweet Baby James* (1969), which contains the classic "Fire and Rain." Taylor was born in Boston in 1948.

4

One of the most recognizable and emulated artists of the rock era, guitarist, writer, singer **Keith Richards** uses signature guitar riffs to merge rhythm and blues, country, reggae, and jazz. Richards' continuously evolving, emblematic guitar work has defined the Stones' sound and has been etched into the canon of rock music. Richards' two credible solo albums *Talk Is Cheap* (1988), and *Main Offender* (1992), are down-to-earth, consummate rock and roll expressions. His creative partnership over three decades with Mick Jagger has resulted in one of the more prolific songwriting teams and legendary performance collaborations in rock music history. Richards was born in Dartford, (Kent) England in 1943.

4

Lead singer of the Rolling Stones, **Mick Jagger** is the indisputable icon of Rock and Roll. His irreverent, dissolute, prancing Dionysian bad boy sexuality on stage, and his raw, 'in your face' blues-inflected vocal style have become the archetype of the form. His prolific creative output has left a rich legacy to the history of Rock and Roll. Jagger applied the same creative resources and charismatic sensuality to weave an indelible characterization in Nick Roeg's classic rock and roll film *Performance*.

5

Rock's original bad boys, the **Rolling Stones** have established themselves as the world's quintessential rock band through three dozen albums and three decades of popularity. Taking their name from a Muddy Waters song, these enduring English rockers have planted their feet firmly in the soil of rhythm and blues since the band's inception in London in 1963. Their artistic integrity as a genuine, hard-working rock and roll band has not diminished after more than 30 years of creative collaboration, numerous world tours, and some well-publicized personnel changes. Creators of both driving rock anthems and tender, introspective love ballads, the Stones were recognized by the music establishment in 1986 with a Lifetime Achievement Grammy and induction into the Rock and Roll Hall of Fame in 1989. Classic Stones albums include: *The Rolling Stones* (1964), *Beggars Banquet* (1968), *Sticky Fingers* (1971), *Exile on Main Street* (1972), *Some Girls* (1978), *Tattoo You* (1981), *Steel Wheels* (1989), *Voodoo Lounge* (1994).

6

The Everly Brothers, Don (born in 1937) and Phil (born in 1939), were raised by musician parents with deep roots in Kentucky bluegrass and country music. The brothers' rockabilly records—noteworthy for their tight harmonies — had an immense impact on contemporary music. Starting with "Bye Bye Love" in 1957, they had eleven singles in the Top 30 during a two-year period. The Everly Brothers were elected charter members of the Rock and Roll Hall of Fame in 1986.

6

She was the strong, clear-voiced earth mother of The Mamas and The Papas. **"Mama" Cass Elliot** was the vocal power behind the California folk-pop group known for its well-crafted harmonies that echoed the flower child sensibilities of the late 60's. From 1966-67, the group scored six Top 5 hits, including "California Dreaming" and "Monday, Monday". After the group broke up in 1968, Mama Cass went solo, putting out three albums. She was born in 1941 and died in 1974.

7

Singer, composer, guitarist, movie maker, political activist **Frank Zappa** reigned in the 60's as the satirical godfather and the original performance artist of avant-garde rock. In 1964 he formed the group The Mothers of Invention, which gave him an outlet for experimental compositions and his acerbic social commentary. After 1970, the eclectic Zappa collaborated with diverse musicians and continued to push the boundaries of music, winning a Grammy in 1988. Some key works include: "Lumpy Gravy" (1967), "We're Only In It for The Money" (1967), "Weasels Ripped My Flesh," "Hot Rats"(1970), " Joe's Garage" (1980), "Jazz From Hell" (1986), "Beat The Boot" (1992), and the film and film score, *200 Motels* (1971). A native of Baltimore, Zappa was born in 1940 and died of cancer in 1993.

8

The multi-faceted **Joni Mitchell** rose to superstar status as a charismatic singer/songwriter in the early 70's. Incorporating intensely autobiographical themes, her lyrics were a powerful celebration of the liberated spirit of women. Progressing musically through a range of highly original and experimental forms from solo acoustic guitar to jazz-oriented structures, Mitchell demonstrated a vocal complexity, lyrical poetic richness, and melodic intricacy that remain unrivaled. At the time of the release of *Court and Spark* (1974), her picture graced the cover of *Time*, and she won her second Grammy. Other albums include, *Blue* (1971), *The Hissing of Summer Lawns* (1974), *Hejira* (1976), *Mingus* (1979), and *Nightride Home* (1991). Born in Alberta, Canada in 1943, Mitchell has also established a reputation as a highly skilled painter.

9

Tough talking, hard drinking, child of the seamy side of the streets, **Rickie Lee Jones** rose to instant stardom with her emotionally riveting and poignant debut album *Ricky Lee Jones* (1979). Difficult to define, this eclectic, formidable creative talent effortlessly fuses elements of bebop, R&B, rock, and folk, creating a uniquely personal sound. A consummate songwriter and guitarist, Jones ranges from moody jazz ballads to upbeat reggae tunes. Her first single, "Chuck E.'s in Love," became a Top 5 hit, and when her self-titled album went platinum, she received the Best New Artist Grammy and the award for best female vocalist in the *Rolling Stone* critics' poll. She also won a Grammy for jazz in 1989. Jones was born in 1954.

10

Cher has had a richly varied career. As part of the high profile singing/songwriting team of Sonny and Cher, she had a #1 hit record, "I Got You Babe," (1965). The couple hosted a popular TV series from '71 to '75. Early on in her career, the darkly beautiful Cher was a pioneer in the creation of a high-profile public and media image that emphasized an imaginative and risqué fashion sensibility. As a solo recording artist, Cher had four Top Ten Hits, and went on to prove herself as a consummate actress. She appeared in the films *Silkwood* and *Mask*, and won an Oscar for *Moonstruck* in 1987. She was born in 1946, and has two children, Chasity and Elijah Blue.

10

Lead singer of the legendary Southern rock group The Allman Brothers Band, **Greg Allman** epitomized a vocal style that demonstrated a natural feel for black music, combining influences of rhythm & blues, soul, jazz, and gospel. The result is a fervent blues belter who gets to the heart of a song. His brief marriage to Cher produced a son, Elijah Blue. Allman was born in 1947 in Nashville.

11

Johnny Mathis is a master interpreter of the romantic ballad—and a virtual institution in American pop music for nearly 35 years. A native of San Francisco, Mathis first sang in church choirs as a child. He was an outstanding athlete in high school and college, nearly abandoning music for a career in sports. Forgoing a chance to join the 1956 U.S. Olympic team in order to record his first album, Mathis has since released close to 100 albums in the U.S. alone. His #1 smash singles include the enduring classics, "Misty," "Chances Are," and "Wonderful, Wonderful." Mathis' early success was phenomenal: in 1957 he racked up four Top 20 singles. His album, *Johnny's Greatest Hits*, released in 1958, remained on the charts for almost 10 years. Mathis has expanded his repertoire to include recordings of famous film themes, a collection of Duke Ellington classics and an album of his most memorable vocal duets. Mathis was born in 1935.

12

With a thunderous heavy metal presence on stage, outrageous costumes and makeup, innovative lighting, bursts of flame, explosions, rising and descending platforms — the heavy metal quartet **Kiss** infused flamboyance, mystery, and theatricality into the music scene, synchronizing music and show. During the 70's and 80's the band proved it could consistently fill the stadiums, and amassed a tremendous international following. Their first live album, the gold *Alive* gives substance to the group's popularity and includes one of rock's great anthems, the classic "Rock and Roll All Nite."

13

Endowed with an incredible stage charisma, and a commanding sense of performance, lead singer **David Lee Roth** fronted the instantly well received Van Halen from its debut album release in 1977 until he chose to launch a solo career in 1985. Following the hit single "Jump" for Van Halen, Roth demonstrated an idiosyncratic blend of self-parody and showmanship on solo hit singles such as "California Girls," and on solo videos such as "Just a Gigolo/I Ain't Got Nobody." He is a native of Indiana and was born in 1955.

14

Well known for their attitude and spectacular stage shows, as much as for their musicianship, this original incarnation of **Van Halen** (before the departure of lead singer David Lee Roth) racked up solid platinum sales right out of the starting gate with the triple platinum debut album *Van Halen* in 1977. The musical brains of the band, both as composer and guitar virtuoso, Eddie Van Halen ranks as one of the most revered pace setters in rock with his hard-driving, pyrotechnic, innovative playing. The platinum album *1984* (1984) had the groups first hit single, "Jump."

15

Jefferson Starship was a 1974 spin-off of Jefferson Airplane, the legendary 60's psychedelic band that launched the San Francisco Sound. *Surrealistic Pillow*,

Jefferson Airplane's signature album, produced two gold singles "Somebody to Love" and "White Rabbit." After the Airplane broke up, Grace Slick and Paul Kanter formed the Jefferson Starship, and their album *Red Octopus* broke records by becoming the number one LP on Billboard on four separate occasions. Grace Slick, the "rock priestess" fabled for her classically influenced vocals and song writing, has had ten top LP's in the 60's, 70's and 80's.

16

Fronted by the risk-taking, multi-talented David Byrne, The **Talking Heads** emerged from New York's new wave scene in 1977, combining elements of African rock, classical music, and funk. The Heads' dynamic concert presence was recorded in the film *Stop Making Sense* directed by Jonathan Demme (1984). The group scored a Top 10 hit in 1983, with "Burning Down The House." In 1986, *Time* dubbed Byrne "Rock's Renaissance Man," for his work in theater, film, and music. He was born in Scotland in 1952.

16

The Irish new wave band **The Boomtown Rats** has enjoyed success in Europe and England, and a controversial hit in America—"I Don't Like Mondays" (1980). In Britain, the group achieved critical success, and racked up nine consecutive hits. The group's leader Bob Geldof organized the Band Aid recording session (November, 1984) and the Live Aid concert (July, 1985), both of which raised funds for African famine relief. Geldof was nominated for the Nobel Peace Prize and knighted for his humanitarian efforts.

17

Futuristically uniformed and robotically gestured, **Devo** was a high concept, electronically-oriented band that reached a serious market in the late 70's/early 80's (the group's biggest single, "Whip It," was a hit in 1980.) Devo was adept at creating imaginative, tongue-in-cheek videos which wove together sci-fi themes, postmodern images, and their philosophy of "de-evolution," which proclaimed the regression of humankind and the triumph of blandness.

18

L.A. native **David Crosby** was a founding member of The Byrds, the seminal 60's folk rock group which boasted marvelously tight vocals and haunting harmonies. Throughout the 70's and 80's, Crosby's soaring tenor vocals were an integral part of various incarnations of Crosby Stills Nash & Young. Following a struggle with substance abuse, a revitalized and resilient Crosby was able to resume his creative life in music, film, and television, using his experiences to promote a socially responsible way of life. Crosby was born in 1941.

19

With massive album sales and a creative durability that consistently confounds their critics, **Aerosmith** is a rock and roll phenomenon. A no-holds-barred rock and roll sensibility, a strong blues underpinning, and finely tuned musicianship qualify the Boston bad boys as heavy metal greats. Plagued by drug problems and potential breakups, the group made a remarkable resurgence with their 1989 album *Pump*, a groundbreaking cross-cultural rap collaboration. The irreverence and raw thrust of lead singer Steve Tyler's vocals combine with the forceful guitar riffs of Joe Perry to form a rapid-fire musical dialogue, the cornerstone of the group's musical identity. With sales totaling more than 35 million, the group continues to rack up hits and Grammy winners, and was voted Best American Band in the *Rolling Stone's* Reader's' Poll.

20

With the essence of Rock and Roll in his soul, his wild intensity of performance, gender-bending persona, gorgeous mouth and gravel glare, singer/songwriter **Steve Tyler** continues to carve out a niche for himself as a rock and roll great. Outspoken and socially conscious since his dramatic comeback from substance abuse problems, Tyler remains one of the most creatively vital rock'n roll voices of the generation.

20

Guitarist **Joe Perry's** anthemic and incisive guitar riffs, and brooding good looks ideally compliment Steve Tyler's extroverted performance persona. Following a credible venture as a solo artist with the Joe Perry Project (1979), Perry rejoined Arrowsmith in 1984 and resurrected the amazing, fertile and successful songwriting partnership.

21

A success story of the mid-70's, **Foreigner** brought together an English-American hybrid of seasoned veterans. Their first album *Foreigner* (1977) went gold, and the group went on to sustain its momentum with multiple hits including "Feel Like the First Time," "Cold as Ice," and

"Hot Blooded." The unerring grooves of master guitarist Mick Jones, and lead vocalist Lou Gramm's power belting were a key to the group's success.

21

One of the best rock groups to come out of the Bay Area, **The Doobie Brothers** rose to prominence in the mid-70's with their close harmonies and distinctive jazz-inflected funk tunes. Their music took on a deeper, more soulful R&B quality as the band added new members—most notably, singer-songwriter-keyboardist Michael McDonald, with his gospel-influenced keyboard style and wide-ranging, luxuriant voice. McDonald co-wrote some of their biggest hits, including "Minute by Minute" and "What a Fool Believes," which won two 1979 Grammy Awards for Record and Song of the Year. McDonald left at the start of the 80's for a solo career and the group disbanded.

22

Infusing a sense of fun into a blend of punk, glitter and trashy 60's rock, **Blondie** emerged from the New York club scene led by sexy, sultry singer Debby Harry and her boyfriend, guitarist Chris Stein. After their disco record "Heart of Glass" was a crossover smash in 1979, the group racked up four #1 hits in less than two years. The group broke up in 1983. This photo was taken at Manhattan's Chelsea Hotel for their '79 LP *Eat to the Beat*.

23

Tim Buckley lived a mere 28 years, leaving behind a legacy of nine albums that won praise from critics, particularly in jazz. A versatile artist with a five-and-a-half octave range, he explored musical innovations from folk rock to avant-garde jazz. Considered underrated by his adherents, Buckley died tragically of a drug overdose in 1975. Buckley was born in Washington, D.C. in 1947.

24

After getting off to a slow start, the straight talking, mainstream rocker **John Cougar Mellencamp** found with his third album *American Fool* the critical success he had been striving after for nearly a decade. Growing up in a rural working class town, the singer/songwriter/guitarist creates a no-apologies, down home brand of Rock and Roll punctuated with touches of country and western. Mellencamp has gained stature as a scrappy musical spokesman who has reclaimed rock as a vehicle for social commentary. In 1986 Mellencamp was named one of the three top pop artists of the year by Billboard Magazine. He was born in Seymour, Indiana in 1951.

25

In 1973, **Peter Frampton** left the English hard rock group that he had formed as a teenager, Humble Pie, to go solo. His album *Frampton Comes Alive* became a pop-culture phenomenon three years later. With sales of over 10 million copies, it shot Frampton to superstardom, and became the best-selling live album of that decade. Problems with drugs and a 1978 near fatal car crash contributed to a subsequent creative slide, but with his 1994 album *Peter Frampton*, he returned to his creative roots. Englishman Frampton was born in 1950.

25

In just ten years **Andy Gibb** sold over 10 million albums world wide and scored three number 1 records in a row. Following up his debut album release with a string of multi-platinum hits including "Shadowdancing," "After Dark," and "Greatest Hits" — he was nominated for 2 Grammy awards. In the early 80's Gibb made a successful transition from recording and concerts to theater and TV host. In 1988, he died at age 30 of a heart virus.

26

Ron Wood's boundless enthusiasm, cracked voice, and stinging slide guitar style were an ideal creative and visual addition to the Jagger/Richards juggernaut (in 1975). Solo works include *Gimmie Some Neck*, and the critically well received *1234*. Wood was born in London in 1947.

26

Singer/drummer/actor **Ringo Starr** was born Richard Starkey in Liverpool, England in 1940. One of the legendary members of the Beatles, he was regarded as one of the finest drummers in rock music, as his dependable backbeat laid a solid foundation for the group's music. After the group disbanded, Ringo expanded his career as an actor, performing in more than a dozen films to date, and recording 10 solo albums since 1970. His 1973 hit LP *Ringo* produced three Top 10 singles.

27

His easy going personality and calm accessibility belie Renaissance man **Herb Alpert's** monumental resume of achievements. In 1962 Alpert and his partner Jerry Moss formed The Tijuana Brass and the beginnings of A&M records in Herb's garage. Groundbreaking A&M was

destined to become the world's largest independent music label. Alpert's consummate and understated trumpet lyricism, his lean and rhythmically focused melodic arrangements in latin jazz, semi-classic, and pop mediums have resulted in thirty-two albums, fifteen of them gold. He has been awarded sixteen Grammy nominations and seven Grammies. A highly skilled painter, Alpert has also starred in four of his own television specials, and is a social activist and philanthropist. Alpert was born in Los Angeles in 1935.

27

The delightfully charismatic **Lani Hall** has recorded in three different languages in a variety of styles from jazz to folk, Latin to pop. Discovered performing in a Chicago club in 1966, she was offered the job as lead singer for the group Brazil '66 by pianist Sergio Mendes. After a highly successful six year stint with the group, Lani launched her solo career with the debut album *Sundown Lady* produced by husband Herb Alpert. In the 1980's, after a string of American successes, Hall explored new musical directions, recording a number of collaborative albums in Spanish that culminated with a Grammy for best vocal. Hall and Alpert were married in 1973, and their relationship has been an inspiring example of creative collaboration and a successful personal partnership.

28

From meager beginnings in West Virginia, **Bill Withers** had a late start in music after working as an airplane mechanic. His deeply soulful voice emerged with the breakthrough single "Ain't No Sunshine" in 1971. He followed up his early success with the gospel-influenced "Lean on Me." Wither's smooth and soulful "Just the Two of Us" and "Turn Your Love Around" achieved gold and Grammies in 1981.

28

Leo Kottke learned to play guitar just by "fooling around." From his start on the coffee house circuit, his lightning skill on the twelve-string and gallows-humor lyrics earned him a solid cult following. Described as "folk eccentric," Kottke's music follows no set course, and sounds like nothing else in popular music. In spite of incredible commercial success, Kottke has characteristically gone his own way, writing the material he wanted rather than seeking commercial acceptability. Kottke was born in Athens, Georgia in 1945.

29/30

The Pointer Sisters debut album by the same name, mixing swing era nostalgia, jazzy scats, and outrageous period costumes, was certified gold in 1974. Constantly exploring new forms over the next two decades, the sisters rang up a string of hits across the music spectrum. They were recipients in 1974 of the Grammy for best vocal performance in the country category.

31

With an astonishing vocal range from smoothly moody to passionate, from superb control to unbridled power, **Chaka Khan** has a vocal style that bridges R&B to funk to up-tempo pop to jazz. Her singing career began at fifteen in Chicago clubs, and by eighteen she was fronting the fledgling group Rufus, which in 1974 won a Grammy for "Tell Me Something Good" (written by Stevie Wonder for Khan). In 1978 Khan made her solo album debut with an instant hit with "I'm Every Woman." She followed that with a string of hits and Grammy Awards, ultimately chalking up seven Grammies. She was born in Illinois in 1953.

32

After nearly 30 years, the vocal/instrumental ensemble **Santana** has become a virtual musical institution. With its infectiously intricate mix of Latin, African, jazz, and R&B rhythms, the group's core sound features the fluid purity of leader Carlos Santana's guitar. Santana has become the stuff of legends and was one of the highlights of the Woodstock Festival of 1969. During the early 70's, the group had several Top 20 singles, including "Black Magic Woman" and "Oye Como Va." Santana branched out to write the score for the film *La Bamba* in 1986. Carlos Santana was born in Mexico in 1947.

32

Rufus took the mid-70's by storm, fueled by Chaka Khan's volcanic vocals and a top-notch group of players, the ensemble blended jazz-rock fusion with a high-energy dance sound. Rufus won a Grammy in 1974 for their slinky and highly funked-up rendition of Stevie Wonder's "Tell Me Something Good." Other hits by Rufus include "Sweet Thing," "You Got the Love," and "Ain't Nobody." Before Chaka Khan left to go solo in 1978, the band received six gold or platinum LPs.

33

Raised in Rhode Island, charismatic, gorgeous, sexy **Claudia Lennear** began her career as one of the "Ikettes,"

the backup singers in the Ike and Tina Turner Revue. Building a reputation as a respected backup vocalist — she sang background vocals on Joe Cocker's classic *Mad Dogs and Englishmen* album—Lennear later released her sizzling pop/soul solo album *Phew*. Lennear performed the title song for the feature film *Klute* and has acted in many feature films.

34

Gladys Knight and the Pips rose to fame in the 60's as part of the Motown roster, but enjoyed some of their biggest hits in the decade after. The flawlessly smooth singing of soul diva Gladys (backed up by her brother and two cousins) resulted in a long string of hits, beginning in 1967 with the #2 smash, "I Heard It Through the Grapevine." Hits continued with "If I Were Your Woman" and "The End of the Road," peaking in 1974 with the Grammy-winning singles "Midnight Train to Georgia," and "Neither One of Us."

35

Born in 1944, **Bobby Womack** is one of the founding fathers of modern soul. A prolific songwriter, wicked left-handed guitarist, and compelling vocalist, Womack was a much-in-demand session guitarist until he revived his solo career in the late 60's. As a brilliant composer, Womack contributed classic hits to major stars including Marvin Gaye, Janis Joplin, The Rolling Stones, Leon Russell, and many others. As a solo performer, Womack has produced soul classics for three decades, and he is regarded by his peers as a superstar who has never quite received his due.

36

Borrowing train fare to get from New Jersey to Harlem's Apollo theater, scrawny and shy teenager **Sarah Vaughan** won first prize in an amateur night contest, and was soon discovered by band leader Earl Hines. Sarah Vaughan was to become the "divine one" and the grand jazz diva whose creamy smooth expressive voice combined with an imaginative ability to compose as she went, elevating her music to art. Ushering in the avant garde age of bebob in the forties, Vaughan by the sixties was singing in front of symphony orchestras. She won her first Grammy for *Gershwin Live* in 1981. Born in Newark, New Jersey, she died in 1990.

37

In her first decade as a recording artist **Whitney Houston** has rocketed to the status of global superstar. Her first three albums have amassed record-breaking sales of over forty million, while her 1992 soundtrack for *The Bodyguard* is the all-time best selling album for a solo artist, garnering her five Grammy awards, and making her the first-ever artist to have seven consecutive #1 hits on the *Billboard* charts. Equally at home with R& B, disco, and soulful ballads, she has superb vocal control, personal poise, physical beauty, a combination of talents that brought her to new heights opposite Kevin Costner in *The Body-guard* in 1992, and won her an Oscar for the film score's hit single "I Will Always Love You." The daughter of Cissy Houston, she was born in New Jersey in 1963.

38

Born in 1948, **Marc Bolan** was the driving force behind the English glitter-rock group T. Rex, (formerly Tyrannosaurus Rex) which had 11 UK Top 10 hits from 1970-74, but only one smash record — *Bang a Gong* — in the U.S. The group's debut album blended acoustic textures with off-beat instruments and Bolan's fantasy-laden lyrics. Bolan's American-born wife, to whom he always referred as "The" **Gloria Jones**, was a singer best known for recording the original version of "Tainted Love." Bolan died in a car crash in 1977.

39

Singer/guitarist/songwriter **Jimmy Cliff** was instrumental in spreading the infectious rhythms of Jamaican reggae around the world. In 1969, his "Wonderful World, Beautiful People" was one of the first reggae songs to become a major international hit. He also penned Johnny Nash's smash record "I Can See Clearly Now." Cliff starred in the acclaimed 1973 film, *The Harder They Come*, which featured several of his reggae tunes. He was born in Jamaica in 1948.

39

Bass-voiced **Ike Turner** stands as a monument in the great hall of American Rock and Roll. Driven by Ike's searing guitar, and weaving gut level sounds of ghetto funk, country, blues, and gospel, Ike's band the Kings of Rhythm exemplified the roots of Rock and Roll. The Phil Spector production of their legendary single "River Deep, Mountain High" (which became a hit in Europe but did less well in the U.S.) and their 1969 tour with the Rolling Stones opened the treasure of Ike and Tina to white American audiences. In 1976 Tina left the group and Ike, and the review disbanded. Drug abuse problems and trouble with the law

forced Ike out of the creative field, but by the 1980's, Ike Turner and the Kings of Rhythm were back on the circuit. Ike Turner was born in the Mississippi Delta in 1931.

40

The High Priest, the Right Reverend, the Genius — **Ray Charles** has a boundless musical gift that has changed the course of popular American music. Blind since the age of seven, Charles was born Ray Charles Robinson in Albany, Georgia in 1930. He began his musical career as a piano-playing crooner performing on the road non-stop and had his first Top 10 rhythm and blues hit record in 1951. By the mid-50's, he had invented Soul, merging gospel sounds with secular sensuality and the compelling rhythms of the blues. In the 60's, Charles helped to expand the popularity of Country and Western. He was the winner of a Grammy Lifetime Achievement Award in 1988.

41

With a voice that ranges from silky smooth to scat improvisation, and with astounding vocal virtuosity (he can mimic musical instruments with uncanny accuracy), **Al Jarreau** has the unique distinction of being the only artist to have won Grammies for best R&B, Best Pop, and Best Jazz Vocals. Jarreau was born in Milwaukee in 1940.

41

Singer/composer/guitarist **Phoebe Snow** possesses one of the richest and most flexible alto voices in contemporary music. Snow got her start in the clubs of Greenwich Village, singing a wide range of songs: jazz, blues, torch, folk, and pop. In 1974, her smash self-titled first album contained the lyrically haunting single "Poetry Man," which became a Top-10 hit. Adopting more of a jazz sound for *Second Childhood*, her second LP, she again made the Top 10. After a hiatus in the 80's, she re-emerged in 1990 with the pleasantly laid-back LP, *Something Real*. Snow was born in New York City in 1952.

42

Born in 1923 into rural poverty in Indiana, Mississippi, singer, songwriter, and guitar master of the Delta blues **Albert King** became a highly revered artist during the blues roots boom of the 60's. Working as a field hand and a construction worker for years while doing music strictly as a sideline, the physically imposing King honed his gritty and powerful vocals and searing instrumental style, playing in small clubs and recording for minor labels in the 50's. After signing with a major company in 1967, he recorded his masterpiece — the album *Born Under a Bad Sign*, which brought him crossover fame. A relentlessly driving, straight-ahead guitarist with a nasty sting, he developed a style noteworthy for its muscular phrasing and fusion of traditional Mississippi bottleneck style with the sighing, swooning sound of a Hawaiian steel guitar. Albert King died in 1992 of a heart attack.

43

Born on a sharecropper's farm near Memphis, **Isaac Hayes** first rose to fame as a brilliant songwriter in the mid-60's, and went on to influence the entire direction of soul music in the 70's. Taking soul down a longer and mellower road, Hayes broadened and softened the instrumental menu. His immense songwriting talents produced timeless soul classics for many artists, including such milestones as "Soulman" and "Hold On, I'm Coming." On his own albums, his deep-bottomed spoken introductions ruminate about the machinations of love, sliding into the achingly beautiful ballads. His 1969 LP *Hot Buttered Soul* is a funk classic, as is his lushly orchestrated, boldly syncopated "Theme From 'Shaft'"— which was awarded an Oscar and two Grammies. It was Isaac Hayes' soulfully luxuriant sound that helped pave the way for the disco explosion. Hayes was born in Covington, Tennessee in 1942.

44/45/46

The story of the metamorphosis of Anna Mae Bullock into lead singer of the Ike and Tina Revue, and the re-emergence of **Tina Turner**, archetype of the feminine creative source, transcends mortality. She **is** a woman who 'Runs With Wolves.' The driving turbine and boundless creative joy of a Tina Turner performance is a spine tingling experience. The poignant and uplifting chronicle of Turner's solo revival in 1984 with her *Private Dancer* album was the subject of the critically acclaimed feature film *What's Love Got To Do With It*. Turner is the queen of rock. She was born in Brownsville, Tennessee in 1938.

47/48

Sensuously beautiful, willowy, New York-born singer-songwriter **Carly Simon** began her recording career in a big way. In 1970 Simon released her self-titled debut album, and its top ten single subsequently won her a Grammy for Best New Artist. Fashioning her own style of emotionally mature and intelligent narrative songs (often based on personal experience and observation),

the versatile Simon has continued to weave award-winning classics. In recognition of her brilliant songwriting talent, Simon was inducted into the Songwriter's Hall of Fame in 1984, and in 1989 received an Academy Award for best original song, "Working Girl." She is also the author of several children's books. Simon was born in 1945, and was married to James Taylor from 1972 to 1983.

49

Spurred by the flamboyant bravado and sexy vocals of frontman Michael Hutchence, Aussie band **INXS** became a major musical force in the 80's. Though they initially embraced a new-wave sound, by the release of their fourth album *The Swing* in 1984, the group had adopted a hard-rock edge accented by high tech textures. This photo was taken in 1988, the year INXS scored its first #1 single, "Need You Tonight," from its quadruple platinum album, *Kick*.

50

The Eagles created for themselves a huge following, immense album sales, and numerous awards over the 70's. Their 1975 album *One of These Nights* turned the group into superstars, spawned three top 10 singles, and is considered one of the finest collections of the decade — largely because of the exceptional melodic skills of principal writers Don Henley and Glenn Frey. When Frey and Henley went solo in 1982, The Eagles disbanded. They reunited in 1994 for a sold-out nationwide concert tour.

51

English singer **Johnny Rotten** was born John Lydon in 1956. Using his nickname as a stage name, he co-founded the notorious punk band the Sex Pistols in 1975. Their raw and ragged 1977 album *Never Mind the Bollocks, Here's the Sex Pistols*, stirred up much controversy in Britain and was eventually banned. The group came to America early in 1978, but broke up by the end of an abbreviated tour. After bandmember Sid Vicious died of a drug overdose in 1979, Rotten returned to using his given name and formed the group Public Image Ltd.

52

Hailing from the quiet suburb of Forest Hills, New York, the **Ramones** were a groundbreaking band in the New York punk scene of the mid-70's. Sporting scruffy, all-black uniforms of ripped jeans, biker boots, and leather jackets, the quartet won national attention in 1976 with their first self-titled album. The band recorded eight albums in the 80's, with its trademark blend of supersonic riffs, slashing guitar chords, and lyrics laced with absurdist-cum-adolescent humor. The Ramones were featured in the 1979 film *Rock 'n Roll High School*.

53

Born in Australia in 1944, singer, songwriter, dancer **Peter Allen** was a riveting, multifaceted performer who came to prominence on New York's circuit and became one of the top cabaret stars of his generation. Signed by A&M records in 1974, he made two genre classics, "Continental American" (1974) and "Taught by Experts"(1976). His 1980 album *Bi-Coastal* was a pop funk tour de force that placed him squarely in the pop-rock mainstream.

54

Jennifer Warnes has been making music to appeal to the heart, the mind, and the soul for over two decades. From a start in the burgeoning folk-rock scene of 1960's Los Angeles, Warnes won the lead role in the L.A. production of *Hair*. Her solo recording career began in 1969, but her first major crossover hit "Right Time of Night" came in 1975, the single from her fourth album. In quick succession Warnes recorded three Academy Award-winning songs, including "Up Where We Belong" (with Joe Cocker). With her more recent releases, *Famous Blue Raincoat* (an album of songs by Leonard Cohen) and *The Hunter* (1992), Warnes artistic risk-taking is apparent.

55

David Soul began his show business career playing guitar and singing in night clubs. When he co-starred in the action-packed police drama Starsky and Hutch (which topped the TV ratings from 1975-79), Soul found himself an instant superstar. During the show's run, Soul recorded an album that reached the top of the charts in America and England; after the show's demise, he moved on to acting in TV movies and feature films, along with becoming increasingly active as a director. He was born David Solberg in Chicago in 1943.

55

Singer/songwriter/pianist **Chi Coltrane** left her hometown of Racine, Wisconsin to play the clubs of Chicago, eventually making her way to California. Coltrane's rollicking, bluesy vocal style on her self-titled debut album yield-

ed a Top 20 hit in 1972: the sexy pop-rock song, "Thunder and Lightning." She has recorded two subsequent LPs, and maintains an active touring schedule in Europe and America. Coltrane is active as an artist-advocate for the environmental movement. She was born in 1948.

56

The mother daughter team of **Naomi and Wynonna Judd** exploded on the Nashville scene in the 80's. Blending an acoustic based sound featuring lead singer Wynonna's superb vocal range, emotional depth, and control against Naomi's high harmonic weave, the Judds became a performance and media phenomenon — and recipients of numerous Grammy and Country Music Association Awards. Naomi, the writer of many of the duo's songs, was forced to retire in 1991 after contracting hepatitis. Wynonna continues as a solo performer and recorded her first solo album *Wynonna* in 1992.

56

A native son of Shelby, North Carolina, **Earl Scruggs** was the banjo virtuoso in the legendary bluegrass duo Flatt and Scruggs. A player since the age of four, Scruggs performs a virtual finger ballet on the banjo — an intricate, nimble fingered style that has come to be known as "Scruggs-Style Picking." He is also a composer and has written scores for several films: with Flatt, he wrote the theme music for the TV show *The Beverly Hillbillies*, and the "Dueling Banjos" number from the film *Deliverance*. Scruggs later formed his own revue with his sons, recording and touring the country, and performing in a diverse range of musical styles. Scruggs was elected to the Country Music Hall of Fame in 1985.

56

Country/Western singer/songwriter **Tom T. Hall** has made a career of revealing dryly humorous, grimly beautiful tales from his own life. He penned Jeannie C. Riley's 1968 smash single, "Harper Valley P.T.A.," along with several hits of his own, including "I Love" in 1974. Hall won a Grammy for his 1972 Greatest Hits album and was voted that year's top country act in the *Rolling Stone* Critics Poll. He was born in 1936 in Olive Hill, Kentucky.

57

Classically trained singer, songwriter, guitarist, artist, actor **Hoyt Axton** began as a folksinger in the late 50's, initially gaining notoriety for his acoustic guitar playing and gruff-voiced vocals in the coffee houses of San Francisco. Axton's prodigious songwriting talent has propduced many folk, country, and rock classics. "Greenback Dollar" became a folk anthem in the early 60's, and Three Dog Night recorded his song, "Joy to the World," which then went on to become a #1 smash in 1971. Axton has had starring roles in some 40 films, done countless TV shows, and has become one of the most sought-after voice talents in the field of radio and television commercials. He was born in Oklahoma in 1938.

57

An accomplished guitarist by the age of six, **Glen Campbell** was a much-in-demand studio player before launching a solo career at the end of the 60's. His intuitive song styling, sweet tenor voice, and accomplished blend of country, pop, rock, folk, and jazz helped him pioneer country music into the mainstream. Campbell made history by winning a Grammy in both country and pop in 1967. 1967 was a seminal year for Campbell, with his string of hits, and the inception of his highly-rated network television show which ran for four seasons. He had crossover hits in 1975 with "Rhinestone Cowboy," and in 1977 with "Southern Nights." Campbell has branched out to the field of gospel music, has published his autobiography, and has also co-starred in the John Wayne western *True Grit*. He was born in 1936 in Delight, Arkansas.

58

Born in 1937 in Bakersfield, California, singer/songwriter/guitarist **Merle Haggard** survived a rough childhood, a series of unskilled jobs, and several brushes with the law. Since he began recording in the 60's, Haggard has released over sixty-five albums. He has been nominated 42 times for CMA awards, has written hundreds of songs (including the classics "Sing Me Back Home," "Okie From Muskogie," and "Silverwings") and has achieved #1 ratings with over 40 of his singles. An uncompromising individualist, he has a richly-textured and plaintive voice with a raw, emotional edge that's unmistakable. As a songwriter he has drawn on the themes of his strife-ridden past to bring emotional depth, lyrical beauty, and sophistication to country music.

59

With her ankle length hair a trademark, **Crystal Gayle** has played a key role in the rapidly growing popularity of country music with her middle of the road, emotionally evocative vocal style. While still in school Gayle signed her first recording contract, and by 1976 she was named the outstanding female vocalist by the Academy of Country Music, followed by awards as Best Female Vocalist of the Year three times. Her fourth album *We Must Believe in Magic* won her a Grammy and became a Platinum seller; its single "Don't It Make My Brown Eyes Blue" became the first recording by a country artist to sell more than a million copies. The youngest of eight children, Gayle was born in the Appalachian coal mining town of Paintsville, Kentucky in 1951.

60

Johnny Cash's life reads like the stuff of a great American romantic novel. Born into a poor sharecropping family (he almost died from starvation as a child), Cash rose out of his roots, successive drug addiction problems, and incarcerations to triumph through his music and strength of spirit. Beginning with his first hit single released in 1955, he has become a legendary and towering presence in the history of country music, producing more than twenty-six albums, and selling over 50 million records world-wide. He has seven Grammy awards, twenty-three songwriting awards, and is the only living entertainer to be awarded entrance into the Country of Music, Songwriters, and Rock & Roll Hall of Fame. He was born in Kingsland, Arkansas in 1932.

61

The music of **Tammy Wynette** reflects the saga of her life. From her beginnings in a shack in Mississippi, she overcame many personal and physical difficulties to achieve world wide acclaim as a country music legend. Pouring out all of the heartache and agony from her turbulent early years, she is a passionate and soulful expression of a country music archetype. Her all-time best-selling country single "Stand By Your Man" in 1969 earned her a second Grammy, and in 1974 she published her autobiography with the same title. Wynette was born in Tupelo, Mississippi in 1942.

62

Highly successful and prolific as a country songwriter, **Willie Nelson** never thought of himself as a performing artist. In 1974 Columbia records gave Nelson control over his own material, and his debut Columbia record *Redheaded Stranger* rose to number 1 on the country lists—and reached the Pop Top 40, making the songwriter/singer a crossover superstar. With a singular lack of artifice, heartfelt vocals and compositions, an engaging hippie image and lifestyle, the iconoclastic and stubbornly independent artist brought hip to country, and progressive rock was born. Nelson has also given credible performances as an actor, notably in the films *The Electric Horseman* and *Honeysuckle Rose*. He was born in Fort Worth, Texas in 1933.

63

A protégé of W. C. Handy, **Furry Lewis** was a country blues musician who was highly regarded in Memphis. Born in 1893 in Greenwood, Mississippi, Lewis was the son of sharecroppers. He made many records during the 20's, but spent most of his working life as a street sweeper for the city of Memphis—choosing to play his music on the side. Combining a bottleneck and finger picking style, his most notable compositions include "Big Chief Blue," "Dry Land Blues" and "I Will Turn Your Money Green." Lewis twice opened shows for the Rolling Stones.

64

A seminal blues figure, **Sleepy John Estes** lost the sight of one eye in childhood and began playing guitar at age 12. Born in 1899, he left his hometown of Ripley, Tennessee to live in Memphis and Chicago—where he performed in clubs and recorded for Blue Bird Records. Estes sang in a high pitched crying style and played guitar in a simplified rhythmic fashion. He recorded many of his own songs in the 30's, compositions which provide a remarkably vivid portrait of a blues' singer's life at that time. Estes retired from music in 1941, but was rediscovered by a new generation; in 1964, he played the Newport Folk Festival. His most famous songs include "Working Man Blues" and "Everybody Ought to Make a Change." He died from a stroke in 1977.

65

A native-born lyric poet of the black urban landscape, **Curtis Mayfield** extended his influence far beyond music, dealing with problems of race and of society in general. Born in Chicago in 1942, Mayfield was the lead vocalist and co-founder of the Impressions, a pacesetting soul group that was elected to the Rock and Roll Hall of Fame in 1991. Mayfield subsequently went on to establish himself as a prolific and evocative performer/writer. His sweet falsetto and flawless pen have created soul standards —"Gypsy Woman," "I'm So Proud," "People Get Ready"— which are woven into the tapestry of American pop. His soundtrack from the film *Superfly* was the acknowledged breakthrough of black rock in the medium of film. Tragically, a 1990 accident has left him paralyzed.

66

In the realm of jazz bass guitar, **Jaco Pastorious** was an unparalleled giant. Irrepressible, uncontrollable, and irreverent. Jaco was a larger than life figure who lived to tragic excess. His life was short — from 1951 to 1987— but his artistic contribution was revolutionary. From 1976 to 1982 he was a member of Weather Report, a startlingly innovative jazz-fusion group. During that time, Jaco virtually reinvented the role of the bass. One of the more influential musicians of his day, he dazzled his contemporaries with a variety of styles from burning bebop to down-and-dirty funk.

67

Richly emotive jazz guitarist **Earl Klugh** has brought his melodic trademark to the pop side of jazz. Discovered as a youngster in Detroit, Klugh demonstrates an eloquent and melodic picking style over fundamental chords and improvised structures. Klugh has many Grammy nominations and has produced several gold records.

67

Classically-trained guitarist/pianist/composer **Egberto Gismonti** studied piano for more than 15 years before he switched to guitar — a switch that grew out of his fascination with "choro," Brazil's native brand of funk music. He then spent two years experimenting with different tunings in his quest for new sounds, using flutes, kalimbas, voice, and bells. Often blending Afro-Brazilian forms with jazz and a contemporary treatment of traditional Amazon Indian music, his works celebrate the richness and com-plexity of his homeland. As a guitarist, his rapid-fire style is totally his own. As a composer, his works have been recorded by artists around the world. Recently, he expanded into a new artistic area by scoring a modern ballet of *Carmen*. Gismonti was born in 1947.

68

John Lee Hooker is an archetypal figure in the evolution of the blues. The great vocalist/guitarist synthesized a country sensibility with a big-city boogie. "Boogie Chillen" was his first hit, featuring only voice, foot-tapping, and stark electric guitar. Hooker, who was born in 1917 in Clarksdale, Mississippi, writes free-form lyrics that seldom rhyme. His musical manner is brittle, his attitude absolutely true-to-life. Hooker's 1989 hit album *The Healer* with blueswoman Bonnie Raitt was a Grammy-winner. His singular approach to the blues won him entry into the Rock and Roll Hall of Fame in 1991.

68

A living bluegrass legend, **Vassar Clements** has accumulated numerous honors, including 5 Grammy nominations. In 1945, at the age of 14, he began playing with the king of bluegrass, Bill Monroe, at the Grand Ol Opry. His phenomenal ability to play any kind of music from bluegrass to pop, jazz and rock, and his adventurous sawing ultimately produced musical collaborations with such diverse artists such as the Rolling Stones, the Nitty Gritty Dirt Band, the Grateful Dead, The Allman Brothers Band, Linda Ronstadt and others. A superb fiddle virtuoso as well as a composer, his *Grass Roots* 1992 album is a tribute to the wellspring of the musical form. Born in 1928, Clements is a native of Kinard, South Carolina.

69

David Oliver is a reggae singer from Florida who had big R&B hits in the late 70's with "Ms." and "I Wanna Write You a Love Song." Oliver moved to Los Angeles in 1967 and teamed with pianist Gene Godfrey. He toured with Mighty Joe Hicks in the mid-70's.

69

Billed "The Crown Prince of Reggae," **Dennis Brown** is a much-admired Jamaican singer/songwriter who has made many true-to-the-roots reggae recordings. A dynamic on-stage performer, he combines serious message songs and soul-wailing love tunes. After several minor hits, his first Jamaican smash was "No Man Is An Island" in 1969. After signing with a major label, Brown scored an R&B hit in 1982, "Love Has Found Its Way." He was born in Kingston, Jamaica in 1957.

70

Dramatically escaping Nazi persecution as a child, **Bill Graham** began his celebrated career as a visionary entrepreneur with his first concert promotion in San Francisco in 1965. Able to deliver well established performers, he also took risks with new acts outside the rock idiom, and his elaborate spectacles of light and sound turned his hugely popular Filmore Ballrooms on both coasts into Meccas for the arts. The versatile, extroverted, and assertive Graham acted in several motion pictures, co-produced *The Doors*, and was an outspoken

proponent of social causes. He died tragically in a helicopter crash in 1991.

70

Desiring to escape the squalor of the Lower East Side ghetto of the Detroit he grew up in, **Berry Gordy, Jr.** turned professional boxer, then assembly-line worker at Ford, and later tried his hand as a songwriter in the late 1950's. With some hit songs to his credit but no money, Gordy decided that the only way to make it in the business was to produce records himself. Borrowing $700 from his family, he set up a recording studio in his apartment and called his new firm Motown (for Motor Town). Gordy's intuitive gift for recognizing new talent proved unerring. Within a few short years he was to sign Smokey Robinson, The Supremes, The Temptations, Marvin Gaye, and ultimately such superstars as Michael Jackson, Gladys Knight and the Pips, Stevie Wonder, Lionel Richie, and many luminaries of the Motown Sound. By the early 1970's Gordy had become a legend listed in Who's Who in America, and Motown had sales exceeding $10 million a year. Gordy expanded into film with *Lady Sings the Blues* and *Mahogany*. In 1983 Motown celebrated a 25 year anniversary, and in 1988 it was sold for $61 million, ending an era.

71

From a high school math teacher in Watts and a model, she went on to become the first woman president of a major motion picture company. In 1980, **Sherry Lansing** was named president of production at 20th Century Fox, generating an impressive list of film production credits including *Nine to Five, The Verdict*, and *King of Comedy*. Currently Lansing is Chairman and CEO of Paramount Motion Picture Group, and earlier, under the banner of Jaffe/Lansing Productions she produced such classics as *Fatal Attraction* and *The Accused*, the latter winning Jodie Foster an Academy Award as best actress. Lansing was born in Chicago in 1944.

71

After receiving B.A., LL.M, and J.D. degrees, **Peter Guber** entered the entertainment business in 1968. Recruited by Columbia Pictures from graduate school, within twenty months he was named president of the studio. Currently his position as C.E.O. of Sony Pictures is simply the latest milestone in a 25 year career in which his brilliant instincts and leadership have made him one of the most successful producers in motion picture history. The list of his critically acclaimed and box office film successes reads like a dictionary of our time, including *Taxi Driver, The Way We Were, The Deep, Midnight Express, Rain Man, Batman, The Color Purple, Flashdance, Boyz N The Hood, Basic Instinct, Sleepless in Seattle,* and *Philadelphia*. Guber and his wife Lynda are deeply committed advocates of educational reform. A native of Syracuse NY, he was born in 1942.

71

With a full-throated voice that can soar through the roof, the Queen of Disco, **Donna Summer**, helped whip up the frenetic fires of the dance fever era. Getting her show business start in a European production of *Hair*, Summer sang a long string of memorable hits, including "Last Dance," "Hot Stuff," "Bad Girls," and "On the Radio." As a songwriter, Summer has proved herself adept in a variety of musical styles, including mainstream rock and gospel. She has won four Grammies for disco, rock, and inspirational music. She was born Adrian Donna Gaines in 1948.

71

Neil Bogart was one of the more dynamic and innovative executives in the rock music industry. In the 60's, he was at the helm of Buddah Records; in the 70's, he directed Casablanca Records, one of the hottest labels of that era. As the head of Casablanca, Bogart worked with Donna Summer, the Village People, Cher, and Kiss. By 1980, he was into a brand new venture, forming the Boardwalk Company with Peter Guber and Jon Peters. Bogart died of cancer in 1982.

72

Quincy Jones' career encompasses the roles of composer, arranger, record producer, artist, film producer, conductor, record company executive, magazine founder (Vibe), and entrepreneur. Born in Chicago in 1933, he began studying trumpet in elementary school and subsequently toured with Lionel Hampton's band as a trumpeter. Jones' particular brilliance as an arranger ultimately emerged from the mid-50's on, as he set a prodigious creative standard arranging and recording such diverse artists as Sarah Vaughan, Ray Charles, Count Basie, Duke Ellington, Frank Sinatra and numerous others. He won his first of many Grammies in 1963 for his Count Basie arrangement of "I Can't Stop Loving You." Jones became VP of Mercury records in 1961, the first black executive of an established record company, and broke the color lines

with his excursion in 1963 into the world of film, ultimately writing more than 33 major film scores. His landmark album in 1989 *Back on the Block* was named Album of the Year, and his historic production of "We Are The World" became the best selling single of all time. His Michael Jackson multi-platinum solo album *Thriller* became the best selling album of all time. In 1985 with Steven Spielburg he co-produced *The Color Purple*, which won 11 Oscar nominations. He is the all-time most nominated Grammy artist with a total of 76 Grammy nominations and 27 Grammy awards — and the recipient of the Grammy Living Legend Award. In 1990 he was the subject of the critically acclaimed documentary feature *Listen Up ...The Lives of Quincy Jones.*

73/74

Native Texan **Steve Martin's** stellar career began as an award-winning television comedy writer. Perhaps the most popular stand-up comedian of the 70's, Martin used numerous TV appearances and concert dates to turn "excuuuuuuse me" and "I am a wild and crazy guy" into national catch phrases. His remarkable fluid physicality became the benchmark of his comedic style. Martin's stature as a leading actor has continued to expand with hit films such as *Parenthood, Roxanne,* and *L.A. Stories* (the latter of which he wrote and produced). Born in 1945, he made the cover of *Time* in 1987. Martin is an avid and respected art collector.

75/76

The alternately brilliant, hilarious, serious, spontaneous **Lily Tomlin** seems to have no end to her comic imagination. Considered one of the greats of American comedy, she is the creator of a cast of archetypal comic characters whose very existence is a social commentary on gender roles and social mores. Her long collaboration with writer Jane Wagner has produced a prodigious body of work, including the Broadway smash *The Search For Signs of Intelligent Life In The Universe.* Besides theater and TV, her film credits are impressive, including *Nashville,* for which she was nominated for an Academy Award. Tomlin was born in 1939 in Detroit.

77

Out of the midwest came one of the most versatile and brilliant comedians of our age, **John Belushi**. Trained in improv, Belushi joined the original cast of TV's *Saturday Night Live* in 1975, introducing the American public to a host of memorable characters—from the Samurai deli counterman to hipster Jake, one-half of the singing Blues Brothers duo. Belushi made a successful leap to the big screen in 1978, starring in the massively popular film *Animal House*. Born in 1949, he died of a drug overdose in Hollywood in 1982.

78

A third generation performer, the vivacious, literate, and articulate **June Lockart** can be summed up as an enthusiastic experimentalist. Her wide-ranging resume as a TV star (*General Hospital, Lassie,* for which she won an Emmy), her numerous feature films, and her award-winning stage performances have brought her international recognition. She enjoys such diverse personal challenges as driving a tank, and traveling the Amazon and the Arctic Circle. She is an active advocate of many social issues and a high profile participant in many cultural arenas. Lockart was born in New York City in 1925.

78

Starring in one of the most popular TV series of all time, M*A*S*H, (the message of which was, in his words, "that people count") actor/writer/director **Alan Alda** used the opportunity to make a brilliant directorial and writing debut. Subsequently Alda became the only artist to win Emmys in all three categories. His sensitive portrayals in film and on stage have generated much critical acclaim for this fine, substantive actor. Alda is an ardent feminist and has campaigned extensively for women's rights. He was born in New York City.

79

From stirring up controversy with her trip to Hanoi during the Vietnam War, to her brilliance and drive as an actress, activist, advocate of physical fitness, and successful businesswoman, the endlessly versatile **Jane Fonda** is an icon of feminine achievement. Among her impressive list of wide ranging credits, she has won two Oscars (*Klute* and *Coming Home*) and an Emmy for her portrayal of a poverty-stricken Appalachian mother in *The Dollmaker.* In 1970, all three Fondas, father Henry, brother Peter, and Jane, graced the cover of *Time*. She was born in 1937 and is married to CNN founder Ted Turner.

80

With dark good looks that could break into disarming smiles, and with his dynamic, loose limbed dancing, **John Travolta** exploded into prominence as a teenage heartthrob,

starring in the 1977 smash motion picture *Saturday Night Fever* — for which Travolta earned an Academy Award nomination. He followed that up with box office successes *Grease* and *Urban Cowboy*, and after a fallow period, resurrected his star status with *Look Who is Talking* and the 1994 film *Pulp Fiction.* He was born in New Jersey in 1954.

81

Dennis Hopper won roles on many TV shows before making the leap to feature films. Hopper appeared in two landmark youth films which defined the struggles of two different generations: *Rebel Without a Cause* in 1955 and *Easy Rider* in 1969. Hopper won much acclaim for his triple role in *Easy Rider* when he co-wrote the film, co-starred, and directed — later receiving an Oscar nomination for best screenplay. In the past two decades, Hopper has created a number of quirky, dangerous, and highly memorable characters in many films. A multi-talented artist, Hopper has won several directorial awards, and his work as a photographer, painter, and assemblage sculptor has been exhibited internationally. Hopper was born in 1936 in Dodge City, Kansas.

82

Born in L.A. in 1962, **Jodie Foster** has become one of the more emotionally moving and prolific creative forces in the film industry, with award-winning credits as a director, producer, and Oscar-winning actress. Beginning her acting career at age 3, Foster shot to international stardom as the streetwise and vulnerable preteen prostitute in Martin Scorsese's *Taxi Driver*. Her stunning performances in *The Accused* (1988) and *Silence of the Lambs* (1991) earned her two Academy Awards for best actress. In 1991 Foster made her motion picture directorial debut with *Little Man Tate* in which she also starred.

83

A native of St. Louis, the delightful and emotionally accessible **Marsha Mason** appeared in numerous Broadway and off-Broadway productions in the early 70's. She landed her first starring film role in 1973's *Blume in Love,* then won an Academy Award nomination for her performance as the heart-of-gold whore in *Cinderella Liberty.* Mason has been nominated three additional times for Oscars as best actress in *The Good-Bye Girl* in 1977, *Chapter Two* in 1979, and *Only When I Laugh* in 1981. She was born in 1942.

84

A singer/songwriter since her teens, actress **Katey Sagal**, who "always wanted to be a star," became one, but not in the way she expected. Discovered acting in a rock musical in 1985, Sagal honed her natural acting talent as the resilient, over the top, feminist-leaning lead in the television sitcom *Married With Children*. Her credible first album release *Well...* (1984 on Virgin records) is an impassioned blend of R&B, pop, and torchy love songs.

85

With an engagingly animated face and wonderfully expressive eyes, **Alfre Woodard** is an idiosyncratic chameleon of a performer whose kudos include Emmys for the hit TV series *Hill Street Blues* and *L.A. Law*, and an Academy Award nomination for the film *Cross Creek*. Infusing her performances with an exceptional intelligence and intensity, Woodard brings to her roles a uniquely energetic, though focused presence. The fiercely private yet outspoken actress is a committed activist and founding member of Artists to Free South Africa. Woodard was born in Tulsa, Oklahoma in 1953.

85

Sensuously beautiful, and possessed of an off-beat sense of humor and style, **Rae Dawn Chong** brought together her considerable talents in a brilliantly imaginative performance in her debut film, *Quest for Fire,* for which she was nominated for a Genie (the Canadian Oscar). Chong was born in Vancouver, Canada in 1962.

86

Actress, recording artist, dancer, and activist **Sue Kiel** was one of the founding members of The Market Theater, South Africa's first multi-racial theater. Emigrating to the United States in 1978, she continued her career with leading roles on stage, and in 1991, she co-founded a Los Angeles multi-cultural youth organization, directing and producing stage and TV programs focused on issues of cultural awareness. Sue and Norman Seeff were married in 1983. They have two children, Tai and Shayne.

86

Elegant and earthy, actress **Lois Chiles** is best known for playing smoky-voiced, smart, and sultry dames. Her credits include the feature films *The Way We Were, The Great Gatsby, Moonraker, Broadcast News, Death on the*

Nile, Until the End of the World, and leading roles on TV and on stage. Chiles is godmother to Sue and Norman Seeff's son, Shayne.

87

Beginning in 1961 **Richard Chamberlain's** creative versatility, dashing good looks, and literate sophistication landed him the title role of *Dr. Kildare,* elevating him to television stardom overnight. Chamberlain followed with critical successes and award-winning performances in the world of mini-series, including such classics as *Shogun, Wallenberg,* and *The Thornbirds.* In addition to his richly varied appearances in feature films, Chamberlain has many and varied leading role stage credits, including an acclaimed transatlantic role as Hamlet.

87

Marjoe Gortner was born on January 14, 1944 into a family that had been ministers for three generations. At 21, Gortner entered the gospel train and by 1971 was a top evangelical figure. Gortner's personal story was the subject of the 1972 Academy Award documentary *Marjoe,* depicting his life and exposing the reality of contemporary evangelism. Leaving the preaching circuit behind him, Gortner subsequently turned to acting on TV and in film.

88

Born in 1906, director **John Huston** was a towering figure among American filmmakers for nearly five decades, weaving tales of the individualist and the quest for self. Although Huston's work cannot be categorized by a single vision or style, it is deeply literate, reflecting his depth and compassionate understanding of his characters. He made his directorial debut in 1941 with *The Maltese Falcon* — a work widely considered the best detective movie ever made. Huston won an Oscar for directing the 1948 classic *Treasure of the Sierra Madre.* He was also nominated for best director for the crime drama *The Asphalt Jungle* (1950), the romantic adventure *The African Queen* (1951), and the darkly humorous *Prizzi's Honor* (1985). He died in 1987.

89

Fleeing Hitler's tyranny, writer/director **Billy Wilder** arrived in Hollywood with no money and scant knowledge of English. His sophistication and outsider's ability to satirize the American experience made his films undisputed classics of the 40's, 50's and 60's. He swept the Academy Awards in 1961, winning three Oscars for writing, directing, and producing the comedy/drama *The Apartment.* Among his works are *The Lost Weekend, Double Indemnity, Sunset Boulevard,* and the ribald comedy *Some Like It Hot,* starring a luminous Marilyn Monroe. Wilder was born in Vienna in 1906.

90

Bert, Ernie, Kermit the Frog, and Cookie Monster. These wonderful Muppet characters (and others) were the brainchildren of producer, screenwriter, director, and visionary **Jim Henson.** Henson first introduced his Muppets on public television's *Sesame Street* in 1969. Their humorous human foibles, true-to-life personalities, and gifts as singers and dancers in sophisticated musical arrangements made them superstars. Henson's talents won him five Emmys, and he was inducted into the Academy of Television Arts and Sciences Hall of Fame. Henson was born in Greenville, Mississippi in 1936. He died of pneumonia in 1990.

90

Ridley Scott is a master of suspense whose contemporary, symbolic, and narrative themes are filmed with graphic brilliance and an artist's discerning eye. A native of Northumberland, England, he began his career as a set designer with the BBC, subsequently establishing himself as an internationally renowned director of commercials before moving into feature films. He ventured into new territory with *Alien* and *Blade Runner,* and with *Thelma and Louise,* which featured female roles that broke stereotypes of women. The latter brought Scott an Oscar nomination in 1992.

91

From the streets of New York's Little Italy, **Martin Scorsese** has emerged as a genius of contemporary American film. He ranks as the most consistently passionate, committed, and inventive director American cinema has seen for decades. Scorsese's work is rooted in his own Italian-American heritage. With a focus on emotionally intense and multilayered character development and a free-wheeling visual style, Scorsese's works have run the gamut from the feminist-themed *Alice Doesn't Live Here Anymore* (1974), to the shockingly violent *Taxi Driver* (1976), to the lyrical period drama *The Age of Innocence* (1993). His blistering boxing masterpiece *Raging Bull* (1980) is regarded by many as the finest film of the 1980's. Born in 1942, Scorsese has received three Oscar Nominations.

92

Known for his highly personalized style, writer/producer/director **Nick Roeg** segued his cinematographer's eye into directing. His first solo effort was the strange but stylish Mick Jagger rock feature, *Performance* (1970). Roeg followed with a series of visionary films, the riveting *Walkabout, Don't Look Now,* and the sci-fi film *The Man Who Fell to Earth* with David Bowie and **Candy Clark.**

93

Following a successful career on Broadway as a dancer and an influential choreographer, **Bob Fosse** turned his Tonys into Oscars. With a distinctive jazz-influenced style, Fosse was the only person to be awarded an Oscar, an Emmy, and a Tony in the same year. He directed a string of successful Broadway musicals (*Damn Yankees* and *The Pajama Game*), and later made his screen directing debut. Besides *Cabaret* (1972), which won eight Academy Awards, he produced stark uncompromising portraits of fame and tragic demise, including the stunning *Star 80,* the hard edged *Lenny,* and the transcendental, Felliniesque, semi-autobiographical *All That Jazz.*

94

Iconoclastic playwright **Eugene Ionesco** was one of the artistic pillars of the absurdist theater movement. In addition to his celebrated plays, such as *Rhinoceros* and *The Bald Soprano,* he wrote screenplays, teleplays, radio scripts, and an autobiography. His stage works have been performed worldwide. A leading intellectual presence in both pre- and post-War France, Ionesco was a long-time resident of Paris, where he was awarded the Legion of Honor. Ionesco was born in Romania in 1912; he died in 1994.

94

Joyce Carol Oates' richly imaginative fiction commonly deals with ostensibly ordinary families caught up in intensely emotional and uncommon experiences. Oates is one of America's more versatile writers and has produced distinguished novels, short stories, plays, and literary criticism. Her best selling 1969 novel *Them* won the National Book Award. Joyce Carol Oates was born in upstate New York in 1938.

95

In 1948 **Norman Mailer** wrote an impassioned, nonstop fifty thousand words in sixty days, *The Naked and the Dead,* a novel based on his experience in WWII. In 1954 he co-founded The Village Voice, establishing a high profile and contentious media presence as a hip social philosopher. With the publication of *Advertisements For Myself,* Mailer established a non-fiction narrative style that was to become his trademark. Two of his journalistic books — *Armies of Night,* and *Executioners Song* — won Pulitzer Prizes. In 1984 Mailer directed *Tough Guys Don't Dance.* He was born in 1923 in Long Branch, New Jersey.

96

Jach Pursel is a full-trance medium who has been channeling a non-physical consciousness identified as Lazaris since 1974. Lazaris has communicated a prodigious and ground-breaking body of information and technique in the areas of psychology of consciousness, metaphysics, and spirituality. Pursel, who channels with his eyes closed, is not aware of what is being said during the trance state and must listen to tapes to learn what has been communicated. Lazaris' international following is estimated in the tens of thousands and includes participants in the growth, religious and spiritual disciplines, as well as health professionals, scientists and other public figures. Jach Pursel is a successful businessman and publisher of art books. He was born in Wisconsin and graduated from the University of Michigan in political science.

97

Ram Dass is an authentic American spiritual teacher. In 1969, as a professor and research psychologist at Harvard University, Dr. Richard Alpert traveled to India and discovered his spiritual Guru, Neem Karoli Baba. Named Ram Dass (servant of God) by his spiritual master and initiated into yogic philosophy and practice, he returned to America to teach a path of compassionate action. His courageously self-disclosing personal search (described in his book *Be Here Now*) was one of the major influences for the emergence of the New Age spiritual movement in the 70's. He was born in Boston in 1931.

97

Harvard Professor and Psychology Ph.D, **Timothy Leary** rose to counter-culture prominence during the 60's as an advocate of the use of psychedelic drugs as a means to enlightenment. His LSD research with colleague Richard Alpert led to their dismissal from Harvard in 1963, and to his subsequent incarceration. Since his release, the irrepressible Leary has continued to present his idiosyncratic brand of philosophy, psychology, and media theories in the form of books, monographs, and lectures. The self-styled "chaos engineer's" books include: *Flashbacks* and *Changing My Mind.* Leary was born in 1920 in Springfield, Massachusetts.

98

The first issue of *Playboy* magazine was produced on a kitchen table in **Hugh Hefner's** modest apartment with a personal investment of $600. On the news stands in December, 1953 without a cover date (Hefner was not sure he would be able to produce another), the issue sold 51,000 copies. *Playboy* grew at a phenomenal rate, and in the early 60's Hefner authored a series of editorial statements on the rights of the individual in a free society. While the magazine liberated attitudes towards nudity and sex, it also set a remarkable literary standard for original writing, articles, interviews, and graphic design. Among his many other notable honors, Hefner was inducted into the Publishing Hall of Fame in 1989. He was born in Chicago in 1926.

98

As co-founder of Apple Computer, and co-designer of the world's first mass produced personal computer, **Steve Jobs** has had a monumental impact on the rapidly changing paradigm of the twentieth century. Jobs' vision of placing the power of the personal computer in the hands of the individual revolutionized the scientific, creative, and technical arenas, as well as the personal lives of 20th century society. Jobs' risk-taking and visionary instincts guided Apple to become a $2 billion company and established Jobs as a high tech pioneer. Born in 1955, Jobs made the cover of *Time* in 1982. In 1988 he left Apple to become president of NeXT, Inc.

99

Standing six-feet three inches, weighing 220 pounds, with a model's well proportioned physique, **Ken Norton** first jumped into the boxing ring at the late age of twenty-four. Using hypnosis as a part of his training technique, he defeated the great Mohammed Ali in twelve rounds, only to lose to him six months later. A holder of the World Boxing Council championship for a brief four months, Norton retired in 1981 to a career in film and sports management. He was born in 1943 in Jacksonville, Illinois.

99

In a celebrated Super Bowl (Super Bowl III in 1969), Pennsylvania-native and New York Jets quarterback **Joe Namath** led the upstart New York Jets of the AFC to an upset victory over the Baltimore Colts of the NFC. Namath was voted the game's MVP and later inducted in the Football Hall of Fame. His good looks, self-effacing sense of humor, and free wheeling lifestyle made Namath a media hero of the 70's. After leaving pro sports, he became a film, TV, and stage actor, appearing in a half dozen major motion pictures.

100

In 1953 **Sir Francis Crick** and co-researcher James Watson determined one of the secrets of life: the elegant and beautiful double helix structure of DNA. The epochal discovery of DNA, the giant molecule of heredity, cleared the way for the unraveling of the human genetic code, transforming the biological sciences, medicine, and bioethics. Crick has continued his research at the Institute in LaJolla, CA. on the physiology of vision and human consciousness. He was awarded the Nobel Prize for medicine in 1962. He was born in England.

Pages 22/23

"Thing about me," **Roz Kelly** has said, "is that I have this raw, primitive quality." Raw, real, ready for the next experience, Kelly has a fiery personality, a feisty spirit — and the sensitive, vulnerable soul of a genuine artist. Actress/singer/dancer/photographer Kelly has appeared in feature films (*The Owl and the Pussycat, Death Wish*), on the stage, and on many TV shows. Best known for her role as Pinky Tuscadero on *Happy Days,* Kelly is also a consummate photographer whose work captures the pathos and raw humanity of her subjects.

Pages 24/25

Gordon DeWitty got an early start in the music business when he became the world's youngest disc jockey in his native Seattle at age 12. Blinded by glaucoma at seven, DeWitty began learning piano and organ at 10. By 20, he was touring with soul singer Bobby Womack— playing keyboards and acting as musical director. DeWitty has written songs for reggae star Johnny Nash (for whom he produced two albums), Bill Withers, Earth, Wind and Fire, and Chaka Khan & Rufus; his work with the latter group earned him a gold record.

Biographical notes were compiled in collaboration with Roberta Ritz, Paul Grein, Lyndie White Wenner and with the assistance of Dawn L. Sinko, Kim Bastyr, Bonni Beauregard, Sue Kiel, Mahmoudah Lanier, John Shapiro, Pete Keseric, Veronica Brice and Nick Arico.

Norman Seeff and Publishers Bob and Lorie Goodman

Years ago we decided to live our dream, surrounding ourselves with state-of-the-art computer technology and software to produce world class books. At the same time, we wanted to enjoy the Hawaiian lifestyle of our rainforest home on the mountain edge of Honolulu, a city more remote from other major urban centers than any in the world. The coming of the Macintosh, and the desktop revolution it spawned, made both our dream and this book possible.

When Lorie and I were introduced to Norman Seeff in 1991, he was looking for a publisher who could reproduce the full range of his imagery. As experienced desktop publishers, we were looking for a truly extraordinary book to bridge the gap between old and new prepress technologies.

In the last few years, the art of prepress (making books ready for press) has undergone a dramatic change. I got my first glimpse of the prepress process as a staff photographer for National Geographic Magazine. *Three years taught me a lot about color reproduction, enough so that I felt comfortable about leaving the* Geographic *to publish two books of my own photography,* The Australians *and* The Hawaiians. *Although each would take four years to complete, I had the excitement of being in charge of everything: paper-making, selecting the author, editor, designer, color house, and printer; and finally marketing and promoting the books worldwide.*

The actual production, however, was done traditionally by talented craftsmen on expensive equipment, and I could only watch from a distance. Other people were making the key decisions about how the images and layouts would ultimately appear. Fortunately their caring and personal attention paid off, as both books became award-winning best sellers.

In 1985, when Richard Cohn and I co-published two books by relatively unknown photographers, I wanted to stretch the limits of excellence in traditional publishing technologies. Those books, Chris Newbert's Within a Rainbowed Sea, *and Rick Cooke's* Molokai: An Island in Time *won thirty-five national and international awards, including* Best Printed Books in America. *In the process of creating them, however, we again turned over the enormously demanding tasks of production to highly skilled professionals. While their work was superb, the cost of that quality left me yearning to find a way to once and for all take the prepress process completely in my own hands.*

My chance to do so came in 1987 when I used a MacPlus, Aldus PageMaker 1.0, and an Apple LaserWriter to produce WhaleSong, *in the words*

of the New York Times, *"The most elegant book yet created on a personal computer." In the years since then, each of my book projects has demonstrated the latest development in desktop technology. In 1991,* VOYAGERS *by Herb Kane, became the first PostScript-generated all color book. In 1993 we showed that it was possible to produce fine color quality with great speed, when we created the environmental book* In The Wake of Dreams *by Paul Berry, in just 174 hours.*

At first sight, Norman Seeff's SESSIONS! *was hands down the most complex layout for a photography book I had ever seen. I understood in my bones what a magnificent treasure these photographs were, for Norman had distilled hundreds of thousands of images into perhaps 300 layouts. Picture editing had been done by projecting the original negatives onto a laser copier; the result was a series of layouts 14 x 22 inches, each containing anywhere from one to forty images. Given Norman's talents as a designer, the speed and ease of their assembly was deceptive—it was not unusual for a layout to include dozens of images laser copied in various enlargements, then trimmed and hand-collaged to make the final spread.*

While the design process of SESSIONS! *posed a challenge for the emerging desktop technologies, I wanted to give Norman what I had given myself, a hands-on approach where every step of the book's production was tuned to his personal vision. As we scanned the orginal photographs and began building the layouts, we often discovered that we needed to make adjustments: a few degrees of rotation, a few percentage points change in size, a change in the highlights or shadows. Asking for these corrections to be done by professionals in traditional prepress would have been costly in both time and money. With the Power Macintosh and its wealth of supporting software and hardware, we had the perfect tools to deal with these tough demands.*

THE PATH TO GETTING THERE

For those of you who have never undertaken the task, creating a picture book ready for press involves many complex and demanding steps: writing and editing texts, selecting slides and/or making prints, designing the layouts, selecting type, choosing paper and binding materials, scanning the pictures, retouching, separating, sizing, assembling, first proofing, out-putting to film, proofing again and again, and finally sending off film and proofs ready for the printer.

The old saying, "A craftsman is only as good as his tools!" applies even more in the digital world of

the Macintosh, where all is linked by a common language and operating system. In a sense, the Macintosh becomes a surrogate craftsperson, executing whatever tasks you require. Marry a powerful computer and operating system with advanced software applications, and there is almost no limit to what you can produce.

THE PACE QUICKENS

We've learned that no sooner do we master one new skillset, than whole new technologies emerge. It appears that we have reached the end of one era in desktop publishing and are entering another. Dramatic new ways of reproducing images on paper are appearing: film that requires no chemistry; cameras that require no film; printing halftone images in six to twelve colors with no screen patterning; frequency modulated (stochastic) screening; and a single type design infinitely resizeable that allows blending of various type designs (Adobe's multiple master type fonts). Like you, perhaps, I find myself excited by this new technology, using words and acronyms that I never heard of a year ago, and wondering where all of this is headed.

CHOOSING SOFTWARE

With the complexity involved in assembling this book, it was critical for our various software programs to work together smoothly. To ensure this we chose the entire suite of Aldus products: Fetch, for organizing our images; FreeHand, to create our spot art; PageMaker and its many Additions, for assembling our pages; TrapWise, to trap our files; PressWise, to recreate our film in printer's spreads.

Other groups of well integrated software were also chosen: QuickScan and ColorAccess from PixelCraft; Photoshop, Illustrator, and Streamline from Adobe; Charger Suites from DayStar; Radius software like RocketShare; and the industry leading FWB drivers.

THE COMPUTERS

We now have a broad mix of models: powerful DayStar 68040 upgraded Mac II's and a IIfx; DayStar PowerPC upgraded Quadra 950's and a 900; an 840AV and 660AV, and what excites us most, the pride of our fleet, the newest PowerMac 8100/80.

To RIP (raster image process) our images for outputting to our imagesetter we chose the incredibly powerful DECpc Alpha axp150 computer. Its Alpha RISC chip blazes along at 150 MHz., so fast that it has reduced our imagesetting time from 55 minutes per spread to 25 minutes, more than doubling the productivity of our most expensive machine, the SelectSet 7000. That translates into big savings.

Digital is developing an even more powerful combination, the Sable—four of these DEC Alpha chips combined in a symetrical multi-processor array, each running at 190 MHz. RIPing large images with this much power should take only a few minutes. With symetrical multi-processors, manipulating a Photoshop image in Windows NT should be near instantaneous. DEC clearly deserves our attention.

SPEAKING OF ACCELERATION

Speed means more than just a fast computer. It involves tightly written code in prepress applications and networking software, plus well engineered monitors, video cards, CPU and Nubus accelerators, storage devices, servers, printers, and imagesetters. All contribute to getting the job done more quickly.

Perversely, the faster our tools, the more complex the tasks become. For instance, the average *SESSIONS!* CMYK file was 37 megabytes in size. Often, seven or more scans made up one spread. Here are the fastest products we know for achieving the essential tasks, profitably and without heartache.

NETWORKS AND STORAGE DEVICES

Our studio has a total of seven computers linked with Novell NetWare 3.1.1. Asanté is our Ethernet connection of choice. Our production hard drives needed to be the best available. We simply went with what everyone was saying, and chose both narrow and wide FWB Hammer drives, their 8-bit 2Gig FWB 2000 Sledge Hammer units and their 4Gig 4200 Wide DiskArray. By also using the SledgeHammer FWB SCSI-2 fast and wide Nubus accelerator cards, we sped up performance another 30-50%. On our 840AV with Apple's internal 1Gig hardrive, we copied a 56 meg file in a little over four minutes. We shaved that down to just over 40 seconds using the Sledge-Hammer and our 4200 FWB drive. Where time is money, choosing FWB products is a no brainer!

In addition we have SyQuest removables and both Sony 3.5 inch MO's and 4mm DAT mechanisms which have proven ultra reliable.

THE SAFEST STORAGE

For absolute storage peace-of-mind, we have two Hewlett Packard T1300's, bullet-proof 5.25 inch 1.3 Gig magneto optical drives that are incredibly well engineered. About twenty of these large MO cartridges provide us quick access (with absolute safety) to our entire library of *SESSIONS!* scans.

ARCHIVING WITH JOY

For archiving we use two 16G HammerDAT DDS2 tape units with self-cleaning heads. I personally recommend Desk Tape software from Optima Technologies. We get more than 8 gigabytes of data on each 90 meter Fuji DDS DAT tape. Our 4mm FUJI-FILM data cartridges are so compact that we can store all of them in a small media safe inside a larger fireproof safe. That's real peace of mind.

MONITORS AND OTHER PREPRESS SYSTEMS

Two Radius 20 inch IntelliColor display monitors are mixed with earlier Radius monitors, as are their video cards, including two of their newest "industry leading" Le MansGT cards. We leaned heavily on two twin DSP equipped PhotoBoosters for our work in Photoshop. Two Stage Two Radius Rocket boards each with a SCSI 2 daughter card increased our output from two workstations by more than 70%.

Radius continues to impress us with what we feel is the best innovative engineering and product design in the industry. They have developed a high-end prepress publishing system based on the Macintosh 950 and three Rocket Cards that we will be installing next. In our experience, a Radius PhotoBooster in a 950 is twice as fast at certain Photoshop tasks as native mode Photoshop on the PowerPC 8100.

Down the road, our CD-ROM of *SESSIONS!* will be created on the elegant Radius VideoVision Studio.

COLOR MANAGEMENT

We have DayStar Power Cache 040s in our Mac IIs, and their DayStar Charger PFS boards in one 950 and 840. While DayStar knows how to deliver raw speed with their PowerPC upgrade boards, they also provide an entire philsophy of image manipulation with their Charger Suites, PhotoMatic, and Color-Match tool sets. We can (among many other tasks) automate Photoshop routines, manipulate our images, e.g. adaptive sharpening, and color match them for output and/or display with Kodak's Precision Color Management System.

DayStar is another example of a company with superbly engineered products that really boost output.

SCANNING THE PRINTS

Ninety-five percent of the *SESSIONS!* photographs were scanned from master silver prints sized to fit the 11x17 inch bed of our 24-bit PixelCraft 7560C scanner. Toward the end of production, we installed PixelCraft's latest model, the superfast 8000, a full 32-bit professional flatbed scanner that we feel leads the world in price, performance, and image quality.

Wherever possible we use PixelCraft's QuickScan and ColorAccess software. For us, it is the finest scanning and color correction software available for the desktop. It is easy to learn, and *very* powerful.

To have an ultimate benchmark for black and white scanner quality, we asked FUJI to scan ten images for us on their $60,000+ black and white ScanArt system. A trained eye can see the difference, and we used six ScanArt scans in the book (spreads 36, 43, 60, 92, & 93). The ScanArt is unequalled in providing a myriad of built-in scanner controls that guarantee high black and white scanner productivity.

COLOR TO BLACK AND WHITE

Six pictures came to us as 35mm color transparencies. For these we chose the Howtek D4000 Scan-Master, a sophisticated drum scanner that provided the high resolution we needed for enlargements as much as 2,500%. ScanMaster images are on spreads 9, 16,17, 62 & 71. At the end of a two hour introduction, we were creating our own RGB, or high-res CMYK on-the-fly, or gray scale scans with adaptive sharpening. To operate a quality drum scanner in that short a time was like a dream come true.

QuickScan software (for the Howtek) from PixelCraft gave us an elegant interface to define and control our tonal range. Both QuickScan and Howtek's own scanning software brought us

Skin texture, shadow to highlight transitions, sharpness, grain, are digitally controllable and require testing each image by applying special tonal curves to find the best results.

All reproductions are 200 line screen duotones, a black plate angled at 45 degrees and a dark brown PMS 463 plate at 15 degrees. Duotone curves set the percentage given to each color.

Seeff's original paper layouts were photo-graphed as 4x5 positives, scanned into Photo-shop on the Howtek, and pasted into a separate channel which guided assembly of the collage.

Fifteen small video frames were scanned, balanced for tone and contrast, retouched, and then electronically merged into a two page reproduction.

Printing one color on another requires precise registration. Aldus TrapWise reads selected areas and colors to automatically spread or choke them by thousandths of an inch.

remarkably close with just default settings. Top quality still required tone adjustments for each image.

We first scanned our images for a 3% highlight and a 95% shadow dot, because we were told printers couldn't hold a 1% dot. But our printer could, so we rescanned for 0 to 100%. Final tonal range was individually created for each image by designing a custom tone curve in Adobe Photoshop. Where we wanted extra shadow detail, or extra white (blown-out) highlights, additional curves were created and applied.

DUO, TRI, OR QUAD-TONES

SESSIONS! needed to be popularly priced. Two plates for each reproduction are cheaper than three or four. They are also easier to keep in register, and require half the material costs at every step in preparation for press. We also believed that by using just one brown ink (PMS 463) and one black ink (both high density Toyo formulated inks), we could achieve top quality.

In the early stages we had a great deal of help from DuPont color expert Mark Samworth, West Coast photographer and prepress expert Steve Johnson, PixelCraft's Gary Wood and Joe and Mollie Schuld. Basically we rediscovered what everyone had told us was true—black and white reproductions are more difficult than color! In black and white, there is no place to hide. Everything depends on tonal range. Until it's right, the picture just doesn't work.

Since every photographic print was different in tone and contrast, scanning and tone correcting became a well trod path of trial and error. Designer and computer wizard Richard Osaki, worked untiringly to bring us to the point where we knew what was still needed for ultimate quality.

At that point, the project was handed over to our new Production Chief, Tony Lau, who went back to remake every spread using all that we had learned. Before this project, Tony had never created a duotone reproduction of any kind. Nor, for that matter, with all my professional photographic experience, had I. The quality achieved is a testament to the extraordinary hardware and software now available to us all, and of course to what always works when the going gets tough, perseverance.

CREATING ONE SPREAD

The print of Lily Tomlin was placed on the scanner bed. The area to be scanned, highlight and shadow points, image size, and resolution were all selected in QuickScan, before we scanned into Photoshop. Average time, 2 minutes and 20 seconds. The other images collaged on that spread were done similarly.

In Photoshop the scans were checked for dot percentages (using the screen densitometer), as well as for scanning artifacts in the deep shadows. At this point all color information was discarded and our 58 megabyte original RGB scan became 19 megabytes in grayscale. Using the master layouts supplied by the photographer, each image was resized if necessary, cropped, rotated, sharpened, despeckled, retouched, and assembled in Photoshop. Duotone curves were then applied, tweaked, and densities checked.

CREATING TEMPLATES

The photographer's layouts were projected Canon Laser copies, hand-cut and pasted together, then recopied on a large format machine. Variations in every step made it impossible for us to match layouts precisely. Each layout was re-photographed, scanned and placed in Photoshop as a transparent template to precisely guide our sizing, rotation, and placement of the scanned images.

COMING HOME TO PAGEMAKER 5.0

The final EPS Photoshop duotone spread was then brought into PageMaker 5.0, where text and other elements were added. PageMaker is the most friendly layout program imaginable. Almost transparent in its abilities, it invites us to be creative.

I type *Command Apostrophe* and I am instantly in control of my type. Click in the toolbox and I can rotate text or images at will. Click on an image and I get another control box that allows me to designate *x* and *y* coordinates for that image. The Library Palette gives me easy access to repeating graphic elements. When I go to print, again, the interface is intuitive and complete. PageMaker 5.0 isn't perfect. It is however, very, very good, and the people who created it stop at nothing to help when needed.

INLINE PROOFING

A QMS 860 Plus system (an EtherNet equipped, fast, 11x17 inch bleed, 1200 dpi printer with 32 megs of memory) made it possible for us to see our progress on paper or transparency at every stage.

With the QMS, we were able to image very large files and get a good idea of what our scanner was doing. It is fair to say that for several months before we installed our FujiProof machine, the entire *SESSIONS!* project hung on the QMS 860 Plus. Its high resolution also allowed us to proof and accurately assess the very sophisticated leading and kerning required in this book's design.

In time and materials saved, we estimate that this QMS printing system paid for itself within the first five months of the project.

DIGITAL PROOFING

Ten months before the book shipped to the printer we brought in a Scitex/IRIS 3047 inkjet printer. Properly calibrated and using the IRIS Graphic Arts ink set, the IRIS printer makes a superb digital proofing device. But our printer preferred traditional contract proofing, and so our IRIS was used for what it also excels at, creating museum quality fine art reproductions of images from *SESSIONS!*

OUTPUTTING TO THE IMAGESETTER

The PageMaker 5.0 file was printed to our SelectSet 7000 imagesetter, at 200 linescreen and 2400 dpi. The RIP we chose is called SoftPIP (for Page Image Processor) from AutoLogic. One of its many features has been a godsend, the ability to take the raster image processed file and generate a screen image of

the exact text and images as they will appear when sent to the imagesetter. On the AutoLogic SoftPIP screen, we can scroll around, examining the entire image BEFORE we commit the first inch of film. With standard hardware RIPs, no matter how powerful, we were always in the dark. SoftPIP tells us on screen *everything* that is happening.

CALIBRATION

We ran test film every morning using our AutoLogic Soft PIP and our X-Rite densitometers to maintain calibration at precise densities. On average, we held (and measured reliably) 1% to 99% dot densities. On good days, every single step on the gray scale was perfect. On the bad days, we would be off 1% on one or two steps. Even Fuji's own technicians were surprised. No special magic! Just attention to every detail, and excellent films and chemistry.

Once we had our processed films, the final step was to make proofs the printer would be asked to match. For this project we chose Fuji Color-Art, or as everyone insists on calling it FujiProof.

PRINTING FRAMES

Contract proofing today is very demanding. Stochastic screening is creating spot sizes on film that are exceptionally tiny, so small that even the best vacuum printing frames have difficulty printing the dots.

We were working with traditional screening at a modest 200 line screen. But we were also intent on highlight transitions that would depend on consistent imaging of 1% and 2% dots on film and proof.

Besides AutoLogic SoftPIP calibration controls and our daily X-Rite calibration routines, our secret weapon was our OVAC-24 from the OLEC Corporation. A compact fully enclosed vacuum and exposure frame, the OVAC-24 leads the industry and is unlike anything else in the market. With its quick and even vacuum drawdown, our Fuji CLD Wedge exposure strips consistently resolved 1% dots on Color-Art.

PROOFS FOR THE PRINTER

As a photographer, I was aware that many of my photographer friends were switching over to Fuji color films, and *Consumer Reports* was consistently ranking Fuji audio and video cassettes highly. Momentum Graphics in Cincinnati turned me on to Fuji prepress products like Color-Art and their imagesetter film and paper. When we brought it into our shop, we discovered a level of quality and ease of use beyond anything we had tried before.

The individual duotone spreads for *SESSIONS!* were proofed for the printer using a black and special Fuji dark brown to mimic the PMS 463 printing ink. So refined is this proofing technology that all emulsions receive the same exposure, the processing chemistry is mostly water with a little soap, and the final image transfers to the paper we will print on.

Color-Art is the final and indispensible step when it comes to the production of fine quality printing.

Robert B. Goodman